ALFRED SISLEY

Royal Academy of Arts, London, 3 July – 18 October 1992
Musée d'Orsay, Paris, 28 October 1992 – 31 January 1993
The Walters Art Gallery, Baltimore, 14 March – 13 June 1993

ALFRED SISLEY

edited by MaryAnne Stevens

with contributions by
Isabelle Cahn, Caroline Durand-Ruel Godfroy,
William R. Johnston, Christopher Lloyd,
Sylvie Patin, MaryAnne Stevens

Royal Academy of Arts, London
Musée d'Orsay, Paris
The Walters Art Gallery, Baltimore

Catalogue published in association with
Yale University Press
New Haven and London
1992

This catalogue was first published on the occasion of the exhibition
'Alfred Sisley'

Royal Academy of Arts, London, 3 July – 18 October 1992
Musée d'Orsay, Paris, 28 October 1992 – 31 January 1993
The Walters Art Gallery, Baltimore, 14 March – 13 June 1993

In London the exhibition is made possible by **elf** in the UK in

association with ⌒ FONDATION
elf

In Paris the exhibition is supported by Aerospatiale and IBM

Presentation of this exhibition in Baltimore is made possible in part
by IBM Corporation and the National Endowment for the Arts.

The exhibition was organised by the Royal Academy of Arts,
London, the Réunion des musées nationaux/Musée d'Orsay, Paris,
and The Walters Art Gallery, Baltimore.

The Royal Academy is grateful to Her Majesty's Government for
its help in agreeing to indemnify the exhibition under the National
Heritage Act 1980 and to the Museums and Galleries Commission
for their help in arranging this indemnity.

Catalogue designed by Sally Salvesen
Typeset by Servis Filmsetting Ltd, Manchester, in
Monophoto Bembo
Printed in Italy by Amilcare Pizzi SpA, Milan

ISBN 0 300 05245 6 (paperbound)
ISBN 0 300 05244 8 (clothbound)
Library of Congress Catalog Card Number 92-50345

Front Cover: Alfred Sisley, *The Bridge of Villeneuve-la-Garenne*,
detail (The Metropolitan Museum of Art, New York, Gift of Mr
and Mrs Henry Ittleson, Jr., 1964), photograph copyright © 1980
By The Metropolitan Museum of Art, Cat. 14.
Back Cover: Alfred Sisley, *View of Saint-Mammès* (The Walters Art
Gallery, Baltimore), Cat. 50.
Frontispiece: Alfred Sisley, *Rue de la Machine, Louveciennes*, detail
(Musée d'Orsay, Paris), © photo RMN, Cat. 19.

CONTENTS

SPONSORS

Presentation of this exhibition at the Walters Art Gallery is supported by generous grants from:

The Florence Gould Foundation
IBM Corporation
The National Endowment for the Arts

DIRECTOR'S FOREWORD

Alfred Sisley has rightly been described as 'master of the sky'. His luminous canvases reflect the artist's subtly varying responses to its condition. Sisley was considered by many of his Impressionist cohorts as the quintessential exponent of their then-revolutionary approach to painting. Now, in retrospect, we can see that his uncompromising definition of landscape as the only appropriate subject matter for painting made him the purest representative of Impressionist ideals.

Immensely popular in its day, Sisley's art has for a variety of reasons remained the least explored of all the Impressionists'. Everyone connected with the present Sisley enterprise is privileged to participate in a landmark event in the evolution of our understanding and appreciation of this great master's work. The project's combination of splendid works of art and first-rate scholarship is something in which we take particular pride.

Sisley is the result of a grand international collaboration of the Royal Academy of Arts in London, the Musée d'Orsay and Réunion des musées nationaux in Paris, and the Walters Art Gallery. To Sir Roger de Grey, President of the Royal Academy, and to Françoise Cachin and Irène Bizot, directors respectively of the Musée d'Orsay and the Réunion, we extend gratitude for assuring an ideal collaborative setting. Curators William R. Johnston in Baltimore and Sylvie Patin in Paris worked in harmonious partnership with the Royal Academy's Mary-Anne Stevens, whose effective coordination of all aspects of the project guaranteed its success. Christopher Lloyd, Surveyor of the Queen's Pictures, played an inestimable part in the realization of both exhibition and catalogue.

Such a glorious presentation of Sisley's finest works has been possible because of the generous cooperation of our many lenders, both private individuals and public institutions. We feel indebted to them for their willingness to share their pictures with an international audience.

Presentation of *Sisley* at the Walters Art Gallery is made possible by the generous underwriting of the Florence Gould Foundation, the IBM Corporation and the National Endowment for the Arts. We very much appreciate the additional support received for this exhibition from The Marion I. and Henry J. Knott Foundation. To these generous sponsor/partners we extend the Walters's and the community's gratitude.

Robert P. Bergman
Director
The Walters Art Gallery

EXECUTIVE COMMITTEE

Piers Rodgers (chairman)
Secretary, Royal Academy of Arts

Robert P. Bergman
Director, The Walters Art Gallery

Françoise Cachin
Director, Musée d'Orsay

Ann Davis
External Relations Manager, Elf Enterprise Caledonia

Allen Jones RA
Chairman, Exhibitions Committee of the Royal Academy of Arts

Pierre Provoyeur
Directeur des affaires culturelles, Fondation Elf

Norman Rosenthal
Exhibitions Secretary, Royal Academy of Arts

MaryAnne Stevens
Librarian and Head of Education, Royal Academy of Arts

Annette Bradshaw
Deputy Exhibitions Secretary, Royal Academy of Arts

EXHIBITION COORDINATORS
William R. Johnston, *Associate Director, The Walters Arts Gallery*;
Christopher Lloyd, *Surveyor of the Queen's Pictures*; Sylvie Patin,
Conservateur-en-chef, Musée d'Orsay; MaryAnne Stevens, *Librarian
and Head of Education, Royal Academy of Arts*

ASSISTANT COORDINATOR
Susan Thompson

TRANSLATORS
David Britt, Ros Schwartz

CATALOGUE ASSISTANTS
Sara Gordon, Jane Martineau

BIBLIOGRAPHY
Juliet Simpson

PHOTOGRAPHIC COORDINATOR
Miranda Bennion

MAPS
Judith Christie

EDITORIAL NOTE

All works are in oil on canvas. Dimensions are given in centimetres to the nearest 0.5 cm; height precedes width.

Abbreviations: b = bottom; t = top; l = left; r = right.

References in the text and at the foot of the entries refer to the Bibliography.

The standard work of reference for Alfred Sisley's paintings is François Daulte, *Alfred Sisley. Catalogue raisonné de l'oeuvre peinte*, Lausanne, 1959. Works listed there are referred to by their catalogue number preceded by 'D'. Works by Sisley not listed by Daulte are referred to as 'non-D'.

Titles of paintings are given as in the catalogue raisonné; where new research has justified a change of title, the 'D' reference is followed by Daulte's title placed in parentheses.

Catalogue entries are signed with the following contributors' initials:

S.P. Sylvie Patin
MA.S. MaryAnne Stevens

W.R.J. William R. Johnston
C.L. Christopher Lloyd

ACKNOWLEDGEMENTS

The exhibition organisers particularly wish to thank François Daulte for his invaluable contributions to the study of Sisley and the preparation of this catalogue. In addition they would like to thank the following people for their advice and support:

Lucie Abadia, Michael D. Abrams, William Acquavella, Mrs Hortense Anda-Bührle, Alex Apsis, Nicole and Philippe Arbel, Françoise Balland, Françoise Balligand, Armelle Barré, Bernard Barryte, Timothy Bathurst, H.E. C.C.R. Battiscombe, William Beadleston, Caroline Benzaria, Malika Bouabdellah, Field Marshall Lord Bramall KG GCB OBE MC, Daniel Bretonnet, Roger Bretonnet, Dr Richard Brettell, Mr Brochard, Harry A. Brooks, Laura Catalano, Philippe Cazeau, Martine Clément, Melanie Clore, Luci Collings, Philippe Comte, Dr Philip Conisbee, Henry-Claude Cousseau, Edwin L. Cox, Marie-Laure Crosnier-Leconte, Pierre Curie, Alain Daguerre, France Daguet, Laure de Margerie, Mme Eliane de Wilde, Thierry de Ganay, Melissa de Medeiros, Peter Dejonger, Anne Distel, Mohammed Djehiche, Miss Doizy, Douglas Druick, Patrick Dupont, Jean Edmonson, Anne-Marie Esquirol-Labit, Dr Manfred Fath, Dr and Mrs Walter Feilchenfeldt, Mrs Ferrat, Dr Hanne Finsen, J. Bogouin Fleury, Dr William H Gerdts, Mr Godoretoski, Lynne Green, Gloria Groom, Véronique Guilton, Frances Haslehurst, Dr Phyllis Hattis, Margot Heller, Jacqueline Henry, Dr Peter C. Hobbins, Thilo Hoffmann, Dr John House, Franz Jayot, Guy Jennings, Dr Flemming Johansen, Sona K. Johnston, Mr and Mrs Paul Josefowitz, Annick Joustra, Suzanne Julig, Raymond Keaveney, Geneviève Lacambre, Fred Lachize, Madeleine Lachize, Jean-Pierre Lajaunie, Maître Lancelin, Solange Landau, Jacques Laÿ, Monique Laÿ, Dr Helmut R. Leppien, Mrs Fernand Leval, Mrs Janice Levin, Mr and Mrs I. Levy, Lucy Longworth, Dr Ulrich Luchkardt, Mrs Massai, Nathalie Maury, Werner and Gabrielle Merzbacher, Olivier Morel, Mrs S. Mossbacher, Jens Peter Munk, John Myers-cough, Cynthia Nakamura, Dr Peter Nathan, Richard Nathanson, Lady Neil, Lady Rupert Nevill, Sasha M. Newman, John Nicoll, Monique Nonne, Danièle Oger, Martha Parrish, Michele Peplin, Ivan Phillips, Joachim Pissarro, William W. Priest Jnr, Timothy Pringle, Nicholas Reed, J. M. Regnault, Dr Joseph Rishel, René Roesch, Anne Roquebert, Francesca Rose, Sylvette Roussel, James Rowndell, Jacques Rufin, Sally Salvesen, Patrice Schmidt, Robert Schmit, Manuel Schmit, Dr Douglas G. Schulz, Susan Seidel, Mr Septières, Dr Lewis I. Sharpe, Kazuko Shiomi, Richard Shone, Juliet Simpson, Michel Strauss, S. Martin Summers, Dr Peter Sutton, Brendt Sverdloff, Mr and Mrs Swanholm, Dominic Tambini, Anne Thorold, Jarmo Valtonen, Brita Velghe, Claus-Dieter Werneyer, Ully Wille, Dr Jörg Wille, Heather Wilson, Wolfgang Wittrock, Michael Wivel, Dr and Mrs Hubert Wolfer, Mr and Mrs David Wood, Dr Michael Wynne, Dr Eric M. Zafran, Dr H. J. Ziemke

They are also particularly grateful to Monsieur René Roesch, President of Les Amis de Sisley, for his untiring support for this project and for his investigations in the Municipal and Departmental Archives. They would also wish to thank Monsieur Septières, Mayor of Moret-sur-Loing, Mr Ray Beaumont-Craggs, Monsieur Brochard and Monsieur Rufin, members of the Association des Amis de Sisley, for their assistance and warm welcome at Moret-sur-Loing.

LENDERS TO THE EXHIBITION

and other owners who wish to remain anonymous

BRIEF CHRONOLOGY

1839: 30 October, birth of Alfred Sisley in Paris, of British parents

1857–59: sent to London to prepare for a career in commerce; visits museums and art galleries, and apparently studies the work of British landscape painters, notably Constable

1860: enters Gleyre's studio through an introduction from Bazille; meets Monet and Renoir

c.1862: visits the countryside around Paris, especially the Forest of Fontainebleau, on sketching trips in the company of Renoir and Bazille

1865: works at La Celle-Saint-Cloud (see Cat. 2, 3, 6)

1866: early Spring, staying at Marlotte with Renoir and Le Coeur; has two paintings accepted by the Salon (see Cat. 4, 5).

1867: working with Renoir and Bazille (see Cat. 7); rejected by the Salon; his mistress, Eugénie Lescouezec, gives birth to their first child, Pierre

1868: one painting accepted by the Salon (see Cat. 6)

1869: birth of their second child, Jeanne

1870: two paintings accepted by the Salon (see Cat. 9); Franco-Prussian War – destruction of Sisley's studio at Bougival

1871: moves to Voisins-Louveciennes, where he stays until early 1875; paints at Louveciennes, Argenteuil, Villeneuve-la-Garenne, Port-Marly and Bougival (see Cat. 10–23, 30, 31)

1872: first direct sales to Paul Durand-Ruel; exhibits for the first time in London

1874: exhibits at Ist Impressionist Exhibition

1875: moves to Marly-le-Roi, where he stays until 1878; paints at Marly-le-Roi and Port-Marly (see Cat. 32–42), and at Louveciennes (see Cat. 46)

1876: exhibits at 2nd Impressionist Exhibition

1877: exhibits at 3rd Impressionist Exhibition

1878: moves to Sèvres; paints along the River Seine at Saint-Cloud, Sèvres and Billancourt (see Cat. 44, 45)

1879: rejected by the Salon

1880: moves to Veneux-Nadon, near Moret-sur-Loing; paints at By, Saint-Mammès (see Cat. 47, 48; 49–52)

1881: exhibits at offices of *Le Gaulois* and *La Vie Moderne*

1882: moves to Moret-sur-Loing; exhibits at 7th Impressionist Exhibition

1883: moves to Les Sablons; exhibits for the first time in the United States (Mechanic's Building, Boston)

1886: moves to Veneux-Nadon; makes final direct sale of work to Durand-Ruel

1887: works included in the 6th International Exhibition at Galerie Georges Petit

1888: one-man exhibition at Galerie Georges Petit, Paris; painting purchased by the State

1889: finally settles in Moret-sur-Loing, where he lives until his death; invited to exhibit at Les XX, Brussels

1890: exhibits at the 7th Les XX exhibition, Brussels, at the Salon du Champ-de-Mars, at Georges Petit's International Exhibition and for the first time at the 'Exposition des Peintres-Graveurs'

1891: exhibits at the 8th Les XX Exhibition, Brussels, the Salon du Champ-de-Mars and the International Exhibition at Georges Petit; breaks with Durand-Ruel, Georges Petit becomes his main dealer; Georges Lecomte publishes article on him in *l'Art dans les deux mondes*

1892: exhibits at the Salon du Champ-de-Mars; Vollard exhibits a work

1893: exhibits at the Salon du Champ-de-Mars; long article on Sisley published by Adolphe Tavernier in *l'Art français*

1894: exhibits at the Salon du Champ-de-Mars; stays in Normandy (see Cat. 72)

1895: exhibits at the Salon du Champ-de-Mars

1896: exhibits at the Salon du Champ-de-Mars

1897: has major one-man show at Galerie Georges Petit, Paris; visits S.W. England and the South Coast of Wales – marries Eugénie Lescouezec in Cardiff; article published on him by Tavernier in *Le Figaro*; health of both him and his wife becomes increasingly precarious

1898: exhibits at the Salon du Champ-de-Mars; death of his wife (8 October)

1899: dies 29 January of cancer of the throat; buried at Moret on 1 February, attended by Renoir, Monet, Cazin and Tavernier; atelier sale held at Galerie Georges Petit, 29–30 April; obituary by Julien Leclercq published in *Gazette des Beaux-Arts*

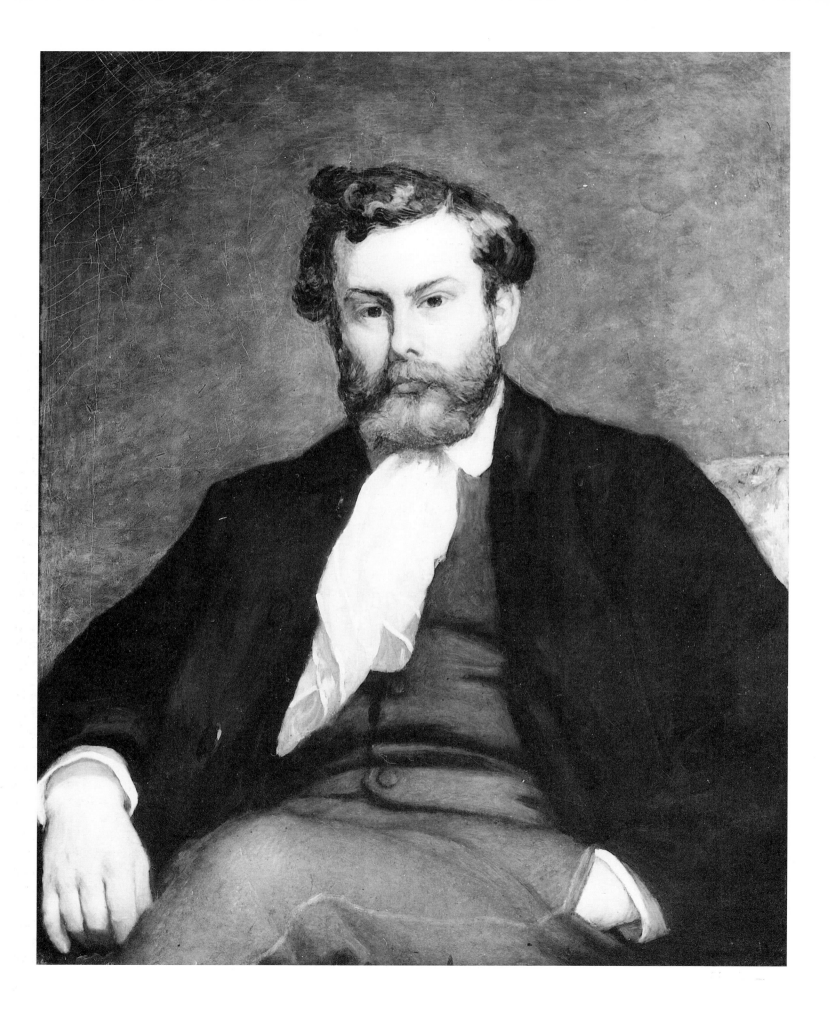

Christopher Lloyd

ALFRED SISLEY AND THE PURITY OF VISION

A Cézanne is a moment of the artist while a Sisley is a moment of nature

Henri Matisse[1]

On 24 February 1895 Camille Pissarro wrote poignantly and prophetically to his son, Lucien: 'No, like Sisley, I remain in the rear of the impressionist line'.[2] While recent scholarship has begun to recognise Pissarro's rightful place in the history of Impressionism, no such assessment of Sisley has yet been forthcoming. The publication of Daulte's catalogue raisonné of the artist's paintings in 1959 provided an indispensable work of reference, but it did not immediately serve as a catalyst or alter the dynamics of writing about Sisley. Indeed, since the artist's death, there has only been a handful of short monographs, intermittent articles, and a few relatively small exhibitions of varying quality held at sporadic intervals (see Bibliography). The quality of the secondary material on Sisley is symbolised by the absence of a penetrating critical study or any tradition of sustained research.

A more serious handicap is the lack of a significant body of primary material in the form of private papers, correspondence or records of financial transactions involving the purchase of artists' materials and the sale of work. It would be unwise to assert if, or to what extent, this paucity of primary and secondary sources has led to the marginalisation of Sisley, but it remains undoubtedly true that in the seminal studies on Impressionism by John Rewald and more recently by Robert Herbert, Sisley is treated perfunctorily. This situation, when compared with the deluge of literature on the other Impressionists and the frequency with which exhibitions of their work are organised, prompts the question as to why Sisley has been so consistently ignored.

The answer may lie partly in the matter of national identity. Sisley was born in Paris to parents of English descent and the artist himself retained British citizenship throughout his life, even though in later life he twice attempted to acquire French nationality.[3] Sisley's family, however, was markedly Anglo-French. His father, William, had by 1839 established a business in Paris. Alfred married a French woman and was bilingual. Yet, for some strange reason this split nationality has created, perhaps unconsciously, an artistic ambiguity and an uncertainty of allegiance. Sisley himself, for example, seems to have been unclear at the outset of his career to which landscape tradition he adhered – the English or the French. George Moore stated that he could even observe such distinctions in Sisley's work: 'Monet's art is colder, more external, and those who like to trace individual questions back to race influence, may, if they will, attribute the exquisite reverie which distinguishes Sisley's pictures to his northern blood'.[4]

Such a proposition can hardly be seriously defended; but it is nonetheless true, in practical terms at least, that, as in the more complicated issue of Pissarro's origins, the reluctance to pigeon-hole Sisley as French or English may have

5

deterred rather than encouraged people from championing the artist.

The question of identity has been exacerbated by what little is known about Sisley as a person. His movements, which are such an important indication of his artistic impulses, can be charted fairly precisely, but the comparatively few, usually brief, letters that have survived provide little insight into character or interests.[5] What the letters do reveal is the constant shortage of money, the persistent difficulty in selling work, the desperate attempts to cultivate collectors, the humiliating requests for financial loans, and the determination to keep feelings of failure at bay while Monet, Renoir and Pissarro began to reap financial gains, especially during the 1890s. Sisley only achieved limited success and little recognition during his lifetime. His plight as an artist was intensified during his later years by the onset of illness. Both the painter and his wife, whom he finally married in 1897 while on a visit to South Wales, died of cancer: his wife, Marie, of cancer of the tongue in October 1898, and the artist, who during the mid-1890s contracted cancer of the throat, only a few months later, early in 1899. The final short letters to his doctor, the collector Dr George Viau, are intensely moving in the context of Sisley's struggle as an artist.[6] Yet, we know from contemporary accounts – notably Renoir's – that the painter had a particularly captivating personality reflected in the apparent love of music, epitomised by his reportedly long-lasting enjoyment of the trio from the Scherzo of Beethoven's septet.[7] Portraits by Renoir (Figs. 1, 2), either of Sisley with his wife or in the company of others, and by Marie Braquemond (Fig. 3) of the artist and his wife capture some of the happier moments before anxiety and illness overcame them. Yet, even if in private Sisley despaired of his wretched state and pitiful circumstances, he rarely revealed his feelings to others. Gustave Geffroy visited Sisley not long before the artist's death and recorded:

> That marvellous day, perfect in its ambience of welcome and friendship, has for me remained marked by the premonition of an ageing artist who sensed that during his lifetime, no ray of glory would shine upon his art . . . Yet everything

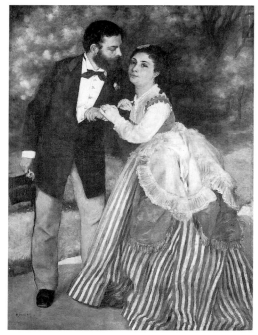

2 Auguste Renoir, *Portrait of Alfred Sisley with his Wife*, 1868 (Wallraf-Richartz Museum, Cologne).

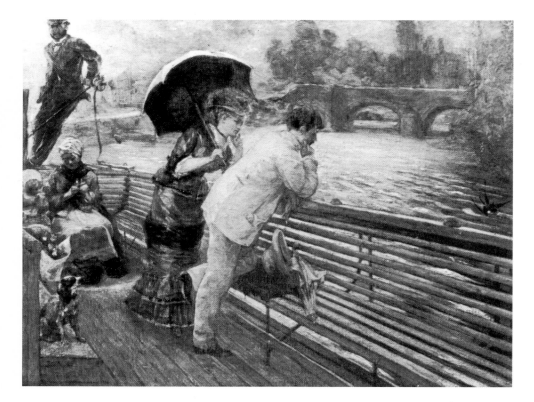

3 Marie Braquemond, *On the Steamer (Alfred Sisley and his Wife)* (Private Collection, Paris).

was magnificent, and harmonious. We spent the morning in the studio and after lunch everybody took charabancs to Moret, the banks of the Loing, and the Forest of Fontainebleau where Sisley, acting as master of ceremonies, spoke with unforgettable charm.[8]

Such rare glimpses of Sisley's personality have therefore meant that with him, more than with other nineteenth-century artists, the character of the man can only be found today in his paintings. These, however, appear to be diametrically opposed to his situation for, as in the words of Théodore Duret, they appear to express 'the smiling mood of nature'.[9]

The failure to find a satisfactory approach to Sisley's paintings, resulting in part from the undeniably variable quality of his output, has posed major difficulties when attempting to evaluate the true nature of his achievement. To be sure, such uncertainty about his artistic gifts emerges early in the critical history of his career. In 1874, for example, Jean Prouvaire, referring specifically to Sisley's six paintings shown in the first Impressionist exhibition, confessed that 'in general we only moderately admire Sisley's paintings'.[10] A comparable lack of enthusiasm was evoked by R. H. Wilenski, who published an article in 1928 entitled 'The Sisley Compromise'. He argued that the artist was too advanced for his contemporaries, but not radical enough for us today:

> Sisley, in fact, when all is said and done, was a minor artist. His pictures are charming; but one-third of their content comes from Corot and the romantics, one-third from Pissarro and Monet, and one-third only from the artist himself. Sisley fused the elements with great discretion. He was never sensational or vulgar. He kept the tones and planes in excellent relation. He had sensibility, good taste and pictorial tact. But he was not a great original master – he was not a Monet, a Seurat, a Degas, or a Renoir.[11]

A considerable amount of early writing on Sisley both during his life and after his death – but not quite all of it, as will be seen – is in this vein. Now, however, that our understanding of Impressionism as a movement is broader and our knowledge of its individual artists somewhat more considered it is easier to appreciate the character of Sisley's work. The contextual analysis of Impressionist painting, for example, poses questions about Sisley's choice of subject-matter and locations. Similarly, the varied facture that can be detected within his oeuvre raises issues about the distinction between a highly finished painting and the rapidly executed and seemingly unfinished sketch. This distinction, like the treatment of subject-matter, is evidently related to the necessity of selling paintings in different outlets such as the Salon as opposed to independent exhibitions, a division of taste that is mirrored in the affiliations of individual dealers. It is possible now, therefore, to adopt an approach that is more likely to reveal the distinctive qualities of the paintings and to identify their significance both in terms of Impressionism and the French landscape tradition as a whole. Indeed, as early as 1900 Camille Mauclair had sensed the need for a proper assessment of Sisley's career after viewing the Centennial Exhibition in Paris:

> Sisley was a veteran of Impressionism. At the exhibition . . . in the two rooms reserved for the works of this School, there were to be seen a dozen of Sisley's canvases. By the side of the finest Renoirs, Monets and Manets they kept their charm and their brilliancy with a singular flavour, and this was for many critics a revelation as to the real place of this artist, whom they had hitherto considered as a pretty colourist of only relative importance.[12]

The fascination of Sisley's art is that unlike his associates, who during the course

4 Alfred Sisley, *Portrait of the Artist's Children. La Leçon*, c.1872, D19 (Private Collection, Dallas).

of their careers radically reconsidered the fundamentals of their art, he remained an avowed Impressionist. For many writers this appears to have been a weakness, but such an interpretation underestimates the significance of Sisley's paintings dating from the 1880s and 1890s and dismisses them as inconsequential attempts to tackle the same issues of composition and colour as Monet or Renoir during those same decades. The result of such a conclusion is to isolate Sisley unjustifiably just at the moment when, by resolving the tensions within Impressionism, he was making his own distinct contribution to the French landscape tradition. As Cézanne once wrote to Roger Marx: 'To my mind one does not put oneself in place of the past, one only adds a new link'.[13] Pissarro, who described Sisley as 'a great and beautiful artist, in my opinion he is a master equal to the greatest',[14] had cause by the end of his life to discuss the matter with the young Matisse. 'What is an impressionist?' Matisse asked Pissarro. 'An impressionist is a painter who never paints the same picture, who always paints a new picture', replied Pissarro, having vouchsafed that 'Cézanne is not an impressionist painter because all his life he has been painting the same picture. He has never painted sunlight, he always paints grey weather'. This prompted Matisse to ask, 'Who is a typical impressionist?' In his answer Pissarro nominated a single artist – Sisley.[15]

Sisley became an artist only after a certain hesitation. He was sent by his family to London in the spring of 1857 for the purpose of training for a career in business and was committed to this course of action for four years. It was, therefore, not until 1860 after returning to Paris that he abandoned his career in business and entered the studio of Charles Gleyre (1806–74). When Gleyre's studio finally closed down in March 1864, although Sisley was by now intent upon becoming an artist, he was cushioned against the financial hardships by his family's successful business ventures. This state of affairs was to change dramatically in 1870–71 with the outbreak of the Franco-Prussian war which caused his father's financial ruin and eventual death, leaving Sisley with a common-law wife and two small children to support (Fig. 4). It was no doubt at this moment that the reality of his

decision to become an artist impinged most forcibly upon him; for the rest of his life he was obliged to live by his paintings.

The circumstances of Sisley's decision to become a painter make it difficult to assess his prime artistic allegiances. It is often stated that while in London he was much inspired by the works he could have seen in the National Gallery where in 1857–59 paintings by English artists such as Gainsborough, Constable, Turner and Crome, as well as works by Dutch and Flemish artists like Hobbema, Koninck, Ruisdael and Rubens, were on view.[16] It is reasonable to imagine that these painters could well have appealed to Sisley at this early stage, given his later proclivities as a landscape painter. He subsequently told Adolphe Tavernier that among artists he particularly admired were 'all those who loved and had a strong feeling for nature'.[17] The validity of such a statement can only be tested in general terms taking Sisley's oeuvre as a whole. Unlike his fellow Impressionists, who to a greater or lesser extent applied themselves to figure subjects, he showed a marked preference for landscape painting. Thus, there are at most stages of his development undeniable affinities in paint texture with Koninck, Gainsborough and Constable; in palette with Turner, and in compositional clarity with Hobbema and Ruisdael. Either few works from Sisley's early years appear to have been painted or few have survived. Possibly this was due to the lack of the spur of financial necessity, or else the artist was simply not prolific at this stage of his life. However, there is one work which is particularly revealing – *Avenue near a small Town* (Cat. 1) dating from *c*.1865. The influence of artists such as Corot and Rousseau can be detected in this early painting as regards subject, composition and technique, but the example of Constable is even more pervasive. The attention to closely observed details, as in the flowers in the foreground or the fencing on the right, the flickering light, and the varied texture of the surface betokens the effect of Constable's great essays in landscape painting, on whatever scale (Figs. 5, 6). In a much-quoted letter to John Fisher describing a fishing expedition his friend and patron had made to the New Forest in Hampshire, Constable remarked,

> How much I can Imagine myself with you on your fishing excursion in the new forest, what River can it be. But the sound of water escaping from Mill dams, so do willows, Old rotten Banks, slimy posts or brickwork. I love such things – Shakespeare could make anything poetical – he mentions 'poor Tom's' haunts among *Sheep cots* – & *Mills* – the Watermist & the Hedge pig. As long as I do paint I shall never cease to paint such Places. They have always been my delight – . . . But I should paint my own places best – Painting is but another word for feeling.[18]

The impact of *Avenue near a small Town* is similarly cumulative, just as in Constable's paintings the figures are enfolded within the landscape, emphasising man's unity with nature.

Sisley, who rarely at any stage of his working life closely defined the activities of his figures within the landscape, appears in this early painting to be emulating Constable's heightened and all-inclusive response to his surroundings. The landscape is virtually catalogued for the viewer as if seen through a magnifying glass, although without any distortion or alteration of focus. Constable had an additive approach to landscape, the importance of this being the refusal on point of principle to exclude anything. It was not an analytical approach, such as emerged towards the middle of the nineteenth century in France when artists stalked the landscape in search of fresh motifs, that resulted in a more accurate or truthful observation of nature achieved by a closer examination of its constituent elements. Where Constable gazed at one particular landscape with an unerring intensity from a fixed position, the Impressionists moved around and through the

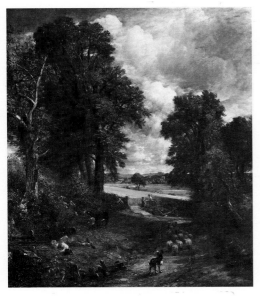

5 John Constable, *The Cornfield*, 1826 (National Gallery, London).

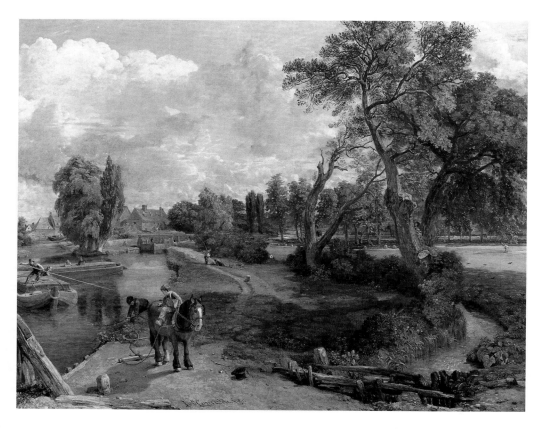

6 John Constable, *Flatford Mill*, 1817 (Tate Gallery, London).

landscape exploring motifs in sequence or rotation, shifting their viewpoints and selecting different juxtapositions. French artists had been alert to Constable's experience since the 1820s and Sisley would have been more fully exposed to his work than his French contemporaries while in London either at the National Gallery or at the South Kensington Museum. He may have read the early biography of Constable by C. R. Leslie. Constable's attention to the variety in the landscape may also have interested Sisley – rushing skies, changing moods and shifting light – and the facture where there seems to be almost a direct relationship between the texture of the paint and the character of the landscape itself. Towards the end of his life Sisley discussed with Tavernier what he termed the 'animation of the canvas', declaring that, 'To give life to the work of art is certainly one of the most necessary tasks of the true artist. Everything must serve this end: form, colour, surface'.[19] The articulation of the surface was a most important aspect of Sisley's paintings. He told Tavernier:

> You see that I am in favour of a variation of surface within the same picture. This does not correspond with contemporary opinion, but I believe it to be correct, particularly when it is a question of rendering a light effect. Because when the sun lets certain parts of a landscape appear soft, it lifts others into sharp relief. These effects of light, which have an almost material expression in nature must be rendered in material fashion on the canvas.[20]

This concern for surface texture became one of the main features of Sisley's paintings during the 1880s and 1890s.

For Sisley, as indeed for other Impressionists, light was the principal agent, but the source of light and its changing effects was the sky, which the artist, again inviting comparison with Constable, insisted was 'never merely a background'.[21] According to Sisley: 'Not only does it give the picture depth through its successive planes (for the sky, like the ground, has its planes), but through its form, and

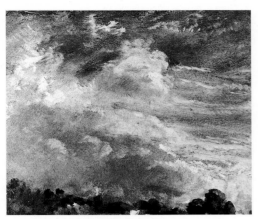

7 John Constable, *Cloud Study*, c.1821
(Royal Academy, London).

through its relations with the whole effect or with the composition of the picture, it gives it movement ...'(see Cat. 34).[22] The skies in the majority of Sisley's mature paintings fulfil that function superlatively well, as contemporary critics like Mallarmé and Mauclair observed. Although he seems not to have made cloud studies as Constable did (Fig. 7), his comments to Tavernier parallel those of the English artist, who wrote in a letter to John Fisher on 23 October 1821,

> It will be difficult to name a class of Landscape, in which the sky is not the '*key note*', the *standard of 'Scale'*, and the chief '*Organ of Sentiment*' ... The sky is the '*source of light*' in nature – and governs everything. Even our common observations on the weather of every day, are suggested by them but it does not occur to us. Their difficulty in painting both as to composition and execution is very great, because with all their brilliancy and consequence, they ought not to come forward or be hardly thought about in a picture ...[23]

It is, as regards this last point – the balance between the sky and the rest of the composition – that Sisley can sometimes be faulted, usually as a result of painting the clouds too forcefully or too sketchily. However, it is, in the final analysis, not just the acknowledgement of the importance of the sky in a painting that establishes a correlation between Constable and Sisley, but the appreciation of similar subjects – river banks, locks, mills, barges and boatyards. In short, Sisley's love of such places as Saint-Mammès and Moret-sur-Loing to the south-east of Paris on the edge of the Forest of Fontainebleau evokes comparisons with Constable's favourite subjects in Suffolk.

Whatever clues to artistic procedure Sisley had managed to glean for himself in London between 1857 and 1859, the tuition that he received in the studio of Charles Gleyre gave him a firm sense of direction. Gleyre was Swiss by origin and had come to Paris during the 1820s to study at the Ecole des Beaux-Arts. Always a difficult, brooding character, Gleyre travelled in the Middle East during the 1830s and subsequently benefited after returning to Paris from the support of Paul Delaroche. His reputation was made by the exhibition at the Salon in 1843 of a mysterious almost symbolist painting entitled *Les Illusions perdues*. He is a difficult artist to characterise, being allied to academic tradition on the one hand by working in a restricted, highly finished style, and to independent tendencies on the other. His pupils, who included Whistler, Monet, Bazille and Renoir, in addition to Sisley, learnt from him the craft of painting with its emphasis on technique and preparation. Yet, at the same time he encouraged 'the development of his pupils' original aptitudes'.[24] Those Impressionists who entered Gleyre's studio during the early 1860s did so in the belief that it might lead to academic and commercial success, but, in so far as it allowed them the freedom to develop their own artistic personalities, Gleyre helped to nurture the Impressionist style. The appreciation of the significance of landscape and the importance attached to drawing from memory, or the study of the model out of doors, clearly encouraged the artistic tendencies of Monet, Renoir and Sisley, but the established procedural training involving *études* and *ébauches*, as well as the preparation of the palette, provided these nascent Impressionists with the practical means to develop their own highly individual and revolutionary techniques. Gleyre is a paradox. It has been remarked that he reflected the most advanced ideas of his period. He stressed composition in the form of sketches and encouraged pupils to paint outdoors and make landscape studies. He laid great emphasis on originality and inculcated in his pupils the need for a personal expression. Although he did not depart from the basic framework established by his predecessor, Delaroche, he seems to have shifted the emphasis of particular elements of the programme.[25]

Sisley's oeuvre during these years in Gleyre's studio and the immediate aftermath includes such pictures as *Avenue of Chestnut Trees at La Celle-Saint-Cloud* (Cat. 2, 3) and *Avenue of Chestnut Trees near La Celle-Saint-Cloud* (Cat. 6). In these paintings Sisley is still adhering to the example of the Barbizon School, but the bolder handling of paint, the stronger contrast of light and shade, the more varied brushstrokes and the richer, darker tonal qualities all belie the more direct approach to painting adopted in these years by Monet, Renoir and Bazille. It is a style that reflects Courbet's, but lacks the robustness of his compositions and technique.

8 Paul Cézanne, *House of the Hanged Man*, 1873–74 (Musée d'Orsay, Paris).

Two paintings dated 1866 were exhibited in the Salon of that year (Cat. 4, 5). Both depict scenes in the small village of Marlotte to the south of Fontainebleau where Sisley painted with Renoir while Monet and Bazille worked at the nearby village of Chailly-en-Bière on the edge of the Forest of Fontainebleau. These two paintings by Sisley are of considerable importance not only in the development of his own style but for Impressionism as a whole. They play a similar role in the artist's oeuvre to the views of L'Hermitage in Pontoise by Pissarro dating from 1867–68. The compositions reveal a painter of considerable control and power. The sharp edges of the buildings and the silhouetting of roof lines against the sky denote a sense of design that is almost prismatic in its tautness, relieved only by patches of open foreground or by the distribution of light. The range of tones extending from ochre and grey to deep chocolate brown offset by patches of brighter local colours (pink, yellow, blue) is evidence of Sisley's potential as a colourist. The spatial organisation of these pictures is even more remarkable, and the precision of the brushwork heightens the visual effect. Both works are indebted in part to Daubigny and stand at the threshold of Sisley's emergence as an Impressionist painter. Beyond that, it is no exaggeration to make comparison with certain paintings by Cézanne (Fig. 8) dating from the 1870s while he was working closely with Pissarro, or even with youthful works by Matisse.

Sisley's association with Impressionism can in one sense be expressed as a set of statistics. He exhibited at the first (1874), second (1876), third (1877) and seventh (1882) exhibitions, on which occasions he included five, eight, seventeen and twenty-seven paintings respectively. If anything, these figures reveal the tensions that became evident among the Impressionists as the habit of group exhibitions evolved. A fragile sense of unity prevailed during the arrangement of the first three exhibitions, but lack of critical acclaim and success, coupled with changes of emphasis gave the remaining five exhibitions a greater variety. The fourth (1879), fifth (1880) and sixth (1881) exhibitions were increasingly dominated by the influence of Degas, with the result that the significance of figure painting overtook that of landscape painting. Only an artist such as Pissarro, who exhibited in all eight exhibitions, could maintain a convincing balance between these two types of painting. New, younger artists were introduced to the group at the time of the fifth exhibition, while painters such as Cézanne, Renoir, Monet and Sisley gradually withdrew. Monet only exhibited at the fourth exhibition with extreme reluctance, whilst Renoir and Sisley decided to seek success at the Salon. In the same year Sisley wrote to Duret:

> I am tired of vegetating, as I have been doing for so long. The moment has come for me to make a decision. It is true that our exhibitions have served to make us money and in this have been very useful to me, but I believe we must not isolate ourselves too long. We are still far from the moment when we shall be able to do without the prestige attached to official exhibitions. I am therefore determined to submit to the Salon.[26]

9 Antoine Chintreuil, *L'Espace*, Salon of 1869 (Musée d'Orsay, Paris).

Unfortunately, Sisley was rejected by the Salon jury. The seventh exhibition, to which Sisley through Durand-Ruel sent the largest representation of his work to date (27 paintings), saw another development. Degas and his followers, such as Rouart and Raffaëlli withdrew. Renoir and Monet joined Sisley and Pissarro in an exhibition that was supported generally by the dealer Durand-Ruel and 'provided, despite its serious exclusions, an otherwise unavailable forum for a collective demonstration of the most advanced, thoughtful, and experimental art being produced at the time'.[27] The final exhibition – the eighth, which was held in 1886 – included younger artists like Seurat and Signac, as well as marking the return of Degas. There were no works by Renoir, Monet or Sisley, and their absence was significant.

During the early years of the 1870s Sisley executed paintings (see Cat. 10–23) that can be described as being specifically Impressionist in terms of compositional procedure, style and subject-matter. Broken brushstrokes, sometimes applying pure colour, form the stylistic basis of these paintings which were no doubt made 'sur le motif'. During the early 1870s, the brushstrokes are characterised by a breadth and suppleness whereby, although the marks themselves are varied, the visual effect is one of evenness. Similarly, the tonality of these paintings is satisfyingly bright, on occasions resembling that of pictures by Chintreuil such as

10 Jean-Baptiste Camille Corot, *Volterra, View of the Town*, 1834 (Musée du Louvre, Paris).

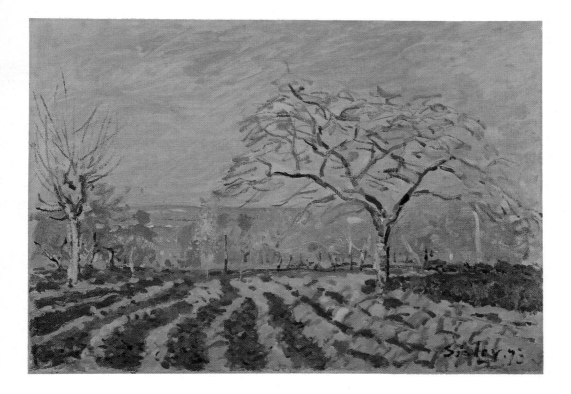

11 Alfred Sisley, *The Furrows*, 1873, D65 (Ny Carlsberg Glyptotek, Copenhagen).

12 Detail of Fig. 11, showing the underdrawing.

13 Detail of Cat. 22, *Street in Ville d'Avray*, showing the underdrawing.

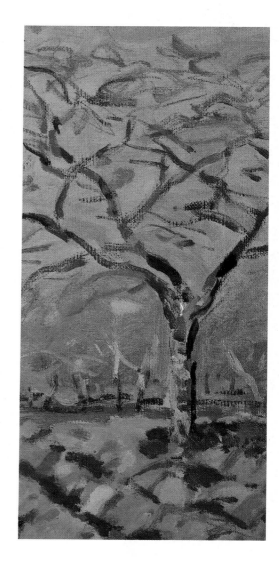

l'Espace (Fig. 9). Sisley seems to have preferred painting in this manner directly onto the canvas throughout his life, making relatively few modifications in the studio. The evidence of letters and the surfaces of the paintings themselves make it clear that Sisley drew in outline straight onto the primed canvas (sometimes marked up with framing lines) either in black chalk or with blue paint (Figs. 11–13). He continued working in the open air bringing the picture to the required degree of finish in accordance with the particular moment or instant that he was painting. This emphasis on the *étude* made *en plein air* that Sisley, Monet and Renoir inherited from French landscape painters of the early nineteenth century and would have learned more about in Gleyre's studio, was here being adapted to a new purpose, namely the recording of the artist's *sensations* before nature on a larger scale than was usual for a finished work. Sisley's methods do not seem to have changed much over the decades: his technique and sense of colour altered profoundly, becoming increasingly complicated, but his preparatory and compositional procedures essentially remained the same. Like Monet, Sisley rarely made preparatory drawings or studies, and those that are known served no consistency of purpose. The one sketchbook that has survived was in fact used by the artist as a *livre de raison* during the early 1880s to record his compositions after they were painted, as Claude Lorrain had done in his *Liber Veritatis*.[28]

The group of paintings by Sisley dating from the 1870s are subject to the strictest pictorial organisation. It is this compositional aspect, in addition to their facture that makes these pictures, in comparison with landscapes by artists of the Barbizon School, specifically modern. Sisley incorporates an almost relentless array of horizontals, verticals and diagonals deployed as plunging perspectives and flat bands of planar divisions (see Cat. 14, 19, 20). The origins of such a style can be found in seventeenth-century French painting carried forward through Henri-Pierre Valenciennes to neo-classical landscape painting culminating in the Italian landscapes of Corot (Fig. 10) dating from the 1820s. Yet Sisley, more so in many cases than even Pissarro and Monet, was more radical than any of his sources, since he seeks to bring order to a world in an ever increasing state of flux. The depiction

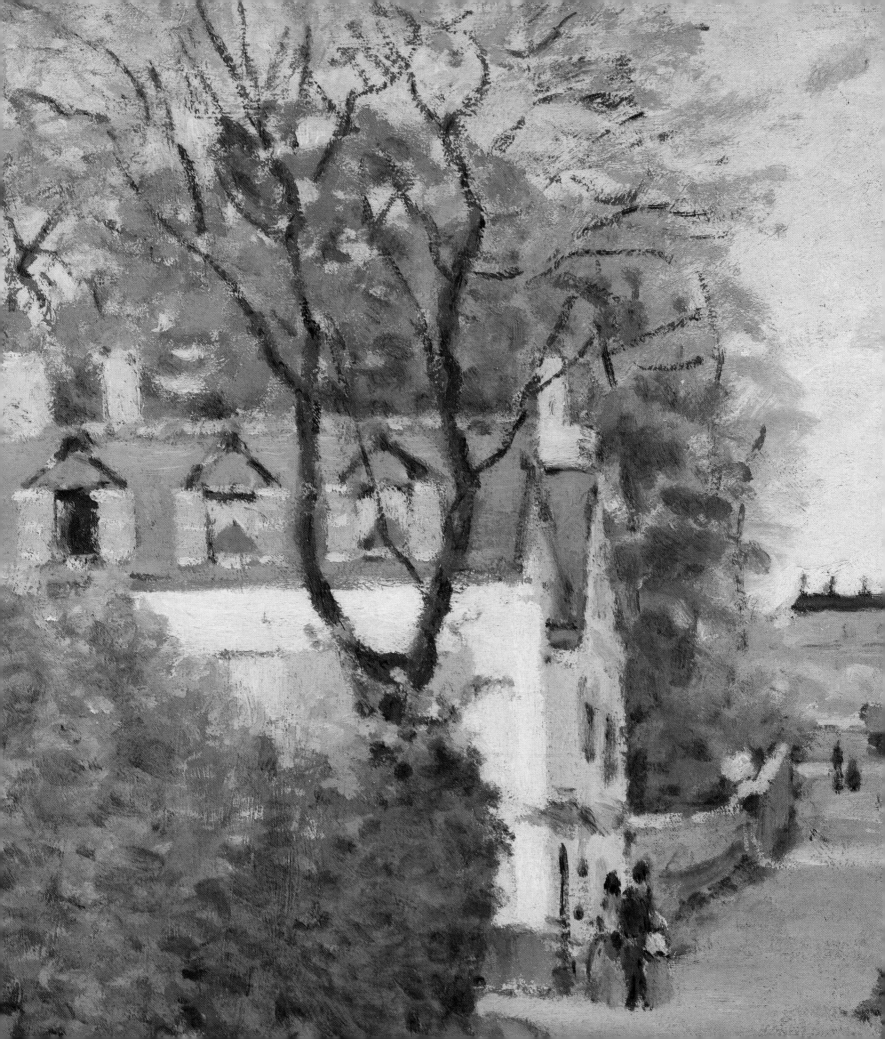

of modernity was best served by a resolute style derived from astute visual analysis and confident technique.[29]

Compared with many of the other Impressionist painters, however, Sisley's world does not at first sight seem to be determinedly modern. Unlike Monet and Renoir, there is a paucity of works depicting Paris during the late 1860s and early 1870s: he is hardly an urban painter. Indeed, of the very few paintings directly inspired by Paris, these are of the Canal Saint-Martin in the north-east of the city, which formed part of a continuous network of waterways extending across the city connecting the upper and lower parts of the Seine after its confluence to the south with the Marne. The Canal Saint-Martin was three miles long at that date and comprised nine locks. It merged into the Bassin de La Villette by which it was joined to the Canal de l'Ourcq. Barges tied up along the canal banks for loading and unloading as can be seen in *Barges on the Canal Saint-Martin* (Fig. 16; see also Cat. 9). As a motif it anticipates Sisley's fascination for Saint-Mammès, but it was, nonetheless, an unusual subject in an urban context even though it had been painted by Stanislas Lépine and occurs in at least one contemporary novel.[30] Significantly, La Villette was an area of Paris that later attracted Seurat (Fig. 14) and the Canal Saint-Martin itself engaged the interest of Braque, when both artists were at the outset of their respective careers (Fig. 17).

Another view of Paris by Sisley is equally puzzling. *View of Montmartre from the Cité des Fleurs, Les Batignolles* (Cat. 8) shows the city from outside the northern perimeter. The formidable bulk of the Butte de Montmartre is silhouetted against the sky and is offset by the slender saplings in the semi-rural foreground. The figures passing along the road make their way to or from the city while Sisley stands apart and observes. The balance here is obviously between urban and rural, but there is something almost symbolic in this view of Montmartre seen from afar. In compositional terms, with the emphasis on the horizontal, the effect is not unlike a fourteenth-century Sienese or Florentine predella panel (Fig. 15). In reality, however, during the 1880s this area at the edge of the city began to be portrayed by Raffaëlli, Neo-Impressionists like Seurat, Signac and Luce, and by Van Gogh more in the spirit of social comment than of visual acceptance.

14 Georges Seurat, *The Drawbridge*, 1885, drawing (Woodner Collection, New York).

15 Sassetta, *Journey of the Magi*, c.1435 (Metropolitan Museum of Art, New York).

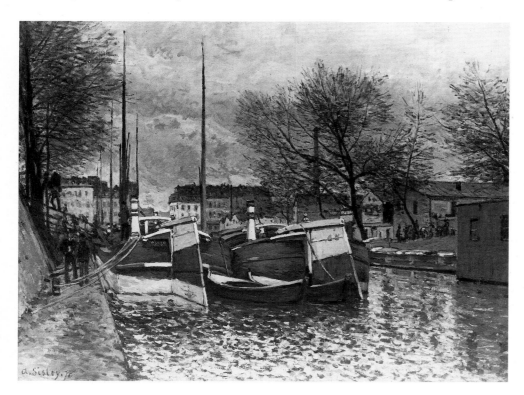

16 Alfred Sisley, *Barges on the Canal Saint-Martin*, 1870, D17 (Oskar Reinhart Foundation, Winterthur).

17　Georges Braque, *The Canal Saint-Martin*, 1906 (Museum of Fine Arts, Houston, Beck Collection).

These paintings of Paris by Sisley cannot be described as a celebration of urban life in any sense of the word, and, in sum, the topographical basis of the artist's world is a gradual, but total, retreat from Paris. His own movements from Louveciennes, Marly-le-Roi and then to Sèvres, where he lived until 1880, are symptomatic of a man who was preeminently a landscape painter, but needed to be near Paris in order to remain in touch with the apparatus of the art market – official and unofficial exhibitions, collectors, dealers and suppliers of materials.

The landscape to the west of Paris extending from Pontoise in the north to Versailles in the south has often been called the cradle of Impressionism. Access to Paris was increasingly facilitated by the extension of the railway so that traditional villages were now being transformed into outlying suburbs used for weekend or summer recreation. Such places in one sense provided an escape from the pressures of urban existence, but in another they were receptacles into which urban problems could overflow. There is, as a result, a balance between the bucolic descriptions of the countryside found in publications such as Emile de Bedollière's *Histoire des environs de nouveau Paris* (dating from the early 1860s) with illustrations by Gustave Doré, or, in terser form, in the standard guidebooks by Adolphe Joanne and Karl Baedeker, and the emergence of the naturalist novel. Paintings by Monet, Pissarro and Sisley, more than any others, concentrate on the social and formal contradictions posed by these developments dating from the middle of the nineteenth century and which increased dramatically as the century progressed. The 'colonisation' by artists of areas to the south-west of Paris was not a new development: Corot had worked at Ville d'Avray, Sèvres and La Celle-Saint-Cloud, Chintreuil near Igny and Bièvre, and Daubigny at Auvers-sur-Oise. But these 'colonies' were essentially retreats where artists could commune with nature, whereas Monet, Pissarro and Sisley chose deliberately to work in Argenteuil, Bougival, Louveciennes and Marly-le-Roi because in such places modernity could be seen invading an environment hidebound by tradition (Fig. 18).

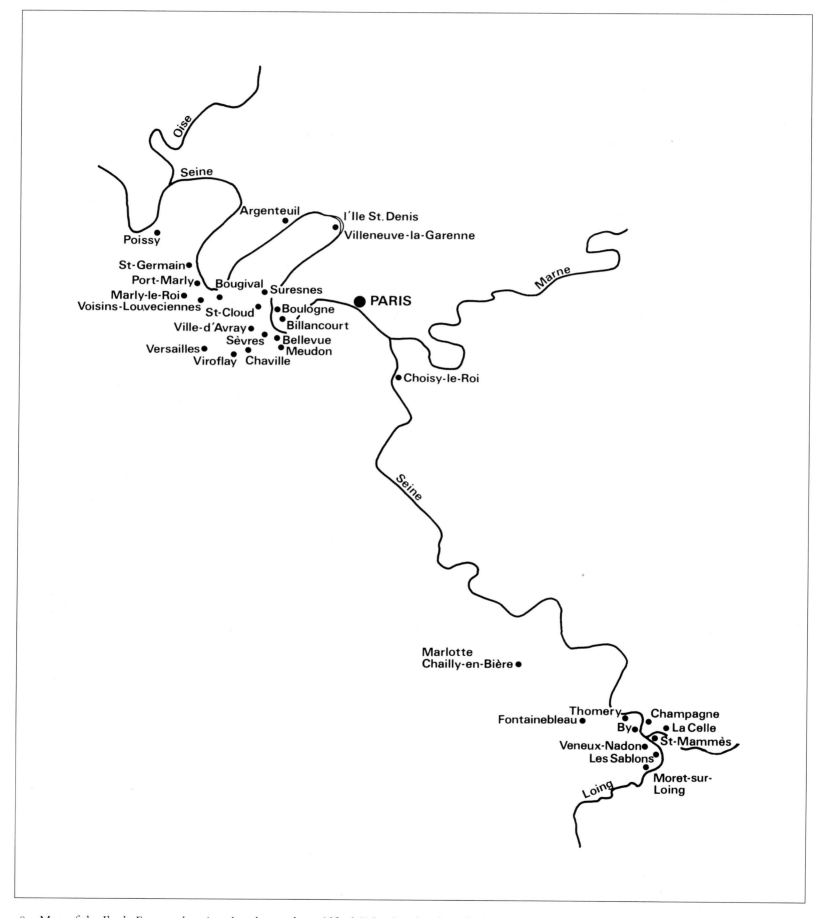

18 Map of the Ile de France, showing the places where Alfred Sisley lived and worked.

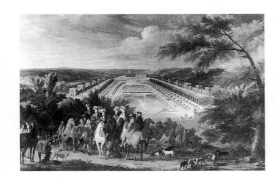

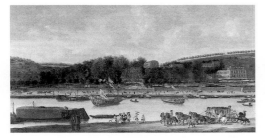

19 J.B. Martin, *The Palace at Marly* (Royal Collection).

20 A. van der Meulen, *View of the Château of Saint-Cloud* (Private Collection).

Sisley's paintings dating from the years 1870–80 concentrated on manifestations of such transformations. It is all the more poignant in his work because many of the motifs included in these pictures are in essence the vestiges of the *ancien régime*: the aqueduct taking water from the Seine to the storage pools in the grounds of the Château de Marly (Fig. 19) that once also supplied the fountains at the Château de Versailles; the impressive pumping station at Bougival (*The Machine de Marly* (Cat. 20), modernised by Napoleon III in 1855–59, which pushed the water up the hillside at Louveciennes and Marly-le-Roi to the famous châteaux built by Louis XIV in the late seventeenth century; the very roads in Louveciennes that Sisley depicted (Cat. 19) were designed in the earlier century for royal carriages taking the court and all its paraphernalia from one residence to another, often past other châteaux like that of Madame du Barry; the park at Saint Cloud (Fig. 20) with its famous fountains; and, finally, what had been the 'royal' porcelain factory at Sèvres. Such buildings, parks and roads belonged to a select order that was swept away in the Revolution leaving only the prose of writers like Saint-Simon to bring them back to life. This same landscape was by the time of the Impressionists used for recreation and exploitation by weekenders and tourists. The privacy of Saint-Simon's diary had now been invaded by the new cast of characters found in the popular novels and stories of Flaubert, Zola and Maupassant, just as the timeless silence of the elegant parks was now pierced by the shrieks and shouts of the swimmers and partygoers of La Grenouillère. The ambiguities redolent in this landscape are also evident in early photographs such as Henri Bevan's *Photographies, Louveciennes et Bougival* (1870), or in written accounts like Louis Barron's *Les Environs de Paris* (1886).[31] The fact that Sisley only hints at these motifs and neglects to give them pride of place in his compositions implies criticism of the invasion of modernity without defusing the tensions that such omissions suggest. On the contrary, he does not so much ignore *la France historique* as extend it into the second half of the nineteenth century.

Interestingly, when Sisley visited England for four months in the summer of 1874 at the invitation of the opera singer Jean-Baptiste Faure, the artist explored motifs that are in many ways comparable with those he was painting in France. Apart from a single view of the Thames in central London (D 113), Sisley hastily withdrew from the metropolis and produced seventeen canvases of the Thames (see Cat. 24–29) at Hampton Court and Molesey. Like the area to the south-west of Paris, that in England had a similar geographical relationship to the capital and was equally dominated by history. Hampton Court Palace (Fig. 21) had been built during the early sixteenth century by Cardinal Wolsey, who on the eve of his downfall gave it to Henry VIII. The palace was considerably enlarged by Sir Christopher Wren for William III and Mary II in the late seventeenth century and was subsequently used by the Hanoverians. In the nineteenth century during the reign of Queen Victoria, who did not like Hampton Court, the palace was opened to the public. Throughout the nineteenth century both the villages of Hampton and Molesey were modernised, symbolised most vividly by the building of a cast-iron bridge across the river Thames (Cat. 24–26; Fig. 22). Access to London was facilitated by the spread of the railway network; the use of the river for economic purposes was further exploited by the modernisation of the lock at Molesey; and the opportunities for developing the river as a recreational asset resulted in regattas and boating trips.[32] In all these respects Hampton Court and Molesey did not differ all that much from Bougival, Louveciennes and Marly-le-Roi.

Sisley's awareness of these developments in both France and England is amply demonstrated by the compositional strength of many of his paintings. The treatment of bridges, roads and rushing water is uncompromising. Old and new – the man-made and the natural – are given equal emphasis both being part of an

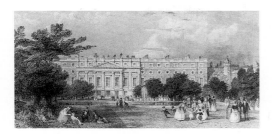

21 *Hampton Court Palace*, Stationer's Almanack, 1840. Drawn by T. Allom, engraved by T.A. Prior (Royal Library, Windsor Castle).

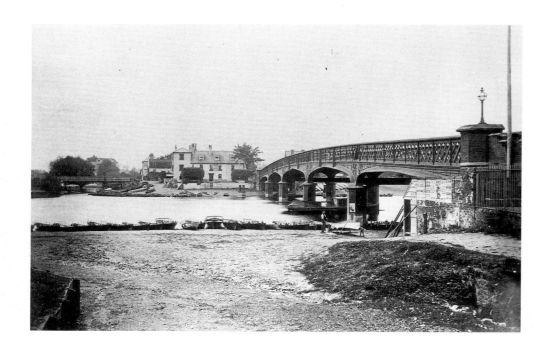

22 *View of Hampton Court Bridge and the Castle Inn*, photograph, 1867.

emerging modern world. This balancing out is very much part of Sisley's determination to articulate the surface of his paintings, but occasionally the central motif is allowed to dominate: the aqueduct at Louveciennes (Cat. 23), the underside of the bridge at Hampton Court (Cat. 26), or the pumping station at Bougival (Cat. 20). In these paintings, particularly *Under Hampton Court Bridge* (Cat. 26), the viewer, as sometimes in the work of Gustave Caillebotte also, is jolted out of the nineteenth century almost into the world of Léger (Fig. 23). Yet, in the majority of the canvases painted in these all-important years Sisley retains a certain degree of objectivity and to that extent the actual meaning of the paintings remains inscrutable. It is difficult to know, for instance, if Sisley is celebrating modernity or deploring it. For this reason these pictures have been aptly described as 'pictorial meditations upon the modernisation of France'.[33] Sisley's real feelings, however, were shortly to be fully revealed.

The critical years towards the end of the 1870s and at the beginning of the 1880s have become synonymous with a hiatus in the development of Impressionism. This resulted as much from the growing disunity stemming from the divergence of individual styles as from the changing personal circumstances of the artists in relation to the varied organisations and institutions that assessed their work. Sisley was no exception to this situation and, indeed, perhaps far more than most of his Impressionist colleagues, these were genuine years of crisis. The failure to sell his paintings or to secure critical acclaim drove him back to try and exhibit his work again at the Salon, but in this, too, he met with no success, unlike Monet and Renoir. Now, therefore, he found himself caught between the novelties of the Impressionist style and the traditional precepts vaunted by the Salon authorities so that he was forced to rely almost solely until the 1890s on that small coterie of collectors and dealers he had so far managed to interest in his work.

Essentially the 'crisis of Impressionism' was induced by stylistic considerations as much as by the conditions of art. Towards the mid-1870s the style evolved by the Impressionists for the purposes of capturing the essence of modern life in the urban context, and the fluctuations of nature in the rural context, had been refined. The question now was how would this style be developed or brought to full maturity, and each of the Impressionists reacted in a different way, thus upsetting the cohesion of the movement by allowing personal doubts and

23 Fernand Léger, *Follow the Arrow*, 1919 (Art Institute, Chicago).

24 (*facing page*) Detail of Cat. 52, *Saint-Mammès: Morning*, 1881 (William A. Coolidge Collection).

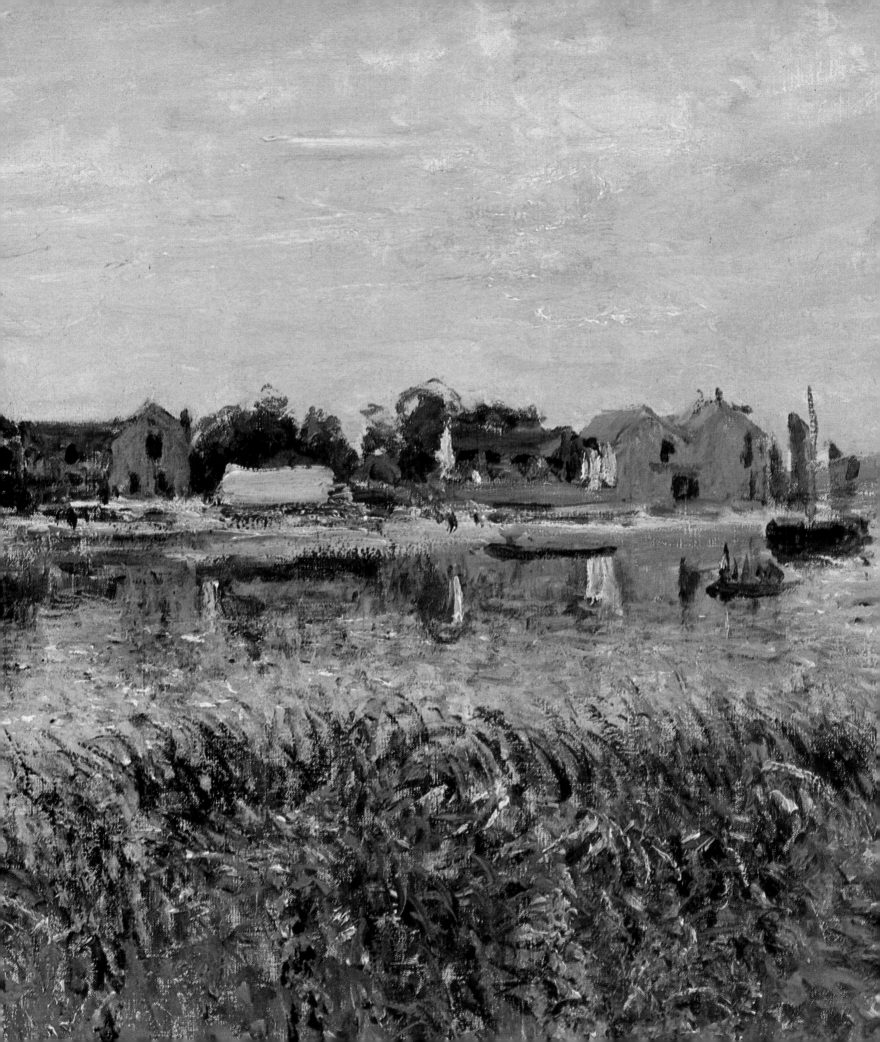

tendencies to surface. Renoir and Monet sought inspiration in travel, which in turn resulted in the development of their individual styles. Renoir, having visited North Africa and Italy, came back with a renewed interest in the human figure and a more linear style, while Monet traversed France in search of new motifs and broadened his style accordingly, becoming more responsive to light and colour as well as to fresh sources of inspiration. Pissarro found his landscape painting increasingly unsatisfactory and concentrated for a time on the human figure before absorbing himself in the theories of Neo-Impressionism. Sisley's reaction was different in that he continued to explore the possibilities of the Impressionist style from within, retaining the same approach to nature and in this sense remaining a true Impressionist painter concerned with light, colour and atmosphere. To a greater extent even than Pissarro, Sisley was content to allow his style to evolve logically from what had gone before, and it is this unswerving allegiance to Impressionism beyond the 1870s that is the most distinctive feature of his work. To the majority of outsiders, however, it seemed to be a severe limitation, or a misjudgment, compounded by the artist's retreat even further from Paris, this time to the south-east where he lived in Veneux-Nadon, Les Sablons and, finally, Moret-sur-Loing – all in the vicinity of the Forest of Fontainebleau. From 1880 motifs of the Seine near its confluence with the Loing began to preoccupy the artist so that, although Sisley may be seen as symbolically reinforcing his alliance and dependency upon the Barbizon School, it was not a retrograde step from the stylistic point of view. In making such a move Sisley – almost literally returning to his roots – was able to develop his landscape painting a stage further. This move, therefore, was the result of a considered decision leading to a stylistic development that can be equated with the artist's purity of vision.

The early critic, Wynford Dewhurst, commented: 'Rare are the artists who distinguish themselves in every branch of art, lucky the man who excelled in one. An example of the latter is Sisley, 'paysagiste' pure and simple, who has left a legacy of some of the most fascinating landscapes ever painted'.[34] Among such landscapes are those painted during the first part of the 1880s at Veneux-Nadon (Cat. 47, 48), Roches-Courtaut and above all at Saint-Mammès (Cat. 49–52), lying at the confluence of the Seine and the Loing, although such pictures are not today so greatly acclaimed as those dating from the first half of the 1870s. As paintings they are more complex, not necessarily because fresh viewpoints have been adopted, but because the working of the surface is more varied. The overlaying of the different parts of the composition was done in such a way that the brushstrokes prescribe form as well as chart distance and portray the mood of nature, especially in the treatment of the sky (Fig. 24).

The broadening of the range of brushstroke evident in these paintings was foreshadowed in works of the mid- and late 1870s where Sisley exposed more of the canvas. This technique differs considerably from that of the early 1870s where carefully constructed compositions are executed with neat, precise brushwork and clear tones. Now in the early 1880s the eye becomes absorbed by the concentrated clusters, the looser, freer and more rhythmical strokes, and the mere licks of paint (as delicate as pastel) that orchestrate the surface of the canvas. Every part of the surface, particularly the sky, is activated so that the very canvas seems to be as tumescent as the earth itself. The artist also takes greater advantage of the texture of paint. Thick, oily, saturated paint facilitated long, flowing, rhythmical brushstrokes, often overlaid with globules added at a later stage to the corrugated surface, whereas powdery, desiccated paint applied with little medium resulted in quick, short or dabbed brushstrokes almost rubbed onto the surface (Fig. 25).

In conjunction with this variety of brushstroke and texture of paint, Sisley adopted a greater intensity in his colours. Indeed, Théodore Duret indicated that

25 (facing page) Detail of Cat. 61, *Banks of the Loing at Moret*, 1890 (Kunstmuseum, Basel).

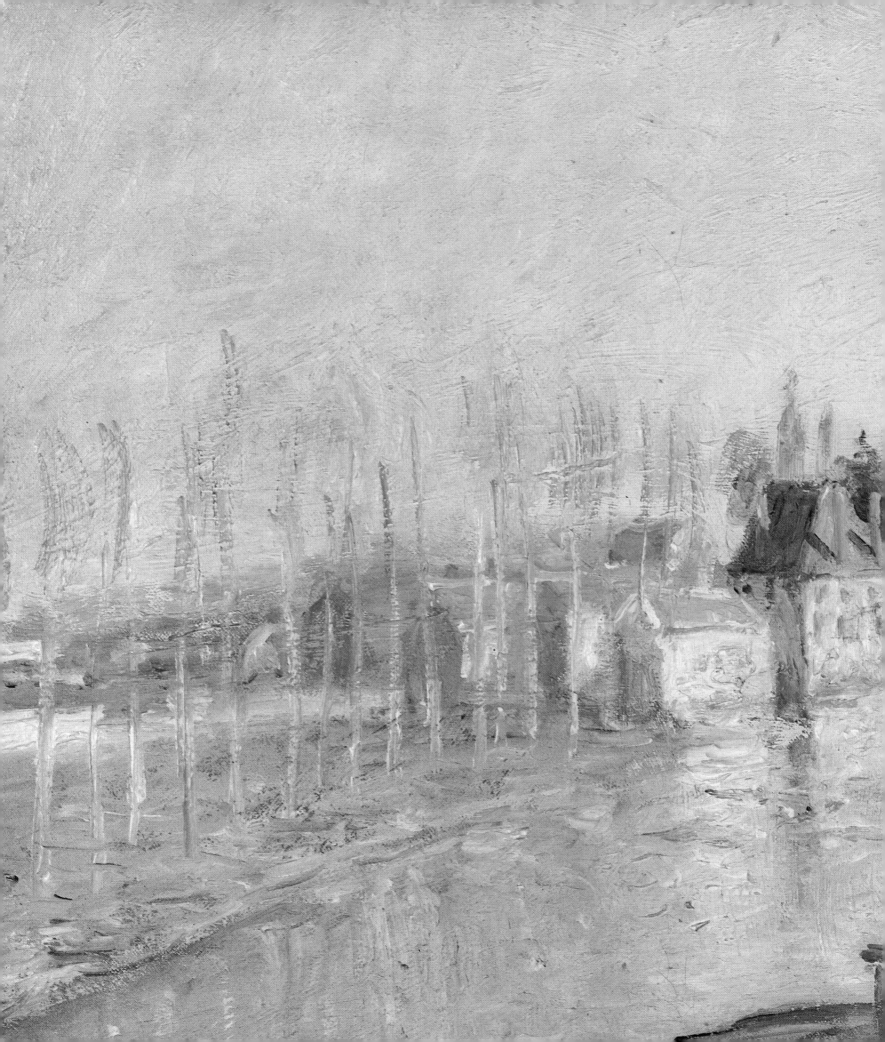

the artist's originality was 'principally shown in a novel and unexpected colouration, which was generally condemned. He was accused of painting in an artificial lilac-coloured tone ... In particular he developed effects of bright sunlight by means of a rose-tinted lilac hue ...'.[35] Sisley's use of colour was obviously not as restricted as Duret implies, but his comment denotes how novel the landscapes of the 1880s were for Sisley's contemporaries (see Cat. 54). A small group of paintings of the Loing canal seen at Saint-Mammès (Cat. 56–58) dating from the mid-1880s reveals a range and intensity of colour (pale blue, straw yellow, lime green, rose pink) that captured the sheer dazzling white vibrancy of bright sunlight. Interestingly, the paintings in this particular group are all executed with smaller, more regular brushstrokes that suggest a knowledge of Neo-Impressionism.

It is, however, more usual to cite the importance of Monet in Sisley's work dating from the 1880s and 1890s. To a very large extent the comparison has proved to be invidious, but not in every instance. A passage from Mauclair's book on the Impressionists is unusual in its praise for Sisley:

> He [Sisley] possessed in the highest degree the feeling for light, and if he did not have the power, the masterly passion of Claude Monet, he will at least deserve to be frequently placed by his side as regards the expression of certain combinations of light. He did not have the decorative feeling which makes Monet's landscapes so imposing; one does not see in his work that surprising lyrical interpretation which knows how to express the drama of raging waves, the heavy slumber of enormous masses of rock, the intense torpor of the sun on the sea. But in all that concerns the *Ile de France*, the sweet and fresh landscapes, Sisley is not unworthy of being compared with Monet. He equals him in numerous pictures; he has a similar delicacy of perception, a similar fervour of execution. He is the painter of great blue rivers curving towards the horizon; of blossoming orchards; of bright hills with red-roofed hamlets scattered about; he is, beyond all, the painter of French skies which he presents with admirable vivacity and facility. He has the feeling for the transparency of atmosphere. . .[36]

The parallels between the work of Monet and Sisley during the 1880s are striking. There are similarities in their approach to nature and in their techniques. Monet's range, as Mauclair implies, may be greater, but the absorption in the fugitive effects and the colours of nature is in both cases total. In pursuing landscape so assiduously there were almost bound to be many points of contact between the two men. One of these lay in the tendency to paint the same subject from differing viewpoints, usually on different occasions, thereby forming a sequence or incipient series. This inclination first appears in Sisley's oeuvre during the 1870s in his depiction of the flood at Port-Marly (Cat. 37–39) and the Abreuvoir at Marly (Cat. 32, 36); it continues in the next decades with the views of Saint-Mammès (Cat. 49–52) and Moret-sur-Loing (Cat. 59–71).

Unlike Monet's better known sequences of obsessive observations undertaken during the 1890s, these paintings by Sisley are conceived as a set of shifting viewpoints and angles of vision as each subject, be it the river bank at Saint-Mammès or the small town of Moret-sur-Loing, is examined in changing conditions of light and season. For Sisley the actual act of looking seems not to have been as intense as Monet's, and his interest in the motifs remains descriptive rather than analytical. Two remarkable paintings of haystacks (Cat. 63) dating from 1891, and a group of three canvases of a meadow in Normandy seen in the full panoply of summer dating from 1894 (Cat. 72; Fig. 117), reveal a more obvious debt to Monet in choice of subject, but it is perhaps in his numerous canvases of the town of Moret-sur-Loing that Sisley demonstrates a consistency of

purpose and eye that can stand a proper comparison with Monet's output. Augustus Hare in his *Days near Paris* (1887) describes the historical aspects of Moret-sur-Loing:

> An excursion may be made from Fontainebleau to the pretty old town of Moret ... The kings of France had a chateau at Moret, of which the principal tower remains, dating from Louis le Gros (1128) ... At either end of the principal street is a fine old gothic gateway, relic of the fortifications of Charles VII (1420), and one of these rises most picturesquely at the end of the bridge of 14 arches over the Loing. The church, built by Louis le Jeune, and consecrated by Thomas à Becket in 1166, only retains a choir of that date. The triple nave and the transept (with mullioned windows filling all the surface of the gable wall) are XIIIc.; the tower XVc.; the principal portal is XVIc. South of the church is a timbered house of XVc. and a little *Hospice* where the nuns make excellent barley-sugar. In the main street, a renaissance house is inscribed 'Concordia des parvae crescunt, 1618'.[37]

Sisley's interest in Moret-sur-Loing had been mounting since he first painted it in 1879 and he wrote to Monet about it in August 1881 from the neighbouring village of Veneux-Nadon (see Cat. 53).[38] Sisley lived in Moret-sur-Loing for a short time in 1882 and returned for good in 1889, subsequently living at two separate addresses in the town.[39] From 1888 and most notably after 1891, the artist stalked the area exploring its approaches along poplar-lined avenues (Cat. 59, 60, 68) and occasionally painting views of its streets and houses. Sisley's chief preoccupation, however, was with the river banks, the bridge (Cat. 65, 66, 71) and the church (Cat. 72). These paintings show him at the height of his powers even if ill-health hampered his progress. All the experience of the previous decades was blended in these canvases which amount to the summation of his output: the paint is richly applied with the impasto more pronounced than in previous works, the brushwork more insistently rhythmical, the execution more rapid, and the colours more vibrant. There is little evidence to show that Sisley painted each canvas at more than one sitting or reworked the surface at later stages. Indeed, the *alla prima* effect of these canvases amounts to a remarkable tour de force.[40] As in the late paintings of the coast of South Wales undertaken at the behest of his Rouennais patron François Depeaux, during his last trip to the British Isles in 1897 (Cat. 73–75), the visual terms of reference are narrower than before in that Sisley is now content to observe single motifs under changing temporal conditions. Technical skills in these final works match the artist's undoubted compositional powers, so that Sisley may be said to have almost created a palimpsest of nineteenth-century French painting in so far as the pictures of the bridge at Moret-sur-Loing can be compared with Corot's late view of the bridge at Mantes-la-Jolie (Fig. 26), while the depiction of the church can be compared with Monet's renderings of the façade of the cathedral at Rouen.

Marcel Proust regarded Sisley's views of the church at Moret-sur-Loing as the most beautiful paintings in the artist's oeuvre.[41] When Sisley began to paint the town, the church appeared as only a topographical feature seen in conjunction with the bridge and the gateways or rising above the houses, serving as a compositional buttress. It was only in 1893 that he began a series of pictures in which the church itself was the principal motif. The architecture is singled out for comment in the Baedeker guide to Northern France: 'The portal is richly adorned with Flamboyant sculptures, and the apse has three rows of windows, those in the middle row being small and round in the Burgundian Gothic style'.[42]

Such descriptions equate the church with the tradition of *Les Voyages pittoresques* (1819–78), which formed part of the conscious revival of French

26 Jean-Baptiste Camille Corot, *The Bridge at Mantes-la-Jolie*, 1868–70 (Musée du Louvre, Paris).

architectural heritage – *la France historique*.[43] Six Church pictures were completed in 1893 and the series was continued in the following year with a further eight canvases (Cat. 71). Although never shown as a group, four were included in the 1894 exhibition of the Société Nationale des Beaux-Arts on the Champ de Mars in Paris. In the fourteen canvases comprising the series Sisley observed the church from a position to the south-west so that he presented himself with an oblique view extending from the west façade fronting the street to the south transept with the covered market (now removed) alongside. The church is depicted at different times of day in lights of varying intensity and under changing weather conditions (Fig. 27). Extra variety is gained within the series by the alternation of vertical and horizontal formats, as well as by slight shifts in viewpoint to left or right, and by moving closer or further away from the building.

There can be little doubt that the main inspiration of this important series of the church at Moret-sur-Loing is the series of the façade of Rouen Cathedral by Monet (Figs. 122–24). Monet's series was begun early in 1892 and completed two years later. It comprised in all thirty canvases, but it was not until May 1895 that he allowed twenty of them to be shown as a series as part of an exhibition organised by Durand-Ruel. The series of Rouen Cathedral made an enormous impact. Pissarro wrote to his eldest son, Lucien, 'I am carried away by their extraordinary deftness. Cézanne, whom I met yesterday at Durand-Ruel's, is in complete agreement with my view that this is the work of a well balanced but impulsive artist who pursues the intangible nuances of effects that are realised by no other painter'.[44] The subject matter, the relationship of the canvases one to another and the technical audacity were the aspects that struck those who saw the *Cathedrals* at whatever stage. The American painter, Theodore Robinson, wrote in 1892, 'They are simply colossal. Never, I believe, has architecture been painted [like this] before, the most astonishing impression of the thing, a feeling of size, grandeur and decay ... and not a line anywhere – yet there is a wonderful sense of construction and solidity. Isn't it curious, a man taking such material and making such magnificent use of it?'[45] There is no evidence that Sisley saw the exhibition in 1895, but the fact that he began his series of the church of Moret-sur-Loing in 1893, when Monet was still at work on the canvases of the façade of Rouen Cathedral, implies that he had seen or heard about Monet's series before its completion. It is interesting, for example, that the Rouennais collector Depeaux supported both Monet and Sisley during the 1890s and owned a canvas from each of the series by the two artists.[46]

Sisley's views of the church at Moret-sur-Loing have been analysed in one of the very few detailed modern studies of the artist. The author, Oscar Reuterswaerd, posits certain differences between the two series: 'Whereas Monet's series reflects the artist's disregard for the details of his subject, Sisley's attest his constant preoccupation with and concentration upon the motif itself'. This, it is then argued, reveals two separate approaches to art whereby Monet seeks 'to reveal the intrinsic value of the artistic means' and Sisley aims to produce 'from the proper distance a reasonably faithful reproduction of the old church at Moret'.[47] This distinction appears to be valid although it does not necessarily follow, as Reuterswaerd argues, that Sisley's series is less impressive, or even less significant, than Monet's. In fact, the artists had two different intentions. Monet wrote that 'the motif for me is nothing but an insignificant matter – what I want to reproduce is what there is between the motif and myself'.[48] In essence, what Monet refers to is the *enveloppe* – the light, air, and atmosphere – containing the motif rather than the motif itself. There is added significance in that Monet chose to depict such ephemeral aspects of reality in the context of a famous French cathedral. For both the architect and the artist are from wholly different standpoints intent upon

27 (*facing page*) Detail of Cat. 71C, *The Church at Moret: Rainy Weather, Morning* (Hunterian Museum, University of Glasgow).

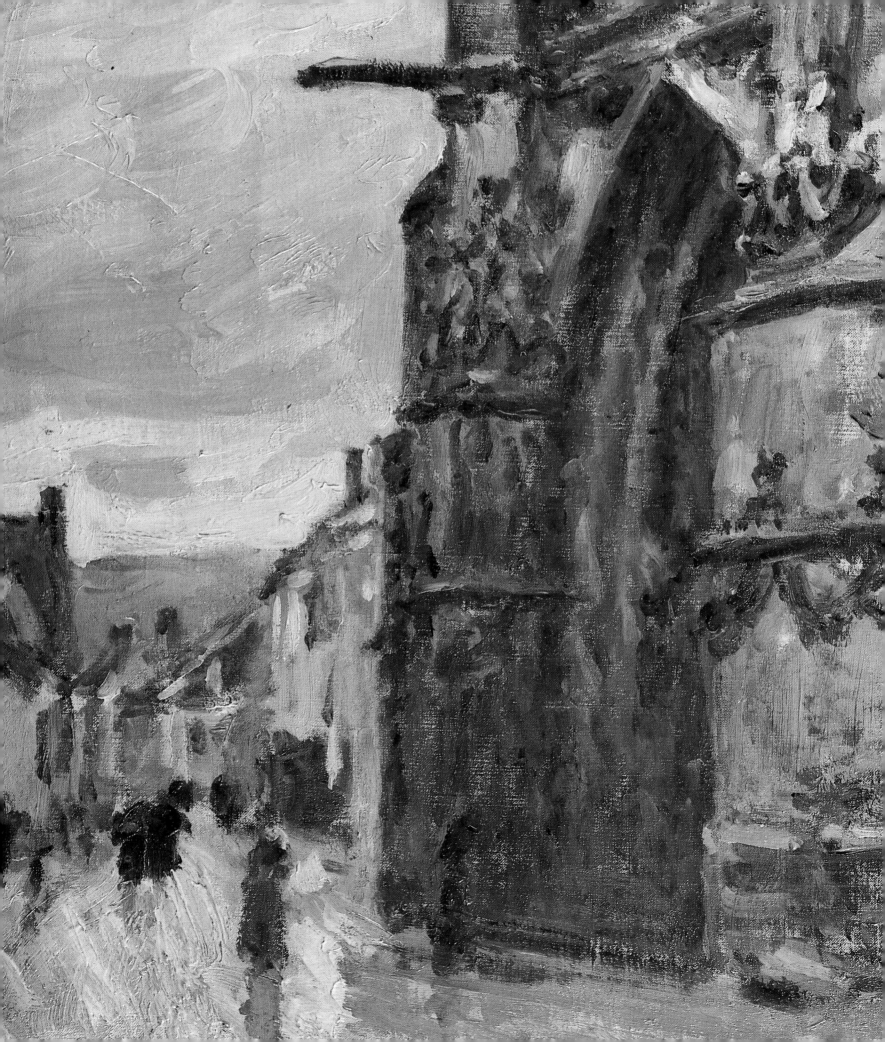

exploring what is essentially invisible: the Gothic architect concerns himself with the principles of divine creation and the artist with the nature of reality.[49] What fascinated Monet was the interaction between solid stone and fugitive light expressed in terms of colour.

In the making of Monet's *Cathedral* series, the ethereal is present everywhere, surrounding the Cathedral with its all-encompassing *enveloppe*, filling the intervals, reflecting, vibrating against the stone facade, shaping or unshaping the details of the sculpture and architecture. It is not referred to symbolically, as in the original construction of the cathedral, it is depicted as an imminent force, painted as an element perspiring through the stone, imbuing the cathedral with all its presence. The sky becomes part of the cathedral, struggling with or caressing the stone façade.[50]

Monet's focus of attention, therefore, was not on the detailed architecture, but on the façade of Rouen Cathedral seen as a whole under changing conditions. The basic shape of the façade served as an armature for a closer analysis of its constituent elements – stone, air, light, colour. It was for this reason that Monet painted the canvases as a series. The purpose was to produce the quintessential essence on each canvas after several intense examinations of that particular effect or moment. The overall unity of the series was later achieved in the studio, just as each individual canvas was constantly reworked after renewed observation. This approach is one that extended beyond Impressionism in that Monet was expressing one moment as part of a continuum, as opposed to the significance of the moment itself.

Sisley, on the other hand, approached the church of Moret-sur-Loing still as an Impressionist. The temporal dimension, in the narrow sense of one particular moment, remained all-important for him and as a result the architecture remained an integral part of each composition. To a certain extent, as an exercise in the controlled examination of a specific motif incorporating a multitude of interlocking verticals and horizontals, Sisley's paintings of the church at Moret-sur-Loing are in a formal sense comparable with Cézanne's depictions of Mont Sainte-Victoire (Fig. 28). The innate sense of compositional balance and spatial intervals that characterises all of Sisley's work is just as important for the development of art as Cézanne's concern for structure or Monet's analysis of reality. While Monet's art became more and more preoccupied with the dissolving of forms in light, Sisley's, like Cézanne's, is more concerned with the resolution of shape, balance and harmony.

An assessment of Sisley could easily end on a biographical note with the funeral oration spoken by Adolphe Tavernier. Moving though those words are, referring to the artist as 'a magician of light, a poet of the heavens, of the waters, of the trees – in a word one of the most remarkable landscapists of his day',[51] it is perhaps more important to ask, in conclusion, to what extent Sisley's work is relevant for the modern viewer. It is possibly unwise to offer any interpretation of the works of an artist who does not seem to have intended his paintings to have been understood in any way other than at their face value – as landscapes. Roger Fry accurately described Sisley as an artist of pure sensibility [52] and it is this that provides an important clue as to Sisley's significance in French painting. Soon after the artist's death critics began to write about Impressionism in historical terms. In 1899 Jules Leclercq, for instance, wrote:

Since the Impressionist school will hold an important place in the history of the painting of this century and while it has established an universal movement, it is certain that Sisley will never be forgotten. The Musée du Luxembourg only owns studies from the Caillebotte bequest; but pictures will become available

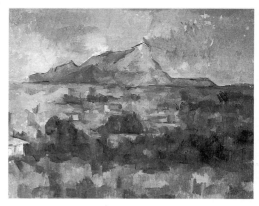

28 Paul Cézanne, *Mont Sainte-Victoire*, 1904–06 (Private Collection, Switzerland).

29 Francis Picabia, *Banks of the Loing and Millhouses at Moret*, 1905 (Private Collection).

from fine modern collections to fill the gaps. Eventually in the distant future the summons will ring out and the day of the Impressionists in the Louvre will have arrived.[53]

Leclercq asserts that Impressionist landscapes can now by the end of the nineteenth century be inserted into the grand tradition of French painting extending from Claude Lorrain and Poussin in the seventeenth century through Fragonard and Boucher in the eighteenth century to Valenciennes and Corot and artists of the Barbizon School in the nineteenth. The connections with Corot have already been stressed and Sisley's associations with the Barbizon School are perhaps more symbolic in topographical terms than stylistic. Sisley's retreat from Paris — he wrote amusingly to Charpentier in March 1895 that he lived 'trop Loing'[54] — and his re-absorption in the landscape on the edge of the Forest of Fontainebleau are indications of the artist's commitment to the French landscape tradition. Both Corot and Monet in their separate ways and at different times adopted diverse approaches to landscape in their later years, but Sisley was single-minded. It is in the landscapes of the 1880s and 1890s that the viewer, according to Leclercq, sees, 'an absolute loyalty to the impression'[55] and he refers to works, 'where this peace of mind, this purity and clarity reign'.[56] In these respects — both aesthetic and moral — Sisley worked at the end of the grand tradition of French landscape painting, whereas Monet from the 1880s begins a search for a new type of landscape that is not wholly dependent upon observation alone.

Yet, just as Sisley's paintings can be fitted into a nineteenth-century context that enhances our understanding of them, so, too, these same paintings can be seen to have a particular relevance for us today. Sisley's decision to live and work around the town of Moret-sur-Loing was a conscious decision that no doubt suited his artistic temperament. As a place it momentarily enticed Pissarro at the end of his life, as well as Guillaumin, and the young Francis Picabia at the start of his career (Fig. 29).[57]

Any explanation for Sisley's own decision, however, that suits what we know of both the artist's work and development in the nineteenth century may lie in the writings of Elisée Reclus (1830–1905).[58] Reclus (Fig. 30) was a radical with anarchist leanings who travelled widely (usually as a political exile) and was almost certainly the most brilliant geographer of his generation. He was appointed Professor of Comparative Geography at the Free University in Brussels in 1892 during the course of the publication of his greatest contribution to the subject: *La Nouvelle géographie universelle, la terre et les hommes* (1875–94, in 19 volumes). It is unlikely that he knew Sisley, although he did meet Pissarro in Belgium in 1894 and may even have known Sisley's work since it was exhibited in Brussels at the exhibitions organised by Les Vingt.[59] The relationship of man to the earth is an abiding theme in the writing of Reclus. He recognised at an early date that the growth of industrialisation not only disfigured the planet, but also created an imbalance that endangered its very existence.

In *The Ocean, Atmosphere and Life*, which forms part of his important study *A Descriptive History of the Phenomena of the Life of the Globe* (1867–68) Reclus entitles the final chapter, 'Influence of Man on the Beauty of the Earth', where it is asserted:

30 *Elisée Reclus*, photograph (Pissarro Archive, Ashmolean Museum, Oxford).

> The nations who at the present day are placed, in consequence of their preeminence in civilization, in the front rank of mankind, take, generally speaking, but very little trouble in the embellishment of nature. Being much more devoted to industrial than artistic skill, they prefer power to beauty. The universal wish of man is to adapt the earth to his requirements, and to take complete possession of it in order to derive from it its immense treasures. He covers it with a network of roads, railways, and telegraphic wires; he fertilizes its deserts and makes himself master of its rivers; he breaks up the rising grounds and spreads them in the form of alluvium over the plains; bores through the Alps, the Andes, and, having united the Red Sea with the Mediterranean, is preparing to mingle the waters of the Pacific with those of the West Indian seas. Nearly all men, being either agents in, or witnesses of, these vast undertakings, allow themselves to be carried away by the fascination of labour, and their only idea is how they can mould the earth into the image which suits them best'.[60]

Against this tendency Reclus upholds the beauty of nature:

> This depravity of taste, which impels men to deface the most lovely scenery, finds its origin in ignorance and vanity, and is henceforth condemned by the verdict of mankind; the mind of man now seeks for beauty, not in vain and purely outward limitations or in a fantastic and false style of decoration, but in the intimate and deeply-seated harmony of his work with that of nature. The man who really loves the land in which he lives knows that his duty is to preserve or even to increase the beauty which it possesses; but if a reckless system has defaced that beauty, then it is incumbent on him to endeavour to restore it. Comprehending the fact that his own personal interest is blended with the interest of all around him, he will repair the injuries committed by his predecessors, he will assist the soil instead of inveterately forcing it, and will work hard for the beautification as well as the improvement of his domain Having become the 'conscience of the earth' by that very fact, man assumes a responsibility as regards the harmony and beauty of nature around him'.[61]

He also warns of the danger of ignoring nature:

> The question as to how far the agency of man serves either to adorn or degrade the aspect of nature may seem an idle one to minds of a so-called positive tendency; but it none the less assumes an importance of the highest order. The

development of mankind is bound up most intimately with the surrounding conditions of nature. A hidden harmony springs up between the land and the nation which is nourished by it, and if any society is imprudent enough to lay a disturbing hand on the elements which form the beauty of its territory, it is ultimately sure to repent of it. In a spot where the country is disfigured and where all the grace of poetry has disappeared from the landscape, imagination dies out and the mind is impoverished; a spirit of routine and sterility takes possession of the soul, and leads it on to torpor and to death.[62]

Sisley's landscapes stand as testimony to the theories of Reclus that are as relevant for our own century, as for that which witnessed the beginning of the disfigurement of nature by man. Leclercq described Sisley's work as 'a free art, frank, poetic, where the spirit can dream, where the eye is gratified, where the hand is learned'.[63]

This description remains valid today, but it was Geffroy who as early as 1894 recognised the significance of Sisley's landscapes and placed them accurately within the nineteenth-century French tradition:

He thus writes his own chapter in the history of our land, of our rivers, of our sky. He claims his place in the museum of landscape which our century will bequeath to posterity. Do not despair, do not say that all is finished after Rousseau, who painted the Forest [of Fontainebleau], after Corot, who painted Artois, after Courbet, who painted Franche-Comté, etc . . . There is a space on the walls of this museum for those who wish to continue this history of France and of the land with their brush, there is a space for Boudin's ports, for Raffaëlli's suburbs, for Monet's countryside and seas – and also for the humble Loing, the peaceful Saint-Mammès, of which Sisley is the charming poet.[64]

1 A. M. Barr, *Matisse. His Art and his Public*, New York, Museum of Modern Art, 1966, p. 38.

2 *Correspondance de Camille Pissarro*, ed. J. Bailly-Herzberg, IV, 1895–98, Paris, 1989, No. 1115, pp. 37–38.

3 See Chronology under 1888 and 1898.

4 G. Moore, *Hail and Farewell. Ave, Salve, Vale*, ed. Richard Cave, Gerrards Cross, 1976, pp. 658–59.

5 See Bibliography.

6 See Bibliography.

7 Cited by A. Alexandre, *Catalogue de Tableaux, Etudes, Pastels, par Alfred Sisley*, Paris, Georges Petit, 1 May 1899: 'It seems to me that this tune, so gay, so musical and so enchanting has been a part of me since I heard it for the first time. It corresponds so closely to everything that I have always been. I sing it continually. I quote it as I work. It has never left me'. For some general observations on the reception of Beethoven's music in France and its effect on landscape painting during the nineteenth century see K. S. Champa in *The Rise of Landscape Painting in France: Corot to Monet*, Currier Gallery of Art, Manchester NH, 1991, pp. 23–51. Bazille was also interested in Beethoven and, like Sisley, attended the concerts given in Paris by Jules Etienne Pasdeloup (1819–87).

8 G. Geffroy, *Sisley*, Paris, 1923, pp. 8–9. Geffroy's account is corroborated as follows by Arsène Alexandre in the preface to the posthumous exhibition organised by Georges Petit (1 May 1899): 'Tout son existence fut en proie à la lutte, à l'inquiétude. Il a été sans cesse à la peine, il n'a guère été à l'honneur. La veille de sa mort, il connaissait les mêmes affres qu'au jour de ses débuts. Que dis-je? Il n'y a ni tendresse ni désespoir à l'heure de l'entrée dans la vie, mais quelle mélancholie et quelle amertume doivent être celles de l'artiste, vieillie chargé de famille, et forcé encore de résoudre, au jour le jour, la terrible difficulté de vivre. Pourquoi ne pas dire que ce fut le sort de Sisley, puis qu'il le supporta avec cet héroïsme farouche et caché qui ennoblit si mystérieusement la vie des solitaires. S'il gémit et déséspera, ce fut en secret, et non pour lui, mais pour les siens. Pour lui, j'affirme, avec ceux qui l'ont connu tout au long de sa carrière, qu'il n'eut jamais que la préoccupation de son art, l'orgueil de vaincre la nature en ce combat journalier que livre l'artiste, l'espoir qu'il aurait fixé sur ses toiles un peu de la beauté fugitive des choses éternelles'.

9 T. Duret, *Manet and the French Impressionists*, Eng. ed., London, 1910, p. 152.

10 P. Toloza [Jean Prouvaire], *Le Rappel*, 20 April 1874, quoted in *The New Painting. Impressionism 1874–1886*, The Fine Arts Museums of San Francisco, and the National Gallery of Art, Washington D.C. 1986, no. 18, p. 142.

11 R. H. Wilenski, 'The Sisley Compromise', *Apollo*, VII (1928), p. 74.

12 C. Mauclair, *The French Impressionists*, Eng. ed., London, 1912, p.140.

13 *Paul Cézanne. Letters*, ed. J. Rewald, 4th ed. Oxford, 1976, p. 313.

14 *Correspondance de Camille Pissarro*, ed. J. Bailly-Herzberg, V, 1899–1903, Paris, 1991, No. 1621, pp. 9–10, 22 January 1899 to his eldest son Lucien: 'Sisley, I hear, is seriously ill. He is a great and beautiful artist, in my opinion he is a master equal to the greatest. I have seen works of his of rare amplitude and beauty, among others an *Inondation* [D 240] which is a masterpiece'. D 240 (see Cat. 38) was in the second Impressionist exhibition (1876).

15 Barr, *loc. cit*, (note 1).

16 For the contents of the National Gallery at this stage of its development see R. N. Wornum, *Descriptive and Historical Catalogue of the Pictures in The National Gallery*, London, 1847. There were numerous subsequent editions during the 1850s.

17 Quoted in R. Goldwater and M. Treves, *Artists on Art from the XIV to the XX Century*, London, 1947, p. 310.

18 *John Constable's Correspondence: VI: The Fishers*, ed. R. B. Beckett, Ipswich, 1968, pp. 77–78.

19 As in Goldwater and Treves, *op.cit.*, pp. 308–10.

20 *Ibid.*

21 *Ibid.*

22 *Ibid.*

23 *John Constable's Correspondence*, VI, 1968, pp. 76–77.

24 A. Boime, *The Academy and French Painting in the Nineteenth Century*, New Haven and London, 1971, p. 63.

25 A. Boime, *op. cit*, p. 65. Also see A. Boime, 'The Instruction of Charles Gleyre and the Evolution of Painting in the Nineteenth Century', in *Charles Gleyre ou les illusions perdues*, Kunstmuseum, Winterthur, 1974–5, pp. 102–24.

26 T. Duret, 'Quelques lettres de Monet et Sisley', *La Revue Blanche*, XVIII (1899), p. 436.

27 J. Isaacson, 'The Painters Called Impressionists', in *The New Painting. Impressionism 1874–1886*, op. cit., p.389.

28 The sketch book is in the Cabinet des Dessins, Musée du Louvre. It was first published by G. Wildenstein, 'Un carnet de dessins de Sisley au Louvre', *Gazette des Beaux-Arts*, 53 (1959), pp. 57–60, but for reproductions of all the pages see F. Daulte, *Alfred Sisley* [1972], Eng. ed. London, 1988, pp. 84–93. On Sisley as a draughtsman see C. Lloyd and R. Thomson, *Impressionist Drawings from British Public and Private Collections*, Oxford, 1986, pp. 34–5 and Nos. 77–80; and R. Shone, '"La Famille": an unpublished Sisley drawing', *The Burlington Magazine*, (1992), pp. 34–35.

29 R. Herbert, 'Industry in the changing landscape from Daubigny to Monet', in *French Cities in the Nineteenth Century*, ed. J. Merriman, London 1982, pp. 139–64, esp. pp. 140–43.

30 Charles Deslys, *Le Canal Saint-Martin* (Paris, 1862) first published in *Le Conteur* in serial form between 15 January 1862 (no. 272) and 24 May 1862 (no. 313).

31 For Bevan see R. Brettell, 'The Cradle of Impressionism', in *A Day in the Country. Impressionism and the French Landscape*, Los Angeles County Museum of Art, 1984, pp. 85–87.

32 N. Reed, *Sisley and the Thames*, London, 1991.

33 *A Day in the Country: Impressionism and the French Landscape*, 1984, no. 23, p. 102.

34 W. Dewhurst, *Impressionist Painting. Its Genesis and Development*, London, 1904, p. 53.

35 Duret, *op.cit.*, pp. 152–53.

36 Mauclair, *op. cit*, pp. 138–40.

37 A. Hare, *Days near Paris*, London, 1887, pp. 284–85.

38 T. Duret, 'Sisley. Documents', *Bulletin des Expositions*, 30 January–18 February 1933, p. 7. Letter to Monet dated 31 August 1881.

39 See Chronology under 1882, 1889.

40 For evidence of the artist painting 'sur le motif' at this stage see the letter from Sisley to Georges de Bellio dated 18 April 1883, 'Le temps a été admirable ici. Je me suis remis à travailler. Malheureusement, comme le printemps est sec, les arbres fruitiers fleurissent, les uns après les autres et défleurissent très vite, et j'en ai en train! Tout n'est pas rose dans le métier de paysagiste. Ce matin le vent était tellement fort qu'il a fallu lâcher. Le temps se couvre, fait rage un peu. (R. Niculescu, 'Georges de Bellio, l'ami des impressionnistes (11)', *Paragone*, XXI (1970), No 249, p. 50.

41 Princesse M. L. Bibesco, *Le voyageur voile*.

M. Proust, Paris, 1947, p. 25, quoting a letter from Proust to Armand d'Aure, Duc de Guiche (27 November 1904).

42 K. Baedeker, *Northern France from Belgium and the English Channel to the Loire excluding Paris and its Environs*, Eng. ed. London, 1899, p. 361.

43 On *Les Voyages pittoresques*, see B. L. Grad and T. A. Riggs, *Visions of City and Country. Prints and Photographs of Nineteenth-Century France*, Worcester Art Museum, 1982, pp. 15–90. The tradition lives on in Abbé A. Pougeois, *L'antique et royale cité de Moret-sur-Loing*, Moret, 1928.

44 *Correspondance de Camille Pissarro*, ed. J. Bailly-Herzberg, IV, 1895–98, Paris, 1989, No. 1138, pp. 75–77. Letter dated 26 May 1895.

45 Quoted in P. Tucker, *Monet in the '90s. The Series Paintings*, New Haven and London, p. 192. Letter of May 1892 to J. Alden Weir cited in D. W. Young, *The Life and Letters of J. Alden Weir*, New Haven, 1960, p. 190.

46 Wildenstein 1345 and D. 819 respectively.

47 O. Reuterswaerd, 'Sisley's 'Cathedrals'. A Study of the Church at Moret Series', *Gazette des Beaux-Arts*, 6 series, XXXIX (1952), p. 197.

48 Quoted in J. Pissarro, *Monet's Cathedral, Rouen 1892–1894*, London, 1990, p. 21.

49 These issues are discussed by Pissarro, *ibid*, pp. 23–27.

50 *Ibid.*, p. 26.

51 Quoted in B. Bibb, 'The Work of Alfred Sisley', *The Studio*, XVIII (1900), p. 149, who gives the text of Tavernier's funeral oration, as does Dewhurst, *op. cit.*, pp. 53–54.

52 R. Fry, 'Sisley at the Independent Gallery', *The Nation and Athenaeum*, 3 December 1927, p. 352.

53 J. Leclercq, 'Alfred Sisley', *Gazette des Beaux Arts*, 3 periode, XXI (1899), p. 236.

54 R. Huyghe, 'Some Unpublished Letters of Sisley', *Formes*, November 1931, p. 153.

55 Leclercq, *op. cit.*, p. 236.

56 *Idem.*

57 Pissarro worked in Moret-sur-Loing from 23 May to 28 June 1902. Like Guillaumin he was frustrated by the bad weather and was forced to paint several interior scenes (see *Correspondance de Camille Pissarro*, ed. J. Bailly-Herzberg, V, 1899–1903, Paris, 1991, Nos. 1902–11 and 2091 pp. 237–44 and 433). For Guillaumin's activities see C. Gray, *Armand Guillaumin*, Chester, Conn., 1974 and for Picabia see W. B. Camfield, *Francis Picabia. His Art, Life and Times*, Princeton, 1979 and M. Borras, *Picabia*, London, 1985.

58 On E. Reclus see M. Fleming, *The Anarchist Way to Socialism. Elisée Reclus and Nineteenth-Century European Anarchism*, London, 1979.

59 See Chronology under 1890 and 1891.

60 E. Reclus, *The Ocean, Atmosphere and Life*, trans. B. Woodward and ed. H. Woodward, London 1873, p. 300.

61 *Ibid.*, p. 298.

62 *Ibid.*, p. 295.

63 Leclercq, *op. cit.*, p. 236.

64 G. Geffroy, *La Vie artistique*, Vol. 3, Paris, 1894, pp. 282–83.

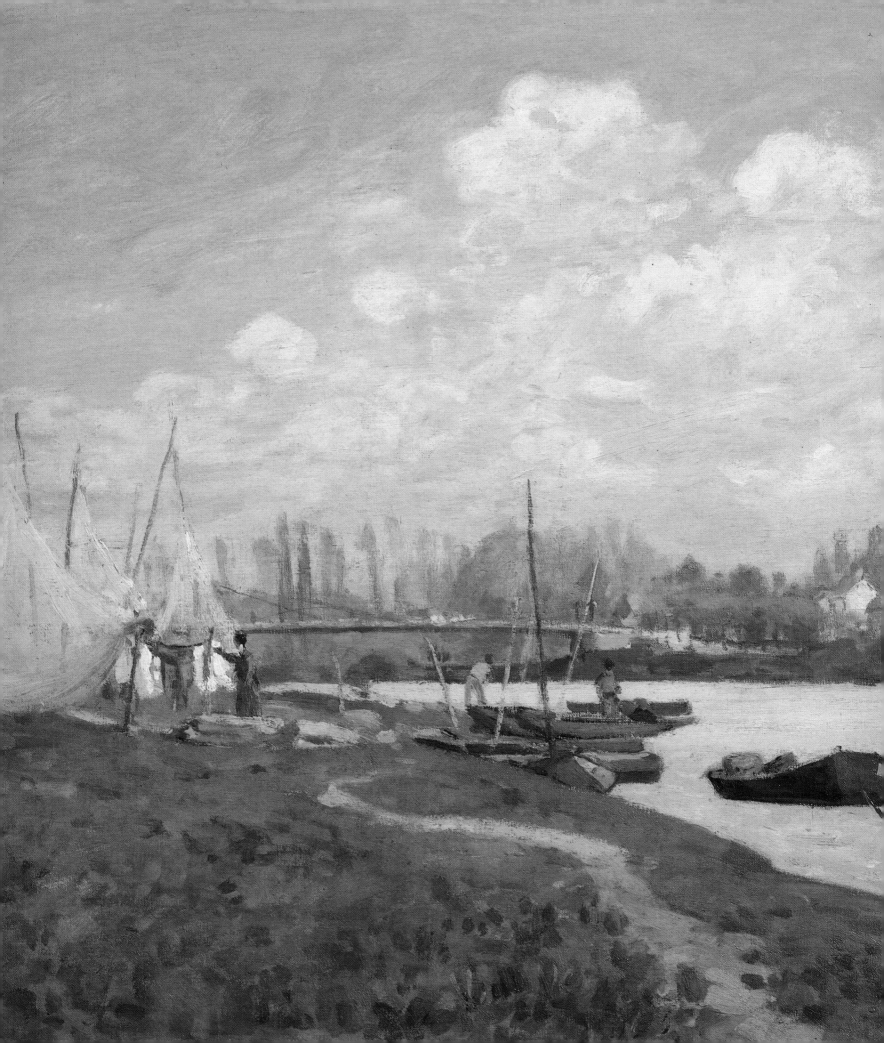

Caroline Durand-Ruel Godfroy

With the assistance of France Daguet

PAUL DURAND-RUEL AND ALFRED SISLEY: 1872–1895

To my great-grandfather, Paul Durand-Ruel

In his *Archives de l'Impressionnisme*, Lionello Venturi wrote in 1939: 'Many paintings by Alfred Sisley are known to us, but we have . . . very little information on him. He was one of the greatest of the Impressionists; he was also the most misunderstood.'[1] The truth is that, of the four great Impressionist painters – Monet, Pissarro, Renoir and Sisley – whose dealer was my great-grandfather, Paul Durand-Ruel (Fig. 32), Sisley was the only one who had no success in his lifetime and who can be classified as one of art's lost souls, a *peintre maudit*.

His life began auspiciously. His family, of English stock, was wealthy enough to allow him to paint solely for his own pleasure. Before 1870, he painted alongside Monet, Bazille, Pissarro and Renoir; and Arsène Alexandre often heard Renoir speak of 'Sisley's unshakable good humour at that time, untroubled by money or by melancholy'.[2] Then, in 1871, Sisley's father ran into business difficulties and

31 (*facing page*) Detail of Cat. 13, *Fishermen spreading their Nets* (Kimbell Art Museum, Fort Worth); probably bought by Durand-Ruel from the artist on 30th April 1872.

32 Eugène Pirou, *Paul Durand-Ruel*, photograph *c.* 1910 (Archives Durand-Ruel, Paris).

died almost penniless, leaving his son with no option but to make a living for himself and his family with his brush.

Such information as we have reveals Sisley as a cultivated but shy and reserved man. He was to die in 1899 without ever enjoying the success that his talent deserved. Over the years he became an embittered figure, seeing very little of his more successful former friends and seldom leaving his retreat at Moret-sur-Loing. Disappointed in his profession, worn out by constant financial worries for which his upbringing had done little to prepare him, and racked by the pain of a throat cancer, he seemed – as Gustave Geffroy reported after visiting him – 'to foresee that not one beam of glory would ever shine on his art, so long as he lived'.[3]

The Archives Durand-Ruel, comprising the firm's stock books, account books, outgoing and incoming correspondence and photographs of paintings taken into stock, are unfortunately incomplete for the period between 1870 and 1890: some books have been lost, and the practice of photographing all works as a matter of course was not introduced until 1896. Furthermore, no positive identification of individual works is possible, as until 1890 the numbering did not run consistently from one stock book to another.

As Paul Durand-Ruel tells us in his memoirs,[4] it was shortly after his return from London – where he had taken refuge during the Franco-Prussian war of 1870–71 and had met Monet – that he became acquainted with Sisley. The two men must have met by late 1871 or early 1872, as the gallery's first direct purchase from the artist – a painting entitled *The Church Path* – was entered in the stock books under the date of Saturday 23 March 1872.[5] This encounter took place at a crucial moment in Sisley's life: he had just lost both his father and his fortune and was having to learn to regard painting, for the first time, as something other than a fascinating pastime.

The archives also reveal that Durand-Ruel bought 25 paintings directly from Sisley in 1872, and 29 in 1873, mostly for 200 francs apiece, though sometimes the price went as high as 500 francs. The archives reflect the life of the gallery, and one is struck by the intense activity that went on: Durand-Ruel had just opened two branches, one in London and the other in Brussels (both were to close down in 1875), and he was regularly dispatching paintings to both and organising exhibitions. In London, six Sisleys were exhibited in 1872,[6] and five in 1873.[7] Works bought from the artist might therefore be shown in Paris, London or Brussels. Durand-Ruel sent works to outside exhibitions as well, and in 1873 a Sisley, *Boat at Moorings*, was shown in Rheims.[8] Also in 1873, he tried, without success, to have two more shown at the Universal Exhibition in Vienna: these were *The Great Avenue* (Fig. 33)[9] and *Woman Seated by the Water*.

In parallel with these activities, Durand-Ruel was planning to publish, as his father had done in 1845, a collection of prints of three hundred of his finest paintings, including three by Sisley.[10] This project was abandoned, but not before the critic Arsène Alexandre had written a preface for it, in which he declared:

> . . . Monsieur Monet is the most skilful and the most daring, Monsieur Sisley the most harmonious and the most timid, Monsieur Pissarro the most real and the most naïve . . . What seems most likely to speed the success of these newcomers is that their paintings are all done in a singularly cheerful range of colours. They are flooded with a blond light, and all is gaiety, clarity, springlike festivity . . .[11]

How wrong he was! The truth, according to Durand-Ruel, was that the works of the future Impressionists, exhibited in 1872 and 1873, 'had done no more than arouse curiosity'.[12] In London they had had no success whatsoever, and those few collectors who actually bought any of them later sent them back.[13] A press campaign now started against Paul Durand-Ruel and the young painters whom

33 Alfred Sisley, *The Great Avenue*, D41, 1872 (Private Collection, Paris).

he championed, and whom the Salon jury spurned. Durand-Ruel himself was described 'as a madman and a fraud'.[14] He lost all credit and sold off at a loss his stock of works by Corot, Millet and Delacroix.

Durand-Ruel no longer had the means to buy the work of the Impressionists, who were reduced to relying on a tiny band of collectors. Between 13 January and 20 April 1874, the Archives Durand-Ruel record the purchase of only six paintings from Sisley, and in 1875 just one; prices ranged from 300 to 800 francs. As for sales, from a total of five in 1873 – one to Faure and four to Hoschedé[15] – they fell to two in 1874 and none in 1875.

Durand-Ruel was not to resume buying until 1880, when he received the backing of Feder, the head of the Union Générale bank; but in the meantime he certainly did not lose interest in the Impressionists in general, or in Sisley in particular. On the contrary: while his means lasted, he bought a painting by Sisley at the first Hoschedé sale.[16] He also owned two of the six Sisleys in the first Impressionist exhibition held at Nadar's studio in the spring of 1874,[17] and went on to show five Sisleys in London.[18] At the famous public auction that Monet, Renoir, Berthe Morisot and Sisley organised on 24 March 1875 in the hope of finding new collectors and making a little money, Durand-Ruel acted as valuer. The sale degenerated into an indescribable shambles – best described as a Happening – and the police had to be called. It was a calamity for the artists concerned; Sisley, who sold 21 paintings, did better than his friends, although the average price of 122 francs was still a long way below the minimum of 200 francs offered by Durand-Ruel. In 1876, Durand-Ruel sold 33 paintings at public auction,[19] at which an *Edge of a Wood* by Sisley seems to have fetched 300 francs.

The second Impressionist exhibition, held at Durand-Ruel's gallery at 11 rue Le Peletier in April 1876, included eight Sisleys, all lent by dealers: Madame Latouche, Martin, Legrand and Durand-Ruel himself, who showed two (Fig. 34).[20] Albert Wolff, the critic of *Le Figaro* and an inveterate foe of the Impressionists, contributed his customary diatribe: 'After the fire at the Opéra,[21] a new calamity has struck the district'. But in the *New York Tribune* the American critic, Henry James, was full of praise for 'the little group of the Irreconcilables,

34 Alfred Sisley, *At the Foot of the Aqueduct, Louveciennes*, D213, 1876 (Oskar Reinhardt Collection, Winterthur).

otherwise known as the 'Impressionists' in painting', which he found 'decidedly interesting'. This was a sign of things to come. As for Sisley, his work was noticed by a number of the critics, including Armand Silvestre, of *L'Opinion*, and Alexandre Pothey, of *La Presse*.[22]

In 1877, Durand-Ruel lent no Sisleys to the third Impressionist exhibition. The best he could do, in January of that year, was to sell eight works by Sisley to Hoschedé.[23] He then lacked the means to buy them back at the second Hoschedé sale, in 1878, which was as big a disaster as the first.

In 1880, thanks to the support of Feder, Durand-Ruel was at last able to buy works from the Impressionists again. It was the end of a very lean time for all of them. The first thing Durand-Ruel did was to conclude a deal with Sisley, 'the poorest and the least successful of all'.[24] This was not a written contract but a gentleman's agreement between artist and dealer: Sisley would sell his work to Durand-Ruel, who undertook to buy it and to make it known. This implies a degree of trust and a community of views between the two sides that was not always to be present in subsequent years.

The gallery archives record that Durand-Ruel resumed buying from Sisley on 23 April 1880. Between 1880 and 1886, the pattern was as follows: 36 in 1880, 45 in 1881, 43 in 1882, 33 in 1883, 23 in 1884, 35 in 1885 and just one in 1886, the last ever recorded as a direct purchase from the painter: making a total of 216, bought for prices ranging from 150 to 600 francs apiece.[25] To this must be added 80 paintings listed in 1881 as stemming from Durand-Ruel himself; these had presumably been part of his personal collection. If we add the 61 paintings bought between 1872 and 1875, we reach a total of 357 works sold by Sisley direct to Durand-Ruel between 1872 and the beginning of 1886 (see Appendix I, p. 50).[26] This does not include those paintings that remained in Durand-Ruel's personal collection and were not recorded in the archives. Nor should we forget the works purchased from collectors, or from other dealers, or at public auctions, which are less easy to keep

track of, because they could easily have passed through the gallery's stock more than once. There were 45 of these between 1880 and 1886 – which gives a total of 261 acquired in that time[27] – and 5 in 1872–73, which gives a grand total of 362 Sisleys recorded as having been purchased between 1872 and 1886.[28] As previously explained, these paintings are very difficult to identify positively.

Sales over the period 1880–85 by no means kept pace with purchases. In 1880, two works by Sisley were sold;[29] in 1881, there were eight.[30] In 1882, twelve were sold, notably to Petit, Bérard and Clapisson.[31] In 1883, Petit was the principal purchaser of the sixteen Sisleys sold in the course of the year.[32] In 1884, only two paintings were sold, both again to Petit. In 1885 and 1886, none were sold at all. These paintings, initially sold for prices ranging from 200 to 450 francs, had appreciated to 1000-1500 francs by 1882, no doubt as a result of the seventh Impressionist exhibition, which was held in that year.

In 1880 and 1881, 'back in business, and rewardingly so',[33] Durand-Ruel worked hard to promote the Impressionists. In 1880 he sent a large consignment, including three Sisleys, to an exhibition at Oran, in Algeria. He also sent eighteen Sisleys on consignment to the offices of the newspaper *Le Gaulois* at the end of 1881. Nothing was sold on either occasion.

This relatively tranquil interlude was rudely terminated in February 1882 by the collapse of Union Générale. Feder was ruined, and Durand-Ruel had to pay him back all the money he had advanced. From December 1882 to 1886 or thereabouts, the dealer – and with him the Impressionists – went through another lean period. Nevertheless, he went on buying from Sisley until 1886.

The seventh Impressionist exhibition, again organised by Durand-Ruel, opened on 1 March 1882. By now, the Impressionist group was by no means as united or as cohesive as it had been. Degas refused to exhibit alongside Monet, Renoir and Sisley; and Renoir, Monet and Caillebotte considered the political views of Pissarro, Gauguin and Guillaumin too 'revolutionary'. However, as Pissarro wrote to Monet: 'For Durand, and even for us, this exhibition is a necessity; I, for my part, would be extremely sorry to disappoint him. We owe him so much that we cannot refuse him this satisfaction. Sisley agrees with me; we understand each other very well.'[34]

In the end, the exhibition opened, without Degas, on the premises of the Panorama de Reichshoffen, at 251 rue Saint-Honoré.[35] In it, Durand-Ruel showed paintings that he owned, including 27 Sisleys – one of which, *Banks of the Loing*, was sold to a Monsieur Boivin.[36] Durand-Ruel was thus able to write to Renoir that 'the exhibition . . . is highly successful with the public. Press opinion is also fairly favourable, with regard to your own paintings and those of Messieurs Sisley, Monet and Pissarro – apart, that is, from a few vicious pieces like that by Albert Wolff.'[37]

In the same year, Durand-Ruel sent one Sisley on consignment to Rotterdam,[38] and two others to the exhibition of the Amis des Arts de la Touraine in Tours.[39] He also sent a varied selection of paintings, including seven Sisleys, to be shown, possibly at the Langham Hotel, in London, in June and July.[40] In all these exhibitions, only one work by Sisley was sold.[41]

The letters from Sisley to Durand-Ruel in the gallery's archives only date from 1881 onward. There is not much that is revelatory in them; they consist mainly of requests for money. In 1882, Sisley's move to Moret-sur-Loing was marked by a lease, for which Durand-Ruel had to sign a power of attorney.[42] There was an occasional mention of a forthcoming exhibition; and, in November 1882, Durand-Ruel received a long letter from the artist, written one day after Sisley and Monet had paid him a visit. Durand-Ruel was preparing to hold a series of one-man shows for the Impressionists. Sisley wrote:

Not only would this be a series of individual exhibitions, but as a whole it would amount to a sort of permanent exhibition; and what a single dealer can do in his gallery, painters cannot do collectively without running the risk of wearying and alienating everybody . . . In my view, our interests and yours do not lie in showing a lot of pictures so much as in doing what it takes to sell what we paint. To this end, a joint exhibition would be far more effective and would be sure to succeed. Those are my arguments against individual exhibitions. What do you think?[43]

In spite of this letter, Durand-Ruel went ahead with his one-man shows at 9 boulevard de la Madeleine.[44] He wrote in his memoirs: 'To show that these exhibitions were held in the painters' own best interests, I had been careful to borrow paintings by each of them from the most important of the major collectors who held their work.'[45]

The Sisley exhibition was held in June 1883, and Faure and Duret supplied two and three works respectively on 26 May. On 28 May, Faure sent five more, and the next day two more came from Dr de Bellio;[46] but not all of these works were hung. Pissarro even wrote to Dr Gachet to ask for a loan of *Barges on the Canal Saint-Martin* from his collection (Cat. 9, detail Fig. 35).[47] A number of the works were Durand-Ruel's own, or came from his apartment.[48] It must have been a superb exhibition, representative of Sisley's entire output.[49] In the following August, some of the works exhibited were sold to Georges Petit; perhaps he had admired them at the exhibition.[50]

The show itself, however, was a failure. Monet asked Pissarro: 'How goes the Sisley exhibition? I have a feeling that in this magnificent weather everyone must have escaped from Paris.'[51] Pissarro replied: 'Nobody came to my exhibition . . . As for the Sisley exhibition, it was worse still. Nothing, nothing.'[52]

All this was highly perturbing. Durand-Ruel had to pay off his debts to Feder, and times once more became very hard. He did what he could to go on buying from the painters, but he could not send them as much money as before, and in 1883–86 Sisley's letters to him consisted entirely of more and more urgent pleas for money.

On 26 March 1883, Sisley wrote: 'I received the 200 francs from you this morning. Thank you. I am not at my wit's end, just concerned about my bills at the end of the month.' On 31 July: 'I am sending you a crate containing two size 10 canvases and one size 20. I am counting on 250 francs each for the size 10s, 400 for the size 20 that you have, and 300 for the size 20 that I am sending you now.'[53] On 24 August, Sisley announced that he was about to leave Moret for Les Sablons, 'a quarter of an hour away from here, where I shall be in better air.' He wrote on 21 November: 'I know business is not exactly booming; but then, again, you have to admit that I don't make excessive demands . . . But I have to be sure of getting 500 francs by the end of the month.'

On 12 December he pressed his dealer further:

I have received the 200 francs you sent me. This is not nearly enough. At the moment I am buying canvases and paints. I have nothing left, and the end of the year is getting closer, when I shall have to repay what I have borrowed, not to mention my liabilities here. How can you expect me to work? From my point of view, things cannot go on like this.

But 200 francs was all that Durand-Ruel could send him.

As success eluded him in France, Durand-Ruel organised more and more Impressionist exhibitions abroad; and everywhere works by Sisley were included, as this letter from Pissarro to Monet shows:[54]

35 (*facing page*) Detail of Cat. 9, *Barges on the Canal Saint-Martin* (Musée d'Orsay, Paris).

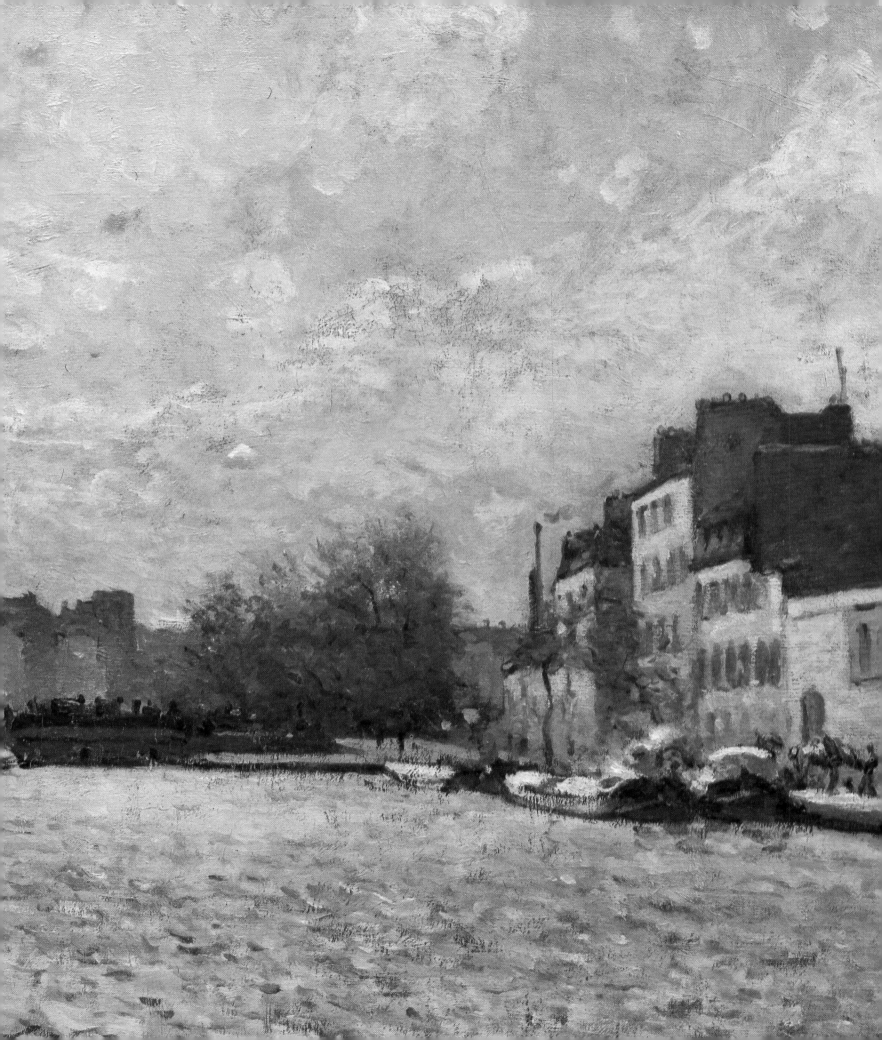

A consignment of our paintings has been sent to an exhibition in Boston.[55] I have heard from Americans that this was a mediocre affair that had no influence whatever. I talked to Durand about it, and he told me it was an experiment; he was taking a chance that offered itself to show us – particularly since it was free of customs duty ... A week or so ago there was talk of an exhibition in Holland.[56] As you may well imagine, Durand is constantly active. He is in a hurry to push us forward at all costs ... In London, for instance, Durand did a deal with a contractor [Dowdeswell & Dowdeswell] who simply stacked our canvases up in a room like the Hôtel des Ventes Paris auction rooms.[57]

In September 1883, for the first time in Germany, 24 paintings, including three Sisleys, sent by Durand-Ruel were shown at the Galerie Fritz Gurlitt in Berlin.[58] Once more, not one Sisley was sold.

The situation became still more alarming in 1884, when crisis struck the general art market. Durand-Ruel himself lost heart and wrote to Pissarro: 'I would like to be free to go off into the desert.'[59] He had huge debts and was on the brink of bankruptcy. The Impressionists were in dire straits, and on 29 August Pissarro wrote: 'I know all too well, alas, that business is at a low ebb; but it is still sad to see how low Sisley has sunk.'[60]

Sisley's letters reflect these concerns. On 7 February 1884 he wrote to Durand-Ruel: 'I have received the 300 francs you sent me. I was counting on more ...' And on 17 March: 'I have quite a lot of paintings under way ... In ten days or so, I shall bring you some paintings ... finished ones, for on that fateful day, 1 April, I shall need a thousand francs or so.' On 13 April he wrote: 'Knowing the difficulty you have in getting paid, I am very sorry to be asking you for money, but after paying my rent I have not a penny.' On 6 June: 'I would like to be able to take your advice and just wait. But unfortunately, here as elsewhere, it is impossible to live without money, and I have none left.'

This was in a year in which Durand-Ruel bought 23 paintings from Sisley and organised, in the spring, another Impressionist exhibition in London, at the Dudley Gallery, to which he sent 24 works. Among these were 12 Sisleys, with asking prices between 1000 and 1500 francs. Not one was sold.[61] In June he lent one Sisley to an exhibition mounted by the Société des Amis des Arts in Nancy.[62] In January, he even rented one to Monsieur Lespiault, director of the Musée de Nérac (Lot-et-Garonne) in southern France.[63]

The next year, 1885, was even worse, though Durand-Ruel is on record as having bought 35 Sisleys, which he made every effort to sell, as he wrote to the artist on 23 July:[64]

I count on you to send me some nice things, preferably small canvases, as finished as possible. You ought even to try your hand at size 5 or 6 canvases.[65] There are some people [collectors] who want small pictures to start with, and in any case it is a good thing to demonstrate that you can adapt your technique to small dimensions.

On 23 August, Sisley replied: 'I have been working hard lately, and I have done some small canvases as you wished.' (Fig. 36)[66]

Meanwhile, taking advantage of a springtime lull, Durand-Ruel sent his son Joseph to Brussels with a number of Impressionist works, including some by Sisley.[67] In the autumn the situation was once more desperate. The letter that Sisley wrote to the dealer on 17 November is a harrowing one:

I have received the 200 francs. This will enable me to settle my promissory note, which expires on the 20th of this month. But after the 21st I shall be penniless again. And somehow I have to pay something to my butcher and my grocer.

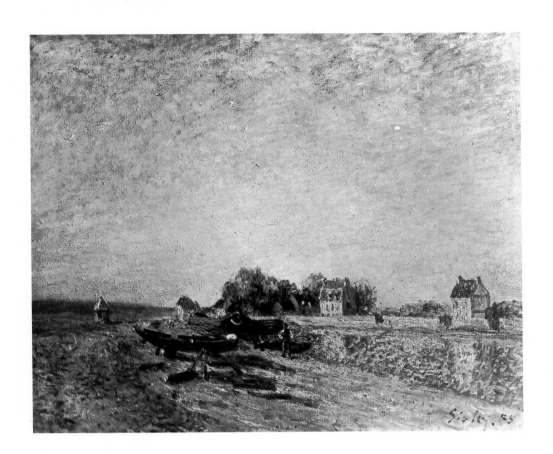

One has had nothing for six months, the other for a year. So I also need some money for myself . . . I am at my wit's end. Tomorrow or the next day, I will send you three canvases; that's all the finished work I have.

But only one of these paintings was bought, and Sisley wrote again on 25 November: 'You are better placed than I to know what collectors like. Just send back the two canvases that you consider less saleable. I will replace them the next time I come.'[68] On top of all these debts there was the artist's rent for the year ending 1 April, which fell due on 22 July.[69] Durand-Ruel assumed responsibility for paying this until November 1886.[70]

Then an attempt was made to discredit Durand-Ruel, once and for all, by having him change his mind on a supposed Daubigny in Georges Petit's collection that he had – rightly – dismissed as spurious at first sight. There was a scandal. Durand-Ruel defended himself in the 5 November issue of *L'Evénement*, and on 7 November Sisley wrote to him: 'Your two letters in *L'Evénement* are very good. You could not have made a better answer, or better revealed to the public the underhand campaign that has been waged against you for so long because of us.'

The support of Sisley and the other Impressionists was not, however, unconditional. They were growing more and more restive, and the prospect of an exhibition in New York did not appeal to them. Pissarro wrote to Monet in October 1885:[71] 'Sisley is not happy! A bad sign . . .' A few days later he reported:

I saw Sisley on Monday. We talked for a long time about exhibitions; he is all for them . . . Sisley says we must make up our minds, one way or the other, within a month, with no shilly-shallying. Everything depends on Durand's attitude . . . The crisis continues . . . All this needs thought. It's a very serious step, because it would mean selling over Durand's head . . . As Sisley says, [the paintings] must be offered through an exhibition; there is only one way . . . But the expense of organising it all![72]

37 'Exposition Alfred Sisley', Galerie Georges Petit, Paris, 14 May–7 June 1917, photograph (Archives Durand-Ruel).

38 Key to the paintings
1 *The Bridge at Villeneuve-la-Garenne*, D37, 1872 (Metropolitan Museum of Art, New York), bought by Durand-Ruel from the artist, 24 August 1872. See Cat. 14.
2 *Snow at Louveciennes*, D52, 1872 (Norton Simon Museum, Pasadena CA), bought by Durand-Ruel from Picq-Veron, 25 June 1892.
3 *Hampton Court Lock*, D119, 1874 (Egyptian State Collection, Cairo), bought by Durand-Ruel from J.-B. Faure.
4 *The Regatta at Hampton Court*, D125, 1872 (Bührle Collection, Zurich), ex Chabrier and J.-B. Faure Collections.
5 *The Seine at Bougival: Autumn*, D88, 1873 (Nationalmuseum, Stockholm), bought by Durand-Ruel from the artist, 1874.

And so, a few days later, Monet wrote to tell Durand-Ruel that he himself, Pissarro and Sisley wished to abrogate the existing gentleman's agreement and intended to exhibit at the gallery of Petit (Fig. 37),[73] Durand-Ruel's direct competitor and the owner of the fake Daubigny. It was the unkindest cut of all, and relations could never be the same again.

From 1886 onward, contacts between Sisley and Durand-Ruel became infrequent. Pissarro, in dire straits, wrote to his son Lucien in January 1886:[74] 'I no longer understand, Renoir and Sisley have nothing', while at the same time informing him of the preparations for the exhibition organised by Durand-Ruel at the American Art Association, New York, for the following spring. On 3 March he told his son: 'I know that Monet, Sisley and Renoir get no more than I do . . .'[75]

The last painting bought by Durand-Ruel from Sisley, for 200 francs, was *Saint-Mammès from the River Loing*, for which he was paid on 8 February 1886. In November of that year, Durand-Ruel paid the artist's rent,[76] as he had undertaken to do, but Sisley never received any more money from Durand-Ruel and sold no more paintings to him.

Early in 1886, Durand-Ruel was on the brink of despair as he worked on his projected show at the American Art Association, to which he dispatched 289 paintings on 19 February: most were Impressionists, but they included some Neo-Impressionists, such as Seurat and Signac, as well as a number of more conventional works. There were fourteen Sisleys among them (possibly including Cat. 16, detail Fig. 39), although none was sold.[77]

The New York event was a success, so much so that its run was extended; and Durand-Ruel, back in Paris on 18 July, started planning another. At long last, his troubles were at an end. Sisley, who wrote to him on 2 August, 'I have just heard that you were back . . . I hope you have had a good and a fruitful trip', did not suspect the capital importance that this trip would have for the Impressionists. In February 1887, Pissarro wrote:[78] 'I saw Sisley . . . He told me that Durand had to sell all the Impressionist pictures to Mr Robinson, which is why the latter has no desire to buy any: he has enough.'[79]

39 (*facing page*) Detail of Cat. 16, *Ferry of the Ile de la Loge: Flood* (Ny Carlsberg Glyptotek, Copenhagen), possibly included in Durand-Ruel's exhibition in New York in 1886.

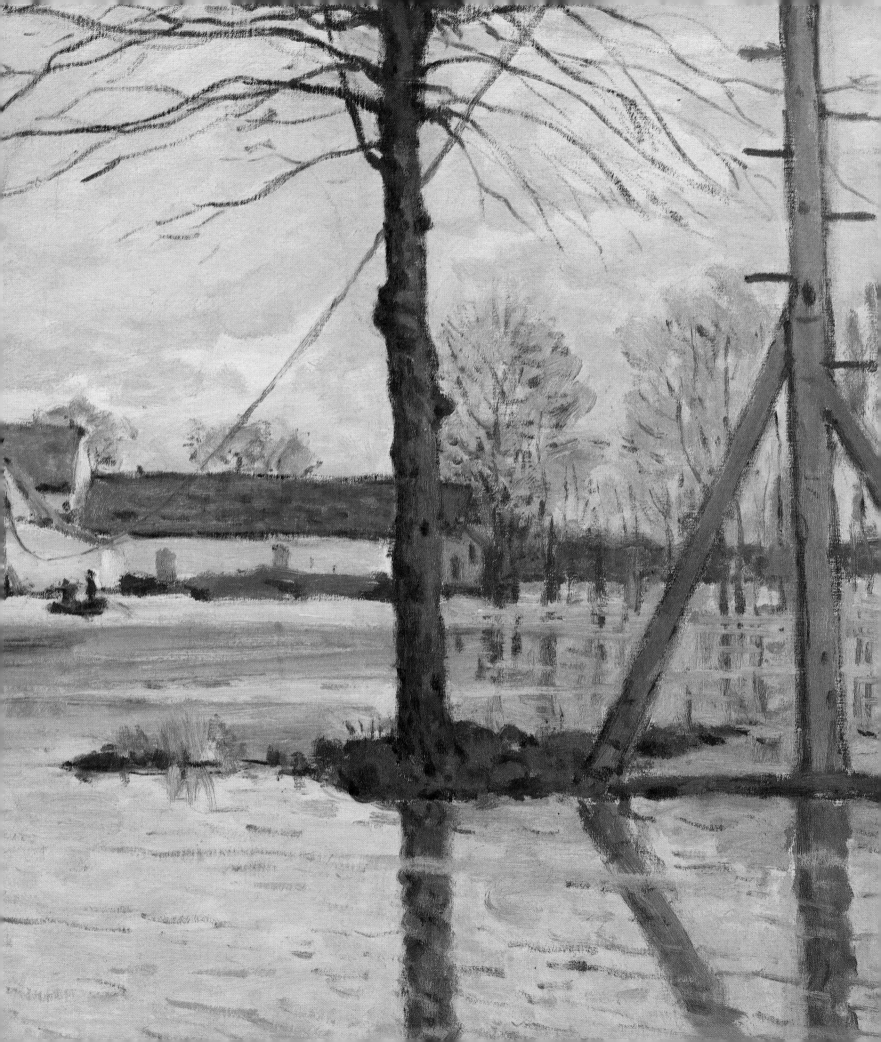

40 Alfred Sisley, *Beside the Loing: the Riverbank*, etching, 1890 (Bibliothèque Nationale, Département des Estampes, Paris); exhibited at the 2nd *Exposition des Peintres-Graveurs*, Galerie Durand-Ruel, March 1890.

Shortly afterwards, Petit opened his *6ᵉ Exposition internationale*, including works by Monet (since 1885), Renoir (since 1886), Sisley, who sent in fifteen works, and Pissarro, from whom we learn that 'the Monets, the Renoirs, the Sisleys ... [are] very much grouped together'.[80] The exhibition had some success, and Monet, whose relations with Durand-Ruel had cooled significantly, took it on himself to tell him so:[81]

> I am convinced that you would have done better to stay here, where you deserved to succeed.[82] ... More or less all of us are at the *Exposition Internationale*, where the buying public is giving us a decidedly warmer reception ... The firm of Boussod now has works by Degas and Monet, and ... will also have Sisleys and Renoirs ... Sisley is having a great success with old work.

The arrival of this letter coincided with the opening of Durand-Ruel's exhibition at the National Academy of Design in New York, in May–June 1887, originally planned for autumn 1886 but delayed by the bureaucratic machinations of American dealers who were jealous of the success he had achieved with the previous show. This time, six Sisleys were exhibited.[83] In May 1887, Durand-Ruel also organised a sale at Moore's Art Galleries in New York, at which six works by Sisley were on offer.[84] On both occasions, results were disappointing.

Nevertheless, Durand-Ruel had faith in America. By 1888 he had consolidated his position and opened a New York branch, to which in that year he sent seventy paintings, including at least twelve Sisleys. Seven of these were sold that same year, which was highly encouraging.[85] In Paris, in the spring of 1888, he put on an exhibition of a wide variety of artists, including all the Impressionists except Monet.[86] This included 24 Sisleys, the great majority of which belonged to the artist or to collectors;[87] but none was sold. Again in the same year, Monsieur Kapferer placed thirty paintings on consignment with Durand-Ruel, including seven Sisleys,[88] five of which the dealer himself bought in 1889.

These five were among seven Sisleys bought by Durand-Ruel in that year. He picked up one at auction on 19 February for 100 francs: *Edge of the Forest of Fontainebleau*.[89] He also sent four of the artist's works to that year's *Exposition Universelle* in Paris.[90] But Sisley was becoming more and more closely involved

with Petit, to whom he now applied for the money he needed to move house.[91]

In 1890, Durand-Ruel bought and sold very little work by Sisley.[92] It was in that year that the dealer's fortunes in Paris revived, thanks to the impetus provided by the United States. In March he organised the second *Exposition des Peintres-Graveurs*, in which Sisley was represented by three paintings or drawings and four etchings (Fig. 40).[93]

In 1891, the Galerie Durand-Ruel took back into stock a large number of Impressionist paintings, among them 110 Sisleys, which had apparently been deposited as security with some of Durand-Ruel's creditors; this was confirmation that business had picked up again. Durand-Ruel also brought out a periodical, *L'Art dans les Deux Mondes*, which ran for only a few months.[94] In it, on 21 February 1891, the critic Georges Lecomte published a long and highly laudatory article on Sisley.[95]

With all his old dynamism, Durand-Ruel sent two works by Sisley for exhibition in Nantes,[96] and five to the *Exposition des XX* in Brussels,[97] with asking prices ranging from 1000 to 1800 francs. Most importantly, in March he put on an exhibition at the J. Eastman Chase Gallery in Boston in which he presented works by Monet and Pissarro and six Sisleys,[98] three of which were sold. The catalogue preface on Sisley was by Frederic P. Vinton, who recalled a visit to the painter in the previous year and quoted him as saying: 'I love the gaiety of nature.'[99]

For Durand-Ruel, hard times were over; but Sisley remained isolated. After meeting him in April 1891, Pissarro wrote to Lucien:[100]

> Yesterday I met Sisley, whom I hadn't seen for at least two years. He is glad if he can keep his head above water. He told me that Durand was our greatest enemy; he tried to do Monet down, and Monet, without hesitating, went straight to Van Gogh,[101] and never looked back from that moment on. Durand then became as pliant as a kid glove, and from being ferocious turned as gentle as a lamb . . . Not being able to support all the Impressionists, Durand has every interest in beating them down as soon as he feels he has stocked up enough . . . He behaves like a modern speculator, for all that angelic sweetness of his. Sisley . . . cannot forgive him for his lack of good faith, for we were trusting and believed his promises.

A devastating verdict, and a totally unjust one. For twenty years, through scandals, discredit and financial difficulties, Durand-Ruel never abandoned the Impressionists – as he easily could have done – but transformed his stock of the 'School of 1830' by continuing to buy Impressionist works. Sisley's words were also the exact opposite of what he had written to Durand-Ruel himself on 7 November 1885. The fact is that by 1891 Renoir and Monet had gained public recognition, while Sisley and Pissarro (who was to say in 1895: 'I am left with Sisley as the tail-end of Impressionism')[102] had not. No doubt both men were discouraged by their former companions' success and disappointed by the offers made to them by Durand-Ruel, which no doubt reflected the state of the market.

Sisley, scarred by life, had become 'suspicious and sulky, not even seeing his old companions any more'.[103] As Arsène Alexandre put it, '. . . he added to his woes by creating imaginary ones for himself. He was irritable, discontented, agitated . . . He became utterly miserable and found life increasingly difficult.'[104]

This, surely, is the explanation for Sisley's ingratitude. Monet returned to the fold in 1891, playing Durand-Ruel off against the competition with the skill of an accomplished businessman, and in 1892 Pissarro accepted a highly advantageous offer to follow suit. Renoir, for his part, had never lost confidence in Durand-Ruel. Contacts with Sisley, however, remained extremely sparse. After 1886 there were no more direct purchases from him, and his account lay dormant until it was

41 Exhibition of Impressionist paintings organised by Durand-Ruel, Grafton Galleries, London, January–February 1905 (Archives Durand-Ruel, Paris).

42 (*facing page*) Key to the paintings
1 *Garden Path at By: May Morning*, D442, 1881 (Private Collection), bought from the artist, 10 May 1882.
2 *Road along the River at Saint-Mammès*, D425, 1881 (Private Collection), bought from the artist, 28 July 1881.
3 *On the Loing: Autumn*, D420, 1881 (National Museum, Budapest), bought by Durand-Ruel, 25 August 1891.
4 *The Riverside at Saint-Mammès*, D514, 1884, ex J.-B. Faure Collection, bought by Durand-Ruel at the Guasco sale, Galerie Georges Petit, Paris, 11 June 1900 (71).
5 *The Seine at Port-Marly*, D326, 1879, bought by Durand-Ruel, 5 Nov. 1890.
6 *The Canal du Loing*, D531, 1884 (Private Collection), bought by Durand-Ruel, 25 August 1891.
7 *The Seine in Paris and the Pont de Grenelle*, D15, 1870 (Private Collection), bought by Durand-Ruel, 23 August 1891.
8 *At the Foot of the Aqueduct, Louveciennes*, D213, 1876 (Oskar Reinhardt Foundation, Winterthur), bought from the artist, 1876 (see Fig. 34).
9 *The Loing at Saint-Mammès*, D523, 1884 (Private Collection), bought by Durand-Ruel at the Lord Radenac sale, Hôtel Drouot, Paris, 15 June 1894.
10 *The Hills of La Celle from La Croix-Blanche: Saint Mammès, Morning*, D555, 1884 (Private Collection), bought from the artist, 24 March 1884.
11 *The Banks of the Meadow at Veneux-Nadon*, D 384, 1880 (Private Collection), bought from the artist, 21 June 1880, exhibited at the 7th Impressionist Exhibition, 1882.
12 *Apple Trees in Blossom: Louveciennes*, D62, 1873 (Private Collection), bought from the artist, 1880.
13 *The Countryside at Viroflay*, D334, 1879 (Private Collection), bought from the artist.
14 *The Railway Station at Sèvres*, D310, 1879 (Private Collection), bought from Camentron, 23 February 1892.
15 *Spring Morning*, D101, 1873 (Private Collection), bought 8 April 1873.
16 *A Park at Louveciennes*, D100, 1873 (Private Collection), bought by Durand-Ruel, 25 August 1891.
17 *View of the Thames and Charing Cross Bridge*, D113, 1874 (Private Collection, London), bought from the artist in 1876.
18 *The Seine at Port-Marly*, D72, 1873 (Private Collection), bought from the artist, 1874.

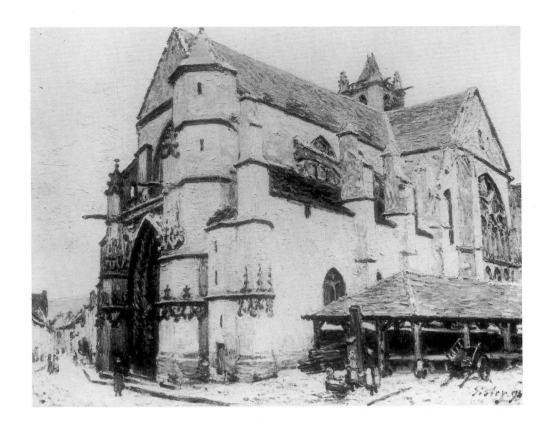

43 *The Church at Moret: frosty weather*,
D819, 1893 (Private Collection), bought by
Durand-Ruel from the François Depeaux
Sale, Hôtel Drouot, Paris, 31 May–1 June
1906 (54).

closed for good in 1888. But Paul Durand-Ruel and his sons nevertheless continued to acquire his work when the opportunity arose (Fig. 41),[105] and to organise group and individual exhibitions with increasing frequency, both in France and abroad.[106]

In 1892, Georges Lecomte published *L'Art impressionniste d'après la collection privée de Monsieur Durand-Ruel*, devoting a chapter of glowing praise to Sisley. But in that year the Durand-Ruel archives contain no more than a brief note from the painter à propos some work sent to an exhibition in Munich.[107] The last contact was a brief exchange of letters between Georges Durand-Ruel and Sisley in July 1895, concerning works to be shown at the *Exposition des Beaux-Arts* in Ghent.[108]

Though Sisley exhibited regularly at the Salon de la Société Nationale (1890–96, 1898) and at Petit's gallery, success continued to elude him. The failure of his one-man show at Petit's in 1897 was the last straw. Would he not have done better to return, as Monet and Pissarro had done, to Durand-Ruel, whose business was expanding steadily from 1892 onward? His sales to the dealer would have guaranteed him an income, as in the past, and he would have had the benefit of the solid network of connections that Durand-Ruel and his sons had created all across Europe and in the United States, with every chance of finding new collectors and greater fame (Fig. 43). But he died, still neglected, in 1899, 'bereft of all joys but the joy of painting, which never left him'.[109]

APPENDIX I
TABLE OF PAINTINGS BOUGHT BY DURAND-RUEL

According to the archives, Durand-Ruel resumed buying works from Sisley on 23 April 1880 and continued to do so until 8 February 1886, at prices that varied from 150 to 600 francs apiece.

Durand-Ruel bought nothing directly from the artist after 8 February 1886 and had practically no contact with him after 1891. The following table shows the quantity of works purchased, year by year, from 1872 to 1891.

| Date | Bought by Durand-Ruel | | Listed by Daulte |
	Direct from Sisley	Other sources	
1872	25	4	56 (1865–1872)
1873	29	1	51
1874	6	2	44
1875	1	0	42
1876–1879	0	0	155 (1876–1879)
1880	36	1	60
1881	45	7	42
		80 ex DR coll.	
1882	43	21	24
1883	33	3	30
1884	23	2	54
1885	35	2	72
1886	1	0	6
1887	0	0	19
1888	0	1	41
1889	0	7	24
1890	0	1	33
1891	0	3	33
Total	277	135	786

It will be seen that between 1872 and the beginning of 1886 Durand-Ruel bought some 400 Sisleys; over the same period, Daulte's catalogue raisonné lists 631 works. In the period 1872–1891, Durand-Ruel bought 412 of Sisley's paintings, and Daulte lists 786 works out of a lifetime total of 884.

These figures do not include the paintings that remained in the dealer's personal collection and do not appear in the archives. Equally, it should be remembered that works bought from collectors, from dealers, or at auction, are more difficult to account for, as they might well have passed through our stock previously. For the reasons given above, these works are in any case very difficult to identify.

1 Lionello Venturi, *Archives de l'Impressionnisme*, Paris 1939, I, p. 28. This work supplements the two primary sources on which this essay is based: the 'Livres de stock' (stock books) and 'Livres de brouillard' (daybooks), both held in the archives of the Galerie Durand-Ruel, Paris.

2 Arsène Alexandre, preface to sale catalogue, *Vente Sisley*, Georges Petit, Paris, 1 May 1899.

3 G. Geffroy, *Sisley*, Paris, 1923.

4 See Venturi *op. cit.*

5 But the first work of Sisley's that was bought by Durand-Ruel and listed in the stock book was an *Snow Effect* (*Effet de neige*), bought from Monsieur Latouche for 200 francs on 12 March 1872.

6 In 1872, the following paintings were shown at the 5th exhibition of the Society of French Artists: cat. no. 120, *Drying Nets*; cat. no. 124, *On the Seine*. It is difficult, if not impossible, to identify Sisley's paintings of this period with any certainty, in view of the lack of variety in the artist's choice of titles and the non-existence of photographs; but it may be conjectured that no. 120, *Drying Nets*, might have been the work bought from Sisley by Durand-Ruel on 30 April 1872 and sent to London on 17 May 1872, *Fishermen Spreading Out Their Nets*, D27; Cat. 13).

7 Exhibited at the 6th exhibition of the Society of French Artists, in 1873: cat. no. 119, *Flower Nursery*; cat. no. 137, *Inundation on the Road to Saint-Germain*; cat. no. 138, *The Louveciennes Woods, near Paris*. Exhibited at the Society's 7th exhibition, also in 1873: cat. no. 114, *The Ile Saint-Denis*; cat. no. 126, *An Orchard in Bloom*.

8 Société des Amis des Beaux-Arts, Le Cirque, boulevard des Promenades, Rheims.

9 It is known from the engravings done for the catalogue *Galerie Durand-Ruel, recueil d'estampes*, that the painting *The Great Avenue* is D41, known as *Banks of the Seine at Bougival*.

10 Though the work was not published, the engravings were done; and so we know which works by Sisley were selected for inclusion. These were *Bridge at Villeneuve-la-Garenne* (D37, Cat. 14), which Faure bought in 1873; *Banks of the Seine at Bougival* (D41); and *Ile Saint-Denis* (D47), the left-hand component of the 'May Triptych', now in the Musée d'Orsay. (The other two components are Pissarro, *Road into the Village* and Monet, *Pleasure Boats*.)

11 Arsene Alexandre, preface to *Galerie Durand-Ruel, recueil d'estampes*, unpublished.

12 Venturi *op. cit.*, II, p. 197.

13 This is confirmed in the stock books by the record of the purchase by Lord Powerscourt, on 31 January 1874, of three paintings, including a Sisley of unknown title, which he sold back to the gallery on 30 January 1875.

14 Venturi, *op. cit.*, II, p. 197.

15 Sold to Faure: *Bridge at Villeneuve-la-Garenne* (D37, Cat. 14). Sold to Hoschedé: *Country Canal Lock*; *The Machine de Marly* (Cat. 20); *Port-Marly during the Flood* (D23); *The Saint-Germain Road near Bougival*.

16 This sale took place on 13 January 1874; the purchase is confirmed in the gallery archives, though the title of the painting is not recorded.

17 The paintings in question were *The Saint-Germain Road* and *Ferry of the Ile de la Loge: Flood* (D21; Cat. 16).

18 Exhibited at the 8th exhibition of the Society of French Artists, in 1874: cat. no. 140, *A Street at Poissy*; cat. no. 144, *A Hill near Poissy*; cat. no. 147, *A Street in the Suburbs*. Exhibited at the Society's 9th exhibition, also in 1874: cat. no. 23, *The Convent*; cat. no. 121, *A Corner of Poissy*.

19 Sale at Hôtel Drouot, Paris, 27 May 1876.

20 *Bank of a Stream (near Paris)*, and *The Aqueduct Path* (?D133 or 213).

21 An allusion to the fire that totally destroyed the Paris Opéra, which then stood at 12 rue Le Peletier, on 28 and 29 October 1873.

22 See Chronology, Critical Summary II, p. 282.

23 Between 19 and 23 January 1877, Durand-Ruel sold 29 paintings to Hoschedé, of which 8 were by Sisley. Six of the titles are known: *Bridge with Ducks* (?D77, 1873); *The Versailles Road, Fog*; *Vineyard, Winter Morning*; *Spring Morning* and *The Machine de Marly*.

24 John Rewald, *The History of Impressionism*, New York and London 1961, p. 453.

25 In his catalogue raisonné, Daulte lists a total of 281 works by Sisley for this period between 1880 and 1885 (See Appendix I).

26 For the period between 1865 and early 1886, Daulte lists 631 works.

27 See note 25.

28 See note 26.

29 One of the two paintings, *The Towpath on the Loing Canal*, was first sold for 200 francs to a Mr Willems, who returned it; it was then sold to Faure. The other, *Banks of the Seine*, was bought by a Monsieur de Tracy.

30 Of these eight paintings, four were sold to Faure: *View of the River Loing, Moret*; *Morning Sun at Saint-Mammès*; *A View of Moret-sur-Loing*; *Saint-Mammès*. Prices ranged from 300 to 450 francs. One was sold to Monsieur Bérard: *Moret Waterfront*, for 400 francs. One was sold to Monsieur Feder: *February Morning at Moret-sur-Loing*, for 400 francs.

31 In 1882, Petit bought ten paintings for 33,000 francs, including 3 by Sisley: *The Loing at Saint-Mammès*; *The Seine at Saint-Ouen*; *Saint-Mammès, Morning*. Bérard also bought 3 Sisleys: *The Seine near Paris*, for 1000 francs; *Wheat Field*, for 1000 francs; *Princess Hill*, for 1000 francs. Monsieur Clapisson bought two: *Saint-Mammès and Hillsides above the River at La Celle*, for 1500 francs; and *Landscape, Stormy Weather* (D317), for 1000 francs. Monsieur May bought one: *Waterside*, for 1000 francs.

32 Georges Petit bought twelve Sisleys.

33 Venturi, *op. cit.*, II, p. 212.

34 Letter from Pissarro to Monet, about 24 February 1882, in Bailly-Herzberg, 1980, I, letter 98.

35 These rooms had been rented by Durand-Ruel for two months. See Venturi, *op. cit.*, II, p. 212.

36 This painting might be the one which was sold for 1200 francs on 30 March 1882, *Spring on the Banks of the Loing* (D412), which is known to have belonged to Emile Boivin.

37 Letter to Renoir from the firm of Durand-Ruel, 10 March 1882, Archives Durand-Ruel. See also Chronology under 1882.

38 At that time Paul Durand-Ruel was in close business contact with the dealer Joseph de Kuyper, in Rotterdam, to whom he sent a Sisley, *Barges at Anchor at the Mouth of the Loing*.

39 Organised by the Société des Amis des Arts de la Touraine, the exhibition was held at the Hôtel de Ville in Tours. The two works by Sisley that were shown there were *Hellhole Farm* and *Banks of the Seine*.

40 This exhibition was probably held at the Langham Hotel, Regent Street, although an alternative location and date for the exhibition are given in Flint, 1984, pp. 44–46 (see Chronology, under 1882). The seven Sisleys on show were *The Path to Thomery*, 1880; *The Little Meadows*, 1881; *Saint-Mammès*, 1881; *Hellhole Farm* (later shown in Tours, see note 39); *Slopes at the Edge of a Wood*; *Louveciennes* and *Rue de Veneux*.

41 This was the *Path to Thomery* shown in London and sold on 31 July 1882 to a Monsieur Marchand or Michaud for 1250 francs.

42 Letter from Maître Popelin, notary at Moret-sur-Loing, to Durand-Ruel, dated 30 August 1882, Archives Durand-Ruel.

43 Letter from Sisley to Paul Durand-Ruel, 5 November 1882. Note that Monet agreed to the dealer's proposals: Venturi, *op. cit.*, II, p. 56, no. 3.

44 The premises consisted of an entresol with a street entrance.

45 Venturi, *op. cit.*

46 According to the Durand-Ruel daybook (Livre de brouillard, Archives Durand-Ruel), on 26 May 1883 Faure sent in *Feig's [Tagg's?] Island*, which was not exhibited, and *Interior of a Forge*; Duret sent in *Road in Sunshine, Rue de Sèvres* and *Louveciennes*, none of which were exhibited. On 28 May, Faure also sent in *Terrace at Saint-Germain* (D164; Cat. 34), *Moret – View of the River Loing* (D462), *Hillsides at Bougival, The Thames at Hampton Court* (D122), and *Morning Sun at Saint-Mammès*. On 29 May, Dr de Bellio sent in *The Sawyer* (D230) and *Path leading to Mont-Valérien*, but these were not shown either.

47 D16, Musée d'Orsay, Paris; see Cat. 9. Letter from Pissarro to Dr Gachet, 26 May 1883, Bailly-Herzberg, 1980, I, letter 153, p. 211–12.

48 At 35 rue de Rome.

49 Alongside some works dating from the early part of Sisley's career, there were others that were probably much later: the last of these was purchased as late as 21 May 1883.

50 On 7 August 1883, Georges Petit bought the following paintings: *The Waterside Street at Saint-Mammès, View of Moret, Hellhole Farm*, and *The Seine at Saint-Denis*; and on 9 August 1883 *Banks of the Seine, Waterside Hut* and *August Afternoon*. All of these had been in the exhibition.

51 Letter from Monet to Pissarro, early June 1883, in Daniel Wildenstein, *Catalogue raisonné de l'oeuvre de Monet*, Paris, 1979, II, p. 229.

52 Letter from Pissarro to Monet, 12 June 1883, in Bailly-Herzberg, 1980, I, letter 158, pp. 216–17.

53 The three paintings sent by Sisley bore the following titles: *The Boatyard at Matrat, Moret*, 250 francs; *View of Moret*, 250 francs; *Towpath, Loing Canal*, 300 francs. Size 10 and 20 canvases are for landscape work, measuring 38 × 55 cm and 54 × 73 cm, respectively.

54 See note 52.

55 This was the *Foreign Exhibition*, a section of the *International Exhibition for Art and Industry* held at the Mechanic's Building in September 1883; in it, for the first time in the United States, Durand-Ruel showed Impressionist paintings. Of a total of eighty works, three were by Sisley: *Saint-Mammès: Autumn Morning; The Great Avenue; Waterside Gate*.

56 In the course of 1883, Durand-Ruel sent to Joseph de Kuyper in Rotterdam a number of paintings in very different styles, including two Sisleys: *The Chestnut Tree at Saint-Mammès* and *Moret Waterfront, Evening*; but it is by no means certain that the exhibition ever took place.

57 The exhibition at Dowdeswell and Dowdeswell, 133 New Bond Street, London, in the spring of 1883, comprised 82 paintings sent in by Durand-Ruel. These included 12 by Sisley, all landscapes painted in the vicinity of Saint-Mammès (although only 8 of these were actually hung; see Chronology under 1883).

58 The three Sisleys shown were *Moret Mills, The Orchard* and *Banks of the Seine*.

59 Letter from Durand-Ruel to Pissarro, 9 June 1884. Archives Durand-Ruel, copies of correspondence.

60 Letter from Pissarro to Monsieur Heymann, 29 August 1884, in Bailly-Herzberg, 1980, I, letter 251, pp. 312–13.

61 These twelve Sisleys were *Old Houses at Saint-Mammès; Little Bridge over the Orvanne; Hoar Frost; Hillside at the Edge of a Wood; Banks of the Seine; The Path to the Pond; May Afternoon; Banks of the Seine at By; Towpath, Loing Canal; Evening at Saint-Mammès; View of Moret; The Riverside at Saint-Mammès*.

62 This is *Iron Bridge* (?D363).

63 This work is *The Loing at Moret*.

64 Archives Durand-Ruel, copies of correspondence.

65 The size 5 and 6 canvases mentioned by Durand-Ruel are landscape formats measuring 27 × 35 cm and 27 × 41 cm, respectively.

66 Sisley sold 17 paintings to Durand-Ruel between 23 August and 31 December 1885, but their dimensions are not recorded in the archives.

67 The Durand-Ruel archives give no details of titles or of possible sales.

68 This is the painting *Farmyard* or *Yard at Les Sablons* (D543), purchased on the following 25 November. The two other paintings were returned to Sisley on 26 November.

69 Letter from Monsieur Cocardon, Sisley's landlord, to Durand-Ruel, 22 July 1885,

Archives Durand-Ruel.

70 Letter from Monsieur Cocardon to Durand-Ruel, 24 November 1886, Archives Durand-Ruel.

71 Letter from Pissarro to Monet, 29 October 1885, in Bailly-Herzberg, 1980, I, letter 292, pp. 352–53.

72 Letter from Pissarro to Monet, *c.* December 1885, in Bailly-Herzberg, 1980, I, letter 298, pp. 357–58.

73 Letter from Monet in Etretat to Durand-Ruel, 10 December 1885, Archives Durand-Ruel.

74 Letter from Pissarro to his son Lucien, 21 January 1886, in Bailly-Herzberg, 1986, II, letter 308, p. 17–18.

75 Letter from Pissarro to his son Lucien, 3 March 1886, in Bailly-Herzberg, 1986, II, letter 318, pp. 29–31.

76 See note 70.

77 The exhibition catalogue includes the following titles: *Bougival; Cloudy Weather; The Beach at Veneaux [sic]; Effect of Snow at Marly; Rue de Marly in Winter; A Garden; On the Seine; Saint-Mammès, le matin; On the Banks of the Seine; The Ferry to the Ile de la Loge; Willow Trees at Veneux; Bridge of Bougival; Landscape with Figures; Morning in Spring*. The catalogue also listed *The Seine at Lavacour*, but in the second edition this was ascribed to Monet.

78 Letter from Pissarro to his son Lucien, 4 February 1887, in Bailly-Herzberg, 1986, II, letter 394, pp. 127–29.

79 Mr Robinson and Mr Sutton jointly ran the American Art Association, New York (see Johnston, p. 56).

80 Letter from Pissarro to his son Lucien, 8 May 1887, in Bailly-Herzberg, 1986, II, letter 421, pp. 161–63.

81 Letter from Monet to Durand-Ruel, 13 May 1887, Archives Durand-Ruel.

82 One of the bones of contention between Durand-Ruel and Monet was the dealer's policy of sending works by the artist to the United States.

83 Works by Sisley exhibited at the National Academy of Design in 1887: *Near Marly; The Seine at Chatou; Landscape Near Moret; Winter Sunshine at Veneux; A Farmhouse at Poissy; At Les Sablons*.

84 Works by Sisley in the sale at Moore's Art Galleries: *Grapes and Walnuts; Autumn at Marly-le-Roi; Winter at Marly-le-Roi; View of Louveciennes; Loing Canal; Moret*.

85 Notably, the following were sold to Mr Andrews: *The Seine at Saint-Mammès; Waterside Village* (D422); *Saint-Mammès, Morning*. Sold to Mr Catholina Lambert: *Saint-Mammès; Les Sablons; At the Edge of the Wood*.

86 The exhibition, which bore no specific title, remained open from 25 May to 25 June 1888.

87 The stock movement records ('Remis en dépôt', Archives Durand-Ruel), indicate that Sisley lent 8 pastels, seven of which were exhibited, and one oil; Monsieur Aubry lent two paintings; Monsieur Dubourg five at least; and Faure one.

88 Monsieur Hermann Kapferer, of 27 avenue de l'Opéra, sent in, among others, 2 works by Degas, 6 by Pissarro, 7 by Sisley, 2 by Monet and 4 by Renoir.

89 D587.

90 There are two relevant sources in the Archives Durand-Ruel. Our stock movement records ('Livres de remis en dépôt') mention 55 paintings, including 4 Sisleys (a *Snow Effect*, *Les Sablons* and two *Saint-Mammès*), as having been sent to the *Exposition Universelle, Pavillon de la Presse*. All were returned on 14 November 1889. The gallery correspondence books ('Doubles de correspondance') record a request, dated 19 June 1889, for a receipt worded as follows: 'Received of Monsieur Guilois by the intermediary of Monsieur Durand-Ruel, 40 paintings for exhibition at the Press Pavilion.'

91 Letter from Sisley to Georges Petit, 9 October 1889, Archives Durand-Ruel. Sisley was moving to rue de l'Eglise, Moret-sur-Loing.

92 Notably, he sold two Sisleys to the actor-manager Coquelin: *Near Moret* and *Pont de Sèvres* (D259).

93 *Moret Bridge, Moret, Evening, Sketch* and four etchings, *The Loing at Moret*. The four etchings (no. 264) were entitled *The Waggon*, *Six moored Boats*, *Houses beside the Water* and *The Riverbank* (see *La Gravure originale au XIXe siècle*, Paris 1962, p. 166).

94 It came out from 22 November 1890 to 2 May 1891.

95 *L'Art dans les Deux Mondes*, 1891.

96 Paintings exhibited Nantes: *Weir on the Loing*; *Bank of the Loing at Moret* (D595).

97 Paintings sent to the *Exposition des XX* in Brussels: the two mentioned in the preceding note, and *The Meadow Bank* (D344?); *Path to the Pond* (D417); *The Canal du Loing*.

98 These six Sisleys were: *Saint-Mammès, Morning*; *Bougival Bridge*; *The Loing Canal* (these three were sold); *Slopes of les Roches Wood, Veneux*; *Woman with Parasol*; *Saint-Mammès*.

99 In English in the original; see Johnston, pp. 62–64.

100 Letter from Pissarro to his son Lucien, 13 April 1891, in Bailly-Herzberg, 1988, III, letter 653, pp. 61–65.

101 This was Théo van Gogh, Vincent's brother, manager of the Galerie Boussod et Valadon in Paris and a friend of the Impressionists, who died a few months after his brother.

102 Letter from Pissarro to his son Lucien, 24 February 1895, in Bailly-Herzberg, 1989, IV, letter 1115, pp. 37–39.

103 John Rewald, *The History of Impressionism*, New York and London 1961, p. 576.

104 Alexandre, *op. cit.* (see note 2).

105 According to the Paris and New York stockbooks, Durand-Ruel bought 84 Sisleys in 1892, 10 in 1893, 11 in 1894, 6 in 1895, 6 in 1896, 17 in 1897, 2 in 1898 and 41 in 1899. The large number of acquisitions in 1892 is explained by the reacquisition of Sisleys held by Feder as collateral for loans made during the difficult years in the 1880s. In 1899 Erwin Davis and Catholina Lambert respectively returned 17 and 10 Sisleys to the New York gallery. The majority of the remaining purchases were made at public sales in Paris.

106 See Chronology and Johnston, Appendix II, pp. 69–70.

107 According to the archives, the firm of Durand-Ruel sent no paintings to the Munich exhibition.

108 Durand-Ruel sent the following paintings: *View of Moret*; *Autumn, Bank of the Loing* (1881, D. 385); *The Dam at Suresnes*. Sisley himself sent two.

109 Alexandre, *op. cit.*

William R. Johnston

ALFRED SISLEY AND THE EARLY INTEREST IN IMPRESSIONISM IN AMERICA 1865–1913

Alfred Sisley did not live to share the public recognition eventually enjoyed by his Impressionist colleagues. Nevertheless, his refined, subtle approach to the movement struck a responsive chord with American viewers and contributed to the enthusiasm for Impressionism in that country. His atmospheric landscapes appeared in many pivotal exhibitions in the United States and were to be found in major private collections before 1914.

As early as the mid-1860s, the amiable and bilingual Sisley was befriended by Americans studying in France. Among them was Daniel Ridgway Knight, a pupil of Gleyre and Meissonier, who, after his return to his native Philadelphia, addressed an affectionate letter jointly to Sisley and Joseph R. Woodwell, a Pittsburgh painter.[1] To Sisley, Knight commented 'I never can forget the real English hospitality of your home and the kindness of your father to a stranger', and continued asking for photographs of the entire Sisley family. Woodwell, in turn, received several letters from Sisley, then in Honfleur, who sent his 'love' to the American's parents and asked him to negotiate the sale of a painting to a 'Mr Wolff' then visiting Paris. Sisley ultimately received a commission from 'Wolff', probably the New Yorker John Wolfe, a diligent collector, who was later recalled as being 'thoroughly commercial' in his taste.[2] Wolfe had begun to buy and sell pictures rather indiscriminately in the 1850s, and in the 1870s assembled a collection for his cousin, the heiress Catharine Lorillard Wolfe, which eventually formed the basis of the Metropolitan Museum of Art's holdings of French academic painting.

However, it was not until over a decade later that Americans had the opportunity to learn of Sisley and his progressive colleagues. In 1879, a broad-ranging survey of developments in French painting appeared in the Philadelphia journal, *Lippincott's Magazine*.[3] The critic, L. Lejeune, acknowledged that earlier rebels in nineteenth-century French painting had won acceptance and that the 'so-called' Impressionists were gaining supporters among amateurs and writers. He went on to criticise the Impressionists' colours, which were to remain an obstacle for many Americans, expressing horror at Gustave Caillebotte's violet hues but defending Sisley's lilac shadows which he believed the artist indeed saw in nature. Lejeune concluded that these painters left a 'disagreeable impression' on him but he at least advised his readers to form their own opinions.

Not until 1883 would Americans have such an opportunity. That autumn, the Parisian dealer Paul Durand-Ruel, determined to test the American market, travelled with a selection of works to the 'Foreign Exhibition' in Boston, where collectors had already responded favourably to the Barbizon masters. In addition to three Sisleys, he brought with him two Manets, six Pissarros and three works

44 (*facing page*) Detail of Cat. 49, *The Bridge at Saint Mammès* (Philadelphia Museum of Art), bought in Philadelphia in 1888 by John G. Johnson.

each by Monet, Renoir, Boudin and Lépine.[4] Catering for less adventurous tastes, he also included a selection of works by more conservative artists, among them the equestrian painter John Lewis Brown, Victor Pierre Huguet, a specialist in North African subjects, and Louis-Émile Benassit, a minor military artist.

The exhibition opened on 3 September in the Mechanic's Building to a mixed reception from the press. *The Art Amateur* expressed particular interest in the Impressionists and noted that 'these young men are not without talent, although their conceit of themselves is certainly excessive'.[5] The *New York Daily Tribune* begrudgingly praised Renoir but dismissed Monet as 'myopic'[6] and *The Art Interchange* observed that the Impressionists saw nature as they portrayed her but suggested that they ought 'to mourn that they are not as other men are'.[7] The latter publication, however, conceded that Sisley and Monet, despite their bad drawing and peculiar colouring, had 'a freshness and piquancy' about their works that gave them a certain charm. Overall, the 1883 show left little impact on America although it stimulated Durand-Ruel's determination to try again.

A subsequent opportunity arose in 1885 when Durand-Ruel was approached by James F. Sutton of New York, a specialist in Chinese ceramics who would eventually become a major collector of Monet's paintings. Sutton was a partner in the American Art Association, an establishment allegedly dedicated to the encouragement and promotion of American Art. This status granted it certain exemptions from customs duties, although the Association actually operated one of New York's more successful auction houses. Responding to Sutton's invitation, Paul Durand-Ruel arrived in New York in March 1886 with 43 cases of pictures valued at $81,799.[8] *Works in Oil and Pastel by the Impressionists of Paris*, which opened at the American Art Galleries on 10 April, was transferred on 25 April to the National Academy of Design where it remained for a month. At the second venue the exhibition was expanded from 289 to 310 pictures with 13 additions borrowed from local collections.[9] This extraordinary array of Impressionist art included 17 Manets, 48 Monets, 42 Pissarros, 39 Renoirs, 15 Sisleys and several Caillebottes, Boudins, Morisots, Seurats and Signacs. As in 1883, Durand-Ruel, desiring financial success, augmented the display with pictures by more conventional artists inadvertently clouding issues for some viewers. To inform visitors, the catalogue for the expanded version at the National Academy of Design included essays, and an introduction by Théodore Duret, one of the most articulate advocates of the Impressionist movement.[10] For Sisley, a review by Gustave Geffrey from *La Justice*, 23 June 1883, was reprinted in translation. Geffrey lauded Sisley as 'the charming and refined poet' for 'the lowly Loing, for the peaceful Saint Mammès', and characterised him as an 'analytical painter', subtle and delightful in the indication of aerial perspective and atmospheric transparencies'.

Luther Hamilton of *The Cosmopolitan*, an enthusiastic convert to Impressionism, proclaimed the 1886 exhibition to be 'one of the most important artistic events that had ever taken place in this country'.[11] Given its size and the novelty of the pictures, it rivalled the sale of the celebrated Mary J. Morgan collection as the *cause célèbre* of the season. The critics, however, remained divided on the worth and validity of the movement, and differed as to the merits and flaws of its individual adherents. For the most part, they responded favourably to Sisley's intuitive rather than doctrinaire approach and to the subtleties of his colour. A reviewer for the *New York Times* noted that the 'noisiest' artists were not always the best, and praised those whose pictures 'while they startle, interest one at first, and gradually win respect'.[12] He cited as an example, 'a delightful bit from the Parisian suburbs, a note of Bougival by Sisley – quite charming'. In devoting two articles to the exhibition, the influential *Art Amateur* critic, Roger Riordan,

portrayed Monet as a follower of Turner, and Pissarro of Millet, and linked Sisley with Boudin. He contrasted the delicate tonalities of Sisley's *Effect of Snow at Marly* favourably with the glitter of a winter scene by Pissarro. His most unqualified praise was reserved for an 'Inundation' in which Sisley appeared to capture the effects 'by accident' though it was really 'due to good drawing, though rapid, and to the delicate observation of tones'.[13]

Approximately $18,000 was realised through sales at the 1886 show, Monet's paintings proving the most marketable. Durand-Ruel was now thoroughly committed to the New York art market and later that winter sent another group of Impressionist paintings including at least one Sisley, which was shown in rented quarters on 23rd Street. These were sold in early May 1887 at the Fifth Avenue auction house of William P. Moore.[14]

More significant however was another collection of pictures exhibited in 1887 by Durand-Ruel at the National Academy of Design from 25 May to the end of June. The *Catalogue of Celebrated Paintings by Great French Masters* began with introductory essays on Delacroix and Cézanne by Ernest Chesneau. Although the Impressionists were not as dominant as in the previous year they were well represented among the 233 works, which also included paintings by Rousseau, Dupré, Monticelli and Meissonier. Monet and Boudin had 11 pictures each, Pissarro and Puvis de Chavannes 10 apiece, and there were six Sisleys, five Renoirs, two Manets and one each by Alfred Stevens and Joseph DeNittis. The press was less forbearing than previously, *Art Amateur* alluding to Sisley's studies of *barnyard* subjects, such as No. 207 *A Farm at Poissy* and No. 208 *At Sablons* as looking more like Roman mosaics than oil paintings.[15]

The early American devotees of Impressionism represented two poles. Self-made individuals such as Erwin Davis and Catholina Lambert, less fettered by convention, amassed what they liked in art, including the Impressionist pictures, with a zeal similar to that with which they conducted business. At the opposite extreme, the avant-garde collectors, including the H.O. Havemeyers and the Potter Palmers, augmented their holdings of Manet, Degas and Monet with the occasional Sisley. Between these extremes, particularly in the nineties and the first decade of this century, the enthusiasts of Romantic and Barbizon painting seeking a modern note to their more traditional tastes were favourably disposed to the pictures of Sisley, Boudin, and Lépine.

Erwin Davis, later characterised as 'one of the heaviest, daring and clever operators of his period', was representative of the first category.[16] Two paper dolls, still surviving with string nooses around their necks, inscribed to Davis and his brother John, attest to their business practices in California where, in rapid succession, Erwin made and lost a fortune in mining investments in the 1860s. Fleeing to Europe, he recouped his fortune by raising a fund to buy Ottoman bonds which he sold short at great profit after fomenting an uprising against the Sublime Porte in Herzegovina. Described as a newly rich 'patron of art', Davis first commissioned the American Impressionist painter Julian Alden Weir in 1880 to act as his agent in Paris. Relying also on the advice of Diaz's pupil, Robert Minor, he assembled a formidable collection of over 400 paintings, predominantly landscapes, by French Romantic, Barbizon, Realist and Impressionist masters. Also included were a number of works by Americans, among them Alfred P. Ryder and Ralph A. Blakelock. Durand-Ruel recalled Davis as a principal buyer at the 1886 Impressionist exhibition, and he was also listed in the National Academy of Design's version of the catalogue as the lender of Manet's *Boy with a Sword*, a Degas *Ballet Dancers*, and Duez's *Family Dinner*. In 1889, the collection having outgrown his apartment at 10 West 30th Street in New York, Davis sold at auction 145 pictures, including three by Manet and two by Degas.

45 Alfred Sisley, *View of a Farm House*, 1885 (Private Collection, Paris). The same farm buildings appear in *Old Cottage at Sablons*, D498, 1883, bought by Catholina Lambert.

46 Bill of Sale from William P. Moore auctioneer, 10 May 1887 (Private Collection, Paris). In addition to the Alfred Sisley which was bought by Theodore Haviland for $150 the receipt lists a Renoir for $280; two Georges Bellengers for $40 and $180; a Degas for $380; two Pissarros for $100 and $275 and a Corot for $500.

True to character, he rigged the sale by having a business associate posing as a dealer from Chicago buy-in the pictures at high prices. Subsequently, to avoid scandal, Davis donated two Manets and Bastien-Lepage's *Joan of Arc* to the Metropolitan Museum of Art. The extent of his commitment to Impressionist landscapes became apparent only when, shortly before his death, he returned to Durand-Ruel 16 Sisleys ranging in date from 1876 to 1885 as well as 17 Monets painted between 1868 and 1885.

Theodore Haviland was another early enthusiast of Impressionism, whose father, an American Quaker, had opened a family porcelain manufactory in Limoges in 1855.[17] An elder brother, Charles, perhaps encouraged by his father-in-law Philippe Burty, the pioneering champion of *Japonisme* and modernism in general, had amassed a wide-ranging collection which included important Impressionist pictures. Theodore, representing the family in New York, bought heavily when Durand-Ruel liquidated his stock at William P. Moore's auction house in May 1887. His purchases included Sisley's *View of a Farm House* (non-D; Fig. 45), probably painted at Sablons in 1885, a Renoir, two Georges Bellengers, one Degas, two Pissarros and a Corot (Fig. 46). The following March, Durand-Ruel also sold him Sisley's *A Yard at Sablons* (D543; Aberdeen Art Gallery and Museum).

Another one of Durand-Ruel's clients at this time was Alden Wyman Kingman, the son of Abel Willard Kingman who had served as A.T. Stewart's Paris representative and had participated in the department store magnate's acquisitions of academic paintings.[18] At the 1886 New York exhibition the young Kingman bought 12 Monet canvases and at least one Sisley, possibly no. 229 in the catalogue, *Saint Mammès, morning*. A few years later, experiencing a change of heart, he returned all his Impressionist holdings to Durand-Ruel. The Sisley landscape sold to the Carnegie Institute in Pittsburgh in 1899 as *Village beside the Marne* (Cat. 51) has the distinction of being the first work by the artist to be purchased by an American institution.

In the 1890s, the American press continued to debate the validity of

Impressionism. In 1892, for example, William Howe Downes contributed a particularly reactionary article to the *New England Magazine*, asserting that the cornerstone of Impressionism lay in 'the use of purple tones' and denounced the movement as a fad which would run its course.[19] As was a common ploy of antagonistic critics, Downes bantered with the term 'impression' observing that on first 'impression', the mannerisms of the works of Pissarro, Monet, Renoir and Sisley outweighed any merits they might possess, an opinion which he claimed was confirmed by further acquaintance with them.

Much more perceptive was Cecilia Waern's review published in the *Atlantic Monthly* in which she divided the Impressionists into *synthétistes* and *luministes*.[20] Among the former, whose formula it was to reduce drawing to the minimum, were included Degas, Forain and Mary Cassatt. The *luministes* on the other hand, whom she regarded as the more original, concentrated on problems of light, the *mélange optique* and the *division du ton*. Among the latter she also identified a subdivision, the *pointillistes*. Although Waern regarded Monet as the poet of the movement, she praised Sisley's 'delicate luminous spring days'.

The Art Amateur also joined the fray, featuring two articles by a 'W.H.W.' denouncing the works of Monet, Pissarro and Sisley as having been 'forced down the throat of the American public'.[21] Fortunately, the magazine added a rebuttal by Roger Riordan, Sisley's champion in 1886, who noted the universality of Impressionism and applauded the 'luminarists', including the Americans Julian Alden Weir and Childe Hassam.

In New York during the nineties, paintings by Sisley appeared intermittently in exhibitions organised by Paul Durand-Ruel and his competitors. *The Collector* for December 1892 briefly referred to Durand-Ruel's new collection of Old Masters, Barbizon artists and Impressionists, among them Sisley.[22] A writer for *The Collector*, commenting on a display of modern Dutch art and Impressionism at Boussod, Valadon & Co. in 1893, reserved his greatest praise for Raffaelli and predicted possible success for Monet and Renoir, but dismissed Sisley as reverting to his 'old methods' and damned Pissarro, suggesting that he might benefit 'by a voyage back to Buenos Ayres [sic]'.[23] Due to an estrangement between the artist and dealer in 1891, Sisley did not appear in Durand-Ruel's Impressionist exhibition for 1894 but three of his landscapes were featured that year in the Fifth Avenue gallery of L. Crist Delmonico, a dealer who had been buying Impressionists at local auctions. Tragically, the artist did not receive a retrospective exhibition until a posthumous show of twenty-eight works was organised by Durand-Ruel's New York gallery in the spring of 1899.[24]

As their biographer Frances Weitzenhoffer observed, Louisine and Henry O. Havemeyer did not care for 'the cheerful, unproblematical world of vacationists, of simple rural settings or of the present everyday life on the Parisian boulevards'.[25] These collectors, who were to play a major role in advancing the Impressionist cause in New York, detested Renoir's paintings and were lukewarm to those of Pissarro and Sisley. During a visit to Paris with her mother in 1874, Louisine had been introduced to Impressionism by Mary Cassatt. The following year, she bought a Degas fan painting, Monet's *The Drawbridge, Amsterdam* and shortly thereafter, a Pissarro fan painting. In 1883, Louisine married Henry, a sugar refiner, previously her uncle by marriage. Eight years later, the couple moved into a residence at 1 East 66th Street, which had been furbished in the aesthetic taste by Louis Comfort Tiffany and Samuel Colman.

Henry had been acquiring Japanese and Chinese art since the 1876 Philadelphia Centennial. About 1889, he became interested in French Romantic and Barbizon pictures and in the early nineties, was also buying European seventeenth-century masters. In 1894, he joined his wife's pursuits, purchasing that January from

Durand-Ruel an early Sisley, *Banks of the Seine near the Ile de Saint–Denis* (D48; Private Collection, Cologne). Although the Havemeyers were to become renowned for the wealth of their Impressionist holdings, only one other Sisley entered the collection, *The Chestnut Avenue* (D286; Robert Lehman Collection, The Metropolitan Museum of Art, New York) bought at the estate sale of the Japanese dealer Tadamasa Hayashi in 1913.

Harris Whittemore of Naugatuck, Connecticut shared similar advanced tastes. He had developed an interest in modern art while studying abroad in the early 1880s, and in 1890 bought his first Impressionist painting, a Monet landscape, from Durand-Ruel. During an extended honeymoon in France in 1893 he was introduced by Mary Cassatt to Arsène Portier, a former employee of Durand-Ruel, who sold him Sisley's *The Dam of the Loing at Saint-Mammès* (non-D) in addition to works by Degas and Morisot.[26]

Among the most fervent collectors in the New York region in the nineties was Catholina Lambert of Yorkshire, England who had emigrated to the United States in 1851.[27] This energetic individual was largely responsible for transforming Paterson, New Jersey into a leading silk-weaving centre. His business necessitated frequent trips abroad. In Paris, as early as 1858, Lambert purchased a landscape by Georges Michel. Perhaps to assuage his sorrow at the early deaths of six of his eight children, he immersed himself in collecting. By 1891/2, Lambert found it necessary to erect an appropriate house for his collection, a crenellated castle known as 'Belle Vista' dramatically perched on the crest of Garrett

47 The Grand Art Hall, Belle Vista Castle, 1896. Many Impressionist paintings were hung on the top balcony, dominated by P.P. Veretshash's view of the Kremlin. Some of the Sisleys are on the recessed wall on the left.

Mountain overlooking the Paterson mills and, in the distance, Manhattan. An opulent, three-storied 'Grand Art Hall' served as the major gallery for his holdings which ranged in date from the Renaissance to the nineteenth century (Fig. 47). Lambert had decided preferences and was particularly partial to the visionary works of both Adolphe Monticelli and the American Albert Blakelock as well as to the landscapes of the Impressionists. He dealt mostly with Durand-Ruel in the nineties, frequently exchanging pictures. Although the castle was open to visitors on Saturday afternoons from 1900, the extent of his collection was not fully appreciated until business reversals forced him to auction his holdings at the American Art Association in New York in 1916. Renoir's *Girls Knitting* fetched $16,200; the Monets ranged from $1,300 to $7,700; Sisleys from $500 to $2,050, whereas the Pissarros realised a paltry $100 to $1,350. In contrast, Blakelock's *Twilight* was bought by the Brooklyn Museum for $20,000. Although only eight Sisleys and six Monets were sold on that occasion, another ten by the former and eighteen by the latter had previously passed through the hands of this passionate acquirer.[28]

Undoubtedly one of the most flamboyant figures collecting in America in the nineties was Charles T. Yerkes, an entrepreneur who provided the inspiration for the character Frank Cowperwood in Theodore Dreiser's novel *The Financier* (1912). After being jailed in his native Philadelphia, Yerkes abandoned his family to marry a Chicago beauty. Subsequently ostracised by Chicagoans because of devious business practices, he moved to New York, where he maintained a sumptuous Fifth Avenue mansion with two large picture galleries. That he collected abroad in the nineties was noted by Sara Hallowell writing from Paris, probably in July 1894: 'Mr Yerkes is now here, his devoted van Beers gulling him as usual'.[29] The Yerkes estate sale in 1910 included important textiles, some dubious Old Masters, and a number of nineteenth-century pictures, although only one, *A View of Trouville* by Boudin, bore any relation to Impressionism. Apparently, like his literary counterpart, Cowperwood, who had furbished his friend's house with art, Yerkes provided for Emilie Grigsby. When the young woman left town after his death, her sale included Benjamin Constant's *Awaiting the Sheik* and two large bathers by Anders Zorn as well as a number of Impressionist paintings, among them Sisley's *Landscape at Veneux* (D383; last listed as Private Collection, Switzerland).[30]

Other New Yorkers who purchased individual paintings by Sisley included James S. Inglis, president of Cottier and Co., a firm dealing in household furnishing and pictures. Inglis began to collect Impressionists in the nineties and at his estate sale in 1910 *Moret from the Fields* (D635; last listed as Private Collection, Switzerland) was sold to Durand-Ruel for $625.[31] Likewise, the broker Earl F. Milliken formed a very select collection of nineteenth-century pictures which included two Manets, two Monets and a winter scene painted in 1874 by Sisley labelled *Neige à Moret* (non-D).[32] Also Henry B. Wilson of New York bought from Durand-Ruel *Saint-Mammès, morning* (D369; formerly Nathan Cummings Collection, Chicago).[33]

In November 1894 the American Impressionist Theodore Robinson visited the Lotos Club in New York where he met Cyrus J. Lawrence, 'a pleasant old gentleman who liked the moderns and had a Degas, several Monets, Sisleys, Puvis etc'.[34] Living in France from 1872 to 1876, Lawrence developed remarkably advanced tastes for his generation. Keenly interested in the *animalier* Antoine-Louis Barye, he participated with William and Henry Walters of Baltimore in organising the 1889 Barye Monument Association exhibition at the American Art Galleries in New York. At his estate sale in New York in 1910, 109 works by or pertaining to Barye were acquired, according to his wishes, by the Brooklyn

Museum for a nominal sum. In addition to seven Cassatts, one Degas, five Monets, two Pissarros, the sale included a number of Boudins, Lépines, Raffaellis and two Sisleys, *The Sand Quay* (D177; last listed Private Collection, Paris) and *View of Moret-sur-Loing* (D741; last listed Private Collection, New York), the latter sold to Lawrence by Durand-Ruel in 1892.[35]

Eleven pictures at the Lawrence sale were bought by 'Henry Chester', actually Henry Walters, a railroad financier and banker who lived in New York and maintained a private museum in his native Baltimore.[36] In 1894, Walters inherited from his father, William, extensive collections of nineteenth-century, predominately French painting and of Chinese and Japanese art. The scope of the family's collection was transformed by the acquisition in 1902 of the contents of the Accoramboni Palace in Rome, mostly Italian Renaissance and later pictures, and Roman antiquities. Henry Walters now set out at the age of 54 to assemble an encyclopedic collection. His purchases of medieval manuscripts, carved ivories, and jewellery and bronzes of all periods undoubtedly reflected a preference which he had shared with his father for art which was finely wrought. However, with the advantages of historical perspective he endeavoured to redress the limitations of his father's holdings of French painting, which dated for the most part from the Second Empire, by adding works from earlier and later in the century. In July 1900 E.J. Blair, undoubtedly representing Henry Walters, bought from Durand-Ruel Sisley's panoramic *The Terrace at Saint-Germain, Spring* (Cat. 34, detail Fig. 48). Three years later Mary Cassatt succeeded in selling him Monet's *Springtime* and Degas's *Portrait of a Woman*, and in 1909 he added Sisley's *Saint-Mammès* (known as 'View on the Marne' (Cat. 50), as well as Manet's masterly *At the Café*.

The renowned Philadelphia jurist, John G. Johnson, followed a similar evolution in taste.[37] Initially, focusing on the nineteenth century, he bought his first Impressionist picture, a Monet, in 1887. Though he continued to acquire nineteenth-century pictures, his interests soon extended to Italian primitives and Dutch and Flemish masters. Unlike most of his contemporaries, Johnson relied on his own judgement and on the opinions of such eminent scholars as Robert Langton Douglas, Wilhelm Valentiner and Roger Fry, rather than those of self-interested dealers. In 1917 he left to the city of Philadelphia his small house at 510 South Broad Street, cluttered with over 1200 works of art. Among them were many Corots and Courbets but, like both Cyrus Lawrence and Henry Walters, Johnson had also been drawn to Sisley, Degas, Raffaëlli, Puvis de Chavannes and Lépine. In 16 March 1888 he bought from the local artist-dealer Charles F. Haseltine a sun-drenched view 'River Scene and Bridge' (Cat. 49, detail Fig. 44) giving in partial payment another Sisley acquired earlier.[38]

The only other Philadelphian who was drawn to Sisley at this time was J. Storm Patterson, an individual whose tastes were apparently catholic. In 1885 he lent to the Union League of Philadelphia a picture entitled *Babies* by Gérôme's Italian pupil Virgilio Tojetti and eight years later he submitted to the same club Sisley's *The Flood*.[39]

Even more receptive than New York to the avant-garde was the Boston area, where modestly sized but highly select collections of modern French painting were being assembled.[40] A contributing factor was the emergence of a distinct Boston school of American Impressionists composed, for the most part, of artists who had trained in France. Notable among them was Joseph Foxcroft Cole, an acquaintance of Sisley's friends Joseph Woodwell and Daniel Ridgway Knight from their days together in the 1860s in France. As early as 1874, Foxcroft Cole had sold a Pissarro to Dr Henry C. Angell, a local collector of French landscapes.[41]

After the initial venture in Boston in 1883, Durand-Ruel had contemplated a second exhibition in 1886, which failed to materialise.[42] However, in March 1891,

48 (*facing page*) Detail of Cat. 34, *The Terrace at Saint-Germain* (Walters Art Gallery, Baltimore), bought on behalf of Henry Walters in 1900.

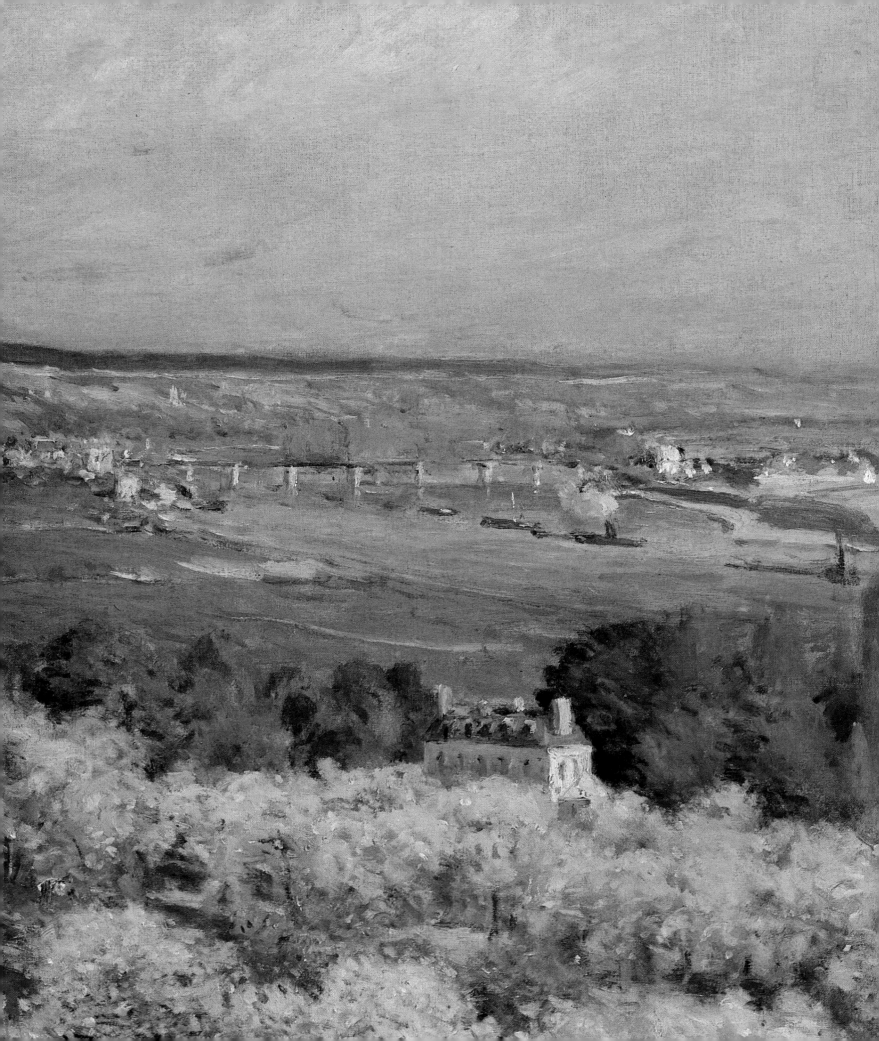

he sent 13 Monets, six Sisleys and four Pissarros to the J. Eastman Chase Gallery at 7 Hamilton Place.[43] The exhibition was accompanied by a catalogue containing essays on the individual artists. That on Sisley was written by Frederik P. Vinton, a local artist who had recently visited Moret. Unlike another American painter, Ernest Lawson, who, upon seeking Sisley's advice had been abruptly told to apply more paint to his canvas and less to himself,[44] Vinton had met with a warm welcome. He recalled walking along the banks of the Loing with Sisley who indicated to him a 'hundred charming *motifs* which he had painted or intended to paint'. On this occasion, Sisley emphasized his love of 'the gaiety of nature' a phrase which, for Vinton, captured the essence of Sisley's art.

In her column, 'Art in Boston', that May, 'Greta', the critic for the *Art Amateur*, reported that former buyers of Barbizon paintings were turning to the French Impressionists whose impact was readily apparent in pictures by their Boston disciples.[45] She also mentioned that Foxcroft Cole was busy importing Monets for 'collectors of authority' and that Vinton was occupied at the Saint Botolph Club lecturing on the 'new light in art' while Ernest Fenellosa spoke of the impact of Japanese art on the modern movement.

At the turn of the century, Bostonians tended to buy paintings by regional artists which they interspersed with their holdings of Impressionists and works by other Durand-Ruel protégés including Maxime Maufra, Henry Moret and Gustave Loiseau. The civil and mining engineer Desmond FitzGerald was among the most venturesome of this generation. During a sojourn in Paris in the summer of 1889, he was transfixed by a visit to the Exposition Monet-Rodin held at Galerie Georges Petit, and subsequently he wrote the Monet entry in the catalogue for the J. Eastman Chase exhibition in 1891. He added a gallery to his house in Brookline which the local Impressionist Dodge MacKnight regarded as 'a veritable Musée MacKnight' though it was particularly rich in Monets, Maufras and Boudins.[46] Two Sisleys appeared at the FitzGerald estate sale in 1927, *Landscape on the Loing* (*Moret-sur-Loing*, D.669; Payson Art Gallery, Portland, Oregon) and *The Banks of the Loing at Moret*, 1886 (non-D).[47] George N. Tyner of Holyoke, Massachusetts, was representative of a somewhat more traditional generation of collectors. In addition to the numerous Barbizon and Realist pictures sold at his estate sale in 1901, there were four Cazins, two Monets, a Pissarro, a Thaulow and Sisley's *On the Banks of the Loing: morning*, 1891 (non-D).[48]

Slightly further afield, John Pickering Lyman assembled an important group of French and American Impressionists and oriental ceramics in Portsmouth, New Hampshire.[49] Three Sisleys entered his collection, *Confluence of the Seine and the Loing* (D620; last listed H. S. Ader Collection, New York), *On the Moret Road* (D467; Museum of Fine Arts, Boston) and *Saint-Mammès: cloudy weather* (D506; The Art Gallery of Ontario, Toronto).

Among the Boston collectors, the most colourful was undoubtedly Robert Jacob Edwards, a ship builder who established a purchase fund for the Museum of Fine Arts in 1916 in memory of his mother Julia Cheney Edwards.[50] William H. Holston of Durand-Ruel denigratingly recalled Edwards as a man who 'knew nothing of art except that through its acquisition he would attract a certain prestige' and who, 'to assure himself of an impressive address', bought 266 Beacon Street, where he resided with his self-effacing sisters, Hannah and Grace.[51] Dealing with Durand-Ruel, the local firm of Doll and Richards, and with the artist Dodge MacKnight who expedited sales for French artists, Edwards formed a collection of Impressionists which he bequeathed to the Museum of Fine Arts with the provision that his sisters could retain them during their lives. Hannah apparently collected independently of her brother, and it may have been she who bought Sisley's *Saint-Mammès: a grey day* and *La Croix Blanche, Saint-Mammès*

49 The Potter Residence, 1350 Lake Shore Drive, Chicago, designed by Henry Ives Cobb, about 1900.

50 The Louis XVI Salon, 1350 Lake Shore Drive, Chicago, about 1900.

(D374 and D509; The Museum of Fine Arts, Boston) which hung in the music room and dining room of the Beacon Street house until her sister Grace died in 1939.

By the turn of the century, prosperous cities further west, no longer content to lag behind the East Coast in culture, sponsored exhibitions in which modern European paintings appeared. Sisley's pictures were shown in Buffalo (1907), Pittsburgh (1895, 1897, 1898, 1900, 1907 and 1910), Saint Louis (1893–1896, and 1904), Columbia, Missouri (1908), and San Francisco (1894).

The most dynamic of the western cities was Chicago where the regal Mrs Potter Palmer held sway.[52] Born Bertha Honoré in Louisville, Kentucky, she was educated at the élite Academy of the Visitation in Georgetown, D.C., where she may have been instilled with feminist leanings which were to remain a lifelong trait. In 1870, Bertha married Potter Palmer, her senior by 23 years. Potter had established a dry goods store, the forerunner of the renowned Marshall Field's department store, and, shortly before the Great Chicago Fire of 1871, opened the first palatial Palmer House hotel. In 1885, the Palmers took possession of 1350 Lake Shore Drive, designed for them in 'the English battlement style' by Henry Ives Cobb (Fig. 49). Its eclectic interior included a Louis XVI salon, Japanese and Moorish rooms, and a 75 foot long gallery eventually hung with three tiers of paintings (Fig. 50).

In artistic matters, the Palmers were advised by Sara Hallowell, a galvanising force in Chicago from 1873 when she took responsibility for the art section of the

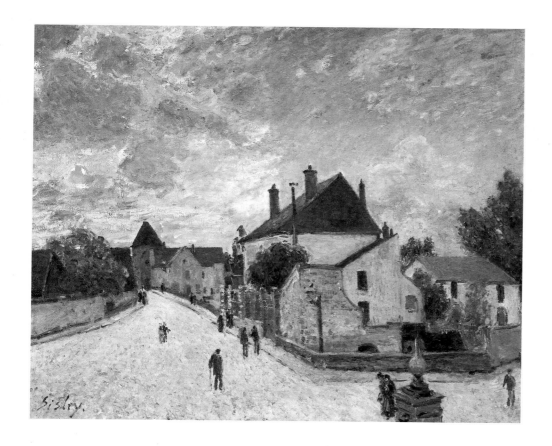

annual Interstate Industrial Exhibitions.[53] While the Palmers were visiting Paris in
1889, she introduced them to Mary Cassatt who, in turn, induced them to buy
their first examples of Impressionism, a Degas and a Renoir.

 Both Bertha Palmer and Sara Hallowell were to figure prominently in the plans
for the World's Columbian Exposition held in Chicago in 1893. The former was
elected president of the Board of Lady Managers which planned the Women's
Building while the latter, declining the directorship of the art department in
favour of a man, Halsey C. Ives, as his 'secretary' organised the 'Loan Exhibition
of Foreign Masters owned by Americans'.[54]

 In 1891 and 1892, while travelling abroad in preparation for the Exposition, the
Palmers, in consultation with Sara Hallowell, acquired a number of Impressionist
works. Bertha was the more progressive, her favourite painting being Renoir's
Two Little Circus Girls which she hung in her bedroom, whereas Potter was drawn
to the melancholy landscapes of J.C. Cazin. Presumably it was Sara Hallowell,
coincidentally Sisley's neighbour in Moret in the nineties, who persuaded the
Palmers to buy two of his works. In September 1892, when delayed in New York
harbour by an outbreak of diphtheria, Sara wrote to Bertha that she had prevented
the Sisley in her care (probably *View of Louveciennes*, D208; The Metropolitan
Museum of Art, New York, acquired from Durand-Ruel, 23 November 1894),
from being fumigated. She acknowledged, however, that Mr Palmer might have
thought such a treatment would have improved its appearance.[55] A couple of
months later the Palmers purchased from Durand-Ruel *Street at Moret-sur-Loing*
(D660; The Art Institute of Chicago), an atypical work which the artist sought to
animate by introducing figures (Fig. 51). When she saw it in the Loan Exhibition
at The Columbian Exposition, the critic Lucy Munroe praised it as 'admirably
rendered'.[56]

During the first decade of this century, critics continued to debate the merits of Impressionism. Meanwhile, younger and more audacious collectors were already turning to Post-Impressionism. In New York, in early 1913, the evolution of modernism from Goya and Ingres to Cubism was admirably illustrated in the Armory Show, a landmark in the history of American taste.[57] Three historical subdivisions were identified, Classicists, Realists, and Romanticists. Sisley, who was represented by a trio of landscapes, was categorised with the Realists along with such artists as Courbet, Manet, Monet and Toulouse-Lautrec; Degas and Puvis de Chavannes on the other hand were Classicists, and Renoir, Van Gogh, and Gauguin were Romanticists. The historical validity of the Impressionist movement had become a moot issue in America.

52 Alfred Sisley, *The Hills of La Bouille,*
near Rouen and the Meadows of Sahurs, D827,
1894 (Private Collection).

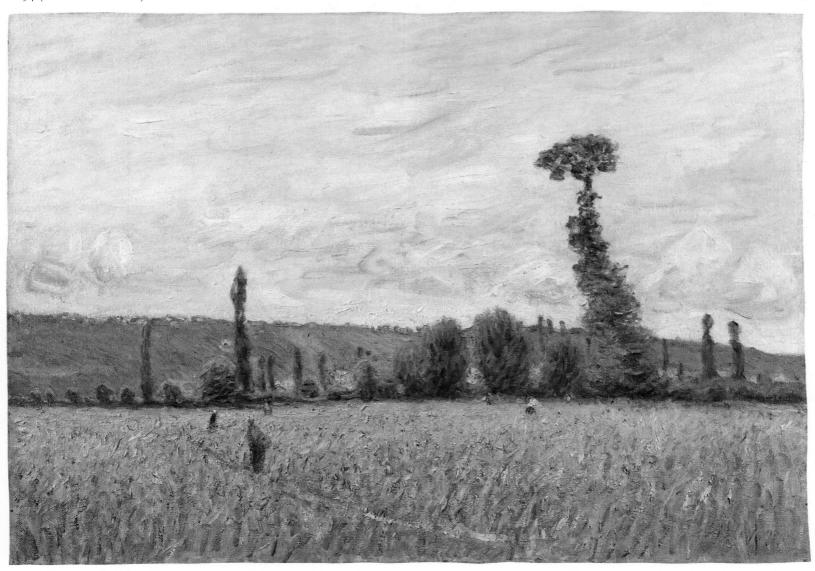

APPENDIX II
PAINTINGS BY SISLEY EXHIBITED IN AMERICA

All titles have been transcribed as given in the exhibition catalogues. Specific paintings have been identified in Daulte 1959 whenever possible.

Boston, 1883
'Foreign Exhibition'
Mechanic's Building, 3 September
166 *Along the Seine*
167 *Grand Promenade*
168 *Autumn Morning at Saint Mammes*

New York, 1886
'Works in Oil and Pastel by the Impressionists of Paris'
American Art Galleries, 10–25 April
National Academy of Design, 25 May
150 *Bougival*
151 *The Seine at Lavacour*
155 *Cloudy Weather*
159 *The Beach at Veneaux* (sic)
161 *Effect of Snow at Marly*
201 *Rue de Marly in Winter*
221 *A Garden*
226 *On the Seine*
229 *St Mammès Le Matin*
232 *On the Banks of the Seine*
235 *Le Bac de L'ile de la Loge*
257 *Willow Trees at Veneux*
258 *Bridge of Bougival*
277 *Landscape with Figures*
286 *Morning in Spring*
The critic for *The Art Amateur*, alluded to an 'Inundation' and to 'Orchard in Bloom' (perhaps no. 286)

New York, 1886–1887
'Collection of Modern Paintings selected during the last summer by Mr Durand Ruel'
Durand-Ruel, December–January
8 Sisleys

New York, 1887
'Celebrated Paintings by Great French Masters'
National Academy of Design, 25 May–30 June
203 *Near Marly*
204 *The Seine at Chatou*
205 *Landscape near Moret*
206 *Winter Sun at Veneux*
207 *A Farm at Poissy*
208 *At Sablons*

53 (*facing page*) Detail of Cat. 55, *The Provencher Watermill* (Museum Boymans-van Beuningen, Rotterdam), exhibited in New York in 1905.

Boston, 1891
'Paintings by the Impressionists of Paris, Claude Monet, Camille Pissarro, Alfred Sisley from the Galleries of Durand-Ruel'
J. Eastman Chase Gallery, 17–28 March
4 *Saint-Mammès – Le Matin*
8 *Pont de Bougival*
13 *Le Canal du Loing*
17 *Coteaux du Bois des Roches à Veneuse* (sic)
21 *Femme à l'ombrelle*
24 *Saint Mammès*

New York, 1892
'Paintings of Sisley, Renoir, J.L. Brown, Degas, Jongkind and Pissarro'
Durand-Ruel Galleries, December

New York, 1893
Paintings of Monet, Renoir, Sisley, Raffaelli, and Pissarro.
Boussod, Valadon Galleries, January or February

Saint Louis, 1893
Saint Louis Exposition and Music Hall 10th Annual Exhibition
February, 1893
229 *The Road to Venaux* (sic)

Philadelphia, 1893
Union League of Philadelphia, 11–27 May
'Inundation' (collection J.S. Patterson)

Chicago, 1893
Loan Exhibition of Foreign Works from Private Collections in the United States, May–October
Village Street, Moret, France (D660)
Lent by Mr Potter Palmer

'Impressionist Paintings' New York, 1894
L. Crist Delmonico Galleries, January
Le Gros Peuplier, 1891
Au Bords du Loing, 1891
Early Spring, 1892

Saint Louis, 1894
Saint Louis Exposition & Music Hall 11th Annual Exhibition, February
304 *The Edge of the Woods*
385 *Saint Mammès, France*

San Francisco, 1894
California Mid-winter International Exposition
513 *The Banks of the Marne*

Saint Louis, 1895
Saint Louis Exposition and Music Hall
501 *View at Louveciennes* (D208)
Lent by M. Potter Palmer

Pittsburgh, 1895
Carnegie Institute
218 *Village on the Shore of the Marne* (perhaps D422)
219 *Inundated Meadow*

Saint Louis, 1896
Saint Louis Exposition and Music Hall
482 *The Edge of the Forest*

Pittsburgh, 1897
'Second Annual Exhibition'
Carnegie Institute, 4 November–1 January 1898
203 *Saint Mammès*

Pittsburgh, 1898
'Third Annual Exhibition'
Carnegie Institute, 3 November–1 January 1898
218 *Village on the Shore of the Marne*
219 *Inundated Meadow*

New York, 1899
'Exposition, Works of Alfred Sisley'
Durand-Ruel Galleries, 27 February–15 March
1 *Les Sablons*
2 *St. Mammès*
3 *Petit pont près Moret*
4 *Prairie Inondée*
5 *Environs de St. Mammès*
6 *Moret*
7 *Vue de Louveciennes*
8 *Raisins et Noix* (D233)
9 *St. Mammès*
10 *Près Moret*
11 *Après-Midi d'août à Veneux*
12 *La Seine à Moret*
13 *Le Soir à St. Mammès*
14 *Pont sur la Marne*
15 *Le Matin à St. Mammès*
16 *Le Moulin Provencher à Moret* (D503)
17 *Chemin à Veneux*
18 *La Seine à Bougival*
19 *Le Gué de L'Epine*
20 *La Serpentine à Londres*
21 *Les Bords de la Marne* (perhaps D426)
22 *Le Matin près du Loing*
23 *Matinée d'Octobre*
24 *Vue de Louveciennes*
25 *Rue à Veneux*
26 *La Berge à St. Mammès*
27 *St. Mammès Le Matin* (D369)
28 *Le Loing à Moret*

Pittsburgh, 1900
Carnegie Institute
225 *Morning Near the Loing*
226 *Near Moret*

Chicago, 1901
'Loan Collection of Selected Works of
Modern Masters'
Art Institute of Chicago, 8–27 January
5 *'Le gué d l'épine'*, lent by D.R. of New
York
26 *'Les Bords de la Marne'*, lent by D.R. of
New York (D426)

Saint Louis, 1904
Universal Exposition
519 *Landscape*
520 *Landscape*
521 *Landscape*

New York, 1905
'Exhibition of Paintings by Alfred Sisley'
Durand-Ruel Galleries, 18 March–8 April
1 *Vue de Louveciennes*, 1873
2 *Moret*, 1885

New York 1905
'Exhibition of Paintings by Alfred Sisley'
Durand-Ruel Galleries, 18 March–8 April
1 *Vue de Louveciennes*, 1873
2 *Moret*, 1885
3 *Prairie inondée*
4 *Les Sablons*, 1885
5 *Moulin Provencher à Moret* [sic], 1880 (pro-
bably D503)
6 *Rue à Veneux*, 1880
7 *La Serpentine à Londres*, 1874
8 *Chemin à Veneux*, 1878
9 *La Seine à Bougival*, 1875
10 *Après-midi d'août à Veneux*, 1882 (possibly
D473)
11 *La Seine à Moret*, 1886
12 *St. Mammès*, 1885
13 *St. Mammès*, 1875
14 *Près Moret*, 1882
15 *Vieilles chaumières à Veneux*, 1881
16 *Marly-le-Roi*, 1874
17 *La Terrasse de St. Germain*, 1875 (D164)

Pittsburgh, 1907
Carnegie Institute
The Terrace at Saint Germain-en-Laye (D164)

Buffalo, 1907
'Exhibition of Paintings by French
Impressionists'
Buffalo Fine Arts Academy, Albright Art
Gallery, 31 October–8 December
76 *Grapes and Nuts*
77 *The Seine at Moret*
78 *Banks of the Marne*
79 *St. Mammès*
80 *View of Louveciennes*, 1876
81 *Borders of the Loing Canal at St. Mammès,
Morning*, 1885

Columbia, 1908
'Second Annual Exhibition of Paintings, Art
Lover's Guild of Columbia'
The Museum of Classical Archaeology of the

University of Missouri, February
25 *The Seine at Moret*

Boston, 1908
'Paintings by Alfred Sisley'
Walter Kimball & Co., 10 March–30 March
1 *La Seine près Bougival*
2 *Sur la route de Moret*
3 *La Serpentine à Londres*, 1874
4 *La Terrasse à St. Germain*, 1875 (D164)
5 *Moulin provencher à Moret*, 1880 (probably
D503)
6 *Prairie inondée*, 1875
7 *La prairie*
8 *Chemin à Veneux*, 1878
9 *Vieilles chaumières à Veneux*, 1881 (possibly
D446)
10 *Près Moret*, 1882
11 *Vue de Louveciennes*, 1873
12 *Pont sur Marne*
13 *Le Matin à St. Mammès*, 1885 (possibly
D571)
14 *Le Soir, Saint Mammès*, 1883

Pittsburgh, 1910
Carnegie Institute
275 *Flood at Moret*

New York, 1912
'Exhibition of Paintings by Sisley', 10 April–
27 April
Durand-Ruel Galleries
1 *Pont sur la Marne* 1872
2 *Vue de Louveciennes* 1873
3 *Pont de Bougival* 1873 (D86)
4 *La Serpentine à Londres* 1874
5 *Raisins et noix* 1876 (D233)
6 *Vue de Louveciennes* 1876
7 *La Seine près Bougival* [sic] 1877
8 *Prairie inondée* 1878
9 *La berge à St. Mammès* 1878
10 *Près Moret* [sic] 1880
11 *Les carrières à Veneux* 1880
12 *Canal du Loing, chemin de halage* 1882
13 *St. Mammès* 1883
14 *Le soir à St. Mammès* 1883
15 *La plaine de Veneux, vue des Sablons* 1884
16 *Sentier sur le haut des Roches-Courtaut* 1884
17 *Paysage près Moret* [sic] 1884
18 *Le canal du Loing* 1884
19 *Bords du canal du Loing à St. Mammès* 1885
20 *Le matin à St. Mammès* 1885
21 *Les Sablons* 1887

Boston, 1913
'Impressionist Painting Lent by Messrs.
Durand-Ruel'
Saint Botolph Club, 20–31 January
7 *Vieilles chaumières à Veneux*
9 *Rue à Veneux*
15 *Prairie inondée*

New York, 15 February–15 March 1913

Chicago, 24 March–16 April 1913

Boston, 28 April–14 May 1913
'International Exhibition of Modern Art,
Association of American Painters and
Sculptors'
69th Infantry Regiment and Armory
506 *Vieilles chaumières à Veneux*, 1881
507 *Chemin du vieux Bac à By*, 1880
508 *Prairie inondée*, 1874

New York, 1913
'Exhibition of Paintings representing Still-life
and Flowers by Manet, Monet, Pissarro,
Renoir, Sisley, André d'Espagnat', Durand-
Ruel Galleries, 20 December 1913–8 January
1914
19 *Raisins et noix*, 1876, $14\frac{7}{8}'' \times 21\frac{3}{4}''$

New York, 1914
Sisley Exhibition, 28 November–12
December
Durand-Ruel Galleries
1 *Les Sablons*, 1887
2 *Le Potager*, 1872 (D50)
3 *La Prairie*
4 *Matin d'hiver*
5 *Les Laveuses* (probably D232)
6 *La plaine de Veneux*, 1884
7 *Prairie inondée*
8 *Petit pont près Moret, l'apres-midi* [sic]
9 *Vue de Louveciennes*, 1876
10 *Confluent du Loing et de la Seine* (perhaps
D622)
11 *Le canal du Loing*, 1884
12 *Au long du bois, automne*, 1885
13 *Vue de Moret*
14 *Saules au bord de l'Orvanne*, 1883 (D478)
15 *Moret le Matin*, 1884
16 *Sentier sur les Roches-Courtaut*, 1884
(perhaps D539)
17 *Bords du canal du Loing à St. Mammès le
matin*, 1885 (D625)
18 *Canal du Loing, chemin de Halage*, 1882
(D457)
19 *La plaine de St. Mammès*

54 *(facing page)* Detail of Cat. 58, *The Banks
of the Canal du Loing at Saint-Mammès*
(National Gallery of Ireland, Dublin),
exhibited in New York in 1914.

Caroline Durand-Ruel Godfroy generously offered information from the archives of her family's firm. Advice and access to his library on American art was provided by Dr William H. Gerdts, and Mrs Cynthia Mead expedited research in New Jersey.

1 The correspondence between Sisley and Daniel Ridgeway Knight (1839–1924) and Joseph R. Woodwell (1843–1911) is preserved in the Joseph R. Woodwell Papers, Archives of American Art, Smithsonian Institution, Washington, D.C., Gift of Carnegie Institute, Pittsburgh, Penn., 1966. See, in particular, Knight to Sisley and Woodwell, 17 January, 31 January 1864, and Sisley to Woodwell, n.d.

2 John Wolfe (1821–94), last listed in the New York City directory at 8 East 68th Street in 1893, was associated with three auction sales, in 1863, 1883, and 1894. The *New York Times*, 12 April 1894, p. 22, alluded to him as 'thoroughly commercial'.

3 L. Lejeune, 'The Impressionist School of Painting', *Lippincott's Magazine*, vol. 24, pt. 2, 1879, pp. 720–27.

4 Hans Huth, 'Impressionists Come to America', *Gazette des Beaux-Arts*, (April 1946), pp. 225–52.

5 'Art at the Boston Exhibitions', *Art Amateur*, October 1883, p. 90.

6 'Foreign Art in Boston', *New York Daily Tribune*, 11 September 1883, p. 4.

7 'Boston Notes', *The Art Interchange*, 1883, undated clippings, p. 80.

8 Huth, *op. cit.*, pp. 238–39.

9 See Frances Weitzenhoffer, 'The Earliest American Collectors of Monet', *Aspects of Monet, A Symposium on the Artist's Life and Times*, (ed. John Rewald, Frances Weitzenhoffer), New York, 1984, pp. 74–91. The American lenders included A.J. Cassatt, Erwin Davis, and H.O. Havemeyer.

10 *National Academy of Design, Special Exhibition, Works in Oil and Pastel by The Impressionists of Paris*, exh. cat., New York, 1886. For Sisley see Nos. 21–23.

11 Luther Hamilton, 'The Work of the Paris Impressionists in New York', *The Cosmopolitan*, June 1886, p. 240.

12 'Painting for Amateurs', *New York Times*, (10 April 1886).

13 'The Impressionist Exhibition', *Art Amateur*, vol. 14 1886, p. 121, and vol. 15, 1886, p. 4.

14 'The Durand-Ruel Picture Sale', *New York Times* 6 May 1887, p. 8.

15 *Art Amateur*, vol. 17, (1887). p. 32. The barnyard subjects include No. 207 *A Farm at Poissy* and No. 208 *At Sablons*.

16 For Erwin Davis (c.1830–1902) see The Erwin Davis papers, The New-York Historical Society, New York.
D271 *The Seine at Bougival*, 1877, bought by Durand-Ruel, 14 April 1899
D340 *Flood at Moret-sur-Loing*, 1879, bought by Durand-Ruel, 14 April 1899
D194 *Winter, Louveciennes*, 1876, bought by Durand-Ruel, 14 April 1899
D318 *A Road near Louveciennes*, c.1879, bought by Durand-Ruel, 14 April 1899
D373 *Old Houses at Saint-Mammès, Autumn*, 1899, bought by Durand-Ruel, 14 April 1899
D391 *The small Meadows in Spring, By*, c.1880, bought by Durand-Ruel, 14 April 1899
D466 *Washerwomen near Champagne*, c.1882, bought by Durand-Ruel, 7 January 1899
D484 *Boatyard at Saint-Mammès*, 1888, bought by Durand-Ruel, 14 April 1899
D491 *The Entrance to Sablons, May*, c.1893, bought by Durand-Ruel, 14 April 1899
D525 *The Loing Canal*, 1884, bought by Durand-Ruel, 14 April 1899
D565 *The Village of Champagne at sunset, View of the Slopes of By, April*, 1885, bought by Durand-Ruel, 7 January 1899
D576 *The Port of Saint-Mammès – morning*, 1885, bought by Durand-Ruel 14 April 1899
D605 *Saint-Mammès Lock*, 1885
D607 *Saint-Mammès, morning, beside the Loing*, 1885, bought by Durand-Ruel, 14 April 1899
D625 *Banks of the Loing Canal at Saint-Mammès: Morning*, 1885, bought by Durand-Ruel, 14 April 1899

17 For the Haviland family see Jean d'Albis, *Haviland*, Paris, 1988. Theodore Haviland's purchases at William P. Moore Auctioneer, 10 May 1887 include No. 49 Renoir $280; No. 58 Bellenger, $40, No. 79 Bellenger, $180; No. 97 E. Degas, $380; Pissarro, $100; Sisley, $150; Pissarro, $275, and Corot, $500 (receipt, family archives).

18 Frances Weitzenhoffer, *op. cit.*, 1984, pp. 80–81.

19 William Howe Downes, 'Impressionism in Painting', *New England Magazine*, vol. 12, 1892, pp. 600–03.

20 Cecilia Waern, 'Some Notes on French Impressionists', *Atlantic Monthly*, vol. 62, April 1892, pp. 535–41.

21 W.H.W., 'What is Impressionism', *Art Amateur*, November 1892, pp. 140–41; W.H.W. and Roger Riordan, 'What is Impressionism', December 1892, p. 5.

22 *The Collector*, vol. 4, No. 3 December 1892, p. 39

23 *The Collector*, vol. 4, No. 7 February 1893, p. 102. Boussod, Valadon and Co. had been incorporated in New York, April 1888 (*New York Times*, 15 April 1888, p. 1).

24 *Exposition, Works of Alfred Sisley*, Durand-Ruel Galleries, New York, 1899. See also *Art Amateur*, New York, vol. 40, No. 5, April 1899, p. 95.

25 Frances Weitzenhoffer, *The Havemeyers, Impressionism Comes to America*, New York, 1986, p. 117.

26 *Ibid.*, pp. 92–93.

27 Flavia Alaya, *Silk and Sandstone, The Story of Catholina Lambert and his Castle*, Passaic County Historical Society, Paterson, 1984, n.p. and Charles DeKay, 'A Castle at Paterson, N.J.', *New York Times Illustrated Magazine*, 19 December 1897, pp. 3–5.

28 Sale, The American Art Association, 21–24 February 1916,
42 *On the Seine* (D111; last listed Private Collection, London)
62 *Louveciennes* (D283; last listed Private Collection)
65 *Landscape* (Non-D)
113 *The Weir at Saint-Mammès* (D595; last listed Miss Effie Seachrest, Kansas)
137 *May Afternoon at By* (D455; last listed L. Jellinek, New York)
149 *A Winter Day, Marly* (D154; last listed Mrs Huttleson Rogers, Claremont)
157 *The Veneux plain* (D456; last listed D. Francopoulos, Athens)
160 *Landscape* (Non D)
Paintings sold earlier include:
The Auteuil Viaduct, 1878 (D291; last listed Private Collection, New York). Sold by Lambert to Durand-Ruel, 14 April 1899.
The Plain of Saint-Mammès: View of the Bois des Roches – afternoon at the end of February (D414; last listed Private Collection, New York). Sold by Lambert to Durand-Ruel, 14 April 1899.
Old Cottages at Veneux-Nadon, snow, (D446; last listed Mrs O.H. Alford, New York). Bought by Durand-Ruel from Sisley 1881. Sold by Lambert to Durand-Ruel, 14 April 1899.
The Tow Path on the Loing Canal, (D457; last listed Private Collection, Switzerland). Bought from Sisley, 1883. Sold by Lambert to Durand-Ruel, 14 April 1899.
Old Cottages at Sablons (D498; last listed

Private Collection). Bought by Durand-Ruel from Sisley, 1883. Sold by Lambert to Durand-Ruel, 14 April 1899.

A Road in Sablons, 1884 (D535; last listed Private Collection, Switzerland). Bought by Durand-Ruel from Sisley, 1884. Sold by Lambert to Durand-Ruel, 16 April 1889.

On the Edge of the Wood, Les Sablons, 1884 (D538; last listed Private Collection, Switzerland). Bought by Durand-Ruel, 1884. Sold to Lambert, 10 April 1888. Sold by Lambert to Durand-Ruel, 14 April 1899.

The Loing Canal, 1884 (D520; last listed Private Collection). Sold by Durand-Ruel to Lambert. Lambert returned to Durand-Ruel, 14 April 1899.

Saint-Mammès: cloudy weather, c.1884 (D506; The Art Gallery of Ontario, Toronto). Sold by Lambert to Durand-Ruel, 14 April 1899.

The Confluence of the Seine and the Loing (Non-D). Sold to Durand-Ruel, 14 April 1899.

29 Curatorial File, Chicago Art Institute, Sara Hallowell wrote to Potter Palmer 9 July (probably 1894).

30 Sale (Yerkes) American Art Association, New York, 5–8 April 1910, and Sale (Grisby), Anderson Auction Galleries, New York, 22–27 January 1912.

31 The socially prominent James S. Inglis lived at 101 Park Avenue. His estate was auctioned at the American Art Association, New York, 9–10 March 1910.

32 Sale American Art Association, 7 February 1902.

33 See François Daulte, *Alfred Sisley*, Lausanne, 1959, No. 369.

34 Theodore Robinson Diaries, Frick Art Reference Library, 24 November 1894.

35 See 'The Fine Collection of the Late Cyrus J. Lawrence, to be sold at Auction Next Month, Art at Home and Abroad', *New York Times*, 2 January 1910, p. 13, and sale Mendelssohn Hall, New York, 21–22 January 1910.

36 Denys Sutton, 'Connoisseur's Haven', *Apollo*, vol. 84, No. 58, December 1966, pp. 2–13, and W.R. Johnston, *The Nineteenth Century Paintings in the Walters Art Gallery*, Baltimore, 1982.

37 'John G. Johnson, Noted Lawyer, Dies', *New York Times*, 15 April 1917, p. 20, and Aline Saarinen, *The Proud Possessors*, New York, 1958, pp. 92–117.

38 A bill from Haseltine Galleries, Philadelphia to John G. Johnson dated 16 March 1888 reads: 1 painting by Sisley 660 CR; 1 painting by Sisley 405 $255.

39 'Paintings by Eminent Artists belonging to a few citizens of Philadelphia', Loan Exhibition, The Union League of Philadelphia, 1893, No. 3 *The Inundation* [*The Flood*].

40 Anne L. Poulet and Alexandra Murphy, 'Corot to Braque, French Paintings from the Museum of Fine Arts', exh. cat., Boston 1979.

41 Martha Bartlett Angell Donor File, Curatorial Department, Museum of Fine Arts, Boston.

42 23 November 1886, J. Foxcroft Cole wrote to J. Eastman Chase introducing Durand-Ruel who was planning a Boston show (Archives of American Art, Smithsonian Institution, Washington, D.C.), Roll 996, pp. 181–347.

43 *Catalogue of Paintings by the Impressionists of Paris, Claude Monet, Camille Pissarro, Alfred Sisley, from the Galleries of Durand-Ruel*, Paris, New York, exh. cat.; for Vinton's essay see pp. 11–12.

44 'Ernest Lawson 1873–1939', exh. cat. University of Arizona Art Museum, Phoenix, 1979, p. 4. Lawson was, in part, the prototype for Frederick Lawson, an artist who visited Moret, in W. Somerset Maugham's novel *Of Human Bondage*, 1916.

45 'Greta', 'Art in Boston', *Art Amateur*, vol. 24, No. 6, (May 1891), p. 141.

46 Dodge Macknight to Eugène Bloch, 13 July 1908, Macknight Papers, *Archives of American Art*.

47 Sale, American Art Association, 21–22 April 1927, Nos. 77 and 89.

48 American Art Galleries, New York, 1 February 1901, No. 68.

49 *Museum of Fine Arts Bulletin* 18, No. 105, February 1920 n.p.

50 See Donor File, Museum of Fine Arts, Boston.

51 William H. Holston Papers, lent to Archives of American Art by Mrs William H. Holston, Archives of American Art, Smithsonian Institution, Washington, D.C..

52 Patricia Erens, *Masterpieces, Famous Chicagoans and their Paintings*, Chicago, 1979, pp. 1–37.

53 'Miss Sara Hallowell Unique in Art World', *New York Times*, 31 December 1905, part 3, p. 6, and John D. Kysela, S.J., 'Sara Hallowell Brings Modern Art to Midwest', *Art Quarterly*, vol. 27, No. 2, 1964, pp. 150–67.

54 Hallowell to Bertha Palmer, 16 January 1892 (?), Bertha Honoré Palmer Correspondence, The Ryerson Library, Art Institute of Chicago.

55 Hallowell to Bertha Palmer, 12 September 1892, Bertha Honoré Palmer Correspondence, The Ryerson Library, Art Institute of Chicago.

56 Lucy Munroe, 'Chicago Letter' *The Critic*, Vol. 20, No. 594, July 1893 p. 30.

57 Milton W. Brown, *The Story of the Armory Show*, New York, 1988, pp. 112–13.

55 (*overleaf*) Detail of Cat. 17, *The Seine at Bougival* (Musée d'Orsay, Paris).

CATALOGUE

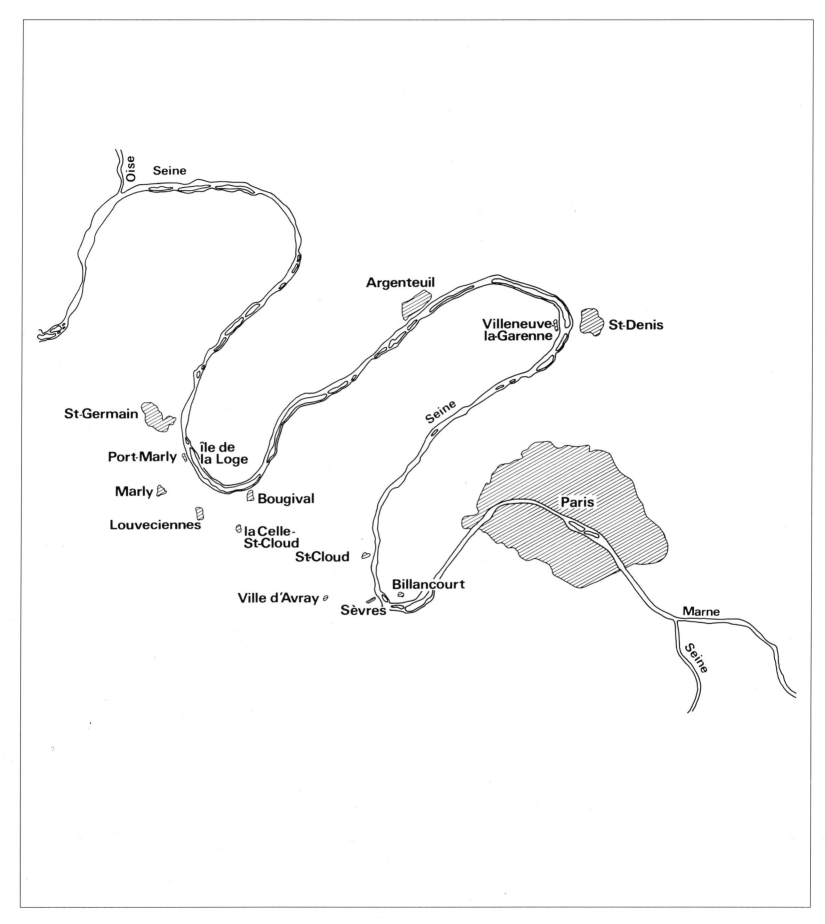

Oise

Seine

Argenteuil

Villeneuve-
la-Garenne

St-Denis

St-Germain

île de
la Loge

Port-Marly

Seine

Marly

Bougival

Paris

Louveciennes

la Celle-
St-Cloud

St-Cloud

Ville d'Avray

Billancourt

Sèvres

Marne

Seine

56 Map of Paris and environs, marking the places where Sisley lived and worked.

MaryAnne Stevens

LA CELLE-SAINT-CLOUD TO LOUVECIENNES: 1865–1875

The modern artists whom we specifically identify [Monet, Renoir, Pissarro, Sisley] have the advantage over equally distinguished older painters of having invented a technique which is richer in its resources (p. 223) ... It is no exaggeration to say that this group of innovators, presaged by a Frenchman, Claude Lorrain, has given us light, that supreme power in painting (p. 234) ... [If Sisley] has less facility than Monet, if he is less florid than Renoir, he possesses the gift of making the atmosphere circulate right through to the tops of the branches of the trees. His is a sincere statement of the complete impression. (p. 236)

Had Sisley been able to read Julien Leclercq's obituary, published in *La Gazette des Beaux-Arts* (10 March 1899), he would have been greatly warmed by the author's acknowledgement of his position not only within the Impressionist movement but more especially within the grand tradition of French landscape painting. For him, such an accolade would have represented a just reward for his life-long commitment to landscape painting.

On the evidence of a small number of paintings which apparently survived the destruction of his studio during the Franco-Prussian War of 1870–71, Sisley was determined, from the moment he left Gleyre's studio in 1862, to become a landscape painter. Unlike his fellow Impressionists, notably Monet, Renoir and Bazille, he chose to tackle neither large-scale figure compositions, nor portraits (see Cat. 1). Rather, he explored the countryside in search of appropriate motifs which he then executed in his studio on a comparatively ambitious scale, for presentation to the official Salon (see Cat. 2, 6). In the period 1865 to 1874, he had his paintings accepted in three Salons, two in 1866 (see Cat. 4, 5), one two years later (see Cat. 6) and two in 1870–71 (see Cat. 9), the last time he presented to the Salon before making an unsuccessful bid for acceptance in 1879.

For an artist seeking to establish himself as a landscape painter during the 1860s, it was almost inevitable that Sisley should turn for his models to the previous generation of French landscapists, notably Théodore Rousseau, Daubigny and Corot, as well as, to a limited extent, Gustave Courbet. Harder to identify precisely are the lessons which he could have learnt from a study of Constable's landscape paintings during his two-year sojourn in London before deciding to commit himself to art. As Christopher Lloyd (q.v. pp. 9–11) has shown, types of composition, the role of figures in the landscape, the primacy of the sky and the pursuit of specific locations imbued with personal resonance suggest knowledge of his British predecessor's achievement. Of equal importance during this period was his interaction with his fellow Impressionists as each one sought to define a distinctive approach to landscape painting. Thus, Sisley's work of the 1860s should be compared with that of Monet (see Cat. 6) and Bazille (see Cat. 1, 2) as well as with contemporary developments in landscape photography (see Cat. 6).

While Constable's example remains a quiet presence beyond *c*.1870, the

influences of the generation of 1830, with the exception of Corot, fall away as Sisley's concern to render the full effects of changing light demanded new technical skills. He adopted a shorter, more broken brushstroke and a bolder palette in his paintings of 1870–71 (see Cat. 9) which suggest an awareness of the technical innovations being wrought by Monet and Renoir in the autumn of 1869 at Bougival and again by Monet, this time accompanied by Pissarro, during the winter of 1869–70 at Louveciennes. The paintings created during the ensuing four years illustrate Sisley's consolidation of his various sources of influence into a personal style in which the fleeting moment of time within a landscape is caught through overlapping layers of subtly graduated tones of greens, greys and blues applied with a soft-edged, square-cut brush (see Cat. 10–22).

This technical evolution during Sisley's formative years, is complemented by the exploration of his own particular pictorial language, in terms both of composition and of approach to motifs. Sisley's compositional procedures, when set beside those of his fellow Impressionists, generally appear somewhat conservative. He frequently adopted the most direct solution to the creation of spatial recession by employing a road (see Cat. 18, 22), a curve of a river (see Cat. 17), a canal (see Cat. 9) or an avenue of trees (see Cat. 1, 6, 19) to enter the depth of his landscapes. When combined with natural 'repoussoirs' to frame and balance his compositions, he appears indebted to the classical tradition of French landscape painting. Yet periodically Sisley rejects such traditional formal scaffolding, creating pictures which are breathtaking in their spatial audacity. The boldly abstract pattern created by the stanchion placed right up against the surface of the canvas in *Ferry of the Ile de la Loge: Flood* (1872, Cat. 16) destabilises what would otherwise have been a conventional river scene, while in *Under Hampton Court Bridge* (1874, Cat. 26) the spectator is confronted with an avenue of receding piers bearing the bridge's surface high above his head in a composition seemingly without precedent in landscape painting. Similarly, two years before Monet, and four before Caillebotte, he discovered the potential of using a bridge plunging into depth at a dramatically steep angle across the composition to establish a new convention for the representation of movement through a landscape (see Cat. 14). Sisley also intermittently manipulated the rules regulating an acceptable, picturesque composition. In *Hampton Court Bridge: the Castle Inn* (1874, Cat. 24), the wide expanse of the gravel road is swept clear of the figures who should normally inhabit it, to create a void impeding the spectator's entry into the depth of the composition (see also Cat. 22, 27). Indeed, a concern to undermine picturesque principles, albeit subtly, can also be found in works as early as the *Avenue of Chestnut Trees at La Celle-Saint-Cloud* (1865, Cat. 2), where the subject of the painting, the clump of chestnut trees, has been suspended between foreground and background, unsupported by any framing elements to left or right. The horizon line, as in later works, such as *The Road from Hampton Court to Molesey* (1874, Cat. 27) and *The Church of Noisy-le-Roi* (1874, Cat. 30), curves away from the centre of the composition, suggesting that the artist has chosen almost at random a slice of an otherwise continuous landscape.

The purpose of these compositional experiments, the landscape motif recorded on canvas, also became for Sisley the object of an increasingly refined approach to specific motifs. In 1866 and 1871, Sisley presented at the Salon two paintings representing the same venue, the village of Marlotte (see Cat. 4 and 5) and the Canal Saint-Martin (see Cat. 9) respectively. Since neither pair can be seen as variants or as pendants – in the strict sense of the word – their presentation demands explanation. Such a pattern of paired, or complementary views of the same venue, usually seen under different seasonal or weather conditions, can be found in paintings created over the ensuing four or five years, for example the

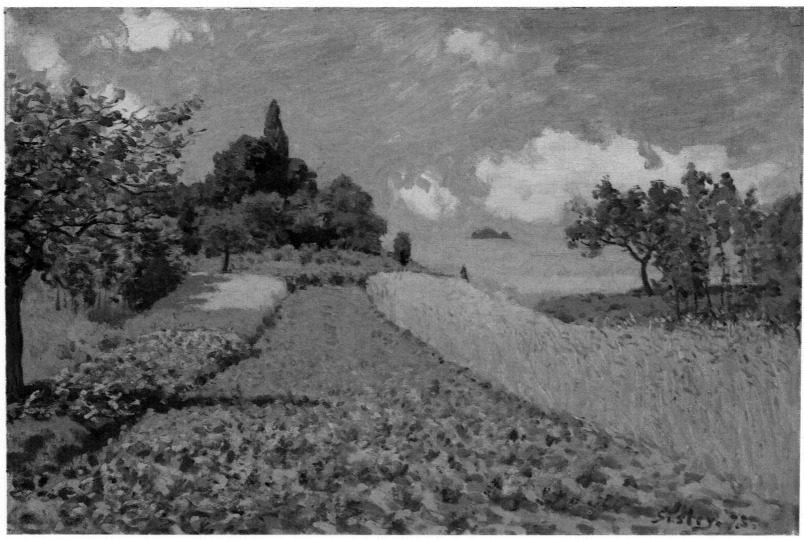

57 Alfred Sisley, *Wheatfield: the Hillside near Argenteuil*, D79, 1873 (Kunsthalle, Hamburg).

chemin de l'Etarché, Louveciennes is shown under winter snow and summer rain (see Cat. 31) and the Seine at Bougival is presented in high summer and autumn (see Cat. 17). Taken on a broader scale, such pairing of subject-matter can be found in Sisley's search to identify the complementary aspects of a specific location; for example the rural calm and the urban bustle of Argenteuil (see Cat. 11 and 12) and the leisured and working landscapes of Villeneuve-la-Garenne (see Cat. 13, 14, and 15; map Fig. 56).

Underlying this approach to a specific landscape is a more controlled method of recording the places in which the artist lived and worked. Starting from the *Rue de Voisins, Louveciennes: First Snow* of 1871–72 (Cat. 10), a review of Sisley's exploration of one small corner of the village to which he moved in 1871 reveals him returning to the site but recording it looking up the street in the opposite direction – under snow (D248) – and shifting his angle slightly leftwards to focus on a small cluster of houses which lies at the junction between the rue de Voisins and the avenue Saint-Martin (D32). This shifting angle of vision, used seemingly to plot his discovery of the relationships between specific locations within a broader landscape presents us with a visual mapping of his progression through that space. Thus, the interdependence of the rue de la Machine (Cat. 19), the Machine de Marly (Cat. 20), the water pipes and the aqueduct bearing water from the machine on the Seine to the parks of Marly and Versailles (Cat. 23 and Fig. 60) is mapped in a sequence of images made in 1873 and 1874 (Fig. 58). A similar, more concentrated approach, is taken at Hampton Court in the summer of 1874,

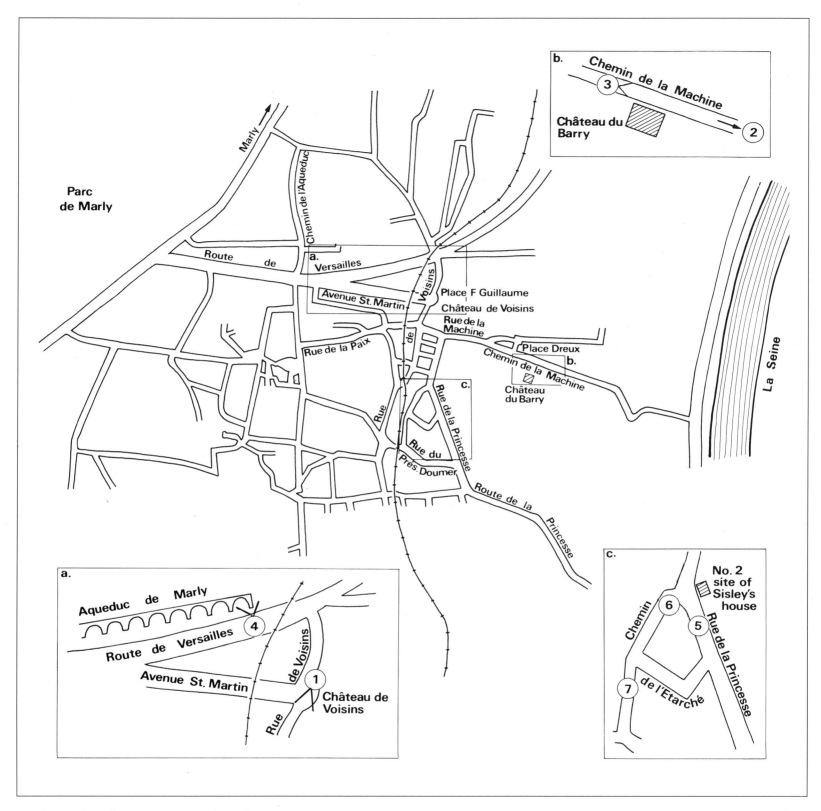

58 Street plan of Louveciennes marking the
locations where pictures were painted

1 *Rue de Voisins, Louveciennes: First
 Snow*, D18, Cat. 10.
2 *La Machine de Marly*, D67, Cat. 20.
3 *Rue de la Machine, Louveciennes*,
 D102, Cat. 19.
4 *The Marly Aqueduct*, D133, Cat. 22.

5 *Chemin de l'Etarché, Louveciennes,
 under Snow*, D146, Cat. 31.
6 *Rue de la Princesse, Louveciennes*,
 D167, Cat. 18.
7 *Snow at Louveciennes*, D282, Cat. 46.

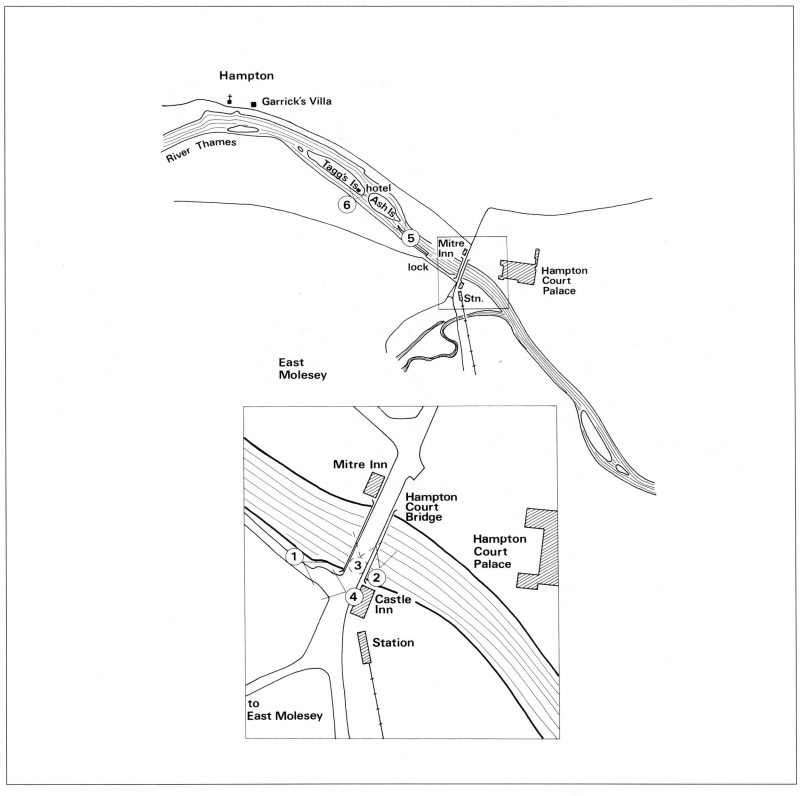

59 Map of the area around Hampton
Court, marking locations where pictures
were painted

1 *Hampton Court Bridge: the Castle Inn*, non-D, Cat. 24.

2 *Hampton Court Bridge: the Mitre Inn*, D123, Cat. 25.

3 *Under Hampton Court Bridge*, D124, Cat. 26.

4 *The Road from Hampton Court to Molesey*, D120, Cat. 27.

5 *Molesey Weir, Hampton Court: Morning*, D118, Cat. 28.

6 *The Regatta at Molesey, near Hampton Court*, D126, Cat. 29.

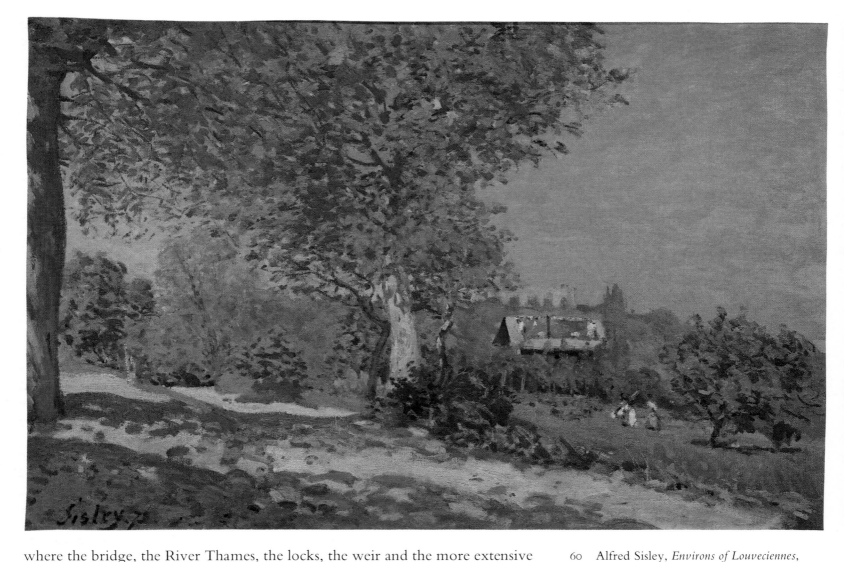

60 Alfred Sisley, *Environs of Louveciennes*,
D49 (Private Collection).

where the bridge, the River Thames, the locks, the weir and the more extensive
views of Hampton village are recorded as a progression upstream from the palace
itself (see Cat. 24–28; Fig. 59). It was this specificity of visual mapping which he
was to pursue with the Watering Place at Marly-le-Roi (1875–77, see Cat. 32, 36,
42), at Saint-Mammès in 1881 (see Cat. 49–52), and finally at Moret-sur-Loing
after 1888 (see Cat. 64–71). To be sure, Sisley's contemporaries, and indeed
predecessors, notably Daubigny, had also plotted the distinctive features of a
given location. Monet, for example, explored Argenteuil between 1871 and 1878,
and Pissarro subjected Louveciennes, and later Pontoise, to similar close scrutiny.
What distinguishes Sisley's approach, however, is its underlying, persistent logic;
he needs to know, to understand how a given landscape 'fits together', how one
view relates to another. Hence, whether he is plotting the same motif from a
slightly different viewpoint, as in the flood scenes at Port-Marly of 1876 (see Cat.
37–39) or whether he is piecing together a landscape, from bridge to lock to weir,
as at Hampton Court, the process is seemingly premeditated, an attempt to
present a more or less extended panorama of a specific location through a sequence
of individual paintings.

 Yet behind the technical evolution, the search for the anti-picturesque and the
innovatory in his compositions, and the stalking of his motifs in order to map in
visual terms his own discovery of a specific venue, Sisley's paintings share with
those of his fellow Impressionists a more general question concerning the
underlying meaning of their subject-matter. On one level it could be argued that

Sisley's decision to become a landscape painter in the mid-1860s presented nothing more than a desire to take to its logical conclusion the programme of the generation of the 1830s (Rousseau, Daubigny, Diaz and Corot), namely that landscape painting is concerned with the representation of the 'real' in which the 'effect' upon the artist is revealed in his rendering of 'light and shade'. To a certain extent, his work, with its evocation of the instantaneous, the everyday, supports this interpretation. Such an aim, however, implies an acceptance of a romantic ambition which celebrated individualism and originality. Yet, the search for novel descriptions of landscape as the subject matter of the paintings made by the new generation of the 1860s does not seem in itself to provide a viable explanation. Champa, in *The Rise of Landscape Painting in France: Corot to Monet* (1991), proposes an alternative approach. Once the traditional meanings of landscape have been cast aside, the only subject-matter left is a celebration of the technical processes by which that landscape is translated onto the canvas itself: 'The subject matter of what is displayed seems more focused on the meaning and the activity of landscape painting itself rather than on any consistently evolving form of the imitation of nature either generic or particular'(p. 25). Thus, for the Impressionists, 'landscape painting was by then an established modern practice with a substantial degree of its expressive range already demonstrated and its language space dedicated to the evocative deployment of strictly technical devices' (p. 51). Here again, Sisley's own work could be cited, notably his evolution of a distinctive method of pictorial notation in his paintings made between 1871 and 1875, where the surface mosaic of square, soft brushstrokes establishes a presence for itself in every way as palpable as the scene which they are employed to describe.

However, to suggest that Sisley's initiation and development as a landscape painter was primarily concerned with the search for originality of expression and the integrity of technique is to negate the very substantiality of the specific locations which he chooses to capture on canvas. While his later landscapes may indeed be primarily concerned with recording his own emotional response to a particular venue, for example Moret-sur-Loing, many of those painted during the 1870s contain overt or covert references which raise their meaning beyond that of mere description or emotional association. The 1867 *Avenue of Chestnut Trees near La Celle-Saint-Cloud* (Cat. 6) depicts a forest ride inherited by the Emperor Napoleon III from the *ancien régime*. The rue de la Machine, Louveciennes, painted in 1873, leads to the Machine de Marly constructed by Louis XIV, passing the walls of the château in which resided the engineer of the machine itself (Cat. 19). The Machine de Marly was rebuilt under Napoleon III (Cat. 20). The Aqueduct, also built at the behest of Louis XIV, carried water to the royal parks of Marly and Versailles (Cat. 23). Yet each of these subjects with their historical references have been treated in that new Impressionist technique, a subversive technique officially discredited for its supposed revolutionary associations.

As Robert Herbert has argued for Monet at Argenteuil, Sisley may have chosen to paint such subjects as a means of endowing them with layers of meaning which could give back to landscape painting a programme of contemporary relevance. However, in Monet's case, the meanings conveyed were wedded to the contemporary circumstances of the location. For Sisley, the conscious invasion of the historically loaded subjects by specifically innovatory compositional arrangements and painting techniques suggests that their meanings were more complex. They may represent the more overt expression of a subversive gesture towards the art establishment which, with the formulation of a more mature Impressionist style in the later years of the 1870s, Sisley had no further need to declare so explicitly on the surface of his landscape paintings.

1 Avenue near a small Town

Allée près d'une petite ville
c. 1865; Non-D
45 × 59.5 cm
Signed br: Sisley
Kunsthalle, Bremen
Exhibited in London and Paris only

From the beginning of his career, Sisley was unequivocally a landscape painter. Only one painted portrait by him has survived (*La Leçon*, 1871, Fig. 4, Private Collection, Dallas; see also, R. Shone, January 1992, pp. 34–35), and a small group of still-lifes (see Cat. 7). During his formative years, he, like Camille Pissarro, neither tackled large-scale figure compositions, as did Renoir and Monet, nor sought to populate his landscapes with anecdotal staffage. *Avenue near a small Town*, possibly one of the earliest paintings by Sisley to have survived, demonstrates this single-minded approach to his chosen subject-matter and illustrates specific formative influences upon his art.

Sisley adopts a traditional viewpoint, setting himself in the centre of the road which recedes to a vanishing point on the horizon. This avoids having to modify the actual landscape in order to create an illusion of space and balance. Progress into the depth of the composition is reinforced by the alternating bands of light and dark greens.

The range of choice of landscape mentors for a young painter emerging in the 1860s was broad. Generally he could turn to the generation of the 1830s, for example, Rousseau, Daubigny, Troyen, Diaz and Corot; or he could align himself with the more robust realism of Courbet. For Sisley, the choice appears to have rested primarily with Corot. In this painting he not only echoes Corot's compositional procedures (see for example, the Ville d'Avray paintings and *L'Eglise de Marisel, près de Beauvais* [1866; Musée du Louvre, Paris] which was exhibited at the Salon of 1867 [no. 378]), but also the classical landscape tradition of Claude Lorrain and Nicolas Poussin, from which Corot himself was descended.

The strength of Corot's influence on the formative years of the younger landscape painter has also been noted in the muted green tones of his palette and the short, almost feathery brushwork which is

particularly evident in the foliage of the trees (see Tokyo-Fukuoka-Nara 1985, no. 1). In this respect the painting shares its technique with one even more closely indebted to Corot, *Lane near Marlotte* (c.1865; non-D; presented by Sisley to Lise Trehaut [repr. Rewald 1968, p. 99]). Sisley's contemporaries certainly noted this early affinity with the older landscape painter. Renoir, with whom Sisley shared his studio in 1865–66, may well have been the link between them (see Chronology, p. 261; see also D. Cooper, 1959). Julien Leclercq, for example, in his obituary article on Sisley, published in the *Gazette des Beaux-Arts* (1 March 1899), declared that, 'Corot's influence, which introduced him to a way of interpreting a more general sentiment, is modified when, attracted by small incidents, he incorporates some notes of colour which he distributes through the work, maintaining a harmonious tonality of the whole which is tinged with a gentle shade of grey' (p.235). Leclercq had preceded this observation by declaring that, '. . . it is Corot who has [impressed] Sisley, Corot pure and silvery, both soft and solid, always broad, profound, infinite, Corot the dreamer, calm and precise, who, beneath the transparent veils and the poetic resonances, is wholly enthralled, as was Racine, by the purity of Ancient Greece, and who, surrounded by the humid, delicious scents of the soil, seems to entertain all the pleasures of the spirit within a state of constant, smiling adoration' (p.234). Sisley himself acknowledged this debt to Corot when he listed himself in the Salon Catalogue for 1866 as 'élève de Corot'.

Sisley was also closely associated with Frédéric Bazille during the 1860s. Indeed, among his contemporaries, Sisley's artistic fortunes were more closely associated with

Bazille's than Renoir's (J. Lanes, December 1966, pp. 645–49). Bazille introduced Sisley to Gleyre's studio, where he was to meet Renoir and Monet, and Bazille and Sisley subsequently worked together, even to the extent of working on the same subject (see Cat. 7). It is not surprising therefore to find a reference to the shorter, rather staccato, more fully laden brushwork used by Bazille in his landscapes of the mid-1860s such as *Landscape at Chailly* (1865; Art Institute of Chicago; Fig. 61) and *Forest of Fontainebleau* (1865, Musée d'Orsay, Paris) being echoed in Sisley's rendering of the grassy bank and the field of standing wheat on the left of *Avenue near a small Town*.

MA.S.

PROV: Johann Friedrich Lahmann; given by the Kunstverein, Bremen, 1937.

EXH: Bremen, 1978, no. 422; Tokyo-Fukuoka-Nara, 1985, no. 1.

BIBL: *Katalog des Gemälde des 19. und 20. Jahrhunderts in der Kunsthalle*, Bremen, 1973, p. 307; Lassaigne and Gache-Patin, 1983, repr. fig. 5.

61 Frédéric Bazille, *Landscape at Chailly*, 1865 (Art Institute of Chicago).

2 *Avenue of Chestnut Trees at La Celle-Saint-Cloud*

Allée des Châtaigniers à la Celle-Saint-Cloud
1865; D1
129.5 × 208 cm
Signed and dated bl: Sisley 65
Musée du Petit Palais, Paris
Exhibited in Paris only

The small number of early paintings which have survived from the period between Sisley's departure from Gleyre's studio in 1862 and the outbreak of the Franco-Prussian War in autumn 1870 is probably due to Sisley's lack of need to live by his brush and to the reported destruction of his studio at Bougival during the Franco-Prussian War (see Chronology, p. 262). Of the few early paintings, all are landscape subjects, with the exception of four still-lifes (see Cat. 43). During this period he continued to live in Paris but travelled into the surrounding countryside to visit the Forest of Fontainebleau (see Cat. 4, 5) and the area around Saint-Cloud, and further afield to Honfleur in the summer of 1867 and Berck on the English Channel in August of 1868 (see Chronology, p. 262).

Emulating the generation of 1830, Théodore Rousseau, Daubigny, Troyen and Diaz, Sisley explored established landscape sites for treatment on a scale almost certainly intended for presentation to the Salon. The *Avenue of Chestnut Trees at La Celle-Saint-Cloud* is one such example. La Celle-Saint-Cloud is located six and a half kilometres from Saint-Cloud, to the west of Paris, between Bougival and Vaucresson. Served by the Paris-Saint Germain railway after 1884, it was considered the most interesting of the three areas of forest which surrounded the village of La Celle. Apart from attracting such artists as Paul Huet and Charles Daubigny, the area of Saint-Cloud had, from the beginning of the century, become a popular, and accessible resort for Parisians eager to escape the constraints of the fast-growing city. Indeed, the absence of any reference to man's intervention in Sisley's painting suggests that he has sought to reinforce the idea of escape into pure Nature and hence conforms to the use to which such woodlands were put by the Paris populace described in, for example, Gustave Flaubert's *Education sentimentale* (1849). Such apparently unpopulated landscapes can also be found in contemporary works by Sisley's associate, Bazille, for example, *Landscape at Chailly* (1865; Art Institute of Chicago; Fig. 61). Yet, whereas Bazille's landscape recedes in a conventional diagonal from rocky foreground to the line of bosky trees in the background, thus creating a carefully structured, 'closed' landscape subject, Sisley's composition runs counter to these conventions. Pushing out beyond the sides of the canvas, the horizon is bent away from the centre apparently suggesting a continuum of location, of which this is merely a slice selected at random. The subject of the landscape, consequently, is suspended within the middle distance, unapproachable through the rocky outcrops which punctuate the foreground. Such an anti-picturesque procedure had already been explored to particular effect in early nineteenth-century English landscapes, notably those of Thomas Girtin.

While the composition is apparently somewhat innovative, its technique suggests that Sisley was well aware of the landscape procedures of his immediate predecessors. The delicate gradations of fairly thinly applied greens in the trees and the foreground indicate a strong debt to Corot (see Cat. 1) while the breadth of brushwork and boldness of paint application especially on the boulders is more akin to Théodore Rousseau and Gustave Courbet.

The scale of this painting, together with the fact that Sisley produced a variant of it (Cat. 3) suggests that he intended it for submission to the Salon. There is no proof that he succeeded in this ambition.

MA.S.

PROV: bt from the artist by J.-B. Faure, 1877; Sir Joseph Duveen, London; given by him to the Musée du Petit Palais, 1921.

EXH: Paris, Gazette des Beaux-Arts, 1937, no. 76; Zurich, 1947, no. 693; Rotterdam, 1952, no. 115; Paris, Petit Palais, 1953, no. 420; Paris, Musée Jacquemart-André, 1957, no. 262; Berne, 1958, no. 1; Chicago, 1978, no. 75; Paris, Grand Palais, 1979; Prague-Berlin, 1982, no. 79; Tokyo, 1982, no. 26.

BIBL: Dewhurst, 1923, repr. p. 97; *La Renaissance*, 1922, p. 144, repr. p.145; *Le Bulletin de la Vie artistique*, 1922, repr. p. 116; *Catalogue du Musée du Petit Palais*, 1927, no. 396; Jedlicka, 1949, pl. 1; Rewald, 1961, repr. p. 99; Venturi, 1953, repr. p. 110; Cogniat, 1978, repr. p. 11; Lassaigne and Gache-Patin, 1983, p. 9, repr. ill. 8.

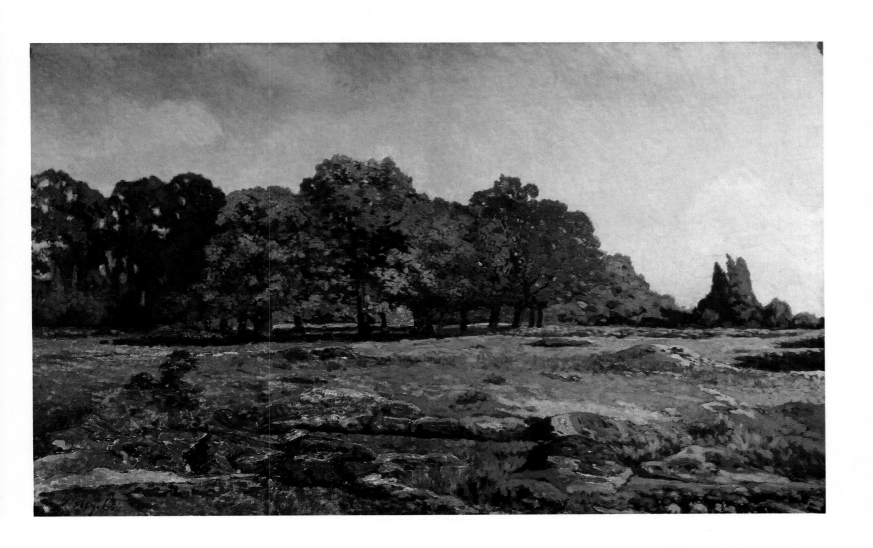

3 Avenue of Chestnut Trees at La Celle-Saint-Cloud

Allée des Châtaigniers à la Celle-Saint-Cloud
c. 1865; D2
50.5 × 65.5 cm
Signed bl: A. Sisley
The Ordrupgaard Collection, Copenhagen
Exhibited in London only

This is a variant, smaller in scale, of the painting of the same title which is securely dated 1865 (Cat. 2). This painting shows a closer view of the clump of trees in the middle distance, which now dominates the composition. Furthermore, it presents us with a more conventional staffage for a bucolic subject: under the trees, a figure is stretched out while another rests on a stick. Both look into the depth of the landscape, as in traditional landscape compositions, to establish the mood of passive contemplation of Nature which the spectator is invited to adopt.

The precise purpose of this painting and its relationship to the larger variant are problematic. Whereas its reduced scale and narrower angle of vision might suggest that it was a preliminary study for the larger work, it bears no evidence of sketchiness or incompleteness. The ground of the canvas is brown, not pink or cream, as might have been expected of a *plein-air* oil sketch by this date, the rocks in the foreground have been carefully delineated, the paint precisely disposed throughout the composition, and recession into depth specifically calculated through the careful location of the horizontal bands of light and shade. Despite the difference in scale, these two paintings may represent early examples of Sisley's persistent, almost obsessive, exploration of a given geographic location or motif from a variety of different viewpoints (as in his sequence of views at Port-Marly [see Cat. 37–39], Marly-le-Roi [see Cat. 32, 35, 36, 42], along the River Seine at Saint-Mammès in 1880–81 [see Cat. 49–52] and at Moret-sur-Loing from *c.*1888 [see Cat. 59–61, 64–66, 70]). Although the composition of this painting, as Champa has noted (1991), with its 'tendency to expand rather than focus', links it to 'the mid-century's practice of Corot, Daubigny and Rousseau' and thus makes it 'somewhat conservative in the mid-1860s' (p.92), it is possible that we are looking at the seed of a new 'serial' approach to landscape which Sisley was to share to a certain extent with his fellow Impressionists, notably Pissarro and Monet, but which he was perhaps to pursue more consistently throughout his career.

MA.S.

PROV: Durand-Ruel, Paris; Wilhelm Hansen, Ordrupgaard, Copenhagen, before 1923; Wilhelm and Henry Hansen Foundation, Ordrupgaard, Copenhagen; The Ordrupgaard Collection, Copenhagen, 1951 as part of the donation to the Danish State.

EXH: Copenhagen, Kunstforeningen, 1889; Copenhagen, 1914, no. 205; Tokyo-Fukuoka-Nara 1985, no.2; Tokyo-Yokohama-Toyohashi-Kyoto 1989–90, no. 46; Manchester, NH-New York, IBM Galleries-Dallas-Atlanta, 1991, no. 109.

BIBL: Huyghe, 1932, p. 236, repr. fig. 48; Rostrup, 1941, p. 14; *Katalog over Kunstværkerne på Ordrupgaard*, 1954, no. 106, repr.; Champa, 1983, p. 92; *Katalog over Ordrupgaardsamlingen*, 1982; Lassaigne and Gache-Patin, 1983, p.53, repr. ill. 58.

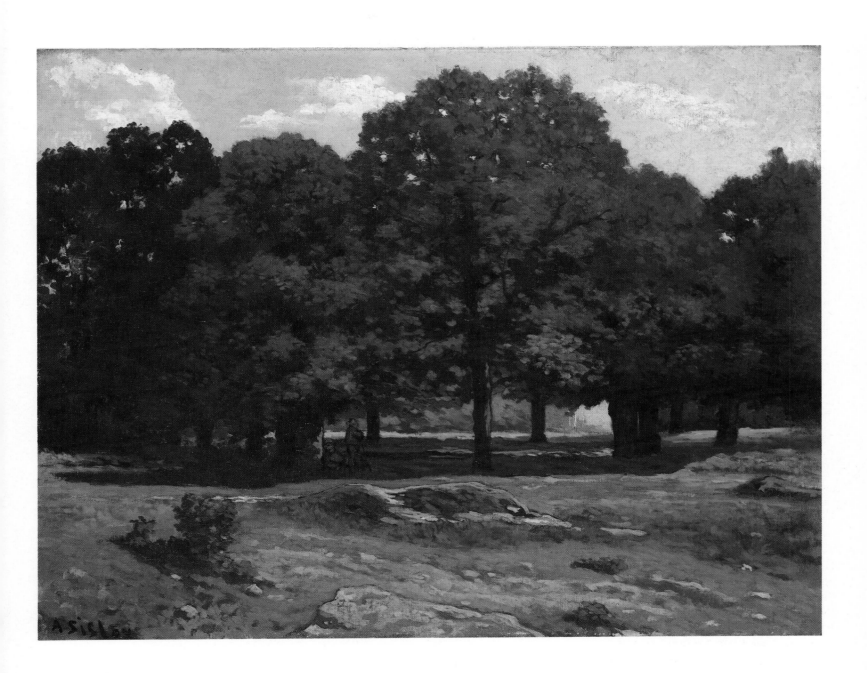

4 Village Street at Marlotte, near Fontainebleau

Rue de Village à Marlotte – près de Fontainebleau
1866; D3
64.8 × 91.4 cm
Signed and dated bl: A. Sisley, 1866
Albright-Knox Art Gallery, Buffalo, New York (General Purchase Funds, 1956)

5 Women going to the Woods: Landscape

Femmes allant au bois – paysage
1866; D4 (known as *Rue de Village à Marlotte – femmes allant au bois*)
65 × 92 cm
Dated br: 1866
Bridgestone Museum of Art, Ishibashi Foundation, Tokyo
Exhibited in London and Paris only

Renoir had been sharing Sisley's Paris studio since July 1865. In February 1866, the two artists, together with Renoir's painter friend, Jules Le Coeur, set out to walk across the Forest of Fontainebleau, via Milly and Courances, to Marlotte, a village on the southern edge of the Forest near the River Loing. The previous year Le Coeur had bought a house in the village described in Joanne's guide as a location favoured by landscape painters and elected by the de Goncourt brothers as 'the chosen birthplace of modern landscape' (1971, p. 73). Monet and Bazille were working close by at Chailly-en-Bière.

It was during this sojourn that Renoir immortalised the presence of the three artists at Marlotte in his painting *The Inn of Mère Anthony* (1866; Nationalmuseum, Stockholm; Fig. 135), showing Le Coeur, Sisley, Mère Anthony (in shadow) and her daughter. Contemporaneously, Sisley prepared his two views of the village, records of his interest in an area which he had visited since the early 1860s (see Chronology, p. 260). It should also be noted that, in a small surviving oeuvre of early works, there has apparently been a desire to identify more works with the Forest of Fontainebleau, e.g. *Avenue of Chestnut Trees at La Celle-Saint-Cloud* (Cat. 6) had a label on its stretcher mis-identifying it as 'La Lisière dans la Forêt de Fontainebleau Durand-Ruel no. 9570', and a painting now in a private collection dated by Daulte (D8) as 1868 and entitled *A Path*

62 Detail of Cat. 4.

near the Parc de Courances was in fact, on stylistic grounds, certainly painted in the years immediately after 1870, and therefore is unlikely to be of a Forest of Fontainebleau subject. Relatively modest in their proportions in comparison to his grand landscape of 1865, *Avenue of Chestnut Trees at La Celle-Saint-Cloud* (Cat. 2), the two views of Marlotte were completed by April 1866 since they were shown at the Salon of that year.

The spatial structure of both landscapes is established by the strident diagonal of the village street which plunges back between sharply defined walls, houses and roofs. The architectonic handling of these latter features recalls an earlier tradition of oil sketching in front of the motif, notably by Corot, where buildings in particular are described in broad zones of sharply contrasted light and shade. Of equal relevance is the definition of buildings in Monet's *Farm in Normandy* (c.1863, Musée d'Orsay, Paris) and in Pissarro's work of the mid-1860s, for example *The Banks of the Marne at Chennevières* (1864–65; National Gallery of Scotland, Edinburgh) and *The Banks of the Marne in Winter* (1866; Art Institute of Chicago), also shown at the Salon of 1866. At this stage in his career, however, Pissarro was deeply influenced by Courbet; this artist's impact on Pissarro's younger contemporary, Sisley, can certainly be seen in the handling of the buildings and in the somewhat bolder brushwork in the village street and the foreground of the two Marlotte pictures. As with his contact with Corot (see Cat. 1), it has also been suggested that it was Renoir, rather than Pissarro, who was the point of contact between Sisley and Courbet (see D. Cooper, 1959).

The figures which Sisley inserts into his two village scenes recall the picturesque tradition of staffage used to describe the rural character of a landscape. However, here they are not just decorative. The women in Cat. 5 are bundled up against the cold, an indication of Sisley's concern with precise seasonal details. They are also setting out to the forest, possibly to collect wood. This is then chopped by the man in Cat. 4 (detail Fig. 62), underlining the symbiotic relationship between the village's location in respect of, and its dependence upon the forest itself. Indeed, Sisley appears to be using figures in a way similar to that of Constable, where a working landscape must necessarily be populated by working figures who are integral to its function.

Sisley's intention in presenting to the Salon two somewhat similar views of the same village is puzzling. To be sure, Rousseau had exhibited two views of the same landscape at the Exposition Universelle of 1855, but their titles indicate that they illustrated different times of day (*The Forest of Fontainebleau, Morning* and *The Edge of the Forest of Fontainebleau at Sunset*). Neither the titles nor the subject matter of Sisley's two paintings accord with that intention. Were his paintings meant to be seen as 'pendants', or, as with his two variants of *Avenue of Chestnut Trees at La Celle-Saint-Cloud* (Cat. 2, 3), as the forerunners of a more sophisticated approach to landscape in which a specific location, be it Hampton Court (see Cat. 24–29), Marly-le-Roi (see Cat. 32, 35, 36) or Moret-sur-Loing (see Cat. 59–61, 64–67), was meticulously explored? A process of visual and emotional discovery was then mapped in a sequence of paintings.

MA.S.

4 PROV: M. Renier, Paris, until 1951; Knoedler and Co., New York; The Albright-Knox Art Gallery, Buffalo, 1956.

EXH: Paris, Salon of 1866, no. 1786; Wolfsburg, 1961, no. 147; New York, 1961, no. 1; San Francisco-Toledo-Cleveland-Boston, 1962, no. 112; Iowa City, 1964, no. 22; New York, 1966, no. 1; Washington, DC, 1968, cat. p. 13; Chicago, 1978, no. ; Los Angeles-Chicago-Paris, 1984, no. 11; Manchester, NH-New York, IBM Galleries-Dallas-Atlanta, 1991–92, no. 110.

BIBL: Fontaine and Vauxcelles, 1922, p. 170; *Gallery Notes*, 1957, repr. p. 32; Rewald, 1961, repr. p. 133; Lanes 1966, p. 645, fig. 59; Daulte, 1972, repr. p. 18; *Painting and Sculpture from Antiquity to 1942*, 1970, p. 261, repr. p. 260; Bellony-Rewald, 1977, repr. p. 51; Cogniart, 1978, repr. p. 16; Bernard, ed., 1986, repr. p. 208; Denvir, 1991, repr. p. 138.

5 PROV: Shojiro Ishibashi, Bridgestone Gallery Tokyo; Bridgestone Museum of Art, Tokyo.

EXH: Paris, Salon of 1866, no. 1785; Tokyo, 1926, no. 523; Tokyo, 1932; Tokyo, National Museum of Modern Art, 1955; Osaka, 1955; Kurume, 1961, no. 21; Tokyo-Fukuoka-Nara, 1985, no. 3; Nashville, TN, 1990–91, no. 31; Manchester, NH-New York, IBM Galleries-Dallas-Atlanta, 1991–92, no.110.

BIBL: Catalogue of the Opening Exhibition, Bridgestone Gallery, 1952, repr.; Dorival, 1958, p. 59; Reidemeister, 1963, p. 33, Daulte, 1972, p. 74; repr.; Champa, 1973, p. 93, repr. fig. 131; *Bridgestone Museum of Art – catalogue*, 1977, no. 34; Lassaigne and Gache-Patin, 1983, ill. 67.

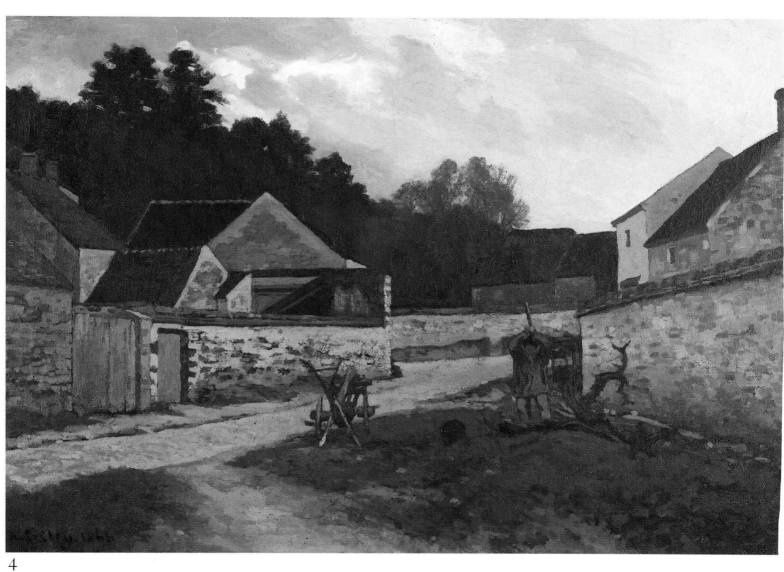

4

5

6 Avenue of Chestnut Trees near La Celle-Saint-Cloud

Avenue des Châtaigniers près de la Celle-Saint-Cloud
1867; D9
95.5 × 122.2 cm
Signed and dated bl: A. Sisley 1867
Southampton City Art Gallery
Exhibited in London only

The subject of this monumental landscape, exhibited at the Salon of 1868, is a ride through a densely wooded part of the forest close to the village of La Celle, which had been the scene of Sisley's two paintings made in 1865 (see Cat. 2, 3). The forest was a popular resort for Parisians 20 km west of Paris beyond Saint-Cloud and six and a half km to the west of the village of La Celle itself.

As with the two earlier landscapes, this painting's debt to Sisley's immediate artistic predecessors can be readily identified. The view down a magisterial avenue of trees has been compared to Hobbema's *Avenue at Middelharnis* (Fig. 63) and Rousseau's *Avenue of Chestnut Trees* (1834, Musée du Louvre, Paris; see Lassaigne and Gache-Patin, 1983, pp. 54–55). The use of the soft, fairly broad brushstroke to apply a subtly shifting range of greens and browns, the core of the structure of the landscape itself, looks back to Daubigny and Corot (see Cat. 1). The small patches of intense green suggest a reference to Courbet, a source which may also have led Sisley to include the deer breaking through the cover to the right of the ride.

Yet, by the latter part of the 1860s, it is also important to assess Sisley's achievement in establishing himself as a landscape painter within the context of the younger generation of 'proto-Impressionists' – Monet, Renoir and Bazille – with whom he had been associated since his days at Gleyre's studio. Here, the interest in a bosky landscape is paralleled in contemporary works by Bazille and Pissarro. Technically, in his handling of paint, Sisley appears to share Renoir's softer application of overlapping layers of greens and greys found in the foliage of *Diana the Huntress* (1867; National Gallery of Art, Washington, DC) and *Woman in a Garden* (1868; Kunstmuseum, Basel), although in both latter instances the choice of brush is broader. However, another, and more immediately relevant source, both in terms of composition, an avenue driving back

into the depth of the canvas, and of the dappled brushwork which, particularly on the trunks of the trees, is identified by sharply differentiated zones of dark and light, is Monet's *Forest Road, Chailly* (1865; Musée d'Orsay, Paris). While both artists may have been acutely aware of their Dutch seventeenth-century predecessors, notably Hobbema and Ruisdael, they also demonstrate knowledge of the early landscape photography of Gustave Le Gray, whose prints, such as *Undergrowth at Bas-Bréau (Forest of Fontainebleau)* (c.1855; Fig. 64), share the crisp, dappling effects of light and shade and, in the case of Sisley's painting, an uncanny resemblance in terms of composition.

Despite the appearance of the deer in the background, Sisley's painting also shares with LeGray's photograph an apparent absence of anecdotal subject-matter. Relying as they both do upon the natural configuration of the ride through a forest to create spatial recession (as Sisley had also done in *Avenue near a small Town*, non-D; Cat. 1), they seem to celebrate a specific wooded location within accepted landscape conventions. Yet both are views of what had been royal hunting grounds. The ride in Sisley's painting was then owned by Napoleon III, a fact which has led Scott Schaeffer (Los Angeles-Chicago-Paris 1984–85, p.70) to suggest that it was this which made it acceptable to the Salon Jury of 1868. What the Jury may not have understood, however, was Sisley's implied disrespect for what was overtly a royal or traditional subject.

In the *Avenue*, Sisley has painted a subject recognisably Imperial in its association, a reference possibly reinforced by the presence of the deer as emblematic of the function of the forest as royal hunting ground. Yet Sisley has chosen to

illustrate the subject in the new tradition of landscape painting epitomised in the work of Rousseau, Millet and Courbet which had been so unequivocally relegated to an inferior position in the hierarchy of pictorial subject-matter by the art establishment in the same year in which Sisley's painting was made (see P. Mainardi, 1987, pp. 176–79). While absence of any firm evidence as to Sisley's political affiliations makes it impossible confidently to suggest that this painting contained a revolutionary message, its confrontation of Imperial or *ancien régime* subject-matter with an innovatory technique presages Sisley's more focused exploration of this particular approach to the search for subject-matter within the new programme of landscape painting laid down by the generation of 1830.

MA.S.

PROV: Henri Haro, Paris; Haro Sale, Hôtel Drouot, 12–13 December, 1911 (225); bt Durand-Ruel for 1000 fr; Durand-Ruel, Paris; bt Mme de la Chapelle, Paris, 13 June 1936; Mme de la Chapelle, Paris; Galerie Mouradian Vallotton, Paris; Southampton City Art Gallery, Chipperfield Bequest Fund, 1936.

EXH: Paris, Salon of 1868, no. 2312; Arts Council (Southern Region), 1948, no. 26; Arts Council at Peterborough, 1953; Exeter, 1955, no. 34; London, Royal Academy, 1962, no. 229; London, Wildenstein and Co., 1970, no. 27; Nottingham, University Art Gallery, 1971, no. 1; London, Royal Academy, 1974, no. 105; Philadelphia-Detroit-Paris, Grand Palais, 1978–79; London, David Carritt Ltd., 1981, no. 1; Los Angeles-Chicago-Paris, Grand Palais, 1984, no. 10.

BIBL: Rewald, 1946, repr. p. 161; Huyghe, 1959, repr. p. 154; Rewald, 1961, repr. p. 187; Roberts, 1970, p. 480; Champa, 1973, p. 93, fig. 134; Lloyd, 1981; Callen, 1982; Bernard, 1986, p. 209; Blanchet and Pericard, 1988.

63 Meindert Hobbema, *The Avenue at Middelharnis*, 1669 (National Gallery, London).

64 Gustave LeGray, *Undergrowth at Bas-Bréau (Forest of Fontainebleau)*, photograph c. 1855 (Gérard-Levy Collection, Paris).

7 Still-Life: Heron with spread Wings

Nature morte – l'héron aux ailes déployées
1867; D5
81 × 100 cm
Signed br: Sisley
Musée Fabre, Montpellier, on deposit from the Musée d'Orsay, Paris
Exhibited in Paris and Baltimore only

This still-life, a genre of painting rare in Sisley's oeuvre, illustrates his relationship with both Bazille and Renoir. The work was painted in 1867 in Bazille's Batignolles studio, 9 rue de la Paix, using the same still-life arrangement, although seen from further round to the left than Bazille in his own *Still-Life: the Heron* (1867; Musée Fabre, Montpellier). Bazille was recorded at work on this still-life in Renoir's *Portrait of Frédéric Bazille*, also dated 1867 (Musée d'Orsay, Paris). By this date the three artists were close associates. Bazille had introduced Sisley to Gleyre's studio in 1860, where the latter met Monet and Renoir. Renoir, Bazille and Sisley explored the Forest of Fontainebleau together from 1862 and in July 1865 planned a journey together down the Seine to Le Havre (see Chronology, p. 261). The following year, Renoir and Sisley frequented Bazille's studio, together with Monet and Pissarro, and in 1867, all three were rejected by the Salon Jury, with Monet, Pissarro, Cézanne and Guillemet. In 1868, Sisley was to use the address of Bazille's studio for his Salon submission, *Avenue of Chestnut Trees near La Celle-Saint-Cloud* (Cat. 7). Sisley's early interest in music, especially the work of Beethoven, may also have been shared with Bazille, who was an enthusiastic attender of the Pasdeloup and Conservatoire concerts (see *Bazille and Early Impressionism*, Art Institute of Chicago, 1978, pp. 154, 156, 161).

Sisley made only nine recorded still-lifes. Four date from before 1870 (D6, D7, D8 and Cat. 7), three from the 1870s (D186, D.233, D234 [see Cat. 43]) and two from 1888 (D661, D662). For Sisley, therefore, in contrast notably to Manet and Cézanne, it would appear that his commitment to record truthfully the visual sensation experienced in front of external nature far outweighed any interest in the detailed analytical description of inanimate objects.

Technically Sisley's use of a relatively heavily loaded brush and his breadth of handling demonstrates a stylistic affinity with that distinctive early Impressionist approach to still-life subjects found in such works as Monet's *Spring Flowers* (Cleveland Museum of Art) and Renoir's *Potted Plants* (Oskar Reinhardt Foundation, Winterthur), both of 1864, and Bazille's other still-life subjects, such as his *Flower Pots* (Mr and Mrs John Hay Whitney Collection, New York) of two years later. Dependent upon the examples of both Courbet and Manet, these still-lifes present an inanimate counterpart to the grand set-piece figure paintings created during the same period.

MA.S.

PROV: Georges Viau, Paris; Viau Sale, Galeries Durand-Ruel, Paris, 4 March 1907 (68); Joseph Reinach, Paris; Mme Pierre Goujon, Paris.

EXH: Paris 1906, no. 263; Paris, Musée Jacquemart-André, 1957, no. 263; Berne, Kunstmuseum, 1957, no. 3.

BIBL: Duret 1906, repr. p. 110; Daulte, 1957, repr. p. 48; Rewald 1961, repr. p. 182; Lassaigne and Gache-Patin, 1983, pp. 9, 57, repr. ill. 69, 70.

8 *View of Montmartre, from the Cité des Fleurs, Les Batignolles*

Vue de Montmartre, prise de la Cité des Fleurs aux Batignolles
1869; D12
70 × 117 cm
Signed and dated bl: Sisley 1869
Musée de Grenoble

Despite being Parisian by birth, Sisley found little in the city to attract him as a painter. When he did turn to Paris, albeit briefly, for his subject-matter in 1869 and 1870, he chose to record neither the obviously picturesque views along the Seine and the fragments of medieval Paris, nor the fashionable newer quarters carved out by Baron Haussmann after 1851. Rather, he was drawn to the more industrial zones of Paris (see Cat. 9, and *The Seine in Paris and the Pont de Grenelle*, 1870, D5; Private Collection) and to this distant view of Montmartre. Even when he visited London in July 1874 (see Cat. 24–29), he only confronted the city itself once in the painting *The Thames and Charing Cross Bridge* (1874, D113, Private Collection) before escaping to the more bucolic environs of Hampton Court.

Sisley had been associated with the Cité des Fleurs, a street in the 17th arrondissement, since 1867. His mistress, Marie-Adelaïde-Eugénie Lescouezec (b. 1834) listed her address as number 27, Cité des Fleurs on the birth certificate of the couple's first child, Pierre, who was born that year. Sisley's association with the street lasted at least until 1870, when the same address appeared in the Salon catalogue for that year (see Cat. 9).

This view of the Butte de Montmartre is taken looking south-east from the Cité des Fleurs. It emphasises the still sparsely developed area between the 'Octroi' walls and the outer ring of fortifications raised by Thiers between 1841 and 1845. For later generations of painters, such as Maximilian Luce, Paul Signac and Vincent van Gogh, and for writers such as Emile Zola, J.-K. Huysmans and Catulle Mendès this area, *les terrains vagues*, represented a twilit, anarchic no-man's land caught between the two closely defined worlds of densely built-up old city and sparse, newly expanding suburbs. Alternatively, it was the entertainment facilities of the Butte which provided subject-matter for Renoir,

Toulouse-Lautrec and, again, Van Gogh. Sisley's painting reveals no such interests. The Butte de Montmartre rises in the middle distance, its bulk pivoted upon the single tower which rises to the left of the escarpment, in a way not dissimilar to his location of the clump of trees in his two *Avenue of Chestnut Trees at La Celle-Saint-Cloud*, painted four years earlier (see Cat. 2, 3), and which he was to use again in such panoramic landscapes as *The Church of Noisy-le-Roi* (1874, Cat. 30) and *View of Saint-Cloud* (D211, 1874, Art Gallery of Ontario, Toronto) and at Moret-sur-Loing (Cat. 67).

This more remote view of the Butte de Montmartre is somewhat reminiscent of the picturesque treatment of the hill with its windmills usually dramatically silhouetted against storm-swept skies, found in the work of Georges Michel and Constant Troyen (e.g. *Descent from Montmartre*, c.1850, Corcoran Art Gallery, Washington, DC). Yet, as in *Avenue of Chestnut Trees at La Celle-Saint-Cloud* (Cat. 2), the extension of the landscape beyond the edge of the canvas and the stark, seemingly arbitrary placement of the recently planted saplings in the foreground belie any such picturesque intentions on the part of the artist.

MA.S.

PROV: Rousselin Collection, Paris; by whom given to the Musée de Grenoble in 1901.

EXH: Paris, Petit Palais, 1935, no. 193; Venice, 1947, no. 11; London, Royal Academy, 1949–50, no. 253; Florence-Rome 1955, no. 98; Berne, Kunstmuseum, 1958, no. 5; Tokyo, Japan Art Center, 1978, no. 2.

BIBL: De Beylie, 1909, repr. p. 107; *Catalogue du Musée de Grenoble*, 1911, no. 429; Focillon, 1928, repr. p. 217; Besson, n.d., pl. 13; Rewald 1961, repr. p. 204; Leymarie, 1955, I, repr. p.71; Champa, 1973; Reims, 1973, repr. p. 160; Lassaigne and Gache-Patin, 1983, p. 62, repr. ill. 76; Bernard, ed., 1986.

9 *The Canal Saint-Martin*

Vue du Canal Saint-Martin
1870; D16
50 × 65 cm
Signed and dated br: Sisley 1870
Musée d'Orsay, Paris
Exhibited in Paris only

During the second half of the 1860s, the possibility of finding suitable subject-matter for landscape paintings in Paris was explored by several of Sisley's fellow Impressionists: Manet, in *The Exposition Universelle, Paris 1867* (1867, Nationalgalleriet, Oslo), Monet in *St Germain l'Auxerois* (1867, Nationalgalerie, Berlin), *The Infanta's Garden* (1867, Allen Memorial Art Museum, Oberlin) and *Quai du Louvre* (1867, Gemeentemuseum, The Hague), and Renoir in *The Champs-Elysées during the Exposition of 1867* (1867, Private Collection) and *The Pont des Arts* (1867, Norton Simon Foundation). All these artists presented Paris as a sunlit, spacious city, in which its newer aspects, the boulevards, apartment blocks and the pavilions of the Exposition Universelle, coexisted with the more venerable gothic churches and seventeenth-century public buildings to provide backdrops for the bustle of urban life. Yet this urban life was not one of toil or poverty, but wealth and leisure. Such interests in the fast-changing face of modern Paris were to be pursued further in the subsequent decade in celebrations of bridges, railway stations and the new boulevards of Haussmann's Paris.

Sisley did not follow the example of his contemporaries when he came to select scenes from Paris. His search for the real, as opposed to the picturesque, led him to the working quays of the River Seine (*Barges*, 1870, D14, Musée de Dieppe and *The Seine in Paris and the Pont de Grenelle*, 1870, D15, Private Collection) and to the industrial eastern quarter of the city around the Canal Saint-Martin. The canal was three miles long and formed part of the extensive system of waterways which linked the Canal de l'Ourcq to the River Seine. Its quays and basins provided facilities for warehousing and small-scale industrial activities, both serviced by barges.

In this view of the Canal Saint-Martin, Sisley has adopted the same one-point perspectival system given to him by a man-made element, that he had already used in his *Avenue near a small Town*

(c.1865, Cat. 1) and in his *Avenue of Chestnut Trees near La Celle-Saint-Cloud* (1867, Cat. 6). While less overtly industrial a scene than his *Barges on the Canal Saint-Martin* (1870, D17; Oskar Reinhardt Foundation, Winterthur; Fig. 16), with barges tied up starkly in the foreground and a smoking factory chimney on the right, the wide expanse of water and sky in *The Canal Saint-Martin* permits Sisley to explore cloud formations, the nature of light and its reflections on the water which were to become one of the hallmarks of his work as an Impressionist (see Cat. 34). Technically, Sisley has used a more heavily loaded brush for the horizontal stabs across the surface of the canvas to delineate reflections, canal side and barges. As in *Barges on the Canal Saint-Martin*, it is tempting to suggest that Sisley has adopted the innovative brushwork which Monet and Renoir had evolved at Bougival the previous autumn as a means of capturing the specificity of the moment and which Monet and Pissarro were to pursue further in the winter of 1869–70 at Louveciennes.

Both this painting and *Barges on the Canal Saint-Martin* were exhibited at the Salon of 1870, where they passed unnoticed by both conservative critics and such supporters of the new 'naturalist' school as Castagnary, Duret and Zola. As with his views of the village of Marlotte (Cat. 4, 5), hung in the Salon of 1866, we are once again confronted with Sisley's decision to present two variations on the same theme. It is tempting to suggest that Sisley was undertaking two exercises: an exploration of a particular location in order to reveal a 'sense of place', and the potential of subjects presented in sequence, which he was to pursue more fully at Moret-sur-Loing.

With the exception of Stanislas Lépine, Sisley's views of the industrial side of Paris preceded those of his contemporaries, such as Monet, with his *Unloading Coal* (1875, Private Collection, Paris) and his successors, such as Signac, Guillaumin, Seurat and eventually Braque.

MA.S.

PROV: Gandoin, Paris; Dr Paul Gachet, Auvers-sur-Oise; M. Paul Gachet, Auvers-sur-Oise; given by him to the Musée du Louvre; transferred to the Musée d'Orsay, 1984.

EXH: Paris, Salon of 1870, no. 2651; Paris, 1954, no. 105.

BIBL: Francastel, 1955, II, repr. p. 81; P. Gachet, 1957, pp. 37, 38; *Catalogue des Peintures, Pastels, Sculptures impressionnistes*, 1958, no. 394; Reidemeister, p. 108, repr.

10 *Rue de Voisins, Louveciennes: First Snow*

Rue de Voisins, Louveciennes – premières neiges
1871/2; D18 (known as *Premières neiges à Louveciennes*)
54.8 × 73.8 cm
Signed br: A Sisley
Museum of Fine Arts, Boston, Bequest of John T. Spaulding (48.600)

This picture, erroneously identified as a view of the rue de la Paix (see Los Angeles-Chicago-Paris 1984–85, no. 19), shows the rue de Voisins as it descends the hill from the route de Versailles to enter the village of Voisins-Louveciennes (Fig. 65). To the right, beyond the fence and trees lies the Avenue Saint-Martin (painted by Pissarro as *Entry to the Village of Voisins*, 1872, Musée d'Orsay, Paris). Behind the wall on the left stands the Château de Voisins, its entrance indicated by the curved break in the wall. What is in fact a rather narrow village street descending towards a jumble of non-descript seventeenth- and eighteenth-century cottages (extensively rebuilt after World War I) has been broadened by Sisley to provide a visual sweep to the entrance of the composition, a device used elsewhere to dramatic effect in paintings such as *Rue de la Machine, Louveciennes* (1873, Cat. 19), *Road from Mantes to Choisy-le-Roi* (1872, D20, Private Collection) and *Rue de la Princesse, Louveciennes* (1872/73, Cat. 17).

The date of this painting is problematic. Daulte has given it to 1870, with no indication whether it was made in the winter 1869/70 or 1870/71. If it had indeed been made at the beginning of 1870, then it would be contemporary to the groups of paintings of roads under snow in the same village created by Pissarro and Monet (e.g. Pissarro's *Route de Versailles, Louveciennes (Snow)*, 1869, Walters Art Gallery, Baltimore, and Monet's *Route de Versailles, at Louveciennes (Snow)*, 1869–70, Private Collection, Chicago). An alternative date of winter 1870/71 has been proposed in the catalogue *A Day in the Country*, presumably on the stylistic grounds that, from what little evidence survives, Sisley's early landscape technique was not as sophisticated as that displayed in this picture. Yet, given that the painting records the first snows at Voisins-Louveciennes, there is no evidence that

Sisley was in Louveciennes between the outbreak of the Franco-Prussian War and the Armistice of 28 January 1871, which brought to a close the Siege of Paris. More plausible is the date of early winter 1871, after Sisley's presumed move to the village, a dating which is supported by the light powdering of snow and the presence of some trees still just in leaf, albeit tinged with an autumnal hue.

Whatever the final date ascribed to this painting, it is the first surviving view of Louveciennes, the village to which Sisley had moved to escape the Commune. Together with its environs, it would provide Sisley with a constant supply of varied subjects over the following three-and-a-half years, before his move in the winter of 1874/5 to Marly-le-Roi. Indeed, indicative of what was to become a characteristic practice, Sisley was to plot this small corner of Voisins-Louveciennes in two other paintings, both of them looking up, as opposed to down, the rue de Voisins: *Rue de Voisins, Louveciennes* (1872, D33 [identified as 'rue de Village']), and *Rue de Voisins, Louveciennes, under Snow* (c.1876, D248 [identified as 'route sous la neige – environs de Louveciennes']). That this section of the rue de Voisins was attractive to the Impressionists is demonstrated by Renoir's painting of the same view as D33 (*Feeding the Hens*, 1895, Private Collection) and Pissarro's of the same view as D18, although taken from slightly further down the street and thus creating a more funnelled composition (*A Street in Louveciennes*, 1871, Manchester City Art Gallery).

The view of the rue de Voisins shown here is indeed a magisterial work within a genre already, as noted above, explored by Monet and Pissarro, but to which Sisley would also return at regular intervals. Roads, under snow or dappled sunlight, leading back into open countryside, to a village or to hills on the distant horizon, came to provide Sisley with a practical formal device which endowed his compositions with instant structure and depth. Yet they and their staffage of local figures may also have served a more literal intent. Robert Herbert has noted (1988, p. 219) that, since the subject-matter of Impressionism was essentially the depiction of landscapes through the eyes of its Parisian recorders, roads in Sisley's views of Louveciennes, as in Pissarro's studies of Pontoise, should be read as routes into or out of the villages in which they, as

Parisians translated to the smaller urban centres close to the capital, were the visitors. This interpretation, however, needs to be modified by the presence in Sisley's landscapes, as in the *Rue de Voisins, Louveciennes: First Snow*, of figures who always seems to 'belong' to the scene into which they have been placed. Thus, when such figures are combined with a road which leads into a working landscape, we sense Sisley revealing his own visual map of a given venue, suggesting knowledge of what lies beyond the edges of the canvas. In this respect, Sisley appears to be proceeding in a way similar to that found in Constable's landscapes, examples of which he could have studied during his stay in London from 1857–59 (see p. 9).

There is a pastel of the same subject, now in the National Museum, Budapest.

MA.S.

PROV: bt by the Nationalgalerie, Berlin, 1897; exchanged Arthur Tooth and Sons, London, for a Cranach; John Taylor Spaulding, Boston; given by him to the Museum of Fine Arts, Boston in 1948.

EXH: Cambridge, MA, 1929, no. 85; London, 1937, no. 15; Manchester, UK, 1949, no. 29; New York, Knoedler, 1950, no. 25; Boston 1948, no. 76; Los Angeles-Chicago-Paris, 1984–85, no. 19.

BIBL: Bibb, 1899; repr. p. 151; Ortwin-Rave, 1945, pl. 19; Rewald, 1961, repr. p. 211; *De Renoir à Vuillard*, 1984, p. 89, repr.

65 Rue de Voisins, Louveciennes, photograph, 1992.

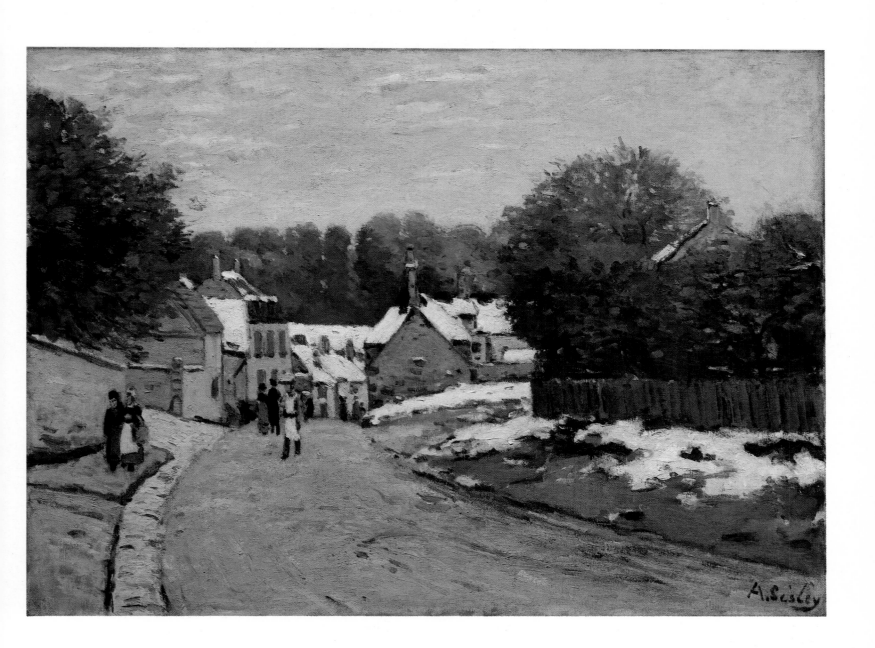

11 *The Bridge at Argenteuil*

Le Pont d'Argenteuil
1872; D30
38.5 × 60.9 cm
Signed and dated br: Sisley 1872
Memphis Brooks Museum of Art, Gift of Mr
and Mrs Hugo N. Dixon

This panoramic view of the River Seine encompasses Petit Gennevilliers on the right, and Argenteuil on the left. The two communities were linked by a road and a railway bridge. The former, seen in the middle distance, was originally built in 1831 while the latter, erected in 1863 of cast iron, can be glimpsed between its arches. Both structures were severely damaged during the Franco-Prussian War but immediately reconstructed (see Monet, *The Highway Bridge under Repair*, 1872, Butler Collection). The hills rising behind Argenteuil are the Heights of Sannois.

A prominent feature of this landscape is the bold white sail of the boat on the left. Further evidence of the yachting associations of the venue can be seen in the forest of thin masts clustered in the yachting basin at the Petit Gennevilliers end of the bridge and the boating sheds on the right. Despite the somewhat wintry aspect of the scene, the location is apparently one for leisure activities. No reference is made to the industrial development which clustered upstream from Argenteuil; rather, two women stroll along the bank in the distance and a man walks purposefully from his skiff moored at the jetty, his oars balanced upon his shoulder.

This painting quietly conveys the main function of Argenteuil in the second half of the nineteenth century, namely as a centre for boating. By the mid-century it had become the most important place for yachting in the immediate vicinity of Paris. In 1850 the town had sponsored a regatta in order to persuade Parisians of the exceptional facilities offered by this part of the Seine, and the following year it was linked to the capital by rail. In 1858, it lured the prestigious sailing club of the Société des Régates de Paris, Le Cercle de la Voile, to relocate its headquarters in the town.

Monet had moved to Argenteuil in December 1871, after his return from Holland. The following year, Sisley appears to have stayed with him there,

making a small number of paintings which record his investigation of the various aspects of the town and its river banks: the picture shown here, views along the River Seine (see *Boats on the Seine at Argenteuil*, almost certainly 1872, D112, Private Collection, *Rue de la Chausée* D31, Musée d'Orsay, Paris, *Boulevard Héloise* D44, National Gallery of Art, Washington, DC and *Grande Rue, Argenteuil* D29, see Cat. 12). Unlike his fellow Impressionists, however, notably Monet, Renoir and Caillebotte, Sisley does not proclaim the town's primary function as a centre for leisure. Even the scene shown here only records this in passing, using the expansive sky and breadth of water as the means for a study in luminosity.

The painting was bought by Edouard Manet, who lent it to the 3rd Impressionist Exhibition held in 1877 (no. 220). Although apparently unnoticed by the critics, among the 16 paintings by Sisley included in that show, it shared with other paintings, notably those by Monet and Renoir of the same period, a determination to evolve a method for capturing as rapidly as possible the fleeting effects of light across a chosen subject while working directly in front of the motif. The resulting apparent lack of finish, noticeable in this painting, was celebrated as a virtue, a central feature of Sisley's work of the 1870s and early 1880s, by critics, notably Octave Mirbeau. In his review of Sisley's contributions to the Salon du Champ de Mars for 1892 Mirbeau recalled that the artist '. . .improvised landscapes with a commendable gusto. . .; he endowed the unfinished with a sort of poetry which was often exquisite', (Mirbeau, 'Le Salon du Champ de Mars – quatrième article – le paysage', *Le Figaro*, 25 May 1892).

The use of a bridge in the background to close off the composition was a device to which Sisley was to return regularly (see Cat. 34, 56, 67). The dominance of his skies also became a characteristic of his work, one which earned him considerable critical acclaim even during his lifetime. An anonymous article published in *Le Figaro* on 27 February 1897 ('Instantané – Alfred Sisley') as a trailer for Sisley's one-man show at Galerie Georges Petit, declared: 'Having learnt very early to master the sublime book of Nature, Sisley immediately excelled in translating the mysterious ambience of the atmosphere, the shimmering ripples of running water. . .

and above all the shifting immensity of great skies'.

M.A.S.

PROV: Edouard Manet, Paris, in 1877; bt Durand-Ruel, Paris, 1883; Allard, 1899; Georges Feydeau, Paris; Feydeau Sale, Hôtel Drouot, Paris, 11 February 1901 (91); Durand-Ruel, Paris, 1901; Paul Cassirer, Berlin, 1901; E. Arnhold, Berlin; Kunheim, Ascona; Dr Fritz Nathan, 1954; Knoedler and Co, New York, 1954; Mr and Mrs Hugo Dixon, Memphis, TN., 1954; given to the Memphis Brooks Museum of Art, 1954, with life interest retained.

EXH: Paris, 3rd Impressionist Exhibition, 1877, no. 220; New York, Wildenstein and Co., 1966, no. 7; New York, Acquavella, 1968, no. 8; Memphis, TN., 1976–77, no. 13/18; Memphis, TN,1977–78, no. 26; Birmingham, 1980, no. 4; Tokyo-Fukuoka-Nara, 1985, no. 5; San Francisco-Washington, 1986, no. 66; Minneapolis, 1989; Memphis, TN, 1990.

BIBL: Bibb, 1899, repr. p. 153; von Tschudi, 1909, p. 10, repr. p. 59; Rewald, 1961, p. 392, repr. p. 290; Lassaigne and Gache-Patin, p. 12.

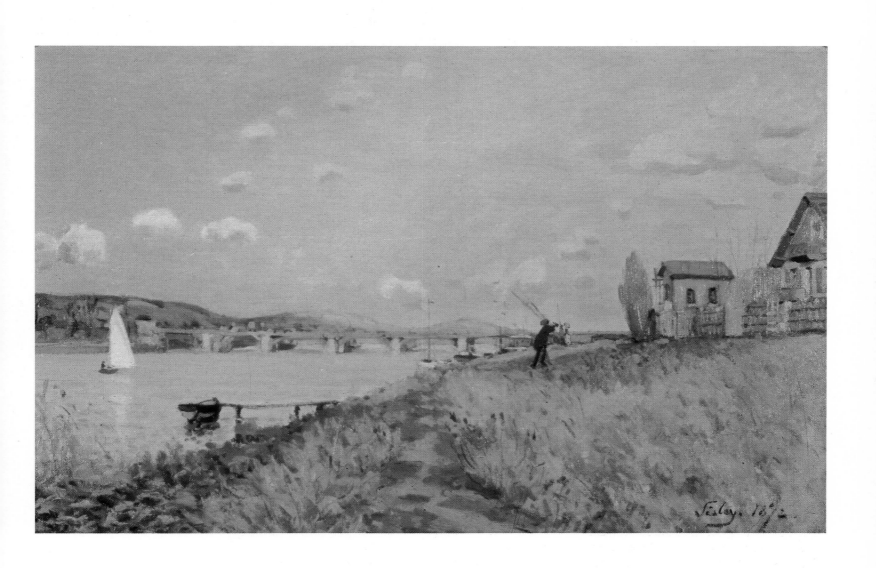

12 *Grande Rue, Argenteuil*

La Grande Rue à Argenteuil
1872; D269 (known as *Une Rue à Sèvres*)
65.8 × 46.7 cm
Signed bl: Sisley
Norfolk Museums Service, Norwich Castle
Museum

This painting has been dated by Daulte '*c*.1877' and identified as 'Une rue à Sèvres'. If the date had been correct, then the location would have been logical, given that Sisley moved from Marly-le-Roi to Sèvres in that year. However, on stylistic grounds alone, John House was persuaded to bring forward its date of execution to *c*.1872–74, arguing that the 'muted colour scheme and broad handling' are unlike the 'clearer colours and broken textures' that Sisley was using by 1877. This view has been supported by Christopher Lloyd who, on the basis of the identification of the subject provided by Daniel Wildenstein's discussion of Monet's painting of the same subject (W344), retitled the painting *La Grande Rue à Argenteuil*' (now the Rue P. Vaillant-Couturier) (Tokyo-Fukuoka-Nara 1985, no. 6, p. 160). The Church in the background is Notre-Dame.

The date of the work can be made even more precise. With the apparent exception of two paintings, Sisley was working in Argenteuil only in 1872, when he was staying with Monet (see Cat. 11). Furthermore, of the two recorded subjects which apparently date from later than 1872 (D79 and D112), one is of a field traditionally located on the 'coteaux d'Argenteuil' (D79, 1873, Fig. 59), the other, *Boats on the Seine at Argenteuil* (D122, Private Collection) which has been dated 1874 by Daulte, possibly on the grounds of its similarity to the background motif of Manet's *Argenteuil* (Musée des Beaux-Arts, Tournai) of the same year, must, on account of its breadth of handling be much closer in date to Sisley's major group of Argenteuil scenes made two years before.

Apart from *The Bridge at Argenteuil* (D32, Musée d'Orsay, Paris), Sisley made three paintings in 1872 which recorded Argenteuil as a working town rather than as a resort. *Boulevard Héloise* (D44 [where it is identified as 'Rue de Sèvres'], National Gallery of Art, Washington, DC) shows the one street in the town whose length and straight alignment approximated it to modern city boulevards. The one shown here and *Rue de la Chaussée* (D31 [where it is identified as 'Place d'Argenteuil'], Musée d'Orsay, Paris) concentrate on the town's more ancient aspects.

The perspectival arrangement of the *Grande Rue*, with the street leading the eye back into a composition which is closed by the spire of Notre-Dame, suggests a parallel with Monet's *Rue de la Barolle, Honfleur* (1864, Museum of Fine Arts Boston) and *Street at Sainte-Adresse* (1867, Sterling and Francine Clark Institute, Williamstown). Both of Monet's early works depend upon the picturesque approach to townscapes which celebrated asymmetrical jumbles of old houses, irregular roof lines and bright local colours. Sisley's view, with its varied roof tops, disjointed street-line and diverse shop fronts, not only shares that tradition but also has close affinities with Monet's Honfleur street scene, both in terms of composition and the definition of forms through the use of sharply defined areas of dark and light. Yet Monet's painting has no pivotal church spire in the background which terminates the view. While it is possible that Sisley could have found this in the scene itself, the similarity between the compositional devices of his street scene and one by Corot which had been exhibited in Paris at the Cercle des Merlitons during the winter of 1871–72 is impressive. Corot's *Douai Belfry* (1871, Musée du Louvre, Paris; Fig. 66) was itself derived from an earlier lithograph by the Douai draughtsman, Motte, and showed the belfry of Douai Cathedral rising at the end of an ancient, narrow street. Sisley had from the beginning of his career been impressed by both the technical and compositional aspects of Corot's work (see Cat. 1–3), and the influence of the older artist was to continue overtly at least until 1874 (see Cat. 17, 22), and to reappear in a more conceptual sense during his Moret-sur-Loing period (see Cat. 64, 65, 70). To suggest, therefore, that Sisley could have learnt from Corot's 1871 street scene is not altogether unreasonable.

Sisley's interest in these three specific locations in Argenteuil was shared by Monet. The latter painted almost identical views of the rue de la Chaussée (W239, formerly Landrin Collection, Paris) and of the Boulevard Héloise (Mr and Mrs Paul Mellon Collection, on loan to the Yale University Art Gallery, New Haven) in 1872, and two years later, made his own version of La Grande Rue (see P.H. Tucker, 1981, pp. 24–28, 33–35).

M.A.S.

PROV: Georges Petit, Paris; Bernheim-Jeune, Paris; Dognin, Paris; Durand-Ruel, Paris, 1928; Morot, Paris, 1928; bequeathed to the National Art Collections Fund by Mrs Dora Fulford, 1945; presented to Norwich Castle Museum, 1945.

EXH: London, Royal Academy, 1974, no. 106; Tokyo-Fukuoka-Nara, 1985, no. 6; Edinburgh, 1986, no. 95; London, Sotheby's, 1989, no. 27.

BIBL: Duret, 1939, repr. p. 85.

66 Jean-Baptiste Camille Corot, *Douai Belfry*, 1870 (Musée du Louvre, Paris).

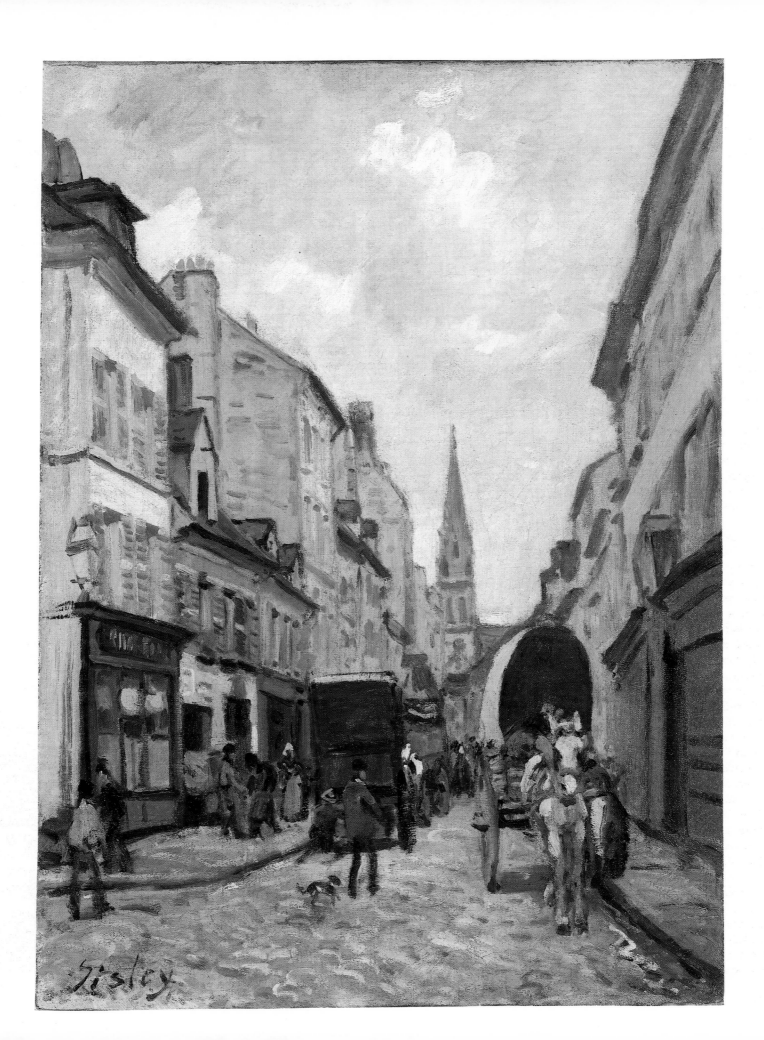

13 Fishermen spreading out their Nets

Pêcheurs étendant leurs filets
1872; D27
50 × 65 cm
Signed and dated bl: Sisley 72
Kimbell Art Museum, Fort Worth, TX

The subject of this painting is the banks of the Seine at Villeneuve-la-Garenne looking downstream to the bridge and across the river to the Ile Saint-Denis. It is dated '72' and was bought directly from the artist by Durand-Ruel on 30 April of that year. The purchase date confirms that the painting was made during a spring campaign at Villeneuve-la-Garenne which also produced *Ile Saint-Denis* (D47; 1872, Musée d'Orsay, Paris [lefthand panel of the 'Triptych May']) and the *Bridge at Villeneuve-la-Garenne* (D38, 1872, Fogg Art Museum, Cambridge, MA), a painting which was subsequently purchased directly from Sisley by Durand-Ruel on 25 June 1872. On 17 May 1872, Durand-Ruel sent *Fishermen spreading out their Nets* to London (see p. 36) where it was included in the dealer's 1872/73 winter exhibition mounted at 168 New Bond Street (no. 120). Sisley had been introduced to Paul Durand-Ruel by Monet and Pissarro early in 1872 (Venturi, II, p.189). On 23 March of that year, he undertook his first direct sale to the dealer ('Le Chemin de l'Eglise', unidentified), thus not only establishing an association with Durand-Ruel that was to last nineteen years but also opening up access to the dealer's London exhibitions which had been held since 1870. In the summer of 1872, at 168 New Bond Street, Durand-Ruel included four paintings by Sisley (nos. 24, 28, 44, 83), all imprecisely titled and hence not readily identifiable. For the show of Winter 1872/73, *Fishermen spreading out their Nets* was accompanied by another painting, 'On the Seine' (no. 124) (see Cat. 15), together with works by Degas, Manet, Monet, Pissarro and Renoir (see Flint, 1984, pp. 357–58).

Fishermen spreading out their Nets is a riverscape at work, not at leisure. Sisley, like his fellow Impressionists, celebrated the River Seine as a leisure resource for Parisians – the centre of yachting, rowing and promenading (see Cat. 11). But this painting, together with *The Seine at Argenteuil* (1872, D28, Musée d'Aix-les-

Bains) and *The Seine at Port-Marly: Heaps of Sand* (1875, Cat. 33), shows a more traditional use of the river as an economic resource. Given that Sisley painted scenes recording the working and leisure aspects of both Argenteuil and Villeneuve-la-Garenne it is tempting to see these two groups as presenting contrasting 'pendants' of each town's activities. In the case of Villeneuve-la-Garenne, where the views of the village were so carefully plotted, from bridge as subject (Cat. 14), to river bank (Cat. 15), to a more distant view of the bridge and river bank (*Bridge at Villeneuve-la-Garenne*, D38, Fogg Art Museum, Cambridge, MA) to a view which records the connection (via the bridge) to the Ile Saint-Denis and hence to Saint-Denis and Paris (*Route de Gennevilliers*, D36, Private Collection), *Fishermen spreading out their Nets* forms part of a particular group of the sequential mapping of a given location which Sisley was to apply to Port-Marly (Cat. 37–39), Marly-le-Roi (Cat. 32, 35, 36, 42), Saint-Mammès (Cat. 49–52) and Moret-sur-Loing (Cat. 59–61, 64–71).

The build-up of variegated greens on the river bank through the use of soft-edged, somewhat square brushstrokes complemented by similar, but more rigorously horizontal ones in the water is very similar to other works created during the early part of 1872, notably two works entitled *The Seine at Argenteuil* (D28, Musée d'Aix-les-Bains and D29, Private Collection, Dallas) and the *Bridge at Argenteuil* (Cat. 11). While *Fishermen spreading out their Nets* is slightly warmer in tonality, it nonetheless shares with the picture in the private collection in Dallas a calm, expansive mood in which freshness of spring light is held almost precariously, a fragile hint of warmth to come. In *Fishermen spreading out their Nets* this finds a substantive equivalent in the delicately suggested presence of the near-transparent fishing nets hung up to dry (detail, Fig. 31).

MA.S.

PROV: bt from the artist by Durand-Ruel, 30 April 1872; M. Mallet Collection, Paris; Sir Felix Cassel, London; James Bourlet and Sons, London, 1937; Wildenstein and Co., Paris and New York; Mr and Mrs John Barry Ryan III, New York; Mrs John Barry Ryan III, New York; William Beadelston, Inc., New York; bought by the Kimbell Art Museum, Foundation Acquisition, Apx 1977.01, 1977.

EXH: London, Durand-Ruel, 1872–73, no. 120; Paris, Galerie Georges Petit, 1897, no. 30; Cologne-Zurich, 1990, no. 54.

BIBL: Fry, 1922, p. 277.

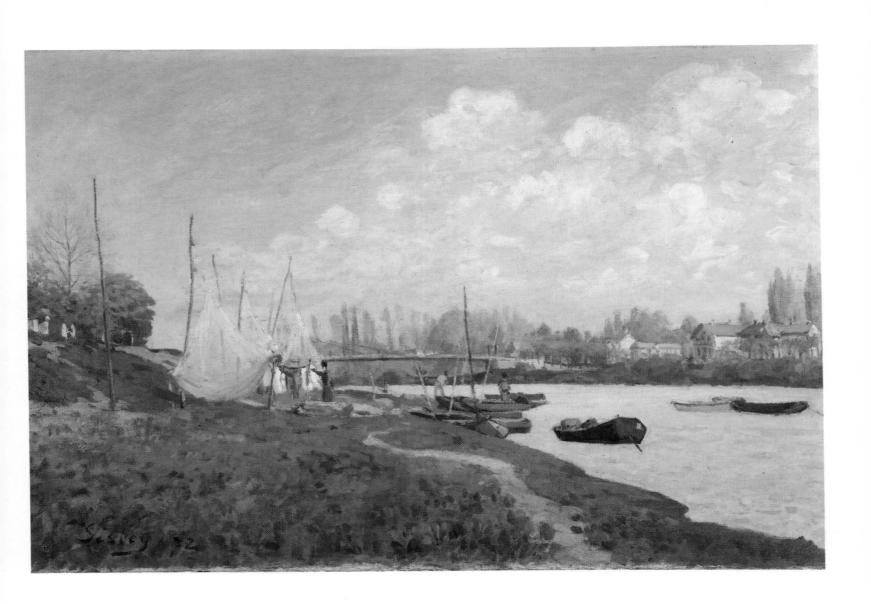

14 The Bridge of Villeneuve-la-Garenne

Le Pont de Villeneuve-la-Garenne
1872; D37
49.5 × 65.4 cm
Signed and date bl: Sisley 1872
The Metropolitan Museum of Art, New York,
Gift of Mr and Mrs Henry Ittleson Jr., 1964

Villeneuve-la-Garenne is a small village which lies across the River Seine from the Ile Saint-Denis, upstream from Argenteuil (see Cat. 11) in the direction of Paris. It served as a modest river port for the town of Gennevilliers which was situated in the centre of the tongue of land created by the northward loop of the Seine before it turns southwards again towards Argenteuil. The cast-iron and stone suspension bridge was opened in 1844 to provide a road link between Gennevilliers, Saint-Denis (via the Ile Saint-Denis) and Paris.

Robert Herbert has pointed out (pp. 226–29) that Sisley's picture gives information about the local economy of Villeneuve-la-Garenne which provides at least one specific reading of the subject. The green rowing boat, which must be about to slip away downstream from the bridge, carries a boatman, and two women sporting straw hats. Herbert suggests that the two women may have hired the boat for a river excursion, an indication that Villeneuve-la-Garenne, like many similar towns along the Seine, possessed agencies for the hire of pleasure craft to the leisured classes of Paris, some of whom are also shown sitting on the bank in the shade of the bridge. Given this emphasis upon Villeneuve-la-Garenne as pleasure resort the dominant presence of the bridge becomes all the more significant. Cutting through the upper left side of the composition, it carries the road which travels from Saint-Denis and hence from Paris into the heart of the village itself.

Herbert also identifies two women 'in the plain clothing of villagers' (p. 227) standing further up the bank in the centre of the composition. Their presence, together with the fact that the bridge leads us into the village, not through and beyond it, suggests that 'Sisley can make us feel that he lived among his villagers along the Seine' (p. 229). This intimation that the artist was indeed interested in providing a more complete exploration of Villeneuve-la-Garenne, from its bridge to its road

connection to Paris, its river bank and its recreational promenades along the banks of the Ile Saint-Denis, and its more traditional function as a fishing port on the Seine is borne out in a group of paintings apparently made during two campaigns in 1872, one in the spring (see Cat. 13), the other in the summer. The spring campaign had produced a more distant view of the bridge, *The Bridge at Villeneuve-la-Garenne* (D36, Fogg Art Museum, Cambridge, MA), a view along the bank with fishing nets, *Fishermen drying their Nets* (Cat. 13), and a view on the Ile Saint-Denis itself (D47, Musée d'Orsay, Paris [part of the 'Triptych May']). That of the summer produced at least a further three compositions, *Villeneuve-la-Garenne* (see Cat. 15), *The Route de Gennevilliers* (D36, Private Collection) and the painting shown here.

Undoubtedly the bridge, by the sheer drama of the viewpoint which makes it burst into the composition from the left, is the focal point of the painting. Sisley had already, in a painting made earlier the same year during his visit to Argenteuil (see Cat. 11), essayed a painting of a bridge, *The Bridge at Argenteuil* (D32, Musée d'Orsay, Paris), in which the potential for indicating depth and movement through a landscape was presented by the diagonal drive of the bridge back across the river into the depth of the composition. However, the earlier painting, possibly taking its inspiration from Monet's *Bougival Bridge* of 1869 (The Currier Gallery of Art, Manchester, NH), retains a sense of human scale by placing the spectator on a level with the road borne by the structure. In the *Bridge at Villeneuve-la-Garenne*, in contrast, the bridge is treated as a monumental structure which both rises above the head of the spectator and dwarfs the people who inhabit its landscape. This bold handling of the subject of a bridge was subsequently explored, to even greater dramatic effect, in Sisley's *Hampton Court Bridge: the Mitre Inn* (1874, Cat. 25), *The Bridge at Saint-Cloud* (1878, Cat. 44) and *The Bridge at Saint-Mammès* (1881, Cat. 49), receiving its ultimate statement in the innovatory spatial arrangement of *Under Hampton Court Bridge* (1874, Cat. 26).

Sisley's essays in bridges may also have had a more symbolic intent. Unlike their picturesque predecessors, for example, Corot's *Le Pont de Mantes-la-Jolie* (1868, Musée du Louvre, Paris; Fig. 26), Sisley's bridges of the 1870s and early 1880s, like

those of his fellow Impressionists, are all of recent construction and frequently sport the most up-to-date technology. Thus, together with those of Monet and Caillebotte, they share a celebration of the modern. But, while both Sisley and Monet during the early 1870s addressed the recently reconstructed bridge at Argenteuil (see Cat. 11), the sheer exhilaration in structure and materials and their potential for moving the spectator swiftly through a landscape was not captured by Monet until his *Railway Bridge at Argenteuil* (Philadelphia Museum of Fine Art), made two years after Sisley's view of the bridge at Villeneuve-la-Garenne.

This painting was one of three bought by Paul Durand-Ruel in 1873. It was engraved for inclusion in an album of 300 prints after the most beautiful paintings in his stock. Although prints of this painting, *Banks of the Seine at Bougival: the Great Avenue* (1872, D41, Private Collection, Fig. 33) and *Ile Saint-Denis* (1872, D47, Musée d'Orsay, Paris) were realised, the publishing project never materialised.

MA.S.

PROV: bt from the artist by Durand-Ruel, 24 August 1872, for 200 fr; bt J.-B. Faure, Paris, for 360 fr; A. Bergaud, Paris; Bergaud Sale, Galeries Georges Petit, Paris, 1–2 March, 1920 (56); bt Gerard Frères, for 37,000 fr; Fernand Buisson, Paris; Sam Salz, New York; Henry Ittleson, Jnr., New York; given by him to The Metropolitan Museum of Art, New York.

EXH: Paris, Petit, 1917, no. 54.

BIBL: *Bulletin de la Vie artistique*, 1920, repr. p. 227; Geoffroy, 1927, pl. 18; Poulain, 1930, pp. 343–46, repr. p. 345; Rewald, 1961, repr. frontispiece; Lassaigne and Gache-Patin, 1983, p. 70, repr. ill. 90; Herbert, 1988, pp. 226–29, repr. p. 227 (detail, p.228).

67 Gustave Caillebotte, *Pont de l'Europe* (Musée du Petit Palais, Geneva).

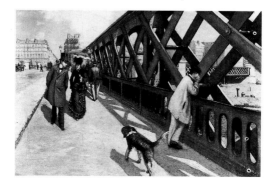

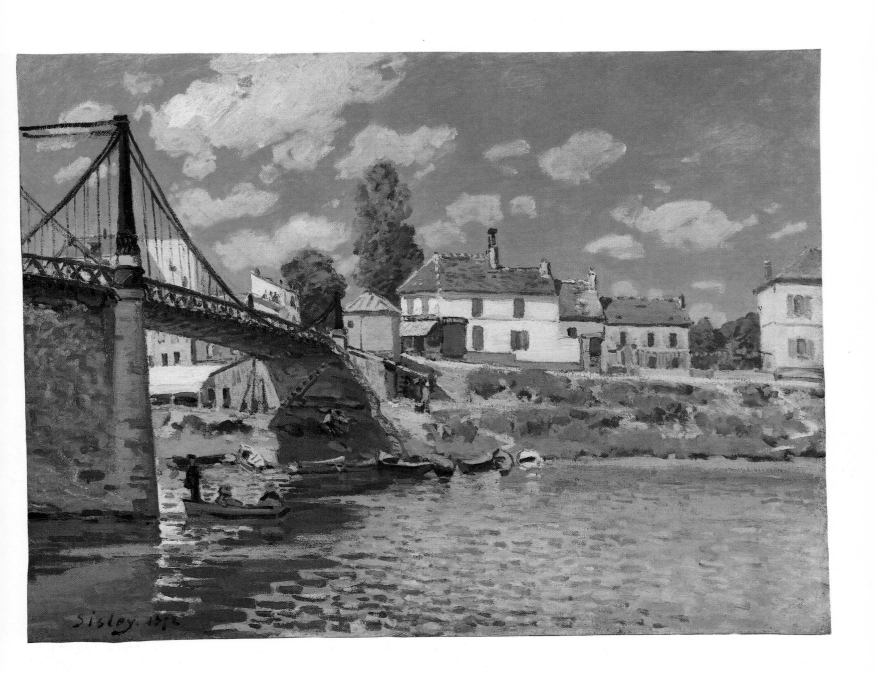

15 *Villeneuve-la-Garenne*

1872; D40 (known as *Village au bords de la Seine*)
59 × 80.5 cm
Signed and dated bl: Sisley 1872
The State Hermitage Museum, St Petersburg

This view through trees to houses on the opposite bank of the Seine continues the landscape downstream in the direction of Argenteuil from the bridge at Villeneuve-la-Garenne (see Cat. 14); the two houses on the extreme left can be seen on the right of the Metropolitan Museum of Art painting. Sisley had visited the village of Villeneuve-la-Garenne both in the early spring (see Cat. 13) and the summer of 1872. The summer campaign produced at least three paintings: the one shown here, *The Bridge at Villeneuve-la-Garenne* (Cat. 14) and *The route de Gennevilliers* (D36, Private Collection).

Given the obvious duplication of houses on the right of *The Bridge at Villeneuve-la-Garenne* (Cat. 14) and on the left of the Hermitage painting, it is tempting to see the two pictures as representing a continuous panorama of the river bank of Villeneuve-la-Garenne. However, the heights of the two canvases are not the same (50 cm and 60 cm respectively) and the tree on the left of the Hermitage painting does not reappear in that of the Metropolitan Museum of Art. Rather, as with other locations visited or lived in by Sisley, the two paintings, taken with the other four made of the same village, form a group that records the artist's exploration of that specific terrain.

The Hermitage painting has none of the compositional drama of *The Bridge at Villeneuve-la-Garenne* (Cat. 14). The modest village houses, strung along the river bank as one of the bands of parallel zones which denote sky, river bank and water, are seen through the frame of trees in the foreground. At first sight, the source of inspiration for such a composition may well have been Monet's *The Seine at Bennecourt* (1868, Art Institute of Chicago), where a young woman sits on a river bank, shaded by trees, beyond whose foliage lies the River Seine and houses on the opposite bank. Yet the composition of this earlier work, unlike Sisley's carefully framed view of Villeneuve-la-Garenne, is inherently unstable. The trees on the left, which traditionally should serve as a framing device, act as a foil to focus attention

neither upon the figure nor upon the buildings in the background, but on the reflections of buildings and sky. This is a presentiment of Monet's exploration of the primacy of inverted vision which he was ultimately to demonstrate in his paintings of his water garden from 1899. For Sisley, no such complex spatial exercises are pursued in his sunlit landscape. Rather, the tranquillity of the scene, stabilised by the framing trees, recalls similar compositional procedures adopted by Corot in such works as *Souvenir of Mortefontaine* (1864, Musée du Louvre, Paris).

Villeneuve-la-Garenne was bought from the artist by Paul Durand-Ruel on 24 August 1872. It may have been the painting exhibited in the winter of 1872 in London by Durand-Ruel under the not very illuminating title of 'On the Seine' (no. 124). Other paintings, however, whose titles and dates of purchase by Durand-Ruel might also qualify them for identification with the exhibited work are *The Bridge at Villeneuve-la-Garenne* (Cat. 14), bought by Durand-Ruel from the artist on 24 August 1872, and *The Seine at Bougival* (1872, D39, Private Collection).

MA.S.

PROV: bt from the artist by Durand-Ruel on 24 August, 1872; P.I. Shchukin, Moscow in 1898; S.I. Shchukin, Moscow in 1912; Museum of Western Painting, Moscow, transferred to The Hermitage, Leningrad in 1948.

EXH: Moscow, 1939, p. 46; Moscow 1955, p. 57; Leningrad, 1956, p. 56; Moscow 1960, p. 35; Bordeaux 1965, no. 72; Paris, Musée du Louvre, 1965–66, no. 71; Otterlo, 1972, no. 55; Washington-New York-Los Angeles-Chicago-Fort Worth-Detroit, 1973, no. 40; Leningrad 1974, no. 60; Moscow 1975, no. 48; New York-Detroit-Los Angeles-Houston-Mexico City-Winnipeg-Montreal, 1975–76, no. 1; Prague, 1976; Lugano, 1987; London, National Gallery, 1988, no. 20.

BIBL: Shchukin Catalogue, 1913, no. 214; *State Museum of Western Art*, 1928, no. 578; *Catalogue de l'art français dans les musées russes*, no. 1106; *Musée de l'Ermitage: La Peinture française de Poussin à nos Jours*, 1957, p. 99; *State Hermitage: Department of Western European Art: Catalogue of Paintings*, 1958, p. 446; *Western European Painting in the Hermitage: 19th-20th Centuries*, 1987, no. 81.

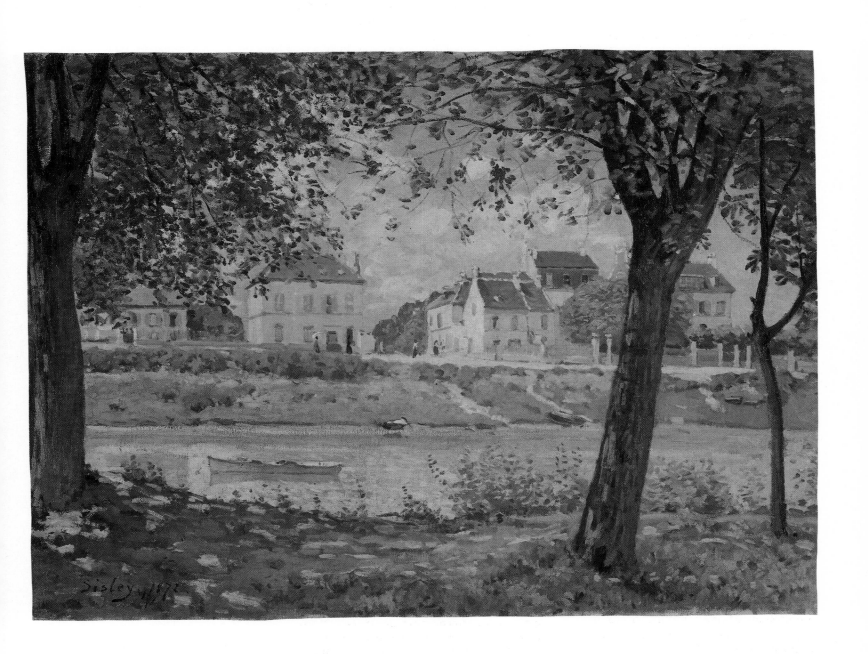

16 The Ferry of the Ile de la Loge: Flood

Le Bac de l'Ile de la Loge – inondation
1872; D21
45 × 60 cm
Signed and dated bl: Sisley 72
Ny Carlsberg Glyptotek, Copenhagen

Living at Voisins-Louveciennes, it was but a short distance for Sisley down to Port-Marly and Bougival on the River Seine. It was here, at Port-Marly, that, in December 1872, Sisley made a group of four paintings (D21–24) which recorded the river in flood, a theme to which he was to return both on the Seine (see Cat. 37–39) and on the River Loing.

Two of the paintings, *Flood at Port-Marly* (D22, National Gallery of Art, Washington DC) and *Flood at Port-Marly* (D23, Private Collection, Long Island) record the effect of the exceptionally high waters on the Seine in December 1872 (Service de la Navigation de la Seine) along the built-up bank of Port-Marly itself. D22 presages the sequence of similar views made in 1876 (see Cat. 37, 38) and D23 focuses on the row of trees lining the quay which Sisley was to paint again, from another viewpoint, in 1876 (Cat. 39). The other two turn their attention to more rural scenes: D24 (*The Flood*, Private Collection) surveys the exceptional expanse of water engulfing bank and meadow, and the painting shown here looks across the river to a narrow finger of an island, the Ile de la Loge, as it lies semi-submerged beneath the flood. At this date the island was linked to the Port-Marly–Bougival bank only by a ferry borne on a cable suspended between two stanchions.

Sisley tends to be seen as the most traditional of the Impressionists, especially in terms of his methods for composing landscape. Working within the classical landscape tradition of repoussoirs and carefully constructed recessional planes, he seems by choice to have sought out those angles of vision within a given landscape which could give him a predetermined 'composed' view, for example a path (see Cat. 31), a river bank (see Cat. 17), the sweep of a hill (see Cat. 34) and appropriately clumped trees (see Cat. 21). The degree to which this implied that he also sought to instil into his scenes an equivalence between his naturalistic views and those ideal landscapes of Arcadia is not

entirely clear, although it was his inherent sense of classical arrangement which invited several contemporary critics to see him as the natural heir to the French classical landscape tradition (see, for example, Adolphe Tarvernier, 1893). At certain moments in his career, however, Sisley could suddenly overturn these conventions, dramatically destabilising all traditional notions of spatial language within a given landscape. *The Ferry of the Ile de la Loge: Flood* is one such example (see also Cat. 26).

The flood had traditionally been the subject of high drama, whether a spectacle created by God's wrath, as in Poussin's *The Flood* (Musée du Louvre, Paris) and Girodet's *The Flood* (1808, Musée du Louvre, Paris) or as a record of Nature's destructive force against which Man is helpless, as in Huet's *Flood at Saint-Cloud* (1855, Musée du Louvre, Paris; Fig. 101). Sisley's representations of the flood are radically different. The composition in *The Ferry of the Ile de la Loge: Flood* has been carefully arranged in parallel bands of foreground, swollen river, distant bank and sky. The composition has been tied down at the centre by the stark verticality of the bare tree and its reflection in the water below. Such formal stability is echoed by the quiet grey tones of the palette. At no point does Sisley imply that the flood had brought destruction in its wake, nor is there a presentiment of worse to come. Even the handling of the main features and their reflections in the water is premeditated; they have been carefully graded from broader, dragged brushwork on the tree and the cable stanchion in the foreground to thin slithers of paint laid over the vertical lines of the trees on the bank beyond (see Fig. 39).

What drama has been instilled into the painting is contained within the bold statement of the cable stanchion on the right. It stands no longer on the bank, but adrift, stranded amid the swirling water. Its very immediacy, foursquare against the surface of the canvas, locks our attention into the plight of the two figures who work their way across the cable in a small boat to a resting point which the flood now denies as a safe haven.

Sisley returned to this view in 1875 (*The Seine at Port-Marly*, non-D, Private Collection, Chicago; Fig. 95), when he showed it under normal water-level conditions. In 1873 he had also explored slightly further up the island (*Boats at the*

Bougival Locks, D90, Musée d'Orsay, Paris).

This painting was bought directly from the artist by Durand-Ruel on 21 January 1873. It was exhibited at the 1st Impressionist Exhibition, held the following year, where it was entered in the catalogue as lent by the Paris dealer (no. 162). With six works included in the show, Sisley generally fared well with the critics, who recognised his delicate, harmonious treatment of landscape (see Chronology, Critical Summary I, p. 282). *The Ferry of the Ile de la Loge: Flood* merited a rare specific, critical reference, being considered as 'among the best landscapes' (de Lora) in the show. The work was subsequently exhibited in London at Dowdeswell's Gallery, 113 New Bond Street, in Durand-Ruel's Spring/Summer exhibition of 1883 (no. 45). The Paris dealer had in fact sent over 12 paintings by Sisley for inclusion in an exhibition which also contained good representations of works by Degas (7), Manet (3), Monet (6), Morisot (3), Pissarro (11), Renoir (8) and Cassatt (2). In the event, only eight works by Sisley were hung, all of which, with the exception of *The Ferry of the Ile de la Loge: Flood*, would appear, from their somewhat uninformative titles, to have been from his later period at Moret. Sisley received mixed notices from the English critics. An anonymous review, possibly by Frederick Wedmore, dismissed him in one sentence: 'Sisley we consider a weaker man' (*Standard*, 25 April 1883, p.2). The reviewer of *The Artist*, however, was more generous, reiterating a familiar comparison with Monet: 'Very like Monet in many ways and yet with a strongly marked individuality of his own is Sisley, whose work is well and fully represented' (1 May 1883, iv, pp. 137–38).

MA.S.

PROV: bought from the artist by Durand-Ruel, 21 January 1873; François Depeaux, Rouen; Depeaux Sale, Galeries Georges Petit, Paris, 31 May, 1906 (58); Prince de Wagram, Paris; Levesque, Paris; Alfred Strölin, Paris; Ny Carlsberg Foundation, 1914.

EXH: Paris, 1st Impressionist Exhibition, 1874, no. 162; London 1883, Dowdeswell, no. 45; Paris, 1899, no. 68; Copenhagen, 1914, no. 197; Copenhagen, 1945, no. 177; Copenhagen, 1957–8, no.131.

BIBL: Petersen, 1929, p. 48; Daulte, 1972, p. 75; Lassaigne and Gache-Patin, 1983, p. 106, repr. ill. 154; Munk, 1991, pp. 47–52, repr. p. 47, fig. 1.

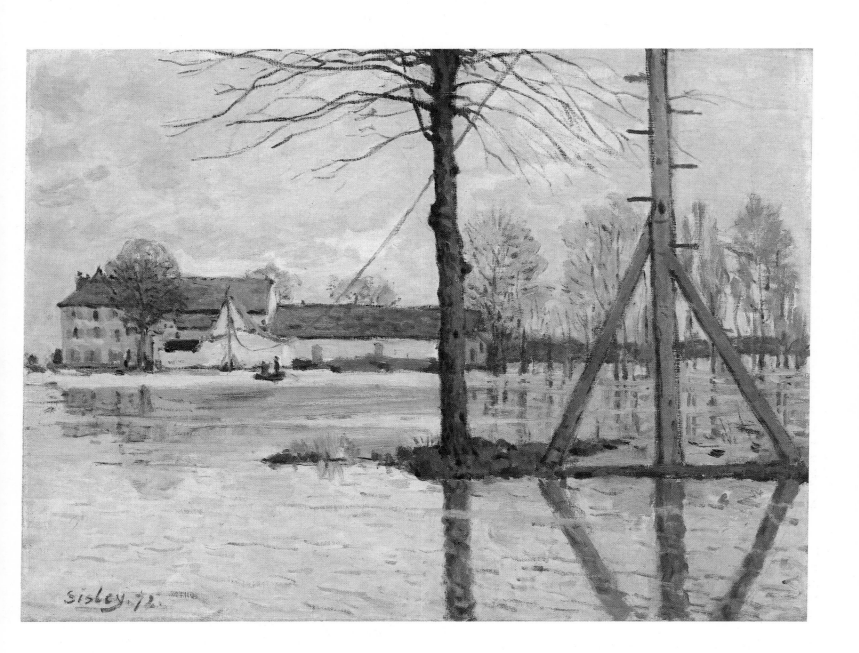

17 The River Seine at Bougival

La Seine à Bougival
1872/73; D87
46 × 65 cm
Signed bl: Sisley
Musée d'Orsay, Paris

By the 1860s, the small town of Bougival, 17 km from Paris on the River Seine between Port-Marly and Chatou, had become a popular resort for Parisians. Lying slightly further away from the centre of Paris and thus as yet untouched by the spreading suburban industrialisation and urban growth which had already hit towns closer in, such as Asnières, Bougival's river banks retained traditional small-scale industries such as saw mills and sand extraction. Backed by the river escarpment which rises to La Celle-Saint-Cloud (see Cat. 2, 3, 6) and Louveciennes (see Cat. 10), Bougival and its buildings were picturesquely clustered along the river bank. It was joined to the Ile de Croissy by a bridge which provided access to pleasant walks along tree-lined paths and to a number of bathing places, notably La Grenouillère. The river itself was in constant use, being the main thoroughfare between Paris and the Channel for barges and steam passenger boats, and a recreation resource for owners of yachts and rowing boats. It was these multifarious aspects of Bougival which Pissarro seized upon in such paintings as *The Wash House at Bougival* (1872, Musée d'Orsay, Paris) with its laundry boat, barges and smoking chimney-stack, while Renoir and Monet had celebrated the crowded leisure resorts in their scenes of La Grenouillère made in September 1869.

None of these obvious characteristics of Bougival attracted Sisley in the landscape shown here. As if turning his back on the very existence of Bougival, he presents us with a languid summer riverscape, with a wide sky spread across an extensive stretch of a peaceful waterway. It is a corner of the Seine as yet untouched by Paris.

Technically, everything has been adjusted to convey the tranquillity of the scene. Unlike his wide riverscapes of the early 1880s (see Cat. 49–52), where each zone of the composition was individually articulated by different types of brushwork, this painting shows an almost uniform application of the square, slightly soft-edged strokes characteristic of Sisley's technique of the early 1870s (detail, Fig. 55). The dominance of the sky as the source of light and the instigator of the mood conveyed in the picture illustrates a feature of Sisley's work which became much praised when, in the later 1880s and 1890s, he began to receive more positive critical acclaim. Tavernier, his most ardent supporter during the 1890s, in an important article of 1893 in which he paraphrased Sisley's ideas about his art, declared that 'Sisley considers correctly that it is the sky which ought to be the means by which the shape of objects is described, for the sky should not be solely a backdrop for a painting – on the contrary, its many layers define the depth in a painting and give movement through their forms, through their pattern which is in harmony with the effect made by a painting or by a composition. I have already said that Sisley always started his painting with the sky and it is only when he is fully satisfied with these initial areas of paint that he moves to the larger conception of his pictures' (*L'Art français*, 18 March, 1893).

Sisley returned to the same site later in the year, when he painted *The Seine at Bougival: Autumn* (D88, National Museum, Stockholm). Apart from the addition of a rowing boat on the left, the similarity of viewpoint may suggest that Sisley saw the two paintings as complementary views, a procedure which he pursued at Louveciennes (see Cat. 10, 31), Marly-le-Roi (see Cat. 36, 42) and later at Moret-sur-Loing (see Cat. 67).

MA.S.

PROV: Drake del Castillo, Paris; Drake del Castillo Sale, Hôtel Drouot, Paris, 6 March 1942 (32); Private Collection.

EXH: Los Angeles-Chicago-Paris, 1984–85, no. 20.

BIBL: Lassaigne and Gache-Patin, 1983, p. 86, repr. ill. 122.

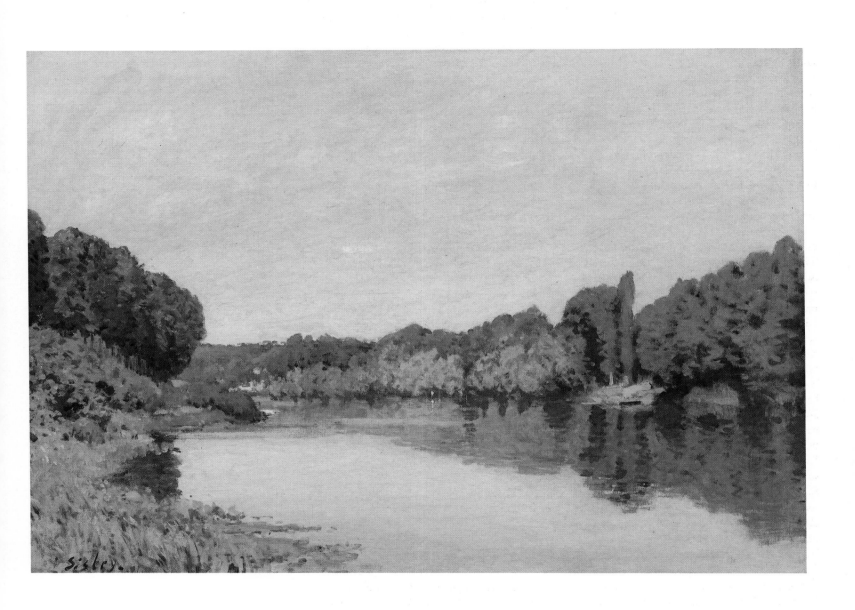

18 *Rue de la Princesse, Louveciennes*

*c.*1873; D167 (known as *Une Rue à Louveciennes*)
38 × 54 cm
Signed bl: Sisley
The Phillips Family Collection

Sisley lived in the house on the left of this painting, 2 rue de la Princesse (destroyed by fire, 1978), at Voisins-Louveciennes, probably from 1871 to early 1875, when he moved to Marly-le-Roi (see Chronology, p. 264, Cat. 10 and Figs 68, 69, 70). Daulte proposes that the work dates from 1875, on account of the fact that another painting of the same house seen from the same direction, *Street in Louveciennes: Evening* (D168, Private Collection), is firmly dated '75'. Several factors, however, suggest an earlier date. While D168 shows the rue de la Princesse in winter, suggesting that it may have been painted early in 1875, shortly before Sisley's removal to Marly-le-Roi, D167 is clearly a summer scene, and thus, if of the same year as D168, must have been painted later that year, recording the house and the village which Sisley had recently vacated. Second, the assumption that the undated picture should be paired with one firmly dated to 1875 is no more plausible than suggesting that it was made

the previous year, on the grounds that Sisley also painted a view of his house, this time from the other direction and under snow (*Road at Louveciennes*, D149, Private Collection; Fig. 69), which is dated 1874.

Indeed, on stylistic grounds, it has been suggested that the painting's 'carefully controlled facture and tightly ordered composition' could invite an even earlier date of 1872/73 (*A Day in the Country*, Los Angeles, 1984–85, no. 22, p. 102). Certainly the square, rather soft-edged brushwork with which the road, the walls of the house and the foliage have been laid in is found in works made between 1872 and early summer 1874, before Sisley's four-month trip to England (see Cat. 24–29). A more conclusive date, however, can be ascribed to the painting by reference to D204 (*Street in Ville d'Avray*; see Cat. 22). This latter picture has now been firmly identified by Richard Shone as taken from the same spot as *Rue de la Princesse, Louveciennes*, but turned 180° to look north up the street towards the château de Voisins (see Fig. 68). This apparent 'pair' to Cat. 18 is definitely dated '1873'. Given the similarity of technique and palette, especially in the slightly autumnal hues of the foliage of the trees in both paintings, the hedge in Cat. 22 and the vine on the wall in Cat. 18, this latter picture can safely be assumed to have been painted at the same time, namely late summer/early autumn of 1873.

It was suggested in *A Day in the Country* (1984–85, *loc. cit.*) that 2 rue de la Princesse, was a restaurant called 'Le Café-Mite'. There was indeed a 'Café Mitte' (*sic*) in Louveciennes in the 1870s. It was recorded in a watercolour by the photographer Henri Bevan (repr. J. and M. Laÿ, 1989, p. 56, fig. 5), but it was located in the Impasse de Voisins.

MA.S.

PROV: bought from the artist by Durand-Ruel in 1877; Jean d'Alayer, Paris; Gaston Bernheim de Villiers; Wildenstein and Co., Paris and New York; bt Lazarus Phillips, Montreal, 1955; The Phillips Family Collection.

EXH: Paris, Durand-Ruel, 1899, no. 125; London, Grafton Galleries, 1905, no. 280; Paris, Durand-Ruel, 1933, no. 38; Paris, Durand-Ruel, 1937, no. 10; New York, Wildenstein, 1965, no. 15; Los Angeles-Chicago-Paris 1984–85, no. 22; Tokyo-Fukuoka-Nara, 1985, no. 18.

BIBL: *Le Bulletin de la Vie artistique*, 1920, repr. p. 266; Bernheim de Villiers, 1949, repr. p. 87; *De Renoir à Vuillard*, 1984, p. 97.

68 Rue de la Princesse, Louveciennes, looking north, photograph, 1992. The site of Sisley's house (destroyed by fire in 1978) is on the right and the chemin de l'Etarché opens to the left (see Cat. 31).

69 Alfred Sisley, *Road at Louveciennes*, D149, 1874 (Private Collection).

70 Rue de la Princesse, Louveciennes, looking south, photograph, 1992. The site of Sisley's house is on the left.

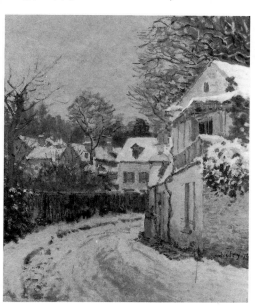

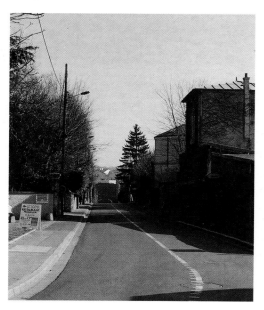

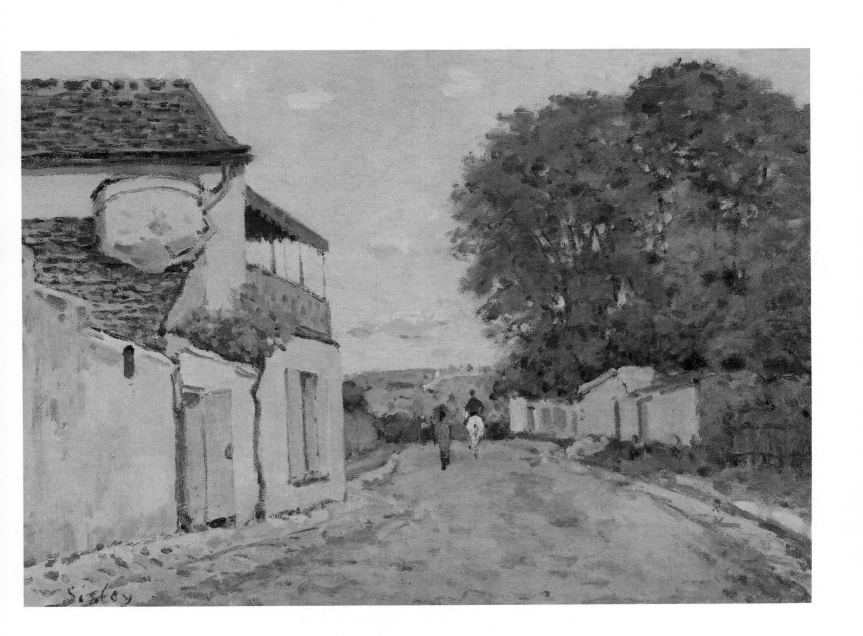

19 *Rue de la Machine, Louveciennes*

1873; D102 (known as *Louveciennes – le Chemin de Sèvres*)
54 × 73 cm
Signed and dated bl: Sisley 73
Musée d'Orsay, Paris

Previously identified as the 'Chemin de Sèvres', the scene of this spectacularly resolved picture is the rue de la Machine, which descends the hill from Voisins-Louveciennes to the Machine de Marly (see Cat. 20) and Bougival, on the River Seine (Fig. 73). On the right rise the walls of the château of Mme du Barry, a seventeenth-century property offered to her by Louis XV in 1769. On the left, behind the more plebian fencing lies an irregular group of small houses, built over the pipes bearing the water from the Machine to the aqueduct to house the water system's personnel. Behind these lies the Place de la Fonderie (now Place Dreux). In the distance can be seen the rooftops of Croissy and possibly Chatou (on the opposite bank of the River Seine from Bougival).

· The road itself is uncompromisingly straight, tidily curbed and planted with regularly spaced, uniformly pruned trees, whose bulbous foliage would provide shade for travellers during the summer months. Here, however, Sisley has recorded the road in winter, the low midday sun creating frozen fingers of shadow on the high walls of the château, and, when orchestrated with the shadows cast by the line of trees, a syncopated rhythm of light and shade on the left of the road and the pedestrian path beyond. The studied clarity of the sky reinforces the atmosphere of a crisp, cold day.

It has been suggested that the subject of this painting is the road itself (Los Angeles–Chicago–Paris, 1984–85, p. 172), with its perspectival plunge and rhythmic bands of shadow (see frontispiece). It has its precedents in the views in Louveciennes which Monet explored between 1869 and 1870 and Pissarro between 1869 and 1872. In their treatment of this motif, all three artists set themselves squarely and centrally upon the road, as if consciously following the examples of Hobbema's *The Avenue at Middelharnis* (1669, National Gallery, London; Fig. 71) and Corot's *Le Chemin de Sèvres* (c. 1855–65, Musée du Louvre, Paris; Fig. 72). Thus, they use the road to establish the spatial organisation of the landscape as a whole. Furthermore, these artists, as visitors from Paris, appear mesmerised by the idea of the road as the way in and out of a village, bearing them both to and from the city which remained the focus of their artistic existence.

However, Sisley may also have intended this specific subject to carry a more particular meaning. The rue de la Machine leads to the Machine de Marly, a subject which Sisley painted several times in the same year as *Rue de la Machine, Louveciennes* (Cat. 20). To the left of the road lie the pipes taking water to the Aqueduct, which he surveyed from a distance in 1873, and returned to with more dramatic results a year later (Cat. 23). A bridge crosses the pipes, providing the subject of another painting made by Sisley from slightly higher up the rue de la Machine in 1873 (*Snow at Louveciennes*, D104, Private Collection). By laying out his route from Voisins-Louveciennes, where he lived, to the Machine de Marly, Sisley was 'mapping' his own journey through this particular landscape.

Equally, the association of the place may also have been of significance to Sisley. Mme du Barry's château had originally belonged to the engineer who built the Machine de Marly, M. Arnold de Ville. The rue de la Machine led him to his pumps, constructed to take water from the Seine to the water gardens of Marly and Versailles at the behest of Louis XIV. Sisley's subject thus seems, not for the first time in his career, to make reference to specific features of the *ancien régime* (see Cat. 6). Yet at the same time he treats such historical 'paraphernalia' as a pure, 'realist' landscape, a genre which had notably failed to gain acceptance with the artistic establishment of both the Salon and the Exposition Universelle of 1867 (see Mainardi, pp. 176–79), in part through its perceived associations with revolutionary and anti-establishment ideas. In addition, Sisley was subjecting his 'subjectless' landscape to the new, 'sketchy' Impressionist techniques which represented a further assault upon the Establishment. Thus, by choosing to paint the subject of Mme du Barry's château and the road to the *Roi Soleil*'s pumps at Marly, was Sisley in some sense subverting the Establishment itself?

He returned to the subject under snow in 1874 (D145, Private Collection), giving more prominence to the château itself.

MA.S.

PROV: A. Dachery, Paris; Dachery Sale, Hôtel Drouot, Paris, 30 May 1899 (47); Joanny Peytel, Paris, by whom given 'in lieu' to the Musée du Louvre, 1914; entered the Musée du Louvre, 1918; transferred to the Musée d'Orsay, Paris in 1984.

EXH: Paris, Exposition de la Centennaire, 1900, no. 616; Copenhagen 1914, no. 126; Paris 1945, no. 00; Los Angeles–Chicago–Paris 1984–85, no. 59.

BIBL: Venturi 1939, II, repr. opp. p. 96; Besson, pl. 17; *Catalogue of the Musée de l'Impressionism*, 1947, no. 267; G. Jedlicka, 1949, pl. 12; Vaudoyer, 1955, pl. 33; Roger-Marx, 1956, repr. p. 7; Daulte, 1957, repr. p. 46; *Catalogue des Peintures, Pastels, Sculptures impressionnistes*, 1958, no. 401; Bazin, 1958, repr. p. 133; Rewald 1961, repr. p. 300; Reidemeister 1963, p. 86 repr.; Lassaigne and Gache-Patin, 1983, p. 74, repr. ill. 96; *De Renoir à Vuillard*, 1984, p. 79, repr.

71 Rue de la Machine, Louveciennes, photograph, 1992. The château of Madame du Barry is on the right.

72 Jean-Baptiste Camille Corot, *Chemin de Sèvres*, 1855–65 (Musée du Louvre, Paris).

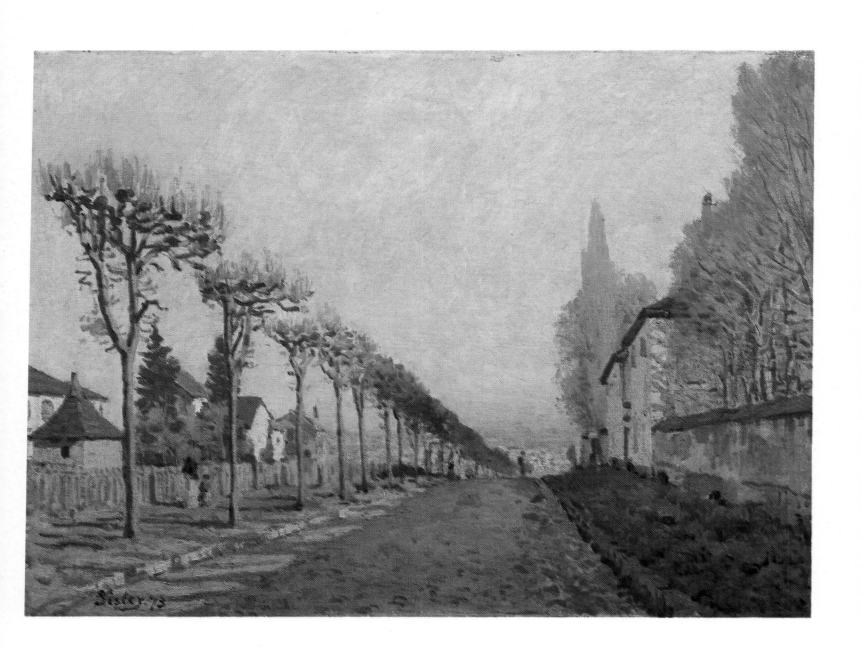

20 *The Machine de Marly*

La Machine de Marly
1873; D67
45 × 64.5 cm
Signed and dated bl: Sisley 73
Ny Carlsberg Glyptotek, Copenhagen

This painting is by far Sisley's most spectacular view of the pumping station at Marly. Commissioned by Louis XIV in 1681 and built by Arnold de Ville and Rennequin Sualem, the station was designed to lift water from the River Seine some 154 metres to supply the basins and fountains of the parks at Marly and Versailles. Originally made of iron and wood, and consisting of 14 waterwheels and 221 pumps, the cumbersome structure was replaced between 1855 and 1859 by Napoleon III with an edifice which consisted of a stone dyke which virtually spanned an arm of the Seine between Port-Marly and the Ile de la Loge (see Cat. 16), a brick shed housing 6 iron wheels and 12 forcing pumps and a steam-driven pumping house, topped by a tall chimney. This latter stood on the river bank beyond the houses shown on the left (Fig. 73). In selecting this particular viewpoint, Sisley has successfully eliminated its presence from his composition. The Machine was demolished in 1968 to effect a widening of the riverside road from Port-Marly to Bougival. All that survives is one small brick shed, isolated in the middle of the water on a small, stone pier, and the pumping station without its chimney.

By placing the brick shed across the middle of the composition, unequivocally parallel to the picture plane, Sisley establishes it as the subject of the painting. All other elements – the sweep of the river, the dyke, the river bank, the cluster of trees and the buildings grouped on the left – are all locked into the weighty mass of the brick shed through a complex network of diagonal lines. It is thus only secondarily that we perceive the figures strolling along the river bank on the left, possibly to avail themselves of one of the guided tours of the Machine.

Technically the painting is highly assured. Like other paintings of the early 1870s, notably *The Bridge of Villeneuve-la-Garenne* (Cat. 14) and *Rue de la Machine, Louveciennes* (Cat. 19), Sisley has applied his paint with flat, rather square brushstrokes,

tightening them slightly in the areas denoting reflections in the water, especially near the dyke, and broadening them when treating the boats in the foreground and the slightly articulated façade of the Machine itself. The crispness with which the bulk of each form has been defined bears comparison with Pissarro's contemporary procedures.

Sisley drew upon the subject of the Machine de Marly for at least six other paintings. In the same year he complemented *The Machine de Marly* with a view taken downstream from the other side of the Machine (D68, Private Collection), and used it as a closing device in the background of two views of the River Seine (D70, Private Collection and D73, Private Collection). Two years later, he returned to the subject at closer range (D174, Private Collection) and again twice in 1876, when he captured the effects upon the architecture of the Machine and its immediate river banks of a River Seine in flood (D215, Private Collection, and D216, Museum of Fine Arts, Boston). In addition, Sisley's need to map the relationship of the Machine, its function and the surrounding landscape, is found in his exploration of its complement, the Aqueduct. Initially seen in the distance in a painting of 1872 (D49, Private Collection, Fig. 60), it becomes the focal point of a composition made two years later (see Cat. 23) and is again explored indirectly in *At the Foot of the Aqueduct at Louveciennes* of 1876 (D213, Oskar Reinhardt Foundation, Winterthur, Fig. 34). The Machine's relationship to Voisins-Louveciennes was also mapped out in Sisley's two views of the rue de la Machine (Cat. 19 and D145, Private Collection).

This persistent investigation of a specific motif and its relationship to a larger landscape can be seen as part of Sisley's procedure for 'mapping' his visual and personal landscapes. Yet again, as with *Avenue of Chestnut Trees near La Celle-Saint-Cloud* (1867, Cat. 6) and *Rue de la Machine, Louveciennes* (1872, Cat. 19), we find Sisley, in his view of the Machine, making an unequivocal landscape painting devoid of any anecdotal or moral intention, out of a building which belonged quintessentially both to the *ancien régime* and to the recently defunct Imperial order. Was Sisley once again subverting the traditional order of things?

Daulte has suggested that *The Machine de Marly* was one of six paintings (five were

listed in the catalogue and one was *hors catalogue*) which were shown by Sisley at the 1st Impressionist Exhibition of 1874 (see Cat. 16). Given Sisley's propensity to use the same or similar titles for his landscapes, there can be no absolute certainty of identification between this painting and the one listed as no. 163, 'La Seine à Port-Marly'. No. 163 was listed with no note of ownership, unlike the *Ferry of the Ile de la Loge: Flood* (Cat. 16), so one line of identification is barred to us. On the other hand, the painting which bore this title in the exhibition was certainly impressive, since it drew considerable praise from critics, such as Chesnau: '*La Seine à Port-Marly* . . . is the ultimate fulfilment of the school's ambitions in the treatment of landscape. I cannot think of any painting, past or present, which conveys so completely, so perfectly, the physical sensation of atmosphere, of being out in the open air'. ('Avant le Salon', *Paris-Journal*, 2 April 1874).

M.A.S.

PROV: Bernheim-Jeune, Paris; Levesque, Paris; Statens Museum for Kunst, Copenhagen, 1914; on long-term loan to the Ny Carlsberg Glyptotek, Copenhagen.

EXH: (?) Paris, 1st Impressionist Exhibition, 1874, no. 163; Copenhagen 1914, no. 200; Copenhagen, 1945, no. 178.

BIBL: Rostrup, 1958, no. 942; Reidemeister, 1963, p. 88; Shone, 1973, p. 9; Lassaigne and Gache-Patin, 1983, pp. 12, 98, repr. ill. 137; Moffett, 1986, pp. 108–09; Munk, 1991, pp. 61–67, repr. p. 63, fig. 14.

73 The Machine de Marly, photograph, *c.* 1870 (Private Collection, Paris).

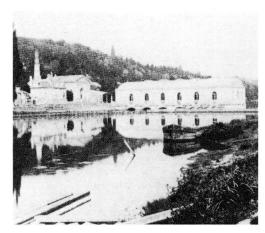

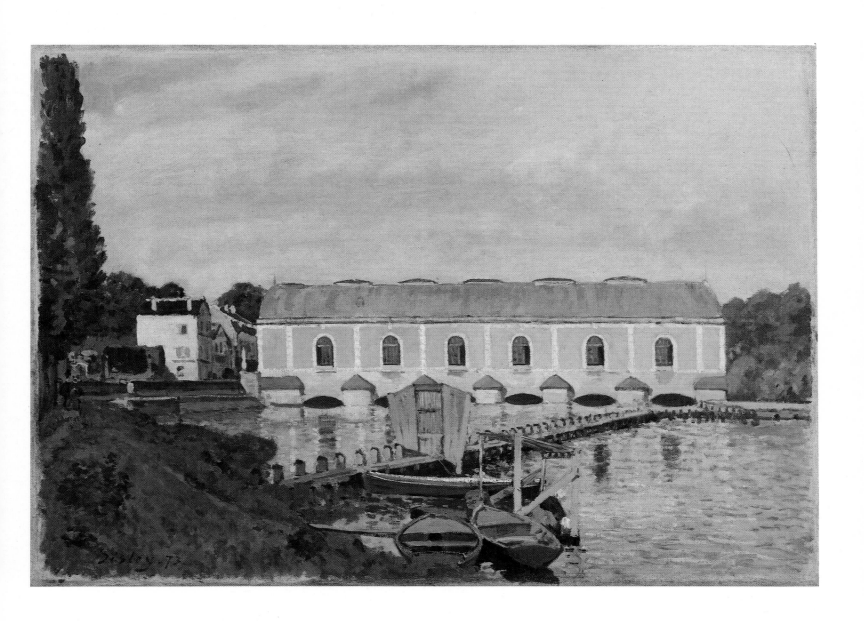

21 *The Fields*

Les Champs
1874; D138
46 × 61 cm
Signed and dated br: Sisley 74
Leeds City Art Galleries
Exhibited in London only

Less overtly dependent upon the drive into depth created by the wedge of planted crop which rises up the hillside in *Wheatfield: the Slopes of Argenteuil* (1873, D73, Kunsthalle, Hamburg; Fig. 59), the spatial recession in this painting has been conveyed through the gently rising curve of the crop which breaks the foreground. Splayed out at the front of the composition, it sweeps upwards, flanked by trees on the left and grass and vines on the right, illustrating Sisley's ability to select those viewpoints for his compositions where recession is given by elements occurring naturally in a landscape. Similar, apparently natural one-point perspectival constructions are to be found in his early *Avenue of Chestnut Trees near La Celle-Saint-Cloud* (1867, Cat. 6) and in *Rue de la Machine, Louveciennes* (1873, Cat. 19), as well as, in a slightly less articulated form, in *The Fields or The Furrows* (1873, Ny Carlsberg Glyptothek, Copenhagen; Fig. 11). Indeed, when *The Fields* is taken in conjunction with *The Fields or the Furrows* and *Wheatfield: the Slopes of Argenteuil*, it seems apposite to place them within a broader context of similarly dramatic handlings of worked, agricultural landscapes, notably Pissarro's *Hoar Frost, the old Road to Ennery, Pontoise* (1873, Musée d'Orsay, Paris), *Ploughed Fields near Osnay* (1873, Collection Durand-Ruel, Paris) and *Ploughed Fields* (1874, Pushkin Museum, Moscow), and the remarkable *Vineyards in the Snow* by Monet (1873, Virginia Museum of Fine Arts, Richmond VA, Fig. 74). The connection between Pissarro's *Ploughed Fields near Osny* and J.-F. Millet's *Winter and Crows* (1862, Kunsthistorisches Museum, Vienna) has already been spelt out (see *Camille Pissarro 1830–1903*, exh. cat., London-Paris-Boston, 1981, no. 31, p. 96). It could equally be made for Monet's painting of the same year and for Sisley's *The Fields* and *Wheatfields*, despite the obvious difference of season. Millet's innovative composition was exhibited at the Salon of 1867 (no. 1080), where it could have been studied by all three artists. Indeed, apart from the expanse of worked terrain in the younger artists' pictures, they also all adopt the pivotal point of the composition set far into the middle distance, created by a clump of trees or a dominant rise in the land formation.

In keeping with works of around the same date, for example *The Fields or the Furrows*, at the Ny Carlsberg Glyptothek, Copenhagen (Fig. 11) and *Wheatfields: the Slopes of Argenteuil*, at the Kunsthalle, Hamburg (Fig. 59), *The Fields* reveals the use of black chalk underdrawing, notably in the trees on the left, the crops in the foreground and the vine stakes on the horizon. The paint has been laid in over a light grey ground, placed on a fine-weave canvas commonly used by Sisley. Only during his four-month stay in England did he depart from this preference for fine canvases, when he adopted a more robust, coarser-weave canvas supplied by Winsor and Newton. The square, rather blocky brushstrokes which define the crops in the foreground are reminiscent of Monet's bold brushwork evolved during the autumn of 1869 at La Grenouillère. His need to establish a rapid means of pictorial notation which recorded both colour and form was echoed in Sisley's own search for such a procedure, although the latter artist always applied it with softer edges and less precise tonal differentiation (see also Cat. 17).

The Fields initially belonged to Picq-Véron, of Ermont-Eaubonne. Like M. Feder, he appears to have been a creditor of Paul Durand-Ruel who held a considerable number of paintings, including fourteen Sisleys (D25, D29, D34, D52, D117, D138, D151, D174, D217, D231, D232, D431, D467, D643: see also Durand-Ruel Godfroy, p. 53, note 105) which the dealer reinstated into his stock on 25 June 1892 after his business fortunes had at last begun to improve.

MA.S

PROV: Picq-Véron, Ermont-Eaubonne; bt Durand-Ruel, 25 June 1892; H. Véver, Paris; H. Véver Sale, Galerie Georges Petit, Paris, 1–2 February, 1897 (110); bt Durand-Ruel, for 650 fr.; Durand-Ruel, Paris; F. Matthiesen, London; Jean-Pierre Durand-Matthiesen, Geneva; Lord Marks of Boughton; Miriam, Lady Marks; Tooth and Co., London; Leeds City Art Galleries.

EXH: Paris, Durand-Ruel, 1930, no. 20; Paris, Durand-Ruel, 1937, no. 11; London, Royal Academy, 1974, no. 107; Tokyo-Fukuoka-Nara, 1985, no. 10; Edinburgh, 1986, no. 99.

BIBL: *Leeds City Art Gallery Concise Catalogue*, 1974, p. 132.

74 Claude Monet, *Vineyards in the Snow* (Museum of Fine Arts, Richmond, Virginia).

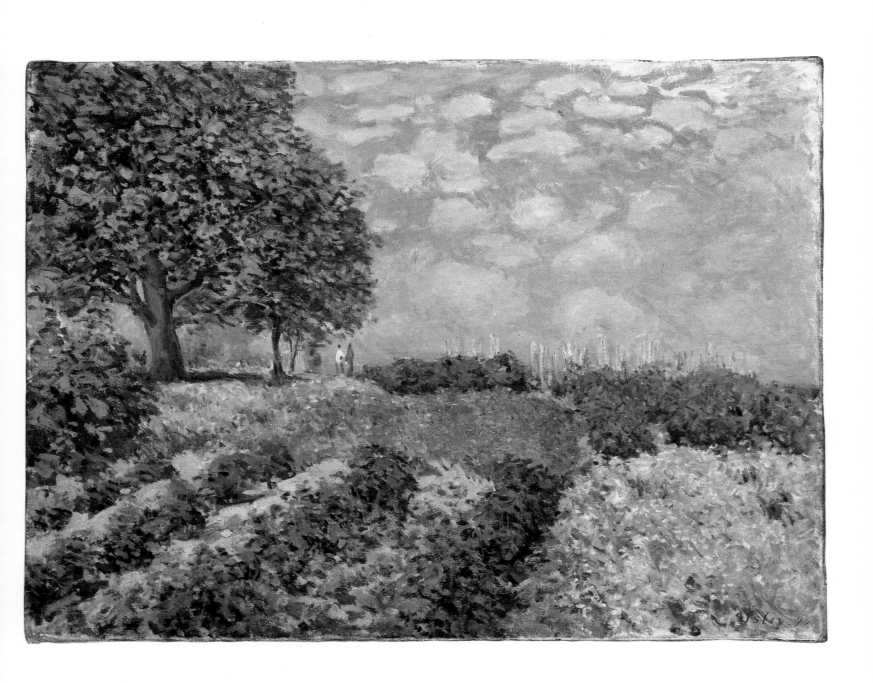

22 *Rue de la Princesse, Louveciennes, looking north*

1873; D204 (known as *Rue à Ville d'Avray*)
55.9 × 47 cm
Signed and dated br: Sisley 73
Private Collection, Dallas

The traditional title of this painting was *Street in Ville d'Avray*, a village that lies to the south-west of Paris between Saint-Cloud and Versailles; it was famous for its associations with Corot. The correct identification of the subject has been established by Richard Shone. The view is painted in the rue de la Princesse, looking north, from a position roughly opposite Sisley's house. For a modern photograph, taken in approximately the same place, see Fig. 68. The view south along the rue de la Princesse is depicted in Cat. 18. Daulte misread the date on the present painting as 1876. The actual date of 1873, given on the lower right of the canvas, is supported by its tonalities and technique, which are remarkably close to Cat. 18 and 19.

The composition is tightly constructed and is dependent upon the road that goes downhill and is then shown rising again in the background, leading to the château de Voisins (see Cat. 10). The focus is therefore on the middle ground. The application of light and shadow is an important element within the picture. The scene is set in an evening light with long cast shadows. The eye is eventually pulled across this extensive area of shadow to the patch of sunlight that strikes the wall on the right and also breaks through in areas in the upper half of the picture. The effects of twilight allow Sisley to demonstrate his skill in establishing the tonal values and also his dexterity in the use of colour.

The composition is somewhat reminiscent of *Rue de Voisins, Louveciennes: First Snow* (Cat. 10), particularly in the use of the road sloping downhill leading into the composition and the positioning of the figures. The bend in the road seen in juxtaposition with the hedge on the left and the wall on the right creates the effect of a tunnel into the recesses of the composition. However, Sisley here adopts a vertical format which compresses all the elements. He only rarely used the vertical format and, interestingly, most examples date from the 1870s: D144 of 1874, D180 of 1875, D221–22 of 1876 in Marly-le-Roi and D312 of 1879 in Sèvres where the contours of the town are even more

pronounced than Cat. 22. A further example is D806 (Cambridge, Fitzwilliam Museum), which in the catalogue raisonné is given a date of 1892 and identified as a street in Moret-sur-Loing. It is, in fact, the rue de Voisins in Louveciennes (see Cat. 10) and dates in all probability from 1876 (Tokyo-Fukuoka-Nara, 1985, No. 21).

Sisley has painted out two trees in the left foreground of *Street in Ville d'Avray* and so eliminated a dramatic, but traditional, repoussoir motif. Such a change was probably made so as not to impede the movement into depth which would perhaps have been disadvantageous in such a tightly constructed vertical composition.

C.L.

PROV: Adolphe Tavernier, Paris; Sale Galerie Georges Petit, Paris, 6 March 1900 (69) to Lazare Weiller for 6,600 fr; Lazare Weiller, Paris; Sale Hôtel Drouot, Paris, 29 November 1901 (45); Private collection, Paris.

EXH: Dallas, 1978, no. 15, repr.; Dallas, 1989, no. 101.

BIBL: Duret, 1906, p. 123, repr.; Lassaigne and Gache-Patin, 1983, p. 12, repr.

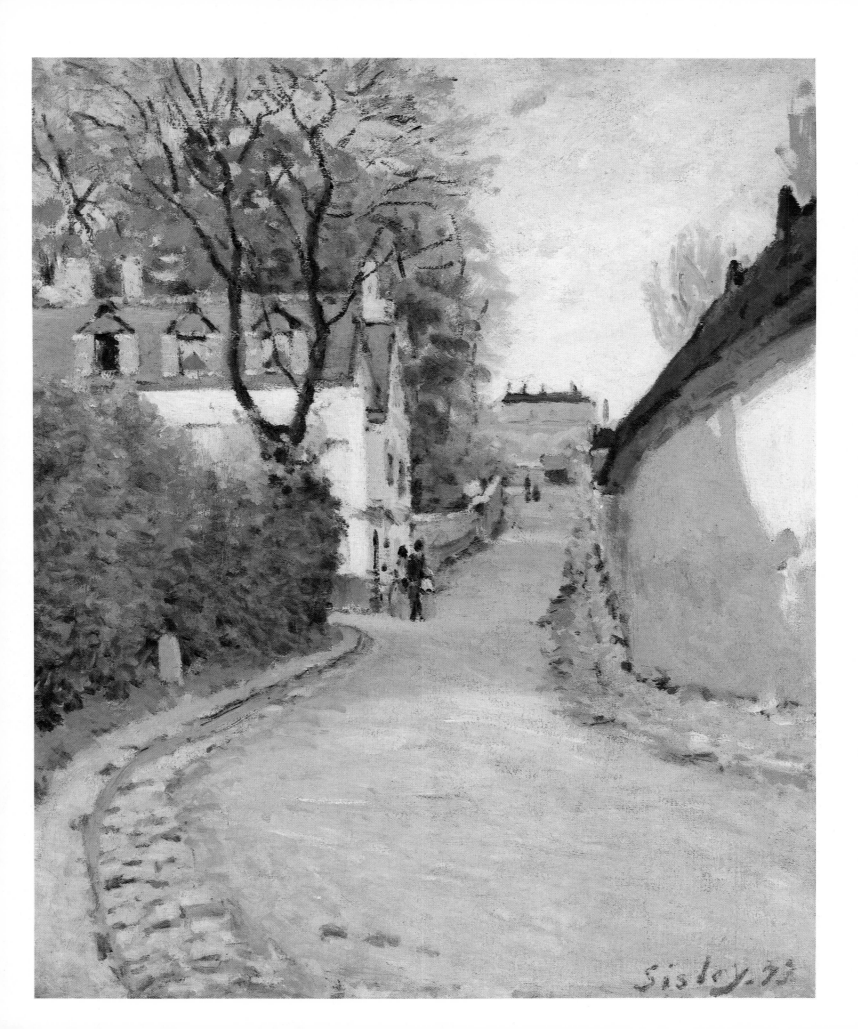

Sisley. 73

23 *The Marly Aqueduct*

L'Aqueduc de Marly
1874; D133
54 × 81 cm
Signed and dated br: Sisley 74
The Toledo Museum of Art, purchased with
funds from the Libbey Endowment, Gift of
Edward Drummond Libbey
Exhibited in Baltimore only

The aqueduct of Marly was built between
1681 and 1684, under the supervision of
Louvois. It was designed to carry water
pumped from the River Seine by the
Machine de Marly (see Cat. 20) up to a
height of 154 metres above the river and
then to carry it to reservoirs on the edge of
Louveciennes, from whence it was used to
supply the elaborate basins and waterworks
of the parks of Marly and Versailles. The
aqueduct consisted of 36 arches and was
643 metres in length.

Sisley had already depicted the aqueduct
two years earlier in *Near Louveciennes*
(1872, D49, Private Collection; Fig. 60).
Placing himself on a road (possibly the rue
de la Paix), Sisley shows the aqueduct
striding across the horizon beyond a line of
trees and above the roof of a small house.
Compositionally the painting is similar to
Camille Pissarro's *Springtime at Louveciennes*
(1868–69, National Gallery, London) and
to a photograph by Henri Bevan made in
1870 (*The Aqueduct at Louveciennes*, Private
Collection, Paris). Ultimately all three
views would appear to derive from Corot's
oil sketches of aqueducts in the Roman
Campagna, made during his first Italian
visit of 1825–28. Other treatments of the
Marly aqueduct adopted equally
picturesque representations; for example,
the view of the aqueduct rising high on the
horizon above Bougival in Monet's *Seine at*

Bougival: Evening (1869, Smith College
Museum, Northampton, MA).

For his second picture of the same motif,
Sisley adopts a far more radical viewpoint.
Standing at the foot of the edifice,
probably on the route de Versailles, he
shows it looming above us, its arches
marching away in a dramatic diagonal
until eventually hidden behind the trees on
the left. Although similar to the viewpoint
adopted by an engraving of the aqueduct
in Victorien Sardou's *Tour de France*, Sisley
has dramatically foreshortened the diagonal
plunge and isolated the terminal tower
(complete with staircase turret, since
demolished) from a building which lies
immediately beyond the right of the
canvas. While the monumentality of the
aqueduct is thus somewhat comparable to
the images of railway viaducts shown in
illustrated magazines of the 1850s and 1860s
(for example, 'Viaduc de Morlaix, sur le
chemin de fer de Paris à Brest', in Louis
Figuier, *Les Merveilles de la Science*, I, Paris
1867, p. 344, and 'Viaduc de Chaumont,
sur le Chemin de fer de Paris à Mulhouse',
Le Monde illustré, I, 9 May 1857; Fig. 76),
its handling is yet another example of
Sisley's apparent subversion of an *ancien
régime* subject through novel compositional
and technical means.

Given the residual, somewhat blocky
technique and the obvious summertime
season of the painting, it must have been
made shortly before Sisley's departure for
England in July 1874 (see Cat. 24). It was
certainly purchased by Durand-Ruel two
years later and, it has been suggested,
might have been exhibited at the 2nd
Impressionist exhibition of 1876 as no. 242.
This latter suggestion was made in *The
New Painting* (San Francisco-Washington
DC, 1986, p.165) on the grounds that no.
242 was owned by Durand-Ruel.
However, the title given in that catalogue
is 'Le Chemin des aqueducs', a reference to
the road which runs under the arches of the
aqueduct on the north-east side of
Louveciennes. *The New Painting* also
suggested an alternative identification for
no. 242, namely *At the Foot of the Aqueduct
at Louveciennes* (1876, D213, Oskar
Reinhardt Foundation, Winterthur, Fig.
34), a painting made looking along the line
of the Aqueduct to a building which stood
on the route du Coeur-Volant.

Although acquired by Durand-Ruel in
1876, the time of year shown in D213 –
high summer – suggests a date of execution
after the opening of the Impressionist

Exhibition in April that year. Perhaps,
more plausibly, neither this painting, nor
The Aqueduct of Marly was no. 242, but the
earlier *Near Louveciennes* (1872), which was
also owned by Durand-Ruel, could well
represent the 'Chemin des Aqueducs'.

Pissarro made a watercolour of the same
view, indicating yet another example of
the two artists' shared subject-matter in
Louveciennes. Apart from adopting similar
positions from which to paint the rue de
Voisins (see Cat. 10), and the bridge over
the water pipes at the corner of the rue de
la Machine (see Cat. 20, and Pissarro, *The
Village of Voisins*, 1872, Private Collection),
they also chose the same building, then a
woodyard and carpentry shop, which lay
at the end of the Aqueduct on the route de
Coeur-Volant, in *At the Foot of the Aqueduct
at Louveciennes* (D213) and *Landscape at
Louveciennes* or *Landscape at Pontoise* (c.
1872, Musée d'Orsay, Paris).

M.A.S.

PROV: bt from the artist by Durand-Ruel in
1876; Alexander Reid and Lefevre, London;
Edward Drummond Libbey; given by him to
the Toledo Museum of Art.

EXH: Paris 1899, no. 130; Paris 1925, no. 16;
Paris 1930, no. 19; London 1951, no. 33.

BIBL: Besson, pl. 20; Jedlicka, 1949, pl. 15;
Reidemeister 1963, p. 83 repr.; Lassaigne and
Gache-Patin, 1983, repr. ill. 142; *De Renoir à
Vuillard*, 1984, p. 87, repr.

75 The aqueduct at Louveciennes, seen
from the Avenue Saint-Martin,
Louveciennes, photograph, 1992.

76 *The Viaduc de Chaumont*, from *Le Monde
illustré*, 1857.

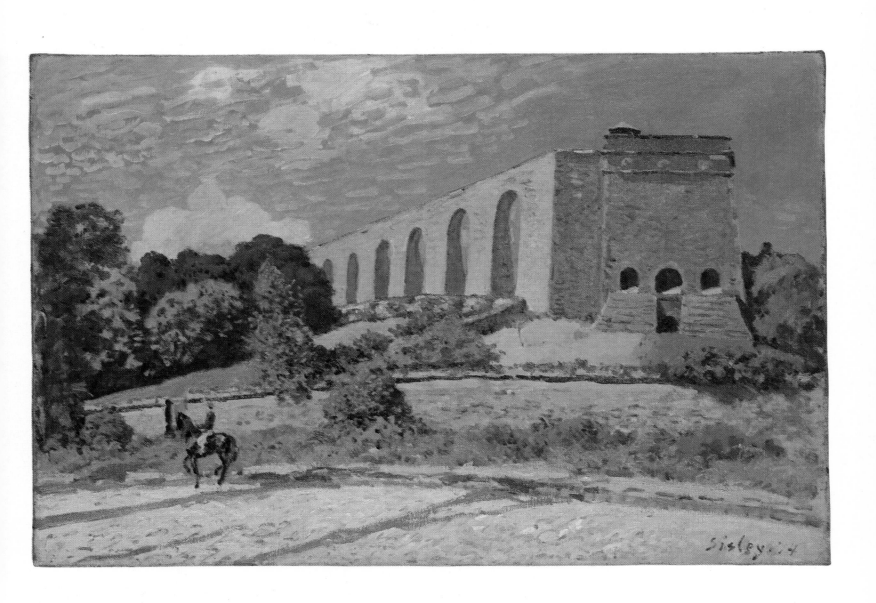

24 Hampton Court Bridge: the Castle Inn

Le Pont de Hampton Court – le Castle Inn
1874; non-D (known as *Une Auberge à Hampton Court*)
51 × 69 cm
Signed and dated bl: Sisley 74
Private Collection
Exhibited in London and Paris only

Sisley had lived in England from 1857 to 1859, while training to enter commerce (see Chronology). He returned to London in July 1874, in the company of Jean-Baptiste Faure, the renowned baritone at the Opéra-Comique and collector of Impressionist paintings, who financed Sisley's trip by agreeing to accept six of the canvases produced by the artist during their visit. After staying briefly at Brompton Crescent, South Kensington, Sisley moved up the River Thames to Hampton Court, the site of a royal palace, where he remained until early October. Rendered easily accessible to London by the railway line, Hampton Court had become a popular leisure resort for the residents of the fast-growing city: the palace and its grounds had been opened to the public shortly after the accession of Queen Victoria (see Fig. 21), and the river offered facilities for boating and swimming.

The bridge at Hampton Court, which carried the road from the palace to the village of East Molesey on the south side of the Thames, was built in 1865, its cast iron arches and crenellated brick entrance walls designed sympathetically to echo the Tudor architecture of the palace itself. Each end was flanked by an inn, the Mitre on the north (see Cat. 25) and the Castle (demolished in 1933) on the south (Fig. 77).

Although it is not known where Sisley stayed while working at Hampton Court, it has been suggested by Nicholas Reed (London 1991, p.14) that, given the fact that one painting was almost certainly made from a west-facing window of the Castle Inn (see Cat. 27) and two others from its river terrace (D123 [see Cat. 25] and D125 [Fig. 79]), he may have taken up residence in the Castle Inn itself. It is this building which provides the focal point for the painting shown here, standing as it does at the head of a road which leads along the southern river bank to Molesey and to the site of *The Road from Hampton Court to Molesey* (D120; Cat. 27).

Iconographically Sisley has presented a scene that epitomises the idea of leisure: elegantly clad figures stroll across the bridge and down the sweep of the road, boats lie tied up under the bridge on the left and the scene conveys a moment caught on a breezy summer afternoon. This immediacy is clearly expressed in the painting's technique. Bright tones have been loosely brushed in over a light grey ground placed over a tightly woven, robust Winsor and Newton canvas. Unlike other contemporaneous works, there is no evidence of any preliminary black chalk drawing line used to map in the main elements of the landscape. Rather, the trees on the right have been swiftly set in place. The architecture of the bridge alone appears to have demanded some preliminary outlining in a dark grey, fine brush line. Only the figures indicate that Sisley returned to the work at a slightly later stage since they have not been put in 'wet on wet', but after the underlying paint layers had dried.

The audaciousness of the composition is remarkable. Unlike Sisley's customary use of a road dotted with figures to lead the eye of the spectator into the distance in the landscape (e.g. Cat. 18, and *The Road from Mantes to Choisy-le-Roi*, 1872, D20, Private Collection), Sisley has pushed his figures to the very edge of the gravel road, establishing it as a broad, vacant zone directly in front of the spectator. Despite the temptation to set this view of a road in England beside those of Camille Pissarro made three years earlier (e.g. *Crystal Palace, London*, 1871, Art Institute of Chicago), the baldness of the centrally placed, empty gravel sweep clearly establishes Sisley's composition as essentially anti-picturesque. In this respect, it is aligned to other instances in Sisley's oeuvre, such as *Spring Morning* (1873, D101, Private Collection, USA), *The Seine at Port-Marly: Heaps of Sand* (1875, Cat. 33) and *Under Hampton Court Bridge* (1874, Cat. 26), where all conventional landscape procedures have been consciously subverted.

MA.S.

PROV: Armand Doria Collection, Paris.

EXH: London, Arts Council, 1971, no. 41; Bordeaux, 1974, no. 131.

BIBL: Daulte, 1971, repr. p. 34; Shone, 1973, fig. 22; Lassaigne and Gache-Patin, 1983, repr. ill. 128; Reed, 1991, p.14, repr. p. 13.

77 *Hampton Court Bridge*, postcard.

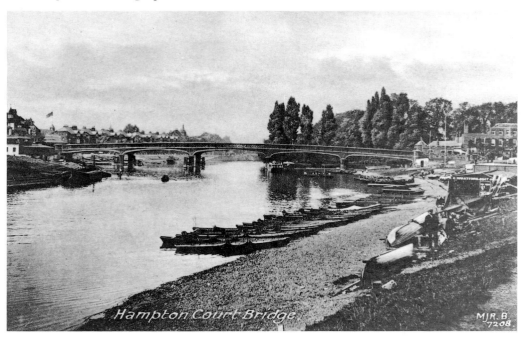

Hampton Court Bridge

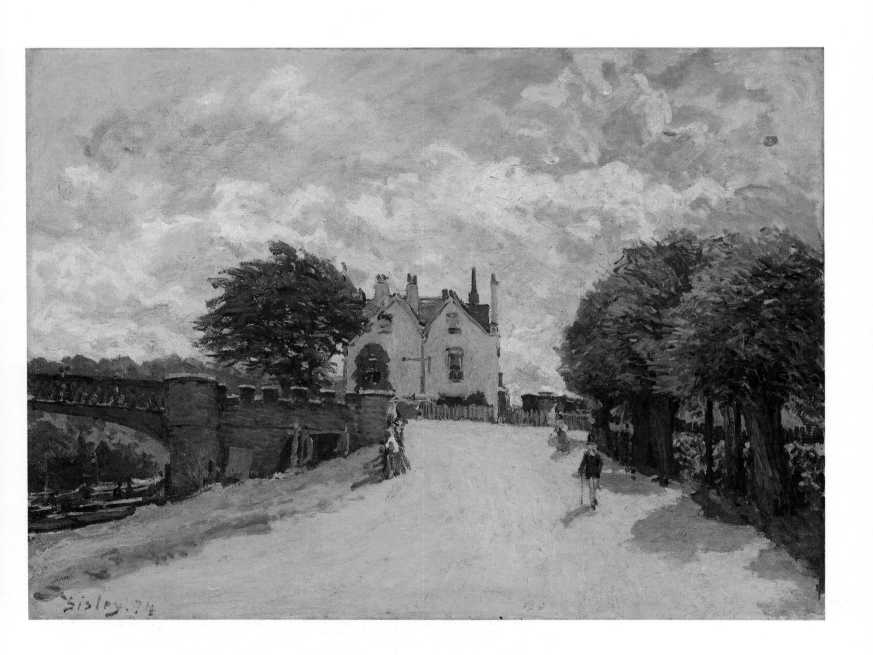

25 Hampton Court Bridge: the Mitre Inn

Le Pont de Hampton Court – le Mitre Inn
1874; D123
46 × 61 cm
Signed and dated bl: Sisley 74
Wallraf-Richartz Museum, Cologne
Exhibited in London and Paris only

This view of the 1865 cast iron and stone bridge spanning the Thames at Hampton Court was made from the river terrace of the Castle Inn, on the southern side of the bridge (see Cat. 24 and Fig. 22). The red brick building on the left beyond the bridge is the Mitre Inn, and the trees on the right screen the entrance to the palace of Hampton Court. This picture is one of two made from the river terrace of the Castle Inn; the other, *The Regatta at Hampton Court* (1874, D125; Fig. 79), extends the view downstream, encompassing the trees on the right of the Cologne painting and including some of the brick buildings of Cardinal Wolsey's original palace.

Sisley made at least 16 known paintings while staying at Hampton Court (D114–26, and three non-D works). Of these, three include the bridge, the one shown here, *Hampton Court Bridge: the Castle Inn* (non-D, see Cat. 24) and *Under Hampton Court Bridge* (D124, see Cat. 26). Unlike his fellow Impressionists, Monet and Pissarro, when they had come to London three-and-a-half years earlier to escape the Franco-Prussian War, Sisley, with one curious exception (*View of the Thames and Charing Cross Bridge*, 1874, D113, Private Collection, UK), chose not to tackle urban subjects. He retreated to an area not dissimilar to that along the River Seine with which he was already familiar. Thus, while the boating and promenading subjects of Argenteuil (see Cat. 11),

Bougival (see Cat. 17) and Villeneuve-la-Garenne (see Cat. 14, 15) anticipate the themes of his Hampton Court scenes (see also Cat. 27–29), so too, in certain cases, he seems to have sought similar focal points such as the bridge shown here. Indeed, there is much in this painting of the Bridge at Hampton Court which suggests a variation on his treatment two years earlier of *The Bridge of Villeneuve-la-Garenne* (1872, D37, see Cat. 14). The bridge slices through the upper left side of the composition, figures disport themselves on the river bank, sculling oarsmen pass under the arches on their way downstream, and genteel rowing boats are drawn up for hire on the bank immediately to the right of the bridge.

MA.S.

PROV: Théodore Duret, Paris; Duret Sale, Galerie Georges Petit, Paris, 19 March 1894 (40), sold for 1350 fr; Private Collection, Elberfeld; deposited with the Elberfeld Museum; Wallraf-Richartz Museum, Cologne.

BIBL: Altona-Behrenfeld, 1933, pp. 26–27; Uhde, Vienna, pl. 55; Reidemeister, 1956, pp. 1–3, repr. p. 2; Lassaigne and Gache-Patin, 1983, p. 90, repr. ill. 126; Reed, 1991, p. 18, repr. p. 17.

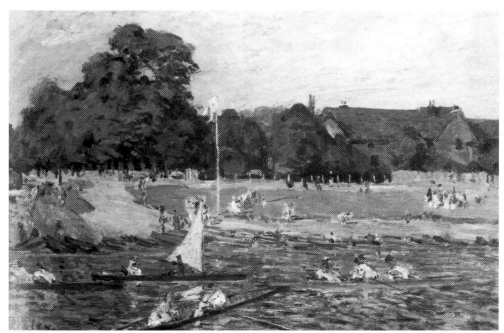

79 Alfred Sisley, *The Regatta at Hampton Court*, D125, 1874 (Private Collection).

78 *Hampton Court Bridge: the Mitre Inn*, postcard.

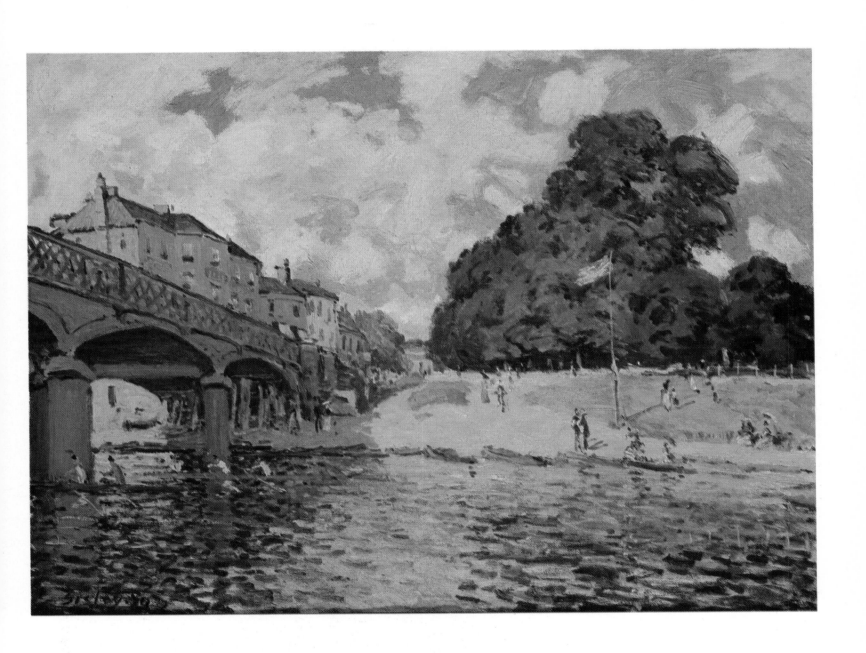

26 *Under Hampton Court Bridge*

Sous le Pont de Hampton Court
1874; D124
50 × 76 cm
Signed and dated bl: Sisley 74
Kunstmuseum Winterthur, presented by Dr
Herbert Wolfer

Compositionally this must be the most daring painting in Sisley's oeuvre, as well as in those of his fellow Impressionists, with the exception of Gustave Caillebotte (see below). It is painted from beneath the 1865 cast iron and brick bridge at Hampton Court, looking through the avenue of piers supporting the roadway above, with, in the background on the right, the river bank which can also be seen in the right side of *Hampton Court Bridge: the Mitre Inn* (Cat. 25).

The subject of this painting is the drama created by the structure of the bridge itself. Such a novel representation of a bridge can be paralleled by Gustave Caillebotte's ability to find dramatic recession and vertiginous plunges into space in the 'modern' architecture of 'Haussmannised' Paris. Yet Caillebotte's earliest essays of this type for example, *The Pont de l'Europe* (1876, Musée du Petit Palais, Geneva, Fig. 67), *Rue de Paris: Rain* (1877, Art Institute of Chicago), *House Painters* (1877, Private Collection, Paris; Fig. 80) and *Boulevard seen from above* (1880, Private Collection, Paris) post-date Sisley's *Under Hampton Court Bridge* by at least two years. Furthermore, these paintings were the product of extensive preliminary studies in which the spatial effects are meticulously worked out to create a premeditated, accomplished statement. What sets Sisley's painting apart from those of Caillebotte is not just its historical precedence but also its conception as an Impressionist painting, worked out in front of the motif itself. That Caillebotte may have known this innovatory composition is suggested by the fact that on Sisley's return to Paris, one of the group of paintings made during the Hampton Court visit, *The Regatta at Molesey* (D126, Cat. 29), was acquired by Caillebotte.

Painted on a Winsor and Newton canvas, part of a batch bought after his arrival in England, the paint is applied boldly, with broad horizontal and vertical brushstrokes used to articulate the arching structure of the bridge itself, and shorter, more jabbed brushstrokes for the water, trees and fragments of sky. The composition apparently demanded a minimal amount of preliminary mapping out, notably with black chalk lines in the trees on the left and in the planning lines which run between the tops of the columns supporting the most distant arch, as if to establish a horizontal base from which the spring of the subsequent arches could take their cue. Further traces of black paint outline can be found in some of the piers and in the boat moored between two of them in the foreground. However, the absence of *pentimenti*, especially in the piers and arches, indicates an incredible sureness in Sisley's original conception of the composition.

MA.S.

PROV: E. Decap, Paris; Decap Sale, Hôtel Drouot, Paris, 15 April, 1901 (28), sold for 3450 fr; Fritz Nathan, Zurich; Dr Herbert Wolfer, Winterthur; given by him to the Kunstmuseum, Winterthur, 1973.

EXH: Winterthur, 1955, no. 181.

BIBL: Reidemeister, 1956, p. 3, repr. p. 3; Lassaigne and Gache-Patin, 1983, p. 91, repr. ill. 129; Reed, 1991, repr. p. 18.

80 Gustave Caillebotte, *House Painters* (Private Collection, Paris).

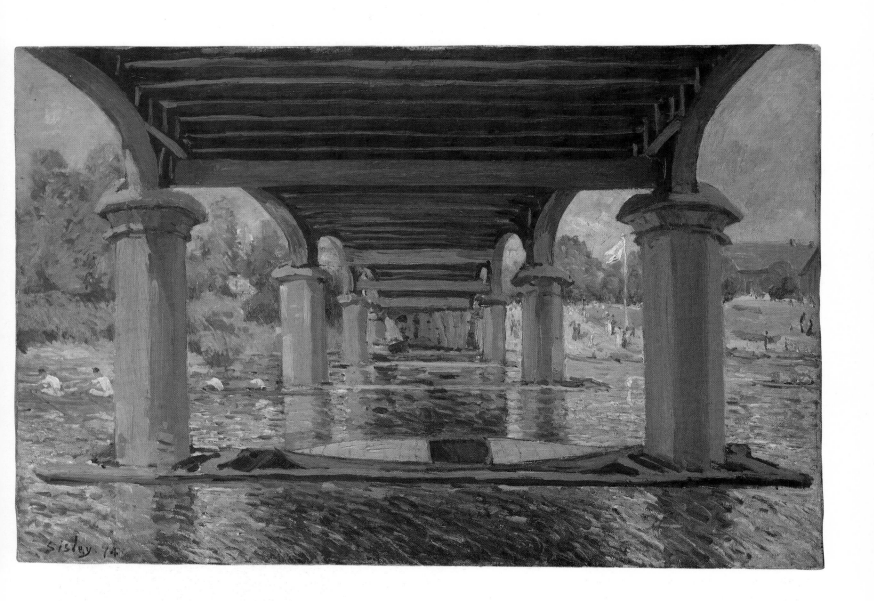

27 The Road from Hampton Court to Molesey

La Route de Hampton Court à Molesey
1874; D120
38.8 × 55.4 cm
Signed and dated bl: Sisley 74
Bayerische Staatsgemäldesammlungen, Neue
Pinakothek, Munich
Exhibited in London only

While Sisley's views of the bridge at
Hampton Court (Cat. 24–26) and *Molesey
Weir, Hampton Court: Morning* (D.118, see
Cat. 28) are constructed with a tight focus
on a single motif, there is another group of
paintings made at Hampton Court, to
which this painting belongs, which are
more panoramic, permitting the artist to
explore to the full the relationship between
the configuration of light in the sky, on the
water and the land (see also *The Thames
with Hampton Church*, 1874, D117, Earl of
Jersey, and two variants of *The Thames at
Hampton Court*, D115 at the Sterling and
Francine Clark Institute, Williamstown,
and D116, at the Virginia Museum of Art,
Richmond, VA).

It has been suggested that Sisley painted
this view from the west side of the Castle
Inn (see Cat. 24) which stood at the
southern end of Hampton Court Bridge,
on the East Molesey side. As with Sisley's
other visual explorations of places in which
he settled or visited; for example
Louveciennes (see Cat. 10, 18, 19),
Villeneuve-la-Garenne (see Cat. 13–15),
Port-Marly (see Cat. 33, 37–39), Marly-le-
Roi (see Cat. 32, 35, 36, 42) and ultimately
Moret-sur-Loing (see Cat. 59–71), his
visual mapping of Hampton Court is no
exception. The sweep of the road in the
Munich painting leads to Molesey Lock,
and lock-keeper's house on the left (both
constructed in 1815; Fig. 81). In another
painting, *A Lock at Hampton Court* (D119,
formerly the Mahmoud Khahil Collection,
Cairo; now Egyptian State Collections),
Sisley presents us with a closer view of the
lock itself. He then in two paintings leads
us up the canalised entrance to the lock,
with the barge walk on the left and a
glimpse of the weir at Molesey on the
right; one is in the collection of the Museo
de Bellas Artes, Buenos Aires (D122), the
other in a Private Collection (D121). From
here, Sisley focuses upon the weir itself, in
his powerful painting, now in the National
Gallery of Scotland (see Cat. 28), before

moving further upstream to produce a
more extensive view of the River Thames
with Garrick's villa and the church at
Hampton (D117, Earl of Jersey).

As in his expansive view of the Bridge at
Argenteuil, painted two years earlier, Sisley
inserts into this view of the River Thames
at Hampton Court those elements –
promenading couples, a double scull on the
river – which denote the primary function
of this part of the Thames. This procedure
was also followed by Monet at Argenteuil,
also in 1872, where he not only populated
the broad curve of the Seine and its river
bank with objects which emphasised the
town's role as a resort, but also explored
the view of the promenade along the river
in opposite directions (*Argenteuil Basin*,
1872, Musée d'Orsay, Paris, and *The
Promenade, Argenteuil*, 1872, National
Gallery of Art, Washington, DC; for
further discussion of Monet's treatment of
these two views, see R. Herbert, 1988, pp.
231–34). While Sisley may have had these
examples in his mind when he selected his
motifs at Hampton Court, he diverged
from them in two significant ways. First,
his approach to the 'mapping' of his chosen
landscape is far more thorough and
systematic than that of Monet, as if he
were engaged in constructing the material
for a sequential progression through that
landscape. Secondly, in both of Monet's
paintings, the artist has retained an
essentially picturesque compositional
structure, using receding lines of trees on
the right in *The Promenade* and on the left
in *The Basin* to encourage the eye to travel
along the river bank into the middle
distance where crucial secondary
information about each landscape is
located. For Sisley, such a picturesque
procedure is only tenuously retained,
notably in the device of the sweeping road.
As in *Hampton Court Bridge: the Castle Inn*
(Cat. 24), this road has been emptied of
any central staffage. It becomes a raw zone
of gravel which balks any attempt to enter
the space beyond. Similarly, Sisley has
stripped away all framing devices and thus
makes the landscape apparently continue
beyond the sides of the canvas, an
unfurling device which he had already used
in works of the 1860s (see Cat. 2, 8) and
was to explore further in such panoramic
views of the mid-1870s as *The Terrace at
Saint-Germain* (1875, Cat. 34) and *View of
Saint-Cloud* (1876, D211, Art Gallery
Ontario, Toronto).

MA.S.

PROV: Jules Strauss, Paris; Strauss Sale, Hôtel
Drouot, Paris, 2 May 1902 (67), sold for 8700
fr; M. Zygomala, Marseille; Zygomala Sale,
Galerie Georges Petit, Paris, 3 June 1903 (41); bt
Durand-Ruel for 7500 fr; Durand-Ruel, Paris;
Private Collection, Basle; Private Collection
Buenos Aires; Neue Pinakothek, Munich, 1961.

EXH: Paris, Petit, 1917, no. 4.

BIB: Pica 1905, repr. p. 145; Reed 1991, p. 23,
repr. p. 25.

81 *The Thames at Molesey*, hand-coloured
wood-engraving, *c.* 1870–80 (Private
Collection).

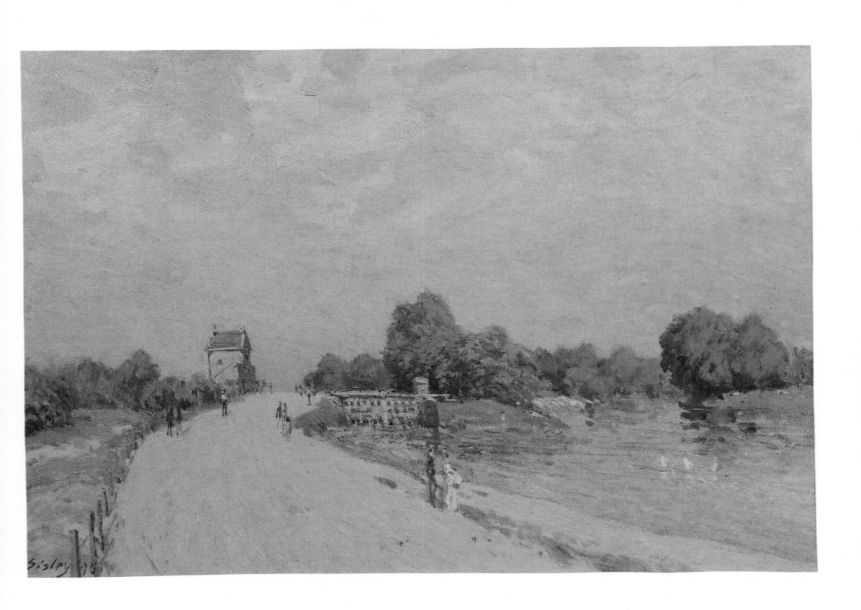

28 *Molesey Weir, Hampton Court: Morning*

L'Ecluse de Molesey près de Hampton Court – effet de matin
1874; D118
51.5 × 68.9 cm
Signed and dated bl: Sisley 74
National Gallery of Scotland, Edinburgh
Exhibited in London and Paris only

The weir, which lies upstream from Hampton Court Bridge, serves to break the flow of the River Thames to create a boating basin and to direct water into Molesey Lock (see Cat. 27). Together with the lock and the lock-keeper's house, the weir was originally built in 1815. It was reconstructed in 1859 and again in 1882, when a walkway was placed across the top of the individual piers (Fig. 82). This painting forms part of a progression of views from the lock (Cat. 27) to the village of Hampton (D117, Earl of Jersey), which records Sisley's visual mapping of this part of the River Thames (see Cat. 26).

Compositionally, this painting has all the taut, innovative drama of *The Machine de Marly* (1872, Cat. 20). As in that earlier work, Sisley has seized upon the dramatic diagonals and horizontals established by the weir, its warning posts and the backdrop of the distant bank. Boldly articulated in black and white, the piers progress back and across the composition, their thrust counterbalanced by the diagonal, downward sweep of the water as it courses across the river steps in the foreground. The composition is stabilised by the rigorous horizontal established by the outline of trees on Ash Island in the background. The bold, purposeful handling of paint gives the picture a technical affinity with *Under Hampton Court Bridge* (Cat. 26), but, as in *Hampton Court Bridge: the Castle Inn* (Cat. 24), the figures seem to have been painted in after the underlying layers of paint had fully dried. The presence of these seemingly unposed, relatively diminutive male bathers inserted as a natural element within the landscape serves to provide additional information about the use to which the pool above the weir was put, rather than to invite thoughts of covert references to mythological bathing subjects.

The immediacy of the main subject, the simplification of its description and the total command of the quality of fragile grey morning light cast from the thin cloud cover above, seem to summarise the critic Adolphe Tavernier's description of Sisley's reported account of his own painting procedures and concerns:

> For him, the interest in a canvas is multiple. The subject, the motif, must always be rendered in a simple way, easily understood and grasped by the spectator. By the elimination of superfluous detail, the spectator should be led along the road indicated by the painter, and from the first, should be made to recognise what the artist has felt. (*l'Art français*, 18 March 1893, np).

The precision of the title denoting a specific time of day – *effet de matin* – is unusual in Sisley's oeuvre for a work of this date. To be sure, since the winter of 1871–72, Sisley had been noting in some of his titles a specificity of season, for example, *Rue de Voisins, Louveciennes: first Snow* (1871–72, Cat. 10) or *The Village of Orée du Bois: Autumn* (D51, 1872, Rijksmuseum Twenthe, Enschede), and at least one of the Hampton Court group of paintings had a similar seasonal subtitle, *The Thames at Hampton Court: first days of October* (D122, Museo de Bellas Artes, Buenos Aires). Temporal specificity does not appear generally in the titles of Sisley's paintings until the later 1870s. It is possible, therefore, that the subtitle to *Molesey Weir, Hampton Court, morning* was appended at a later date, perhaps when it was included in the artist's major retrospective exhibition held at the Galerie Georges Petit in Paris in March 1897. Jean-Baptiste Faure lent the painting, together with others, to the exhibition, presumably as a result of Sisley wishing to assemble the most comprehensive representation of his oeuvre. This is supported by a letter dated 31 December 1891 to an unnamed recipient whom Sisley had never met in person, requesting that he lend five paintings to the exhibition: 'I [...] the contributions of my friends and collectors in order to try, as much as possible, to avoid a sense of monotony by showing paintings from all my periods' (Getty Archive, California).

MA.S.

PROV: J.-B. Faure, Paris; Mme Faure, Paris; Arthur Tooth and Sons, London; Mrs Elizabeth Kleinwort by 1942; Mrs Oliver Parker, London by 1949; Arthur Tooth and Sons, London; Mr and Mrs A. Maitland, 1957; given by Sir Alexander Maitland to the National Gallery of Scotland, Edinburgh in 1960.

EXH: Paris, Petit, Sisley, 1897, no. 141; Paris, Petit, 1917, no. 50; London, Royal Academy, 1932, no. 463; London, National Gallery, 1942, no. 53; Venice, 1947, no. 14; London, Royal Academy, 1949–50, no. 233; London, Hayward Gallery, 1973, no. 43; Edinburgh, 1986, no. 100.

BIBL: Pallucchini, 1948, p. 19, pl. 14; Reed, 1991, p. 30, repr. p. 33.

82 *Molesey Weir*, postcard.

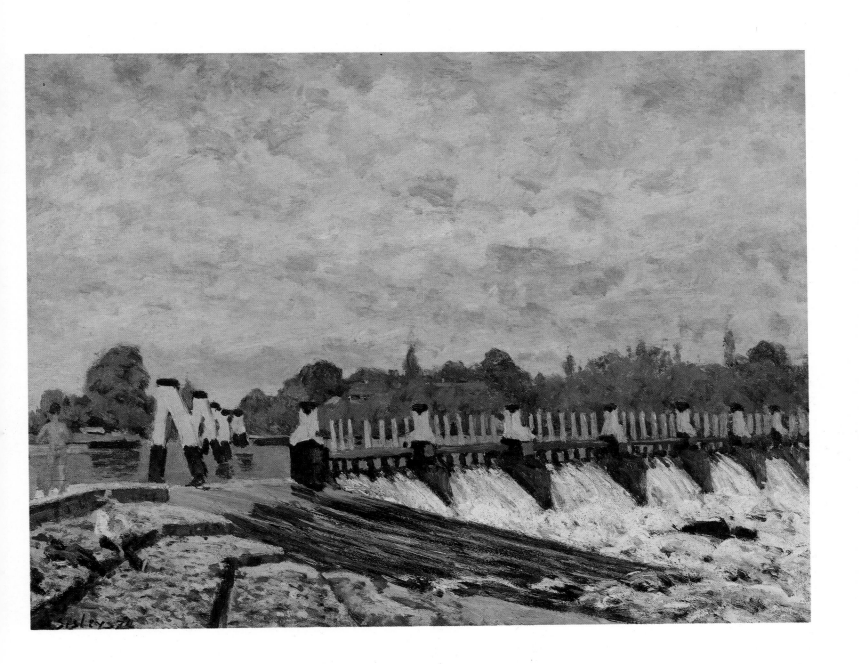

29 The Regatta at Molesey, near Hampton Court

Les Regattes à Molesey (près de Hampton Court)
1874; D126
62 × 92 cm
Musée d'Orsay, Paris
Exhibited in London and Paris only

Two regattas took place annually at Hampton Court, both of which were recorded by Sisley during his sojourn there in 1874. Hampton Court Regatta established by 1867 covered a course downstream from Hampton Court Bridge to Thames Ditton, and was the subject of Sisley's painting, *The Regatta at Hampton Court* (D125, Fig. 79). The regatta shown in the Musée d'Orsay picture was of more recent vintage. Founded for amateur oarsmen, it was only one year old when Sisley recorded it. It covered a course on the Thames above the weir at Molesey (see Cat. 28), ending at the Taggs Island Hotel, the building which figures on the right of the Musée d'Orsay painting. The regatta quickly grew in popularity and by the 1880s was ranked second only to that held at Henley.

The summer of 1874 seems to have been a bumper season for Impressionist scenes of boating in general, and regattas in particular. While Manet, Monet and Renoir recorded the yachting parties, boating basins and regattas on the Seine at Argenteuil, Sisley twice captured the sculling competitions on the Thames. In all these scenes, it is the sparkle of light on the water, the movement of the boats as they scud across the river and the elegance of the spectators, which appear to have captured the artists' attention. Sisley's *Regatta at Molesey* is no exception. Here, with rapid brush strokes and no preliminary underdrawing, we are invited to glimpse past the fluttering flags to the area of most interest, the competing craft, their outlines blurred by their rapid progress towards the winning line. A touch of the elegance of the event is suggested by the group of white clad, blue capped oarsmen, who drape themselves nonchalantly around the flag pole on the left of the composition.

In the boating scenes made both at Argenteuil and at Hampton Court during the summer of 1874, the artists remained spectators who viewed their subjects from the distance of the river bank. A position of greater proximity to his subject-matter could be achieved exceptionally by Monet, who set up his studio on a small boat, and floated it into the river itself. Yet none, not even Manet in *Boating* (1874, Metropolitan Museum of Art, New York), could convey in their paintings that sense of participation in the sport which Caillebotte was to achieve in his group of rowing compositions started three years later, for example, *Oarsman in a Top Hat* (c.1877, Private Collection, Paris), *Oarsmen*, 1877, Private Collection, Paris; Fig. 83) and *Canoes* (1878, Musée de Rennes).

MA.S.

PROV: Gustave Caillebotte, Paris; Caillebotte Bequest to the Musée du Luxembourg, 1894; transferred to the Musée du Louvre, Paris, in 1929; transferred to the Musée d'Orsay.

EXH: Barcelona, 1917, no. 1454; Geneva, 1918, no. 133; London, Hayward Gallery, 1973, no. 44.

BIBL: Geffroy, 1923, pl. 9; Geffroy, 1927, pl. 26; Heilmaier, 1931, repr. p. 136; *Catalogue des Peintures et Sculptures exposées au Musée de l'Impressionnisme*, 1947, no. 272; Cassou, 1953, pl. 25; *Catalogues des Peintures, Pastels et sculptures impressionnistes*, 1958, no. 406, Ribault-Menetière, 1958, p. 7; Bazin, 1958, repr. p. 301; Lassaigne and Gache-Patin, 1983, repr. ill. 136; Reed, 1991, p. 48, repr. back cover.

83 Gustave Caillebotte, *Oarsmen*, 1877 (Private Collection, Paris).

30 The Church at Noisy-le-Roi: Autumn

L'Eglise de Noisy-le-Roi – effet d'automne
1874; D134
46 × 61 cm
Signed and dated br: Sisley 74
Glasgow Museums; The Burrell Collection
Exhibited in London only

The village of Noisy-le-Roi lies between Versailles and Saint-Germain-en-Laye, south-west of Louveciennes and Marly-le-Roi, on the edge of the Forest of Marly. In so far as the painting obviously records an autumnal scene – as its title implies – and is firmly dated '74', the picture must have been made after Sisley's return to France following his four-month trip to England (see Cat. 24–29).

The composition is apparently constructed according to anti-picturesque principles. The subject is the church with its belfry, which has been placed in the middle distance with little obvious visual access to it from the foreground. Any progression through the landscape is barred by the two fences and the line of stumpy trees which run parallel to the picture plane and by the long bands of purple-grey paint which serve to describe the shadows cast by trees excluded from the composition to the right of the canvas. As in his earlier works, such as *Avenue of Chestnut Trees at La Celle-Saint-Cloud* (1865; Cat. 2) and *View of Montmartre from the Cité des Fleurs* (1869, Cat. 8), Sisley has allowed the landscape to fall away towards the edge of the composition, creating a pivotal point in the belfry itself. It was this particular procedure which he was also to pursue in his early views of Moret-sur-Loing.

Technically the painting is much less dependent upon the build-up of overlapping soft, squarish brushstrokes which was the hallmark of Sisley's paintings made between *c.*1870 and his departure for England in July 1874. However, as in these earlier works, there is still some underdrawing in both black chalk and thin blue or grey oil paint. Very few preliminary sketches survive in Sisley's oeuvre. Yet well into the 1870s, in this painting and *Route de Louveciennes* (D103, Musée Royaux des Beaux-Arts, Brussels, dated by Daulte *c.*1873, but which on stylistic grounds must be *c.*1875), there is evidence of such underdrawing, suggesting that Sisley's normal practice was to plot a composition rapidly in either chalk or oil directly onto the primed canvas itself before laying in the colour.

The Church at Noisy-le-Roi may have been included in the auction of Impressionist paintings held on 24 March 1875 (see Bodelsen, 1968, pp. 333–36). It subsequently passed into the collection of A. Dachery, who also owned *The Rue de la Machine, Louveciennes* (1872, Cat. 19). It was then included in the Vente Dachery held at the Hôtel Drouot in Paris on 30 May 1899, at which Durand-Ruel secured four works by Sisley from the 1870s, including *The Rue de la Machine, Louveciennes* (lot 47), an indication yet again of the dealer's determination to amass a sizeable stock of works from what he considered to be Sisley's finest period.

MA.S.

PROV: Morisot, Monet, Renoir and Sisley Sale, Hôtel Drouot, Paris, 24 March 1875; Durand-Ruel; A. Dachery, Paris; Dachery Sale, Hôtel Drouot, Paris, 30 May 1899 (48); bt Baron Henri de Rothschild, Paris for 8500 fr; Baron Henri de Rothschild, Paris; Sir William Burrell, Lanark; The Burrell Collection, Glasgow Museums.

EXH: Paris, Rosenberg, 1904, no. 42; London, Tate Gallery, 1929; Glasgow 1946; Arts Council of Great Britain 1947–48, no. 71; Arts Council of Great Britain 1950–51, no. 49. Glasgow 1951, no. 355; Arts Council of Great Britain 1953; London, Marlborough, 1955, no. 32; Arts Council of Great Britain, 1960, no. 48; London, Royal Academy, 1962, no. 232; Aberdeen, 1963, no. 39; Inverness, 1966, no. 39; Edinburgh, 1968, no. 27; Nottingham, 1971, no. 3; London, Royal Academy, 1974, no. 108; London, Hayward Gallery, 1975, no. 59; Arts Council of Great Britain, 1977–78, no. 51; Edinburgh, 1986, no. 103.

BIBL: Glasgow Art Gallery, 1953, p. 76; Chasse, 1957, repr. p. 51; *De Renoir à Vuillard*, 1984, p. 123, repr.

31 The Chemin de l'Etarché, Louveciennes, under Snow

Le Chemin de l'Etarché, Louveciennes, sous la neige
1874; D.146 (known as *Jardin à Louveciennes – effet de neige*)
55.9 × 45.7 cm
Signed and dated br: Sisley 74
The Phillips Collection, Washington, DC

During the summer of 1872 Sisley painted a view of a path winding its way between a garden, a wall and cottages at Louveciennes. Down the path, a woman walks away from the spectator, her umbrella open to protect her from the rain (*Garden at Louveciennes*, D95, Private Collection, Japan; Fig. 85). In 1874, Sisley returned to almost exactly the same spot to paint the scene under snow, the resultant composition once again marked by a dark-clad figure, this time walking towards the spectator, umbrella unfurled to shield her from the snow. Dated '74', the picture was probably painted during the winter 1874/75, a period during which Sisley made a number of views of Louveciennes under snow (D145, 148, 150). He was to return to the subject of a path under snow at Louveciennes in 1878 (D282, Cat. 46).

The path in this painting has been identified as the chemin de l'Etarché (Tokyo 1985, no. 12, p. 126). It describes three sides of a square from the rue de la Princesse, where Sisley lived from 1871 to 1874/75 (see Cat. 18; Figs. 87, 88). This painting and D95 were almost certainly painted from a window of Sisley's rented accommodation at 2 rue de la Princesse. There are two other views of the chemin de l'Etarché, both taken from the end of the lane; one was painted in 1874 (*Corner of the Village of Voisins*, D142, Musée d'Orsay, Paris, Fig. 86), the other, under snow, in 1877 (*Snow at Louveciennes*, D282, see Cat. 46).

There are two ways to understand Sisley's approach to this group of paintings. On the one hand, the four views of the chemin de l'Etarché are part of that visual mapping which is characteristic of his exploration of a given geographic site (see his approach to Villeneuve-la-Garenne, Cat. 13–15, and to Hampton Court, see Cat. 24–29). More specifically, it has been suggested that three of the paintings of the chemin de l'Etarché (i.e. D95, 146 and 282) 'almost form a series' (Tokyo 1985, p. 162), Rewald juxtaposing D95 and the one shown here (D146), and Shone grouping

the two snow scenes (D146 and 282). However, a 'series' implies a group of paintings in which a particular motif is recorded in different seasons or conditions of weather and light. In this group, two paintings record almost identical weather conditions (D146 and 282) while one takes a notably different view of the lane itself (D142). However, within this group, there are indeed two paintings of almost exactly the same view seen in opposite seasons, the summer one (D95; Fig. 86) and the Phillips Collection one shown here (D146). If we look elsewhere in Sisley's oeuvre of the early 1870s, we find similar 'pairings' of paintings where the same motif is shown in different weather or seasonal conditions: winter and summer scenes in *Snow at Louveciennes* (1874, D150, Courtauld Institute of Art, London) and *Route de Marly-le-Roi* (1875, D175, Private Collection); crisp, clear, winter light on a frosty scene and leaden overcast sky above a snow-clad scene in *Rue de la Machine, Louveciennes* (1873, D102, Cat. 19) and *Snow on the Route de Louveciennes (Rue de la Machine)* (1873, D145, passed via Christie's London, 15 November 1983 [10]); and the same subject seen under flood water and at

86 Alfred Sisley, *Corner of the Village of Voisins*, D142 (Musée d'Orsay, Paris).

84 (*facing page*) Detail of Cat. 31.

85 Alfred Sisley, *Garden at Louveciennes*, D95, 1872 (Private Collection, Japan).

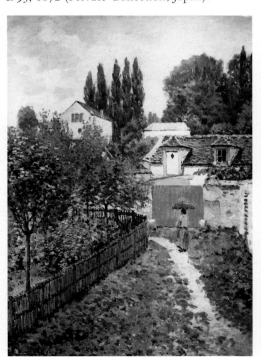

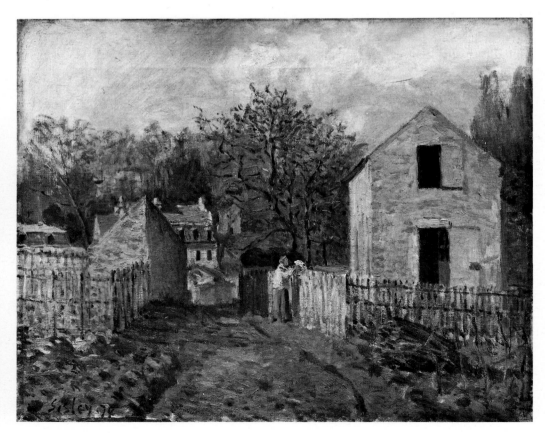

87 Chemin de l'Etarché, Louveciennes, looking west from the rue de la Princesse, photograph, 1992.

88 Chemin de l'Etarché, Louveciennes, looking north, photograph, 1992.

normal water level in *The Ferry of the Ile de la Loge: Flood* (1872, D21, Cat. 16) and *Banks of the Seine at Port-Marly* (1875, D240, Private Collection, Chicago, Fig. 95). Tempting though it might be to suppose that these 'pairs' were conceived as pendants, that is, complementary views on canvases of the same dimensions to be hung together, the measurements of the individual pictures deny this possibility. Those of *Snow at Louveciennes* (D150) and *The Route de Marly-le-Roi* (D175) are 47 × 56 cm and 60 × 74 cm respectively, those of the two views of the Rue de la Machine (D102 and D145) are 59 × 73 cm and 38 × 74 cm, those of the Ile de la Loge (D21 and D240) are 45 × 60 cm and 55 × 65.5 cm, and those of the summer and winter views of the chemin de l'Etarché (D95 and D146) are 65 × 46 cm and 55 × 46 cm. We are forced to conclude that, while the artist's interest in recording familiar scenes under different weather or light effects was certainly established by the early 1870s, this was not regarded as part of a systematic programme which would present a sequence of views conceived from the beginning as a coherent visual whole.

MA.S.

PROV: Paul Rosenberg and Co. Paris and New York; Duncan Phillips, Washington, DC, in 1923; The Phillips Collection, Washington, DC.

EXH: Paris, Rosenberg, 1904, no. 37; Cambridge MA. 1929, no. 85; New York, Wildenstein, 1966, no. 18; San Francisco-Dallas-Minneapolis-Atlanta, 1981–2, p. 48; Tokyo-Fukuoka-Nara, 1985, no. 12.

BIBL: Fry, 1922, repr. p. 276; Newlin Prige, 1924, repr. p. 18; *The Phillips Collection. A Museum of Modern Art and its Sources*, 1952, p. 93; Venturi, 1953, p. 115, repr. fig. 84; Rewald, 1973, p. 289, repr. p.289; Shone, 1973, pl. 27; Lassaigne and Gache-Patin, 1983, p. 82, repr. ill. 119; *De Renoir à Vuillard*, 1984, p. 102.

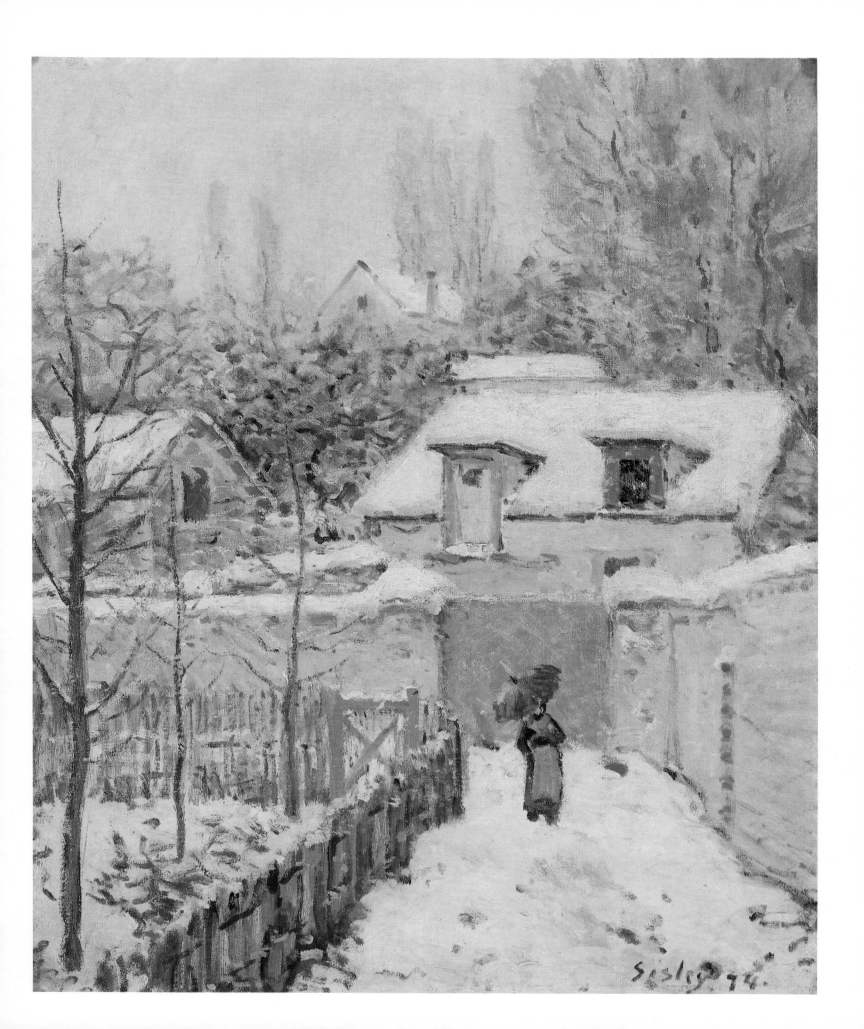

Christopher Lloyd

MARLY-LE-ROI AND SEVRES: 1875–1880

During the years when Sisley lived in Marly-le-Roi and Sèvres, he painted some of the finest pictures in his oeuvre. Indeed, the scenes of the flood at Port-Marly dating from 1876 (see Cat. 37–39) are amongst the best-known images in the canon of Impressionist art. The flooding of the banks of the River Seine provided Sisley with a subject which, in its fluctuations of motion and time, epitomised Impressionism. The artist expressed the immediacy of the scenes in his treatment of light and colour, but the compositions and the technique remained carefully constructed and tightly controlled. To this extent the paintings of the flood at Port-Marly can be closely related to those works undertaken at Louveciennes (see Cat. 19), Villeneuve-la-Garenne (see Cat. 13) and Hampton Court (see Cat. 24–29) earlier in the decade. There is, however, one important distinction and this lies in the fact that Sisley painted the flood six times in 1876. There are, of course, differences of significance between each of these paintings, but they can, none the less, be described as a 'series' in so far as Sisley is concentrating on a single motif seen from different angles and under changing conditions. The paintings were never exhibited as a series, but it is likely that the artist worked on them at the same time even if he did not regard them as forming a whole. This Monet was to do later with the series of Rouen Cathedral beginning in 1892, an example which Sisley was himself to follow (see Cat. 71).

The flooding was not the only occasion when Sisley repeatedly explored specific motifs during this period. The watering place at Marly-le-Roi (see Cat. 32, 36, 42) was also painted from a number of different viewpoints as was the Seine at Bougival (see Cat. 40, 41). Like the earlier depictions of the Machine de Marly (see Cat. 20), these paintings all have an independent visual coherence and lack any premeditated sequential element.

The paintings of the areas around Marly-le-Roi and Sèvres (Fig. 90) continue themes that Sisley had begun to explore during the early 1870s. Vestiges of aristocratic society and associations with the *ancien régime* based at Versailles abound in the views of Marly-le-Roi (see Cat. 32), Saint-Germain-en-Laye (see Cat. 34), and Saint-Cloud (see Cat. 44). The Duc de Saint-Simon in his *Memoirs* remarked: 'Who could help being repelled and disgusted at the violence done to Nature?' (*Saint-Simon at Versailles*, ed. and trans. L. Norton, London, 1980, p. 232). Sisley's preference for these places, however, does not necessarily imply a total rejection of modernity. On the contrary, he seems to be accepting modernity as part of an evolving historical process. He does not paint the more traditional views back over Paris that could be seen from Saint-Germain or Saint-Cloud, but incorporates the bridges and *quais* that were the basis of one of the principal aspects of France's economy. The barges at the quai de Grenelle near the centre of Paris or further along the Seine at Billancourt (see Cat. 45) anticipate one of the artist's

89 (*facing page*) Detail of Cat. 35, *The Fourteenth of July at Marly-le-Roi.*

90 Alfred Sisley, *The Porcelain Works at Sèvres*, D307, 1879 (Private Collection).

chief preoccupations at Saint-Mammès during the 1880s (see Cat. 49–52, 56–58). These paintings recall Sisley's early interest in the Canal Saint-Martin (see Cat. 9), but they also signal his further withdrawal from Paris and in so doing open up the possibility of undertaking fresh subject-matter as the result of a renewed exploration of the landscape.

The second half of the 1870s was a period of reassessment for the Impressionists. The tensions within this group of independent artists often came to the surface as each Impressionist exhibition was organised, and arose because of evolving styles, changing emphases and contrasting personalities. Having exhibited in 1874, Sisley participated again in 1876, and 1877, but his lack of financial success also made him reconsider his position as regards the Salon. Even there he failed to win acceptance in 1879 and thereafter his art was practised more or less in isolation with the support of a few collectors and dealers together with the encouragement of fellow artists like Pissarro and Monet.

These years, therefore, saw a considerable change in Sisley's style. The compositions after 1876 tended to become more complex with less emphasis on recession and balance. Instead, the overlaying of the various parts of a composition and the creation of an interlocking pattern began to absorb his attention (see Cat. 40, 41) before being rethought again during the next two decades. At the same time, a greater variety enters Sisley's technique. The short soft-edged square brushstrokes of earlier years that resulted in an even surface on the canvas were replaced by heavily-worked, more intricate textures comprising a large range of brushstrokes. The priming on the canvas continued to play a significant role (see Cat. 42), but towards the end of the decade Sisley was more concerned with building up the layers of paint on the surface. Concomitant with these richly textured surfaces was a greater sophistication in the application of colour. The tonal qualities of the paintings of the early 1870s accorded well with Sisley's compositional principles of those years, but now the greater intensity and wider range of colour, as in the work of Monet and Renoir, matched the more agitated character of the brushwork.

It is fair to describe the years 1875–79 as transitional. This should not be interpreted in any derogatory sense, as Sisley was adjusting his style and reflecting on the subject-matter of his painting in a highly creative way. The results of this adjustment were to be given full expression during the 1880s and 1890s. In a very real sense Sisley was at a turning point during the years at Marly and Sèvres.

32 The Watering Place at Marly-le-Roi: Snow

L'Abreuvoir de Marly-le-Roi – neige
1875; D154 (known as *Jour d'hiver à Marly*)
50 × 65 cm
Signed and dated br: Sisley 75
Private Collection

The painting shows the pond at Marly-le-Roi (Fig. 93) and was in all probability painted shortly after Sisley came to live in the village at 2, avenue de l'Abreuvoir during the winter of 1874–75. Together with *The Watering Place at Marly-le-Roi* (D152, National Gallery, London; Fig. 92), the picture was almost certainly among the first group of works in which the artist explored this particular motif. The pond is bounded by a wall, and surrounded by a row of bollards, but here it is sunken and the surface frozen. Beyond this is the more extensive buttressed wall of the park at Marly. The painting in the National Gallery looks along the côte du Coeur-Volant leading south-east uphill to Louveciennes. By contrast, visible in the present painting is the avenue des Combattants, which runs south-west along the other side of the park. The roads meet beside the watering place and form the place de l'Abreuvoir (Fig. 94). The avenue des Combattants is depicted in another painting of the same date (D153, *Marly-le-Roi: Snow*; Fig. 91), but this omits the watering place.

The pond was constructed during the late seventeenth century as part of an extensive system supplying water for the cascades, fountains and terraced pools for which the château at Marly-le-Roi was famous. By the mid-nineteenth century,

the reservoir had lost its prestigious royal connotations to become a place for horses to drink and somewhere to wash clothes.

Sisley painted at least six pictures of Marly-le-Roi during this initial winter campaign. The similarities between Cat. 32 and the picture in the National Gallery which was exhibited in the 2nd Impressionist exhibition of 1876 (San Francisco-Washington, DC, 1986, p. 165, where identified as no. 240) extend beyond subject-matter to technique and composition. *The Watering Place at Marly-le-Roi* has recently been cleaned and examined on a technical basis. It is thinly painted, with ample use being made of the beige-coloured ground, especially in the sky. A limited range of mauve-tinted blues have been brushed on to this ground 'to suggest the leaden atmosphere of a winter afternoon, briefly illuminated by a sudden fire of orange sunlight.' (Bomford *et al.* 1991, p. 150). *The Watering Place at Marly-le-Roi: Snow* is more finished than the painting in the National Gallery and less emphasis is placed on the coloured ground, particularly in the sky. As a result there is an overall blue tonality to the picture and the distant rose-red tint of the setting sun seems more dramatic. Greater attention to detail is also paid in the depiction of the architectural elements. As a composition, Cat. 32 is altogether more resolved.

Compositionally, both paintings make successful use of the balance between the horizontal and the vertical. The bollards in the foreground of Cat. 32 are symptomatic of this duality, stretching rhythmically across the lower half of the composition, but at the same time they serve in the Renaissance tradition of one-point

perspective as a set of vertical markers, like orthogonals. The eye leaps across the foreground and the frozen pond. It is then led up the avenue des Combattants along the principal vertical axis, which is also emphasised in the upper half of the composition by a single tree towering over the others in the park. The tacit use of geometry embraces both the architectural features and the natural forms to the extent that 'the picture planes enter into a living dialogue' (Munk, 1991, p. 70) that was possibly inspired in Sisley and Pissarro alike by the work of Hobbema (for example *The Avenue at Middelharnis* of 1669, Fig. 63).

C.L.

PROV: Catholina Lambert, New York; Sale Hotel Plaza, New York, 21–24 Feb 1916 (149) bt Durand-Ruel for $1200; Durand-Ruel, New York, by whom sold to Mrs Huttleston Rogers, 7 February 1944; Mrs Huttleston Rogers, Claremont, VA.

EXH: New York, Durand-Ruel, 1917, no. 7; New York, Durand-Ruel, 1934, no. 49; Baltimore, 1936, no. 21; New York, Durand-Ruel, 1938 no. 5; New York, Wildenstein, 1966, no. 17; New York, Acquavella Galleries, 1968; Tokyo-Fukuoka-Nara, 1985, no. 17.

BIBL: Reidemeister, 1963, p. 99, repr.; Shone 1979, pl 29; *De Renoir à Vuillard*, 1984, p. 114; Bomford *et al.* 1991, no. 7; Munk, 1991, pp. 68–70.

93 The Watering Place at Marly-le-Roi, looking up the côte du Coeur-Volant, photograph, 1992.

94 The Watering Place at Marly-le-Roi, looking up the avenue des Combattants.

91 Alfred Sisley, *Snow at Marly-le-Roi*, D153 (Musée d'Orsay, Paris).

92 Alfred Sisley, *The Watering Place at Marly-le-Roi*, D152 (National Gallery, London).

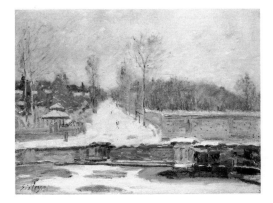

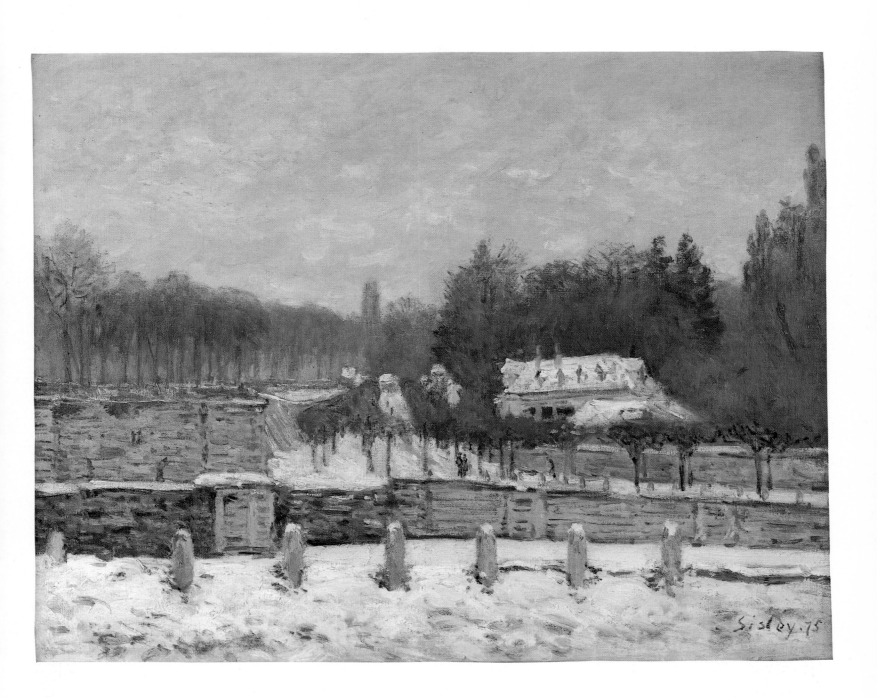

33 The Seine at Port-Marly: Heaps of Sand

La Seine à Port-Marly – tas de sable
1875; D176
54.5 × 73.7 cm
Signed and dated bl: Sisley 75
The Art Institute of Chicago,
Mr and Mrs Martin A. Ryerson Collection

Port-Marly lies on the left bank of the River Seine between Saint-Germain-en-Laye and Bougival. This is a stretch of the river that was much favoured by Monet, Pissarro, Renoir and Sisley, but each with a different emphasis. Sisley is here concerned with the economics of river life. The men in the boats are dredging the river in order to provide the barges and river boats with a clear channel extending all the way from Le Havre to Paris via Rouen. During the middle decades of the nineteenth century barges were still the principal form of internal transport for freight. Sand was dredged up from the river bed with buckets and piled up in heaps on the banks, as in the lower left corner of Cat. 33, before being sold to building contractors and gardeners. The poles on the right were for mooring the boats along the bank or for steadying them while at work in the middle of the river as in *The Seine at Port-Marly* also of 1875 (Private Collection, Chicago, non-D, Fig. 95). These craft seem to be of a standard design and appear to have been used for several different purposes in the area of Bougival and Port-Marly. The activities shown in Cat. 33 are depicted in two other pictures by Sisley of 1875 (D177, 178, both entitled *The Sand Quay*). These have been painted from slightly further away, with the result that D177 reveals more of the quayside in the lower left corner.

The location was one that was well known to Impressionist painters during the late 1860s and early 1870s, but it was one that was most favoured by Pissarro and Sisley, who emphasised both the factory and the wash-house. Chronologically, Pissarro was the first to explore the motif in his two pictures of 1872 (*The Seine at Port-Marly*, Earl of Jersey and *The Wash House*, Musée d'Orsay, Paris). Sisley's earliest renderings (D172, D173) date from the following year and there are altogether five similar views dating from 1875, including Cat. 33 (D159–60 and 177–78).

The artist returned there in 1876 (D217, Sotheby's, London, 7 April 1976 (5)), 1877 (Tokyo-Fukuoka-Nara, 1985, no. 26) and in 1879 (D315, mistitled in the catalogue raisonné *The Wash House at Billancourt*, and D325–26). In all these compositions Sisley moved up and down the bank altering his viewpoint, but always concentrating on the general features of the scene, as opposed to one particular aspect. The motifs presented by this stretch of the river are also recorded in the photographs of Henri Bevan dating from *c.* 1870 (*A Day in the Country*, 1984–85, figs 22–23). As observed by M. and Mme Jacques Laÿ (verbal communication) and contrary to the argument first advanced by Richard Brettell (*Pissarro*, 1980–81, pp. 19–20 and *A Day in the Country*, 1984–85, no. 17), the site recorded in all these paintings by Sisley and Pissarro is at Port-Marly and not at La Grenouillère, which was so memorably painted by Monet (National Gallery London, and Metropolitan Museum, New York) and Renoir (Oskar Reinhart Foundation, Winterthur and Nationalmuseum, Stockholm) in August and September of 1869.

The present painting is notable for its bright tonality with the vivid blues of the sky and water contrasted with the yellow of the sand and the ochre of the winter foliage. The careful adherence to the tonal qualities within the picture recalls paintings of the early 1870s (Cat. 16, 18), but the simplified structure of the factory and the sketchier style used for the trees on the right, where the paint is thinly and drily applied, anticipates the looser style of the later 1870s (compare Cat. 44). The piles of sand in the lower left corner serve as a dramatic repoussoir motif.

C.L.

PROV: Dr Georges Viau, Paris; Sale Galerie Durand-Ruel, Paris, 4 March 1907 (74); bt in by Durand-Ruel; Durand-Ruel, Paris and New York; Georges Bernheim-Jeune, Paris, 1920; Mr and Mrs Martin A. Ryerson, Chicago, by whom given to The Art Institute of Chicago, 1933.

EXH: Paris, Petit, 1897 no. 19; Paris, *Exposition centennale*, 1900, no. 614; Paris, Petit, 1917, no. 64; Chicago, *A Century of Progress*, 1933 no. 302; New York, Wildenstein, 1966, no. 19; Albi, 1980; Los Angeles-Chicago-Paris 1984–85, no. 23.

BIBL: Maxon, 1970, pp. 83, 286; Shone, 1979, p. 8, repr.; Brettell, 1987, p. 39, repr.

95 Alfred Sisley, *The Seine at Port-Marly* (Private Collection, Chicago).

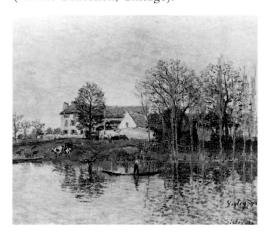

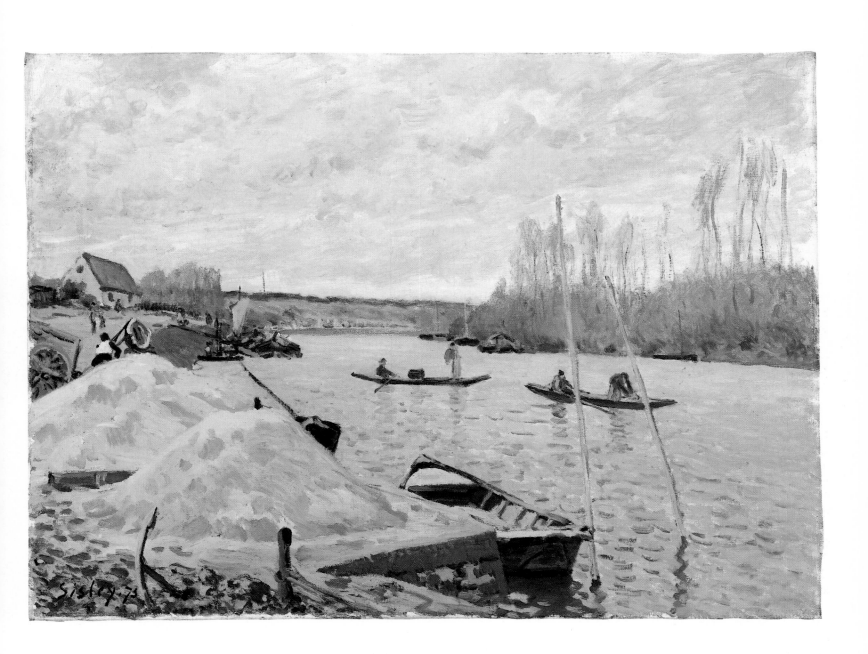

34 The Terrace at Saint-Germain: Spring

La Terrasse de Saint-Germain – printemps
1875; D164
73.6 × 99.6 cm
Signed and dated bl: Sisley 75
The Walters Art Gallery, Baltimore

Of all the landscapes depicted by Sisley, that at Saint-Germain-en-Laye has the greatest historical resonance since the town was a royal residence from 1542 until 1701. Baedeker's *Guide* announces that the town is quiet and 'noted for its beautiful situation and healthy air, which as far back as the twelfth century onwards caused it to be a favourite summer residence of the kings of France. It is much frequented in summer by Parisians, and there are a number of English residents'. (1904 ed., p. 366). Such trumpetings are echoed in every guide book and are not unduly exaggerated.

The original château had close associations with Francis I, Henry IV and Louis XIII but it was also the birthplace of Louis XIV who later commissioned J.H. Mansart to rebuild the château and Le Nôtre to create a garden and to landscape the park and adjoining forests. Louis XIV's court was based at Saint-Germain-en-Laye until he began to refashion Versailles in 1682, a decision that the Duc de Saint-Simon, for one, bitterly regretted (*Saint-Simon at Versailles*, ed. and trans. L. Norton, London, 1980, p. 231). Afterwards, the château was occupied by the exiled Stuart court. James II died at Saint-Germain-en-Laye in 1701 and was buried in the chapel there.

Sisley has here painted a panoramic view of the town of Saint-Germain-en-Laye with the château visible in the upper-left of the composition and the famous terraces stretching into the distance. The town spreads down the slope to the river where there is a bridge across to Le Vésinet (detail Fig. 48). The lower part of the town was called Le Pecq. The foreground is dominated by an orchard and a vineyard. This view of the valley is as seen from close to Port-Marly.

The terraces at Saint-Germain-en-Laye extended beyond the formal gardens of the château and provided a commanding view over the River Seine. The terrace was divided into two parts, the Petite Terrasse separated from the Grande Terrasse by the Rond-Point du Rosarium. The Grande

Terrasse was one of the acknowledged masterpieces by Le Nôtre and was completed in 1673 after four years of work. It stretched for 2400 metres along the edge of the Forest of Saint-Germain at a height of 75 metres above the river. As Baedeker pronounced, the terraces provide 'a magnificent survey of the valley, the winding river, and the well-populated plain. The middle distance resembles a huge park sprinkled with country houses' (1904 ed., p. 369). Visitors to Saint-Germain-en-Laye walked along the terraces to look back towards Paris where Montmartre was visible on the horizon. Sisley obviously concentrates on the town of Saint-Germain-en-Laye in this painting, and it is perhaps significant that he prefers to look downstream and thus eschews the popular view towards Paris. The artist painted a variant of this composition in 1876 (D214).

Panoramic views of the Seine Valley form part of an established iconography adhered to by a wide range of artists including Cotman, Turner, Bonington, Rousseau, Huet, Corot, Pissarro and Monet, all of whom depicted Rouen in this way (Lloyd, 1986, pp. 75–93). It is to the topographical tradition, enshrined in such publications as *Turner's Annual Tour – the Seine* (1834) or J. Janin, *La Normandie* (1844) that Cat. 34, as well as D163, 165, 166, of the Seine Valley and dating from 1875, should be related. However, as in Cat. 27, Sisley subverts the tradition by suggesting a continuation of space beyond the confines of the canvas and rendering the landscape as an aggregate of details captured at random, as opposed to being specifically ordered or prearranged. In so far as it is an 'open' and not a 'closed', or bounded, landscape *The Terrace at Saint-Germain: Spring* can be described as moving away from the picturesque tradition.

A painting entitled *The Terrace at Marly* was included as no. 226 in the 3rd Impressionist exhibition of 1877, but there is no corroborative evidence to suggest that the picture can be identified with Cat. 34.

C.L.

PROV: bt by Durand-Ruel from the artist in 1880; Jean-Baptiste Faure, Paris; Charles Guasco, Paris; Sale Galerie Georges Petit, Paris, 11 June 1900 (67) bt Durand-Ruel for 12,000 fr; Durand-Ruel Paris and New York; E.J. Blair, Baltimore, 1900; Henry Walters, by whom bequeathed to The Walters Art Gallery, Baltimore, 1931.

EXH: Paris, Petit, 1889, no. 62, New York, Rosenberg, 1961 no. 7; New York, Wildenstein, 1967 no. 50.

BIBL: Packard, 1952, p. 3, repr.; Johnston, 1982, p. 143, no. 156, repr.; Lassaigne and Gache-Patin, 1983, p. 11, repr.

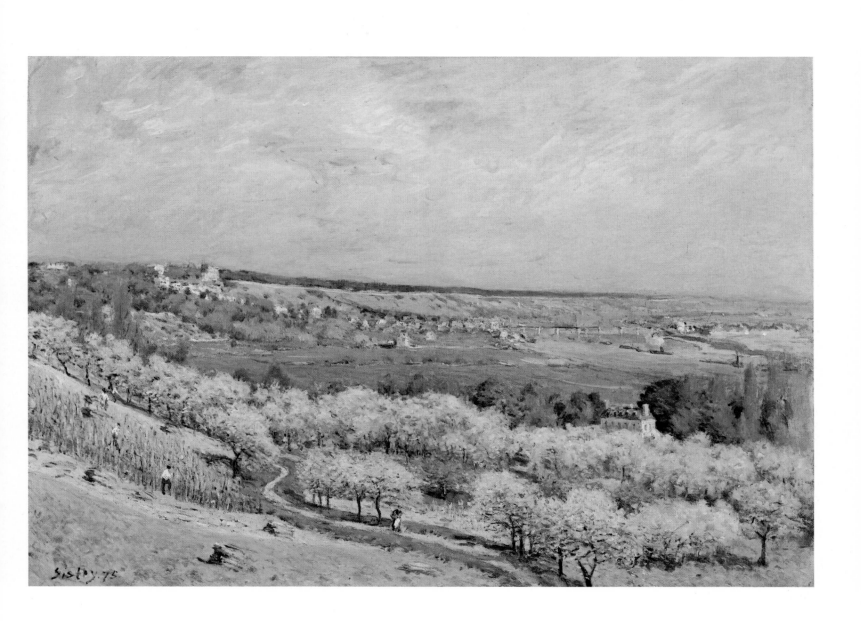

35 The Fourteenth of July at Marly-le-Roi

Le Quatorze Juillet à Marly-le-Roi
1875; D170
53.5 × 72.5 cm
Signed and dated br: Sisley 75
By kind permission of the North Bedfordshire
Borough Council (who own the painting) and
the Cecil Higgins Art Gallery, Bedford (where
it is on display)
Exhibited in London only

The painting is unusual among the group
of works executed while Sisley lived in
Marly-le-Roi on account of its subject-
matter. The location is the place de
l'Abreuvoir (Fig. 96) from which the two
roads skirting the Parc de Marly – the
avenue des Combattants (Cat. 32) and the
côte du Coeur Volant (Cat. 42; Fig. 93) –
emanate. The vantage point is almost
certainly the avenue de l'Abreuvoir which
leads into the place de l'Abreuvoir. It was
here that the artist lived and the view from
above implies that Sisley may have
witnessed the scene from a room in his
own lodgings, as in a painting dating from
a year later (D195, incorrectly titled *Snow
at Louveciennes*), which looks in the same
direction but includes the garden in the
foreground. The pond is on the left of the
composition and the grounds of the
château de Marly fill the background.

The rain enhances the fugitive effects of
light and colour. Unusually for Sisley, the
sky is leaden and evenly painted. For once
it is the most subdued part of the
composition. Elsewhere the jaunty angles
of the umbrellas, the billowing flags and
the shadows that resemble pools of water
enliven what is otherwise a carefully
structured painting (detail Fig. 89). A flag-
pole marks the centre of the composition
while the perspectival treatment of the
avenue of trees establishes the mid-point.

There is possibly some influence of
Japanese prints evident in this painting,
perhaps as transmitted through a
printmaker such as Félix Buhot. The title
of the painting needs to be treated with
some degree of scepticism, as the
celebration of the Fourteenth of July
marking the fall of the Bastille in 1789 was
only officially declared a national holiday
after the election of Jules Grévy as
President of the Republic in 1879 and first
honoured in 1880. The date on Cat. 35 (if
correctly interpreted) must therefore rule

out any direct association with Bastille
Day. None the less, celebrations were held
in Paris before that date on such occasions
as Mardi Gras, the Foire aux Pains d'Epice
and the series of Universal Exhibitions
organised first by Napoleon III in the
middle of the century and thereafter during
the Third Republic (Reff, 1982, pp. 233–
66). Manet (Mellon Collection, Upperville
and Bührle Foundation, Zurich) and
Monet (Musée des Beaux-Arts, Rouen and
Musée d'Orsay, Paris) both painted the *Fête
de la Paix* on 30 June 1878 that occurred
during the Universal Exhibition of 1878
following a spontaneous celebration (*Fête
de la Fédération*) on the day of the opening
(1 May). The Universal Exhibition of 1878
was the first to be held after seven years of
political instability in the wake of the
Commune and so led to widespread
popular rejoicing. The situation outside
Paris was slightly different in so far as there
was a greater emphasis on local festivities.
These had traditionally been associated
with religious festivals, but by the second
half of the nineteenth century they had
gradually assumed a more civil and
ceremonial character connected, for
instance, with markets and regattas.
Pissarro at Pontoise and Monet at
Argenteuil painted such occasions in the
early 1870s. It was not unusual for the
French national flag to be flown at local
fêtes as well as at the newly ordained
public holidays. Cat. 35 therefore need not
necessarily represent a national festival, but
a local fête, albeit one somewhat spoiled by
rain. Typical of Sisley's approach to his
subject-matter, however, is the
juxtaposition of the *Tricolore* with its
republican connotations against a
background that includes the grounds of
the Château at Marly-le-Roi.

C.L.

PROV: M. Guillou, Marly-le-Roi; Chicandart,
Paris; Hector Brame, Paris; Tooth, London; bt
Lady Baillie in March 1958; Lady Baillie,
London; North Bedfordshire Borough Council.

EXH: London, Wildenstein, 1963, no. 28;
London, Tooth, 1972.

BIBL: Reidemeister 1963, p. 97, repr.; Daulte
1972 (ed. 1988), p. 37, repr; Grubert 1983; *De
Renoir à Vuillard*, 1984, p. 14, repr; Serri 1989,
p. 34; Munk, 1991, p. 73, repr.

96 Place de l'Abreuvoir, Marly-le-Roi,
photograph, 1992.

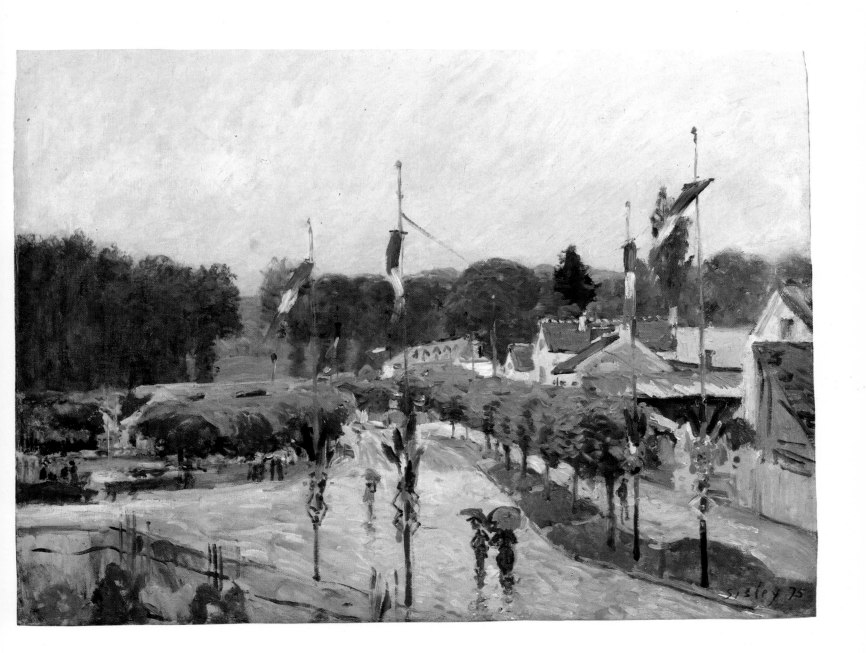

36 The Watering Place at Marly-le-Roi

Baignade de Chevaux à Port-Marly
1875; D172
38 × 61 cm
Signed and dated bl: Sisley 75
Private Collection, Switzerland
Exhibited in London and Paris only

This view of the watering place at Marly-le-Roi was painted from near the avenue des Combattants (Fig. 97) and therefore looks in the opposite direction from Cat. 32. The artist was facing north-east and the wooded area dominant in the upper right half of the composition is part of the Forest of Marly. The wide ramp, by which horses gained access to the water, is a prominent feature of this particular view of the pond. The group of houses, also visible on the far side, probably includes the one (2, avenue de l'Abreuvoir) in which Sisley took lodgings early in 1875 (see Cat. 32).

A painting in the collection of M. Jacques Guerlain, Paris (D171, *The Watering Place at Marly in Summer*), is comparable in composition and is also dated 1875. For this, however, Sisley has moved further away from the pond, so that the water is seen in the middle distance and an avenue of trees has been included on the left, thereby making a more balanced composition. D171 shows the full extent of the bollards encircling the south side of the pond. On the other hand, the exact view shown in the present painting is seen in D173, but with a figure leaning over an iron fence in the foreground. Sisley eliminates the fence in Cat. 36 and has devised a composition seen from above as though hovering over the water, which enables him to imbue the foreground with a sense of drama, as in Cat. 35. This emphasis on water in the lower half of the composition is reminiscent of the paintings of the flood at Port-Marly (Cat. 37). The present composition is anticipated in D69 of 1873 and is repeated in D243 (incorrectly entitled *Melting Ice on the Seine at Port-Marly*), which is dated 1876 and is one of three winter scenes of the pond undertaken during that year (see Cat. 42).

The success of the present composition depends upon the division of the surface into horizontal bands, offset, first by the diagonal thrust of the Forest of Marly leading downwards to the mid-point and, second, by the curvaceous ripples extending outwards across the water. The boldness of the architectural forms in the middle distance on the right and their relationship to the hill behind recalls procedures adopted by Pissarro (for example, *The Côte du Jallais, Pontoise*, Metropolitan Museum of Art, New York) during the late 1860s which were explored further by Cézanne (for example, the mistitled *Côte du Galet, Pontoise*, Private Collection, Philadelphia, formerly Caroll S. Tyson Collection) during the mid-1870s. Although Sisley has depicted the pond in summer, the tones are muted as a result of the clouds obscuring direct sunlight. The clouds moving across the sky are reflected in the water so that the solidity of the buildings is counterbalanced by the less substantial rhythms in the upper and lower halves of the painting. There is evidence of some underdrawing in blue paint and black chalk in the centre of the composition.

C.L.

PROV: bt from the artist by Durand Ruel on 22 June 1881; sold to Paul Bérard on 8 April 1882; Paul Bérard Sale, Paris, Galerie Georges Petit, 8–9 May 1905 (35)); bt Paul Rosenberg for 12,500 fr;, Paul Rosenberg and Co., New York and Paris, by whom sold to Emil G. Bührle in 1954.

EXH: Paris, Rosenberg, 1904, no.3; Winterthur Kunstmuseum, 1955, no. 183; Zurich, Kunsthaus, 1958, no. 197; Berlin, Schloss Charlottenburg, 1958, no. 22; Munich, Haus der Kunst, 1959, no. 150; Edinburgh, 1961, no. 28; Lucerne, 1963.

BIBL: *Sammlung Emil G. Bührle*, 1958, no. 197, repr.; Reidemeister, 1963, p. 96, repr.; *De Renoir à Vuillard*, 1984, p. 108, repr.; Munk, 1991, pp. 71–73, repr.

97 The Watering Place at Marly-le-Roi, looking towards the site of Sisley's house, 2 avenue de l'Abreuvoir, photograph, 1992.

98 The site of Sisley's house, 2 avenue de l'Abreuvoir, Marly-le-Roi, photograph, 1992.

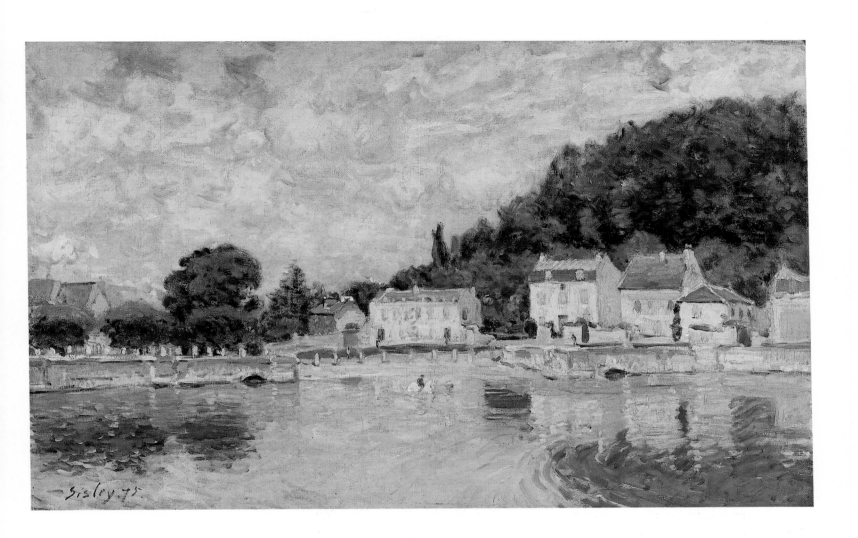

37 Boat in the Flood

La Barque pendant l'inondation
D239; 50 × 61 cm
Signed and dated br: Sisley 76
Musée d'Orsay, Paris
Exhibited in London only

The extensive flooding of Port-Marly in the spring of 1876 was recorded on two occasions in *l'Illustration* (18 and 25 March 1876, pp. 182 and 203 respectively; Fig. 100). The ebb and flow of the waters of the River Seine as it burst its banks inspired an important and justly famous group of paintings by Sisley that have become one of the touchstones of Impressionism (see Cat. 38).

The composition of Cat. 37 forms a suitable introduction to the group of paintings executed at Port-Marly dating from 1876. In some respects the artist was returning to a motif that he had first painted in 1872 (D21–24; see Cat. 16), but in the later pictures he focuses more intensely on the human predicament caused by the flood. For the present composition, Sisley has positioned himself in the rue Jean Jaurès at the point where it issues into the rue de Paris (formerly the route de Saint-Germain). The oblique angle means that the wine-merchant's shop becomes more prominent with the artist expending considerable efforts on detailing its architectural features, particularly in the upper section. In addition, and in conjunction with Fig. 99, the inscriptions on the side of the building can be made out: *A St. Nicolas* above with *Cagne le Franc . . . Vins* below. Cagne le Franc may possibly have been the name of the owner. The flood is still in full spate. The technique is looser than in Fig. 99, but not as sketchy as Cat. 38. The figures – one in the ferry and the other on a temporary landing stage – are neatly aligned with the corner of the wine merchant's and with the row of chestnut trees so that their dark vertical forms create a syncopated rhythm across three-quarters of the composition extending from left to right. The overall light tonality of the painting is also offset by the black pigment used for the window openings, making a sharp contrast between light and dark. The curvilinear tops to the windows in the mansard roof are echoed in the shapes of the clouds.

The painting was in the collection of Ernest Hoschedé, who was one of the first supporters of the Impressionists and whose wife, Alice, became Monet's second wife. Hoschedé, an industrialist, was declared bankrupt on 18 August 1877 only a few months after lending three pictures by Sisley to the third Impressionist exhibition (April 1877). His collection was sold in early June 1878. The financial results of the sale, which included thirteen works by Sisley, were disappointing.

C.L.

PROV: Ernest Hoschedé, Paris; Sale Paris, 5–6 June 1878, bt Durand-Ruel; Durand-Ruel, Paris, by whom sold to Camondo, 17 March 1892; Comte Isaac de Camondo, by whom bequeathed to Musée du Louvre, 1908.

BIBL: *Catalogue de la Collection Isaac de Camondo*, n.d., no. 201; Besson, n.d. pl. 29; Colombier, 1947, pl. 7; *Catalogue*, 1947, no. 274; Venturi, 1953, p. 117, repr.; *Catalogue*, 1958, no. 409; Bazin, 1958, p. 301, repr.; Bodelsen, 1968, pp. 339–40; Daulte, 1972 (Eng. ed. 1988), p. 42, repr.; Shone, 1979, p. 9, repr.; Lassaigne and Gache-Patin, 1983, p. 106, repr.; *De Renoir à Vuillard*, 1984, p. 127, repr.; Sterling and Adhémar, 1990, p. 431; Munk, 1991, pp. 58–59, repr.

99 Alfred Sisley, *Flood at Port-Marly*, D236 (Thyssen-Bornemisza Collection, Madrid).

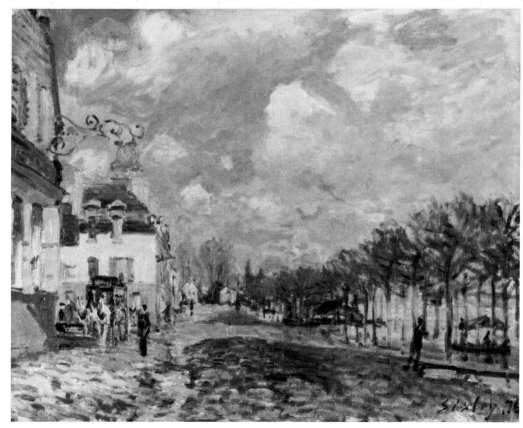

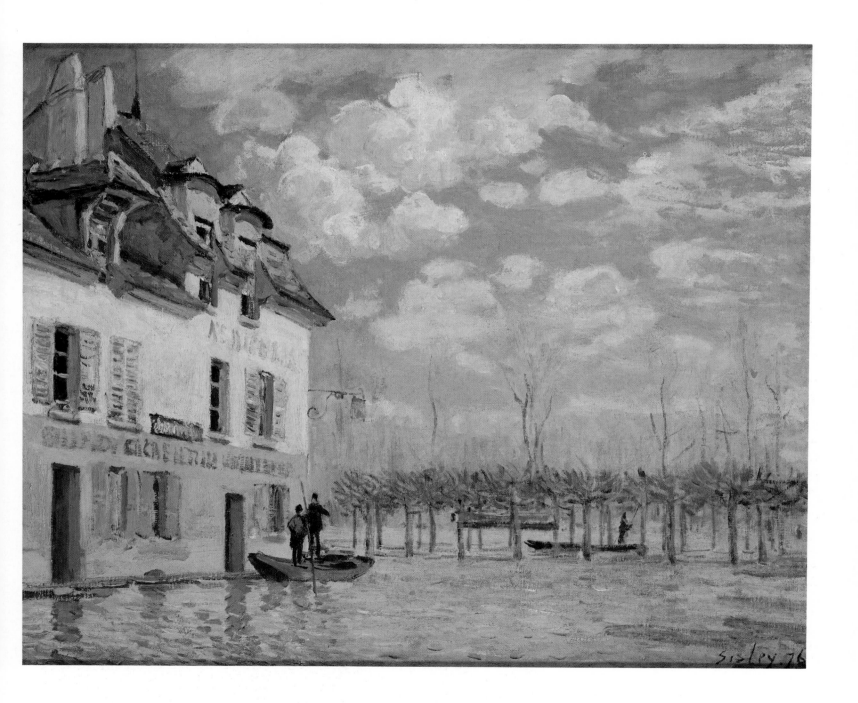

38 Flood at Port-Marly

L'Inondation à Port-Marly
1876; D240
60 × 81 cm
Signed and dated bl: Sisley 76
Musée d'Orsay, Paris
Exhibited in Paris only

The painting was included in the 2nd Impressionist exhibition held in April 1876 at 11, rue le Peletier, Paris, when it was lent by Legrand. Sisley exhibited eight landscapes at the exhibition all of which were hung in the second room where fifteen works by Renoir, seventeen by Monet and eight by Caillebotte were also shown. The critics wrote favourably about Sisley's contribution. Cat. 38 was later owned by Adolphe Tavernier, who was one of the artist's most loyal collectors and a close friend. Like Cat. 37, this painting was subsequently acquired by Isaac de Camondo, who bequeathed both pictures to the Musée du Louvre. The fact that Camondo owned two of Sisley's flood pictures, both dated 1876, suggests that they were seen as a pair and possibly as part of a sequence.

The composition repeats one of the flood at Port-Marly first essayed in 1872 (D22, Mr and Mrs Paul Mellon Collection, see Cat. 16) and is directly comparable with the painting now in the Musée des Beaux-Arts, Rouen (D237) also of 1876, which was owned by François Depeaux, another keen collector of works by Sisley and Monet. These three paintings depict the wine merchant's shop from the rue de Paris (formerly the route de Saint-Germain) extending along the river bank at the junction with the rue Jean Jaurès. Comparison with Fig. 99 demonstrates how far up the rue de Paris the artist has advanced. For the painting in Rouen, Sisley had moved slightly closer to the building and shifted his viewpoint fractionally to the left, although less of the wine merchant's shop is actually shown. Previously, in 1872, Sisley had also moved to the right (D23), but in 1876 he did not repeat the view, although Cat. 37 is similar.

Both Cat. 38 and the picture in Rouen can be counted among Sisley's masterpieces in so far as they are triumphs of both his compositional and tonal skills. The surface is composed of three vertical sections marked by the edge of the building and the telegraph pole. These same indicators chart the depth of the picture space, the building serving as a repoussoir motif between the telegraph pole and the horizon. The solidity of the building itself is contrasted with the umbrella-like chestnut trees and the slender telegraph pole, so that essentially the left half of the composition is closed and the right half open. Similarly, there is considerable play upon the contrast between the towering form of the building in the middle-distance and the low horizon in the far-distance. The centre of the painting is filled by the boats and the elaborate landing-stage, but beyond that the eye escapes down river towards Saint-Germain-en-Laye. In effect, where the outer edges of the composition are still, the centre bustles with activity. The arrangement of these forms results in a composition of perfect harmony. This sense is enhanced by the tonal qualities of the picture. The flood appears to be at its worst and the sky remains stormy. The overall blue-grey tone is muted, but in addition to the peach-ochre colour used for the lower half of the building which is reflected in the water, there are hints of various reds in the roof, the shop sign and the skyline. Although there is an undeniable variety in the handling of Cat. 37, 38 and Fig. 99, the treatment of the subject-matter is comparable in all three pictures and differs from the intensely poetic visual effect created in Cat. 40 and 41.

C.L.

PROV: Legrand, Paris; Paindeson, Paris; Pellerin, Paris; Adolphe Tavernier, Paris; Sale Galerie Georges Petit, Paris, 6 March 1900 (68), bt Camondo for 43,000fr; Comte Isaac de Camondo, Paris, by whom bequeathed to the Musée du Louvre, 1908.

EXH: Paris, 2nd Impressionist Exhibition, 1876, no. 244; Paris, Petit, 1899, no. 63.

BIBL: Duret, 1906, p. 121, repr.; *Catalogue de la Collection Isaac de Camondo*, n.d., no. 200; Jamot, 1914, p. 58, repr.; Geffroy, 1927, repr. pl.21; Besson, n.d., pl. 28; Focillon, 1928, p. 219, repr.; Rewald, 1946, p. 313, repr.; *Catalogue*, 1958, no. 411; Bazin, 1958, p. 160, repr.; Ribault-Ménètière, 1958, p. 7; Daulte, 1972 (Eng. ed. 1988), p. 42, repr.; Shone, 1979, pl. 34; Lassaigne and Gache-Patin, 1983, p. 106, repr.; *De Renoir à Vuillard*, 1984, p. 127, repr.; Moffett, 1986, p. 146, repr.; Sterling and Adhémar, 1990, p. 431, repr.; Munk, 1991, p. 58, repr.

100 *Floods at Poissy*, from *l'Illustration*, 18 March 1876.

LE BOULEVARD DE MIGNAUX A POISSY.

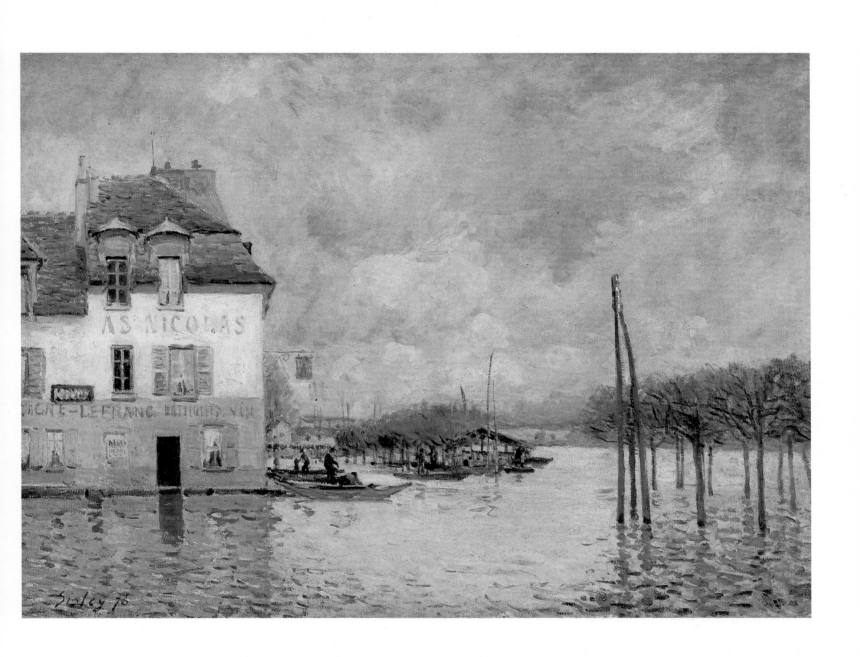

39 *Flood at Port-Marly*

L'Inondation à Port-Marly
1876; D241
46 × 55cm
Signed and dated br: Sisley 76
Lent by the Syndics of the Fitzwilliam
Museum, Cambridge

While nearly all the views of Port-Marly in flood concentrate on the section of the rue de Paris (formerly the route de Saint-Germain) before the junction with the rue Jean Jaurès (see Cat. 37, 38), only two are painted beyond that point. In D238 (Private Collection, New York) Sisley positioned himself closer to the river in the avenue of chestnut trees. The houses along the rue de Paris are evident at the left edge of the composition so that the boats, the flood water and the river form the real subject of the picture. The present painting is exceptional in the context of the flood in that the view of the rue de Paris is seen from the other direction, looking back from further down the river bank towards the junction with the rue Jean Jaurès. The buildings of Port-Marly, therefore, appear on the right. Sisley had, in fact, painted more panoramic views of the village seen from this direction, but under snowy conditions in 1875 (non-D, exhibited Artemis, 1981, no. 9, Private Collection, London).

The tree trunks in Cat. 39 create a series of verticals placed at intervals that divide the surface of the canvas horizontally into eight nearly equal parts. Where there is a gap in the trees on the right the artist has instead used the vertical created by the separation of the terracotta house from the white one next to it. This carefully chosen viewpoint allows the verticals to establish a sense of depth as well as movement across the composition. It is, by any standards, a remarkable demonstration of the traditional use of perspective that in the context of the Italian Renaissance brings to mind such pictures as *The Hunt in the Forest* by Paolo Uccello (Ashmolean Museum, Oxford). Sisley in Cat. 39 is perfecting a compositional device that he had been exploiting from early on in his working life (see Cat. 6, 19).

The shallow diagonals formed by the boats in the foreground and by the disposition of the figures in the right half prevent the composition from becoming too rigid. Local colours (brick-red, terracotta, grey-blue, and olive green) enliven the overall sombre tonality of the painting which is dominated by a rainy sky.

The paint surface is varied, in so far as the warm ochre ground is apparent owing to Sisley's broken and hasty brushstrokes, but the sky, the houses and the foreground have been solidly painted. The branches of the trees on the far right have been deftly brushed over the sky with a series of free, rhythmical strokes. Those of the other trees are sketchily laid-in relying on the sharp contrast between the black pigments and the light ground to create a series of spark-like accents in the middle of the composition.

C.L.

PROV: Bernheim-Jeune, Paris; M. Hirsch, Paris; Sold, Hôtel Drouot, Paris, 5–6 December 1912 (47); M. de Rochekouste, Paris; Bignou, Paris; Knoedler, New York; Alex Reid and Lefevre, London, by whom sold in 1929 to Sykes; Captain S.W Sykes, London, by whom given to the Fitzwilliam Museum, Cambridge, 1958.

EXH: Paris, Rosenberg, 1922, no. 92; New York, Knoedler, 1929, no. 22; Nottingham, 1971, no. 7; London, Royal Academy, 1974, no. 110; London, Artemis, 1981, no. 11; Tokyo-Fukuoka-Nara, 1985, no. 25.

BIBL: Goodison and Sutton, 1960, pp. 196–97, repr.; *De Renoir à Vuillard*, 1984, p. 126, repr.

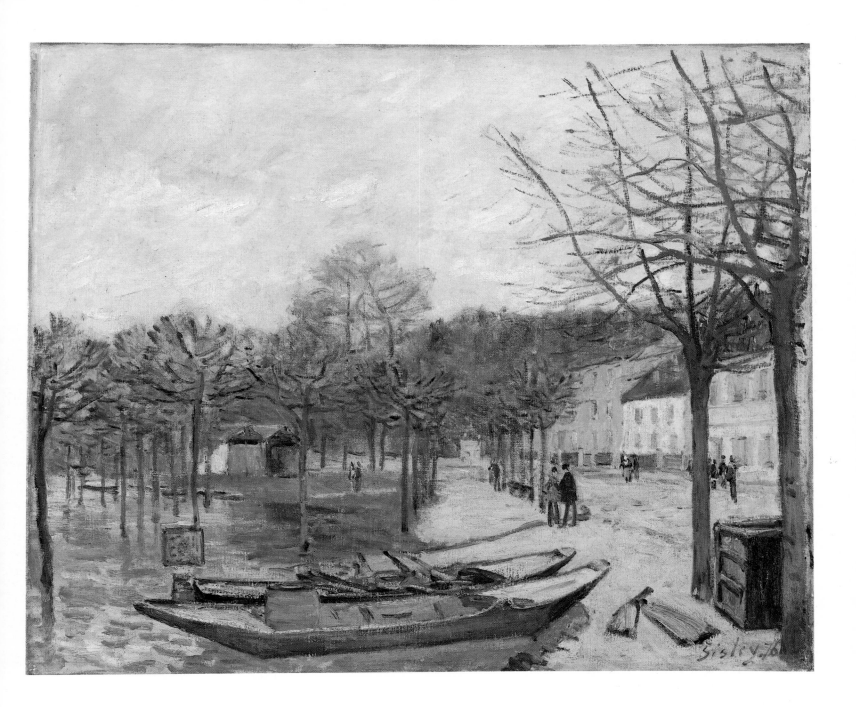

40 The Banks of the Seine in Autumn: Flood

Au bords de la Seine en automne – l'inondation
1876; Non-D
49 × 65cm
Signed and dated bc: Sisley 76
Private Collection
Exhibited in Baltimore only

The subject of the River Seine in flood was first essayed by Sisley in 1872 (see Cat. 16) and was to preoccupy him on several occasions in 1876 (Cat. 37–39), the year in which the present painting and the related picture, *The Banks of the Seine in Autumn* (Cat. 41), were also executed. The identification of the buildings in these two paintings is still elusive, but it is clearly the same stretch of the river. The grouping of the buildings and the signs of industry suggest that the river is the Seine to the west of Paris, as opposed to the more densely wooded, rural areas to the south-east. There is, however, one essential difference between the two paintings, in that the present picture, which is dated 1876, shows the river in full flood. This accounts for the major compositional changes. It is apparent, for example, that Sisley has here moved in front of the leaning tree that is such a prominent feature of Cat. 41 and has established himself by an outcrop that is not visible either in Cat. 41 or in the more detailed depiction in the left half of that composition (D224, *October Morning*) which he must have painted at the same time.

If the title of D224 is correct, then this particular sequence of flood pictures must have been painted after Cat. 37–39, but this cannot be corroborated. The trees have been used as a screening device in several areas of the present painting, but in a less dramatic way than in Cat. 41. The surface has been thinly painted and a peculiarity of the signature right of centre is that it is arranged, deliberately or not, to resemble an artist's palette. The tonal qualities, echoing those of Corot, match Cat. 41 fairly closely, but the rose-red/violet hue that spreads throughout the picture is offset by the grey-green and grey-black forms of the trees and the cast shadows in the flooded areas in the left foreground.

Another view of this stretch of river is seen in D475, which was owned by François Depeaux but is differently titled, *Winter Sunset (The Seine at Saint-Mammès)*, in the catalogue raisonné where it is given a date of 1883. This depicts a similar view, but from further back and with less emphasis on the trees on the left. The path from which Cat. 40 and 41 were painted, however, is clearly shown.

C.L.

PROV: Bignou Collection, Paris; Binet Collection.

EXH: Dallas, 1989, no. 103.

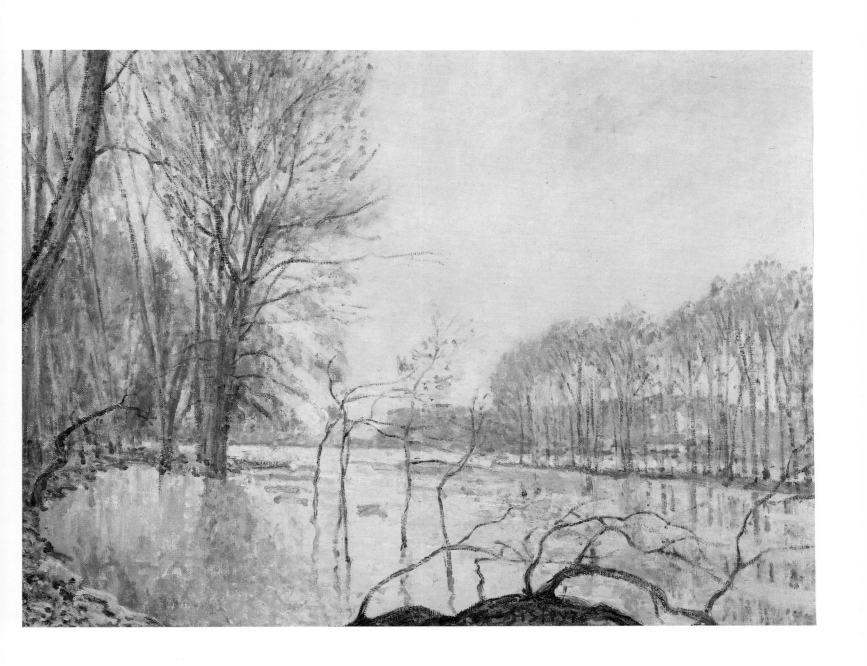

41 The Banks of the Seine in Autumn

Au bords de la Seine en automne
1876; D223
46 × 65 cm
Signed bl: Sisley
Städelsches Kunstinstitut, Frankfurt am Main;
property of the Städelschen Museums-Vereins
e.V.
Exhibited in London and Paris only

The painting is comparable in subject and style with Cat. 40, only now the flood seems to have receded. This composition in particular heralds the stylistic preoccupations of the later decades of Sisley's life, beginning, during the first half of the 1880s, with those paintings undertaken at Veneux-Nadon, Les Sablons, By and Les Roches-Courtaut along the banks of the River Seine to the south-east of Paris and culminating in the river views of Saint-Mammès (see Cat. 49–52, 56–58) and Moret-sur-Loing (see Cat. 62, 69). In these places Sisley combined his interest in the commercial activities of the river with its natural scenery. Like Monet and Pissarro during the second half of the 1870s, the artist concerned himself with overlapping forms within his compositions. Comparisons may be made with *Banks of the Seine, Island of La Grand Jatte* (Musée Marmottan, Paris) painted by Monet in 1878 or *Côte des Boeufs, Pontoise* (National Gallery, London) painted by Pissarro in 1877, or, more immediately, *Banks of the Oise near Pontoise, grey Weather* (Musée d'Orsay, Paris) painted by Pissarro 1878. All of these indicate a fascination for more complicated compositions with shapes and forms emerging from beneath or through superimposed parts. The surfaces of these paintings are multi-layered and the artists seem just as concerned with pattern as with colour.

In Cat. 41, the river establishes the recession into depth and in so doing forms a diagonal that is countered by the slender tree-trunk which seems almost to have been arrested in its stately fall into the water. The evidence of chalk underdrawing in the tree suggests that Sisley took great care in mapping its exact position on the canvas. The tree enfolds a ferry boat within the lower right corner of the composition, seen approximately on a line with the figures on the bank. The activity, therefore, is contained within the

lower half of the picture, but the tree only temporarily blocks the eye from penetrating the distant view, just as the tops of the poplars on the island in the middle of the river do not screen the houses all that effectively. How Sisley developed these motifs can be seen by comparing Cat. 41 with D404, 405, 407–12, 414 and 420 dating in all probability from the spring of 1881, and with D433, 435 and 437 from the autumn of the same year.

The subdued qualities of this picture skilfully evoke a damp autumnal day by a river in partial flood with a hint of the sun breaking up the mist. The suppleness of the brushwork and the delicacy of the silvery tonal values anticipates such a picture as the *Canal du Loing*, (D816, Cat. 69) of 1892, while the composition recurs in views of Moret-sur-Loing seen in winter (D715, 716, 717) painted by Sisley in the last year of his life. All these paintings demonstrate Sisley's continuing allegiance to Corot, in this instance to the late *souvenir* pictures that were so much admired in their day, and to earlier flood scenes (Fig. 101).

C.L.

PROV: Bernheim-Jeune, Paris; Weisdenbusch, Wiesbaden; given to the Städelsches Kunstinstitut by Herr Stadtrater Viktor Mossinger, 1899.

EXH: Paris, Orangerie, 1951, no. 82

BIBL: E. Holzinger and H.J. Ziemke, *Städelsches Kunstinstitut. Die Gemälde des 19. Jahrhunderts*, 1972, pp. 372–73; Lassaigne and Gache-Patin, 1983, p. 108, repr.

101 P. Huet, *Flood at Saint-Cloud*, 1855 (Musée du Louvre, Paris).

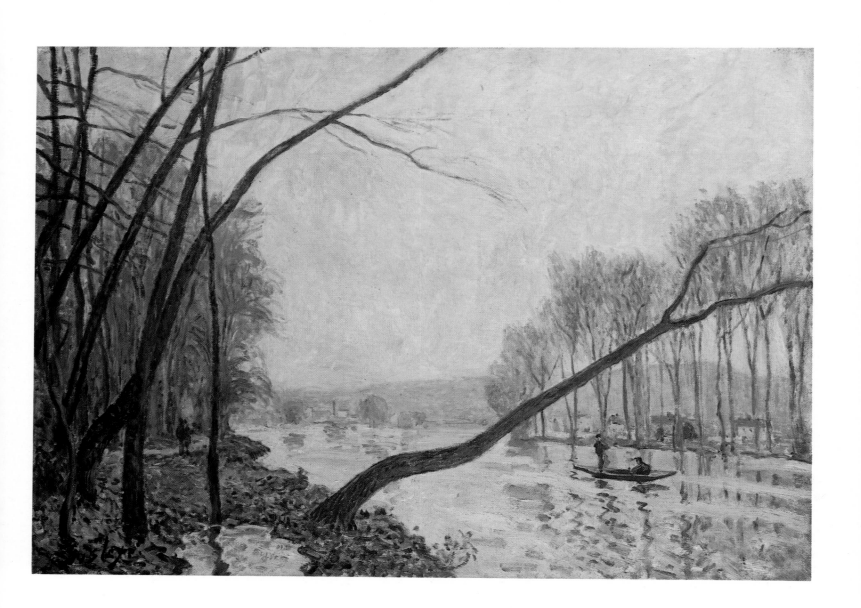

42 Watering Place at Marly-le-Roi: Hoarfrost

L'Abreuvoir à Marly-le-Roi – gelée blanche
1876; D244
37.8 × 54.9 cm
Signed and dated br: Sisley 76
Virginia Museum of Fine Arts, Richmond, VA
Collection of Mr and Mrs Paul Mellon

The painting is one of three, all dated 1876, of the watering place at Marly-le-Roi which may be described as a recapitulation of motifs undertaken during the previous year. The other two paintings are D243 and 246. In some respects the group serves as an *envoi* before Sisley moved on to Sèvres in the following year. As has been seen, D243 is closely related to Cat. 36 and in the same way the present painting has its counterpart in D169 of 1875 (Fig. 102) and in D157 also of 1875 entitled *The Watering Place at Marly-le-Roi: Snow* (Private Collection). The view of the pond in both these paintings is taken from the Côte du Coeur-Volant (Fig. 103) and therefore looks towards the more open landscape extending to the north-west of Marly-le-Roi. The ramp down which the horses entered the water is also evident in these compositions, but, where in Cat. 36 it is a dominant element, here and in the painting in Chicago it is given less emphasis. The shift in viewpoint between the two representations of the pond is in fact small, but the dramatic change in the background that resulted demonstrates the variety that Sisley found within a small space of the landscape of Marly-le-Roi. The differences between Cat. 36 and the Chicago painting (Fig. 102) are significant. The earlier composition is more panoramic in contrast with the present one in which the artist has approached further down the road and focused more precisely on the buildings. The composition is closed on the left by the two houses beyond the ramp which, in the Chicago painting, is positioned just to the left of centre. The dynamism of the picture dating from 1875 is derived from the serpentine rhythm of the road, the play of sunlight, the movement of the clouds and the use of shadows – all seen in the context of summer. The plunge into the picture space is no less dramatic in Cat. 42, but it is the seasonal elements that serve to move the eye across a composition where the progression from shadow to sunlight is given greater potency by the iridescent qualities of a hard frost seen under a clear sky.

The technique of Cat. 42 would seem to have several factors in common with the recently cleaned painting in the National Gallery, London (D152, see Cat. 32). The blue tones extending from mauve to grey-black are applied over a beige coloured priming that is barely concealed under the thinly applied top layer of paint. The water of the pond and the frost reflect the overall blue tone, while the beige ground is given greater intensity by the orange-brown highlights used to accent the road in the foreground and the walls of the buildings.

Sisley's choice of the pond at Marly-le-Roi is significant in that his paintings of it are in marked contrast with eighteenth- and early nineteenth-century salon depictions. For Sisley, the appeal of the subject lies in the utilitarian, domestic use of the pond, as opposed to its original purpose as part of an ornamental landscape motif. Indeed, Sisley looks away from the gardens of the château at Marly, as though deliberately turning his back on them.

C.L.

PROV: François Depeaux, Rouen; sold Galerie Georges Petit, Paris, 31 May–1 June 1906 (57)); bt Durand-Ruel for 8,000 fr; Durand-Ruel, Paris, by whom sold to Paul Cassirer, 17 Nov. 1913; Paul Cassirer, Berlin; Dr Curt Hirschland, Essen; Wildenstein, New York; Mrs Hirschland, New York; Mr and Mrs Paul Mellon.

BIBL: *De Renoir à Vuillard*, 1984, p. 107, repr.; Munk, 1991, pp. 73–74, n. 20.

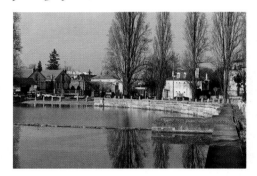

103 The Watering Place at Marly-le-Roi, looking towards the avenue de l'Abreuvoir, photograph, 1992.

102 Alfred Sisley, *The Watering Place at Marly-le-Roi* (Art Institute of Chicago).

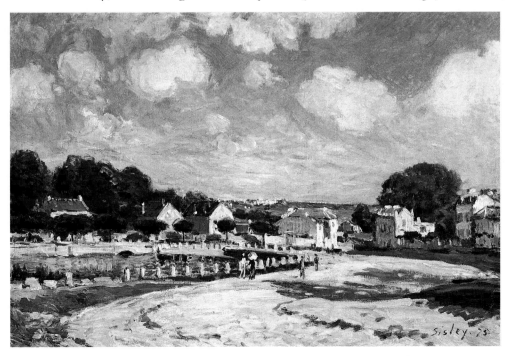

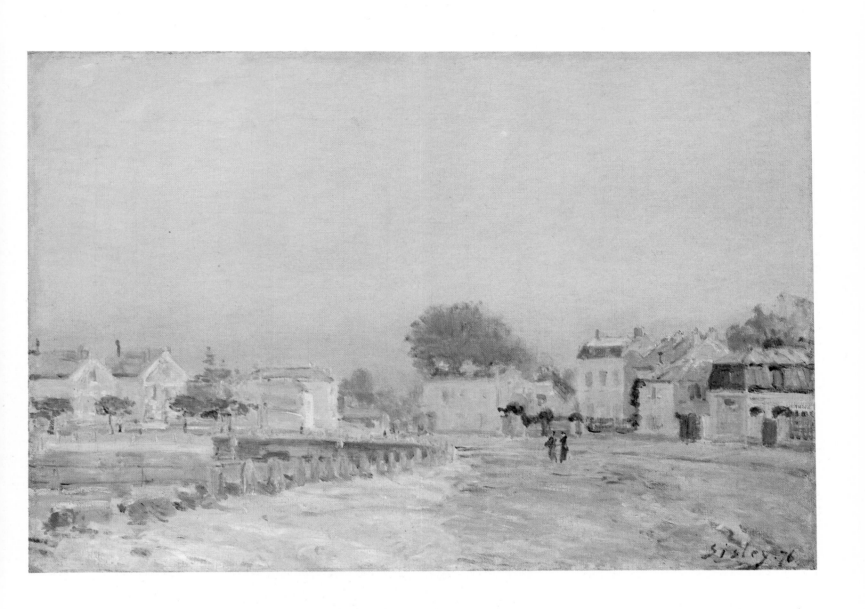

43 Still-Life: Apples and Grapes

Nature morte – pommes et raisins
1876; D234
46 × 61 cm
Signed br: Sisley
The Sterling and Francine Clark Art Institute,
Williamstown

Sisley rarely painted still-lifes (see Cat. 7) and of those that he did, the present example, together with a closely related painting of grapes and nuts (D233, Fig. 104, Museum of Fine Arts, Boston) are among the finest. The earliest group (painted *c.* 1867) comprises a dead heron (D5, Musée d'Orsay, on loan to the Musée Fabre, Montpellier, Cat. 7), a fish (D6), and a pheasant (D8), as well as a still-life of apples (D7). There are two later still-lifes of fish (D661, 662), the second of which is dated 1888. The compositions of both Cat. 43 and the painting in Boston are the most elaborate and complex of the still-lifes undertaken by Sisley, as regards both composition and the treatment of light. The compositional skills applied in the artist's landscapes are equally evident here and to such a degree that it is surprising Sisley did not execute more still lifes. Presumably such pictures did not sell well.

The high viewing point in Cat. 43 allows for a wide expanse of table surface. The rounded edge is echoed by the fruit and the handle of the basket while the drapery in the upper right corner softens the effect of the edge of the table to form a diagonal. The relationship between these two elements is reinforced by the handle of the basket, which is also aligned with the creases in the table cloth. These diagonals are also emphasised by the positioning of the apples on the tablecloth, but are countered by the angle of the knife. Similarly, the movement from light to dark (lower right to upper left) and from direct light to half-light (lower left to upper right) establishes a counterpoint within the composition.

Partly because the fruit is placed on a flat plate, the painting in Boston seems to be more concerned with the relationship between straight edges and angles. None the less, it is almost certain that both paintings make use of the same table and the same room. Although neither is dated, it is highly likely that they were painted at a similar date, which Daulte surmises to be 1876. They were exhibited together in New York at Wildenstein's in 1966 (nos. 28 & 29).

Sisley's fruit does not belong to the fecund world of Courbet or the prismatic universe of Cézanne. His treatment of still-life is closer to Monet's in 1880: *Grapes and Apples* (The Art Institute, Chicago), *Grapes and Apples* (The Metropolitan Museum of Art, New York) and *Grapes, Apples and Pears* (Kunsthalle, Hamburg). The viewpoint in all these paintings by Monet is similar to Sisley's, allowing for an abundant display of fruit, while the flickering light emphasises its succulence. Both Sisley and Monet take advantage of the reflective qualities of the crumpled white tablecloth so that its luminescence not only offsets the warm tones of the fruit, but also as a surface is in danger of being almost literally stained by all the colour contained within those rounded forms that so tempt the viewer. Sisley saturates the painting with light, unlike Renoir who prefers a suffused iridescence, or Manet whose style remains essentially chiaroscural.

C.L.

PROV: Mrs Allen Hay, New York, from whom bt by Durand-Ruel, 2 March 1899; Durand-Ruel, Paris, by whom sold to Mancini, 13 November 1899; M. Mancini, Paris; Knoedler, Paris and New York; R. Sterling Clark, New York.

EXH: New York, Wildenstein, 1966, no. 29.

BIBL: Clark Art Institute, 1956, no. 124, repr.; Daulte, 1972 (Eng. ed 1988), p. 38, repr.; Lassaigne and Gache-Patin, 1983, p. 59, repr.

104 Alfred Sisley, *Still-Life: Grapes and Nuts*, D233 (Museum of Fine Arts, Boston).

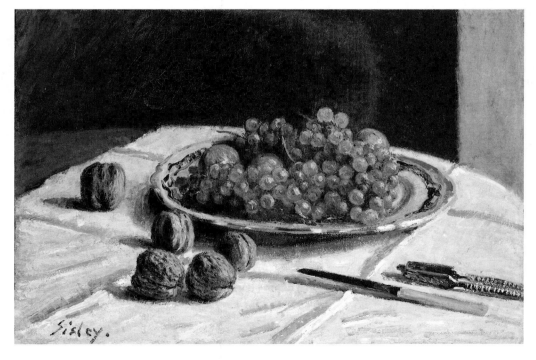

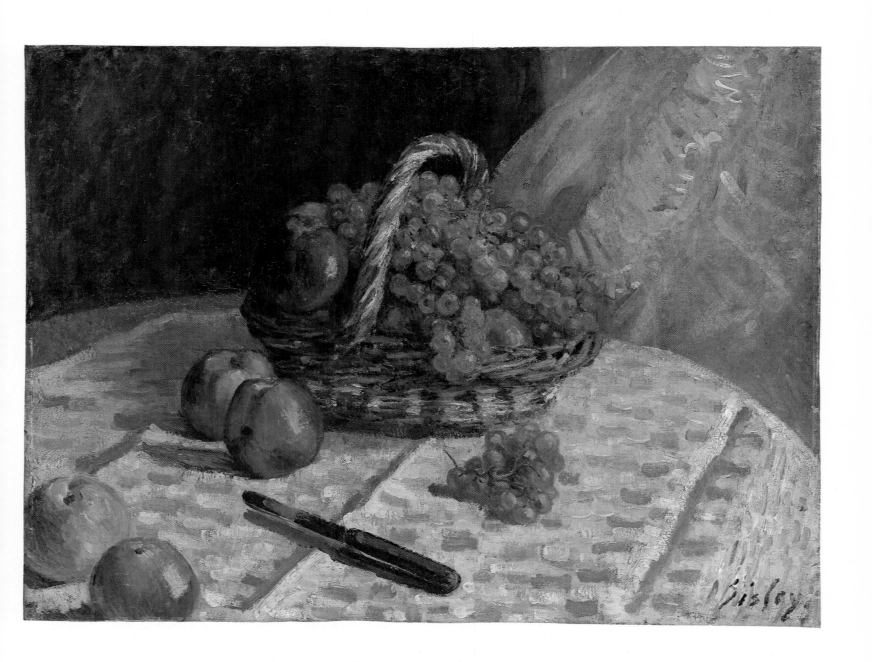

44 The Bridge at Saint-Cloud

Le Pont de Saint-Cloud
1877; D255
50 × 61 cm
Signed bl: Sisley
Dr and Mrs George Dean, Bloomfield Hills, MI

Saint-Cloud was a place particularly evocative of eighteenth-century France. The Baedeker guide (1904 ed. p. 38) describes the town's characteristics somewhat perfunctorily: '*St Cloud*, a small town (7195 inhab.), rises in an amphitheatre on the left bank of the Seine. . . It owes its name to a monastery founded here by St Clodoald (522–560), grandson of Clovis, and its importance to the château, destroyed in the war of 1870.' The château dated back to the sixteenth century, but it was acquired and rebuilt by Louis XIV to designs by J.H. Mansart and A. Lepautre. Napoleon frequently stayed at Saint-Cloud and there were subsequent associations with the history of France resulting from events during the reign of Charles X. It also served as the principal summer residence of Napoleon III. The chief attraction of Saint-Cloud, however, after 1870 was the Park, to which the Baedeker guide devoted more attention. It was famous for its fountains and cascades. 'The *Jet Géant*, or great jet, to the left of the cascades, rises to the height of 130 feet.' The Park covered an area of 980 acres and the climax of the visit was the viewing platform where there was a tower known as the Lantern of Diogenes (destroyed in 1871) with a commanding view of Paris across the Bois de Boulogne. The Park was frequently painted during the eighteenth century, notably by Fragonard (*The Fête at Saint-Cloud*, Paris, Banque de France), and during the early nineteenth century by Paul Huet (*Les Ormes at Saint-Cloud*, Paris, Musée du Petit Palais, or *The Flood at Saint-Cloud*, Paris, Musée du Louvre; Fig. 101), and Corot (*The Entrance to the Park at Saint-Cloud*, Paris, Mme David-Weill Collection). Sisley, by contrast, was more interested in the town, ignoring the view of Paris.

In this painting Sisley has viewed the town of Saint-Cloud from the bridge which fills the left quarter of the composition. The use of the bridge as a dramatic repoussoir motif almost literally conveying the viewer into the landscape is a familiar device in Sisley's work. It occurs, for instance, in Cat. 14 and 25 of 1872 and 1874 respectively, as well as in *The Bridge at Saint-Mammès* (Cat. 49). In Cat. 44 the flow of the water is counterbalanced by the stone structure of the bridge and by the town of Saint-Cloud, both of which could be described as the more anchored parts of the composition. Sisley painted the bridge at Saint-Cloud seen from the right bank of the river with the town beyond in D253 and 254, both given dates of 1877 in the catalogue raisonné. These two pictures are more orthodox views, in that they establish more clearly the relationship of the bridge to the town and thus serve to set Saint-Cloud in a proper context. The park at Saint-Cloud may have offered a calm and peaceful escape from urban existence, but the town appears to have been noisier. 'The cafés in the Place d'Armes are frequently visited, especially on Saturday afternoons, by wedding parties of the humbler classes from Paris', is how it is expressed in Baedeker (1904 ed., p. 339).

The style of Cat. 44 is vigorous. The rushing water in the foreground has a surface licked by strokes of orange and violet colour with touches of luminous white. The sky is equally animated and vividly coloured, although with more grey and less blue. The spire of the church reaches up over the buildings in the town which are depicted by quixotic dabs of colour (red, blue-grey, purple, white, green) amounting to a confection and dynamism that is reminiscent of certain paintings by Cézanne dating from the mid-1870s (for example, *Auvers-sur-Oise, Panoramic View*, The Art Institute, Chicago, 1873–75). The slashed horizontal strokes used for the black forms of the barges tied up at the *quai* are remarkable both in terms of colour and the degree of spontaneity. The painting reveals Sisley at his most vital and energetic.

C.L.

PROV: Emil Staub-Terlinden, Männedorf; Wildenstein, Paris and New York; Edward G. Robinson, Los Angeles; Private Collection; Hirschl and Adler, New York.

EXH: Paris, Galerie des Beaux-Arts, 1937, no. 112; Los Angeles-San Francisco, 1956–57, no. 62; New York, Wildenstein, 1966, no. 32.

BIBL: Daulte, 1957, p. 51, repr.

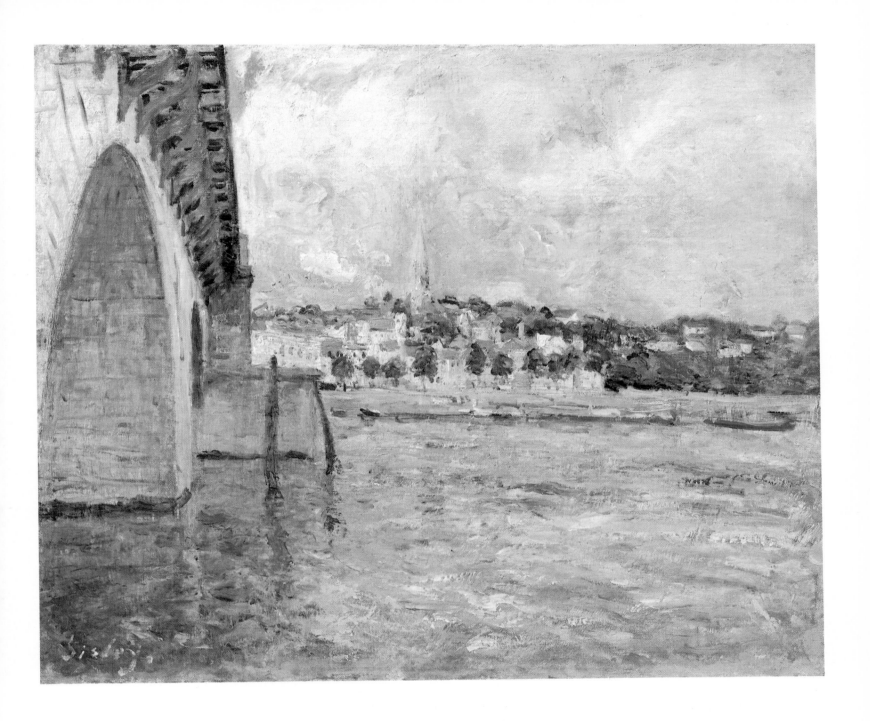

45 Barges unloading at Billancourt

Le Déchargement des péniches à Billancourt
1877; D274
50 × 65 cm
Signed and dated bl: Sisley 77
The Ordrupgaard Collection, Copenhagen
Exhibited in London and Paris only

Billancourt is situated on the right bank of the River Seine on the south-west side of Paris opposite the Parc de Saint-Cloud. It was a barge-port and primarily an industrial area. Most people would have seen Billancourt across the river from the train or from the steamer on the way to Saint-Cloud. While the barge-port established on the north-east side of the city at the Canal Saint-Martin had interested Sisley at an early date (Cat. 9), he had at the same time in another painting of 1870 noted its counterpart at the Quai de Grenelle to the south-east by the Pont de Grenelle (D15). The ribbon of industrial development along this section of the Seine, extending down the river from the Pont de Grenelle past the Pont d'Auteuil and the Point-du-Jour to Billancourt, and finally to Surèsnes, continued to fascinate the artist at various intervals during the late 1870s. These subjects anticipate the sites explored by Seurat, Signac and Guillaumin during the following decade in paintings that emphasise the industrialisation of Paris, just as Sisley's depiction of the barge-port at Billancourt foreshadows his work at Saint-Mammès (Cat. 52, 56–58).

There are several general views of Billancourt: D251, 252, 266 and 268, all of 1877, and D319 and 347, both of 1879. Most of these pictures emphasise the industrial aspects of the town seen from a distance. Cat. 45 is comparable with D273, 275, 276 in so far as the artist has approached much closer to Billancourt. Of these paintings, however, it is with D273 (Fig. 105) that there is a clear relationship. Both compositions are broad, panoramic views notable for low horizon lines. These allow for a vast expanse of sky, which by this date had become one of the hallmarks of Sisley's paintings and was remarked upon by contemporary critics. The rhythmical activity of unloading the barge is contained in the immediate foreground while the clouds sail elegantly overhead. These two parts of the composition are separated by the thin strip of the bank on the opposite side of the river, but they are joined by the barge's mast right of centre and by the tree on the left. A most significant aspect of this painting is its bright tonality, the palette here being reminiscent of Renoir during the late 1870s with its deep blue and straw yellow offset by lush greens and pithy reds. This was one of the main features of Sisley's style that would be developed during the early 1880s.

C.L.

PROV: Pontremoli, Paris; Bignou, Paris; Wilhelm Hansen, Copenhagen, by whom bequeathed to The Ordrupgaard Collection.

EXH: Paris, Rosenberg, 1904 no. 33; Tokyo-Yokohama-Toyohashi-Kyoto, 1989–90, no. 47.

BIBL: Swane, 1954, no. 108, repr.; Rostrup, 1958, pl. 38, repr.; Lassaigne and Gache-Patin, 1983, p. 103, repr.

105 Alfred Sisley, *Boats on the Seine*, D273 (Courtauld Institute of Art, London).

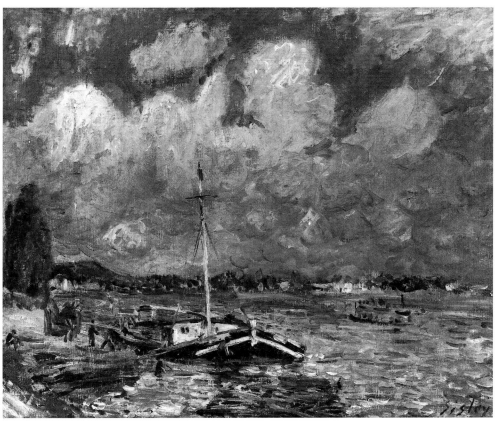

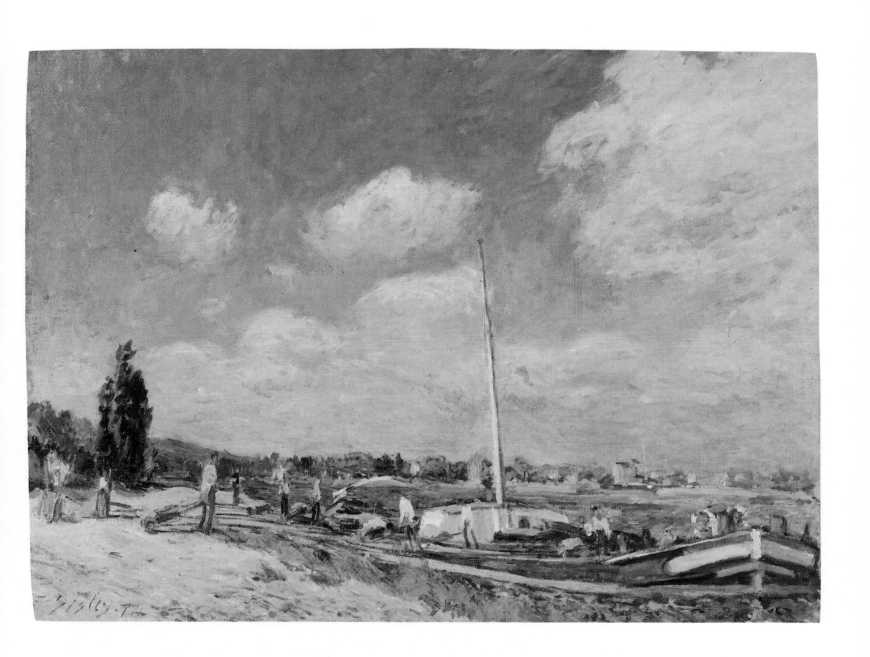

46 *Snow at Louveciennes*

La Neige à Louveciennes
1878; D282
61 × 50 cm
Signed and dated br: Sisley 78
Musée d'Orsay, Paris

The subject of this painting is the chemin de l'Etarché, a narrow *allée* off the rue de la Princesse where Sisley had lived in Louveciennes (see Cat. 18; Fig. 70). The view of the chemin de l'Etarché seen from Sisley's own house in the rue de la Princesse was painted in 1873 (*Garden at Louveciennes*, Fig. 85) and in 1874 (Cat. 31). The first of these paintings depicts the *allée* in summer and Cat. 31 under snow. As such, the paintings may be seen as a possible pair. The present picture is related in format to the works of 1873 and 1874, but only to Cat. 31 in the depiction of snowy conditions. The evidence of *Corner of the Village of Voisins* of 1874 (D142, Musée d'Orsay) reveals that Cat. 31 was painted at the other end of the chemin de l'Etarché looking towards the turning seen in Cat. 46. The houses in the background of D142 are those in the rue de la Grande Fontaine and they recur in Cat. 46. It is clear from the position of the wall at the end on the left and the tree on the right, as seen in D142, that Sisley has moved further along the chemin de l'Etarché and positioned himself closer to the turning.

Comparison with Cat. 31 reveals how Sisley's style advanced during the late 1870s. The paintings do admittedly show two different types of snow scene. The earlier one is lighter in tone with a considerable amount of local colour, while Cat. 46 is almost monochromatic in the use of grey-blue tones set against ochre and white. The sky in the painting of 1874 seems to have been painted over a ground with a warm pink tone, whereas in Cat. 46, the grey is applied over an ochre-coloured ground which creates a heavy leaden sky. For an appreciation of its technique Cat. 46 may be compared with *Street at Ville d'Avray* (Cat. 22, detail Fig. 13). The difference in the brushwork is revealing. The neat, crisp dabs here give way to longer, sketchier strokes that are altogether more vibrant and buoyant. The earlier picture is more self-controlled stylistically, marking the perfection of Sisley's mature style, while the present picture is more experimental and more abandoned. The viewer is not quite sure what the artist might do next.

C.L.

PROV: Comte Armand Doria; Doria Sale, Galerie Georges Petit, Paris, 4–5 May 1899 (223) for 6,050 fr; George Feydeau; Feydeau Sale, Hôtel Drouot, Paris, 4 April 1903 (42) for 11,000 fr to Camondo; Comte Isaac de Camondo, Paris, by whom bequeathed to the Musée du Louvre, 1908.

EXH: Louveciennes, 1984, no. 39 and p. 102, repr.

BIBL: *Catalogue de le Collection Isaac de Camondo*, n.d. no. 203, repr.; Besson, n.d., pl. 14, repr.; *Catalogue*, 1947, no. 277; Vaudoyer, 1955, pl. 35, repr.; *Catalogue*, 1958, no. 414; Bazin, 1958, p. 188, repr.; Ribault-Ménètière, 1958, p. 7; Daulte, 1972 (Eng. ed. 1988), p. 45, repr.; Shone, 1979, pl. 26, repr.; Lassaigne and Gache-Patin, 1983, p. 28, repr.; Sterling and Adhémar, 1990, p. 431, repr.

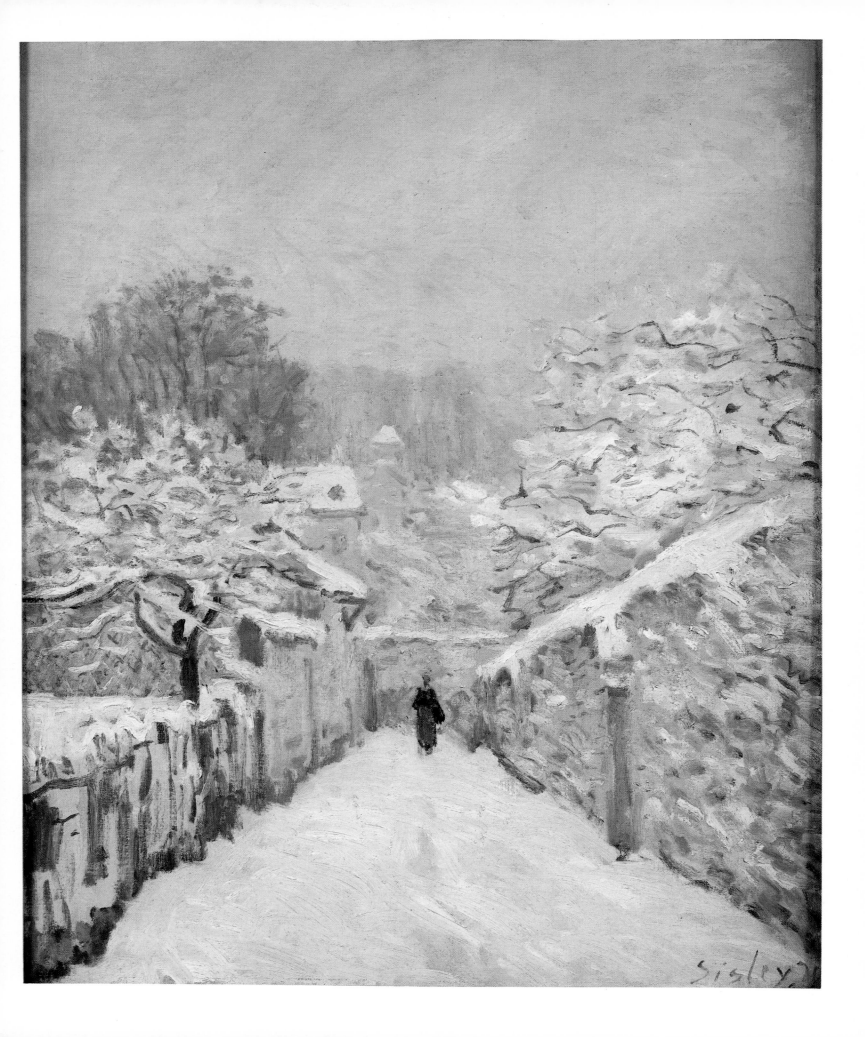

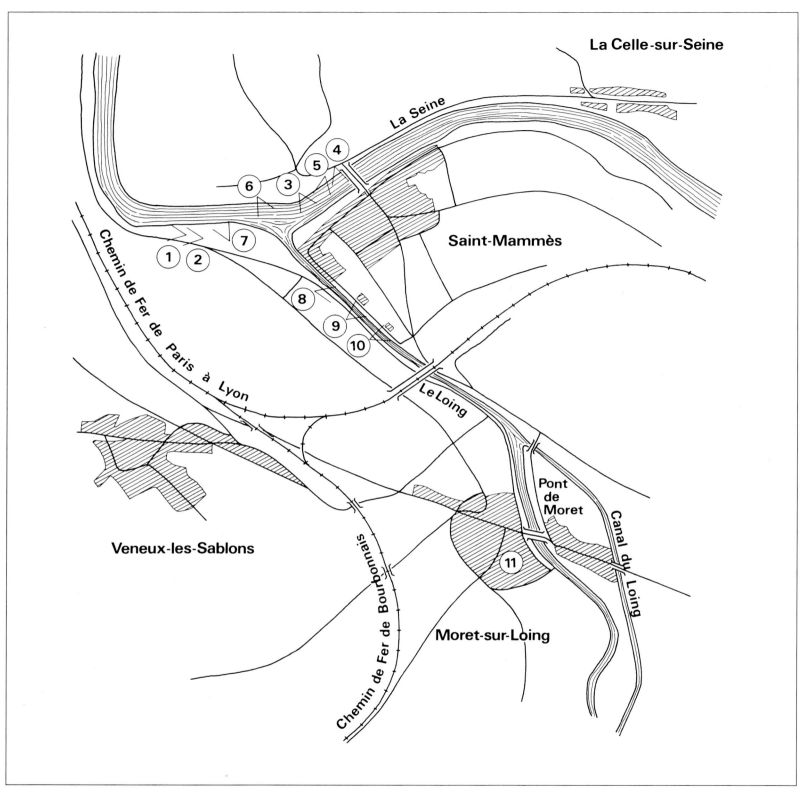

106 Map of Moret-sur-Loing and environs, showing locations where pictures were painted

1 *The Small Meadows in Spring: By*, D391, Cat. 47.

2 *Banks of the Seine at By*, D392, Cat. 48.

3 *View of Saint-Mammès*, D422, Cat. 51.

4 *The Bridge at Saint-Mammès*, D424, Cat. 49.

5 *Saint-Mammès*, D426, Cat. 50.

6 *Saint-Mammès: Morning*, D421, Cat. 52.

7 *The Lane from By to Bois des Roches-Courtaut: Indian Summer*, D433, Cat. 53.

8 *Banks of the Loing at Saint-Mammès*, D608, Cat. 56.

9 *Saint-Mammès – Canal du Loing*, D615, Cat. 57.

10 *Banks of the Canal du Loing at Saint-Mammès*, D625, Cat. 58.

11 *The Bridge at Moret*, D761, Cat. 64; non-D, Cat. 65; D817, Cat. 70.

Sylvie Patin # VENEUX-NADON AND MORET-SUR-LOING: 1880–1899

Sisley . . . had found his country . . .

The words are those of Gustave Geffroy, who continues: 'the fringes of the Forest of Fontainebleau, the small towns strung out along the banks of the Seine and the Loing: Moret, Saint-Mammès and the rest. . .'[1]

Settling at Veneux-Nadon in 1880, Sisley made the area his own. This move, which at first sight looks like a break in the artist's life, can also be seen as a return to the past, a rediscovered allegiance to the scenes of his early career, which were not far away at Barbizon, Chailly-en-Bière and Marlotte (see Cat. 2–6).[2]

His move to the region coincided with a significant phase in the development of Impressionism, and one to which Sisley's reaction must be measured as surely as has that of his fellow Impressionists, Monet, Renoir and Pissarro. After the search during the second half of the 1870s to capture on canvas the transient moment observed in the external world, the success of the Impressionists' approach was thrown into question by a combination of personal self-doubt and the criticism of their erstwhile loyal supporter, Emile Zola. In June 1880, he accused them of having as yet created no masterpiece that would survive the test of time. While Monet, Renoir and Pissarro responded by questioning the fundamental principles which underlay their art, Sisley appears to have remained convinced of the validity of the aims of Impressionism, remaining to the end, as contemporary critics rightly observed, a true Impressionist.

Sisley's art did not stand still during his last two decades, and modifications to his technique, palette and approach to subject matter were certainly introduced. For example, it was in the Saint-Mammès river scenes of 1881 (Cat. 49–52) that he began to analyse the various sections of a landscape through the application of different types of brushstroke. Or again, he realised the full potential of using a specific type of brushstroke and quality of paint to identify the mood of a landscape, be it thin, flat strokes of dry, almost chalky paint to convey a becalmed, crisp winter day (Cat. 53, 61), or bolder, more fully laden strokes of pigment let down with more oil to capture the shimmering heat of a mid-summer day (Cat. 65). His palette also extended to include a more consistent application of dabs of primary colours during the mid-1880s, possibly reflecting contact with Neo-Impressionism (Cat. 56–58), and his range of tonalities came to be centred more consistently on an axis of green and lilac, such as is also found in the contemporaneous work of Guillaumin, Toulouse-Lautrec and the Belgian Neo-Impressionists. Finally, it was in these closing two decades of his life that Sisley's concern to provide visual maps of the locations in which he lived or worked is most coherently realised. This can be seen not only in his shifting angle of vision along the riverbank at Saint-Mammès (Cat. 49–52), but also, more impressively,

in the circular panorama made of Moret-sur-Loing, from its bridge, to its gatehouse, riverbank, wash-house and avenue of poplar trees (see Cat. 59–61, 64–70). This process achieves its most complete statement in his views of the Church at Moret (see Cat. 71A–G), where his angle of vision barely shifts from western portal to south transept as he concentrates upon 'mapping' the movement of light and shade, rain and sun across the building itself.

Sisley found the Moret region replete with potentially promising subjects: 'I have started work again; I have several canvases in hand (watersides)',[3] he wrote to Paul Durand-Ruel from Les Sablons on 7 March 1884; these were some of the many views of the Seine and Loing that he was painting at Saint-Mammès, where the confluence of the two rivers gave a special atmosphere to the river-port (see Cat. 49–52). Moret-sur-Loing held a particular charm. On 31 August 1881, while still living at Veneux-Nadon he conveyed to Monet his impressions of the small town were he was to set up house in September 1882: 'It's not a bad part of the world, rather a chocolate-box landscape... Moret is two hours away from Paris, with plenty of houses to rent... Market once a week, very pretty church, some quite picturesque views...'[4] Although he temporarily left Moret for the nearby village of Les Sablons in October 1883, he returned to settle permanently in November 1889. The town, redolent with history,[5] still retained many medieval features which appear in Sisley's work: the castle keep, a city gate (the Porte de Bourgogne, Cat. 64), the church (see Cat. 71A–G) and numerous ancient houses and streets. It was also magnificently situated beside the Loing, with a bridge and, in Sisley's day, a number of watermills (see Cat. 55). The artist had always chosen his subjects from the places in which he lived. It was this characteristic in his work which was noted both by J.-K. Huysmans in a review of the 6th International Exhibition held at the Galerie Georges Petit in 1887,[6] and, retrospectively, by Geffroy, who recognised it as the prime source of the artist's greatness.[7]

As a pure landscape painter, Sisley's name was most frequently linked by critics to that of Monet, especially from the 1880s onwards. In part this was provoked by an interest in similar themes: haystacks (see Cat. 63); the landscapes at Moret, with the church in the distance that echo those of Vétheuil (see Cat. 67). Above all, Sisley's paintings of the church at Moret are said to have been inspired by Monet's series of *Rouen Cathedral* (see Lloyd, p. 26 and Cat. 71). Indeed, as early as 1873, Théodore Duret had mentioned in the same breath the names of Monet and Sisley.[8] Fourteen years later Paul Signac dismissed Sisley as 'a prettified, bourgeois version of Monet'[9] – whom, we should remember, he profoundly admired. In the same year, in the 6th International Exhibition at the Galerie Georges Petit, Félix Bracquemond 'thought the Sisleys very good, and the Monets very beautiful'.[10] And in 1893 the two men's work found equal favour with the painter Alfred Lebourg: 'I hear wonders of Monet's Rouen Cathedrals ... Monet is in tremendous form ... Sisley, on the other hand, is discouraged. Both men possess great and, I may say, equal talents. The older I get, the more I admire these masters, Monet and Sisley.'[11] For Pissarro, there were times when he felt rather left out ('Petit has undertaken to push Monet and Sisley');[12] but at other times it was Monet's success in particular that he envied. In 1895 he wrote: 'I am left with Sisley at the tail-end of Impressionism.'[13] As Geffroy put it, 'fashion had not smiled on Sisley as it was starting to smile on Monet'.[14]

Some critics however also sought to identify those qualities peculiar to Sisley. In the 1870s such a distinction was drawn by Armand Silvestre[15] and Stéphane Mallarmé.[16] The following decade it was pursued further by J.-K. Huysmans, who considered Sisley 'one of the most gifted of all [painters]'.[17] Echoing views expressed earlier by Théodore Duret,[18] he praised the less robust, the quieter character of his work.[19] Returning to the subject in 1906, Duret recognised

Sisley's distinctive relationship with nature and the personal tonalities of his palette,[20] while Geffroy, in his biographical study of the artist published in 1923 praised his ability to capture 'nature in delicately outlined and nuanced settings'.[21] Harmony, delicacy, refinement, subtlety: such were the qualities that defined Sisley's artistic individuality for all these critics.

Monet and Sisley also had a number of collectors in common. The Rouen industrialist François Depeaux (1853–1920),[22] for example, entertained both artists on his estate at Le Mesnil-Esnard, saw them both in London and, in 1900, he invited Monet's son Michel to stay with him in Swansea,[23] where Sisley had worked three years before, which suggests that he had influenced Sisley's choice of location. Furthermore, the cover of the catalogue of the Depeaux sale in 1906 mentions in one breath '46 works by Sisley. Important works by Claude Monet'. The two names were once more linked in the catalogue of the Masson sale on 22 June 1911: 'Important works by Monet and Sisley'. Count Isaac de Camondo (1851–1911) was another collector who had an equal affection for Monet's *Cathedrals* and Sisley's landscapes.

During the last period of Sisley's life, the two men were so close that on the point of death Sisley called Monet to his bedside to entrust his children to his protection: 'A week ago, poor Sisley sent for me, and I could see, that day, that this was a last farewell. Poor dear friend, poor children!'[24] And it was Monet who took charge of organising Sisley's atelier sale for his children's benefit, donating 'the best thing we have' (namely a Norwegian landscape) as a contribution to the success of the enterprise.[25] The same year, Monet once again gathered Sisley's friends together to present one of the artist's paintings to the Musée du Luxembourg (*The Loing Canal*, Cat. 69).

Sisley had never been jealous of Monet's success. Nor during the last two decades of his life, despite persistent financial stress, did he objectively have as much reason so to be. During the course of the 1880s, collectors and critics[26] began to afford him greater recognition.[27] He was given one-man exhibitions at Durand-Ruel in 1883 and a major retrospective at Galerie Georges Petit in 1897, as well as having his works included in exhibitions in London, Brussels (Les XX) and the United States.[28]

Official recognition was also at hand: the first State purchase came in 1888, when *September Morning* (1888; D692, Fig. 154) was bought, and then deposited with the Musée d'Agen. Five works by Sisley entered the Musée du Luxembourg as part of the Caillebotte bequest (see Cat. 29). When the bequest was exhibited in 1897, Pissarro told his son Lucien: 'Duret ... told me that I was very well represented; those least well represented are Sisley and Monet, both of whom nevertheless have some very good things.'[29] Finally, at the Salon de la Société Nationale des Beaux-Arts, where Sisley exhibited several times from 1891, the City of Paris acquired a *Church at Moret*, which is now in the Musée du Petit Palais (Cat. 71G).

In a letter to Lucien, on 22 January 1899, Pissarro predicted Sisley's place in history: 'They say that Sisley is very gravely ill. He is a fine and great artist. In my opinion he is a master equal to the very greatest. I have seen again some of his works that have a rare breadth and beauty, including a *Flood* that is a masterpiece.'[30]

Sisley died on 29 January 1899, the only one of the Impressionists who never enjoyed in his lifetime anything like the major success that immediately followed his death. At the Tavernier sale, on 6 March 1900, the *Flood* (Cat. 38) was sold to Count Isaac de Camondo for the considerable sum of 43,000 francs. Works by Sisley again reached high prices at the Blot sale on 9–10 May; in the preface to the catalogue, Geffroy repeated what he had said a year earlier, at the atelier sale:

On the day when Sisley's death was announced ... a tremor ran through the public ... The paintings suddenly gained a new prestige...The order of precedence began to fall into place. Alfred Sisley took his rightful place in the glorious lineage of landscape painters ... Any museum and any gallery that now claims to tell the story of the great art of our century would tell that story incompletely if it were not to present ... the gentle, delicate, luminous, shimmering paintings that mark the evolution of Alfred Sisley's talent.[31]

On 1 February 1899, Monet and Renoir were among those who followed their friend's coffin to the Moret-sur-Loing cemetery, at the foot of a rocky outcrop of the Forest of Fontainebleau. He was buried beside his wife, who had died in the previous October. In 1911, 'his' small town paid him a posthumous tribute: 'The people of Moret have raised a subscription to erect a monument to him ... It is their way of honouring the memory of an artist who lived among them.'[32]

1 Gustave Geffroy, *Sisley*, Paris 1923, p. 19.
2 See D. Bretonnet, *Moret, flâneries dans les siècles*, Etrepilly 1983, p. 248.
3 See Lionello Venturi, *Les Archives de l'Impressionnisme*, II, Paris 1939, p. 58.
4 See 'Sisley', *Bulletin des expositions*, Galerie d'Art Braun, Paris, 30 January–18 February 1933, p. 7.
5 See D. Bretonnet and J. Rufin, *Guide illustré, Moret-sur-Loing*, Fontainebleau 1984; see also G. Lesage, 'L'Eglise de Moret, les travaux de 1842 à 1908', *La Revue de Moret et de sa région*, 2nd quarter, 1987, pp. 41–43; 'Sisley à Moret, 1889–1899', *La Revue de Moret et de sa région*, 1st quarter, 1987, special issue; *Sur les pas des impressionnistes; Alfred Sisley à Moret-sur-Loing, Veneux, Saint-Mammès, itinéraire de ses toiles*, with drawings by P. Brochard, Moret-sur-Loing 1989.
6 'Noteworthy ... M. Sisley's locations.' J.-K. Huysmans, 'L'Exposition internationale de la rue de Sèze', *La Revue indépendante* (8 June 1887), p. 353.
7 Geffroy, *op. cit.*, p. 11.
8 Letter from Duret to Pissarro, 26 April 1873, in Janine Bailly-Herzberg, ed., *Correspondance de Camille Pissarro*, Paris 1980, I, p. 79.
9 Letter from Signac to Pissarro, Comblat-le-Château, 30 June 1887, in Bailly-Herzberg, *op. cit.*, vol. 2, Paris 1986, p. 188.
10 Letter from Pissarro to his son Lucien, 15 May 1887, in Camille Pissarro, *Lettres à son fils Lucien*, ed. John Rewald with the assistance of Lucien Pissarro, Paris 1950, p. 148.
11 Letter from Lebourg to F. Roux, Rouen, 13 November 1893, in F. Lespinasse, *Alfred Lebourg (1849–1928)*, Arras 1983, pp. 102–03.

12 See note 10 above.
13 Letter from Pissarro to his son Lucien, 24 February 1895, in Pissarro, ed. J Rewald, *op. cit.*, p. 370. See also letter of 11 April 1895, *ibid.*, p. 377: 'Business is excessively bad, and, along with Sisley, I am the worst treated ... '
14 Geffroy, *op. cit.*, pp. 7–8.
15 'At first sight it is hard to decide what differentiates M. Monet's painting from that of M. Sisley ... A little study will soon make it plain to you that [of the Impressionists] M. Monet is the most skilful and the most daring, M. Sisley the most harmonious and the most timid ...' A. Silvestre, exh. cat., *Galerie Durand-Ruel: recueil d'estampes gravées à l'eau-forte*, Paris 1873; reprinted in D. Riout, ed., *Les Ecrivains devant l'Impressionnisme*, Paris 1989, p. 37.
16 'MM. Claude Monet, Sisley and Pissarro ... A somewhat superficial observer might really take all these works for those of a single man ... Nevertheless, our visitor would modify his first impression ... and would perceive that each artist has his favourite topics ... Sisley captures the fleeting moments of the day, observes a passing cloud, and seems to capture it in flight. On his canvas, a light breeze blows, and the leaves still shiver and tremble.' S. Mallarmé, 'The Impressionist and Edouard Manet', *The Art Monthly Review*, London, (30 September 1876); reprinted, trans. P. Verdier, in Riout, *op. cit.*, p. 37.
17 J.-K. Huysmans, 'L'Exposition des indépendants en 1880', in Huysmans, *L'Art moderne*, Paris 1883; reprinted in Riout, *op. cit.*, p. 257.
18 'Sisley is less bold, perhaps, than Monet; he treats us to fewer surprises; but he is

never left high and dry, as Monet sometimes is, through trying to render effects so fleeting that there is no time to capture them ... He shows a likeness and affinity with them [his predecessors] in the brushwork and layout of his canvases, but he is nonetheless independent in his manner of feeling and interpreting Nature.' Th. Duret, *Les Peintres impressionnistes*, Paris 1878; reprinted in Riout, *op. cit.*, p. 218.
19 'The so-called Impressionist painters, MM. Claude Monet and Sisley, have returned to the scene ... M. Sisley, who with M. Pissarro and M. Monet was one of the first to turn to Nature ... With an artistic temperament less abrupt, less nervous, and an eye initially less wild than those of his two fellow-artists, M. Sisley is of course less strongly defined, less personal than they. He is a painter of genuine worth ... His work has resolution; it has emphasis; there is a pretty, smiling melancholy in it, and often a beatific charm.' Huysmans, *L'Art moderne*, Paris 1883; reprinted in Riout, *op. cit.*, pp. 298, 302–03.
20 '... within the Impressionist group, Claude Monet and Sisley are in a sense inseparable; they form a pair, much more like each other than either is like any of the others; nevertheless, they remain individuals, and each has his own palette and his own way of seeing and feeling. It may be said of Sisley, as his characteristic feature, that he succeeded in rendering Nature with a smile. His work has charm ... Sisley was a sensitive soul who took delight in Nature ... His originality manifested itself above all in a new and unexpected approach to colour, which came in for some condemnation. He was

accused of painting in an artificial, lilac colour scale.' Th. Duret, *Histoire des peintres impressionnistes*, Paris 1906, pp. 107–8.

21 'A lively personality appears ... A countryman's joy in painting is revealed, an aptitude for seeing Nature in delicately outlined and nuanced settings. He also pursued diffusions of light, orchestrations of tones.' Geffroy, *op. cit.*, p. 21.

22 On the collectors, see A. Distel, *Les Collectionneurs des impressionnists*, Paris 1989; and on Depeaux, see letter from Pissarro to his son Lucien, 23 January 1896, in Pissarro, ed. J. Rewald, *op. cit.*, p. 397.

23 Letter from Monet to Alice Monet, London, 24 March 1900, in D. Wildenstein, *Claude Monet, biographie et catalogue raisonné*, vol 4, Lausanne and Paris 1985, letter 1537. See also letter 1543 to Alice Monet, London [28 March 1900].

24 Letter from Monet to Geffroy, 29 January 1899, in Wildenstein, *op. cit.*, vol. 4, letter 1434; letter from Monet to Pissarro [June 1883], *ibid.*, vol. 2, letter 1979.

25 Letter from Monet to Julie Manet, Giverny, 23 March 1899, in Wildenstein,

op. cit., letter 1449. The work donated by Monet for the Sisley studio sale at Galerie Georges Petit, 1 May 1899, was no. 65 in the catalogue, *The Village of Sandviken under Snow*, The Art Institute of Chicago; W1397). On the part played by Monet in the organisation of the sale, see A. Alexandre, preface to Sisley studio sale catalogue, Galerie Georges Petit, Paris, 1 May 1899, p. 16.

26 There were exceptions to this pattern, notably Octave Mirbeau, who wrote a stinging review of Sisley's paintings shown in the 1892 Salon du Champ-de-Mars (*Le Figaro*, 25 May 1892). His most ardent defender was Adolphe Tavernier, a not-very distinguished critic, but one who published a laudatory article on the painter in 1893. Sisley responded to this with a letter to Tavernier, Moret-sur-Loing, 19 March 1893 (R. Huyghe, 'La grande pitié d'un maître impressionniste, Lettres inédites de Sisley', *Formes*, November 1931, p. 153): 'I have just read your study ... It is a tremendous fillip to me ... I could never wish to be better "explained"; I shall certainly not be explained with greater mastery.'

27 Letter from Pissarro to his son Georges,

10 November 1897, in Bailly-Herzberg, *op. cit.*, Paris 1989, IV, p. 397.

28 See Durand-Ruel Godfroy, Johnston, and Cahn, Documentary Chronology.

29 See letter from Pissarro to his son Lucien, 16 March 1897, in Pissarro, ed. J. Rewald, *op. cit.*, p. 435; also letter of 10 March 1897, *ibid.*, p. 433: 'Sisley's are perhaps not the most finished things, but interesting all the same.' The five Sisleys that Caillebotte bequeathed to the Musée du Luxembourg (all now in the Musée d'Orsay) are: *Farmyard at Saint-Mammès* 1884; R.F. 2700); *Edge of the Forest in Spring* 1885; R.F. 2784); *Saint-Mammès* (1885; R.F. 2785); *The Seine at Suresnes* 1877; R.F..2786); *Molesey Regatta* 1874; R.F. 2787).

30 See Pissarro, ed. J. Rewald, *op. cit.*, p. 465.

31 G. Geffroy, preface to Sisley atelier sale catalogue, Galerie Georges Petit, Paris, 1 May 1899, p. 6; reprinted in sale catalogue of Blot collection, Paris, Hôtel Drouot, 9–10 May 1900, pp. 139–40, and in Geffroy, *op. cit.*, p. 28. See also J. Leclercq, 'Alfred Sisley', *Gazette des Beaux-Arts*, March 1899, p. 236.

32 Th. Duret, 1906, *op. cit.*, p. 125.

47 *The Small Meadows in Spring: By*

Les Petits Prés au printemps – By
c.1880; D391
54 × 73 cm
Signed bl: Sisley
Tate Gallery, London, presented by a body of
subscribers in memory of Roger Fry, 1936
Exhibited in London only

In January 1880, succumbing to financial
pressures, Sisley withdrew from the Paris
suburb of Sèvres to the *départment* of Seine-
et-Marne where he lived for the remainder
of his life. Until September 1882, he lived
in the village of Veneux-Nadon, now
Veneux-les-Sablons, about three miles west
of Moret.

This painting shows the small meadow
path on the south bank of the Seine at a
bend west of Saint-Mammès, below the
confluence of the Seine and Loing. The
meadow is known as *Le Lutin*. A paved
road has superseded the path between
Veneux and the nearby hamlet of By, now
By-Thomery. Depictions of paths along
riverbanks, often in wooded settings, had
appeared in Sisley's oeuvre since the mid-
70s (see Cat. 40, 41) but these were to
become a regular compositional feature of
his works of the early 80s. At the 7th
Impressionist Exhibition held in 1882 Sisley
submitted two such works, *The Path to By*
(no. 165, D435) and *Chemin des fontaines at
By* (no. 180, D434, now known as *Chemin
des fontaines near By: May Morning*). These
paths were occasionally dotted with
figures. The same path from the opposite
direction is shown in *The Path through the
Small Meadows at By, Stormy Weather*
(D405; Musée Masséna, Nice). Another
landscape closely resembling the
composition of the Tate painting is *Banks of
the Seine at By* (D392; Cat. 48).

Predominantly cool colours with hints
of burgeoning foliage in the central mass of
trees and shrubs in the otherwise leafless
landscape suggest that the season is early
spring, and the lengthening shadows falling
to the north-east, that it is late in the day.
Throughout his work, from the early 1870s
onwards, skies played a significant role. In
the landscape, the preoccupation with skies
is linked with the pursuit of their
reflections in the river, which adds a
transitory note and confirms Sisley's
conviction that landscapes must record the
fleeting moment.

In the eighties, Sisley exploited the
tension between the rich, variegated
surfaces of his paintings and the suggestion
of recession. While continuing to employ
the traditional recessional motif of a path
leading back into the depth of the
landscape, a practice found in his less-
adventurous landscape paintings of the
mid-1870s, at the same time he introduces a
cross-rhythm of increasingly complex
interlocking planes. In this painting, for
example, straggly boughs cropped at the
right by the frame establish the immediate
foreground which cuts across the depth
imparted by the path punctuated by
diminishing figures extending to the
horizon, and the clusters of trees on the
left.

Erwin Davis, of New York, the
pioneering American champion of
Impressionism, acquired this painting
though Durand-Ruel in New York and
retained it until shortly before his death at
the turn of the century even though he had
liquidated a significant portion of his
holdings a decade earlier.

W.R.J.

PROV: Erwin Davis, New York; Durand-Ruel,
New York, 14 April 1899; Arthur Tooth and
Sons, London, 1931; presented to the National
Gallery by a body of subscribers in memory of
Roger Fry 1936; transferred to the Tate Gallery,
1953.

EXH: New York, Durand-Ruel, 1927 no. 15;
Paris, Durand-Ruel, 1930, no. 51.

BIBL: Laver, 1937, pl. 104; McGreevy, 1938,
p. 181, repr. p. 197; Bell, 1940, p. 38, repr.;
Roe, 1942, p. 146, repr. p. 173; Davies, 1946,
p. 87; Cogniat, 1978, p. 45, repr.; Lassaigne and
Gache-Patin, 1983, p. 118, repr.

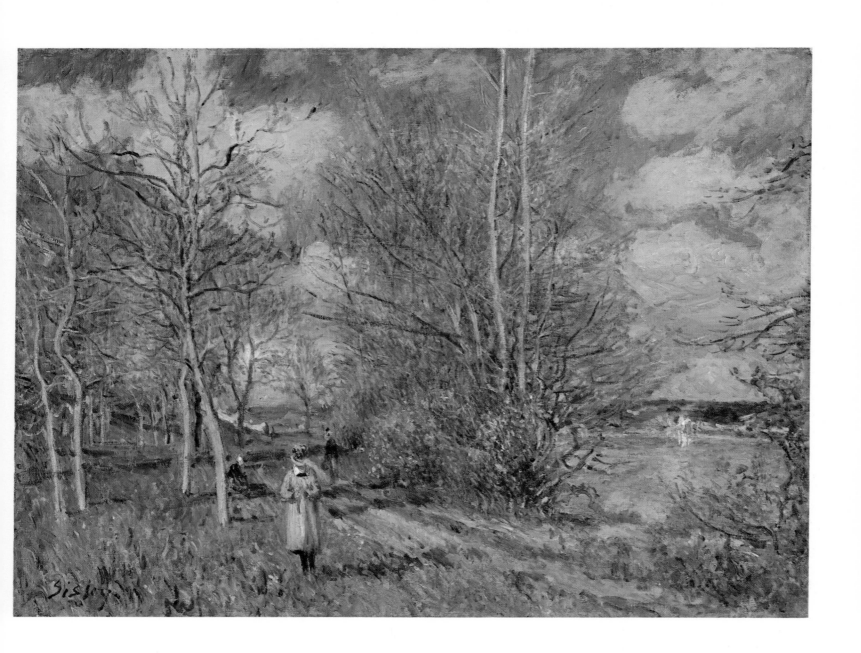

48 *Banks of the Seine at By*

Bords de la Seine à By
1881; D392
54 × 73 cm
Signed bl: Sisley
The Sterling and Francine Clark Art Institute,
Williamstown
Exhibited in Baltimore only

PROV: G.-A. Camentron, Paris; Durand-Ruel,
Paris, 1891; R. Sterling Clark, New York, 1948;
The Sterling and Francine Clark Art Institute
1950.

EXH: San Francisco, 1939.

BIBL: *A Selection of Paintings from Durand-Ruel
Galleries*, New York, 1948, no. 2, pl. 14;
Sterling and Francine Clark Art Institute,
Williamstown, 1956, no. 126, pl 43.

Among the twenty-seven paintings by
Sisley included by his dealer Paul Durand-
Ruel in the 7th Impressionist Exhibition of
1882 were a number whose titles gave
more than merely geographic locations.
Rather they contained references to times
of day, months or weather conditions,
suggesting that Sisley wanted to capture
the ephemeral effects of weather and time
as much as describe the more physical
aspects of the landscape. Less doctrinaire in
approach than Claude Monet, he
frequently returned to the same site to
explore the visual potential of a particular
scene under different temporal and seasonal
conditions.

Neither the Tate (Cat. 47) nor the Clark
painting bears a supplementary title, both
recording approximately identical views
under similar weather conditions.
However, to assert that they are variants,
or one a reprise of the other, would be
misleading. In terms of location, Sisley has
moved a few yards up the Seine from the
position taken up in the Tate Gallery
painting, and has turned his angle of vision
slightly to the left. Additional trees have
thus been introduced in the immediate
foreground, a boat on the river-shore, and
a hill-side on the left. Likewise, whereas the
shadows cast in the Tate Gallery picture
suggest that the scene was caught in the
afternoon, those in the Clark painting
appear to indicate morning or noon.
Unusually, in both pictures the figure of
the girl plays a significantly greater role in
the composition than is characteristic for
Sisley. In the Tate picture she has assumed
a static pose serving as a note of colour
and, perhaps, imparting a sense of intimacy
to the scene, whereas in this work she
appears more actively engaged in the
landscape, walking as she does along the
path and observing the river.

Though Sisley did not date his views of
the path to By he does not seem to have
returned to the site after his move from
Veneux-Nadon to Moret in September
1882.

W.R.J.

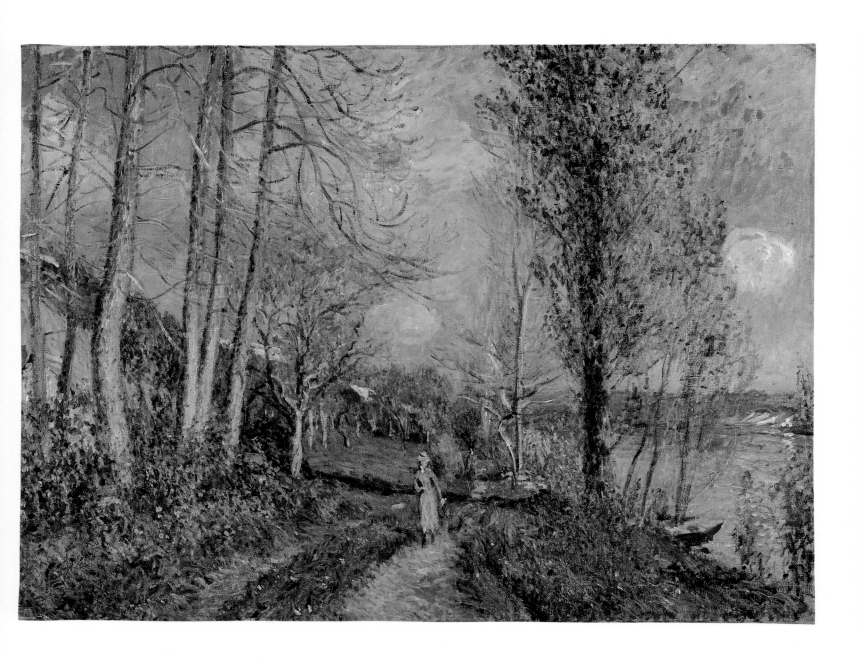

49 The Bridge at Saint-Mammès

Le Pont à Saint-Mammès
1881; D424 (known as *Le Pont de Villeneuve*)
54.6 × 73.5 cm
Signed br: Sisley
Philadelphia Museum of Art, John G. Johnson
Collection

In this work Sisley has returned to a compositional device which he used to great effect in the 1870s: a bridge extending diagonally across a river to a town on the opposite bank. Earlier examples include *The Bridge of Villeneuve-la Garenne*, 1872 (D37; Cat. 14) and *Hampton Court Bridge: the Mitre Inn*, 1874 (D123, Cat. 25). Indeed, this painting's similarity in subject to Cat. 14 may have given rise to its misnomer, *Bridge at Villeneuve*, which first appeared in John G. Johnson's catalogue of 1892. As was confirmed by Leopold Reidemeister in 1962 (curatorial file, The Philadelphia Museum of Art), the view shown is actually of the bridge which crosses the Seine at Saint-Mammès. The structure, subsequently replaced by a concrete bridge, is identifiable by its iron span carried on stone piers and arches.

In this tranquil afternoon scene Sisley shows sunlight filtered by a thin layer of clouds striking the bridge. Though employing a uniformly delicate impasto he has varied his brushstrokes of deep and greyish blues applying them in the expansive sky in broad, curving sweeps with traces of unblended pigments. The row of poplars on the opposite shore is so lightly rendered that the grey ground colour remains visible. Seen through the trees are the church and houses of Saint-Mammès with their brown and bright-red roofs and contours outlined in white. Reflections of the trees, buildings and the bridge in the tranquil surface of the river are suggested by short, horizontal dabs of various blues, greens and dark umber colours, with ripples indicated by scumbly white lines. In the foreground, the artist has left the reeded bank loosely defined with broad, only partially blended diagonal strokes of tan, ochre, red and dark green.

When taken in conjunction with other views of Saint-Mammès from across the Seine, for example Cat. 50–52, the role of Cat. 49 as part of a sequential unveiling of the extent of the river port as it stretches out along the river bank is evident. It is tempting to read such a sequence from left to right (or north-east to south-west), opening with this painting, followed by the two view of Saint-Mammès (D426 and D422, Cat. 50 and 51) and closed on the right by D421 (Cat. 52). It is this shifting of the angle of view which Sisley had explored less systematically during the previous decade (see Cat. 37–39). Possibly derived from the sequential organisation of albums of Japanese prints, such a procedure was to find its resolution in his views of the Canal du Loing made in the mid-1880s (see Cat. 56–58) and of the town and bridge of Moret-sur-Loing (see Cat. 59–61, 64–68, 70).

Sisley is not known to have repeated this specific view of the bridge which he recorded in his sketchbook (Fig. 107). When incorporating the bridge into other landscapes painted during the first half of the 1880s, for example, *Sunrise, Saint-Mammès* (1880, D376, Private Collection), it is always pressed back into the composition, functioning in a sense as a marker for the middle ground. Indeed, the viewpoint and dramatic composition of this painting represent a return to the artist's interests of the previous decade. Nor does the work, in its execution, recall Sisley's interests of the mid-1880s, where greater evenness of facture and the juxtaposition of heightened colours have suggested an awareness of Neo-Impressionism (see Cat. 56). The work therefore, is thought to date from around 1881, being made within the year of his arrival in the Saint-Mammès region.

W.R.J.

PROV: Haseltine Galleries, Philadelphia; John G. Johnson, 1888; Philadelphia Museum of Art, 1933.

EXH: San Francisco, 1939–40, no. 140.

BIBL: Valentiner, 1913–14, vol. 3, p. 149, no. 1082; *John G. Johnson Collection*, Philadelphia, 1941, p. 66; Canaday, 1959, p. 191, repr. p. 251; Reidemeister 1963, p. 154, repr.; Lassaigne and Gache-Patin, 1983, p. 21, repr.

107 Alfred Sisley, *Saint-Mammès*, drawing from the Sisley sketchbook, fol. 16 (Département des Arts Graphiques, Musée du Louvre, Paris).

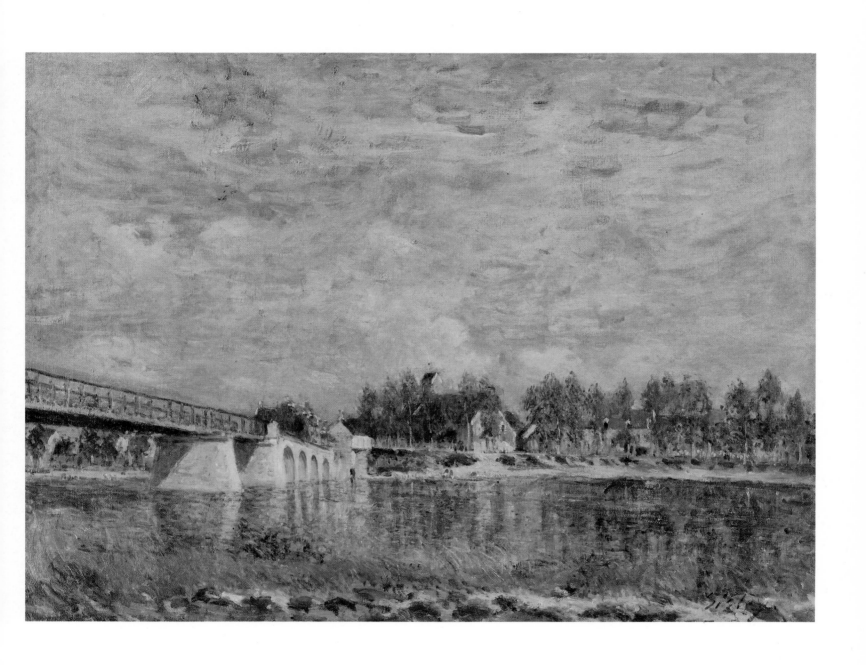

50 *View of Saint-Mammès*

Vue de Saint-Mammès
1881; D426 (known as *Les bords de la Marne*)
54 × 73 cm
Signed bl: Sisley
The Walters Art Gallery, Baltimore

Sisley has returned to a motif not far distant from that depicted in his *Barge at Saint-Mammès* (D388; formerly Theo Pitcairn collection, Bryn Athyn, PA). Moving down the River Seine from the bridge shown in *The Bridge at Saint-Mammès* (Cat. 49) and swivelling his position slightly, he presents a perspective of the Quai de Seine, its old houses screened by a row of poplar trees, from a point on the north bank of the river, slightly upstream from *Saint Mammès: Morning* (Cat. 52) and the two paintings entitled *View of Saint-Mammès* (see Cat. 51). The same small boat or barge from which the Pitcairn picture derives its title is nestled in the foliage on the bank. Near the end of the *quai* is a chestnut tree, identifiable by its rounded form and deep coloration, which serves as a central motif in several paintings dated 1880 including *The Chestnut Tree at Saint-Mammès* (D371) and *Boatyard at Saint-Mammès* (D372).

The Pitcairn and the Walters pictures share a pronounced diagonal composition with the densely overgrown river bank occupying much of the bottom and right foreground. In the latter painting, the diagonal recession is reinforced by low-lying clouds streaking across the sky from the west. What distinguishes this work from the other views of the Quai de Seine is the surety and vigour with which it has been executed. The swaying grasses and shrubs in the foreground are interpreted in bold, overlapping strokes applied in rhythmical patterns. In the sky, the impasto of the long, broad curves of paint is clearly visible and for the row of houses, dabs of pasty pigment are employed. The sense of spontaneity is reinforced by large areas of grey ground colour left exposed in the corners of the painting.

In the winter scenes, such as *The Lane from By to Bois des Roches-Courtaut* (Cat. 53) a uniform dryness of technique imparts to them a winter chill. In contrast the carefully differentiated zones of brushwork for swaying grasses, houses, water and sky in this painting, and in Cat. 49, 51, 52, describe a more systematic analysis of the formal structure of a landscape (see Fig. 21). This is very similar to a procedure applied by Monet in his paintings made in the early 1880s.

A preponderance of Sisley's paintings of the early 1880s are not dated and in many, the sites have been misidentified. A label on the reverse of this work refers to it as *Banks of the Marne*, the title retained by François Daulte in his catalogue raisonné.

As was true of many paintings of the 1880s, this picture was deemed by Durand-Ruel to be appropriate for the North American market. Initially acquired in 1893 together with two Monets by Sir William Van Horne of Montreal, it was returned to the dealer's New York gallery the following spring. Ironically, Van Horne subsequently emerged as one of Canada's most audacious champions of Impressionism and Post-Impressionism and was also a most discerning collector of Old Master, Romantic and Realist paintings. An accomplished amateur painter himself, Van Horne employed a modified Impressionist technique.

W.R.J.

PROV: Durand-Ruel, Paris; bt Sir William Van Horne, Montreal, 6 May 1892; returned to Durand-Ruel, New York, 15 April 1893; bt Henry Walters, Baltimore, from Durand-Ruel, 12 January 1909.

EXH: Buffalo, 1907, no. 7; Baltimore 1951, no. 116; Wolfsburg, 1961, no. 58; Tokyo-Fukuoka-Nara, 1985, no. 31, Montreal 1989–90, no. 54.

BIBL: Johnston, 1982, pp. 143–44, no. 157, repr.

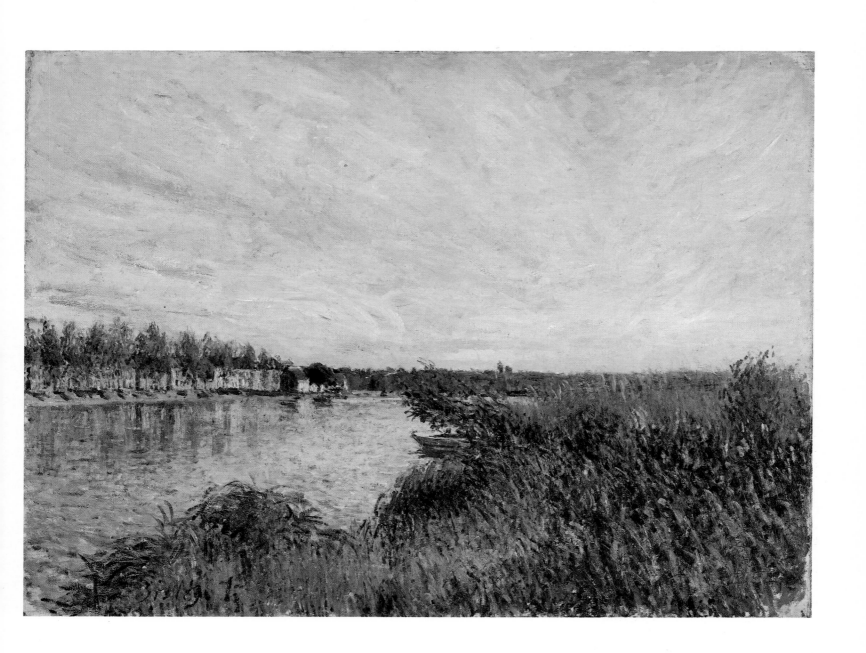

51 *View of Saint-Mammès*

Vue de Saint-Mammès
1881; D422 (known as *Village sur les bords de la Marne*)
54 × 73.7 cm
Signed br: Sisley
The Carnegie Museum of Art, Pittsburgh;
Museum Purchase 1898

This view across the Seine showing the *quai* at Saint-Mammès was painted from the same vantage point as in *Saint-Mammès: Morning* (Cat. 52) though looking slightly to the east. Both works illustrate the artist's singular powers of perception which allowed him to extrapolate to the full the visual potential of a particular site however mundane and lacking in dominant features it might be. There is a similar expansiveness to this view with depth suggested by atmospheric recession and by a glimpse of the gently rolling terrain at the far right. Again it is dawn and the sunlight, filtered by a light morning haze, silhouettes the house-tops and trees against the sky. Nothing stirs the air, allowing the river to mirror the houses on the quay. In the foreground, the grasses and reeds are less dense than in *Saint-Mammès: Morning* (Cat. 52) and a tremulous effect is achieved by the glistening surfaces of the bent stalks catching the light.

Inevitably, Sisley's Saint-Mammès views invite comparison with Claude Monet's paintings of 1879–80 showing Lavacourt and Vétheuil from the Seine. Sisley remained rooted to his subjects, conveying in his views every perceived sensation, no matter how delicate and fugitive. For him, the ephemeral is trapped by his sequential exploration of a given location, which, in this case, involves not only four shifting views along the Seine at Saint-Mammès but also the retention of the line of the river bank which sets a fixed horizon for each composition. In Monet's work, however, as landscape forms became more incorporeal, dissolving in the sunlight, the internal balance of the composition was established by the counterbalance of actual form with reflected form.

Like so many works of the early 1880s, *View of Saint-Mammès* figured prominently in the early collecting of Impressionism in America. Durand-Ruel sold it to W.L. Andrews, a New York merchant, in 1888, and subsequently resold it to one of his most regular clients for Impressionist works, A.W. Kingman. When acquired by the Carnegie Institute in 1898 the painting became the first by the artist to enter an American public collection.

W.R.J.

PROV: bt from the artist by Durand-Ruel, 23 July 1881, as *Village au bord de l'eau*, stock no. 1483; Mr Andrews (probably William L. Andrews of New York), 16 October 1888; A.W. Kingman, 11 April 1892; bt Durand-Ruel, 5 March 1896; Carnegie Institute, 1898.

EXH: Pittsburgh, 1898 no. 203; Colorado Springs December 1946; Omaha, 1957; Pittsburgh, 1959, no. 1; New York, Paul Rosenberg and Co., 1961, no. 16; New York, Wildenstein and Co., 1966 no. 47; New York, Acquavella, 1968; Tokyo-Fukuoka-Nara, 1985, no. 31; Pittsburgh-Minneapolis-Kansas-Saint-Louis-Toledo, 1990, no. 83.

BIBL: F. Myers, *Carnegie Magazine*, Pittsburgh, 1965, p. 33, repr.; Fromme, 1981, p. 256; *Carnegie Institute Collection Handbook*, 1985, p. 98, p. 99, repr.

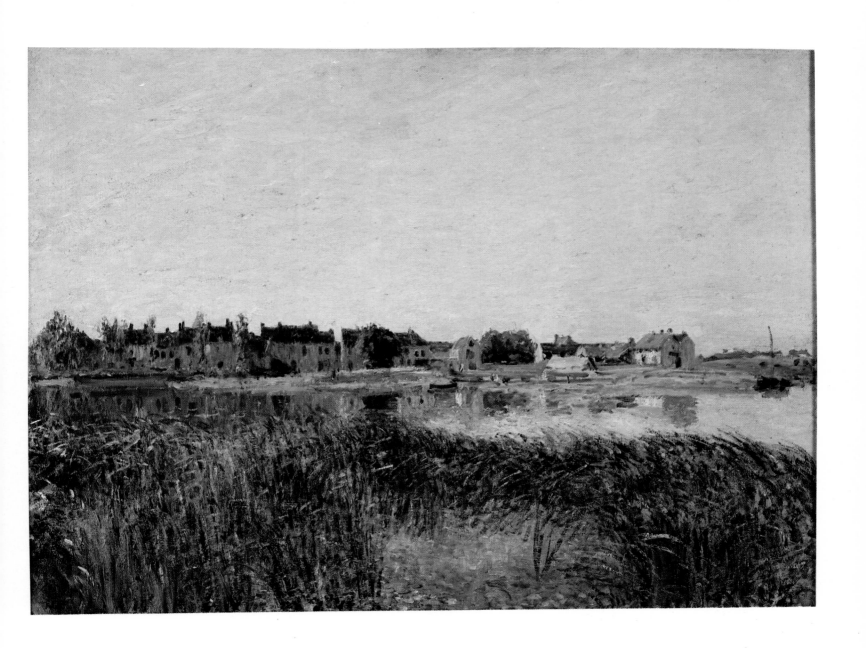

52 Saint-Mammès: Morning

Saint-Mammès – le matin
1881; D421
50 × 73 cm
Signed br: Sisley
William A. Coolidge Collection

PROV: F. Gérard, Paris; Bernheim-Jeune, Paris; Paul Cassirer, Berlin; Siegfried Arndt, Berlin-New York; bt from Knoedler and Co., by William Coolidge in 1959.

EXH: Paris, Petit, 1917, no. 7.

When he first stayed at Veneux-Nadon, Sisley was attracted to the waterways of Saint-Mammès. Describing the region to Claude Monet, he wrote on 31 August 1881:

> It's not a bad part of the world, rather a chocolate-box landscape, of the rest, you must remember it. On my side, when I arrived there were many fine things to do, but they have worked on the canal, cut the trees, made quais, aligned the banks. (*Bulletin des Expositions*, II, Galerie d'art, Braun et Cie, January and February, 1933, p. 7).

In this work Sisley depicts the confluence of the Seine and Loing rivers at Saint-Mammès seen from the north bank of the Seine. On the left, old houses line the Quai de Seine and on the right, a number of barges are moored. Other views of this site seen from slightly varying angles and distances include *Barge at Saint-Mammès*; (D388; formerly Theo Pitcairn Collection, Bryn Athyn, PA), *View of Saint-Mammès* (Cat. 50) and *View of Saint-Mammès* (Cat. 51). With the exception of the Pitcairn painting which may predate the others, Sisley employs a low horizon which emphasises the expansiveness of the sky, clear and blue but for the wisps of cloud. Sunlight rakes the shoreline, tree tops and several of the houses, but leaves the remainder of the quay in deep blue and mauve shadows. The buildings cast long reflections on the shimmering surface of the water. As was his custom for such river scenes, Sisley includes the marshy shoreline with its reeds and grasses in the immediate foreground (detail, Fig. 24).

The areas of differentiated brushwork, and the proximity of locations suggest that this painting and two other views of Saint-Mammès (Cat. 51 and Cat. 50) were contemporaneous. To this group could also be added *Bridge at Saint-Mammès* (Cat. 49). Daulte assigns them a date of 1881, the year of Sisley's arrival in the region.

W.R.J.

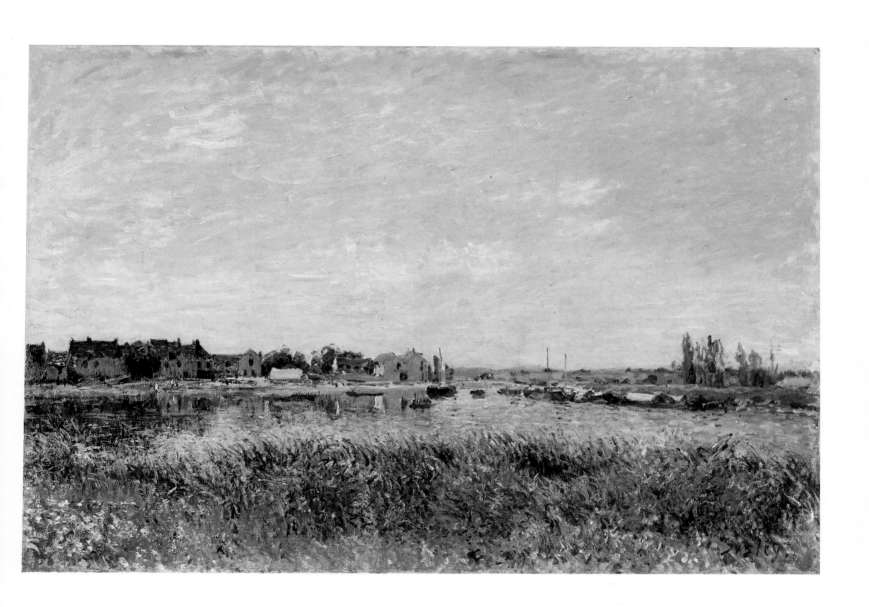

53 The Lane from By to Bois des Roches-Courtaut: Indian Summer

Chemin de By au Bois des Roches-Courtaut – été de la Saint-Martin
1881; D433
60 × 81 cm
Signed bl: Sisley
The Montreal Museum of Fine Arts Collection,
purchase John W. Tempest Bequest

The title, referring to the été Saint-Martin, identifies the season during which this painting was made. The feast of St Martin falls on 11 November; 'St Martin's summer' can be interpreted as 'Indian summer'. When Sisley arrived in the region of Veneux-Nadon in 1880 he was much taken by the less kempt aspects of the terrain. Frequently he portrayed foot paths through woods and thickets, and along overgrown river banks (see Cat. 47). Roches-Courtaut figures in at least eight works from the period, usually in views of wooded areas or as an elevated vantage point overlooking the Seine valley. This painting shows the east-west bend in the Seine, just downstream from Saint-Mammès. The Path to By (D435; Camille Bloch Collection, Berne) closely resembles it in composition whereas The Path to Bois des Roches-Courtaut, Winter Morning (D408, Musée du Louvre, Victor Lyons Collection, Paris) depicts the same path from the opposite direction. Sisley was particularly drawn to such sites during the colder seasons when the trees were bare, permitting the delineation of tangled, twisted trunks and branches of scraggly overgrowth. Here the river is seen during the afternoon when the shadows are beginning to lengthen. A crispness in the air, despite the sunlight, is suggested by the clarity of the atmosphere. The stillness is imparted to the scene by reflections of the sky and the receding row of poplars on the opposite shore of the river's tranquil surface. Although contrasting the golds, russets and umber colours of the vegetation with the various blues in the sky and water, Sisley retains a chromatic unity with touches of lilac, blue and mauve in the shadows in the overgrowth.

The surface of the canvas is richly variegated, the artist using irregular, staccato brushstrokes for the immediate foreground and attenuated, curving, often agitated lines drawn in scumbled paint for the tree branches. The sky and water are more thinly rendered with partially blended colours. The interplay between surface texture and spatial depth is particularly pronounced in this work. A sense of recession has been achieved both compositionally, in the tunnel-like pathway and the diminishing row of poplar trees, and atmospherically, the sky and its reflection in the river regressing from a strong cobalt blue to muted greys and blues near the horizon.

Though none of the related river scenes were dated by the artist, Daulte suggests that this painting was executed in 1881, Sisley's second autumn in the region. Paintings of the same area, Path on the Roches-Courtaut: Autumn (D437), The Woods at Roches-Courtaut, near By (D403) and The Road to By (D435), are recorded as having been bought from the artist by Durand-Ruel between November 1881 and January 1882. Thus, although none of these works was dated by the artist, it may be assumed that the Montreal painting was painted around November 1881.

W.R.J.

PROV: Durand-Ruel Galleries, Paris-New York, by 1921; The Montreal Museum of Fine Arts, John W. Tempest Bequest, 1923.

EXH: New York, Durand-Ruel, 1921, no. 7 as Chemin de By aux bois des Buches-Courteau; Toronto-Montreal-Ottawa, 1954, no. 62; Montreal circulating exhibition, 1966–67, no. 87; Tokyo-Fukuoka-Nara, 1985, no. 33.

BIBL: Catalogue of Paintings, Montreal, 1950, p. 107; European Paintings in Canadian Collections, Modern Schools, Toronto, 1962, p. 158.

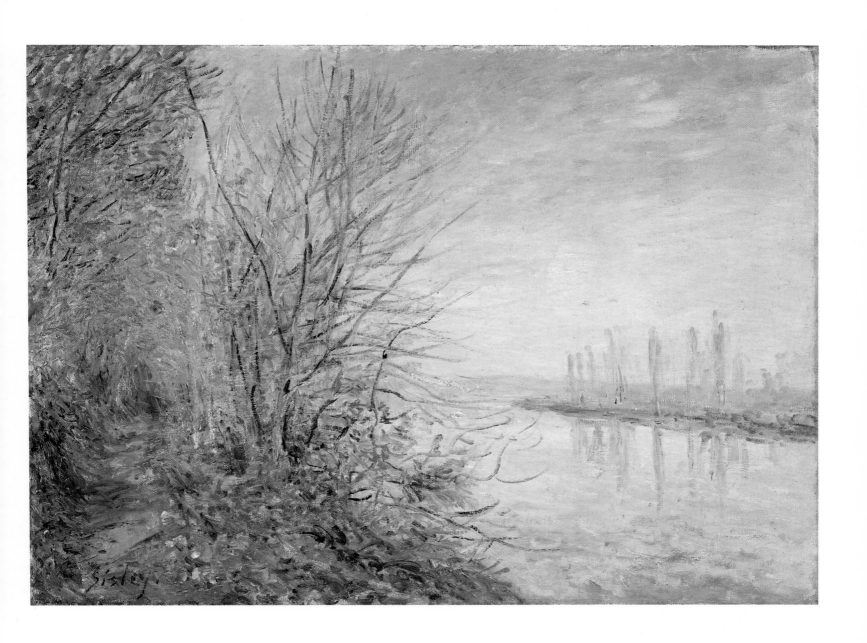

54 *Willows on the Bank of the Orvanne*

Saules au bord de l'Orvanne
1883; D478
50 × 70 cm
Signed and dated br: Sisley 83
Private Collection, Switzerland

PROV: bt by Durand-Ruel from the artist,
21 May 1883; Durand-Ruel, New York; Private
Collection, Paris.

EXH: New York, Durand-Ruel, 1914, no. 14;
San Francisco, 1938; London, Malborough
Galleries, 1955, no. 44.

This remarkable landscape appears to be an anomaly in Sisley's production in the early 1880s, both in choice of site and composition. Although the Orvanne, a small stream which runs parallel to the east bank of the Loing canal and flows into the Loing river at Moret, figured prominently in the artist's work in 1890/91 it occurred only twice earlier, in this painting and in *Little Bridge over the Orvanne, March Morning* (D375) of 1880. Lacking are the receding paths and rivers, and expansive skies characteristic of his compositions in the eighties. Instead Sisley has shown a wooded scene which in its density recalls the Fontainebleau forest interiors of V.N. Diaz and J.L. Dupré and serves to corroborate Christopher Lloyd's observation that the artist had, at this point in his career, returned to his Barbizon roots (see Lloyd pp. 22, 170).

Despite the seemingly random overgrowth Sisley has maintained tight control over the scene, dividing it into a progression of planes: the grassy foreground with willow trees and glimpses of water; the midground including patches of reeds on the opposite bank, a row of poplars and a fence; and beyond in the background, a clearing and the houses serving as a central focal point. A figure, leaning against the pruned willow at the right, adds a point of interest. As was his custom, Sisley varied the brushwork defining the foliage in the foreground with slashing strokes, using a more pliant application of his pigments in the midground, and treating glimpses of sky with modulation. It is a sun-drenched scene and the vibrant blue sky, though screened by trees, retains a dominant role. Because of its intensity, the light creates patterns of shadow, particularly in the foreground, varying in both hue and saturation. The lilac-tinted shadows which distracted French and American critics alike are particularly apparent in the tree trunks, foliage and the roofs of the houses.

W.R.J.

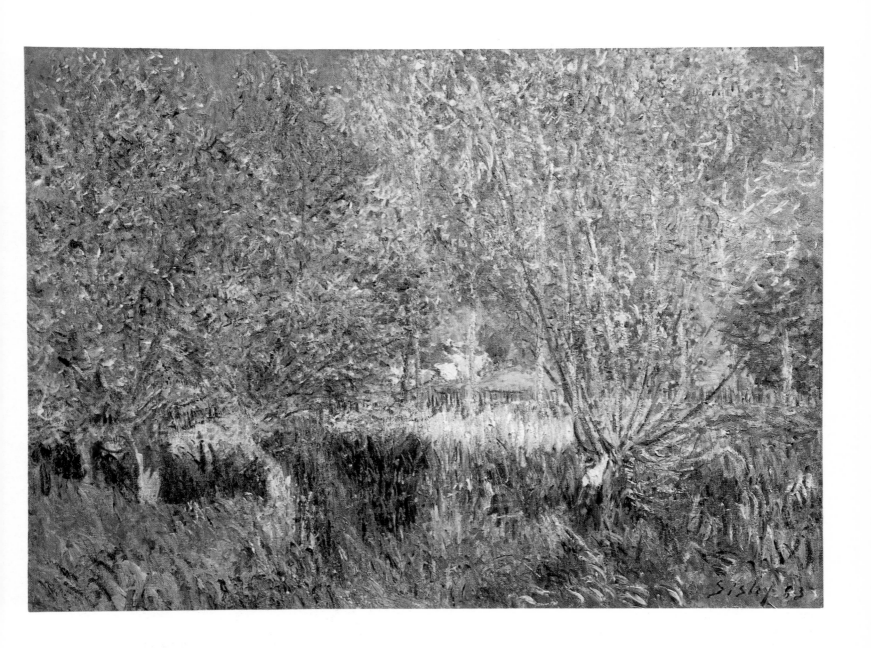

55 *The Provencher Watermill at Moret*

Le moulin Provencher à Moret
1883; D503
54 × 73 cm
Signed br: Sisley
Museum Boymans-van Beuningen, Rotterdam
Exhibited in London and Baltimore only

In 1888–91, Sisley was to paint several pictures of the watermills at Moret; this earlier view of the Provencher watermill, which occupied the middle of the bridge over the Loing, dates from 1883. A view of the same wooden bridge, seen from the stone bridge of Moret, under snow, was made nine years later and is now in the Musée des Beaux-Arts, Algiers (D725, Fig. 109).

Sisley several times painted a bridge driving across a landscape. On a number of occasions during his career, he sought out these structures, often using their configurations to produce some of his most innovative compositions. While in the *Provencher Mill*, the spectator is not positioned directly under the receding arches of a bridge, as in for example, *Under Hampton Court Bridge* (1874, Cat. 26), the important plunge into depth of the wooden structure relates the composition to such paintings as *The Bridge of Villeneuve-la-Garenne* (1872, Cat. 14) and *Hampton Court Bridge: the Mitre Inn* (1874, Cat. 25).

A pencil sketch in the Sisley Sketchbook now in the Département des Arts Graphiques, Musée du Louvre, Paris, confirms the date of the *Provencher Mill* to the autumn of 1883 (fol. 7, Fig. 108). This small book containing sixty-one sketches (12 × 19 cm) entered the Louvre as part of the Moreau-Nélaton bequest, together with a number of paintings by Sisley now in the Musée d'Orsay (see Wildenstein, 1959, pp. 57–60). These are not preparatory studies for works to be painted later but subsequent sketches kept as a record of works made in 1883–85. The sketchbook is a *livre de raison*, such as some painters maintain throughout their careers to provide a first-hand chronology of their work. In Sisley's case, the period covered is a very brief one (the cover bears the dates November 1883 to Summer 1885); within the book dates for a number of works that are otherwise undated are given. Although not consistent throughout, it also supplies

invaluable information such as title and, in some cases, dimensions, precise viewpoint and, where applicable, price and purchaser's name. The sixty-one folios of this sketchbook were first reproduced in full by François Daulte at the end of one of his monographs on Sisley (1974, pp. 84–93).

It is always instructive to juxtapose the painting with the subsequent drawing. The drawing related to the *Provencher Mill*, while carefully summarising the overall disposition of riverbank, trees in the background and the two stone buildings of the mill, lays greatest emphasis, in bold parallel lines of black chalk, on the wooden structure of the bridge itself.

All that remains of the mill today is the foundations and the waterwheel in its housing, in the middle of the bridge. The rest was destroyed during the Second World War, in August 1944.

S.P.

PROV: (?) bt by Durand-Ruel from the artist, 24 December 1883 (*Le moulin Provencher à Moret*, 400 fr, Archives Durand-Ruel); Durand-Ruel, Paris; sold by Durand-Ruel to Huinck, 13 April 1931 (Archives Durand-Ruel); Huinck en Scherjon, Amsterdam; D. G. van Beuningen, Vierhouten; A. E. van Beuningen-Charlouis, Vierhouten; bequest of Mrs A. E. van Beuningen-Charlouis to Museum Boymans-van Beuningen, Rotterdam.

EXH: New York, Durand-Ruel, 1927, no. 14; Paris, Durand-Ruel, 1930, no. 38; Amsterdam, Huinck en Scherjon, 1931, no. 25; Rotterdam, 1949, no. 150; Paris, Petit Palais, 1952, no. 196; Rotterdam, 1955. no. 208; Amsterdam, van Wisselingh, 1962, no. 45; Laren, 1964, no. 70.

BIBL: Jedlicka, 1949, repr. pl. 29; *Catalogue of the D.G. van Beuningen Collection, Rotterdam*, 1949, no. 150, repr. pl. 191; Van Guldener, repr. p. 189; Wildenstein, 1959, pp. 57–60, repr. p. 58; Lassaigne and Gache-Patin, 1983, p. 130, repr. fig. 188.

108 Alfred Sisley, *The Provencher Watermill*, drawing from the Sisley sketchbook (Département des Arts Graphiques, Musée du Louvre, Paris).

109 Alfred Sisley, *Moret Bridge*, D725 (Musée des Beaux-Arts, Algiers).

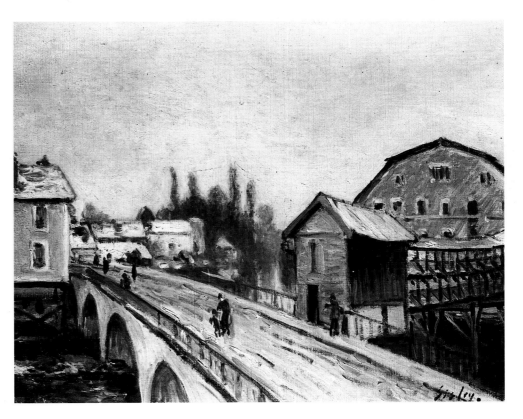

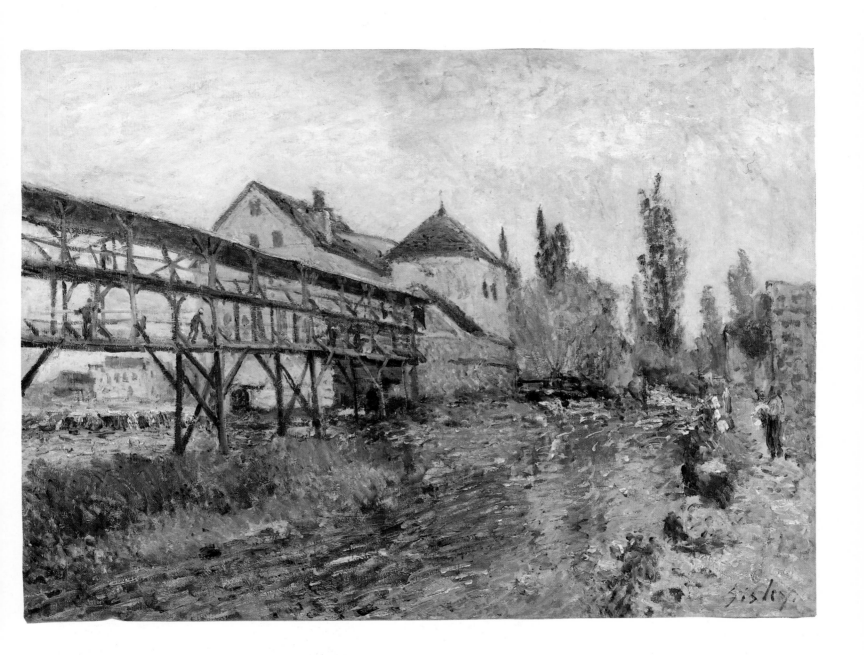

56 The River Loing at Saint-Mammès

Bords du Loing à Saint-Mammès
1885; D608
54.6 × 74 cm
Signed and dated br: Sisley. 85
Collection of Arnold and Anne Gumowitz, New York

During the first half of the 1880s while living in Veneux-Nadon, Les Sablons and Moret, Sisley frequented the port of Saint-Mammès at the confluence of the Rivers Seine and Loing. It is here that he painted, over a number of years, views of both the picturesque river bank and the working quays, the latter frequently incorporating barges with their prows decked with colourful bunting for festive occasions. Looking across the semi-canalised River Loing from the west, several houses of Saint-Mammès are visible on the opposite bank, immediately adjacent to a set of locks. Further upstream, at the far right, extending across the river, the Paris-Lyons railway viaduct can be seen with its distinctive double span and high arches.

A similar prospect occurs in a smaller painting of about the same date misnamed *The Seine at Saint-Mammès* (non-D; Tokyo-Fukuoma-Nara, 1985, no. 35). In the latter and in other works showing the viaduct, however, including *The Loing at Saint-Mammès*, (1885, D461, Private Collection), *Canal du Loing* (1885, D574, Mr and Mrs Robert H. Weir, Atlanta), and *The Banks of the Loing at Saint-Mammès* (1885, D575, Private Collection, Paris), the structure serves as a central focal point on the horizon. Yet, in keeping with the characteristic procedures for investigating specific locations, these latter views merely extend the angle of Sisley's vision from a more northerly position, which incorporates the Cleveland and Dublin pictures (see Cat. 57, 58) and pivots onto the one shown here, before turning southwards to take in these more frontal views of the viaduct itself. Similar views are also reworked in an etching (Fig. 110) and a drawing (Fig. 111).

That it is near mid-day during the summer is suggested by the warm hues of the vegetation and by an absence of shadows. The unusually robust technique apparent in this painting confirms the artist's evolving style and increasing strength despite his isolation from colleagues and his financial straits. On the shore in the foreground, reeds and grasses are suggested by curving, slashing strokes superimposed on each other in diagonal and vertical patterns. In contrast, the reflections of the houses and trees on the rippling surface of the river are masterfully indicated by horizontal, overlapping dabs. For the sky, struck by the intense glare of a midday sun, the artist reverted to his customary thin, broadly applied layers. Although employing unusually intense tones in this sunlit scene, Sisley has imparted both unity and harmony to his canvas, counterbalancing the roof colours for example, with touches of red in the clouds, on the prows of the barges and in the reflections on the water. Similarly, the hues of the sky are recalled in the various blues, purples and mauves in the river and in the foreground vegetation.

The intensification of his palette and the seemingly more systematic application of small brushstrokes suggest that Sisley was aware of the Neo-Impressionist developments of Seurat. It is unclear as to how he might have made contact with this elaboration of Impressionism, first presented to the public in *La Baignade* (1884, National Gallery, London). From the documentary evidence, it would appear that from 1883 to 1889, he remained at Les Sablons, dogged by ill-health and acute financial worries. He may, however, have made brief trips to Paris where, rather than studying Seurat's work at first hand, he discussed the new technique with Camille Pissarro, by then a committed advocate of Neo-Impressionism.

W.R.J.

PROV: Mrs Grace Clark, New York; Wildenstein and Co., New York, 1947; Mr and Mrs William Goetz, Los Angeles; Mr and Mrs Arnold Gumowitz, New York, 1988; Sale, Sotheby's New York, 6 November 1991, (20) (bought in).

EXH: San Francisco, 1959, no. 54; Los Angeles, 1967, no. 19.

BIBL: 'The Modern House of Mr and Mrs William Goetz in Hollywood', *Vogue*, 15 April 1949, p. 95.

110 Alfred Sisley, *Banks of the Loing: The Riverbank*, etching (Département des Estampes, Bibliothèque Nationale, Paris).

111 Alfred Sisley, *On the Loing at Saint-Mammès*, drawing from the Sisley sketchbook, fol. 39 (Département des Arts Graphiques, Musée du Louvre, Paris).

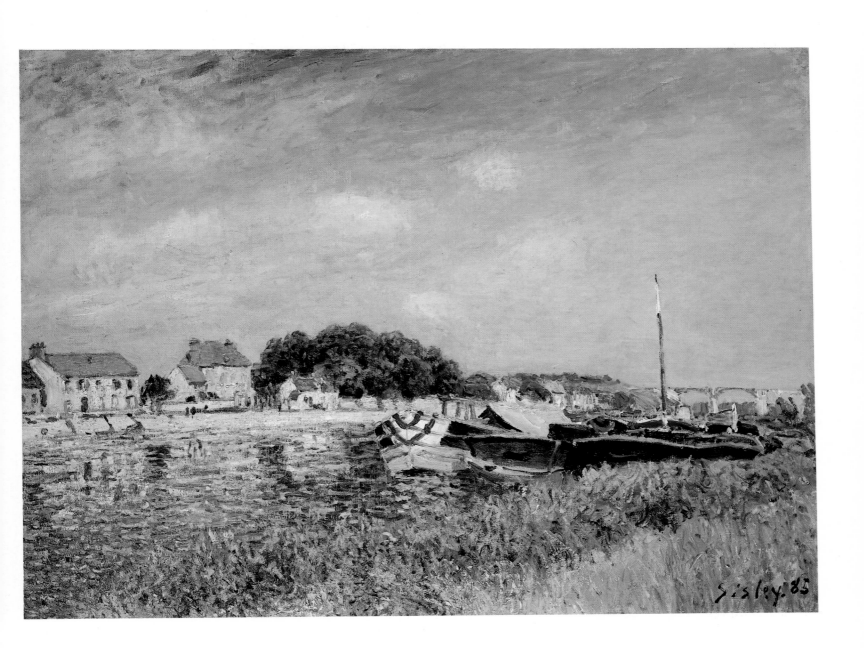

57 Saint-Mammès: Canal du Loing

1885; D615
46 × 53.3 cm
Signed and dated br: Sisley. 85
The Cleveland Museum of Art, Gift of Mr and
Mrs Lewis B. Williams from The Blair Trust

PROV: bt by Durand-Ruel from the artist,
1887; L.B. Williams, New York, 10 November
1926; Cleveland Museum of Art, Gift of Mr
and Mrs Lewis B. Williams from The Blair
Trust.

EXH: New York, Durand-Ruel, 1917, no. 6;
New York, Durand-Ruel, 1921, no. 18; New
York, Durand-Ruel, 1925, no. 5; Gifu-
Kamakura, 1982–83; Tokyo-Fukuoka-Nara,
1985, no. 37.

BIBL: *Handbook of the Cleveland Museum of Art*,
Cleveland, 1978, p. 217.

In this sunlit view of the Loing canal at
Saint-Mammès light falls from the north-
west suggesting that it is a summer
afternoon. Sisley has angled his view of the
houses along the banks to the north of that
taken up in D608 (see Cat. 56). The two
buildings on the opposite bank recur in
Sisley's river views of 1884 and 1885. The
large building with a brown, hipped roof
and dormers was once a house but today
serves as the bargemen's freight office.
Although human figures are of secondary
importance in his compositions, frequently
being little more than accents of colour (see
Cat. 24), Sisley nevertheless preferred sites
reflecting human activity, as in this scene
on the outskirts of the town, where a skiff
has been raised on blocks, two men
converse beside another boat, and barges
are tied up to the side of the canal.

In a letter dated 23 July 1885, Durand-
Ruel asked Sisley to concentrate on smaller,
more saleable paintings, mentioning size 5
or 6 canvases (Durand-Ruel Godfroy, 1986,
p. 309, no. VI). Sisley acquiesces to this
request in a letter dated 23 August, 1885
(*ibid.*, p. 309, no. VIII). This view of the
Canal du Loing may indeed be an example
of his new resolution. Furthermore, even
more so than in *Banks of the Canal du Loing
at Saint-Mammès* (Cat. 58), Sisley has
employed small touches of deftly but
coherently applied pigment over much of
the canvas using high toned, though
relatively unsaturated colours to achieve a
harmonious, unified picture field which
prompts comparison with Neo-
Impressionism (see Cat. 56).

This composition is recorded in a
summarily executed drawing numbered 56
and identified as *St Mammès (coté du Canal)*
in the *livre de raison* (Fig. 113). It is one of
sixteen records of this part of the Loing,
where a set of locks controls the fall of the
river just before it enters the River Seine
(fols 3, 41–49, 51, 54, 56, 59, 61).

W.R.J.

112 Alfred Sisley, *Banks of the Loing: Houses beside the River*, etching (Département des Estampes, Bibliothèque Nationale, Paris).

113 Alfred Sisley, *Saint-Mammès (beside the Canal)*, drawing from the Sisley sketchbook, fol. 86 (Département des Arts Graphiques, Musée du Louvre, Paris).

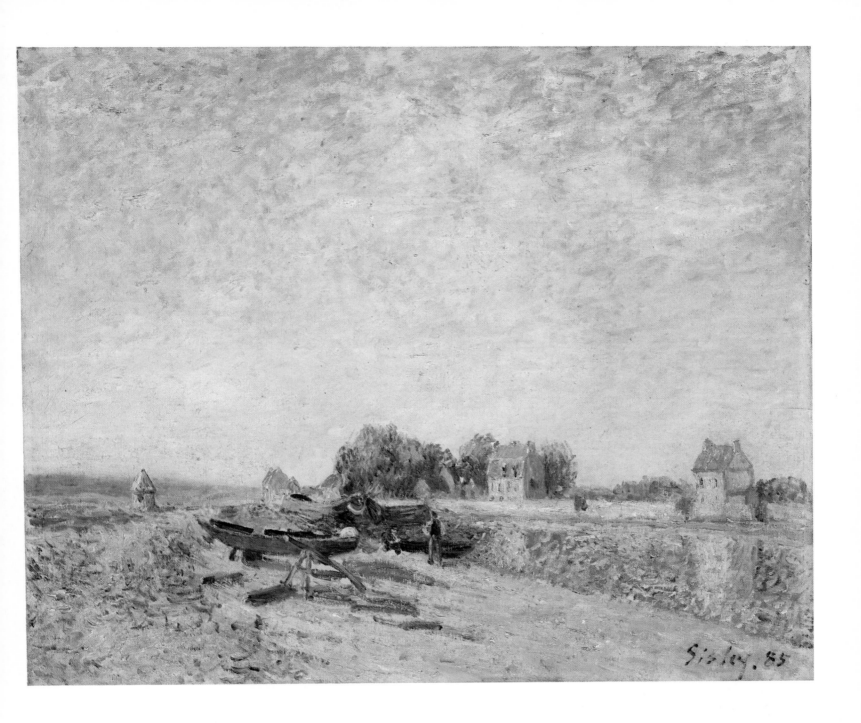

58 The Banks of the Canal du Loing at Saint-Mammès

Bords du Canal du Loing à Saint-Mammès
1885; D625
38 × 55 cm
Signed and dated br: Sisley 85
The National Gallery of Ireland, Dublin

Following his exploration of the bridge, river bank and quayside of Saint-Mammès during 1880–81 (see Cat. 49–52), Sisley switched his attention to the River Loing and its canal, which joined the Seine at Saint-Mammès. From 1882 to 1885, he created a considerable body of work which explored the riverscape between the mouth of the Loing and the viaduct which strode across the river valley carrying the railway line from Moret-sur-Loing to Saint-Mammès (Cat. 56). In all these paintings, it was the cluster of small houses which lies beside the locks at the mouth of the Canal which attracted his attention (see Reidemeister 1963, p. 150 for a modern photograph of the site). In 1885, in the Cleveland and Gumowitz Collection paintings (Cat 56, 57; see also D609, 610, 612, 616, and Tokyo-Fukuoka-Nara 1985, no. 38), it is the full group which is recorded, while in the Dublin picture, as in D626 (*The Loing at Saint-Mammès*, Tokyo-Fukuoka-Nara 1985, no. 42), the focus of the composition is centred upon the square, stocky building which lies at the upstream end of the group. Such focused exploration of a specific motif, seen looking upstream, downstream and directly across from the opposite bank, illustrates once again Sisley's ability to devise a variety of different compositions through minimal shifts in viewpoint.

Banks of the Canal du Loing at Saint-Mammès has been thought to be dated 1888, but Daulte recorded the date as '1885'. Close comparison with paintings such as *Saint-Mammès: Canal du Loing* (Cat. 57) created in the earlier year reveal considerable stylistic differences while *Banks of the Canal du Loing at Saint-Mammès* shares with the earlier painting a heightened luminosity and a hint of a residual reference to Neo-Impressionism in the right foreground. The brushwork is looser and more lively, and the colour contrasts far more vivid, most noticeably in the juxtaposition of the red-orange roof against the intense blue, cloudless sky.

The cluster of houses along the bank of the Loing at Saint-Mammès provided Sisley with the subjects for his only etchings. Around 1890 he created four etchings entitled *The Waggon* (Fig. 159), *Houses beside the River* (Fig. 110), *The Riverbank* (Fig. 112), and *Six Beached Barges* (Fig. 40). They were exhibited in that year at the 2nd exhibition of the Société des Peintres-Graveurs under the group title of 'Le Loing à Moret'. Since their zinc plates remained in the Henri Guérard atelier until 1972, it has been suggested by Michel Melot and Michael Brunet (*L'Estampe impressionniste*, Paris, Bibliothèque Nationale, 1974, p. 151) that Henri Guérard, founding Vice-President of the Société des Peintres-Graveurs, had probably been responsible for inviting Sisley to participate in the Society's 2nd exhibition (as he did also Renoir), and that he, as an accomplished print-maker, may have helped Sisley make the plates. Sisley was only once more tempted to experiment with prints when, in 1897, the dealer Ambroise Vollard commissioned a lithograph of the Canal du Loing for inclusion in the latter's second *Album des Peintres-Graveurs* (see Chronology, p. 278, and Fig. 163). Like his fellow Impressionists, with the exception of Pissarro and Degas, Sisley does not appear to have viewed the print as a medium which could provide a sufficiently challenging alternative or complement to painting as a channel for their creativity.

C.L.

PROV: Durand-Ruel, Paris; Erwin Davis, New York; bt back by Durand-Ruel, 14 April 1899; Durand-Ruel, Paris; National Gallery of Ireland, Dublin, 1934.

BIBL: White, 1968, p. 76, no. XVII, repr.; *National Gallery of Ireland. Illustrated Summary Catalogue of Paintings*, 1981, p. 151, repr.; Quinlan, 1984, p. 40.

EXH: Tokyo-Fukuoka-Nara, 1985, no. 41.

114–16 Alfred Sisley, drawings from the Sisley sketchbook, fol. 50, 52, 55 (Département des Arts Graphiques, Musée du Louvre, Paris).

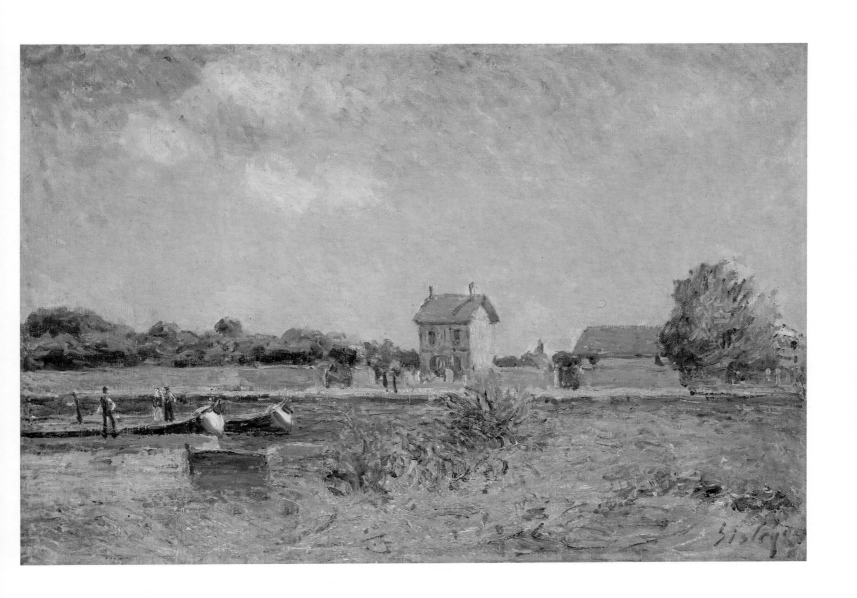

59 The Poplar Avenue at Moret: Cloudy Day, Morning

L'Allée des peupliers à Moret – temps couvert, le matin
1888; D674
59 × 73 cm
Signed and dated bl: Sisley 88
Private Collection

'What artists do I love? To take just the contemporaries: Delacroix, Corot, Millet, Rousseau, Courbet, our masters. All who have loved Nature and felt strongly.' The words were Sisley's, spoken to the critic Adolphe Tavernier in January 1892. Tavernier printed them in an article in the 18 March 1893 issue of *L'Art français*. Sisley identified strongly with the landscape painters of the Barbizon School, who had apparently abandoned both the classic, traditional principles of the composed, historical landscape and the picturesque look of the Romantic landscape, and had turned to a vision closer to Nature itself (see Cat. 1–6).

At Moret, Sisley several times painted the poplars that stood along the Loing (see Cat. 60, 68); notably, in the same year, 1888, he painted *The Poplar Avenue at Moret* (D689, Private Collection, Japan), looking in the same direction, and *The Bridge at Moret* (D675, Private Collection), which completes the avenue that recedes behind the artist's easel in both D689 and Cat. 60. In the work shown here, the rigorous verticals of the trunks and the horizontals of their shadows on the ground are balanced by the free play of their leaves against an overcast sky. Sisley has thus succeeded in endowing a highly structured composition with a sense of atmospheric lightness. As so often, he humanises the landscape by adding a few figures. The foreground dominates, but there is a glimpse of the distance.

In his preface to the catalogue of the Sisley retrospective at the Galerie Georges Petit in February 1897, L. Roger-Milès praised Sisley as a painter of landscape and dwelt at some length (pp. 17–20) on his affinity for trees:

> In paintings of radiant serenity, he unfolds the poetry of water, trees and sky in Nature ...
>
> The tree is one of the strongest factors through which he expresses life. Water helps to express life in its existence in space; trees express life in their existence in time.
>
> Sisley no more paints a portrait of a tree than Corot does; and yet he knows them all. He has studied every one; he has dissected them; but what he gives us are harmonies of trees in Nature: elements whose essence is variety, recording the seasons and the hours with all the colour effects that are proper to foliage.
>
> It is for us, the spectators, to enumerate the essence embodied in his works: the poplar, in all its nobility, with its pyramidal tip, like a thought that takes wing towards the skies; here the elm, with its crabbed branches, its sturdiness and vigour, its knotted grey bark, its trunk fissured and hollowed by age; there the chestnut, tall and placid, firmly supported by a crowd of visible roots; the oak, proud and majestic, imperious in its great age, but with tenderly murmuring leaves; the beech, the acacia, the weeping willow, and so many others, their airy masses blazing or murmuring in chorus as they line a foreground river or mount to the brow of a hill in serried ranks. Sisley has recorded all these giants; he has analysed the sap that flows in them, and to render them he has extracted from his palette deep blues and old golds that span, between them, every note of the songs that they sing ...

S.P.

PROV: E. Decap, Paris; bt Durand-Ruel, Paris, 25 July 1893; bt E. Laffon, 4 June 1929; E. Laffon, Paris; Private Collection, Scotland; Reid and Lefevre, London, 1960; Sale, Sotheby's New York, 4 November 1982 (39); Private Collection.

EXH: Paris, Durand-Ruel, 1902, no. 10; London, Grafton Galleries, 1905, no. 307; Paris, Durand-Ruel, 1910, no. 76; New York, Durand-Ruel, 1921, no. 2; New York, Durand-Ruel, 1927, no. 27; Paris, Durand-Ruel, 1930, no. 58; London, Marlborough, 1955, no. 48.

BIBL: Alexandre, 1933, p. 182, repr. p. 190.

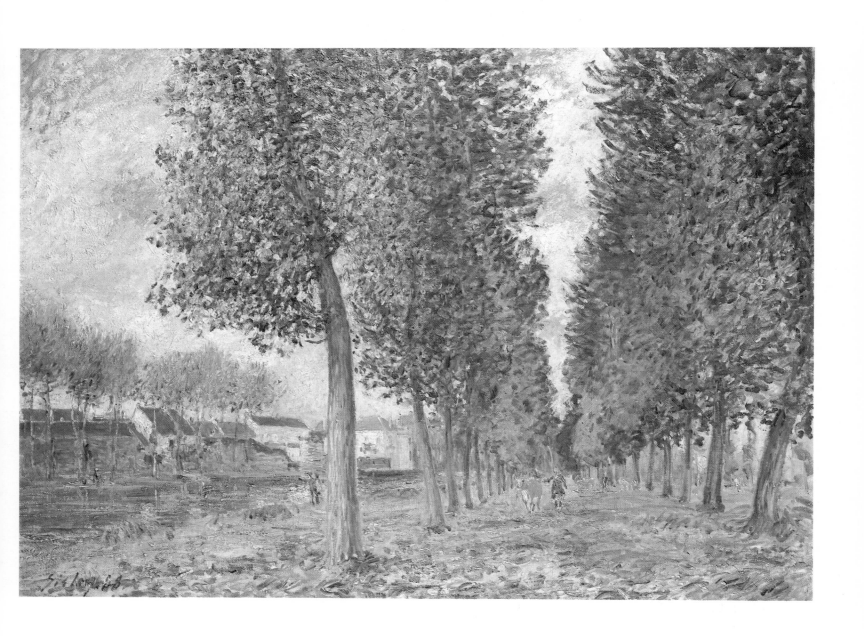

60 Moret Wash-House, Indian Summer, Sunday Afternoon

Le Lavoir à Moret, été de la Saint-Martin, dimanche après-midi
1888; D686
54 × 73 cm
Signed and dated br: Sisley 88
Private Collection

In all the villages where Sisley lived and painted, he took pleasure in the homeliness of the landscape and in the details of everyday life. Here he shows the wash-house at Moret, on the left bank of the Loing, where the women went to do their laundry. The right-hand side of the composition is given a rhythmic, vertical emphasis by the trunks of a line of trees; their shadows stretch along the ground, while their leaves invade the clear blue sky.

This work is one of a sequence in which Sisley plots the landscape immediately downstream from Moret. While similar views are to be found in *Evening at Moret: end of October* (1888, D685), *The Banks of the Loing at Moret: Morning* (1888, D687) and *September Morning at Moret-sur-Loing* (1888, D688), where the wash-house and the tall white house beyond it act as pivotal features in the composition, the avenue of poplar trees which makes its entrance on the right of this painting becomes the subject, through a shift of angle of vision, of such works as *Poplar Avenue at Moret* (D689, Private Collection, Japan) and *Poplars at Moret-sur-Loing: August Afternoon* (D676). On his return to this location eighteen months later, Sisley was to turn his angle of vision through 180 degrees, taking up a position in the tall house in the background to give a plunging view across the roof of the wash-house itself (see *Banks of the Loing at Moret*, Cat. 61).

The title of this painting provides a specificity of season, an 'Indian summer', which the autumnal tints of the leaves reinforce. Sisley had a particularly keen response to the passage of the seasons:

He sought to express the harmonies that prevail, in all weathers and at every time of day, between foliage, water and sky; and he succeeded ...
He loved river banks; the fringes of woodland; towns and villages glimpsed through the trees; old buildings swamped in greenery; winter morning sunlight; summer afternoons. He had a delicate way of conveying effects of foliage. (Geffroy 1923, pp. 20–21).

S.P.

PROV: L. Benatov, Paris; Private Collection, Paris; Mrs M. D. Carr; Acquavella Galleries, New York, 1968; Private Collection.

EXH: New York, Acquavella Galleries, 1968, no. 43, repr.; New York, Beadleston, 1983.

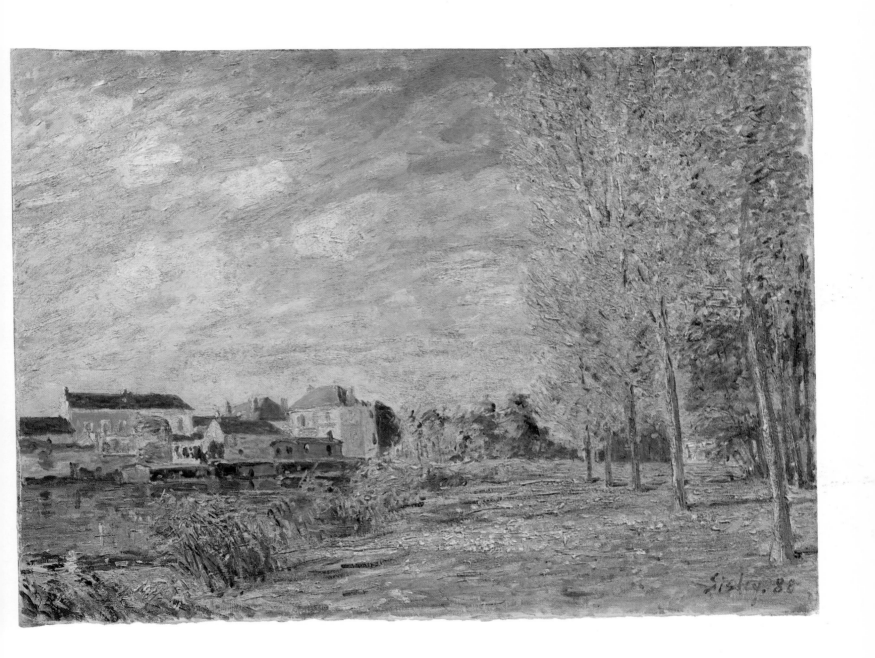

61 Banks of the Loing at Moret

Bords du Loing à Moret
1890; D733 (known as *Bords du Loing à Moret, avril*)
60 × 73 cm
Signed and dated bl: Sisley 90
Dr h.c. Emile Dreyfus-Stiftung, Kunstmuseum, Basel
Exhibited in London and Paris only

This is another view of the wash-house on the bank of the Loing (see Cat. 60), but painted eighteen months later, in 1890. This time, its roof fills the foreground, with a glimpse of Moret bridge behind. On the opposite bank are some 'houses catching the sun' (as mentioned in the description in the Petit sale catalogue; see Provenance). The poplars are the same trees that are visible in the earlier painting. Despite the title given in the catalogue raisonné, there is little in this painting to suggest that it is spring; leafless trees and cool tones indicate a more wintery season.

Technically this work is of considerable interest. Painted in short, rapid brush-strokes, the composition is plotted out with only a minimum of underdrawing. This is either in thin blue oil paint, as in the houses in the foreground, or in a salmon pink which can be identified under the trees on the distant bank. The placing of these trees also suggests that the work must have been created over a few sessions; they have been painted over the surface denoting the bank itself and are rendered in clean brush-strokes which have then been penetrated by horizontal jabs of similar toned paint to indicate shadow and depth (Fig. 25). Most strikingly, the painting appears to be unvarnished. Such a condition is now rare among Sisley's paintings and presents two possible explanations: he may have generally preferred his canvases unvarnished, as did Monet at this period, or he may have taken such a decision specifically in respect of this painting, since the matt, somewhat chalky paint surface conveys admirably the crisp, dry light of a winter afternoon.

Gustave Geffroy was highly susceptible to the charm of such views as this:

> And here are the banks of the Loing: willows and poplars; mornings as fair as the youth of the world itself; dew evaporating in a golden halo around feathery treetops; the blue shade of a village; boats tilted on the river bank; cottages illumined like fairytale palaces; white light and mauve light; the silvery leaves of willows, shivering in a fresh breeze ... (Geffroy 1923, p. 16).

There is a very close variant of this composition (D734, Private Collection) which differs only to the extent that the roof of the wash-house has been reduced in area and the viewpoint made slightly less precipitous.

S.P.

PROV: Georges Petit, Paris; Société anonyme des Galeries Georges Petit, 1st Sale, Paris, Hôtel Drouot, 27 April 1933 (114); bt H. Müller for 36,000 fr; H. Müller, Basel; Private Collection; Öffentliche Kunstsammlung, Basel (permanent loan from Emile Dreyfus Foundation, 1970); Kunstmuseum, Basel (Dr h.c. Emile Dreyfus-Stiftung).

EXH: Paris, Petit, 1930; London, Knoedler, 1931, no. 21.

BIBL: *Kunstmuseum Basel, 150 Gemälde 12.-20. Jahrhundert*, 1981.

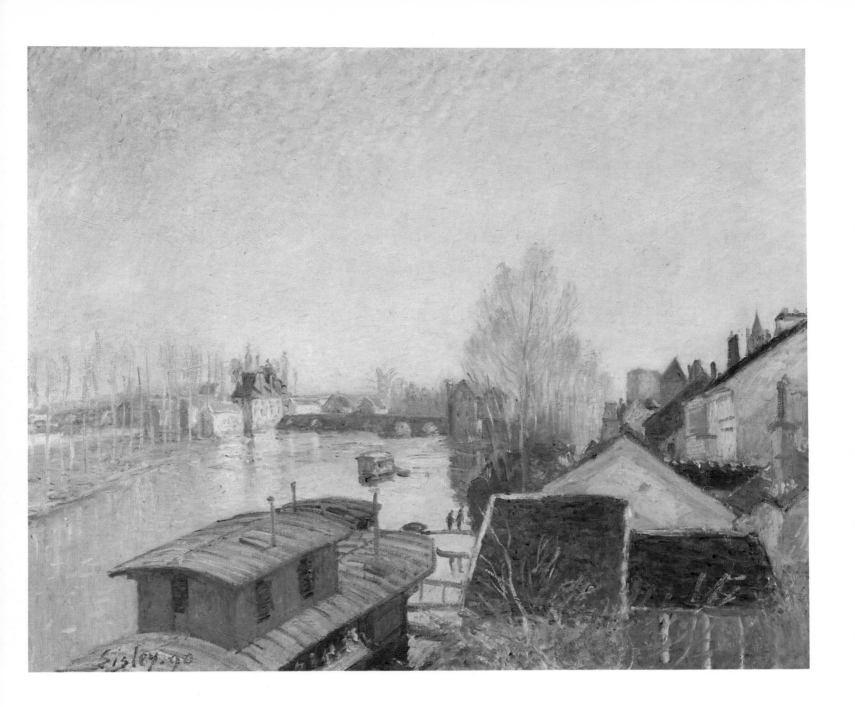

62 Bend in the River Loing, Summer

Tournant du Loing en été
1890; D740
60 × 80 cm
Signed and dated br: Sisley 90
Private Collection. (We would like to thank Mr
Richard Nathanson of London for arranging
the loan of this painting)

A magnificent summer afternoon: on the
right, the river bank lined with
flowering shrubs that lean out over the
water. Far over to the left, the calm
surface of the Loing, with a picturesque
mosaic of aquatic greenery at water
level: flat, pale leaves, stiff reeds, infinite
reflections.

On the left, a proud row of poplars,
their sun-gilt crowns massed against a
distant, filmy sky in which vast, downy
clouds sail by.

To the right, in the distance, beyond a
group of plane trees, is a limestone
escarpment that partly lies in direct
sunlight.

This description is to be found in the
catalogue of the sale of the Depeaux
collection in 1906 (lot 69; see Provenance).
Conceived markedly in depth, this
landscape is one more instance of Sisley's
characteristic sense of space; he is always
suggesting the third dimension by
introducing a road, or an avenue of trees,
or a watercourse.

After settling permanently in Moret-sur-
Loing in 1889, Sisley applied himself to a
range of local subjects, the majority of
which involved the relationship between
land, water and sky. The subject shown
here was initially explored in at least two
paintings of 1888, *The Loing at Moret*
(D559, Private Collection, London) and
Bend of the Loing: Spring, D637, Private
Collection, UK). However, in terms of
scale and degree of finish, this one of 1890
is by far the most impressive, and would
appear to have been intended as a
considered statement by the artist.
Technically the work demonstrates the use
of different types of brushstroke to establish
the formal structure of the composition, a
procedure which Sisley had begun to apply
in the first years of the 1880s (see Cat. 49–
52). The sky with its scudding clouds has
been thinly scumbled, the grasses in the
foreground rendered in longer, curving
strokes, the trees in short stabs, and the
water in thin layers of horizontal brush-
strokes raked through with what would
appear to be a small comb. This latter
technique successfully suggests the
overlapping layers of water and reflection,
an effect which Monet had achieved using
the same method in some of his paintings
of the Creuse Valley, made in 1889, for
example, *Valley of the Creuse (Sunlight
Effect)*, (1889, Museum of FIne Arts,
Boston).

The first owner of this painting, François
Depeaux, collected not only the works of
Sisley but also those of Monet (see
'Veneux-Nadon to Moret-sur Loing', p.
185); and the water plants on the surface of
the river here recall the effects obtained by
Monet, from 1895 onwards, in his views of
the lily pond at Giverny.

S.P.

PROV: François Depeaux, Rouen; Depeaux Sale,
Galerie Georges Petit, Paris, 31 May-1 June
1906 (69), bt in by Durand-Ruel on behalf of
Depeaux (Archives Durand-Ruel and Isaac de
Camondo's annotated copy of sale catalogue,
now in Bibliothèque du Musée du Louvre,
Paris); on consignment, Durand-Ruel, Paris, 7
June-30 November 1906 (see Archives Durand-
Ruel); François Depeaux, Rouen; Depeaux
Estate Sale, Hôtel Drouot, Paris, 30 June 1921
(65); E. Beyeler, Basel; Private Collection.

EXH: Basel, Beyeler, 1956, no. 5; London, David
Carritt, 1981, no. 18.

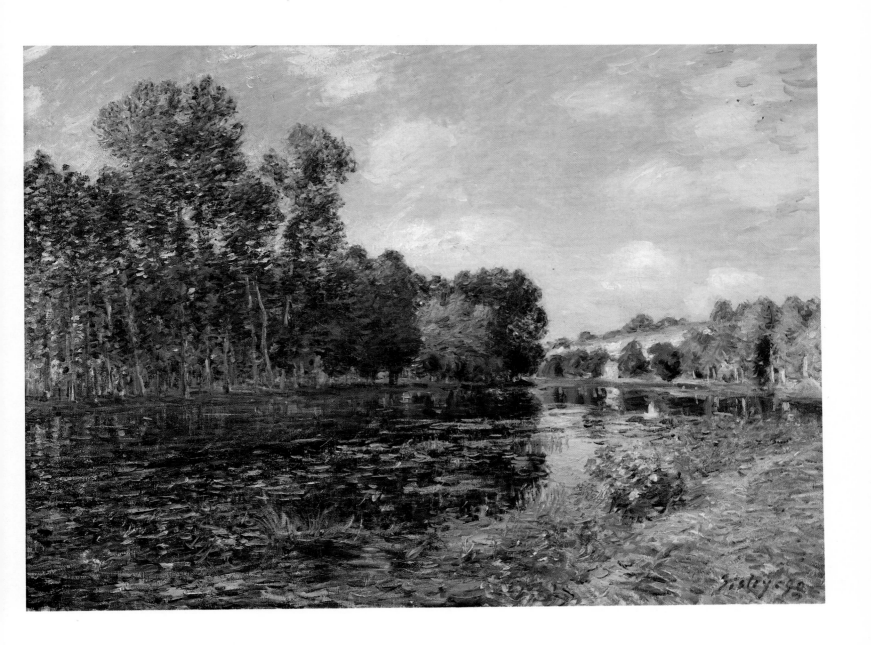

63 Haystacks at Moret, Morning

Les Meules de paille à Moret, effet du matin
1891; D772
73 × 92 cm
Signed and dated bl: Sisley 91
National Gallery of Victoria, Melbourne,
Felton Bequest, 1913

Two paintings of the autumn of 1891 introduced a new theme into Sisley's work: *Haystacks at Moret in October* (formerly Tavernier collection, now Musée de Douai; D771; Fig. 117) and the painting acquired by the National Gallery of Victoria, *Haystacks at Moret, Morning*. The catalogue of the 1906 Depeaux sale (see Provenance) describes this as follows:

> Four fine, round hay stacks in a field on the right, set off by the reddish soil; in the background, poplars lining a distant road; on the left there are two more ricks. One peasant in the field.

Both paintings were exhibited in the artist's lifetime: the former at the International Exhibition organised in December 1891 by Durand-Ruel's rival, the dealer Georges Petit, at the Salon du Champ-de-Mars in 1895 and at Sisley's one-man exhibition mounted by Petit in February 1897; the latter only at the 1897 exhibition, where the catalogue described it as already in the Depeaux collection.

In dealing with this subject, Sisley was following the example of Pissarro (*The Rick, Pontoise*, 1873, Private Collection, Paris; *Harvest at Montfoucault*, 1876, Musée d'Orsay, Paris). Above all, he must surely have been profoundly impressed by the fifteen or so pictures of grainstacks painted by Monet at Giverny in 1890–91 and exhibited at Durand-Ruel's in May 1891. But although Monet's examples may have suggested the choice of subject, they did not appear to have presented Sisley with a challenge to produce his own series, since he painted only the Melbourne and Douai pictures that summer. Thus, whereas Monet's *Grainstacks* were to be seen as a group recording an equilibrium between transient light, weather conditions and seasonal effects, and the more eternal qualities of Nature, with each painting completed later in the studio, Sisley's haystacks appear to have been selected at random and completed in front of the motif itself. They are, therefore, in keeping with the principles of Impressionism of the 1870s, records of the specific qualities of an October day, or the sparkle of sunlight. The distant poplars that close off the composition may be an echo of Monet's use of the same tree in his *Fields* and *Grainstacks*.

Sisley returned to the subject of haystacks in 1895, when he made four paintings. *The Ricks* (D844, Private Collection) gives considerable emphasis to the stack itself, as in the Melbourne and Douai pictures, while the other three merely record them as part of a broader landscape composition (*A Clearing in the Forest*, D841; *The Valley*, D842; and *Edge of the Forest*, D843).

S.P.

PROV: François Depeaux, Rouen (from 1897 at latest; see 1897 exhibition catalogue cited below); Depeaux Sale, Hôtel Drouot, Paris, 25 April 1901; bt Lehman for 7,600 fr; Lehman, Paris; François Depeaux, Rouen; Depeaux Sale, Galerie Georges Petit, Paris, 31 May–1 June 1906 (233); bt Durand-Ruel for 4,500 fr; Durand-Ruel, Paris; bt National Gallery of Victoria for 18,840 fr, 14 April 1913 (Archives Durand-Ruel); Felton Bequest, National Gallery of Victoria, Melbourne.

EXH: Paris, Petit, 1897, no. 81; Manchester, UK, 1907–8, no. 185; Paris, Durand-Ruel, 1910, no. 78.

BIBL: Martin Wood, 1916, p. 230, repr. p. 234; Geffroy, 1927, repr. pl. 51; Besson, n.d., repr. pl. 8; Jedlicka, 1949, repr. pl. 47; Daulte, 1957, repr. p. 52; *The National Gallery of Victoria* 1973, pp. 56–7, repr.; *French Impressionists and Post-Impressionists, National Gallery of Victoria*, 1976, repr.

117 Altred Sisley, *Haystacks at Moret in October*, D771, 1891 (Musée de Douai).

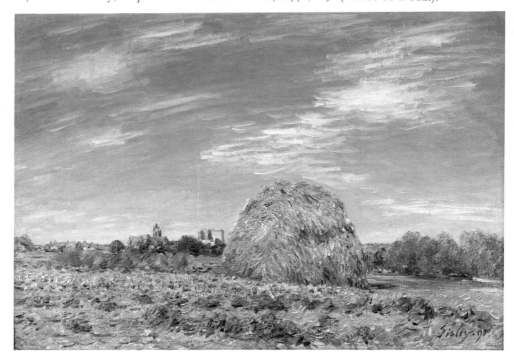

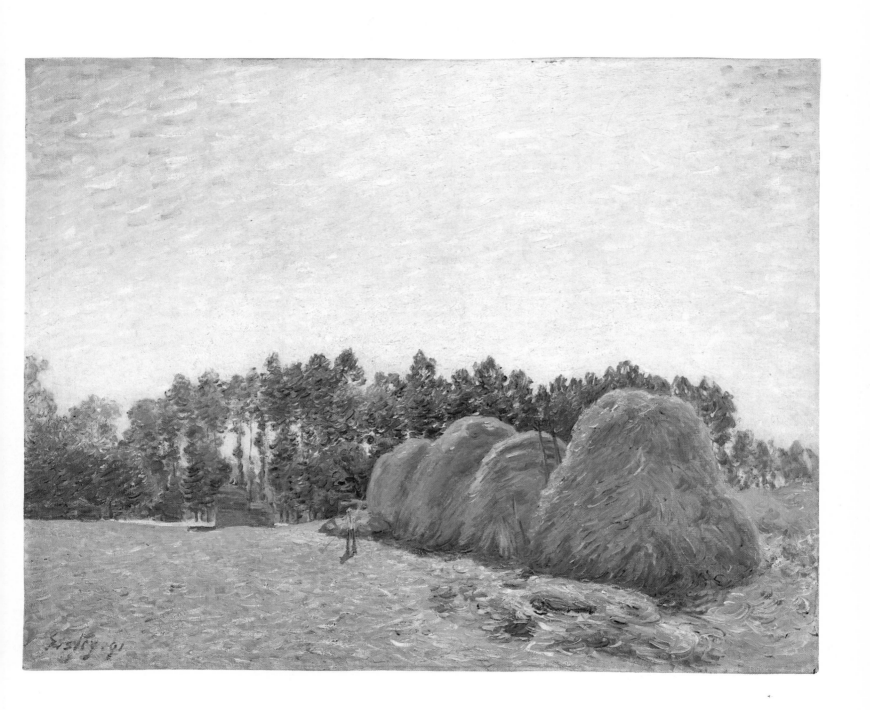

64 Moret-sur-Loing: the Porte de Bourgogne

Moret-sur-Loing – la Porte de Bourgogne
1891; D761
65 × 92 cm
Signed br: Sisley
Private Collection

Moret church, the lofty gate, the bridge, the frail trees on the bank. Monumental white masses of cloud pile up in the blue sky. The water in the river is low, and in it greenery comes to the surface in wide banks and tufts. A few tiny figures.

Such is the description of this work given in the catalogue of the 1911 sale of the collection of Maurice Masson, who had specialised in the works of Sisley and Monet (see 'Veneux-Nadon to Moret-sur-Loing', p. 185, and Provenance, below). The title under which the work is listed there (as lot 37) is the *Porte de Bourgogne*. This is the lofty, twelfth-century town gateway at the western end of the bridge. Here it stands out against the sky, slightly to left of centre. At the far left, the roof and tower of Moret church are outlined against the clouds; in the foreground, between the two central arches of the bridge, is the Provencher watermill (see Cat. 55). The centre of the composition is occupied by the postern gate that links the streets of the town with the poplar-lined embankment that runs along the River Loing.

The poplars, and the overall lighting, serve to emphasise the decorative character of the scene, on which the painter commented in a letter to Monet on 31 August 1881: 'It's not a bad part of the world, rather a chocolate-box landscape...' (quoted p. 198).

The works by Sisley in the Masson sale were described in the catalogue by Achille Segard, who rightly said of this work:

The Porte de Bourgogne ... [is] the most complete, and, by virtue of its size, also the most important [work]. All that the artist loved is concentrated in this one painting: the skies, the waters and the banks of the little river Loing, beside which he had settled, and the place that he loved above all others, with its old church, its huddled houses, its age-old bridge, its grassy banks. He has created an epitome, as it were, of all the separate motifs from which, in isolation, he extracted so many magnificent paintings.

Sisley first adopted this particular view of Moret-sur-Loing in three paintings of 1888, D665, D666 and D676, the latter taken from a view-point slightly further back on the nearside bank, allowing the poplars to provide a frame for the bridge, church, Porte de Bourgogne and houses. He was to return to it again in 1892, with a small group of not very resolved paintings (D787, 789, 791 and 792). But, as with any of his explorations of a specific location, the view must not be seen in isolation. Rather, it provides a section of Sisley's visual mapping of Moret, which encompasses the bridge (see Cat. 65 and 70) before shifting downstream to include this view and then the line of poplar trees screening the houses beyond, found in *Moret-sur-Loing: Sunset* (D790, Cat. 66).

S.P.

PROV: Charles Guasco, Paris; Guasco Sale, Galerie Georges Petit, Paris, 11 June 1900 (65); bt Georges Petit for 15,000 fr; Georges Petit, Paris; Rosenberg, Paris; bt Rosenberg Fils; bt Bernheim-Jeune, 9 October 1906; Bernheim-Jeune, Paris; bt Maurice Masson for 8,000 fr, 25 October 1906 (Archives Durand-Ruel, no. 15130); Maurice Masson, Paris; Masson Sale, Hôtel Drouot, Paris, 22 June 1911 (37); Léon Orosdi, Paris; Orosdi Sale, Hôtel Drouot, Paris (including 22 paintings by Sisley), 25 May 1923 (62); bt G. Bernheim for 50,000 fr (according to Daulte 1959); Acquavella Galleries, New York; bt John T. Dorrance, Jr, 19 June 1982; Dorrance Sale, Sotheby's New York, 18–19 October 1989 (35); Private Collection.

EXH: Paris, Bernheim-Jeune, 1911, no, 38; Tokyo-Sapporo-Osaka-Nagoya-Ueno, 1974, no. 62.

BIBL: Réau, 1926, VII, p. 596, repr. fig. 374.

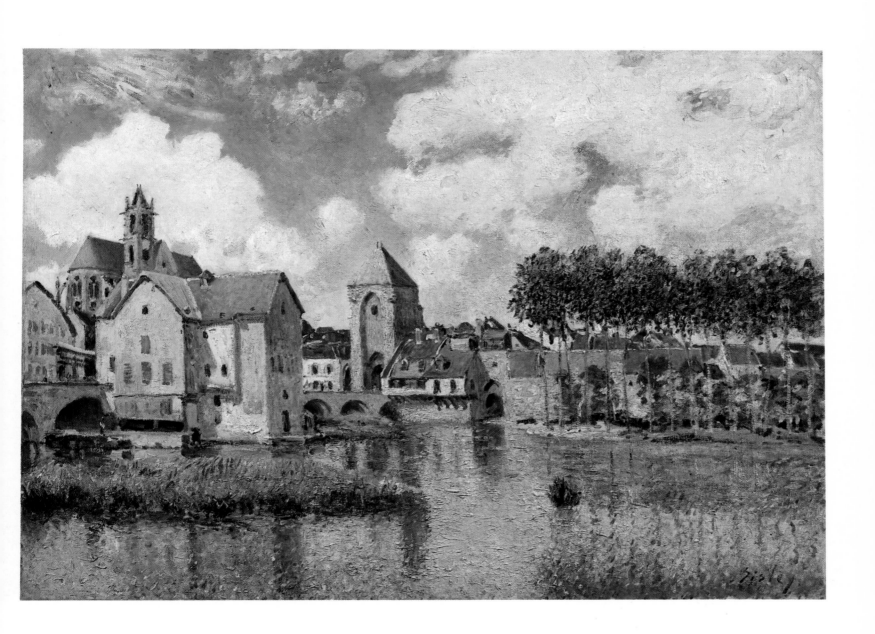

65 *Moret Bridge*

Pont de Moret
1892; non-D
73 × 92 cm
Signed and dated br: Sisley 92
Private Collection

Ever since his days at Argenteuil and
Villeneuve-la-Garenne (see Cat. 11, 14),
not forgetting the few months he spent at
Hampton Court (see Cat. 25, 26), the
bridge as a motif had been a constant
preoccupation for Sisley. In the last few
years of his life, he took a particular
interest in the bridge at Moret-sur-Loing, a
dominant architectural feature that links
the historic town centre with the road to
Saint-Mammès. After appearing several
times in the backgrounds of his paintings, it
emerged in a number of works painted
from 1887 onwards to become the
principal subject (as in *Moret Bridge* of 1890,
Musée des Beaux-Arts, Algiers; D725).

Crossing the Loing on a succession of
arches, the bridge was interrupted in the
centre by the town watermills; its western
end led up to the Porte de Bourgogne,
which was the entrance to the town itself.
In this view, dated 1892, the Provencher
mill can be seen beyond the grassy
riverbank in the foreground. The bridge,
which connects the foreground with the
opposite bank, dominates the centre of the
composition. Sisley had painted Moret
from a very similar viewpoint in 1890
(*Moret Bridge*, D721) and in 1891
(*Downstream from Moret Bridge: Morning*,
D754, and *Moret Bridge, Morning*; D758).
This study of sky and water is a highly
representative work of the period.

S.P.

PROV: Gez, Paris; André Weil, Paris; Alex Reid
and Lefevre, London; Private Collection, New
Jersey.

EXH: London, Reid and Lefevre, 1968, no. 25.

BIBL: *Burlington Magazine*, December 1968, repr.

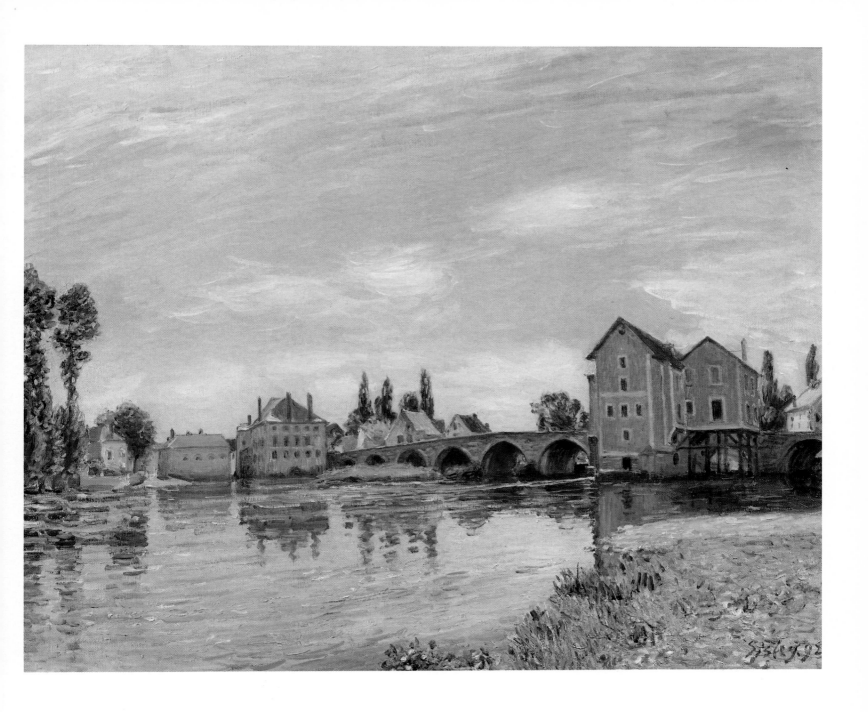

66 *Moret-sur-Loing: Sunset*

Moret-sur-Loing au soleil couchant
1892; D790
65 × 81 cm
Signed and dated br: Sisley 92
Mr and Mrs Gordon P. Getty

One year after painting *Moret-sur-Loing: the Porte de Bourgogne* formerly in the Masson Collection (Cat. 64), Sisley painted the small town again, this time at the end of the day; his viewpoint has moved along the right bank of the Loing to a position already used in *The Loing at Moret*, 1891, D762).

The architectural element is less in evidence, though one end of the Provencher watermill and a number of arches of the bridge remain, surmounted by the Porte de Bourgogne. Sisley has shifted the emphasis to the row of poplars that runs along the river bank; their crowns are outlined against the sky in a *contre-jour* effect. Here Sisley has concentrated on the study of light, showing how a beloved landscape catches the last rays of the sun.

S.P.

PROV: Galerie Georges Petit, Paris, Sisley atelier sale, 1 May 1899, no. 9, repr., sold for 5,700 fr (see *Bulletin de l'art ancien et moderne*, no. 18, 6 May 1899, pp. 147–48); Knoedler and Co., Paris and New York; Private Collection.

EXH: Paris, Petit, 1897, no. 41.

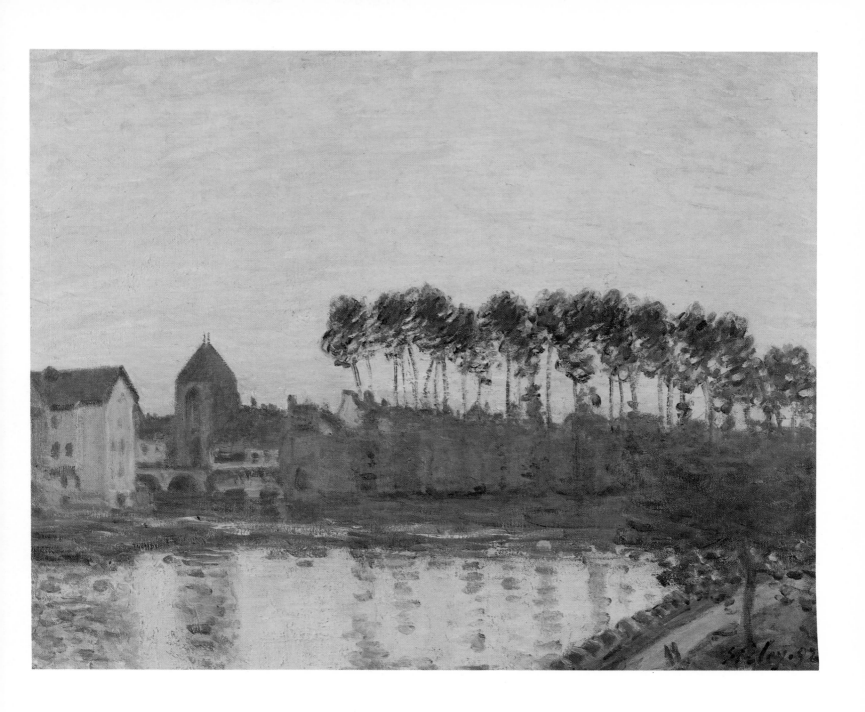

67 The Matrat Boatyard, Moret-sur-Loing, Rainy Weather

Le Chantier à Matrat, Moret-sur-Loing, temps pluvieux
1892; D814
60 × 73 cm
Signed and dated bl: Sisley 92
Yale University Art Gallery, New Haven, Gift of Helen G. Altschul, widow of Frank Altschul, B.A. 1908

PROV: Georges Petit, Paris; bt Boussod-Valadon, 15 March 1901; Boussod-Valadon, Paris; bt Mme Delamare, 11 December 1903; Mme Delamare, Paris; Captain Benz, Paris; Meyer-Goodfriend, New York; Meyer-Goodfriend Sale, American Art Association, New York, 4–5 January 1923 (89); Mr and Mrs Frank Altschul, New York; Gift of Mrs Altschul to Yale University Art Gallery, New Haven, 1983.

EXH: Paris, Champ-de-Mars, 1893, no. 976; New York, Wildenstein, 1966, no. 66; Tokyo-Fukuoka-Nara, 1985, no. 46.

For this view, Sisley has returned to the boatyard at Matrat, downstream from Moret, looking south towards the small town, which he had recorded four years earlier in *The Boatyard at Matrat, Sunset on the Loing, Moret* (D693, Private Collection, USA; see also D 669–672, and D691). It was under the title of 'Le Chantier à Matrat' that this work was shown at the Salon du Champ-de-Mars in 1893 (no. 976). Still present in the distance are the arches of the bridge and the roof and tower of Moret church.

This was not the first time in Sisley's career that he was to paint almost identical views of the same scene under different weather conditions. However, as in the case of the *Chemin de l'Etarché, Louveciennes, Snow* (1874, Cat. 31), and other similar examples made during the 1870s (see Cat. 36, 42), these two views of the boatyard at Matrat cannot be seen as literal pendants since their dimensions are significantly at variance (50 × 73 cm and 73 × 93 cm). Rather, they demonstrate the artist's continuing interest in the effects of different weather conditions and light on a given landscape which he was to explore most fully in his 'series' of the church at Moret (see Cat. 71).

Sisley rarely makes the activity of work the subject of his landscapes. Rather, as here, he captures the homely quality of the scene, which he has enlivened, in his customary manner, with a tiny figure in the foreground.

Christopher Lloyd (Tokyo-Fukuoka-Nara, 1985, no. 46) drew a link between this painting and a pen and ink drawing, also dated 1892 (Fig. 118).

S.P.

118 Alfred Sisley, *Moret-sur-Loing*, 1892, drawing (Private Collection, Paris).

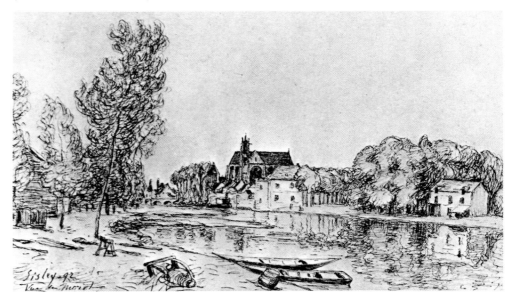

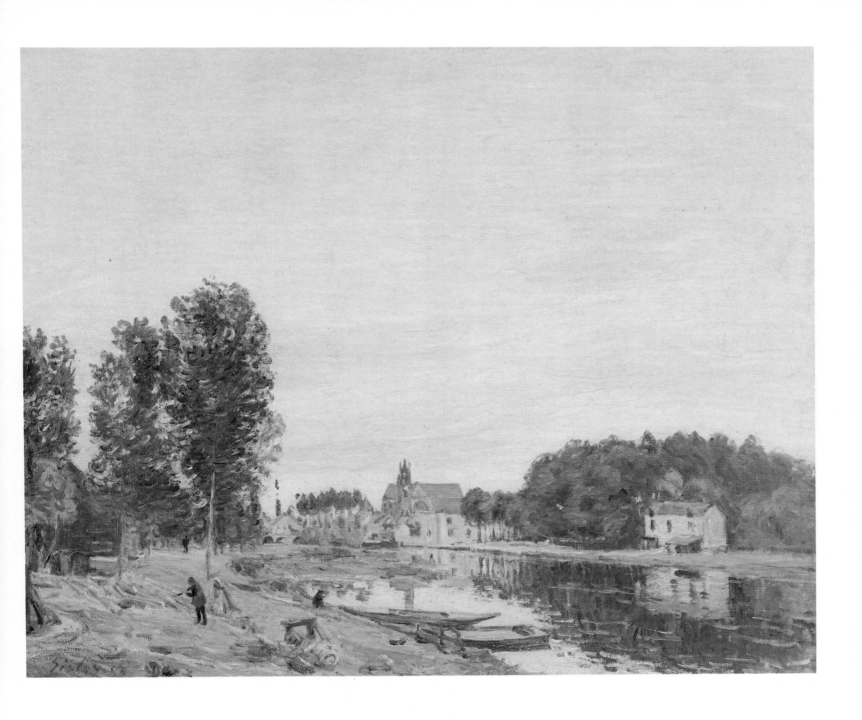

68 Banks of the Loing at Moret

Moret, bords du Loing
1892; D815
60 × 73 cm
Signed and dated br: Sisley 92
Musée d'Orsay, Paris
Exhibited in Paris only

This view of the Loing and Moret is complementary to *Moret Wash-House, Indian Summer, Sunday Afternoon* (Cat. 60) and to *The Poplar Avenue at Moret* (D689). Here, once more, sky and trees occupy a large part of the canvas; the poplars line the course of the Loing and frame the landscape, leading the eye from the foreground into depth, where it encounters more trees and the buildings of Moret itself. The trees help to organise the space, and to create the depth that was a constant preoccupation with Sisley. In this respect, and in keeping most notably with the compositional procedures used by his contemporary, Pissarro, Sisley adopts a characteristically conservative approach to spatial recession.

This painting forms part of a sequence in the artist's visual mapping of Moret. A shift of angle to the right would reveal the avenue of poplars along the right bank of shift of angle to the right would reveal the avenue of poplars along the right bank of the Loing recorded in Cat. 60, while a turn through 90 degrees would present a direct confrontation with the church and the line of poplars before the houses of Moret on the left bank (see Fig. 119, Cat. 64, 66).

This work was once in the collection of Count Isaac de Camondo, and was among the eight paintings by Sisley that Camondo bequeathed to the Louvre in 1911; the most celebrated of these is the *Flood at Port-Marly*, of 1876 (D240; Cat. 38), which he had bought at the Tavernier sale on 6 March 1900.

Another great collector, Gabriel Cognacq, possessed a very similar work by Sisley, painted four years earlier: *The Banks of the Loing at Moret: Morning* (1888, D687).

S.P.

PROV: Count Isaac de Camondo, Paris; bequest of Count Isaac de Camondo to the Musée du Louvre, Paris, 1911; Musée du Louvre, Paris (exhibited from 1914); Musée du Louvre, Galerie du Jeu de Paume, Paris (from 1947); Musée d'Orsay, Paris (from 1986; inv. R.F. 2024).

EXH: Brive-La Rochelle-Angoulême-Rennes, 1955, no. 23; Paris. Bibliothèque Nationale, 1957, no. 98; Japan, 1961, no. 105.

BIBL: *Catalogue de la Collection Camondo*, 1914, 2nd ed. 1922, no. 206; Borgmeyer, 1915, repr. p. 491; Besson, n.d., repr. p. 58; Venturi, I, 1939, p. 100; du Colombier, 1947, repr. pl. 9; Paris 1958, no. 421; Paris 1961, no. 1757, repr. pl. 700; Paris 1972, p. 349; Paris 1973, p. 159, repr. p. 111, 4th ed., 1979, p. 173, repr. p. 125; Lassaigne and Gache-Patin, 1983, repr. fig. 203; Paris 1986, IV, p. 218, repr.; Sterling and Adhémar, II, p. 431, repr.

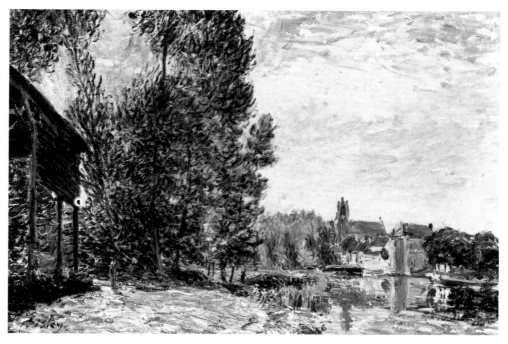

119 Alfred Sisley, *The Banks of the Loing at Moret: Morning*, D670, 1888 (Private Collection, Switzerland).

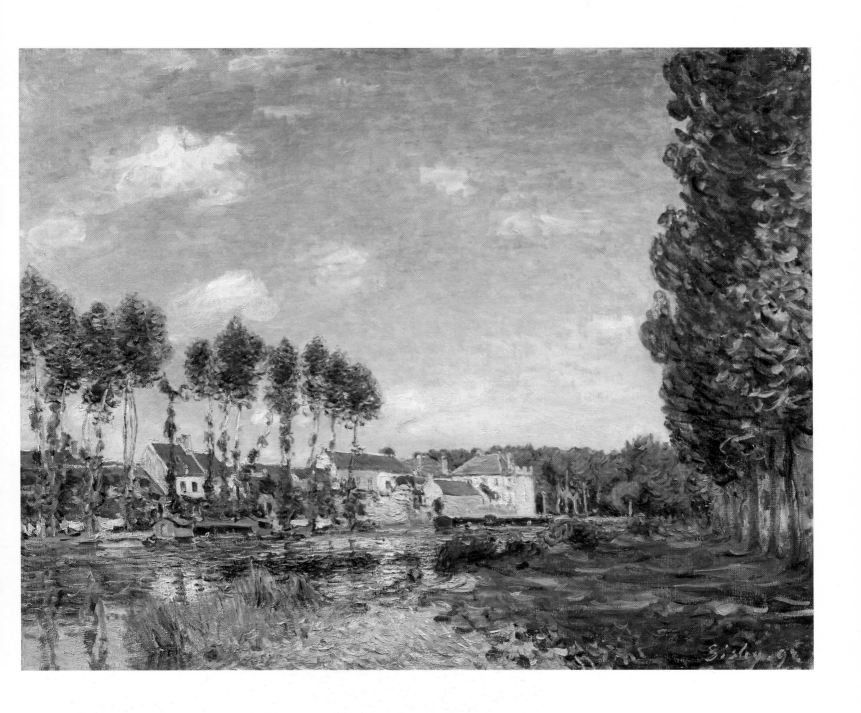

69 *The Loing Canal*

Le Canal du Loing
1892; D816
73 × 93 cm
Signed and dated br: Sisley 92
Musée d'Orsay, Paris
Exhibited in Paris only

For part of its course, the Loing runs alongside the Loing Canal, before the two merge just downstream from Moret as they flow towards Saint-Mammès. In his book on Sisley, Gustave Geffroy makes special mention of this painting and its subject:

> He paints a sunlit, frosty winter day. The earth, the sky, the canal, the skeletal tracery of the trees, all is pinkish mauve; the air is golden. Three parallel paths, receding into depth, lead into the poplar-lined distance. Beside the metallic water, a dark man walks with a pale horse, both minute by comparison with the quickset hedge that crackles and burns with colour. (Geffroy 1923, pp. 16–17.)

One of many views of the Loing Canal painted by Sisley, this work entered the Luxembourg in 1899 thanks to a donation by a group of the artist's friends, organised by Monet; it is now in the Musée d'Orsay. Its unusual layout repeats the composition of a very similar work painted the year before (*The Loing Canal: Winter*, 1891, Musée des Beaux-Arts, Algiers; D756; Fig. 120). In both the painter has taken up his position just where the canal starts to bend slightly, and looks across to the opposite bank through a row of bare-trunked poplars. This approach to the motif is a late echo of perspective effects used earlier in Sisley's career, in works in which roads curve away to the horizon (see Cat. 18, 22).

The canal has now lost its lines of trees, as can be seen from the modern photograph that Reidemeister juxtaposes with the painting (see p. 142).

In the very same year in which he made this decorative work, painted at sunset, Sisley talked about his art to Adolphe Tavernier, who published his words in *L'Art français* on 18 March 1893 and reprinted them in the preface to the catalogue of the exhibition *L'Atelier de Sisley* organised by Galerie Bernheim-Jeune in December 1907 (pp. 8–10):

... subjects must be rendered with their own texture. Above all, they must be enveloped in light, as they are in Nature. That is the progress that remains to be made.

The sky must be the means of this (the sky cannot just be a background)

I stress this part of the landscape because I want you to understand the importance that I attach to it.

As an indication: I always begin a picture with the sky

S.P.

PROV: Gift of a group of the artist's friends to the Musée du Luxembourg, Paris, 1899; Musée du Louvre, Paris (transferred in 1929); Musée du Louvre, Galerie du Jeu de Paume, Paris (from 1947); Musée d'Orsay, Paris (from 1986; inv. 20723).

EXH: San Francisco, 1915, no. 75; Barcelona, 1917, no. 1455; Madrid, 1918, repr.

BIBL: Paris 1923, new ed. 1924, no. 543, repr. p. 108; Geffroy 1923, repr. pl. 56; Paris 1927, p. 49; Besson, n.d. repr. pl.10; Venturi, 1939, I, p. 100; du Colombier, 1947, repr. pl. 10; Paris 1947, no. 282; Jedlicka, 1949, repr. pl.48; Fougerat, n.d. repr. p. 6; Paris 1958, no. 422; Paris 1961, no. 1758; Reidemeister, 1963, repr. p. 142; Daulte 1974, repr. p. 61; Paris 1972, p. 350; Paris 1973, p. 159, repr. p. 111, 4th ed., 1979, p. 173, repr. p. 125; Lassaigne and Gache-Patin, 1983, p. 142, repr. fig. 202; *Chefs-d'oeuvre impressionnistes et post-impressionnistes*, 1986, p. 112, repr. p. 113; Paris 1986, p. 217, repr.; Paris 1990 II, p. 429, repr.

120 Alfred Sisley, *The Loing Canal: Winter*, D756, 1891 (Musée des Beaux-Arts, Algiers).

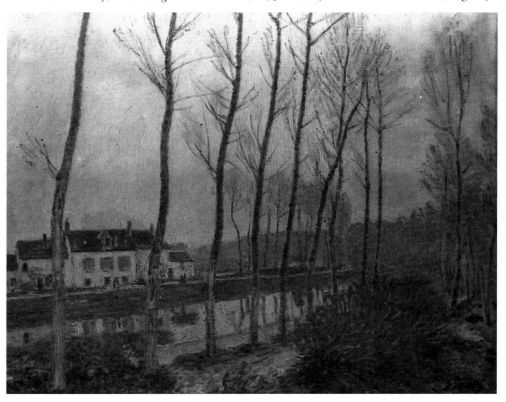

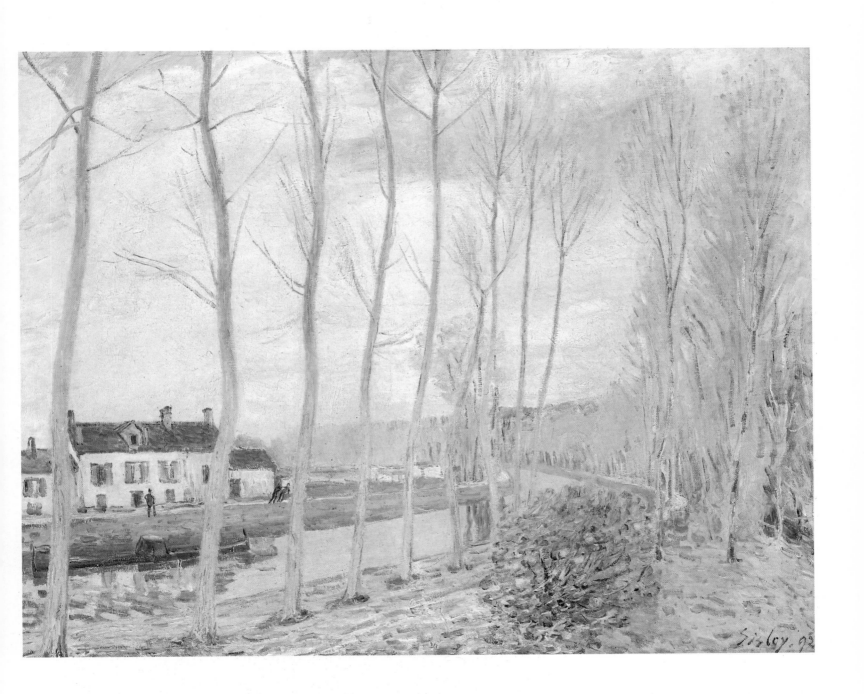

70 *Moret Bridge*

Pont de Moret
1893; D817
73 × 92 cm
Signed and dated bl: Sisley 93
Musée d'Orsay, Paris

Ever since the early 1870s, at Argenteuil (see Cat. 11), Villeneuve-la-Garenne (see Cat. 14), and Hampton Court (see Cat. 25–27), the bridge as a motif had been a constant preoccupation with Sisley. In the last decade of his life, it was the bridge at Moret-sur-Loing (Fig. 121), a dominant architectural feature that links the historic town centre with the road to Saint-Mammès, which captured his creative interests. This bridge appeared several times in the backgrounds of his paintings, and in some works from 1887 onwards it became the principal subject (as in the *Moret Bridge* of 1890, D725, Musée des Beaux-Arts, Algiers; Fig. 109).

Crossing the Loing on a succession of arches, the bridge was interrupted in the centre by the Moret watermills; its western end led up to the Porte de Bourgogne, which was the entrance to the town itself (see Cat. 64). In this view, it is seen in a close view from the right bank, and the arches beyond the centre are masked by the Provencher Mill (see Cat. 55), which also conceals part of the postern on the far bank; this can be glimpsed just to the right of the mill, before the near end of the row of poplars. The Porte de Bourgogne towers over the roof of the mill, and beyond the bridge, on the left, is the church. As so often in Sisley's art, there is an unobtrusive human presence, that of the tiny figures who are outlined against the bridge.

Rigorously constructed, using a diagonal thrust into depth common to Sisley's compositions of bridges (see Cat. 14, 25, 44) and lively in colour, this work dates from 1893. It records a section of Sisley's shifting angle of vision, as he maps out the full sweep of the riverscape at Moret, from bridge to wash-house (see Cat. 61) to avenue of poplars (see Cat. 59, 60, 68). It is representative of Sisley's attachment to its theme, of which Geffroy writes:

> And here is Moret bridge, the mill, the three poplars that Sisley so often celebrates

He paints Moret bridge, in the morning, after rain. The atmosphere is pure and fresh; the masses of the houses and trees are clearly outlined in the pure air, with no halo of mist or of refracted sunlight. The rustic bridge arches the river to either side of the mill; behind are houses with cosy roofs, low, countrified buildings, a dense wood, three giant poplars. Reeds lean over at the water's edge. A calm sky, with milk-white nimbus clouds unmoved by any breath of air. The bank is green; the bridge and the houses are in harmonies of violet, closer to pink than to blue. The Loing, clear, transparent, unwrinkled, expansive, reflects stones and greenery, clouds and reedbeds. The river is as deep as the sky; it has the same wealth of forms and colours as the landscape that it mirrors.

How often Sisley painted this Moret bridge! He hewed it in broad, plain masses, in a single vigorous impulse. What sureness there is in all this fire and energy! What rightness in the placing of every object, the definition of planes, the light! Beneath what limpid, mother-of-pearl skies, iridescent with blues and pinks, and above what calm or boiling waters, do those dark arches bow beneath their burden of history! How remote are the landscapes before which this massive construction appears, transforming houses and trees into weightless apparitions that a breath of air might blow away!

The painter leaves his landscape in autumn; he comes back to it in spring. His Moret, his Loing, his bridge, his mill, return to life in the new season. The youthful light transfigures the age-old stones. (Geffroy 1923, pp. 16–18).

S.P.

PROV: François Depeaux, Rouen (according to Daulte 1959); Dr Eduardo Mollard, Paris (from 1939, at the latest; see 1939 exhibition catalogue cited below); bequest from Enriqueta Alsop, in the name of Dr Eduardo Mollard, to the Musée du Louvre, Galerie du Jeu de Paume, Paris, 1972; Musée d'Orsay, Paris (from 1986; inv. R.F. 1972–35).

EXH: Paris, Rosenberg, 1939, no. 35; Los Angeles-Chicago-Paris, 1984–85, no. 57/64;

BIBL: Besson, n.d. repr. pl. 57; Adhémar, 1973, p. 289, repr. p. 286; Paris 1973, p. 159, repr. p. 111, new ed. 1979, p. 173, repr. p. 125; Bellony-Rewald, 1977, repr. pp. 236–37; Paris 1986, IV, p. 221, repr.; Paris 1990, II, pp. 434–35, repr.

121 *The Bridge at Moret*, photograph, 1882.

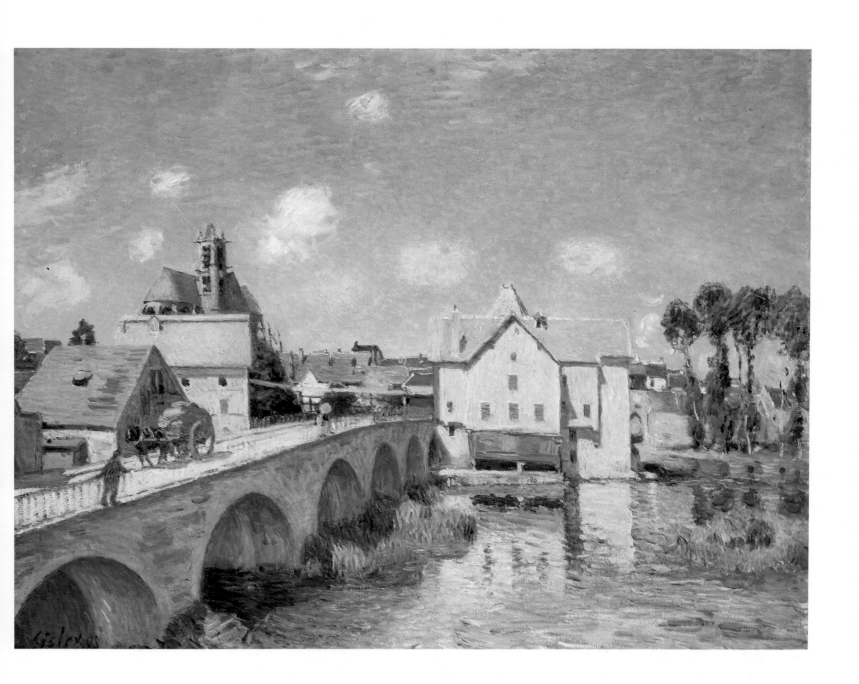

While still living at Veneux-Nadon, Sisley had been struck by the beauty of the church of Notre-Dame at Moret-sur-Loing. After he finally settled at Moret in November 1889, Sisley initially incorporated the church in the backgrounds of his views of the town, with its tower outlined against the sky (see Cat. 67). The tower dominated the view from the modest garden of Sisley's rented house on the corner of rue du Château (now rue du Donjon) and rue Montmartre. Living, as he did, so close to the church, which loomed above the surrounding houses and narrow streets, it is no surprise to find that Sisley painted it some dozen times in the two years 1893 (D818–822, and the work in the Hunterian Art Gallery, University of Glasgow) and 1894 (D834–840).

This group of compositions has been interpreted as a 'series', closely comparable with Monet's thirty views of Rouen Cathedral (Figs. 122–24). In painting these different versions of a single motif, in varying conditions of light and weather with only the slightest variations in position, Sisley was following Monet's example. Not long before, in two sustained periods of work in 1892 and 1893, Monet had observed Rouen Cathedral and captured its constantly changing appearance at different times of day (all the *Cathedrals* which he dated on the canvas bear the year '1894', when they had been finished in his studio at Giverny). Like Monet, Sisley set out to show the changing appearance of his motif at all times of day, in different seasons, and through a succession of atmospheric changes, as is shown by the titles he gave to the works – 'in sunshine', 'under frost', 'rainy weather – morning' (detail Fig. 27), 'afternoon', 'in rain', 'evening', 'after rain', 'in morning sun' – which echo those of Monet's *Grainstacks*, *Poplars* and *Cathedrals*. It was twenty years since Sisley had made his first approach to the 'series' technique, tracing a single motif through seasonal change in two highly contrasted studies, one in summer and one under snow (see Cat. 31).

Oscar Reuterswaerd (see BIBL:) has pointed out the analogies, as well as the differences, between the works of the two artists. They chose similar viewpoints, looking towards the west front from the south-west; the Moret west front has a Flamboyant Gothic portal that forms the main entrance to the church. Where Sisley

71A *The Church at Moret: Morning Sun*

L'église de Moret au soleil du matin
1893; D818
81 × 65 cm
Signed and dated br: Sisley 93
Kunstmuseum Winterthur, presented by Dr Herbert Wolfer
Exhibited in London and Paris only

PROV: Etienne Bignou, Paris (according to Daulte 1959; no further information in Archives Bignou); Alex Reid and Lefevre, London; I. van Wisselingh, Amsterdam; Dr Willi Raeber, Basel; Private Collection.

EXH: London, Reid and Lefevre, 1954, no. 20; Bern, 1958, no.88

BIBL: Lassaigne and Gache-Patin, 1983, p. 150, repr. fig. 13.

122–24 Claude Monet, *Rouen Cathedral* (Musée d'Orsay, Paris).

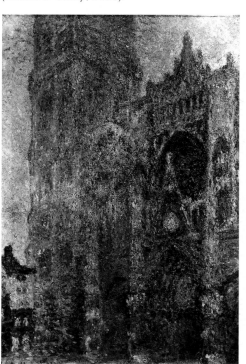
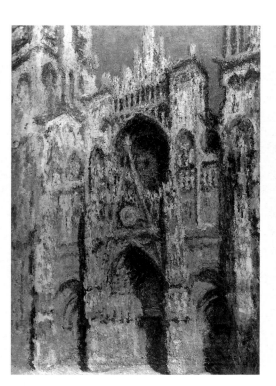
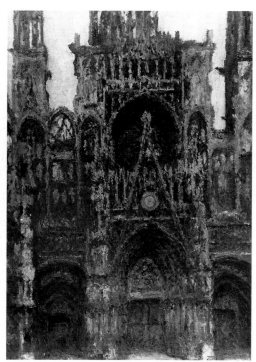

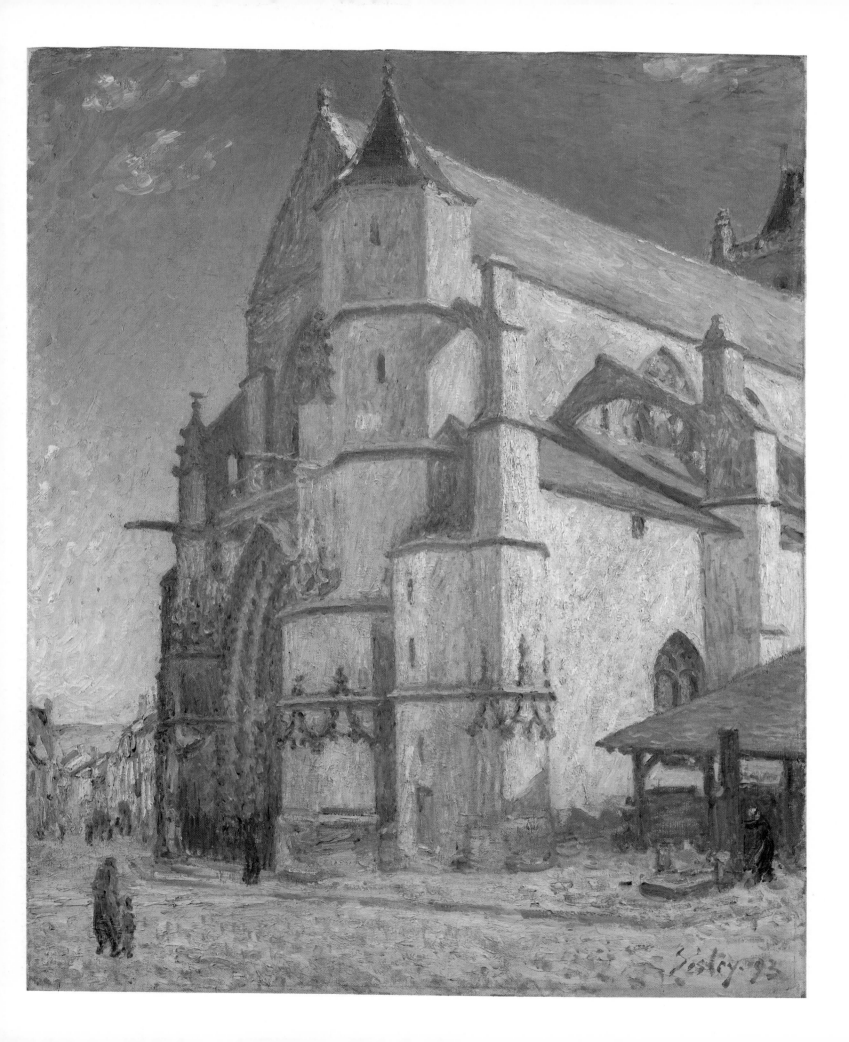

differs from Monet, and asserts his independence, is in his characteristic determination to convey all the detail of the architectural forms.

Monet dealt with solid objects by stressing their ephemeral nature; what he sought to express was their 'momentariness'. Tracing the play of light and shade across the cathedral façade, he analysed not the object but the transformations undergone by that object as its lighting changed. He was trying to paint the impalpable; his concern was with the air and the light, and thus much more with the element that existed *between* his eye and the cathedral than with the cathedral in itself. The Gothic architecture was not studied for its own sake: it served as a base for painterly exploration. Not even so solid a motif as a historic building was immune to the dissolution of forms by light: 'everything changes, stone though it is', wrote Monet (letter to Alice Monet, 5 April 1893). To suggest the physical texture of his chosen subject, Monet used a curiously rugged paint surface that captures light and recreates the vibrancy of sunshine.

By contrast, Sisley has set out to affirm the permanent nature of the building; its architecture massively dominates the canvas. When Sisley extends his field of view further to the east, we can identify all the detail of the stone carving on the south side of the church, from west end to transept (see D834, Cat. 71D). Sisley alternates between an upright format (which Monet uses consistently) and a landscape format (as in the painting in Glasgow, Cat. 71C, and D837, Cat. 71F). Whereas Monet's compositions neglect the third dimension, Sisley's show the church in its spatial context at the heart of the small town, with the street, the passers-by, the covered market since demolished and fountain to the right, and the sky.

Had Sisley actually seen Monet's *Cathedrals*? Or did he know of them only by hearsay? They were not shown publicly until May 1895 at Durand-Ruel's Gallery, by which time Monet had reworked and completed them in his studio at Giverny. Furthermore, did Sisley ever intend to create a 'series'; did he want to exhibit all the works together? We do know that four paintings of Moret church by Sisley (including D822, Cat. 71B) were shown at the Salon de la Société nationale des Beaux-Arts on the Champ-de-Mars in April–May 1894. Two were shown at the

same Salon in 1896 (one of which, D840, Cat. 71G, is now in the Musée du Petit Palais). Then, in February 1897, three versions appear as nos. 40, 48 and 74 in the catalogue of the Georges Petit retrospective (including D822, Cat. 71G, and D836, Cat. 71E; see EXH: sections of those entries).

Technically, Sisley's *Churches* present little evidence of being as 'finished' as Monet's *Cathedrals*. They have been rapidly painted, with little evidence of significant overpainting at a later stage (see Cat. 71A). However, the fact that he did exhibit a small group of the paintings in the Salon du Champ-de-Mars in 1894 suggests that some 'serial' interpretation could be read into the *Churches*. Given their concentration on a particular motif, they can be seen as the culmination of Sisley's life-long concern to capture on canvas the various views of a particular location, be it Louveciennes, Marly-le-Roi, Port-Marly, Saint-Mammès, or Moret-sur-Loing. The visual mapping upon which Sisley had embarked at the beginning of his career, albeit tentatively (see Cat. 10, 13–15), where a motif is explored under varying weather conditions and from different angles of vision, has now been funnelled into a virtually static angle of vision, the mapping now confined to observations of light upon a single motif.

Some of the *Moret Church* paintings went straight into the collections of Dr George Viau (D822, Cat. 71A) and François Depeaux (D819). But several were still in the artist's studio at his death: his daughter Jeanne (Mme Dietsh) kept two of these

71B *The Church at Moret: Afternoon*

L'Eglise de Moret – l'après-midi
1893; D822
81 × 65 cm
Signed and dated br: Sisley 93
Private Collection, Lausanne
Exhibited in London and Paris only

PROV: bt from the artist by Dr Georges Viau, Paris, 1895; see 1897 exhibition catalogue cited below); Durand-Ruel, Paris (according to Daulte 1959; no additional information in Archives Durand-Ruel); Jean-Baptiste Faure, Paris; Mme Jean-Baptiste Faure, Paris; placed on consignment with Durand-Ruel, Paris, by Mme Faure; bt Durand-Ruel, New York, and Georges Petit, Paris, 1 February 1919 (Archives Durand-Ruel); Ludwig Charrell, New York; Knoedler and Co., New York; Otto M. Gerson, New York; Private Collection, Lausanne.

EXH: Paris, Champ-de-Mars, 1894, no. 1062; Paris, Petit, 1897, no. 48; Paris, Petit, 1899, no. 77; Paris, Petit, 1917, no. 55; New York Fine Art Associates, 1958, no. 54; Schaffhausen, 1963, no. 129; Lausanne, Château de Beaulieu, 1964, no. 83; Paris, Orangerie, 1967, no. 85; Paris, Durand-Ruel, 1971, no. 49; Tokyo-Sapporo-Osaka-Yamaguchi-Nagoyu-Tokyo-Ueno, 1974, no. 63; London, David Carritt, 1981, no. 19.

BIBL: Reuterswaerd, 1952, p. 199, repr. fig. 9, p. 202; Daulte, 1961, p. 42, repr. pl. 27; Daulte, 1974, repr. p. 63.

125 Alfred Sisley, *The Church at Moret*, drawing (Private Collection).

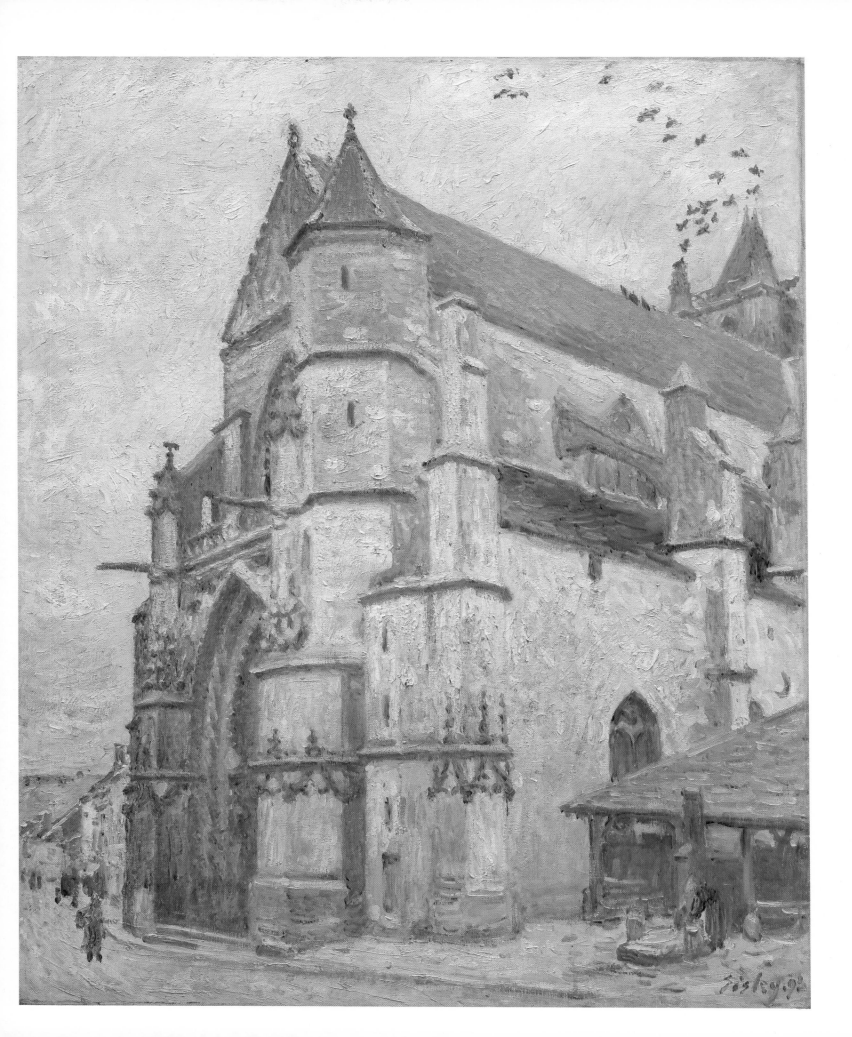

(one of which was D837, Cat. 71F), and six others were disposed of at the studio sale held in aid of the artist's children on 1 May 1899 (nos. 10–15 in the sale catalogue, Galerie Georges Petit, including the Glasgow painting, Cat. 71C; D834, Cat. 71D; D836, cat. 71E).

Ever-present in the townscape of Moret-sur-Loing as it is in Sisley's paintings and drawings (Fig. 125; see Daulte 1972, p. 62), the church of Notre-Dame remained with the artist, movingly, throughout the last years of his life – as our partial reconstruction of the series shows.

One contemporary testimony is provided by Julie Manet (1878–1966), the daughter of Berthe Morisot and Eugène Manet, whose diary was started in 1893, when she was fourteen. Staying with her mother at Valvins with Mallarmé, who was her legal guardian after her father's death, Julie wrote in her diary:

> Thursday 21 September. After a rainy morning, the day turned sunny, and we drove out to Moret. It's very pretty; we went there through the open country and came back through the forest. We saw Sisley at Moret. (Manet, 1979, p. 19).

Denis Rouart corroborates this entry:

> On 18 September [1893], Berthe and her daughter went back to Valvins. A few days later, they went with the Mallarmés to Moret, where Sisley was painting a series of *Churches* – inspired, or so Mallarmé thought, by Monet's series of *Cathedrals*. (Denis Rouart, Paris 1950, p. 177).

S.P.

71C *The Church at Moret, Rainy Weather, Morning*

L'Eglise de Moret, temps pluvieux, le matin
1893; Non-D
65 × 81 cm
Signed and dated br: Sisley 93
Hunterian Art Gallery, University of Glasgow

PROV: Sisley Atelier Sale (with pictures offered by other artists for the benefit of the artist's children), Galerie Georges Petit, Paris, 1 May 1899 (12), sold for 2600 fr (see *Bulletin de l'art ancien et moderne*, no. 18, 6 May 1899, pp. 147–48); Dr Georges Viau, Paris; Dr W. Boyd, Claremont; Robertson and Bruce Ltd, West Ferry, Dundee; R. W. Honeyman, Glasgow (*c.* 1944); Mrs M. C. W. Honeyman, Glasgow; Hunterian Museum, University of Glasgow (since 1980).

EXH: Edinburgh, 1929, no. 334; Tokyo-Fukuoka-Nara, 1985, no. 47.

BIBL: Reuterswaerd, 1952, p. 200; *Burlington Magazine*, lxxii (1980), p. 873, repr.

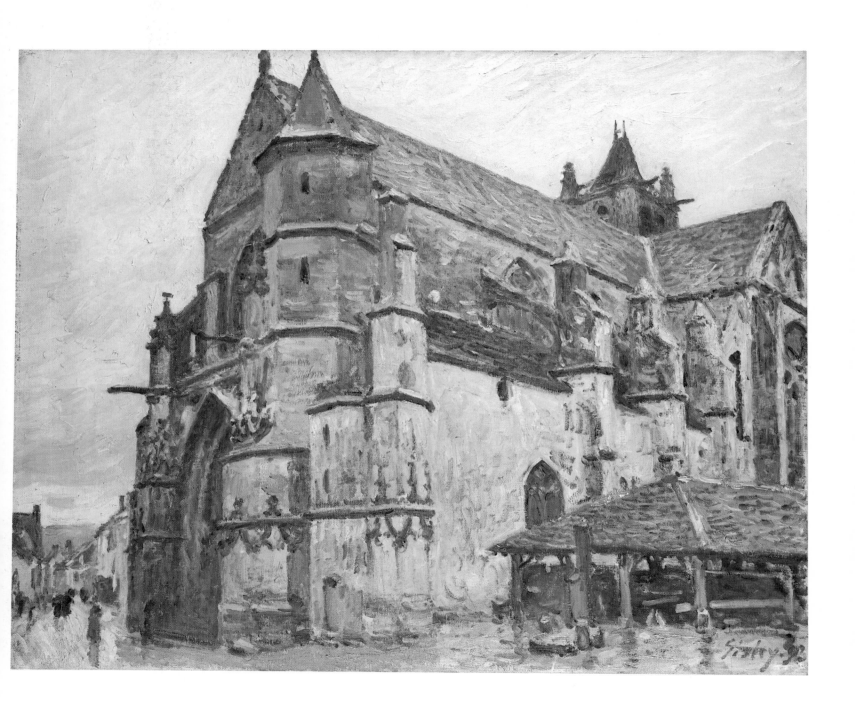

71D *The Old Church at Moret in the Rain, Looking towards the Transept*

La Vieille église de Moret par la pluie, côté du transept
1894; D834
73 × 60 cm
Signed and dated bl: Sisley 94
Birmingham City Museums and Art Gallery

PROV: Sisley Atelier Sale (with pictures by other artists for the benefit of the artist's children, Galerie Georges Petit, Paris, 1 May 1899 (15), sold for 3,000 fr (see *Bulletin de l'Art ancien et moderne*, no. 18, 6 May 1899, pp. 147–48); Lacroix, Paris; Lacroix Sale, Hôtel Drouot, Paris, 12 April 1902 (62); bt Ernest Cognacq for 3,900 fr; Ernest Cognacq, Paris; Baillehache, Paris; Mme Jos. Hessel, Paris; Etienne Bignou, Paris (repr. in Archives Bignou as no. 375, *Moret Church and the Covered Market*); Alex Reid and Lefevre, London; Captain S. W. Sykes, London; bt Corporation Art Gallery, Birmingham, 1948 via Alex Reid and Lefevre, London; City Museum and Art Gallery, Birmingham (inv. P. 26.48).

EXH: Paris, Durand-Ruel, 1902; Paris, Galerie Barbazanges, 1920; Paris, Hessel, 1924; Paris, Knoedler, 1924, no. 18; London, Lefevre, 1926; London, Royal Academy, 1949–50, no. 263; London, Agnew and Sons, 1957, no. 12; Nottingham, 1971, no. 14; London, Royal Academy, 1974, no. 113; Tokyo-Fukuoka-Nara, 1985, no. 48.

BIBL: Reuterwaerd, 1952, pp. 199–200; *City Museum and Art Gallery, Catalogue of Paintings*, Birmingham 1960, p. 135.

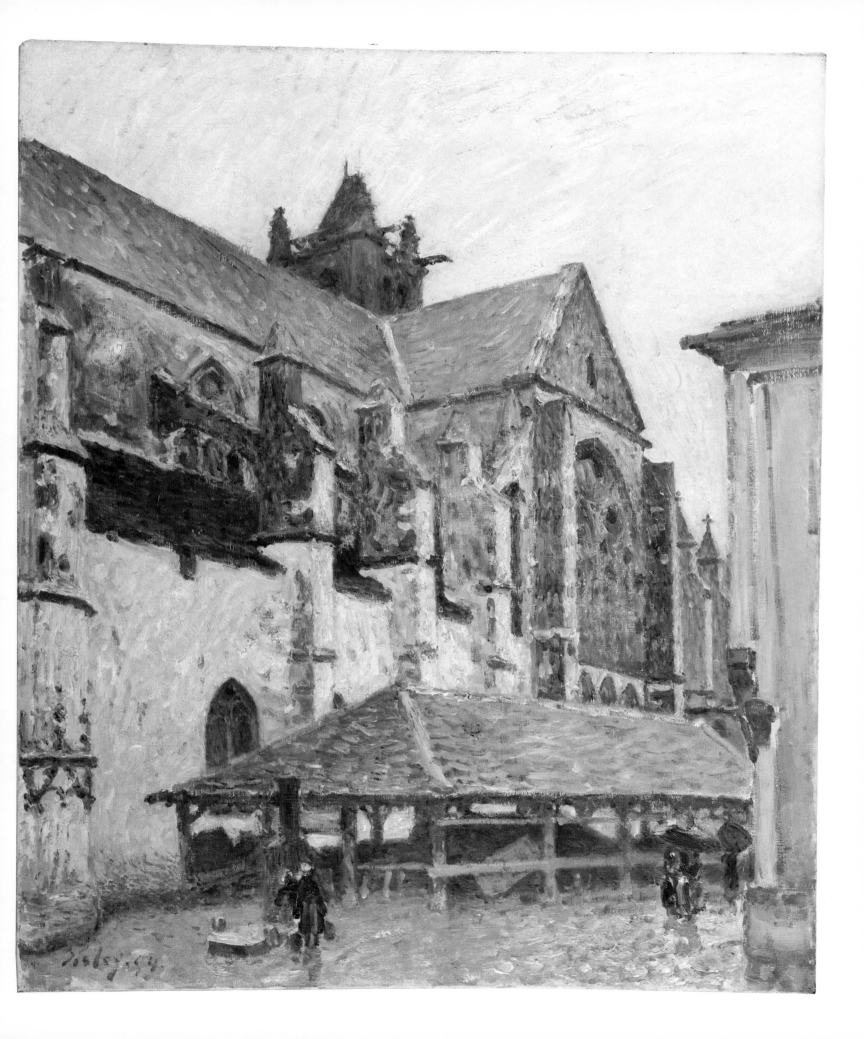

71E *The Church at Moret after Rain*

L'Eglise de Moret, après la pluie
1894; D836
73 × 60 cm
Signed and dated bl: Sisley 94
The Detroit Institute of Arts, City of Detroit
Purchase

PROV: Sisley Atelier Sale (with pictures offered
by other artists for the benefit of the artist's
children), Galerie Georges Petit, Paris, 1 May
1899 (14), sold for 3,000 fr (according to Daulte
1959) or for 2,850 fr (see *Bulletin de l'art ancien et
moderne*, no. 18, 6 May 1899, pp. 147–48); Léon
Payen, Paris; Payen Sale, Hôtel Drouot, Paris,
29–30 June 1916 (107); bt Durand-Ruel for
3,000 fr; Durand-Ruel, Paris; bt Albert Kahn,
acting for the Detroit Institute of Arts, for
32,000 fr, 20 November 1920 (*Bulletin of The
Detroit Institute of Arts*, cited in BIBL: below;
Archives Durand-Ruel); The Detroit Institute
of Arts (inv. 20114).

EXH: Paris, Petit, 1897, no. 40; New York,
Wildenstein, 1966, no, 67.

BIBL: *Bulletin of The Detroit Institute of Arts*,
Detroit, May 1921, II, pp. 71, 73; Geffroy,
1927, repr. pl. 55; Duret, 1939, repr. p. 86;
Venturi, 1939, I, p. 100; Reuterswaerd, 1952,
pp. 196–97, 200, repr. fig. 2 p. 195; Daulte,
1957, repr. p. 53; *The Detroit Institute of Arts,
Album, French Art*, 1966, repr.

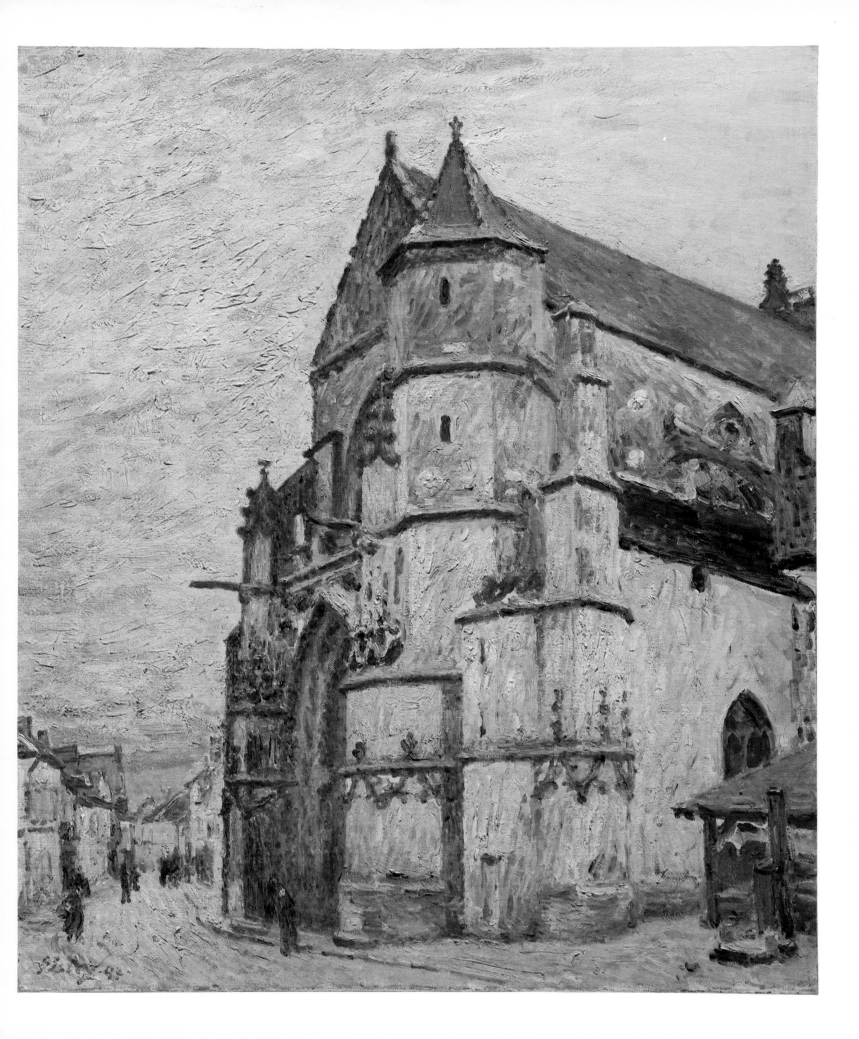

71F *The Church at Moret in Sunshine*

L'Eglise de Moret au soleil
1894; D837
73 × 92 cm
Signed and dated br: Sisley 94
Private Collection, Switzerland
Exhibited in London and Paris only

PROV: Mme Dietsh-Sisley, née Jeanne Sisley, daughter of the artist, Paris; Deitsh-Sisley Sale, Hôtel Drouot, Paris, 18 May 1909 (2); bt Paul Rosenberg for 2,000 fr; Paul Rosenberg, Paris; Max Emden, Berlin; Lutjens, Amsterdam; Walter Feilchenfeldt, Zurich; Private Collection, Zurich.

EXH: Paris, Rosenberg,1904, no. 44; Paris, Bernheim-Jeune, 1907, no. 18; Tokyo-Fukuoka-Nara, 1985, no. 49.

BIBL: Reuterswaerd, 1952, pp. 196, 198, 200, 202, repr. fig. 5, p. 198; Reidemeister, 1963, repr. p. 139.

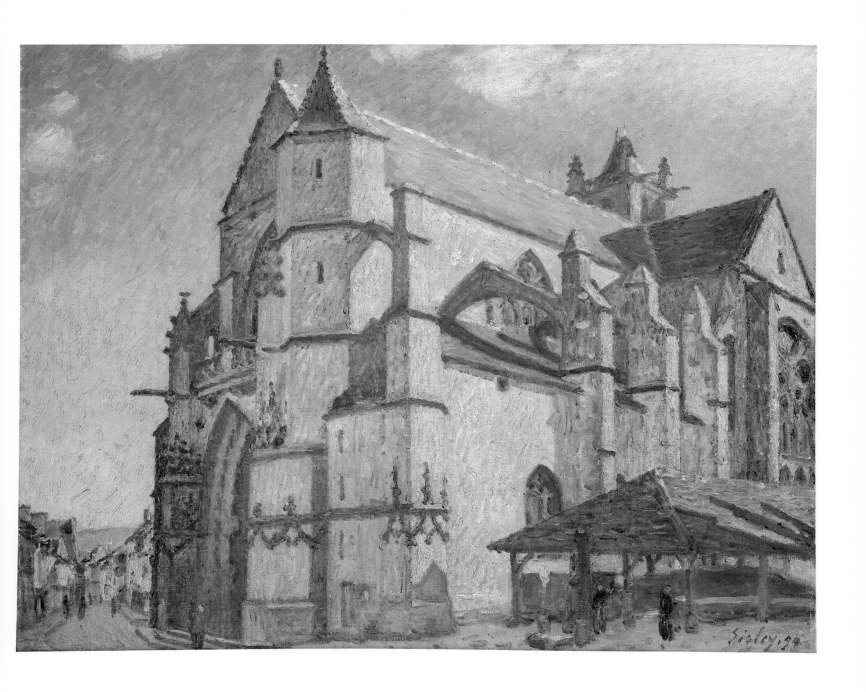

71G *The Church at Moret, Evening*

L'Eglise de Moret, le soir
1894; D840
100 × 81 cm
Signed and dated br: Sisley 94
Musée du Petit Palais, Paris

PROV: Purchased by the City of Paris at the Salon de la Société Nationale des Beaux-Arts, Champ-de-Mars, July 1896, for 4,000 fr (Archives de la Seine); Musée du Petit Palais, Ville de Paris (inv. 118).

EXH: Paris, Champ-de-Mars, 1896, no. 1149; Paris, Petit, 1897, no. 74; Bern, 1947, no. 97; Zurich, 1947, no. 298; Vienna, 1949, no. 27; Rotterdam, 1952, no. 128; Paris, Petit Palais, 1953, no. 423; London, Wildenstein, 1955, no. 219; Warsaw, 1956, no. 89; Bern, 1958, no. 89; Paris, Bibliothèque Nationale, 1965, no. 287; New Delhi, 1977, no. 56; Paris, Grand Palais, 1977, repr. p. 35; Tokyo-Fukuoka-Nara, 1985, addendum no. 3;

BIBL: *Catalogue des collections municipales*, 1904, no,. 110, ed. 1906, no. 120; *Palais des Beaux-Arts de la Ville de Paris, Catalogue sommaire des collections municipales*, 1927, no. 395; Jedlicka, 1949, repr. pl. 44; Reuterswaerd, 1952, repr. p. 201; *Musée du Petit Palais. Catalogue sommaire illustré des peintures*, 1982, no. 767, repr.; Lassaigne and Gache-Patin, 1983, pp. 150–51, repr. fig. 213.

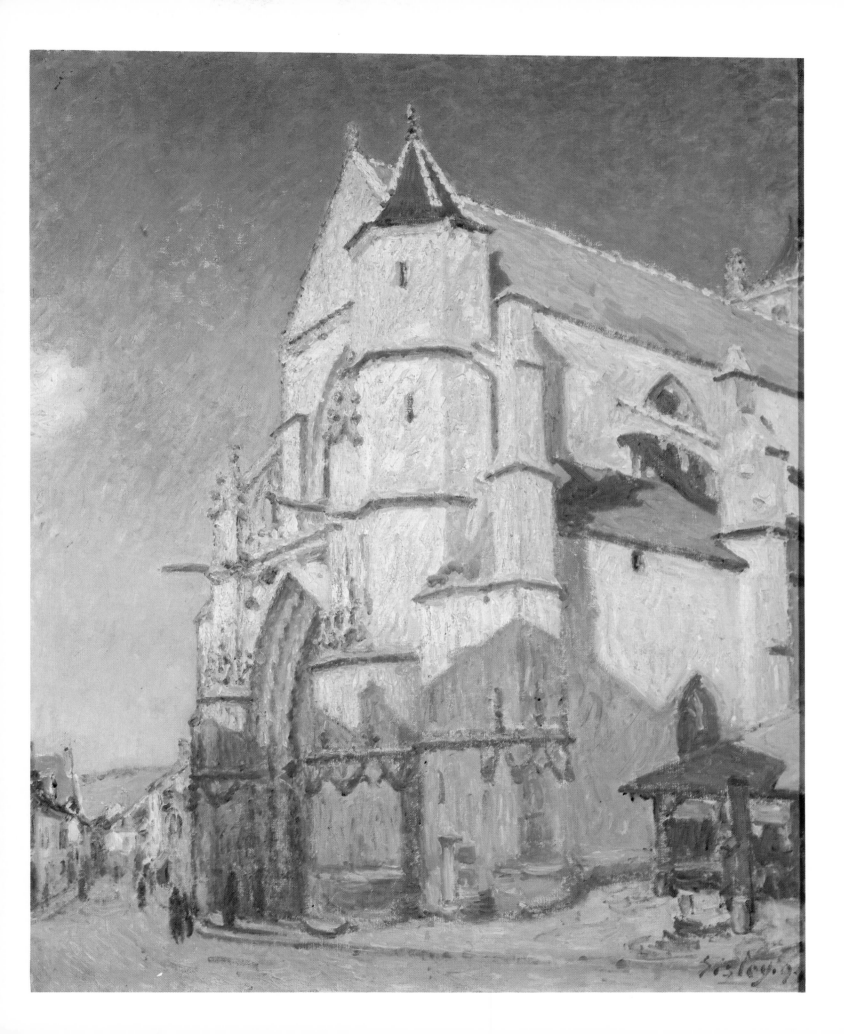

72 A Corner of the Meadow at Sahurs, in Normandy, Morning Sun

Un coin de la prairie de Sahurs, en Normandie, soleil du matin
1894; D825
73 × 92 cm
Signed and dated br: Sisley 94
Collection of Janice H. Levin, New York, partial gift to The Metropolitan Museum of Art, 1991 (1991.277.3)

Sisley lived an increasingly withdrawn life at Moret-sur-Loing. Nevertheless, in the summer of 1894, he travelled to Normandy, going first to Rouen, where he stayed at the Hôtel du Dauphin et d'Espagne, jointly owned by the painter and collector Eugène Murer (1846–1906) and by Murer's half-sister. Murer charged concessionary prices to artists and often accepted canvases from his friends in lieu of board. The results of such arrangements were to be seen in 1896, when, on 16 March, Murer opened an exhibition at the hotel of works by Pissarro, Monet, Renoir, Guillaumin and Sisley. A year later, financial failure led to the sale of the hotel.

It must have been a relief to Sisley to escape from urban Rouen and stay on François Depeaux's estate at Le Mesnil-Esnard (see 'Veneux-Nadon to Moret-sur-Loing', p. 185). Of the seven paintings that Sisley made in Normandy, Depeaux bought five (D823–826, 829); and he donated two of these, *The Waterside Path at Sahurs* (D823) and *The Seine at Sahurs, Gust of Wind* (D824), to the Musée des Beaux-Arts in Rouen. Sisley's favourite subjects were the steep slopes of La Bouille, to the south of Rouen, and the riverside meadows at Sahurs. The painting exhibited here, formerly in the Depeaux collection, displays the vast extent of sky that characterises so many of Sisley's works, whether painted in Normandy or on the banks of the Loing.

This painting is one of three showing virtually the same scene (see *The Hills of La Bouille, Normandy: Morning*, D826, Private Collection, and *The Hills of La Bouille, near Rouen, and the Plain of Sahurs*, D827, Private Collection; Fig. 52). Characteristically, Sisley has explored a confined location, each painting representing a slight shift of his angle of vision to encompass a path leading into the distance (D826 and D827), a clump of trees on the left (D825 and D826) and, in all three, the tall, strangely shaped trees along the horizon. Although the dimensions of two of the three are identical (D826 and D827), it would appear that, as with other examples of Sisley's explorations of the same motif, such as the Chemin de l'Etarché (see Cat. 31) and the Boatyard at Matrat (see Cat. 67), the intention was to create neither a 'series' nor a set of pendants. Rather, the breadth of scene and its tall trees provided Sisley with an opportunity to analyse the structure of the landscape through the same system of carefully differentiated areas of brushwork which he began to apply in the early 1880s (see Cat. 49–52).

S.P.

PROV: François Depeaux, Rouen; Depeaux Sale, Hôtel Drouot, Paris, 25 April 1901; bt Durand-Ruel for 8,300 fr according to Daulte 1959; (no information in Archives Durand-Ruel); François Depeaux, Rouen; Depeaux Sale, Galerie Georges Petit, Paris, 31 May–1 June 1906 (50); bt Durand-Ruel for 3,600 fr (see Isaac de Camondo's annotated copy of sale catalogue, now in Bibliothèque du Musée du Louvre, Paris); Durand-Ruel, Paris (Archives Durand-Ruel); bt M. Longuet, 19 June 1923; M. Longuet, Paris; Longuet Sale, Hôtel Drouot, Paris, 3 March 1933 (84); bt Durand-Ruel; Durand-Ruel, Paris; Private Collection, Paris; Levin Collection, New York.

EXH: Manchester, UK, 1907–08, no. 179; Paris, Durand-Ruel, 1914, no. 33; Venice, 1938.

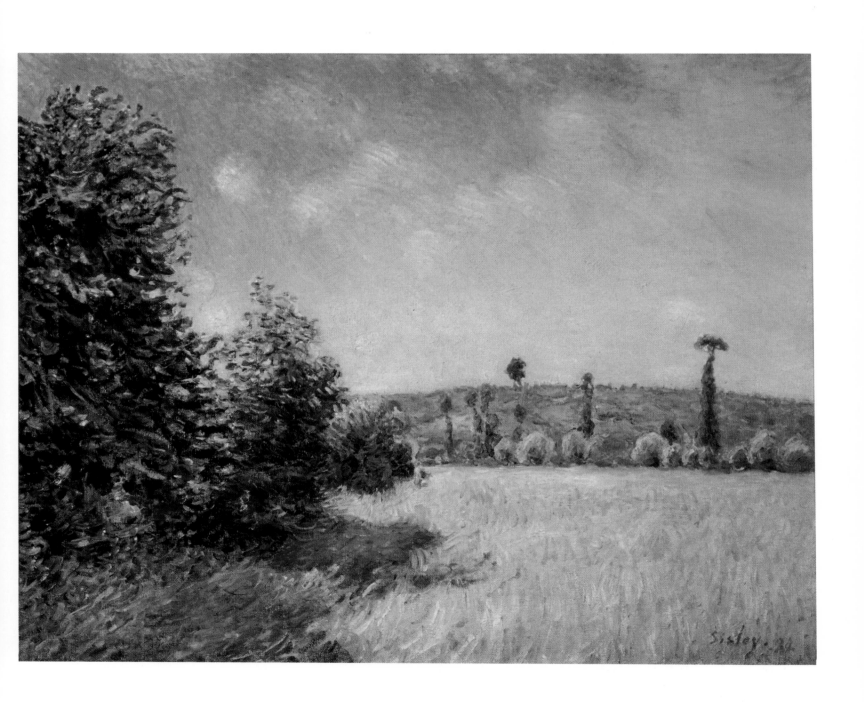

73 Cardiff Roads

La rade de Cardiff
1897; D866
54 × 65 cm
Signed and dated bl: Sisley 97
Musée des Beaux-Arts, Reims

In May 1897, Sisley paid his last visit to his ancestral homeland. Once more, he was following in the footsteps of the collector who had become a friend, François Depeaux. After a few days in London, an advance from Depeaux enabled him to spend four months in Britain; he toured the South of England and then went to stay at Penarth, near Cardiff. From there he wrote to Gustave Geffroy on 16 July:

> I have been here for a week, after travelling across the South of England by rail and spending three days at Falmouth in Cornwall. I am now resting from my exhausting travels and shall shortly be starting work. The countryside is pretty, and the Roads (Figs 126, 127), with the big ships sailing into and out of Cardiff, is superb I don't know how long I shall stay at Penarth. I am very comfortable here, 'in lodgings' with some very decent folk. The climate is very mild, and has indeed been too hot these last few days, especially now, as I write. I hope to make good use of what I see around me and to return to Moret's fair city in October or thereabouts. (Daulte 1959, p. 36)

The painting now in Reims shows Cardiff Roads; it is laid out in progressively more remote planes, from the tree that stands out in the foreground to the skyline, where the twin expanses of sea and sky, harmonised in the same colours, meet each other. Beyond the figures silhouetted against the water (identified in the 1901 catalogue of the *Vente . . . Louis Schoengrun* as 'a small girl, standing next to her seated mother'; see Provenance), we look out towards the sailing ships; there is one long vessel in the centre of the composition. To the left we glimpse the end of the jetty; this is the very spot from which Sisley saw the 'superb' view that he described to his friend Geffroy.

This composition can be read as a direct reminiscence of Monet's views of Cap d'Antibes, painted in 1888, in which the foreground is occupied by Mediterranean

vegetation, with a distant glimpse of the old town of Antibes beyond. The Monet-Sisley derivation has been discussed by Christopher Lloyd (Tokyo-Fukuoka-Nara, 1985, no. 52), who points specifically to Monet's *Montagnes de l'Estérel* of 1888 (Courtauld Institute Galleries, London). However, Lloyd identifies a specific difference between the approach of the two artists in the inclusion of figures in Sisley's painting, imbuing it with an element of narrative.

Daulte and Lloyd have both drawn attention to the existence of two preparatory drawings for this painting, one at the Musée du Petit Palais, Paris, and the other in a private collection in New York (Figs 126, 127, reproduced together in Daulte 1972, p. 70).

On 10 September 1897, Pissarro wrote to his son Georges: 'I didn't tell you that Sisley wanted to put on an exhibition. He has brought back some sea pieces from England, and I heard from Viau that, like me, he was looking for buyers' (Bailly-Herzberg IV, 1989, p. 397). And another son, Félix, told his father that, according to *Le Journal* for 4 October, Sisley had 'done some splendid paintings by the sea, in a little corner of the world that hardly anyone has ever heard of: he is probably going to put on an exhibition' (*ibid.*, p. 398). The anonymous article which Félix Pissarro read in *Le Journal* provided further information:

> The Impressionist master has brought back from Penarth and Langland Bay a series of admirable sea pieces, in which the strange flavour of that landscape, little frequented by painters, is rendered with an art that is as captivating as it is personal. We may shortly expect an influx of admirers to the celebrated

painter's studio at Moret. (Quoted by Bailly-Herzberg, *ibid.*)

Together with two other seascapes painted in Wales (*Lady's Cove: Rough Sea*, D873, and *The Wave: Langland Bay, Wales*, D877), this work was shown in the following year at the Salon de la Société nationale des Beaux-Arts (as no. 1133).

A number of Sisley's British landscapes found their way into the French collections of Depeaux (D870, 875, 879), Count François Doria (D867) and Adolphe Tavernier (D865). However, of the seventeen paintings that Sisley produced in Wales, the work shown here and five others (D868, 869, 871, 876, 880; see Cat. 74) were still in the painter's studio at his death. They were dispersed at the posthumous studio sale, held at the Galerie Georges Petit a few months later for the benefit of Sisley's children.

S.P.

PROV: Sisley Atelier Sale (with pictures offered by other artists for the benefit of the artist's children), Galerie Georges Petit, Paris, 1 May 1899 (22), sold for 4,050 fr (see *Bulletin de l'art ancien et moderne*, no. 18, 6 May 1899, pp. 147–48); Louis Schoengrun, Paris; Schoengrun Sale, Hôtel Drouot, Paris, 7 February 1901 (26); bt Durand-Ruel for 3,300 fr; bt Henry Vasnier for 7,000 fr, 19 February 1902 (Archives Durand-Ruel); Henry Vasnier, Paris; Bequest of Henry Vasnier to Musée des Beaux-Arts, Reims, November 1907; Musée des Beaux-Arts, Reims (inv. 907.19.233).

EXH: Paris, Champ-de-Mars, 1898, no. 1133; Paris, Durand-Ruel, 1902, no. 39; Reims, 1948, no. 102; London, Hayward Gallery, 1973, no. 46; Tokyo-Fukuoka-Nara, 1985, no. 52; Japan, circulating exhibition, August 1986–March 1987, no. 76.

BIBL: Duret, 1906, repr. p. 126; *La Galerie Vasnier à Reims*, 1909, p. 67; Daulte, 1974, repr. p. 81; Lassaigne and Gache-Patin, p. 146, repr. fig. 211.

126 Alfred Sisley, *Cardiff Roads*, drawing (Private Collection, New York).

127 Alfred Sisley, *Cardiff Roads*, drawing (Musée du Petit Palais, Paris).

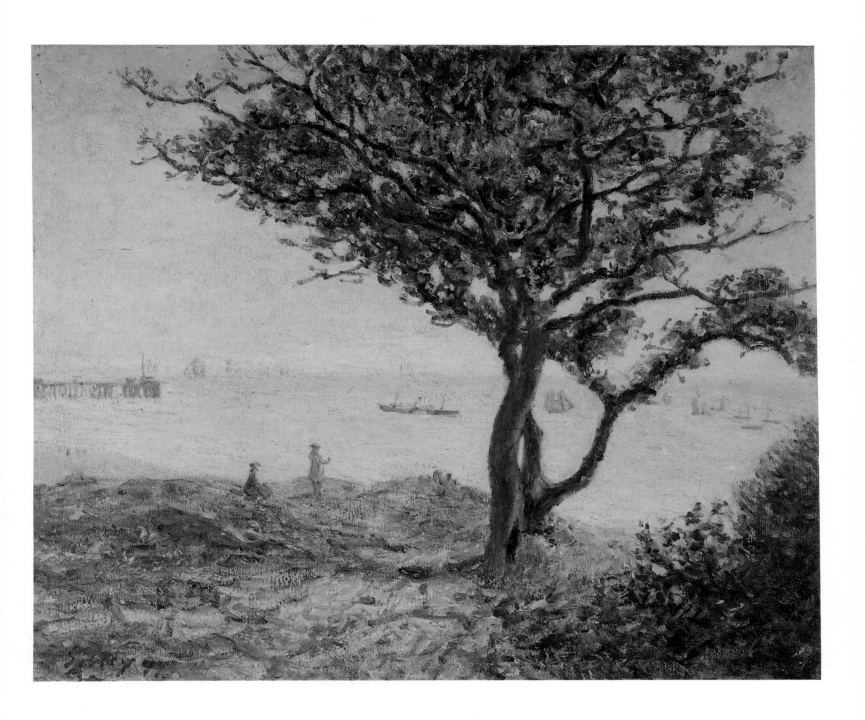

74 *Lady's Cove, West Side, Wales*

Lady's Cove, côté ouest, Pays de Galles
1897; D880
54 × 65 cm
Signed and dated bl: Sisley 97
Bridgestone Museum of Art, Ishibashi
Foundation, Tokyo

To the north-west of Cardiff, the Swansea area has a rocky, west-facing coastline with high cliffs; it offers locations as impressive as the cliffs of Etretat, Dieppe and Pourville, painted by Monet. Lady's Cove (now called Rotherslade Bay) encloses a sheltered beach within the wider sweep of Langland Bay (see London, Hayward Gallery, 1973, p. 61).

The description of the painting now in Tokyo, given in the sale catalogue of the Collection Depeaux in 1906 (see Provenance), underlines the dramatic nature of that part of the Welsh coast: 'On the right, the rocky shoreline, with one enormous block jutting into the sea, which hurls at it great green rollers with plumes of foam . . .'.

Like several others of the seventeen works that Sisley brought back from Wales, *Lady's Cove* belonged to François Depeaux, who presented two other pictures from the same group (D875, 879) to the Musée des Beaux-Arts, Rouen. The industrialist seems to have responded with particular warmth to Sisley's vision of a part of the world where he himself had coal-mining interests (see 'Veneux-Nadon to Moret-sur-Loing', above, p. 185).

In his monograph on Sisley (1923, pp. 25–26), Gustave Geffroy discussed the paintings inspired in the artist by the view of those Welsh coasts:

> He sometimes left his retreat in Seine-et-Marne for summer excursions, on which he carries us in the mind's eye to the English [*sic*] coast, to Cardiff, at the foot of the cliffs at Penath [*sic*]. He offers us views of Lady's Cove, Storr Rock and Landgland [*sic*] Bay: beaches where the waves foam like *mousseline*; the rhythmic advance of the tides; rocks teeming with vegetation; the transparent shadows that the land casts across the sea; ships that pass, lost in immensity

S.P.

PROV: Sisley Atelier Sale (with pictures by other artists for the benefit of the artist's children), Galerie Georges Petit, Paris, 1 May 1899 (26), sold for 2,900 fr (see *Bulletin de l'art ancien et moderne*, no. 18, 6 May 1899, pp. 147–48); François Depeaux, Rouen; Depeaux Sale, Hôtel Drouot, Paris, 25 April 1901; bt Baron de Saint-Joachim for 2,200 fr; Baron de Saint-Joachim, Paris; François Depeaux, Rouen; Depeaux Sale, Galerie Georges Petit, Paris, 31 May–1 June 1906 (237); bt in by Durand-Ruel, acting on Depeaux's behalf, for 1,100 fr; on consignment with Durand-Ruel, Paris, 7 June–30 November 1906 (Archives Durand-Ruel); Depeaux estate Sale, Hôtel Drouot, Paris, 30 June 1921 (66); Kuga, Osaka; Shojiro Ishibashi, Tokyo; Bridgestone Museum, Tokyo.

EXH: Tokyo, Bridgestone Gallery, 1957, no. 5; Kurume, 1961, no. 21; Kurume, 1963, no. 7;

BIBL: Dorival, 1958, p. 59; *Catalogue de la Bridgestone Gallery, Tokyo*, 1965, no. 32; *Catalogue du Bridgestone Museum of Art*, 1974, no. 41; Lassaigne and Gache-Patin, 1983, p. 146, repr. fig. 210.

128 Alfred Sisley, *Drawing Room of the Osborne Hotel*, drawing (Dr B. Jean Collection).

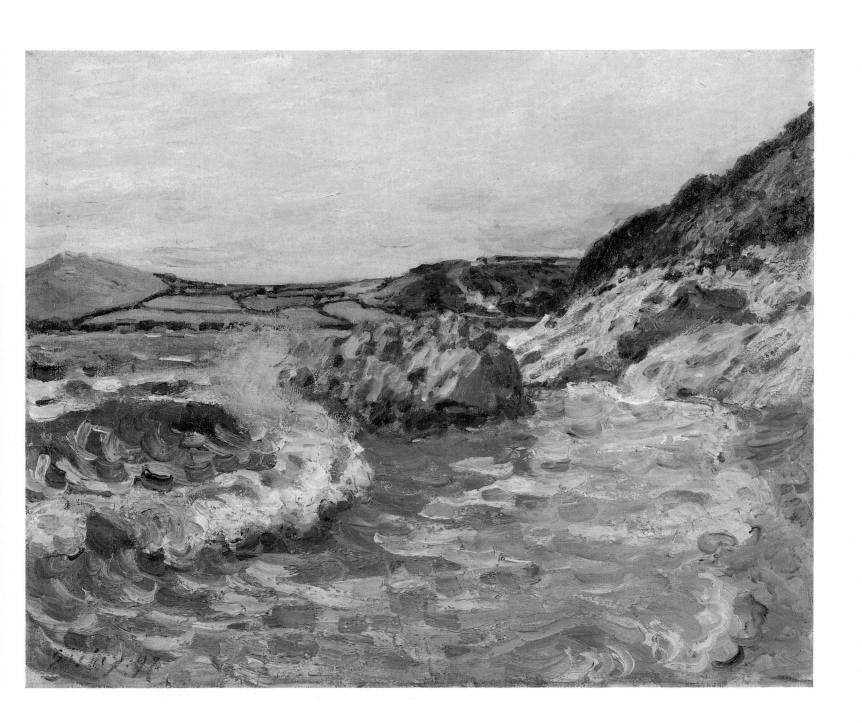

75 *Langland Bay, Morning*

Langland Bay, le matin
1897; D881
65 × 81 cm
Signed and dated bl: Sisley 97
Kunstmuseum, Bern
Exhibited in London and Paris only

The principal motif in the composition is here shown in close-up; it is Storr's Rock, in Langland Bay, to the west of Swansea. The painter seems to have observed it from the beach at Rotherslade Bay, then a fashionable resort, below the Osborne Hotel, where he was staying (Fig. 128).

The touch is free, and white highlights have been added here and there to suggest foam. To render the asperities of the rock, the paint has been worked over with a dry brush. The contrast in colour and paint quality between the dark, motionless rock and the shifting waters is similar to that studied by Monet at Belle-Ile a decade before (see Monet, *Storm, Coast of Belle-Ile*, 1886, Musée d'Orsay, Paris; Fig. 129). Did Sisley, who had waited until the last years of his life before tackling the subject of the sea, have in mind the example of his friend Monet, who – by contrast – had always been a tireless painter of the marine world?

Monet's paintings have often been likened to Japanese prints, and particularly to the studies of waves and rocks in Hokusai's *Manga*. This composition by Sisley has also been related to Japanese art (see Munich, Haus der Kunst, 1972, no. 710). While Sisley's application of Japanese motifs and compositional procedures is never as clearly stated as Monet's, his use of certain elements can be found elsewhere in his work, especially in his later years, for example, *Cardiff Roads*, D866, Cat. 73, and *The Loing Canal*, D816, Cat. 71.

Storr's Rock provided Sisley with material for two other paintings in which, as in the one shown here, the rock holds centre stage against a backdrop of sea (*The Wave: Langland Bay, Wales*, D877, and *Storr's Rock, Lady's Cove: Evening*, D878). It also occurs integrated into two more-conventional views of Lady's Cove (D879 and D880).

Since the seascapes painted in Wales were among Sisley's last works, it comes as no surprise to find that this and two other Welsh works (D873, 877) belonged to the artist's daughter, Jeanne Sisley, later Mme Dietsh.

S.P.

PROV: Mme Dietsh-Sisley, née Jeanne Sisley, daughter of the artist, Paris; Dietsh-Sisley Sale, Hôtel Drouot, Paris, 3 June 1919 (7), sold for 5,550 fr; Marquis de Gramont, Paris; Duc de Trévise, Paris; Duc de Trévise (and others) Sale, Sotheby, London, 9 July 1936 (114); G. D. Thompson, Pittsburgh; E. and A. Silbermann, New York; E. Beyeler, Basel; bt Kunstmuseum, Bern, March 1958; Kunstmuseum, Bern (inv. 1851).

EXH: (?)Paris, Bernheim-Jeune, 1907, no. 21; Recklinghausen, 1957, no. 174; Basel, Beyeler, 1957, no. 3; Berne, 1958, no. 91; Munich, Haus der Kunst, 1972, no. 710; London, Hayward Gallery, 1973, no. 49; Tokyo-Fukuoka-Nara, 1985, no. 53.

BIBL: *Aus der Sammlung Kunstmuseum Bern*, 1960, p. 172; Cogniat, 1978, p. 59, repr. p. 47; *Gemälde des 19. Jahrhunderts, Kunstmuseum, Bern*, 1983, repr.; Lassaigne and Gache-Patin, 1983, p. 146, repr. fig 212.

129 Claude Monet, *Storm: Coast of Belle Ile* (Musée d'Orsay, Paris).

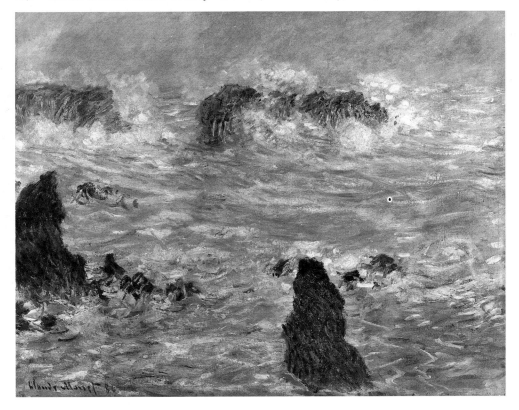

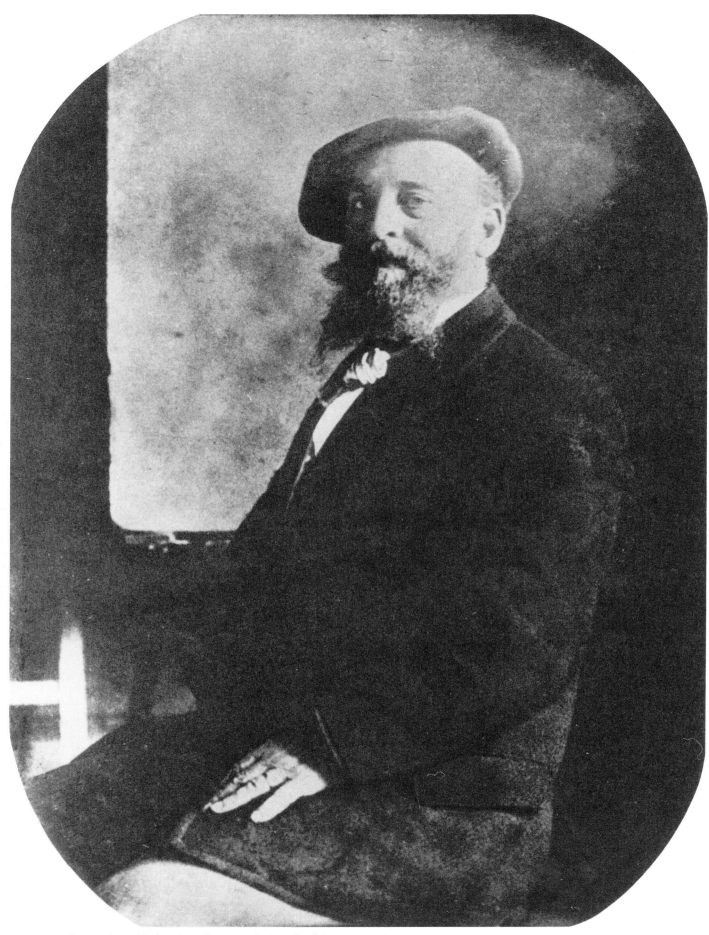

130 Joseph P. Jiolo, *Alfred Sisley*, photograph (Musée d'Orsay, Paris).

DOCUMENTARY CHRONOLOGY

Isabelle Cahn

1839

30 October Alfred Sisley was born in Paris, 19 rue des Trois Bornes, in the 4th arrondissement (now 11th arrondissement). He was the second son of a merchant connected with the textile trade, William Sisley (born in Dunkirk) and his wife, Felicia Sell, who were English (Figs. 131, 132). His maternal ancestors, who came from Kent, were smugglers. (Archives de Paris, compiled from Register Office records; C. Sisley, 1949, p. 252)

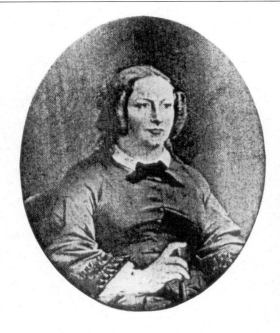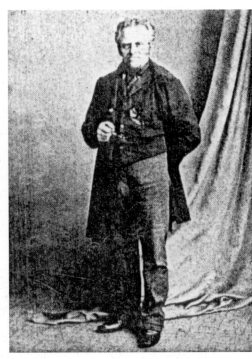

131, 132 Felicia Sell and William Sisley, the artist's parents, photographs (Musée d'Orsay, Paris).

1857–59

Sisley was sent to England to prepare for a commercial career. He visited museums and exhibitions where he admired Turner and Constable and developed a keen interest in Shakespeare's plays. He had no aptitude for business. (Duret 1919, p. 69; Geffroy 1923, p. 9)

1860

Through Bazille, Sisley joined Gleyre's studio which he attended for (?) two years; here he met Renoir and Monet. 'The studio is only open four days a week.' 'M. Gleyre (we call him 'le Patron', the boss, at the studio) comes in twice a week and inspects the work of each student, correcting his drawing or painting. From time to time he sets us a subject for composition, which everyone does to the best of their ability'. (Letter to Tavernier, 19 January 1892, Paris, Institut Néerlandais, Fondation Custodia, no. 1973–

A.1; Meier-Graefe 1912, p. 16; Duret 1919, p. 69; Renoir 1981, p. 120; letter from Bazille to his mother, 1 December 1862, Chicago 1978, p. 191, no. 1; letter from Bazille to his father, 1863?, Chicago 1978, p. 191, no. 4)

As a young man, he often went to the Pasdeloup concerts and had listened with 'indescribable pleasure' to the trio from the scherzo of one of Beethoven's septet (op. 20

in E flat major for clarinet, horn, bassoon, violin, cello and double bass): 'This tune was so gay, so lyrical, so enchanting . . . that it seemed to be part of me from the moment I heard it, so closely did it correspond to my innermost feelings. I am always singing it. I hum it as I work. It has never left me. . .'. (Alexandre, 'Lendemains de lutte', posthumous sale cat., 1899)

1861

Sisley recorded in the visitor's book as staying at the Ganne inn in Barbizon: 'Sisley esq., twenty two years'. (Billy 1947, p. 77)

1862

Having left the Gleyre studio, Sisley worked in Chailly, then in Marlotte near Fontainebleau (Fig. 133): 'Those years were entirely devoted to studying', he wrote later. 'When I was young', wrote Renoir, 'I would take my paintbox and a shirt, and Sisley and I would leave Fontainebleau, and walk until we reached a village. Sometimes we did not come back until we had run out of money about a week later.' (Letter to Tavernier, 19 January 1892, Paris, Institut Néerlandais, Fondation Custodia, no.1973–A.1; Manet 1987, p. 118)

133 Eugène Cuvelier, *Au Bas Bréau, Fontainebleau*, 1864, calotype (Société Française de Photographie).

1863

13 November Following a report by Maréchal Vaillant, Ministre de la Maison de l'Empereur et des Beaux-Arts, sent to the Surintendant des Beaux-Arts, new regulations concerning the Ecole impériale et spéciale des Beaux-Arts were issued by decree. Article 14 of these regulations specified that: 'Young people who want to take classes at the Ecole must (...) prove their French citizenship and be aged between 15 and 25 years. Students not holding French citizenship will be allowed to take classes on an exception-only basis, with the authorisation of the Minister.' The reorganisation provoked a heated controversy among artists and students. A protest addressed to the Emperor was circulated around the studios. It was signed by many architects and artists, including one of Gleyre's students, J.C. Beauverie. (Decree published in the *Gazette des architectes et du bâtiment*, 1863, no. 14, p. 194–196. *Règlement de l'Ecole impériale et spéciale des Beaux-Arts, 1864*; Petition printed in the *Gazette des architectes et du bâtiment*, 1863 no. 15 and in *Le Moniteur* of 29 November 1863)

1864

The American painter, Daniel Ridgway Knight, who had known Sisley at Gleyre's studio, corresponded with him and his fellow countryman, Joseph R. Woodwell, on his return to Philadelphia. He asked Sisley not to forget to send him a photograph of his mother, as promised, because he wanted to have pictures of the whole family. He recalled the kindness of Sisley's father and his open-handed hospitality. He nostalgically described his life with his friends in Paris, the Boulevards, the Café Mazarine, the Crèmerie Jacob. (Letter from Ridgway Knight to Sisley and Woodwell, 17 and 31 January 1864, Pittsburgh, Smithsonian Institution, Archives of American Art)

Renoir painted a portrait of Sisley's father, which was exhibited at the Salon of 1865 (no. 1802) under the title *Portrait of M. W.S.* (Musée d'Orsay, Paris; Fig. 134).

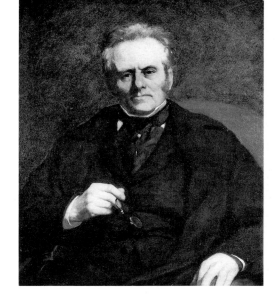

134 Pierre-Auguste Renoir, *Portrait of M. W.S.* (William Sisley), 1864 (Musée d'Orsay, Paris).

July Renoir was living with Sisley, 31 avenue de Neuilly near Porte Maillot. He invited Bazille to join them and a young model, 'le petit Grange', for a cruise on the Seine. He planned to be towed to Rouen by the 'Paris et Londres' then to go on to watch the regattas at Le Havre. (Letter from Renoir to Bazille, 3 July 1865, Daulte 1952, p. 47; in this letter, Renoir calls Sisley 'Henri', this name also appeared in the exhibition catalogue of the Société des Amis des Arts in Pau in 1877 ('Sysley Henri') and 1878 ('Sisley Henry'); Sisley had a brother called Henry.)

Sisley was working at La Celle-Saint-Cloud (see Cat. 2, 3).

1866

February Sisley, Renoir and Jules Le Coeur crossed the forest of Fontainebleau on foot. They went to Milly and Courances. Renoir posed his friends, Lecoeur, Sisley and the proprietress's daughter for the painting, *Mère Antony's Inn* (Fig. 135), which depicts the main room of the inn at Marlotte. (Letter from Jules Le Coeur, 17 February 1866, Cooper, 1959, p. 322 n. 5)

May Sisley exhibited two canvases at the Salon: no. 1785, *Women going to the Woods: Landscape*, and no. 1786, *Village Street at Marlotte, near Fontainebleau* (see Cat. 5, 4). His address in the Exhibition Catalogue was 15 rue Moncey in Les Batignolles. (Salon cat. 1866)

August Sisley and Renoir were staying with Le Coeur's family in Berck. (Letters from Charles Le Coeur and his daughter, Marie, to Madame Joseph Le Coeur, August 1866, Cooper, 1959, p. 322 no. 5)

Gatherings of artists at Bazille's studio included Monet, Renoir, Sisley, etc (London–Paris–Boston, 1980–81, p. 59)

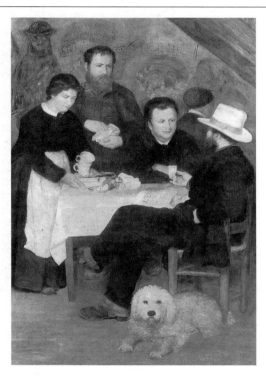

135 Pierre-Auguste Renoir, *Mère Antony's Inn*, 1866 (Nationalmuseum, Stockholm).

1867

Together with Monet, Cézanne, Guillemet, Bazille, Pissarro and Renoir, Sisley was rejected by the Salon. That year, Corot and Daubigny, who championed the young painters, were not on the selection committee.

30 May He signed a petition, drawn up by Bazille, demanding that the Surintendant des Beaux-Arts should hold a 'Salon des Refusés.' His signature appeared at the top of the list, after those of Monet, Renoir and Pissarro and was followed by Guillemet, Oller, Le Coeur and many others. (Paris, Archives du Louvre, série X Salon 1867)

June Sisley was staying in Honfleur. He needed 120 francs because his companion (Eugénie Lescouezec) was ill (then pregnant with their first child). He had to go to her. He asked Joseph Woodwell to persuade a certain Mr Wolfe to buy one of his pictures or, failing that, to sell some of his frames or his canvases. (Letter to Joseph R. Woodwell, no date, [1867], Pittsburgh, Smithsonian Institution, Archives of American Art)

6 June Sisley begged Joseph Woodwell to tell Mr Wolfe that he would soon paint the picture commissioned by him. He did not have the right size of stretcher. He was considering leaving Honfleur soon because of the bad weather. (Letter to Joseph R. Woodwell, 6 June [1867], Pittsburgh, Smithsonian Institution, Archives of American Art)

17 June Birth of Pierre Sisley, son of the painter and his companion, Marie-Adélaïde-Eugénie Lescouezec, a florist, born on 17 October 1834 in Toul. Her Paris address was 27 Cité des Fleurs. Sisley was still in Honfleur, in the Saint-Siméon quarter, at the time of the birth. (Pierre became an artist, then a decorator.) (Archives de Paris, compiled from Register Office records; Toul, Municipal Archives; Moret-sur-Loing, Municipal Archives, population census, 1891; death certificates of Eugénie Lescouezec and Alfred Sisley)

July Guillemet was also staying in Honfleur. Monet was at Sainte-Adresse. (Letters from Monet to Bazille, 9 and 16 July 1867, Wildenstein, I, 1974, p. 424 no. 35, 36a and 36b)

1868

Early in the year, Bazille and Renoir moved to 9 rue de la Paix in the Batignolles (renamed at the end of the year, rue de la Condamine), to an apartment which had one room with a fire and a studio (Figs 136, 137). Sisley listed this address in the catalogue for the Salon of 1868. The rue de la Condamine was fairly near the Café Guérbois, where a group of artists and writers in Manet's circle met regularly. Sisley did not join these gatherings as has previously been reported. (Letter from Renoir to Bazille [1868], Poulain 1932, p. 153–4; Archives de Paris, cadastral records D1 P4 L/1, 1862; Salon cat., 1868; Tabarant 1947, p. 117)

May Sisley exhibited one painting at the Salon: no. 2312 *Avenue of Chestnut Trees near La Celle-Saint-Cloud* (D9; Cat. 6). (Salon cat., 1868)

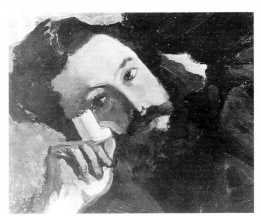

136 Frédéric Bazille, *Sisley* (destroyed, photograph Archives Skira).

137 Frédéric Bazille, *The Condamine Studio*, 1870 (Musée d'Orsay, Paris).

1869

29 January Birth of Jeanne-Adèle Sisley, second child of the painter and Eugénie Lescouezec. The address on the birth certificate was 27 Cité des Fleurs. Eugénie Lescouezec no longer worked as a florist. (Jeanne Sisley married Fernand Louis Georges Diets. She died on 4 February 1919 in Paris, 26 rue Vivienne.) (Archives de Paris, compiled from Register Office records; Paris, 2nd arrondissement; death certificate, where her married name is spelt 'Diets'; on the catalogue for the sale of her collection in 1919, the name is spelt 'Dietsh' [Sale, Hôtel Drouot, Paris 3rd June 1919])

1870

May Sisley exhibited two paintings at the Salon: no. 2650, *Barges on the Canal Saint-Martin*, and no. 2651, *The Canal Saint-Martin* (see Cat. 9). His address in the Salon catalogue was 27 Cité des Fleurs. (Salon cat., 1870)

19 July France declared war on Prussia. During the hostilities, Sisley lost everything he owned in Bougival. Like so many others, his house was looted and destroyed by the occupying forces. A letter to Pissarro and his wife, who had taken refuge in England, reported on the disasters in the region:

'Bougival is even worse ... people who live here have been shot.' Sisley took refuge in Paris. (Letter to Tavernier, 19 January 1892, Paris, Institut Néerlandais, Fondation Custodia, no. 1973–A.1; Letters from Madame Ollivon to Pissarro, 27 March and 11 June, 1871, Paris, Hôtel Drouot, 21 November 1975 [137–5])

4 September After the Defeat of Sedan (2 September), the Third Republic was proclaimed.
During the war, Sisley's father became ill. His name appeared in the Didot-Bottin of 1870 as an agent for 'W. Horace Harding, button maker, specialising in linings and materials for tailors, 7 Forster Lane, Cheapside, London EC'; the address given 11 rue Neuve Saint-Augustin, Paris. After his father's death, later that year at his home, 1 passage Violet in the 10th arrondissement, Sisley was left with no financial support. (Duret 1919, p. 70; Didot-Bottin 1870; Archives de Paris, compiled from Register Office records, death certificate. An alternative date for his father's death is 5 February 1879, at Congy, Marne [Archives Départementales, sous-série 2E 184/8])

1871

After the siege of Paris and the armistice signed on 28 January, Béliard sent Pissarro news of their friends who had stayed in France: Manet, Zola, Guillemet, Guillaumin, Cézanne, etc. He added 'I haven't seen Fantin, Ciselet (sic), Renouard (sic) for ages.' (Letter from Béliard to Pissarro, 22 February 1871, Paris, Hôtel Drouot, 21 November 1975 [6])

18 March–28 May Paris Commune

26 November Jacques, the third child of the painter and Eugénie Lescouezec, was born at 41 rue Nollet. This child probably died at a very early age. (Paris, Town Hall in 17th arrondissement, birth certificate)

Sisley may have taken up residence at 2, rue de la Princesse, in Voisins-Louvecienues. (see Cat. 10 and March 1872)

1872

Winter-early spring Sisley was staying with Monet at Argenteuil (Fig. 138; see Cat. 11, 12). (Letter to Pissarro, 29 November 1872, Paris, Hôtel Drouot, 21 November, 1975 [183])

12 March First purchase of a painting by Sisley, *Snow*, by Durand-Ruel, for 200 francs, from the dealer, Louis Latouche. (Paris, Durand-Ruel Archives, gallery stock book)

23 March First purchase of a painting by Sisley, *The Church Path*, by Durand-Ruel, direct from the artist. (Paris, Durand-Ruel Archives, gallery stock book)

March Although the four-yearly population census for the Louveciennes District was held in March 1872, there is no record of Sisley's residence in Voisins-Louveciennes. The only reported address for the painter in the village is found in the exhibition catalogue of the Société anonyme des artistes peintres, sculpteurs, graveurs, etc ... (1874). (Letter to Tavernier, 19 January 1892, Paris, Institut Néerlandais, Fondation Custodia, no 1973–A.1)

18 June A petition drawn up by Charles Blanc was sent to the Ministre de l'Instruction Publique des Cultes et des Beaux-Arts demanding a 'Salon des Refusés'.

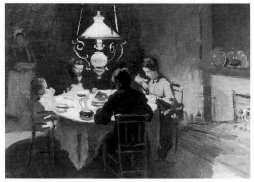

138 Claude Monet, *The Sisley Family*, 1868–69 (Bührle Foundation, Zurich).

It was signed, among others, by Pissarro, Manet, Fantin-Latour, Renoir, Cézanne, and Jongkind. Sisley abstained. (Archives Nationales, F21 535)

Summer Four of Sisley's paintings were included in Durand-Ruel's '4th Exhibition of the Society of French Artists', at the German Gallery, 168 New Bond Street, London (no. 24, 28, 44, 83). (Exh. cat.; Flint, 1984, p. 357)

Sisley working again at Villeneuve-La-Garenne (see Cat. 14, 15)

September Guillemet saw some of Sisley's paintings at Durand-Ruel's gallery: 'Very good. But less so in his detailed treatment of nature perhaps'. (Letter from Guillemet to Pissarro, 3 September 1872, Paris, Hôtel Drouot, 21 November 1975, no. 79)

November Two of Sisley's paintings were included in Durand-Ruel's '5th Exhibition of the Society of French Artists', 168, New Bond Street, London (no. 120, 124). (Exh. cat.; Flint, 1984, p. 358)

Sisley gave Pissarro one of his landscapes 'painted last winter in Argenteuil'. Monet, Pissarro and he planned to organise a dinner in honour of Durand-Ruel. (Letter to Pissarro, 29 November 1872, Paris, Hôtel Drouot, 21 November 1975, [183])

December The Seine floods its banks; together with the floods of March 1876, January 1879, December 1882 and January 1885, it ranked among the most important ones. Sisley paints his first set of 'flood' paintings at Port-Marly (see Cat. 16). (Service de la Navigation de la Seine)

1873

April Monet was waiting for Pissarro's cousin to visit Argenteuil, probably with the intention of selling him one of Sisley's paintings. (Letter from Monet to Pissarro, 22 April 1873, Wildenstein 1974, I, p. 428 no. 64)

Summer Three of Sisley's paintings were included in Durand-Ruel's '6th Exhibition of the Society of French Artists', 168 New Bond Street, London (no. 119, 137, 138). (Exh. cat.; Flint, 1984, p. 358)

Winter Two of Sisley's paintings were included in Durand-Ruel's '7th Exhibition of the Society of French Artists', 168 New Bond Street, London (no. 114, 126)

27 December La Société anonyme coopérative des artistes peintres, sculpteurs, graveurs etc. was set up by Monet, Renoir, Pissarro, Sisley, Morisot, Cézanne and others.

Durand-Ruel sent one of Sisley's paintings, *Moored Barge*, listed in the catalogue under the title *Saint-Ouen*, to the exhibition of the Société des Amis des Beaux-Arts in Reims which was held at Le Cirque, boulevard des Promenades. (Exh. cat.)

1874

13 January Auction of paintings from the collection of Ernest Hoschedé, a cloth merchant and connoisseur. Three of Sisley's paintings were sold for 575 francs, 520 francs and 230 francs to Laurent-Richard and to the dealer, Hagermann. (Archives de Paris, D48 E3 art. 64, Bodelsen 1968, pp. 332–33; Distel 1989, p. 95)

Spring Three paintings were exhibited at Durand-Ruel's '8th Exhibition of the Society of French Artists', 168 New Bond Street, London (no. 140, 144, 147). (Exh. cat.; Flint 1984, p. 359)

5 March Doctor Gachet urged Pissarro to organise an auction of paintings by Manet, Monet, Sisley, Piette, Gautier, Degas, Guillaumin, Cézanne and 'everyone in the cooperative' in order to help Daumier who had become virtually blind. (Letter from Gachet to Pissarro, 5 March 1874, Paris, Hôtel Drouot, 21 November 1975 [26])

15 April–15 May First exhibition of the Société anonyme des artistes peintres, sculpteurs, graveurs, etc., 35 boulevard des Capucines (Fig. 139). Sisley exhibited six paintings, two of which belonged to Durand-Ruel (see Cat. 16). Only five were listed in the exhibition catalogue (no. 161–65). His address in the catalogue was 2 rue de la Princesse, Voisins. (Exh. cat.; San Francisco-Washington 1986, p. 123). For a survey of the critical response to the exhibition, see Cahn, Critical Summary I, p. 282.

139 Nadar's Studio, boulevard des Capucines, (Bibliothèque Nationale, Paris).

Summer Sisley visited England with Jean-Baptiste Faure, a baritone with the Paris Opéra-Comique. He stayed at Brompton Crescent, London and then at Hampton Court, west of the capital, where he painted 'several major studies' (see Cat. 24–29, detail, Fig. 142). (Coquiot 1924, p. 162–63; letter to Tavernier, 19 January 1892, Paris, Institut Néerlandais, Fondation Custodia, no. 1973–A.1)

Summer Two of Sisley's paintings were exhibited at Durand-Ruel's '9th Exhibition of the Society of French Artists', 168 New Bond Street, London (no. 23, 121). (Exh. cat.; Flint 1984, p. 359)

17 December The last general meeting of the Société anonyme coopérative des artistes peintres, sculpteurs, graveurs etc., agreed on liquidation and the reimbursement of subscriptions paid up for the second year. Sisley attended this meeting with Renoir (Fig. 140), Monet, Degas, Molins, Cals, Rouart, Latouche, Bureau, Robert, A. and L. Ottin, Colin, Béliard. (Paris, Hôtel Drouot, 21 November 1975 [82])

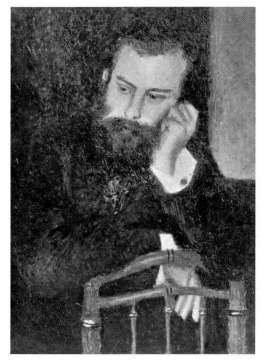

140 Pierre-Auguste Renoir, *Portrait of Sisley* (Art Institute of Chicago).

1875

Late winter/early Spring Sisley moved to Marly-le-Roi, 2 avenue de l'Abreuvoir (Fig. 96). (Address given in the cat. of the 2nd Impressionist exhibition, 1876; Marly-le-Roi, Municipal archives, population census, 1876, the name of the painter was incorrectly spelt 'Ciseley'; letter to Tavernier, 19 January 1892, Paris, Institut Néerlandais, Fondation Custodia, 1973–A.1)

23 March Exhibition of 'Paintings and Watercolours by Claude Monet, Berthe Morisot, A. Renoir, A. Sisley' at the Hôtel Drouot. The public was very hostile towards these paintings (Bodelsen 1968, p. 333). The auction was held on 24 March. The auctioneer was Charles Pillet, Durand-Ruel's valuer. Philippe Burty wrote the preface to the sale catalogue. All of the twenty paintings sent by Sisley were sold, with the exception of one, which was bought back by the artist for 60 francs. The average price of his paintings was

around 127 francs; Sisley's takings from the auction amounted to 2455 francs. Durand-Ruel bought twelve paintings. The other purchasers were Dubourg, Arosa senior, Chesneau, Lecorf (?), Billou (?), Vuibert. (Archives de Paris D48 E3 art.65; Bodelsen 1968, p. 333–336; Vollard [1918] p. 75; Duret 1919, p. 72)

Summer (?) One painting by Sisley was exhibited at Durand-Ruel's, 168 New Bond Street (no. 74). (Flint 1984, p. 360)

1876

Spring A French dealer, Deschamps, mounted an exhibition, 'French and other Foreign Painters', at 168 New Bond Street, London. One painting by Sisley was included (no. 31). (Flint 1984, pp. 4–5, 360)

March The Seine burst its banks. Sisley painted views of the flooded village of Port-Marly (Fig. 141; see Cat. 37–39). (Service de la Navigation de la Seine; 'La Seine en crue', *l'Illustration*, 18 March 1876, p. 182; C. Flammarion, 'Les inondations', *l'Illustration*, 25 March 1876, p. 203; D236–243)

April 'Second Exhibition of painting by MM. Béliard, Legros, Pissaro (*sic*), Bureau, Lepic, Renoir, Caillebotte, Levert, Rouart, Cals, Millet (J.B.), Sisley, Degas, Monet (Claude), Tillot, Desboutin, Morisot (Berthe), François (Jacques), Ottin junior', at Durand-Ruel's gallery, 11 rue Le Peletier. Sisley exhibited eight pictures, four of which belonged to 'Père' Martin, a dealer living at 52 rue Laffitte, two to Durand-Ruel, one to Madame Latouche who owned a shop selling 'top quality paints and modern paintings', 34 rue Lafayette, and one to Legrand, a former employee of Durand-Ruel who specialised in the sale of Impressionist paintings, Renoir and Sisley in particular, and opened up a shop around 1877, 22a rue Laffitte (no. 237–44). (Exh cat.; San Francisco-Washington 1986, p. 165; Distel 1989, p. 33–34, 40; Bailly-Herzberg 1980, I, p. 118, n. 5). For a survey of the critical response to the exhibition see Cahn, Critical Summary II, p. 282.

VUE DE POISSY.

141 *The Floods at Poissy*, from *l'Illustration*, 18 March 1876.

142 (*facing page*) Detail of Cat. 25, *Hampton Court Bridge: the Mitre Inn* (Wallraf-Richartz Museum, Cologne).

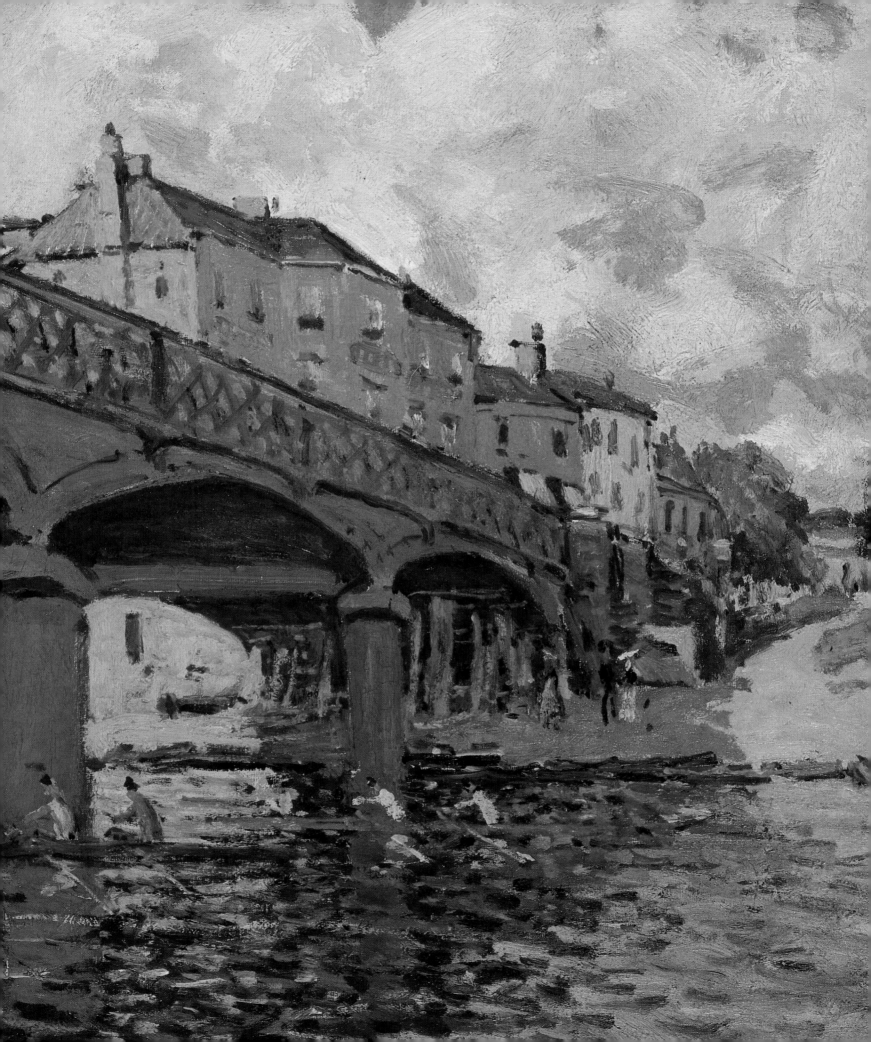

30 September Mallarmé published an article, 'The Impressionists and Edouard Manet', in the English journal *The Art Monthly Review*, where he analysed the work of Manet and several other Impressionists. Sisley, he wrote 'captures the fleeting moments of the day, watches a passing cloud and seems to paint it in flight. On his canvas, the breeze makes the leaves tremble and rustle. He likes to paint them especially in spring, when the young leaves on the slender branches vie with each other as they unfurl, when, the last leaves, red, golden and russet, fall in autumn, for space and light are then one, and the leaves flutter in the breeze, preventing the painting from becoming an impenetrable mass, too heavy to give the impression of movement and life.' (Verdier 1975, pp. 153–54)

October Sisley thanked Pissarro for having sent a collector to him, a Mr Beriot, who was going to purchase two studies. He announced that he was going to pay a surprise visit to Pontoise. (Letter to Pissarro, 15 Oct. [1876], Paris, Hôtel Drouot, 21 Nov. 1975 [184])

3 November Caillebotte drew up an early will, which made provision for the funds necessary for the next Impressionist exhibition which included: 'Degas, Monet, Pissarro, Renoir, Cézanne, Sisley, Melle Morizot (*sic*)', and bequeathed his collection to the Musée du Luxembourg. (Paris, Archives du Louvre, P8)

1877

Sisley exhibited two paintings at the Salon held by the Société des Amis des Arts at the Musée de Pau: *A Road, near Marly, in Summertime* (no. 411), *Snow* (no. 412). Both paintings were on sale for 300 francs. (Exh. cat.)

April Sisley took part in the 3rd Impressionist exhibition in which he showed seventeen landscapes, three lent by Hoschedé, three by Dr de Bellio, two by Charpentier, one by Duret, one by Manet, one by M.CH (no. 211–27). His address in the catalogue was given as 'at Marly-le-Roi'. (Exh. cat.; San Francisco-Washington 1986, p. 206). For a survey of the critical response to the exhibition, see Cahn, Critical Summary III, p. 282.

7 April Impressionist dinner organised at the Café Riche and chaired by Zola, 'an Impressionist writer'. ('Un vieux Parisien', *L'Evénement*, 8 April 1877)

28 May A public sale of the works of Caillebotte, Pissarro, Renoir and Sisley was organised at the Hôtel Drouot. The auctioneer was Léon Tual, the valuer from A. Legrand. Eleven of Sisley's paintings were sold for between 105 and 165 francs. The total amount raised by Sisley at the auction was the derisory sum of 1387 francs. (Bodelsen 1968, pp. 336, 339)

Each Wednesday, Eugène Murer (Fig. 143) organised a lunch in the back room of his restaurant, 95 boulevard Voltaire, frequented by artists, men of letters and connoisseurs such as Doctor Gachet. Sisley accepted his invitations. 'A man with a healthy appetite, and a weak stomach, he captivated us over dessert with his witty jokes and his infectious laughter' (Murer). It was through Guillaumin that Murer had met Cézanne, Pissarro, Sisley and Renoir. In 1887 he owned 28 of Sisley's paintings. (Gachet 1956, pp. 78, 154, 157; Alexis, *Le cri du peuple*, 21 Oct. 1887) Murer offered to sell Sisley's paintings for him. The latter did not have many paintings in stock and was not working very much. He offered to sell Murer a size 30 canvas for 130 francs and promised him another painting in three months. (Letter to Murer, [1877], Paris, Bibliothèque d'Art et d'Archéologie, Fondation Doucet, no. 11849)

8 November Murer organised a lottery at his restaurant with one of Pissarro's pictures as a prize. Doctor Gachet, Sisley, Pissarro and Guillaumin attended the lunch. When inviting Doctor Gachet, Murer told him: 'You will also be able to see the magnificent Sisleys that I have at home to show Mr Laurent-Richard'. The latter had bought two of the artist's landscapes at the Hoschedé auction in 1874. (Letter from Murer to Gachet, 5 November 1877, Gachet 1956, p. 157)

143 P. Outin, *Murer*, 1864 (Département des Arts Graphiques, Musée du Louvre, Paris).

1878

15 January Sisley exhibited three landscapes at the Musée de Pau in the Salon of the Société béarnaise des Amis des Arts: *Springtime in Marly* (no. 318), *The Watering Place, Marly: Snow* (no. 319), and *The Seine at Marly* (no. 320). The prices marked in the catalogue were respectively 350, 350 and 300 francs. *The Seine at Marly* was sold during the exhibition as indicated by the catalogue for the following year. (Exh. cat.)

Spring Duret published a 36 page pamphlet called *Les Peintres impressionnistes*.

6 June Following Ernest Hoschedé's bankruptcy, his collection was auctioned by order of the court at the Hôtel Drouot. Thirteen of Sisley's paintings were sold for a total of 1560 francs, in other words, for an average price of 120 francs per painting. *The Flood* was knocked down to Georges Petit for 251 francs. Murer, Faure, Hecht, Dollfus, Duret and May bought works. (Archives de Paris, report of the sale by order of the court, Hoschedé, D48 E3 art.3, Bodelsen 1968, p. 340)

August Sisley, short of money, asked Duret to find him a sponsor who would pay him 500 francs per month for six months in exchange for thirty canvases. At the end of this period, he would be able to sell on twenty of the paintings for the total sum already paid. He would therefore retain ten canvases. This arrangement was suggested to him by the auctioneer, Tual, who also advised him to organise an auction of his works the following winter. (Letter to Duret, 18 August 1878, *Revue Blanche*, 15 March 1899, pp. 436–37)

Duret found a buyer for seven of Sisley's canvases. This was Jourde, the Editor of the newspaper, *Le Siècle*. (Letter to Duret, [no date], *Revue Blanche*, 15 March 1899, pp. 436–37)

Sisley offered Duret one of his latest paintings for 30 francs. (Letter to Duret, no date, Sèvres, Paris, Hôtel Drouot, 5 June 1991 [VI])

October Sisley moved to Sèvres, 7 avenue de Bellevue, in the Pont quarter (Fig. 144). (Letter to Murer, 27 October 1878, Paris, Bibliothèque d'Art et d'Archéologie, Fondation Jacques Doucet, no. 11850; letter to Tavernier, 19 January 1892, Paris, Institut Néerlandais, Fondation Custodia, no. 1973–A.1; letter to Charpentier, [1879], Robida 1958, p. 83) Sisley signed a sales agreement with Murer for his paintings. (Letter to Murer, 27 October 1878, Paris, Bibliothèque d'Art et d'Archéologie, Fondation Jacques Doucet)

144 The avenue de Bellevue and the rue Basse, Sèvres, photograph (Municipal Archives, Sèvres).

1879

3 February Sisley, 'Gleyre's student' exhibited three landscapes at the Société des Amis des Arts de Pau: *The Seine at Bougival: Flood* (no. 264), *The Seine at Marly-le-Roy* (*sic*) (no. 265), and *The Seine at Le Pecq: Springtime* (no. 266). The paintings were for sale at 300, 250 and 250 francs. (Exh. cat.)

14 March Sisley announced that he was going to send some paintings to the Salon because 'we still have a long way to go before we can afford to disregard the prestige gained from official exhibitions.' He was depending on Duret and his friends to support him in his venture. Like Renoir and Cézanne, Sisley refused to take part in the fourth Impressionist exhibition. (Letter to Duret, 14 March 1879, *Revue Blanche*, 15 March 1899, p. 436)

28 March Sisley had to move and needed 600 francs. He asked Charpentier to lend him 300 francs and to give him the name of a friend who would be likely to pay 300 francs in exchange for paintings. (Letter to Charpentier, 28 March 1879, Huyghe, *Formes*, 1931, p. 152)

Sisley was rejected by the Salon.

He needed 400 francs and offered Charpentier six canvases, five of which were new, in exchange for this sum. (Letter to Charpentier, [1879], Huyghes, *Formes*, 1931, p. 152)

145 Anon., *A Gymnastic Society marching in the Grande-rue, Sèvres*, photograph (Municipal Archives, Sèvres).

April Sisley was able to move to Sèvres, 164 Grande-rue, in the Closeaux quarter (Fig. 145) with the help of the money sent to him by Charpentier. (Letter to Charpentier, 11 April 1879, Huyghe, *Formes*, 1931, p. 152; his name does not appear on the population census for the district, as Sisley had left the town when the 1881 census was being carried out.)

June Renoir suggested to Charpentier that he organise a Sisley exhibition: 'he has 40 lovely canvases, and some of them would be bound to sell'. (Letter to Charpentier, 12 June 1879, Florisoone, *L'Amour de l'art*, February 1938, p. 35)

June Murer asked Sisley to pay back the money he had lent him. Their relationship seemed to be deteriorating as was indicated by Sisley's reply: 'it is always distressing to be asked to repay a debt when you are in a corner and have promised to repay it.' (Letter to Murer, 20 June 1879, Paris, Bibliothèque d'Art et d'Archéologie, Fondation Jacques Doucet, no. 11851)

July Several canvases by Sisley, Monet and Pissarro were exhibited in the offices of the newspaper, *L'Evénement*. (Letter from Gauguin to Pissarro, 26 July 1879, Paris, Hôtel Drouot, 21 November 1975 [30])

September Monet, whose wife Camille had just died, wrote to Pissarro to enquire about arranging a sale of paintings by Sisley and Pissarro, to establish where he himself stood. (Letter from Monet to Pissarro, 26 September 1879, Wildenstein 1974, I, p. 437 no. 164)

December Sisley informed Murer that he would be unable to repay him before May. (Letter to Murer, 6 December 1879, Paris, Bibliothèque d'Art et d'Archéologie, Fondation Jacques Doucet, no. 11855)

1880

Sisley went to live near Moret-sur-Loing, in Veneux-Nadon, 88 route de By (now rue Victor Hugo; Figs 146, 147). (Letter to Tavernier, 19 January 1892, Paris, Institut Néerlandais, Fondation Custodia, no. 1973–A.1; Veneux-les-Sablons, Municipal Archives, 1881 census)

With loans from Feder, the banker, Durand-Ruel resumed his purchases of Impressionist paintings, Sisley in particular. (Rewald 1986, p. 291)

April Sisley did not take part in the fifth Impressionist exhibition, in the hope of exhibiting at the Salon. (Letter from Pissarro to Fénéon, 8 September 1886, Bailly-Herzberg 1986, II, p. 68 no. 350)

146 Veneux-les-Sablons, the confluence of the Seine and the Loing.

27 June Hard pressed by Murer because of his debts, Sisley replied: 'We have been in business together long enough for you to leave me in peace for the present. You will not lose your money.' (Letter to Murer, 27 June 1880, Charavay sale cat., September 1975 [36698–1])

End June In reply, Murer demanded the repayment of all the money he had lent to him over the past two years, i.e. 1200 francs. He told him to keep the twelve canvases he owed and said he was going to use debt collectors to recover the sum in 100 francs notes. (Letter from Murer to Sisley [June 1880], Charavay sale cat., September 1975 [36698–2])

September Durand-Ruel sent 233 paintings, including three of Sisley's, to an exhibition in Oran, Algeria. (Durand-Ruel Archives)

147 Sisley's house, the old road to By, photograph.

1881

Early in the year, Sisley exhibited in the offices of *La Vie Moderne*, 7 boulevard des Italiens. This was a newspaper founded by Charpentier in 1879. (Daulte 1959, p. 342; *La Vie Moderne*, no. 1, 10 April 1879)

April–May Sisley did not take part in the sixth Impressionist exhibition.

Summer He was staying in Ryde, on the Isle of Wight, where he waited in vain for the painting materials that should have been sent by his suppliers, Bertrand et Compagnie. (Letter to Durand-Ruel, 6 June 1881, Venturi 1939, II, p. 55, no. 1)

August–September Gauguin was concerned about the number of paintings that Durand-Ruel was buying from Sisley and Monet, 'who paint pictures at top-speed', fearing that he would not be able to sell them. (Letter from Gauguin to Pissarro [August-September], Merlhès 1984, p. 22 no. 17)

Durand-Ruel entrusts eighteen of Sisley's works to the newspaper, *Le Gaulois*. (Durand-Ruel Archives)

1882

1 February Bankruptcy of the Union Générale which brought about the collapse of the French Stock Exchange. The Director of the Union, the banker, Feder, Durand-Ruel's main sponsor, asks him to repay all loans. (Venturi 1939, I, p. 60)

February Dr de Bellio was thrilled at Manet's decoration as Chevalier of the Legion of Honour in December 1881. He was amazed that the same honour has not been awarded to Monet, Degas, Sisley, Renoir, Cézanne and Pissarro. (Letter from de Bellio to Pissarro, 1 February 1882, Paris, Hôtel Drouot, 21 November 1972 [23])

1–31 March Durand-Ruel sent twenty-seven of Sisley's landscapes (no. 162 – 188) to the 'Septième exposition des Artistes Indépendants', in the Salons du Panorama de Reichshoffen, 251 rue Saint-Honoré. (Exh. cat.; San Francisco-Washington 1986, p. 394; for a survey of the critical response to the exhibition see Cahn, Critical Summary, V, p.283)

June–July Durand-Ruel organised an exhibition in London, probably at the Langham Hotel, Regent Street including seven of Sisley's paintings. (Durand-Ruel Archives. Flint [1984] suggests that the

exhibition of 'certain French Impressionists' held in July 1882, at 13 King Street, St James's, was organised by Durand-Ruel; no catalogue survives, but it included works by Sisley, Degas, Cassatt, Renoir and Monet, as well as Millet and Delacroix. [see Anon., 'The Impressionists', *The Standard*, 1 July 1882, in Flint 1984, pp. 44 – 46, 360])

September Sisley had moved to Moret-sur-Loing (Fig. 148). He asked Durand-Ruel for 600 francs to pay for his moving costs. (Letter to Durand-Ruel, 14 September 1882, Venturi 1939, II, p. 55 no. 2)

1 October–1 November Durand-Ruel sent paintings by Monet, Pissarro, Renoir and Sisley to the exhibition of the Société des Amis des Arts in Touraine, held at the Hôtel de Ville, Tours. Two paintings by Sisley were exhibited: *Banks of the Seine* (no. 311) and *Hellhole Farm* (no. 312). The address given in the catalogue was Durand-Ruel's, 1 rue de la Paix. The same applied for Monet, Renoir and Pissarro. (Exh. cat.)

13 October Sisley asked Durand-Ruel for an advance of 400 francs. (Letter to Durand-Ruel, 13 October 1882, Durand-Ruel Godfroy *Archives de l'Art français*, vol. XXVIII, 1986, p. 308 no. 1)

31 October Sisley owed Durand-Ruel 1000 francs. He gave him 2700 francs worth of canvases and promised him 1500 francs worth of canvases by 21 December. (Letter to Durand-Ruel, 15 July 1883, Venturi 1939, II, p. 57 no. 4)

148 View of Moret-sur-Loing, photograph, 1992.

4 November Over lunch, Monet and Sisley raised the issue of exhibitions. Sisley was more in favour of group showings, as he believed that the public would eventually become bored with one-man shows. Monet was intending to organise two exhibitions during the winter, one of a landscape painter, Sisley or himself, and the other of Renoir or Degas. Sisley wanted to preserve the unity of the Impressionist group around Durand-Ruel. He sent Monet the copy of a letter to Durand-Ruel in which he proposed an annual joint exhibition be organised instead of a series of one-man shows. (Letters from Monet to Durand-Ruel, 3 and 10 November 1882, Wildenstein 1979, II, p. 221 no. 299–300; letter from Sisley to Durand-Ruel, 5 November 1882, Venturi 1939, II, p. 56 no. 3)

1883

April Dr de Bellio (Fig. 149) tended Sisley's wife. (Letter from Sisley to de Bellio, 18 April 1883, Niculescu 1970, p. 50 no. 33)

15 April–20 July Only eight out of the twelve paintings that Sisley sent to the exhibition of paintings, drawings and watercolours of 'La Société des Impressionnistes' at Dowdeswell and Dowdeswell, 133 New Bond Street, London, were displayed (no. 4, 15, 19, 21, 22, 33, 35, 45). (Durand-Ruel Archives; Flint 1984, pp. 55–64, 361–62)

3 May Sisley attended Manet's funeral at the Passy cemetery. This was the last time he saw Renoir. (J. Manet 1987, p. 157)

May–June Durand-Ruel sent two canvases by Manet, three by Monet, three by Renoir, three by Sisley, six by Pissarro, three by Boudin, and three by Lépine to the 'Foreign Exhibition', a section of the 'International Exhibition for Art and Industry', which was to take place in Boston in the Mechanic's Building: 'From what the Americans have said, it was a mediocre exhibition, which lacked influence. I spoke about this to Durand; he replied that it was an experiment, that he took advantage of the opportunity to show us, – especially as he was exempt from customs duties.' (Bailly-Herzberg 1980, I, p. 209 n. 1; letter from Pissarro to Monet, 12 June 1883, Bailly-Herzberg 1980, I, p. 217, no. 157)

1–25 June Durand-Ruel exhibited sixty of Sisley's paintings in his gallery, 9 boulevard de la Madeleine. Monet, who could not come to the opening night of the exhibition, was concerned about its success and Durand-Ruel's way of doing business: 'How is the Sisley exhibition going? Everybody seems to have left Paris because of the magnificent weather.' (Exh. cat.; letter from Pissarro to Monet, 12 June 1883, Bailly-Herzberg 1980, I, p. 216 no. 157; letter from Monet to Pissarro [June 1883], Wildenstein 1979, II, p. 229 no. 357)

23 June Gustave Geffroy published an article on Sisley in *La Justice*.

22 July Sisley thanked Durand-Ruel for the 200 francs that he sent him. He was ill and confined to bed. (Letter to Durand-Ruel [22 July 1883], Durand-Ruel Godfroy *Archives de l'Art français*, vol. XXVIII, 1986, p. 308 no. II)

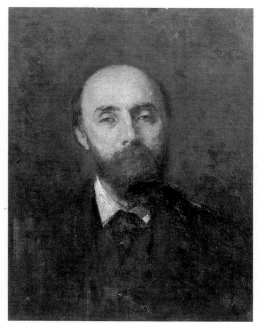

149 Grigorescu, *Georges de Bellio*, c. 1877 (Musée Marmottan, Paris).

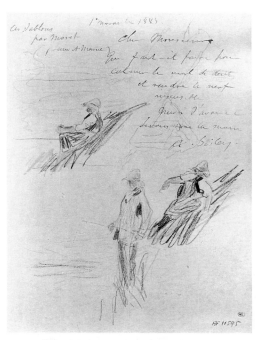

150 Illustrated letter from Sisley, 1 November 1883 (Département des Arts Graphiques, Musée du Louvre, Paris).

July Sisley, who had just recovered from his illness, was unable to carry his canvases to Durand-Ruel unaided. He sent him two size 10 canvases and one size 20 canvas which he calculated at 250, 400 and 300 francs and drew up a statement of amounts owing. (Letter to Durand-Ruel [erroneously dated 15 July, 31 July 1883], Venturi 1939, II, p. 57 no. 4)

24 August Sisley told Durand-Ruel of his intention to leave Moret because the climate did not suit him, and to move to Les Sablons, a neighbouring district. (Letter to Durand-Ruel, 24 August 1883, Venturi 1939, II, p. 58 no. 5)

September Durand-Ruel sent some Impressionist paintings for the first time to Germany, to the Fritz Gurlitt gallery in Berlin, where there was an exhibition of 24 paintings, three of which were by Sisley. (Durand-Ruel Archives)

3 September Opening of the 'Foreign Exhibition' at the Mechanic's Building in Boston where three of Sisley's paintings were exhibited. *The Art Interchange* singled out Sisley. (Exh cat.; 'Boston Notes', *The Art Interchange*, 1883; see also Appendix II, p. 69)

October Sisley had moved to Les Sablons. He asked Durand-Ruel for 500 francs. (Letter to Durand-Ruel, 8 October 1883, Durand-Ruel Godfroy, *Archives de l'Art français*, vol. XXVIII, 1986, no. III)

1 November Suffering from a raging toothache, Sisley asked how to 'dull the pain ... and numb the nerve.' (Fig. 150; letter to an unknown recipient, 1 November 1883, Paris, Musée du Louvre, Département des Arts Graphiques, Fonds Orsay)

21 November Sisley thanked Durand-Ruel for sending 300 francs. He worked as much as possible despite the winter weather and promised to send him some canvases soon. He was depending on the sum of 500 francs at the end of the month. (Letter to Durand-Ruel, 21 November 1883, Venturi 1939, II, p. 58 no. 6)

December Sisley was short of money; the 200 francs sent by Durand-Ruel were not enough to set him back on his feet. (Letter to Durand-Ruel, [12 December 1883], Durand-Ruel Godfroy, *Archives de l'Art français*, vol. XXVIII, p. 308 no. IV)

1884

January Sisley took part in the exhibition of the 'Cercle artistique de la Seine', 3bis rue de la Chaussée d'Antin: 'Several Impressionists exhibited, and the sincerity of their paintings put the other works to shame. Several paintings are worth noting: the *Sente de la Justice at Pontoise* and the *Oise at Pontoise*, by Camille Pissarro, – the *Snow* and the *Flood at Saint-Germain*, by Sisley, – two excellent canvases by Renoir, – and Mary Cassatt's *Woman with Fan*, deep in a daydream.' (Fénéon, 'Exposition du Cercle artistique de la Seine', *La Libre Revue*, 16 January 1884, Halperin 1970, I, p. 22)

January From Bordighera, Monet instructed Durand-Ruel to send his very best wishes to Renoir, Pissarro and Sisley. (Letter from Monet to Durand-Ruel, 23 January 1884, Wildenstein 1979, II, no. 391)

7 March Sisley asked Durand-Ruel for 400 francs. (Letter to Durand-Ruel, 7 March 1884, Venturi 1939, II, p. 58–59 no. 7, letter kept in Paris, Musée du Louvre, Ms 310)

9 March Sisley thanked Durand-Ruel for sending him 200 francs: 'There is nothing I dislike more than having to ask for money – so I only do it as a last resort and I think you must agree that I always ask for very modest sums.' (Letter to Durand-Ruel, 9 March 1884, Venturi 1939, II, p. 59 no. 8)

16 March Sisley showed the pastels that he had produced during the winter to a connoisseur at the Hôtel Byron in Paris. (Letter to an unnamed recipient, 16 March 1888, Paris, Archives du Louvre, Ms 310)

17 March He thanked Durand-Ruel for the 100 francs he had sent him and was waiting for the remainder of the promised sum – he was going to need 1000 francs by 1 April. He was to give Durand-Ruel some canvases in ten days' time. (Letter to Durand-Ruel, 17 March 1884, Durand-Ruel Godfroy, *Archives de l'Art français*, vol. XXVIII, 1986, p. 309 no. V)

25 March Durand-Ruel bought five paintings from Sisley for 1700 francs. (Paris, Durand-Ruel Archives, Brouillard 1881–1884, Durand-Ruel Godfroy, *Archives de l'Art français*, vol. XXVIII, 1986, p. 309 no. V no. 1)

Spring Durand-Ruel organised an exhibition of twenty-four Impressionist works at the Dudley Gallery in London, including twelve by Sisley. (Durand-Ruel Archives; not recorded in Flint, 1984)

31 May–15 July The Durand-Ruel Archives indicate that the dealer sent one of Sisley's paintings, *The Iron Bridge*, to the exhibition held by the Société des Amis des Arts in Nancy. The exhibition catalogue, however, refers to no. 410 as *The Pond (Meuse)*. There is no record of Sisley visiting north-east France, and the catalogue title may well have been mistranscribed. (Exh. cat.)

June–August Murer exhibited his collection of paintings at the Hôtel du Dauphin et d'Espagne, which he and his half-sister owned in Rouen: 9 by Pissarro, 1 by Cézanne, 4 by Sisley, 1 by Gauguin and several by Guillaumin. 'The Murer exhibition isn't bad, apart from the frames', commented Gauguin. In 1884, the latter owned two paintings by Sisley, whom he wrongly spelt as 'Sysley' in his Rouen notebook in which he listed the details of his collection. By 1888, he only had one left. (Bailly-Herzberg 1980, I, p. 39; letter from Pissarro to Murer, [July 1884], Bailly-Herzberg 1980, I, p. 309 n. 2; letter from Gauguin to Pissarro, [around 10 July 1884], Merlhès 1984, p. 65 no. 49 and p. 396 n. 141; Cogniat, Rewald, 1962, p. 121; Paris, Musée du Louvre, Département des Arts Graphiques, Fonds Orsay, *Album Briant* p. 5)

December The Manet family and Antonin Proust decided to hold a banquet at 'Père' Lathuile's to celebrate the anniversary of Manet's exhibition at the Ecole des Beaux-Arts. Pissarro refused to go. Monet contacted Renoir so they could decide on a common course of action. The latter wrote to Sisley and Pissarro asking how they felt about it and told Caillebotte to ask around. Degas accepted the invitation. Monet sent his contribution, on the off-chance, while waiting to find out what everybody else had decided to do. (Letter from Monet to Pissarro, [sometime soon after 12 December 1884], Wildenstein 1979, II, p. 257 no. 538)

December Having published an article on Degas, Mirbeau wanted to write a series of articles on Whistler, Monet, Renoir, Sisley and Pissarro. (Letter from Durand-Ruel to Pissarro, 15 November 1884, Bailly-Herzberg 1980, I, p. 234 n.2)

1885

5 January Banquet in Manet's honour: 'Everyone thinks this is ridiculous and unnecessary, but everyone will be there and no-one feels able to refuse.' (Letter from Monet to Pissarro, 3 January 1885, Wildenstein 1979, II, p. 257 no. 542)

7 January First Impressionist dinner held. (Letter from Monet to Pissarro, 3 January 1885, Wildenstein 1979, II, p. 257 no. 542)

20 March Theo van Gogh (Fig. 151), the manager of the Galerie Goupil, bought one of Sisley's paintings for 300 francs. He sold it again the same day to the collector Desfossés for 400 francs. (Rewald 1973, p. 5 and appendix I)

151 Theo van Gogh, photograph (Rijksmuseum Vincent van Gogh, Amsterdam).

June Durand-Ruel organised an exhibition in the Hôtel du Grand Miroir in Brussels. (Durand-Ruel Archives)

12 June Sisley again asked Durand-Ruel for money. Guillemet was working at Les Sablons. (Letter to Durand-Ruel, 12 June 1885, Venturi 1939, II, pp. 59–60 no. 9)

21 June Sisley thanked Durand-Ruel for sending him 100 francs and promised to send him some 'light' canvases in the near future. (Letter to Durand-Ruel, 21 June 1885, Durand-Ruel Godfroy, *Archives de l'Art français*, 1986, p. 309 no. VI)

23 July Durand-Ruel sent 200 francs to Sisley and 300 francs to M. Cocardon, his landlord. He asked Sisley to let him have some small canvases which would be easier to sell. He advised him to try some size 5 or size 6 canvases. (Letter from Durand-Ruel to Sisley, 23 July 1885, Durand-Ruel Godfroy, *Archives de l'Art français*, 1986, p. 309 no. VII)

23 August Sisley thanked Durand-Ruel for the 100 francs that he had received and told him to expect some small canvases. (Letter to Durand-Ruel, 23 August 1885, Durand-Ruel Godfroy *Archives de l'Art français* 1986, p. 309 no. VIII)

27 October Monet was working at Etretat. He asked Pissarro for news of Renoir, Cézanne and Sisley and wanted to know how Durand-Ruel's business was going. (Letter from Monet to Pissarro, 27 October 1885, Wildenstein 1979, II, p. 263 no. 599)

Durand-Ruel, involved in a scandal concerning fake paintings, was defended by his painters, Renoir, Pissarro and Sisley: 'Everyone believes that you are right. This is not simply a business matter – it is a question of artistic merit: something which you have championed for many years. For my part, I am very grateful to you.' Durand-Ruel published two letters in his defence in *L'Evénement*, 5 November. (Bailly-Herzberg 1980, I, p. 353 n. 4; letter to Durand-Ruel, 7 November 1885, Venturi 1939, II, p. 60 no.10)

17 November Sisley thanked Durand-Ruel for sending him 200 francs, which was partly used to pay off his debts. He was living in abject poverty. (Letter to Durand-Ruel, 17 November 1885, Venturi 1939, II, pp.60–61 no. 11)

25 November Sisley took back two of his canvases which Durand-Ruel considered too difficult to sell. (Letter to Durand-Ruel, 25 November 1885, Venturi 1939, II, p. 61 no. 12)

December Sisley urged Pissarro and Monet to organise a joint exhibition. (Letter from Pissarro to Monet [sometime in December 1885], Bailly-Herzberg 1980, I, p. 357 no. 298)

Sisley, Pissarro and Monet had decided to sell their paintings direct if the opportunity arose. (Letter from Monet to Durand-Ruel, 17 December 1885, Wildenstein 1979, II, p. 270 no. 642)

1886

Sisley moved to Veneux-Nadon, 32 route Nationale (Fig. 153; now 35 avenue de Fontainebleau). He appeared on the nominal roll for the district as head of household, painter and foreigner. His children were also registered as foreigners. (Veneux-les-Sablons, Municipal archives, population census, 25 June 1886)

January He wanted to ask Pissarro how to make fans. (Letter from Pissarro to his son Lucien, [23 January 1886] Bailly-Herzberg 1986, II, p. 19 no. 309)

153 Les Sablons, the station in front of Sisley's house, on the old main road.

152 Saint-Mammès, the confluence of the Loing and the Canal du Loing, photograph, 1992.

8 February Durand-Ruel bought a painting from Sisley for the last time: *By the Canal, Saint-Mammès*. (Paris, Durand-Ruel Archives, stock book from the gallery)

March Durand-Ruel was invited to the United States by James F. Sutton, an American business man who was a great art-lover and specialist in Chinese ceramics. (Rewald 1973, p. 9; Rewald 1986, p. 342)

10 April–25 May Fifteen paintings by Sisley were shown at the exhibition 'Works in Oil and Pastel by the Impressionists of Paris', organised by Durand-Ruel at the American

Art Galleries in New York. Théodore Duret wrote the preface for the catalogue which also contained a translation of the article by Gustave Geffroy first published in *La Justice* on 23 June 1883. From 25 May the works were exhibited at the National Academy of Design for one month with paintings loaned from individual collections. (Exh. cat.; Callen 1974, p. 170; see also Appendix II, p. 69)

15 May–15 June Sisley did not take part in the eighth and last Impressionist exhibition.

2 August Durand-Ruel returned from the United States. Sisley again asked him for money. (Letter to Durand-Ruel, 2 August 1886, Venturi 1939, II, p. 61 no. 13)

10 October–30 November Exhibition in Nantes, organised by John Flornoy, one of Pissarro's former students. Sisley sent a painting, *Edge of the Forest in Spring: Morning*. He gave his address in Les Sablons and also Durand-Ruel's address, rue de la Paix, in Paris. (Exh. cat.)

December–January (1887) Exhibition of eight of Sisley's paintings at the American Art Galleries in New York, 'Collection of modern paintings selected during the past summer by Mr Durand-Ruel'. (Exh. cat.; see also Appendix II, p. 69)

1887

February According to Sisley, Durand-Ruel had sold almost all of his Impressionist paintings to Mr Robertson. (Letter from Pissarro to his son Lucien, 4 February 1887 and [1 March 1887], Bailly-Herzberg 1986, II, p. 129 no. 394 and p. 137 no. 400)

April Sisley asked Dr de Bellio to find a buyer among his friends for three of his canvases which were with the picture-framer, Dubourg; two were on sale for 250 francs and one for 600 francs. (Letter to de Bellio, 6 April 1887, Saffroy sale cat., March 1984, no. 1762)

5 and 6 May Durand-Ruel organised an auction in New York at Moore's Art Gallery of 'The Durand-Ruel collection of French Paintings', including six of Sisley's paintings. (Durand-Ruel Archives)

8 May–8 June Fifteen of Sisley's paintings were shown at the 6th 'Exposition Internationale de Peinture et de Sculpture' at the Galerie Georges Petit, 8 rue de Sèze. Works by Besnard, Brown, Cazin, Kroyer, Libermann, Monet, Morisot, Pissarro, Raffaëlli, Renoir, Whistler, Rodin, etc., were also exhibited. His address recorded in the catalogue was 'in Les Sablons, near Moret'. 'Sisley is very successful with some of his older paintings', wrote Monet to Durand-Ruel. Sisley told Georges Petit that he had sold one of his paintings, no. 147, to Mr Hamman: *May: Morning*. (Letter to Petit, 19 May 1887, Archives du Louvre; letter from Monet to Durand-Ruel, 13 May 1887, Wildenstein 1979, III, p. 223 no. 788)

14 May Galerie Boussod et Valadon bought one of Sisley's paintings for 700 francs, *The First Days of Autumn*, which was sold to Dr Viau on 20 June 1895 for 1000 francs. (Rewald 1973, appendix I)

15–16 May The Martinet Sale was organised in aid of his wife at the Hôtel Drouot with paintings donated by artists. Sisley's paintings were warmly received, which prompted Signac to retort: 'The public and the buyers are certainly snapping up second and third rate artists. What is Sisley? A middle-class, prettified Monet that people will fight over to decorate the living rooms of apartments rented for 4800 francs on the boulevard Haussmann or the rue Taitbout. This is our revenge. And how sweet it is...'. (Letter from Signac to Pissarro, 30 June 1887, Paris, Hôtel Drouot, 21 Nov. 1975, no. 175)

25 May–30 June Six of Sisley's paintings were displayed at an exhibition 'Celebrated Paintings by Great French Masters', organised by Durand-Ruel at the National Academy of Design in New York. (Durand-Ruel Archives; see also Appendix II, p. 69)

22 June Theo van Gogh bought two of Sisley's paintings *Courtaut, rocky Plateau* and *The Abandoned House*, for 500 francs each. He sold them again on 11 June and 23 November 1891 for 700 francs and 2000 francs (500 dollars) to Chapuy and to Widener, a collector from New York. (Rewald 1973, appendix I)

10 August Theo van Gogh sold one of Sisley's paintings, *The Seine*, for 325 francs to Aubry which he bought from Dubourg for 225 francs three days earlier. (Rewald 1973, appendix I)

21 August New purchases were made by Theo van Gogh: three paintings – *View of Chatou, Moret*, and *The Seine*, bought for 125 francs, 145 francs and 145 francs from Legrand, and sold the next day to Guyotin for 200 francs, 200 francs and 150 francs. (Rewald 1973, appendix I)

21 October Paul Alexis published an article 'Les Impressionnistes de la collection Murer', in *Le Cri du peuple*.

1888

17 January A note was sent from the Direction des Beaux-Arts asking if an inspector could view one of Sisley's landscapes (1865), which was with M. Legrand, an art dealer, 40 rue Blanche. (Paris, Archives Nationales, F21 2112)

27 January A note: 'Mr Sisley/September morning – 1000 F.' (Paris, Archives Nationales, F21 2112)

2 February An order from the Ministère de l'Instruction Publique, des Cultes et des Beaux-Arts for the purchase of Sisley's painting *September Morning* (Fig. 154), 1000 francs 'chargeable to the account for works of art'. (Paris, Archives Nationales, F21 2112)

4 February Sisley was notified of the purchase of his painting by the State. He was asked to deliver it to the Palais des Champs-Elysées, to the depository for works of art belonging to the State, which had been notified that he was coming. (Draft of the letter from the Ministère de l'Instruction Publique, des Cultes et des Beaux-Arts to Sisley, 4 February 1888, Paris, Archives Nationales, F21 2112)

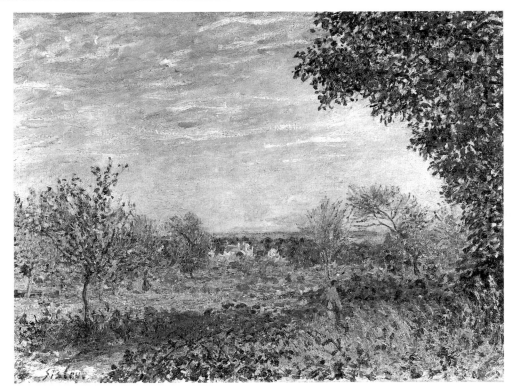

154 Alfred Sisley, *September Morning*, c. 1887 D692, (Musée des Beaux-Arts, Agen).

5 February Sisley thanked Castagnary, the Directeur des Beaux-Arts, for buying his canvas: 'I am grateful to you and I would have come to thank you in person tomorrow, if I had not been unwell'. (Letter from Sisley to Castagnary, 5 February 1888, Paris, Archives Nationales, F1 2112)

8 February *September Morning* was placed with the State art collection, unframed and unvarnished. The inventory listed it as no. 1179. (Note by the exhibition administrator, responsible for works of art, 8 February 1888, Paris, Archives Nationales, F21 2112)

18 February Sisley received 1000 francs in payment for his painting. (Payment receipt, 18 February 1888, Paris, Archives Nationales, F21 2112)

20 February Sisley delivered canvases to the auctioneer, Tual, who was going to sell them for him. He set a minimum price of 100 francs. (Letter to Tual, 20 February 1888, sales receipt from the Abbaye bookshop, no. 235, April 1978, no. 224)

April Sisley asked Monet how the plans for their group exhibition were coming along. Renoir took space at Durand-Ruel's gallery. Monet refused to take part. (Letters from Monet to Alice Hoschedé [27 April 1888], [29 April 1888], and to Berthe Morisot [just before 25 May 1888], Wildenstein 1979, III, p. 236, no. 882, p. 237 no. 891)

May Sisley asked the new Director of Fine Arts for permission to borrow the picture which had been bought by the State as he wanted to show it at an exhibition. Castagnary, who had just died and who had been behind the purchase, had promised him that he could. (Draft of the letter to the Ministère de l'Instruction Publique, des Cultes et des Beaux-Arts, May 1888, Paris, Archives Nationales, F21 2112)

25 May–25 June 'Exhibition' organised by Durand-Ruel in Paris with works by Brown, Boudin, Caillebotte, Lépine, Morisot, Pissarro, Renoir, Sisley and Whistler. Seventeen paintings and eight pastels or gouaches by Sisley were shown. (Exh. cat.)

29 May *September Morning* was loaned to Sisley for the exhibition at Durand-Ruel's gallery. The painting was to be returned with its frame to the curator of the depository. (Draft of the letter from the Ministère de l'Instruction Publique, des Cultes et des Beaux Arts to Sisley, 29 May 1888, Paris, Archives Nationales, F21 2112)

30 May Sisley asked Duret what formalities had to be completed to take out French citizenship. (Letter to Duret, 30 May 1888, *Bulletin des expositions*, II, 30 January–18 February 1933, p. 6)

Sisley was on the list of exhibitors suggested by Theo van Rysselberghe for the 'Exposition des XX' in Brussels. (Letter from Rysselberghe to Maus, [1888], Octave-Maus 1980, p. 65)

Theo van Gogh sent several Impressionist paintings to Holland where they were greeted with indifference. (Rewald 1973, pp. 28–29)

28 June *September Morning* was handed back to the depository for works of art belonging to the State, complete with frame. (Note by the Exhibition administrator, responsible for works of art, 28 June 1888, Paris, Archives Nationales F21 2112)

December One-man exhibition of Sisley's paintings took place at the Galerie Georges Petit, 12 rue Godot-de Mauroy. (Fénéon, 'Tableaux de Sisley', *La Cravache*, 15 December 1888, Halperin, I, 1970 p. 133; *L'Art français*, no. 87, 22 December 1888)

1889

19 April Order to deposit the painting by Sisley bought by the State with the Musée des Beaux-Arts in Agen. (Paris, Archives Nationales, F21 2112)

5 June The painting was withdrawn from the depository of works of art belonging to the State and crossed off the inventories. It was then transferred to Agen. Several years later, Sisley commented bitterly: 'A canvas exhibited in such conditions is as good as lost'. (Note by the Exhibition administrator, responsible for works of art, Paris, Archives Nationales F21 2112; letter to Tavernier, 15 May 1893, Paris, Institut Néerlandais, Fondation Custodia, no. 1973–A.1)

22 June Sisley suggested that Dr de Bellio should sell five of his paintings to his nephew in Bucharest, Alexandre de Bellio, for 700 francs apiece. (Letter to de Bellio, 22 June 1889, Daulte 1959, p. 32; Niculescu 1970, p. 48, 64 n. 94)

31 October Three of Sisley's paintings, including *Saint-Cloud* and *Meudon Station*, were shown at the Kunstforeningen in Copenhagen (Fig. 155), an exhibition of French and Scandinavian Impressionists, organised by the Society of Friends of the Arts.

(Madsen, *Politiken* 9 and 10 Nov. 1889; Bodelsen 1970, p. 612)

November Sisley left Veneux to settle in Moret (Figs 156, 157). (Regnault [in press], p. 167)

155　The Kunstforeningen building (Bymuseum, Copenhagen).

156, 157　Sisley's house, rue Montmartre, Moret-sur-Loing, photographs, 1992.

End December Sisley asked Georges Petit to loan six of his paintings to the 'Exposition des XX' in Brussels, which he had agreed to support a fortnight earlier. (Letter to an unnamed recipient, 20 December 1889, Los Angeles, Archives at the Getty Center for the History of Art and the Humanities, no. 870349)

1890

16 January Henri de Groux, who wanted the painter, Degouve de Nuncques, to be included in the 'Exposition des XX', criticised the presence of Sisley and other artists: 'I thought it was appropriate to protest against the invasion of Les XX by this pack of dull, unskilled jokers, and against our phoney obsession with exhibiting their daubs as a means of publicity.' (Letter from Henri de Groux to Octave Maus, 16 January [1890], Block 1984, p. 50)

23 January Sisley explained to Maus that Georges Petit had refused to lend his paintings to the Les XX exhibition. (Letter from Maus to Bloch, January 1890, Block 1984, p. 99 note 93)

Possibly encouraged by Henri Guérard, vice-president of the Société des Peintres-Graveurs, Sisley made four etchings (Figs 40, 110, 112, 158). (Leymarie and Melot 1971, p. xxxii)

February The Société Nationale des Beaux-Arts, a splinter group of the Société des Artistes Français was founded. Sisley was invited to take part in the inaugural exhibition of this 'alternative Salon' as an 'associate member'. (Rewald 1986, p. 379 no. 20; letter to Roll, February 1890, Daulte 1959, p. 34)

February–March Six paintings by Sisley, guest artist, were listed in the catalogue for the 7th Les XX exhibition. His address in the exhibition catalogue was 19 rue Montmartre in Moret; he was still living at the same address in 1891, with Eugénie Lescouezec and their two children. (Exh. cat.; Moret-sur-Loing, Municipal archives, population census of 1891, nominal roll)

March Sisley was in touch with Isidore Montaignac, a former employee of Georges Petit, over the sale of his paintings. (Letter from Pissarro to his son Lucien, 23 March 1891, Bailly-Herzberg 1988, III, p. 47 no. 646)

Sisley did not contribute to the collection which Monet started up in order to buy Manet's *Olympia* for the Musée du Luxembourg.
(List of amounts received as at 18 March 1890, Wildenstein, III, 1979 p. 255 no. 1047)

6–26 March 'Deuxième exposition de peintres-graveurs' held at Durand-Ruel's gallery where two paintings, a sketch and four etchings by Sisley were shown. Philippe Burty wrote the preface for the catalogue. (Exh. cat.)

13 March Sisley thanked Dr de Bellio for the 50 francs he had sent him. (Letter to de Bellio, 13 March 1890, Paris, Institut Néerlandais, Fondation Custodia, no. 7345)

15 May Sisley exhibited six paintings at the Société Nationale des Beaux-Arts (Salon du Champ-de-Mars). (Exh. cat.)

December Five of Sisley's paintings were shown at the Exposition Internationale (first of a new series) at Galerie Georges Petit, 8 rue de Sèze. (Exh. cat.; J. Antoine, 'Critique d'Art', *La Plume*, 43, 1 February 1891, p. 61)

158 Alfred Sisley, *Beside the Loing: the Wagon*, etching (Département des Estampes, Bibliothèque Nationale, Paris).

1891

February Sisley was annoyed about the rumour that he was exhibiting in Berlin. (Letter to Roll, 22 February 1891, Paris, Hôtel Drouot, 19 December 1975, no. 134)

February–March Durand-Ruel sent five paintings by Sisley, guest artist, to the 8th Les XX exhibition in Brussels. (Durand-Ruel Archives; Exh. cat.)

21 February Georges Lecomte published an article on Sisley in *l'Art dans les deux mondes*.

17–28 March An exhibition 'Paintings by the Impressionists of Paris: Claude Monet, Camille Pissarro, Alfred Sisley from the Galleries of Durand-Ruel, Paris and New York' was held in Boston at the Chase Gallery, 7 Hamilton Place. Six of Sisley's

paintings were exhibited. (Exh. cat.; see also Appendix II, p. oo)

April Disappointed by Durand-Ruel's apparent attitude, Sisley confided his resentment about his dealer to Pissarro, whom he had not seen for at least two years. This led to a complete break with Durand-Ruel, and his replacement as sole dealer by Georges Petit. (Letter from Pissarro to his son Lucien, 13 April 1891, Bailly-Herzberg 1988, III, pp. 62–63 no. 653)

April He donated a canvas for the sale in aid of the children of the painter John Lewis-Brown, who had died on 14 November 1890. (Letter of 12 April 1891, Paris, Hôtel Drouot, 23–24 October 1980 [330])

Spring Durand-Ruel sent two paintings, *The Weir on the Loing*, priced at 1000 francs, and *Banks of the Loing*, at 1500 francs, to the exhibition held by the Société des Amis des Arts in Nantes at the Galerie Préaubert. (Durand-Ruel Archives; Exh. cat.)

15 May As a member of the Société National des Beaux-Arts, he exhibited seven paintings at the Salon du Champ-de-Mars. (Exh. cat.)

18 August By chance, he discovered that one his canvases was being exhibited in Munich and asked Durand-Ruel if this was his doing. There are no records of any consignment despatched to Munich in the Durand-Ruel archives. (Letter to Durand-Ruel, 18 August 1891, Venturi 1939, II, p. 63 no. 16; Paris, Durand-Ruel archives)

November Sisley set the price of several canvases at 500 francs for size 15 canvases and 800 francs for size 20 canvases. (Letter to an unnamed recipient, 5 November 1891, Bodin Sale 1986 [29, letter no.301])

December Le Barc de Boutteville, a recently established dealer on the rue Le Peletier, suggested exhibiting canvases by Georges Pissarro and other artists such as Anquetin, Lautrec, Sisley, Luce, Gausson, Paillard, Gauguin, Schuffenecker, Bernard and Sérusier. Sisley, however, did not take part in the 'Exposition des Impressionnistes et Symbolistes' held at Le Barc de Boutteville's gallery from December 1891 to February 1892. (Letter from Pissarro to his son Lucien, 9 December 1891, Bailly-Herzberg 1988, III, p. 161–162 no. 726; cat.)

Winter One work by Sisley was included in the exhibition of 'La Société des Beaux-Arts', held at Mr Collie's Rooms, 39B Old Bond Street, London (no. 1). (Flint 1984, p. 363)

December–January 92 Five of Sisley's paintings were shown at the International Exhibition of painting at Galerie Georges Petit, 8 rue de Sèze: 'Although it is not easy to categorise Mr Sisley's work, it has been produced by a painter whose artistic standing is of the highest order.' (Exh. cat.; Fénéon, 'Galerie Georges Petit. Exposition internationale de peinture', *Le Chat noir*, 9 January 1892, Halperin 1970, I, pp. 207–8)

1892

19 January Sisley wrote a short biography in response to a request from his friend, the critic Adolphe Tavernier (Fig. 37). (Letter to Tavernier, 19 January 1892, Paris, Institut Néerlandais, Fondation Custodia, no. 1973–A.1)

12 February Galerie Boussod et Valadon bought three paintings by Sisley back from the American, Haseltine, for 1400 francs, 390 francs and 390 francs, and sold a canvas, originally bought for 390 francs, to E. A. Wolcott on 14 March for 1500 francs. (Rewald 1973, appendix I)

7 May Sisley exhibited seven paintings at the Société Nationale des Beaux-Arts (Salon du Champ-de-Mars).

25 May Mirbeau published his fourth article on the Champs-de-Mars exhibition in *Le Figaro*, criticising Sisley's later works: '. . . it seems that tiredness, weariness has set in. His brush has lost its precision, his drawing has become sloppy. His work exudes a sense of despondency. Am I wrong? The canvases at this exhibition are nothing more than a pale shadow of the paintings that I recall so enthusiastically from the distant past, paintings which were so pretty, so fresh and so vibrant! The flower's sweet perfume, which I used to enjoy so much, has faded.' Sisley asked Magnard, the editor of the paper, to publish a reply to Mirbeau's article, 'the intention to discredit me in this article is

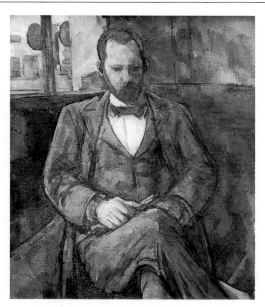

159 Paul Cézanne, *Ambroise Vollard*, 1899 (Musée du Petit Palais, Paris).

so blatant that you must allow me to defend myself.' He sent a copy of his letter to Tavernier. (Mirbeau, 'Le salon du Champ-de-Mars. Quatrième article, Le paysage', *Le Figaro*, 25 May 1892; letter to Tavernier, 1 June 1892, Huyghe, *Formes*, 1931, p. 153)

7 June Sisley could not attend the ballot held by the Société Nationale des Beaux-Arts but he voted 'for Lebourg as member and L. Stevens as associate member'. (Letter to an unnamed recipient, 7 June [1892?], Hôtel Drouot sale cat., 13 November 1991 [84])

Vollard (Fig. 159) exhibited one of Sisley's paintings in the window of his gallery. It was sold in five minutes. (Vollard 1984, p. 51)

Summer–Autumn One painting by Sisley included in the Continental Gallery, London, 'Paintings from the Paris Salons' (no. 105). (Flint 1984, p. 364)

November Sisley prepared his submission for the Chicago International Exhibition. (Letter to Tavernier, 11 Nov. 1892, Paris, Institut Néerlandais, Fondation Custodia no. 1973–A.3)

December Exhibition 'Paintings of Sisley, Renoir, J.L. Brown, Degas, Jongkind and Pissarro' at Durand-Ruel's gallery in New York. (Exh. cat.; see also Appendix II, p. 69)

1893

January A collector bought one of Sisley's paintings for 7500 francs from Georges Petit. (Letter from Mirbeau to Pissarro, [10 or 12 January 1893], Mirbeau 1990, p. 136 no. 58)

January or February Exhibition organised by the Galerie Boussod et Valadon in New York: 'Paintings of Monet, Renoir, Sisley, Raffaëlli and Pissarro'.

February Sisley exhibited at the annual '13' exhibition in Antwerp. ('Informations', *Journal des Arts*, 15–18 February 1893, p. 2)

One of Sisley's paintings was shown at the tenth annual exhibition in Saint-Louis (United States). (Exh. cat.; see also Appendix II, p. 69)

Winter–Spring One of Sisley's paintings included in an exhibition held by the Continental Gallery, London (no. 105). (Flint 1984, p. 363)

13 March–1 April Joyant organised a Sisley exhibition at the Galerie Boussod et Valadon which was welcomed by the press. Tavernier published a long article praising the artist. (Rewald 1973, p. 80; R.M., 'Deux expositions', *Le Voltaire*, 16 March 1893; C. Yriarte, 'Beaux-Arts. Les petits salons', *Le Figaro*, 2 April 1893; Tavernier, 'Sisley', *L'Art français*, 18 March 1893)

19 March Sisley thanked Tavernier for his article. (Letter to Tavernier, 19 March 1893, Huyghe, *Formes*, November 1931, p. 153)

April Sisley was elected by ballot during the general meeting of the Société Nationale des Beaux-Arts to be a member of the board of examiners for painters. ('Echos artistiques', *L'Art français*, 1 April 1893)

He refused to send a drawing of one of his canvases for the illustrated catalogue of the exhibition held by the Société Nationale des Beaux-Arts (Salon du Champ-de-Mars): 'Last year you asked me for two drawings for an illustrated catalogue ... Some time later you asked me to select a canvas for you to photograph. But instead of photographing the one I chose, you took a picture of a different one...'. (Letter to H. Durand-Tahier (?), Hôtel Drouot sale cat., 13 November 1991 [86])

1 May Opening of the Chicago Universal Exhibition. Sisley was not one of the French painters chosen by the jury. One of his paintings, however, was exhibited in the 'Loan Exhibition of Foreign Works from Private Collections in the United States', organised by Mrs Hallowell, which ran from May to October. ('L'Art français à Chicago', *L'Art français*, 6 May 1893, no. 315; Exh. cat.; see also Appendix II, p. 69)

10 May Opening of the exhibition held by the Société Nationale des Beaux-Arts (Salon du Champ-de-Mars). Sisley, a member, exhibited six works. (Exh. cat.)

May Some of Tavernier's friends were trying to persuade the State to buy one of Sisley's paintings. 'I would certainly be delighted if the painting they bought was destined for the Musée du Luxembourg. Otherwise, I must admit, I'm not at all keen on the idea.' (Letter to Tavernier, 15 May 1893, Paris, Institut Néerlandais, Fondation Custodia no. 1973–A.4)

11–27 May One of Sisley's paintings *The Flood*, belonging to J. S. Patterson, was shown at the Union League exhibition in Philadelphia. (Exh. cat.; see also Appendix II, p. 69)

3 June Sisley thanked Gabriel Mourey for the paragraph he devoted to him in his article on the Coquelin collection. (Letter to Mourey, 3 June 1893, Paris, Hôtel Drouot, 30 May 1990 [177])

11 June He wrote saying that he would not be able to attend the banquet at the Société Nationale des Beaux-Arts: 'It would be too much trouble for me to come, as I live so far from Paris'. (Letter to Durand-Tahier (?), 11 June 1893, Hôtel Drouot sales cat. 1991 [86])

8 October–6 November Monet, Renoir, Sisley and Pissarro exhibited at the Kunstkring in The Hague. Sisley showed three paintings. (Exh. cat.)

25 November Sisley drew up a holographic will clearly indicating his English nationality and making provisions for his companion Marie-Adélaïde-Eugénie Lescouezec and in the event of her death, his children, Pierre and Jeanne. This document was deposited with other records at the office of Maître Popelin, the notary at Moret-sur-Loing, 30 January 1899. (Moret-sur-Loing, notarial archives)

December Exhibition at the Galerie Martin-Camentron, (Paris), of works by Degas, Monet, Cassatt, Morisot, Pissarro, Sisley, Manet, Renoir, Guillaumin and 'some fine paintings by the 1830 school'. ('Maîtres modernes', *l'Art français*, 9 December 1893)

161 *(facing page)* Detail of Cat. 67, *The Boatyard at Matrat, Moret-sur-Loing* (Yale University Art Gallery), exhibited at the Salon du Champ-de-Mars in 1893.

1894

January Three of Sisley's paintings were exhibited at the Delmonico Galleries in New York. (Exh. cat.; see also Appendix II, p. 69)

February Two of Sisley's paintings were shown at the eleventh annual exhibition in Saint-Louis (United States). (Exh. cat.)

Sisley took part in the 'California Mid-Winter International Exhibition'. (Exh. cat.; see also Appendix II, p. 69)

21 February Death of Caillebotte. Renoir, the executor of his will, wrote to Roujon, the Directeur des Beaux-Arts, about his legacy which bequeathed his collection to the Musée du Luxembourg and to the Musée du Louvre. Only six of Sisley's paintings were accepted in 1897, after the artist had been consulted by Bénédite, the director of the Musée du Luxembourg (Fig. 160). (Paris, Archives du Louvre, will dated 3 November 1876; letter from Renoir to Roujon, 11 March 1894, Archives du Louvre; Distel 1989, p. 262)

6 March One of Sisley's landscapes was exhibited at the third international exhibition at the Kunstlerhaus in Vienna. (Exh. cat.)

19 March Sale of Théodore Duret's collection of paintings and pastels at Galerie Georges Petit. Among the forty-two works, there were three by Sisley. One painting was bought back by Duret for 1350 francs, one for 1550 francs by Durand-Ruel and another for 1100 francs by Magnien. (Bodelsen 1968, pp. 345–46)

160 Alfred Sisley, *Farmyard at Saint-Mammès*, 1884, (Musée d'Orsay, Paris).

25 April Sisley exhibited eight paintings at the exhibition held by the Société Nationale des Beaux-Arts (Salon du Champ-de-Mars). (Exh. cat.)

2 June Auction at the Hôtel Drouot of the art collection owned by the widow of the dealer, Tanguy. The prices obtained were very low. Two paintings by Sisley were sold for 185 francs apiece to someone called Delineau. (Bodelsen 1968, pp. 346–48)

Summer Sisley was staying in Normandy (see Cat. 72; D823–27, 829, 830). From Sahurs (Normandy), he sent Georges Petit the dimensions of the painting he wanted to show in Vienna. Some time later, he asked him if the paintings he had just exhibited in Vienna had been returned and whom he needed to contact to get them back. (Letters to an unnamed recipient, 25 June and undated, Hôtel Drouot sale cat., 13 November 1991 [85])

Gustave Geffroy devoted a laudatory chapter to Sisley in *La Vie artistique*, 3rd series, 1894.

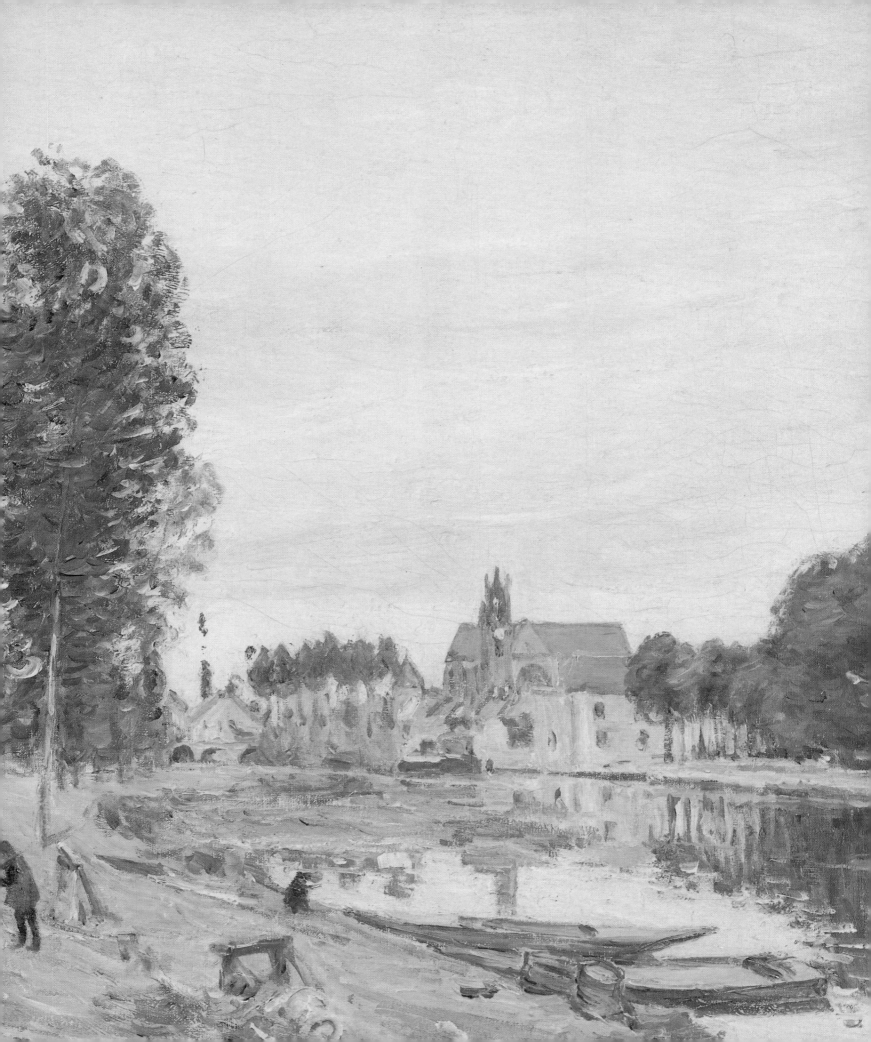

1895

February One of Sisley's paintings was shown at the twelfth annual exhibition in Saint-Louis (United States). (Exh.cat.; see also Appendix II, p. 69)

24 February Pissarro complained bitterly that his works were not selling well: 'They say that there is no money around, which is only comparatively true. Monet sells, doesn't he, and for high prices. Renoir and Degas also sell, don't they? No, I remain in the same boat as Sisley, bringing up the rear of Impressionism.' (Letter from Pissarro to his son Lucien, 24 February 1895, Bailly-Herzberg 1989, IV, p. 37 no. 1115)

March As in previous years, Sisley abandoned the idea of attending what he jokingly called the 'Pris de rhum' dinner (a pun on the 'Prix de Rome'), organised by Charpentier. This was because, he wrote, he lived 'too far away' (another pun on the similarity between the French word 'loin' and the village 'on the Loing' where he lived), and his travelling costs would be too great. (Letters to Charpentier, 2 March 1895 and [undated], Huyghe, *Formes*, 1931 p. 153)

25 April Sisley showed eight paintings at the exhibition held by the Société Nationale des Beaux-Arts (Salon du Champ-de-Mars). (Exh. cat.)

25–26 April Sale of works by Degas, Monet, Guillaumin, Renoir, Sisley and Pissarro by the American Art Association in New York on behalf of James F. Sutton. (Bailly-Herzberg 1989, IV, p. 71 n. 2)

May Sisley suggested to a collector that he choose one painting out of his 'best canvases', shown at the exhibitions held by the Société Nationale des Beaux-Arts. He would then sell this painting to him for 1800 francs. (Letter to an unnamed recipient, 18 May 1895, Paris, Institut Néerlandais, Fondation Custodia, no. 1984–A.165)

June Sisley was ill and was under the care of Dr Viau. (Letter to Tavernier, 6 June 1895, Paris, Institut Néerlandais, Fondation Custodia no. 1973–A.5)

1 September–28 October He exhibited at the Ghent exhibition, which took place every three years, along with Pissarro, Monet, Fantin-Latour, etc. (Sluyt, 'A propos du Salon de Gand', *La Revue Blanche*, 1 October 1895, p. 336)

23 November–13 December Exhibition organised by Murer at the Bodinière, rue Saint-Lazare. The preface to the catalogue was written by François Coppée (using the intitials L.H.) and Paul Alexis. ('Agenda de la semaine', *L'Illustration*, 23 November 1895, p. 426; Bailly-Herzberg 1989, IV, p. 124 n. 1)

Two paintings by Sisley were exhibited at the 'International Exhibition of Contemporary Painting' at the Carnegie Institute in Pittsburgh. (Exh. cat.; see also Appendix II, p. 69)

1896

Sisley has his first meeting with Vollard to discuss a project to publish a second album of Peintres-Graveurs. Vollard asked him for a colour lithograph. The album was published in 1897, and included *Beside the River: Geese* (Fig. 162). (Vollard 1984, pp. 180–277)

February One of Sisley's paintings was shown at the thirteenth annual exhibition in Saint Louis (United States). (Exh. cat.; see also Appendix II, p. 69)

25 April–30 June Sisley exhibited seven paintings at the exhibition held by the Société Nationale des Beaux-Arts (Salon du Champ-de-Mars). (Exh. cat.)

16 May Opening of an exhibition organised by Murer at his hotel in Rouen. He adorned the ground floor with all the canvases in his collection, supplemented by other works by Pissarro, Monet, Renoir, Guillaumin and Sisley. An advertisement appeared in the Bodinière catalogue: 'Hôtel du Dauphin et d'Espagne, 4 and 6 place de la République, two minutes from the Exhibition –

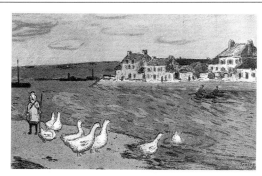

162 Alfred Sisley, *Beside the River: Geese*, coloured lithograph, only state (Département des Estampes, Bibliothèque Nationale, Paris).

magnificent collection of Impressionist paintings including thirty canvases by Renoir. Viewing free of charge, from 10 to 6 daily'. (Gachet 1956, p. 164)

7 December Sisley sent a canvas to Tavernier. (Letter to Tavernier, 7 December 1896, Paris, Institut Néerlandais, Fondation Custodia, no. 1973–A.7)

December He signed an agreement with Georges Petit to organise an exhibition 'in February, in the main room of his gallery.' He suggested the price of 800 francs for size 15 canvases and 1500 francs for size 25 canvases, and gave Petit the names of some art-collectors who would probably lend him some works. He also contacted people who owned his paintings to persuade them to lend them to him for the exhibition. (Letter to Tavernier, 23 December 1896, Paris, Institut Néerlandais, Fondation Custodia, no. 1973–A.8; letter to Petit, 13 December 1896, Paris, Hôtel Drouot, sale cat. 10 June 1974, [133]; letter to Petit, 23 December 1896, Paris, Archives du Louvre MS 310; letter to an unnamed recipient, 31 December 1896, Los Angeles, Archives at the Getty Center for the History of Art and the Humanities, no. 870349)

1897

January Sisley had flu. However, he was actively involved in the preparations for his exhibition. (Letter to an unnamed recipient, 12 January 1897, Paris, Archives du Louvre, MS 310)

February Durand-Ruel sent eleven Impressionist paintings, including two by Sisley, to an exhibition in Dresden. (Durand-Ruel Archives)

1–2 February The sale of the Vever collection took place at Galerie Georges Petit with excellent results: 21,000 francs for a canvas by Monet, 10,000 francs for a Degas, 2500 francs for a Sisley. Sisley asked Petit to keep a catalogue for him. (Letter to Petit, 24 January 1897, Paris, Hôtel Drouot, 10 June 1974 [134])

5–28 February 146 paintings and 5 pastels by Sisley were exhibited at Galerie George Petit, 8 rue de Sèze. L. Roger-Milès wrote the preface to the exhibition catalogue. (Exh. cat.)

7 February Opening of the Salle Caillebotte at the Musée du Luxembourg with selected paintings from the bequest. 'The stir created by the Impressionists is doing the rounds of the press; everyone is having a say and is being more or less reasonable. . . . The weakest paintings are those by Sisley and Monet who have, nonetheless, some very fine things on show.' (Letter from Pissarro to his son Lucien, 16 March 1897, Bailly-Herzberg 1989, IV, p. 337 no. 1380; 'Instantané', *Le Figaro*, 7 February, 1897; A. Alexandre, 'La Vie artistique – Exposition Alfred Sisley', *Le Figaro*, 7 February, 1897)

March Sisley did not intend to exhibit with the Société Nationale des Beaux-Arts (Salon du Champs-de-Mars). (Letter to an unnamed recipient, 25 March 1897, Hôtel Drouot sales cat, 13 November 1991 [84])

7 April He warned that, should he be elected, it would be impossible for him to be a member of the jury for the Salon du Champ-de-Mars (Société Nationale des Beaux-Arts) that year. (Letter to an unnamed recipient, 7 April 1897, Hôtel Drouot sales cat, 13 November 1991 [84])

12 May Anonymous, posthumous sale at Galerie Georges Petit of the collection owned by P. Aubry, a Parisian collector, including 13 Jongkinds, 11 Sisleys and 5 Monets, bought from Theo van Gogh in August 1887. *The Seine* by Sisley, purchased for 150 francs, was sold for 2350 francs. (Rewald 1973, p. 105)

23 May Sisley was expecting a visit from Gustave Geffroy. (Letter to Geffroy, 23 May 1897, Los Angeles, Archives at the Getty Center for the History of Art and the Humanities, no. 870349)

July–September Sisley visits England, supported by the Rouenais industrialist and collector, Depeaux (see Cat. 73–75).

9 July After staying for several days in Falmouth, Cornwall, Sisley moved to Penarth, a seaside resort near Cardiff. He was living at 4 Clive Place. He met the French Consul in Cardiff, Adolphe de Trobiaud. (Letter to Tavernier, 18 August 1897, Paris, Institut Néerlandais, Fondation Custodia, no. 1973–A.1)

16 July Sisley had just read two books by Gustave Geffroy. He greatly enjoyed *L'Enfermé*, 'a book which is in a class of its own'. (Letter to Geffroy, 16 July 1897, Daulte 1959, p. 36)

3 August Adolphe de Trobiaud, the French Consul in Cardiff, in his capacity as registrar, drew up a certificate in which Eugénie Lescouezec acknowledged being the mother of Sisley's children. As the children took the nationality of the father, they were considered to be English. When he came of age, Pierre opted for French nationality. (Archives at the Ministry of Foreign Affairs; letter from Sisley to the Garde des Sceaux, (French equivalent of Lord Chancellor), 31 January 1898, Archives Nationales, no. BB11/ 3560, no. 867X98)

5 August Sisley married Eugénie Lescouezec at the Town Hall in Cardiff; the witnesses were E. and P. Lindsley. (Cardiff, Register Office, marriage certificate, no. 146)

18 August Sisley was staying in Langland Bay, at the Osborne Hotel. (Letter to Tavernier, 18 August 1897, Paris, Institut Néerlandais, Fondation Custodia, no. 1973–A.11)

163 Alfred Sisley, photograph (Bibliothèque Nationale, Paris).

1 October He returned to Moret with twelve canvases painted during his stay in England. (Letter to Tavernier, 16 October 1897, Paris, Institut Néerlandais, Fondation Custodia, no. 1973–A.12)

24 October An article signed 'Le Masque de Fer' [Adolphe Tavernier] announced his return to France. (*Le Figaro*, 24 October 1897)

26 October Sisley thanked Tavernier for the article published in *Le Figaro* and *Gil Blas*. (Letter to Tavernier, 26 October 1897, Paris, Institut Néerlandais, Fondation Custodia, no. 1973–A.13)

4 November–1 January 1898 One of Sisley's paintings was exhibited at the Second Annual Exhibition which took place at the Carnegie Institute in Pittsburgh. (Exh. cat.)

7 November Sisley told Tavernier that, as a result of the articles published in the press, he had received visits from some art-collectors: Decap, several painters, Bazalgette, Melle Halowell 'An American lady who is very influential in her own country and is very well-known in Paris by the dealers.' (Letter to Tavernier, 1897, Huyghe, *Formes*, November 1931 p. 154)

26 November Sisley thanked Charpentier for his visit to Georges Petit's gallery. He was unable to leave Moret because he had the flu. (Letter to Charpentier, 26 November 1897, Paris, Bibliothèque d'Art et d'Archéologie, Fondation Jacques Doucet, no. 11853)

1 December Sisley reports that more collectors had come to Moret to visit him (Fig. 163). (Letter to Tavernier, 1 December 1897, Paris, Institut Néerlandais, Fondation Custodia, no. 1973–A.14)

14 December Sisley thanked Vollard for sending the Peintres-Graveurs album, which 'must have been very successful'. (Letter to Vollard, Paris, Hôtel Drouot, 30 January 1980 [69])

Murer's hotel in Rouen had to be sold off due to bad management. The marriage of his sister, Marie Meunier, which caused family squabbles, led to the collection being sold. Three Sisleys were placed with Camentron, rue Laffitte. (Gachet 1956, p. 177)

1898

January Sisley was suffering from excruciating neuralgia.

He was still thinking about applying for French citizenship and he instructed his friend Tavernier to draft a letter to the Garde des Sceaux. (Letter to Tavernier, 28 January 1898, Huyghe *Formes*, 1931 p. 154)

31 January He sent his request for naturalisation to the Minister of Justice clearly indicating that his son had opted for French nationality when he had come of age and had completed his military service (5 years as a non-commissioned officer in an infantry regiment in Rouen), that he had two uncles who had become naturalised Frenchmen and who were in the Foreign Legion, and that he had married a French woman. (Letter to the Garde des Sceaux, 31 January 1898, Paris, Archives Nationales; report from the Gendarmerie Nationale, 14 April 1898, Paris, Archives Nationales, no. BB11/3560, no. 867X98)

3 February Sisley filled out a request form for naturalisation. (Paris, Archives Nationales, no. BB11/3560, no. 867X98)

2 April Following this request, the Sous-Préfet for Fontainebleau wrote to the Gendarmerie Nationale in Moret, requesting further information about Sisley. (Report from the Gendarmerie Nationale, 14 April 1898, Paris, Archives Nationales, no. BB11/3560, no. 867X98)

14 April The police department in Moret compiled a report on Sisley's activities and morality: 'His behaviour, morality and integrity are very sound: he is quiet and peace-loving, he does not visit anyone and lives a very secluded life. His views do not seem to pose a threat to national security.' (Paris, Archives Nationales, no. BB11/3560, no. 867X98)

16 April The Préfet for Seine-et-Marne viewed his request for naturalisation favourably, stating: 'Mr Sisley's wife, who is of French origin, refuses to comply with any

formality for her reinstatement'. She had become English by her marriage. (Paris, Archives Nationales, no. BB11/3560, no. 867X98)

1–15 May Sisley exhibited five canvases painted in England at the exhibition held by the Société Nationale des Beaux-Arts (Salon du Champ-de-Mars). (Exh. cat.)

12 May The file for Sisley's request for naturalisation was transferred by the Préfet for Seine-et-Marne to the Minister of Justice. (Paris, Archives Nationales, no. BB11/3560, no. 867X98)

1–18 June There was an exhibition of paintings by Renoir, Monet, Sisley and Puvis de Chavannes at Galerie Durand-Ruel, connected with an 'Exhibition of recent works by Camille Pissarro'. (Letter from Pissarro to his son Lucien, 29 May 1898, Bailly-Herzberg 1989, IV, p. 486)

Summer A colour lithograph by Sisley was shown at the first exhibition of the 'International Society of Sculptors, Painters and Gravers' at the Knightsbridge Skating Rink, London. (Exh. cat.)

August Summer exhibition at Galerie Georges Petit with works by Detaille, de Neuville, de Nittis, Heilbuth, Lambert, Jacquet, Lazerges, Luminais, Jongkind, Sisley, Roybet, Boudin, C. Jacques, Stevens, Ziem, Flameng, etc. ('Agenda de la semaine', *L'Illustration*, 13 August 1898, p. 111)

11 August Sisley criticised the text by Tolstoy *Qu'est-ce que l'art?*, denouncing art for art's sake, excerpts of which were published in *La Revue Blanche* on 18 January 1898: 'I think he would have done a lot better to avoid tackling an issue which has already been done to death and which, more often than not, makes people say the most *outrageous things*.' (Letter to E. Halpérine-Kaminsky, the translator of the original manuscript, 11 August 1898, Los Angeles, Archives at the Getty Center for the History of Art and the Humanities, no. 870349)

8 October Sisley's wife, Eugénie Lescouezec, died from cancer of the tongue at Moret. The death was notified by her son Pierre and a neighbour. Sisley, who was very ill, did not go to the funeral which took place on 9 October at the cemetery in Moret. Only her children were present. (Moret-sur-Loing, death certificate; Renoir 1981, p. 132; parish archives at Notre-Dame de Moret, certificate of burial which states: Marie Eugénie Lescouezec 'wife of Sisley')

3 November–31 December Two of Sisley's paintings were shown at the third annual exhibition at the Carnegie Institute in Pittsburgh. (Bailly-Herzberg 1989, IV, p. 489 n. 1; 'Agenda de la semaine', *L'Illustration*, 19 November 1898, p. 331; see also Appendix II, p. 69)

November Sisley consulted a doctor 'recommended by some American friends ... a pseudo-homeopath.' He complained of being 'in the doctor's clutches for five months'. (Letter to Tavernier, 6 November 1898, Paris, Institut Néerlandais, Fondation Custodia, no. 1973–A.6)

28 November He suffered a massive haemorrhage. (Letter to Dr Viau, Daulte 1959, p. 37)

11 December He was still weak from the haemorrhage. His illness was becoming worse. (Letter to Dr Viau, 11 December 1898, Paris, Institut Néerlandais, Fondation Custodia, no. 6738a)

31 December He was in a very poor state of health. His extremely swollen neck hampered breathing, coughing or turning his head. He asked Dr Viau to recommend a doctor who would not cost him 'more than 100 to 200 francs'. (Letter to Dr Viau, 31 December 1898, *Bulletin des expositions*, 1933 p. 8)

1899

1 January Sudden but temporary improvement in his state of health. (Letter to Dr Viau, 1 January 1899, *Bulletin des expositions*, 1933 p. 9)

January Durand-Ruel sent 20 Impressionist paintings, including 3 by Sisley, to an exhibition at Arnold and Gutbier's gallery in Dresden. (Durand-Ruel archives)

13 January Sisley, racked with pain, was at the end of his tether. (Letter to Dr Viau, 13 January 1899, *Bulletin des expositions*, 1933 p. 9)

21 January He asked Monet to come and see him. Several days later, the latter wrote to Geffroy: 'Sisley is said to be extremely ill. He is a truly great artist and I believe he is as great a master as any who has ever lived. I looked at some of his works again, which have a rare breadth of vision and beauty,

especially one of a flood which is a masterpiece.' (Letter from Monet to Geffroy, 29 January 1899, Wildenstein 1985, IV, p. 337 no. 1434; letter from Pissarro to his son Lucien, 22 January 1899, Rewald 1950, p. 465)

29 January Sisley died at Moret. According to Vollard, he had cancer of the throat and had two operations before he died. (Moret-sur-Loing, death certificate; Vollard 1937, pp. 180–81)

31 January Lucien Pissarro read the news of Sisley's death in the London newspapers. 'I am really very upset about it', he wrote to his father. (Letter to his father, 31 January 1899, Rewald 1950, p. 466)

End January The Ernst Arnold Gallery in Dresden organised an exhibition of Impressionist paintings (Pissarro, Monet, Sisley, Renoir), of pastels by Degas, drawings by Van Rysselberghe, and water colours, etchings and paintings by Signac. The manager of the gallery asked Pissarro to persuade Sisley to send him two or three works. (Letter from Adolf Gutbier to Pissarro, 28 January 1899, Paris, Hôtel Drouot, 21 Nov. 1975, no. 85)

1 February Sisley was buried at the cemetery in Moret (Fig. 164) 'in the presence of his children and a large gathering of people'. Renoir, Cazin, Monet and Tavernier attended the funeral. (Parish archives at Notre-Dame de Moret, certificate of burial; letter from Monet to Geffroy, 3 February 1890, Wildenstein 1985, IV, p. 337 no. 1435)

February Monet visited Moret on several occasions to help the painter's children. He instigated a sale on their behalf and planned to organise 'a fine exhibition of his best works' at a later date. (Letter from Monet to Geffroy, 3 February 1899, Wildenstein 1985, IV, p. 337 no. 1435)

Galerie Bernheim, 8 rue Laffitte, organised an exhibition of fourteen of Sisley's paintings. ('Agenda de la semaine', *L'Illustration*, 1 and 18 February 1899, p. 99, 115)

11 February The Préfet for Seine-et-Marne told the Minister of Justice that Sisley, who had been on the point of receiving French naturalisation, was dead. (Letter from the Préfet of Seine-et-Marne to the Minister of Justice, 11 February 1899, Paris, Archives Nationales, no. BB11/3560, no. 867X98)

16 February–8 March 'Exhibition of paintings by P.A. Besnard, J.C. Cazin, C. Monet, A. Sisley, F. Thaulow and pottery by E. Chaplet' at Galerie Georges Petit, including 21 paintings by Sisley. (Exh. cat.)

27 February–15 March Exhibition of 'Works of Alfred Sisley', at Galerie Durand-Ruel in New York, with 28 of the artist's paintings. (Exh. cat.; see also Appendix II, p. 69)

March–April Monet wrote to several of his artist friends, asking them to support a sale which he was organising on behalf of Sisley's children. He asked Arsène Alexandre and Gustave Geffroy to collaborate on the preface to the catalogue. Renoir, Pissarro, Lebourg, Cazin, Besnard, Jean, Raffaëlli, Vuillard, Carrière, Ménard, Cassatt, Morisot (donated by her daughter), Caillebotte (donated by his brother) took part in the sale, as well as Montenard and A. André, Rodin, Bartholomé and Cézanne. (Letter from Monet to Durand-Ruel, 17 March 1899, to Thaulow, 20 March 1899, to Lebourg, 3 April 1899, to Rodin, 3 April 1899, to Julie Manet, 23 March 1899, to Alexandre, 3 April 1899, to Geffroy, 3 April 1899, to G. Petit, 9 April 1899, to Geffroy, 10 April 1899, Wildenstein 1985, IV, pp. 337–38 no. 1445, 1446, 1454, 1455, 1449, p. 338 no. 1452, 1453, no. 1456, 1457)

April–6 May 'Exhibition of paintings by Monet, Pissarro, Renoir and Sisley' at Galerie Durand-Ruel, Paris, including 34 paintings by Sisley. (Exh. cat.; 'Agenda de la semaine', *L'Illustration*, 6 May 1899)

26 April Monet tried to advertise the sale on behalf of Sisley's children by publishing the preface to the Atelier sale catalogue in *Le Figaro*, the newspaper for which both Alexandre and Geffroy worked. (Letter from Monet to Alexandre, 26 April 1899, Wildenstein 1985, IV, p. 338 no. 1460)

27 April Pierre Sisley signed his father's canvases which were still in the studio for the Atelier Sale. (Letter from Monet to Petit, 27 April 1899, Wildenstein 1985, IV, p. 338 no. 1462)

29–30 April Exhibition (Atelier Sale) at Galerie Georges Petit of the works to be sold on behalf of the artist's children. (Letter from Monet to Geffroy, 3 April 1899, Wildenstein 1985, IV. p. 338 no. 1453)

1 May Sale of 'Paintings, studies and pastels from his studio and those given to his children by other artists'. (Exh. cat.)

26 June Pierre Sisley settled his parents' estate, witnessed by Maître Pinsard, the notary at Moret-sur-Loing, 28 April 1899. The inheritance document belonging to Marie-Louise-Adélaïde Eugénie Lescouezec 'wife of Sisley' stated: 'M. and Mme Sisley were subject to English legislation, according to which all property acquired during the marriage belongs to the husband'. The only legacy she left her children was her wardrobe, estimated at fifty francs.

The legacy of Alfred Sisley comprised his wardrobe, estimated at fifty francs, furniture (950 francs) and the money obtained from selling his paintings, on 1 May, 115,640 francs, i.e. a total of 116,640 francs. (Dammarie-les-Lys, regional archives for Seine-et-Marne)

164 Sisley's grave at Moret-sur-Loing, photograph, 1992.

CRITICAL SUMMARY
Isabelle Cahn

I
Ist Impressionist Exhibition
1874

Sixteen of the twenty-three articles published about the first Exhibition of the Société anonyme des artistes peintres, sculpteurs, graveurs, etc., drew attention to Sisley's works. The painter was prominently placed alongside the major representatives of the 'Impressionist School', Degas, Monet, Pissarro, Morisot and other now less well-known artists, including Rouart, Latouche, Beliard and Lépine.

This place of honour made him the target of several savage reviews but his paintings were criticised more for a certain delicateness than for too much daring: '. . .perhaps his perception of nature is too insubstantial?' (Montifaud). Silvestre assessed him as the artist who was 'the most harmonious and the most timid' of the group, despite 'two canvases in which daring technique appears [to him] to be more successful [. . .] the *Orchard* and the view of *Port-Marly*'; Prouvaire half-heartedly compliments his 'delightful work'. D'Hervilly, writing ambiguously, included his paintings, with those of Degas and Rouart, among the most 'exquisite' landscapes in the exhibition. In general, his work was not scathingly attacked by the journalists. Some paintings were even singled out for the highest praise: '. . . *The Seine at Port-Marly*, which is the ultimate fulfilment of the school's ambitions in the treatment of landscape. I cannot think of any painting in the past or now which conveys so completely, so perfectly, the physical sensation of atmosphere, of being out in the open air' (Chesneau). *The Ferry of the Ile de la Loge* was, in Lora's opinion, to be ranked 'among the best landscapes'. Sisley was immediately seen as one of the leading representatives of the new 'plein aire' school along with Monet, Pissarro and Degas.

E. Chesneau, 'Avant le Salon', *Paris-Journal*, 2 April 1874; P. Burty, 'Chronique du jour', *La République française*, 16 April 1874; E. d'Hervilly, 'L'Exposition du Boulevard des Capucines', *Le Rappel*, 17 April 1874; L. de Lora, 'Petites nouvelles artistiques. Exposition libre des peintres', *Le Gaulois*, 18 April 1874; [E. Zola], 'Lettre de Paris', *Le Sémaphore de Marseille*, 18 April 1874; E. Drumont, 'L'Exposition du boulevard des Capucines', *Le Petit Journal*, 19 April 1874; 'Nos informations', *La Liberté*, 20 April 1874; A. Silvestre, 'Chronique des Beaux-Arts', *L'Opinion nationale*, 22 April 1874; J. Prouvaire, 'L'Exposition du Boulevard des Capucines', *Le Rappel*, 25 April 1874; P. Burty, 'Chronique du jour. Exposition de la Société anonyme des artistes', *La République française*, 25 April 1874; L. Leroy, 'L'Exposition des Impressionnistes', *Le Charivari*, 25 April 1874; E. Cardon, 'Avant le Salon. L'Exposition des révoltés', *La Presse*, 29 April 1874; J. Castagnary, 'Exposition du Boulevard des Capucines. Les Impressionnistes', *Le Siècle*, 29 April 1874; E. Chesneau, 'A côté du Salon', *Paris-Journal*, 6 May 1874; E. Chesneau, 'A côté du Salon II. Le plein aire', *Le Soir*, 7 May 1874; E. Chesneau, 'A côté du Salon II. Le plein aire', *Paris-Journal*, 7 May 1874; M. de Montifaud, 'Exposition du boulevard des Capucines', *L'Artiste*, May 1874, pp. 307–13.

II
2nd Impressionist Exhibition
1876

The public and the critics awaited the second Impressionist exhibition with great curiosity. It was given wide press coverage (more than forty articles have been recorded). Out of the thirty-four reviews studied, thirteen ignored Sisley's contribution. However his pictures were given pride of place in the main room of Durand-Ruel's gallery alongside Lepic's seascapes, Monet's landscapes, the indoor scenes of Berthe Morisot and Caillebotte, and Renoir's portraits. Apart from the caustic remarks by the journalists from *L'Evénement* and *La Chronique des arts et de la curiosité*, most of the critics liked his contribution. Rivière was even sorry that there were not more paintings by him. He was showing eight paintings – in other words, two more than in 1874. *The Flood*, depicting a recent event which had fired the imagination of his contemporaries, was received with unanimous enthusiasm: 'this painting may be the best one in this exhibition of "intransigeants"' (Bigot), in any case 'a painting of huge importance (. . .) with its pretty Saint-Nicolas inn, its half-submerged trees, its broad horizon, its pale blue, cloudy sky (. . .)' (E. Blémont). The scene rang true: 'you would happily go inside that inn to enjoy a meal of fried gudgeon, freshly caught beneath the window'. (G. d'Olby)

Sisley's paintings, with their subtle hues, were not as disturbing as Monet's works whose dazzling garish tones bewildered the spectator. In comparison with the 'intransigeants' and the 'art reformers' – Monet and Pissarro, in d'Olby's opinion – Sisley's moderation, his 'grace' and 'solidity' were comforting (Silvestre). In the bright April sunshine, opinions were kinder to the artist than during the gusts of March 1875, when the disastrous auction of Impressionist paintings took place.

A. Pothey, 'Chronique', *La Presse*, 31 March 1876; 'Courrier de Paris', *Le Petit Moniteur Universel*, 1 April 1876; P. Burty, 'Chronique du jour', *La République française*, 1 April 1876; A. de L[ostalot], 'L'exposition de la rue Le Peletier', *La Chronique des arts et de la curiosité*, 1 April 1876; 'La journée à Paris. L'exposition des Impressionnistes', *L'Evénement*, 2 April 1876; A. Silvestre, 'Exposition de la rue Le Peletier', *L'Opinion nationale*, 2 April 1876; A passer-by [E. d'Hervilly], 'Les on-dit', *Le Rappel*, 2 April 1876; A. de L[ostalot], 'L'exposition des Impressionnistes' (sic), *Le Bien public*, 4 April 1876; Baron Schop, 'La semaine parisienne', *Le National*, 7 April 1876; M. Chaumelin, 'L'exposition des Intransigeants', *La Gazette des étrangers*, 8 April 1876; C. Bigot, 'Causerie artistique. L'exposition des Mirlitons. L'Exposition des "Intransigeants"', *L'Audience*, 9 April 1876; E. Blémont [E. Petitdidier], 'Les Impressionnistes', *Le Rappel*, 9 April 1876; G. d'Olby, 'Salon de 1876', *Le Pays*, 10 April 1876; A. Baignères, 'Exposition de peinture par un groupe d'artistes, rue Le Peletier, II', *L'Echo universel*, 13 April 1876; G. Rivière, 'Les intransigeants de la peinture', *L'Esprit moderne*, 13 April 1876; Bertall, 'Exposition des Impressionalistes rue Lepeletier (sic)', *Le Soir*, 15 April 1876; P. Burty, 'The exhibition of the "Intransigeants"', *The Academy*, 15 April 1876; P. Dax, 'Chronique', *L'Artiste*, 1 May 1876; E. Zola, 'Deux expositions d'art au mois de mai', *Le Messager de l'Europe*, June 1876.

III
3rd Impressionist Exhibition
1877

The Impressionist exhibition was held in Durand-Ruel's gallery as it had been the year before. Pride of place was given to the stalwarts: Monet, Pissarro, Sisley, Renoir, Guillaumin, etc, who displayed their works side by side in the main room, giving 'this room an inexpressible, almost musical gaiety'. (Rivière)

Some fifty articles and cartoons greeted the event on the rue Le Peletier, while the 3,500 paintings on display at the salon that year deterred more than one critic and weakened the enthusiastic response elicited by official art. With the exception of the review in *La Petite République Française*, which accused all Impressionists of suffering from some sort of eye disease or from St Vitus's dance, a great variety of opinions was expressed by the critics. Sisley was first associated with Cézanne's extremism (Sébillot, Bertall), then praised for his moderation. In the opinion of the harsh critic, Louis Leroy, he was 'erratic'. His familiar Ile-de-France landscapes were still appealing with their poetic naturalism, described by Georges

Rivière: '... his great landscape, a road after the rain has stopped, with water dripping from tall trees, the damp cobbles, the puddles reflecting the sky, was charged with an enchanting poetry.' Zola praised Monet and Sisley for being 'two highly talented landscape artists (...) who both depict, in their different ways and with remarkable realism, the world of nature.' The *Woodcutters* was a focus of attention. It was used to illustrate the cover of *L'Impressionniste* of 28 April; Maillard, *La Petite République Française*, Bigot and Proth, spoke highly of the painting.

On the other hand, some journalists, dissatisfied with the impression of simple sincerity which they received from these landscapes, criticised them for 'a lack of light and visual strength' (Bigot). 'It is an unforgivable sin – wrote Philippe Burty – to reduce a tree to a disembodied ghost; where the trunk and branches, which have the same intrinsic beauty as the human body and limbs, are unfairly made to appear as lifeless as a telegraph pole, with shapeless twigs'. Emile Bergerat made an even stronger statement about the vagueness of his and Pissarro's work, 'to mention only those Impressionists [who] present us with an indistinct scumble where a vertical brush-stroke represents a tree and a smear of paste is a house, we have every right to wonder if Messr. Pissarro and Sisley can do anything else, if they consider them finished works and why they have decided to treat us in such a cavalier fashion.' Impressionism seemed to be both the school of blurred painting and the melting-pot of original talent. The division among the critics is a reflection of the force of this new painting, from which several trends and individual painters emerged. The columnist of *La Revue politique et littéraire* even hinted at the rifts to come: 'The time is approaching when they will each go their own way, asserting their individual personalities more and more, following the dictates of their own character, without losing anything by it... M. Sisley, M. Levert and M. Maureau could well do likewise. Claude Monet will remain alone, surrounded by half a dozen disciples ... and he will revive the school of insipid hues and fly the Impressionist flag again.'

G. Rivière, 'L'exposition des Impressionnistes', *L'Impressioniste*, no. 1, 6 April 1877, p. 26; L.G., 'Le Salon des 'Impressionnistes'', *La Presse*, 6 April 1877; 'Les Impressionnistes', *Le Rappel*, 6 April 1877; A.P., 'Beaux-Arts', *Le Petit Parisien*, 7 April 1877; P. Sébillot, 'Exposition des Impressionnistes', *Le Bien Public*, 7 April 1877; G. Maillard, 'Chronique. Les Impressionnistes', *Le Pays*, 9 April 1877; Bertall, 'Exposition des Impressionnistes', *Paris-Journal*, 9 April 1877; 'Exposition des Impressionnistes', *La Petite République Française*, 10 April 1877; L. de Lora, 'L'Exposition des Impressionnistes', *Le Charivari*, 11 April 1877; G. Rivière, 'L'Exposition des Impressionnistes', *L'Impressionniste*, no. 2, 14 April 1877, pp. 1–6; E. Bergerat, 'Revue artistique', *Journal Officiel de la République Française*, 17 April 1877; [Zola], 'Notes parisiennes', *Le Sémaphore de Marseille*, 19 April 1877; Ph. B. [Burty], 'Exposition des Impressionistes'(sic), *La République Française*, 25 April 1877; C. Bigot, 'Causerie artistique. L'Exposition des "Impressionnistes"', *La Revue politique et littéraire*, 28 April 1877, pp. 1045–48; cover of *L'Impressionniste*, no. 4, 28 April 1877.

IV
7th Impressionist Exhibition 1882

'Sisley has around thirty canvases which have a completely English flavour', commented Pissarro about the paintings displayed at the 7th Impressionist exhibition. With twenty-seven landscapes of the area around Moret, the one exception being *The Seine at Saint-Denis*, this was the last time that Sisley exhibited with the Impressionists.

This year, the critics publicised the disagreements which were beginning to create rifts between the members of the group, leading to its disintegration. 'The most independent artists in the group of 'Indépendants' have left the field clear' (La Fare). Degas, Mary Cassatt, Raffaëlli had withdrawn, Sisley, after an absence, had rejoined the ranks of the faithful: Monet, Pissarro and Renoir. Compared with the excesses of the new exhibitors, Gauguin in particular, the painting by the veterans was appreciated for its moderate naturalism and praised by Huysmans and Havard: 'M. Sisley. One of the first, with M. Pissarro and M. Monet (...) who went and sought nature, who dared to consult her and who tried to depict accurately the feelings she aroused in him.' Monet and Sisley 'are also gradually renouncing their astounding perspectives. When they take up their standpoint and map out their skyline, they do not overly distance themselves from this gloomy land which you and I, mere laymen, simply walk upon.' The painters had quietened down, it seemed, or the visitor's eye had become accustomed to the new school. 'M. Sisley is a believer, a conscientious man who does not do anything just for effect (...) you may dislike his painting, but you must respect it. I would like to praise this artist for painting more or less as everybody else does, in other words with a brush. This is not common with the 'Indépendants' and several of them seem to paint with matchsticks, toothpicks, dessert knives or even simply with the thread from their tubes of paint' (C. Flor).

The Impressionist technique was as shocking as ever, and the critics took pleasure in imagining the painters working with the most preposterous means. It took someone as spiteful as Albert Wolf, a sworn enemy of the Impressionists, to accuse Sisley of '*painting with a gun*, for they say that he stuffs tubes of paint down the barrel of a rifle and shoots them at the canvas. He then signs the work!'

Although Sisley's landscapes are occasionally compared to works by Monet (Havard, Sallanches, Silvestre), they differ from them in their use of colour – his scale of colours was dominated by light blues, greens and greys. He excelled in the half-tones of autumn on the banks of the Loing, the changing skies of the Ile-de-France (Hepp, Chesneau): he 'has become the master of the banks of the Seine and its waters, in which the autumn leaves and the opalescent reflections of the skies, lightly dappled with cloud, rendered in a soft grey which seems to exude melancholy, are shattered into thousands of bright splinters from a moving mirror.' The delicacy of his palette baffled other critics who took pleasure in comparing his greys and browns to barbotine (Vassy, Salanches).

In 1882, the challenges of the 'Intransigeants' were already a thing of the past. 'With an artistic temperament which is less volatile, less highly-strung, with a calmer vision, than his two colleagues [Pissarro and Monet], ... less specific, less personal than them' (Huysmans), Sisley was the incarnation of the moderate and sincere aspect of Impressionism.

La Fare, 'Chez les Impressionnistes – Les cinq', *Le Gaulois*, 23 February 1882; H. Marriott, 'Petite Gazette d'art' *La Vie Moderne*, 25 February 1882, p. 125; P. de Kakow, 'L'exposition des Indépendants', *Gil Blas*, 1 March 1882; G. Vassy, 'L'actualité. Les peintres impressionnistes', *Gil Blas*, 2 March 1882; A. Wolf, 'Quelques expositions', *Le Figaro*, 2 March 1882; Fichtre [Gaston Vassy], 'L'actualité. L'exposition des peintres indépendants', *Le Réveil*, 2 March 1882; H. Havard, 'Exposition des artistes indépendants', *Le Siècle*, 2 March 1882; La Fare, 'Exposition des Impressionnistes', *Le Gaulois*, 2 March 1882; C. O'Flor, 'Deux expositions', *Le National*, 3 March 1882; A. Hepp, 'L'Impressionisme'(sic), *Le Voltaire*, 3 March 1882; A. Sallanches, 'L'exposition des artistes indépendants', *Le Journal des Arts*, 3 March 1882; A. Hustin, 'L'exposition des peintres indépendants', *L'Estafette*, 3 March 1882; C. Bigot, 'Beaux-Arts. Les Petits Salons', *La Revue politique et littéraire*, 4 March 1882, pp. 278–82; J. de Nivelle, 'Les peintres indépendants', *Le Soleil*, 4 March 1882; E. Chesneau, 'Groupes sympathiques. Les impressionnistes', *Paris-Journal*, 7 March 1882; E. Hennequin, 'Beaux-Arts. Les expositions des Arts libéraux et des artistes indépendants', *Revue littéraire et artistique*, 11 March 1882, pp. 154–55; A. Silvestre, 'Le Monde des arts. Expositions particulières. Septième exposition des artistes indépendants', *La Vie Moderne*, 11 March 1882, pp. 150–51; P. de Charry, 'Beaux-Arts', *Le Pays*, 14 March 1882; L. Leroy, 'Exposition des impressionnistes', *Le Charivari*, 17 March 1882; 'Nouvelles parisiennes', *L'Art moderne*, 19 March 1882, pp. 92–93; H. Rivière, 'Aux Indépendants', *Le Chat noir*, 8 April 1882, p. 4; J.-K. Huysmans, 'Les indépendants et le Salon officiel en 1882', appeared in *L'Art moderne*, 1883.

BIBLIOGRAPHY

compiled by Juliet Simpson

l'Abbaye 1978, *Bulletin de la vente de la librairie de l'Abbaye*, April 1978, 1 letter from Sisley to Tual, 1888, no.224

Aberdeen 1950, *Aberdeen Art Gallery. Catalogue of Oil Paintings, Water Colours, Drawings, Modern Sculpture*, Aberdeen 1950

Adhémar 1973, H. Adhémar, 'Galerie du Jeu de Paume, Dernières acquisitions', *La Revue du Louvre et des Musées de France*, 4–5, 1973, p. 289

Adhémar and Dayez-Distel 1973 & 1979, H. Adhémar and A. Dayez-Distel, *Musée du Louvre, Musée du Jeu de Paume*, Paris 1973 (revised 1979)

Alaya 1984, F. Alaya, *Silk and Sandstone, The Story of Catholina Lambert and his Castle*, Passaic County Historical Society, Paterson 1984

Alazard 1939, J. Alazard, *Catalogue des Peintures et Sculptures exposées dans le Musée national des Beaux-Arts d'Alger*, Paris 1939

d'Albis 1988, Jean d'Albis, *Haviland*, Paris 1988

Alexandre 1897, A. Alexandre, 'L'Exposition Alfred Sisley', *Le Figaro*, 7 February 1897

Alexandre 1899, A. Alexandre, *Catalogue de Tableaux, Etudes, Pastels par Alfred Sisley*, Paris 1899

Alexandre 1930, A. Alexandre, *La Collection Canonne*, Paris 1930
A. Alexandre, 'La Collection Canonne', *La Renaissance* 4, April 1930, pp. 85–108

Alexandre 1933, A. Alexandre, 'La Collection E.L...[Laffon]', *La Renaissance* 10–11, November 1933, pp. 179–84 (pls pp. 185–201)

Alexis 1887, P. Alexis, 'Impressionnistes de la Collection Murer', *Le Cri du peuple*, 21 October 1887

Amis de Sisley 1989, Amis de Sisley, *Sisley à Moret-sur-Loing – Veneux – St Mammès, itinéraire de ses toiles*, Moret-sur-Loing 1989

Angell, Martha Bartlett Angell Donor File, Curatorial Department, Museum of Fine Arts, Boston

Angrand 1971, P. Angrand, 'Sur deux lettres inédits de Sisley', *Chronique des arts* (supplément), *Gazette des Beaux-Arts* 78, July-September 1971, pp. 33–34

Anon 1888, 'Echos Artistiques – Tableaux de Sisley à Georges Petit', *L'Art français* 87, 22 December 1888

Anon 1897, 'Instantané – Alfred Sisley', (unsigned review) *Figaro*, 7 February 1897

Anon 1947, 'The Modern House of Mr and Mrs William Goetz in Hollywood', *Vogue*, 15 April 1949, p. 95

Anon 1973, 'La Chronique des Arts, Principales acquisitions des musées en 1972', *Gazette des Beaux-Arts* 137, February 1973, p. 40

Anon 1981, 'La Chronique des Arts, Principales acquisitions des musées en 1980', *Gazette des Beaux-Arts* 304, March 1981, p. 56

Archives, Archives de Toul, Archives municipales de Moret-sur-Loing, Archives de Veneux-les-Sablons, Archives de la paroisse de Notre-Dame de Moret, Archives départementales de Seine et Marne, have also been consulted

Archives of American Art, *Joseph R. Woodwell Papers*, correspondence between Sisley, Daniel Ridgeway Knight (1839–1924) and Joseph R. Woodwell (1843–1911), Gift of Carnegie Institute, Pittsburgh, Penn., 1966 *Macknight Papers*
William H. Holston Papers, lent to the Archives of American Art by Mrs William H. Holsten

Archives Durand-Ruel, *Archives Durand-Ruel*, Paris, numerous letters from Sisley to Paul Durand-Ruel; 1 letter from Sisley to Dr de Bellio; 1 letter from Sisley to Georges Petit; 5 letters from Sisley to Georges Viau; letters from Durand-Ruel to Renoir and Monet; 2 letters from Cocardon (Sisley's dealer) to Durand-Ruel; Gallery Stock-book of sales and suppliers

Archives Getty Center, *Archives of the Getty Center for the History of Art and the Humanities*, Los Angeles, 1 letter from Sisley to an unknown addressee, 1889, no.870349; 1 letter from Sisley to an unknown addressee, 1896, no.870349; 1 letter from Sisley to Geffroy, 1897, no.870349; 1 letter from Sisley to E. Halpérine-Kaminsky, 1898, no.870349

Archives des Musées nationaux, *Archives des Musées nationaux, Musée du Louvre*, Paris Petition, 30 March 1867, *Salon de 1867* (série X), ms; *Autographs du legs A.S. Henraux*, MS310 (3), 1 letter from Sisley to Durand-Ruel, 1884, 1 letter from Sisley to Georges Petit, May 1887, 1 letter from Sisley to an unknown addressee, p. 954; 1 letter from Sisley to Petit 1890?,1 letter from Sisley to Petit, 1896, 1 letter from Renoir to Roujon, March 1894; 1 letter to an unknown addressee, 1897, p. 964; *Legs Caillebotte, P8, ms.*, 9 letters by Renoir – dossier classified chronologically; *Département des Arts Graphiques*,

Fonds Orsay, Album Briant; 1 letter from Sisley to an unknown addressee, 1883

Archives Nationales, *Archives Nationales*, Paris, Doc. F21 535, 1 letter from Sisley to Garde des Sceaux, 1898; National Police Report (on Sisley's naturalisation), Doc. BB11/3560, no.867X981; 1 letter from the Préfecture, Seine-et-Marne, to the Minister of Justice, Paris, 1899, Doc. BB11/3560, no.867X98; 1 letter from Sisley to Castagnary 1888; notes of instruction from the Directeur des Beaux-Arts and the Minister for Public Instruction, 1888 re. purchase and conservation of works by Sisley, Doc.F21 2112

Archives de Paris, *Archives de Paris* Doc. D1 P4 L/1 1862 (Cadastral records); Record of the Sale of the *Collection Ernest Hoschedé* (1874–5), Docs. D48 E3 art. 64, D48 E3 art.65 & D48 E3 art.3

Archives Ribault-Ménétière, *Archives Jean Ribault-Ménétière*, Paris
1 letter from Sisley to Gustave Geffroy; 1 letter from Sisley to Georges Petit; 1 letter from Sisley to Alfred Roll

Art Amateur 1883, 1886, 1887 & 1899, 'Art at the Boston Exhibitions', *Art Amateur*, October 1883, p. 90, 'The Impressionist Exhibition', *Art Amateur* 14, 1886, p. 121 and 15, 1886, p. 4, *Art Amateur* 17, 1887, p. 32 (review of Sisleys in exhibition 'Celebrated Paintings by the Great French Masters', organised by Durand-Ruel at the National Academy of Design, New York 1887, 25 May–30 June), *Art Amateur* 40, April 1899, p. 95 (review of 'Exposition, Works of Alfred Sisley' at Durand-Ruel Galleries, New York 1899)

Atalone 1909, Atalone, *La Galerie Vasnier à Reims*, Paris 1909

Baedeker 1899, K. Baedeker, *Northern France from Belgium and the English Channel to the Loire excluding Paris and its Environs*, English ed. London 1899

Bailly-Herzberg 1980, J. Bailly-Herzberg ed., *Correspondance de Camille Pissarro*, I (1865–1885), Paris 1980

Bailly-Herzberg 1986, J. Bailly-Herzberg, ed., *Correspondance de Camille Pissarro*, II (1866–1890), Paris 1986

Bailly-Herzberg 1988, J. Bailly-Herzberg, ed., *Correspondance de Camille Pissarro*, III (1891–1894), Paris 1988

Bailly-Herzberg 1989, J. Bailly-Herzberg, ed., *Correspondance de Camille Pissarro*, IV (1895–1898), Paris 1989

Bailly-Herzberg 1991, J. Bailly-Herzberg, ed., *Correspondance de Camille Pissarro*, V (1899–1903), Paris 1991

Baltimore n.d., *Catalogue of Paintings, Walters Art Gallery, Baltimore*

Baltimore 1936, *Handbook of the Collection, Walters Art Gallery*, Baltimore 1936

Barr 1966, A.M. Barr, *Matisse. His Art and his Public*, New York 1966

Bates 1952, H.E. Bates, 'French Painters V, Pissarro and Sisley', *Apollo* LX, June 1952, pp. 176–80

Bazin 1947, G. Bazin, *L'Époque impressionniste*, Paris 1947

Bazin 1958, G. Bazin, *Trésors de l'Impressionnisme au Louvre*, Paris 1958

Belgrade 1939, *Catalogue du Musée de Prince-Paul*, Belgrade 1939

Bell 1940, G. Bell, 'Invaded Landscapes', *The Studio* 120, 1940, p. 38

Bellony-Rewald 1977, A. Bellony-Rewald, *Le Monde retrouvé des impressionnistes*, Paris 1977

Bénédite 1923, L. Bénédite, *Le Musée du Luxembourg, Peintures, Ecole Française*, Paris 1923

Benoist 1953, L. Benoist, *Catalogue et Guide du Musée de Nantes*, Nantes 1953

Bernard 1986, B. Bernard, *The Impressionist Revolution*, London 1986

Berne 1960, *Aus der Sammlung Kunstmuseum Bern*, Berne 1960

Berne 1983, *Gemälde des 19. Jahrhunderts, Kunstmuseum, Bern*, Berne 1983

Bernheim de Villiers, 1949, G. Bernheim de Villiers, *Little Tales of Great Artists*, Paris and New York 1949 (first published as *Petites Histoires des grands artistes*, Paris 1940).

Berthelot 1930, P. Berthelot, 'Exposition Sisley', *Beaux-Arts* VIII, 1930, p. 12

Besson 1934, G. Besson, *La Peinture française au XIXe siècle*, Paris 1934

Besson 1954, G. Besson, *Sisley*, 'Collection des Maîtres', Paris 1954

Beylie 1909, Général de Beylie, *Le Musée de Grenoble*, Paris 1909

Blanche 1920, J.-E. Blanche, *Quatre-vingt ans de peinture libre*, Paris 1920

Block 1984, J. Block, *Les XX and Belgian Avant-Gardism 1868–1894*, Ann Arbor 1984

Bibb 1899, B. Bibb, 'The Work of Alfred Sisley', *The Studio* 18, 1899, pp. 149–56

Bibesco 1947, Princesse M. L. Bibesco, *Le voyageur voilé. M. Proust*, Paris 1947

Billy 1947, A. Billy, *Les Beaux jours de Barbizon*, Paris 1947

Birmingham 1960, *Catalogue of Paintings*, Birmingham City Museum and Art Gallery, Birmingham 1960

Blanchet and Pericard 1988, L. Blanchet and M. Pericard, *Les Peintres et les Yvelines*, Paris 1988.

Bodelsen 1968, M. Bodelsen, 'Early Impressionist Sales 1874–94 in the Light of some Unpublished 'procès-verbaux' ', *The Burlington Magazine* CX, 1968, pp. 331–49

Bodelsen 1970, M. Bodelsen, 'Gauguin the Collector', *The Burlington Magazine* CXII, 1970, pp. 590–615

Bodin 1986, *Vente Bodin*, 1986, 1 letter from Sisley to an unknown addressee, 1891, no.29 (letter 301)

Boime 1971, A. Boime, *The Academy and French Painting in the Nineteenth Century*, New Haven and London 1971

Boime 1974–75, A. Boime, 'The Instruction of Charles Gleyre and the Evolution of Painting in the Nineteenth Century' in exhib. cat., *Charles Gleyre ou les illusions perdues*, Winterthur 1974–75, pp. 102–24

Bomford et al. 1991, D. Bomford, J. Kirby, J. Leighton, and A. Roy, exhib. cat., *Art in the Making*, New Haven and London 1991

Borgmeyer 1915, Ch. L. Borgmeyer, 'A Few Hours with Duret', *Fine Arts Journal* XXXII, no.11, November 1915

Boston 1920, Boston, *Museum of Fine Arts Bulletin* 18, February 1920, no.105

Boston 1955, *Summary Catalogue of European Paintings*, Boston 1955

Bourgeois 1928, S. Bourgeois, *The Adolphe Lewisohn Collection of Modern French Paintings and Sculptures*, New York 1928

Bowness and Callen 1977, A. Bowness and A. Callen, exhib. cat., *The Impressionists in London*, London and Paris 1977–78

Breeskin et al. 1955, A.D. Breeskin, G. Boas, and G. Rosenthal, *Handbook of the Cone Collection*, The Baltimore Museum of Art 1955

Bretonnet 1983, D. Bretonnet, *Moret, flâneries dans les siècles*, Etrepilly 1983

Bretonnet and Rufin 1984, D. Bretonnet and J. Rufin, *Guide illustré, Moret-sur-Loing*, Fontainebleau 1984

Brettell 1984, R. Brettell, 'The Cradle of Impressionism' in exhib. cat., *A Day in the Country. Impressionism and the French Landscape*, Los Angeles, Chicago, Paris 1984–85, pp. 85–87

Brettell 1985, R. Brettell, 'Le paysage impressionniste et l'image de la France', in exhib. cat., *L'Impressionnisme et le paysage français*, Paris, 1985, pp. 22–41

Brettell 1987, R. Brettell, *The Art Institute of Chicago – French Impressionists*, New York 1987

Bricon 1900, E. Bricon, *Psychologie d'art, les maîtres de la fin du XIXe siècle*, Paris 1900

Brown 1988, Milton W. Brown, *The Story of the Armory Show*, New York 1988

Buenos Aires 1934, *Boletin del Museo Nacional de Bellas Artes*, Buenos Aires 1934

Bührle 1958, *Katalog der Sammlung Emil G.Bührle*, Zurich 1958

Bültner 1966, H. Bültner, *Farbige Gemälde – Wiedergaben, Alfred Sisley*, Leipzig 1966

Burlington Magazine, CXXII, 1980, pp. 870, 872.

Busch and Keller 1954, G. Busch and H. Keller, *Handbuch der Kunsthalle Bremen*, Bremen 1954

Callen 1971, A. Callen, 'Jean-Baptiste Faure, 1830–1914', unpubl. MA Dissertation, University of Leicester, 1971

Callen 1974, A. Callen, 'Faure and Manet', *Gazette des Beaux-Arts* 83 (March 1974), pp. 157–78

Callen 1982, A. Callen, *Techniques of the Impressionists*, London 1982

Canaday 1959, J. Canaday, *Mainstreams of Modern Art*, New York 1959

Cartier 1957, J.-A. Cartier, 'Sisley, le plus timide et le plus harmonieux des impressionnistes', *Le Jardin des Arts* 33 (July 1957), pp. 533–38

Cassou 1953, J. Cassou, *Die Impressionisten und ihre Zeit*, Lucerne 1953

Cézanne 1976, *Paul Cézanne. Letters*, ed. J. Rewald (4th edition), Oxford 1976

Champa 1973, K.S. Champa, *Studies in Early Impressionism*, New Haven and London 1973

Champa 1991, K. Champa, exhib. cat., *The Rise of Landscape Painting in France: Corot to Monet*, New Hampshire 1991

Charavay 1975, *Vente Charavay*, September 1975, *Catalogue*, 1 letter from Sisley to Murer 1880, no.36698–1

Charmet 1957, R. Charmet, 'Alfred Sisley', *Arts* 621 (1957), p. 14

Chesneau 1875, Ernest Chesneau, 'Beaux-Arts', *Paris-Journal*, 24 March 1875, p. 3 (review of Impressionist Sale of 1875 at the Hotel Drouot)

Cleveland 1978, *Handbook of the Cleveland Museum of Art*, Cleveland 1978

Cogniat 1978, Raymond Cogniat, *Sisley*, Naefels 1978

The Collector 1892, 1893, *The Collector* 4, 3 December 1892, p. 39 (on Durand-Ruel's new collection of Old Masters, Barbizon artists and Impressionists, including Sisley), *The Collector* 4, 7 February 1893, p. 102 (on Sisley at a display of modern Dutch art and Impressionism at Boussod, Valadon & Co. New York 1893

Cologne 1965, *Wallraf-Richartz Museum, Köln, Verzeichnis des Gemälde*, Cologne 1965

Compin and Roquebert 1986, I. Compin and A. Roquebert, *Catalogue sommaire illustré des peintures du Musée du Louvre et du Musée d'Orsay, Ecole française*, Paris 1986

Constable 1968, *John Constable's Correspondence: VI: The Fishers*, ed. R. B. Beckett, Ipswich 1968

Cooper 1954, D. Cooper, *The Courtauld Collection*, London 1954

Cooper 1959, D. Cooper, 'Renoir, Lise and the Le Coeur Familly: A Study of Renoir's Early Development, I: Lise; II: The Le Coeurs', *The Burlington Magazine* CI, 1959, pp. 163–71 and 322–28

Coquiot 1899, G. Coquiot, 'Alfred Sisley', *La Vogue* I, 1899, pp. 137–38

Coquiot 1924, Gustave Coquiot, *Des Peintres maudits*, Paris 1924

Dale 1953, *French Paintings from the Chester Dale Collection*, Washington 1953

Daulte 1952, F. Daulte, *Frédéric Bazille et son temps*, Geneva 1952

Daulte 1953, F. Daulte, *La Collection Rosensaft, de Monet à Chagall*, Vevey 1958

Daulte 1954, F. Daulte, 'Oscar Reinhart lègue ses collections à la Suisse', *Connaissance des Arts* 26, 15 April 1954, pp. 22–27
F. Daulte, *Le Dessin français de Manet à Cézanne*, Lausanne 1954

Daulte 1957, F. Daulte, 'Découverte de Sisley', *Connaissance des Arts* 60 (February 1957), pp. 46–53

Daulte 1959, F. Daulte, *Alfred Sisley, Catalogue raisonné de l'Oeuvre peint*, Lausanne 1959

Daulte 1961, F. Daulte, *Les Paysages de Sisley*, Lausanne 1961

Daulte 1972, F. Daulte, *Alfred Sisley*, Milan 1972 (French edition, Paris 1974)

Daulte 1984, F. Daulte, exhib. cat., *L'Impressionnisme dans les Collections Romandes*, Lausanne 1984

Davies 1946, M. Davies, *National Gallery Catalogue of the French School*, London 1946

DeKay 1897, C. DeKay, 'A Castle at Paterson, N.J.', *New York Times Illustrated Magazine*, 19 December 1897, pp. 3–5

Delaborde de Montcorin 1930, E. Delaborde de Montcorin, *Alfred Sisley, 1839–1899*, Moret-sur-Loing 1930

Delteil 1923, L. Delteil, *Camille Pissarro, Alfred Sisley, Auguste Renoir – Le peintre-graveur illustré*, vol. XVII, Paris 1923

Denvir 1987, B. Denvir (ed.), *The Impressionists at First Hand*, London 1987, repub. 1988 and 1991

Deslys 1866, C. Deslys, *Le Canal Saint-Martin*, Paris 1866, first publ. as a serial in *Le Conteur* (Journal Illustré, ancien Journal de la guerre), Paris, from 15 January 1862, no.276 – 24

May 1862, no.313

Detroit 1921, *Bulletin, Institute of Arts*, Detroit, May 1921

Detroit 1966, *The Detroit Institute of Arts, Album, French Art*, Detroit 1966

Dewhurst 1904, W. Dewhurst, *Impressionist Painting. Its Genesis and Development*, London 1904

Dieterich et al. 1977, B. Dieterich, P. Krieger and E. Krimmel-Decker, *Nationalgalerie Berlin – Bestandskatalog 19. Jahrhundert*, Berlin 1977

Dissard 1912, P. Dissard, *Catalogue du Musée de Lyon*, Paris 1912

Distel 1989, Anne Distel, *Les Collectionneurs des Impressionnistes: amateurs et marchands*, Paris 1989

Dorival 1958, B. Dorival 'Un Musée japonais d'art français', *Connaissance des Arts* 81, November 1958, pp. 58–63

Dormoy 1930, M. Dormoy, 'La Collection Schmitz', *L'Amour de l'Art*, 1930

Downes 1892, William Howe Downes, 'Impressionism in Painting', *New England Magazine* 12, 1892, pp. 600–3

Du Colombier 1947, P. Du Colombier, *Sisley au Musée du Louvre*, Paris-Brussels 1947

Dublin 1981, *National Gallery of Ireland. Illustrated Summary Catalogue of Paintings*, Dublin 1981

Durand-Ruel 1947, *A Selection of Paintings from the Durand-Ruel Galleries*, 1, New York 1947

Durand-Ruel 1948, *A Selection of Paintings from the Durand-Ruel Galleries*, 2, New York 1948, *A Selection of Paintings form the Durand-Ruel Galleries*, 3, New York 1948, *A Selection of Paintings from the Durand-Ruel Galleries*, 4, New York 1948

Durand-Ruel Godfroy 1986, C. Durand-Ruel Godfroy, 'Quelques lettres inédites de Sisley à Paul Durand-Ruel', *Archives de l'Art Français* XXVIII, 1986, pp. 307–9

Duret 1878, Th. Duret, *Les Peintres impressionnistes*, Paris 1878

Duret 1899, Th. Duret, 'Quelques lettres de Monet et Sisley', *La Revue Blanche* XVIII, 1899, pp. 434–37 (12 letters from Sisley to Duret)

Duret 1906 & 1936, Th. Duret, *Histoire des peintres impressionnistes*, Paris 1906, repr. 1936

Duret 1910, Th. Duret, *Manet and the French Impressionists*, London and Philadelphia 1910

Duret 1910, Th. Duret, *Manet and the French Impressionists, Pissarro, Claude Monet, Sisley, Renoir, Berthe Morizot [sic], Cézanne, Guillaumin*, trans. J.E Crawford Flitch, London (G. Richards) 1910

Elias 1914, J. Elias, 'Die Sammlung Moreau-Nélaton', *Kunst und Künstler*, 1914

Eon 1897, H. Eon, 'Orientalistes – Eugène Clary – Dezaunay – Sisley', *La Plume*, 1 March 1897, p. 159

Erens 1979, P. Erens, *Masterpieces, Famous Chicagoans and their Paintings*, Chicago 1979

Erwin Davis, (c.1830–1902), *The Erwin Davis Papers*, The New York Historical Association

Faure 1902, *Notice sur la Collection J.-B. Faure, suivie du Catalogue des tableaux formant cette collection*, Paris 1902

Fechter 1910, P. Fechter, 'Die Sammlung Oskar Schmitz', *Kunst und Künstler*, VIII (1910)

Fénéon 1888, Felix Fénéon, 'Quelques Impressionnistes (Exposition des tableaux de Mme Berthe Morisot, de MM Camille Pissarro, Renoir, Sisley, J.-L. Brown, Caillebotte, de M. Whistler, et de MM. Boudin et Lépine', *La Cravache*, 2 June 1888, Fénéon, 'Tableaux de Sisley', *La Cravache*, 15 December 1888, in J. Halperin, *Felix Fénéon, Oeuvres plus que complètes* (2 vols), I, Geneva 1970, p. 133

Fiquet 1926, 'La Galerie Fiquet', *La Renaissance* 9, September 1926, p. 526

Flint 1984, K. Flint, *The Impressionists in England*, London 1984

Fleming 1979, M. Fleming, *The Anarchist Way to Socialism. Elisée Reclus and Nineteenth-Century European Anarchism*, London 1979

Florisoone 1938, Michel Florisoone, 'Renoir et la famille Charpentier, lettres inédits', *L'Amour de l'Art* XIX (February 1938), pp. 31–40

Focillon 1928, H. Focillon, *La Peinture aux XIXe et XXe siècles – Du Réalisme à nos jours*, Paris 1928

Fonds Jacques Doucet, *Fondation Jacques Doucet*, Paris, Bibliothèque d'Art et d'Archéologie, 1 letter from Sisley to Murer, 1877; 2 letters to Murer, 1879, nos. 11851 & 11855; 1 letter from Sisley to Charpentier, 1897, no.11853; 1 letter from Sisley to Tavernier

Fosca 1959, F. Fosca, 'Alfred Sisley, 1839–1899', *La Tribune de Gènève* 69, 26 March 1959

Fougerat n.d., E. Fougerat, 'Sisley', *Médécines et Peintures* 69, n.d.

Francastel 1937, P. Francastel, *L'Impressionnisme*, Paris 1937

Francastel 1943, P. Francastel, *Monet, Sisley, Pissarro*, 'Les Trésors de la peinture française', Geneva 1943

Francastel 1946, P. Francastel, *Nouveau dessin, nouvelle peinture*, Paris 1946

Francastel 1955, P. Francastel, *Histoire de la peinture française*, 2 vols., Paris 1955

Frankfurter & Brockway n.d., A. Frankfurter and W. Brockway, *The Albert D. Lasker Collection, Renoir to Matisse*, New York n.d.

Fry 1927, R. Fry, 'Sisley at the Independent Gallery', *Nation and Athenaeum*, 3 December 1927, p. 352

Gachet 1956, P. Gachet, *Deux amis des impressionnistes. Le Docteur Gachet et Murer*, Paris 1956

Gachet 1957, P. Gachet, *Lettres impressionnistes au Dr Gachet et à Murer*, Paris 1957 (1 letter from Sisley to Eugène Murer)

Gauguin 1962, Paul Gauguin, *Carnet de croquis*, ed. R. Cogniat and J. Rewald, Paris 1962

Gauthier 1933, M. Gauthier, 'Hommage à Sisley', *L'Art vivant* 170, March 1933, pp. 116–117

Geffroy 1883, Gustave Geffroy, 'Exposition Alfred Sisley', *La Justice*, 23 June 1883

Geffroy 1894, G. Geffroy, *La Vie moderne*, III, ('Histoire de l'Impressionnisme') Paris 1894, (on Sisley, see pp. 282–5)

Geffroy 1923, G. Geffroy, *Sisley*, 'Les Cahiers d'Aujourd'hui', Paris 1923

Geffroy 1927, G. Geffroy, *Sisley*, 'Les Cahiers d'Aujourd'hui', Paris 1927

Geneva 1954, *Guides illustrés, 2. Peinture et Sculpture*, Musée d'Art et d'Histoire, Geneva 1954

George n.d., W. George, 'Oskar Reinhart Collection', *Formes*, Paris n.d

Gerkens & Heiderich 1973, G. Gerkens and U. Heiderich, *Katalog der Gemälde de 19. und 20. Jahrhunderts in der Kunsthalle Bremen*, Bremen 1973

Gerstein 1989, Marc S. Gerstein, exhib. cat., *Impressionism – Selections from Five American Museums*, intro. by R. Brettell, St. Louis Art Museum 1989

Glasgow 1953, *French Paintings, Glasgow Art Gallery*, Glasgow 1953

Gilardoni 1954, V. Gilardoni, *L'Impressionismo*, Milan 1954

Goetz 1967, *Selected Paintings from the Collection of Mr & Mrs William Goetz*, Los Angeles 1967

Goldwater and Treves 1947, R. Goldwater and M. Treves (eds), *Artists on Art*, New York and London 1947

Goodison and Sutton 1960, J. Goodison and D. Sutton, *Fitzwilliam Museum Cambridge. Catalogue of Paintings*, I, Cambridge 1960

Gordon Roe, F. Gordon Roe, 'France's Debt to British Art, Part II', *The Connoisseur*, January 1942

Grabar 1943, H. Grabar, *Camille Pissarro, Alfred Sisley, Claude Monet nach eigenen und fremden Zeugnissen*, Basel 1943

Grad & Riggs 1982, B.L. Grad and T.A. Riggs, *Visions of City and Country. Prints and Photographs of Nineteenth-Century France*, Worcester Art Museum 1982

Grenoble 1911, *Catalogue des tableaux, statues, bas-reliefs et objets d'art exposés dans les galeries du Musée de peinture et de sculpture*, Grenoble 1911

'Greta' 1891, 'Greta', 'Art in Boston', *Art Amateur* 24, 6 May 1891, p. 141

Gronkowski 1927, C. Gronkowski, *Catalogue sommaire des collections municipales, Palais des Beaux-Arts de la Ville de Paris*, Paris 1927

Guenne 1937, J. Guenne, 'Sisley, poète des lointains', *L'Art vivant* 209, February-March 1937, p. 40.

Grubert 1983, H. Grubert, 'Cecil Higgins and his Collection', *Apollo* October 1983, p. 304

Hamilton 1886, L. Hamilton, 'The Work of the Paris Impressionists in New York', *The Cosmopolitan*, June 1886, p. 240

Hancke 1910, E. Hancke, 'Die Sammlung Stern', *Kunst und Künstler*, August 1910

Hannema 1949, D. Hannema, *Meesterwerken uit de Verzameling D. G. Van Beuningen*, Rotterdam 1949

Harambourg 1985, L. Harambourg, *Dictionnaire des Peintres Paysagistes Français au XIXe Siècle*, Neuchâtel 1985

Hare 1887, A. Hare, *Days Near Paris*, London 1887

Hautcoeur 1948, L. Hautecoeur, *Catalogue de la Galerie des Beaux-Arts*, Geneva 1948

Heilmaier 1931, H. Heilmaier, 'Alfred Sisley', *Die Kunst für Alle*, 63, 1931, pp. 137–44

Herbert 1982, R.L. Herbert, 'Industry in the changing landscape from Daubigny to Monet', in *French Cities in the Nineteenth Century*, ed. J. Merriman, London 1982, pp. 139–64

Herbert 1988, R.L. Herbert, *Impressionism, Art Leisure and Parisian Society*, New Haven and London 1988

Hoetink 1968, H. R. Hoetink, *Franse tekeningen uit de 19e eeuw*, Rotterdam 1968

Hoff 1973, J. Hoff, *The National Gallery of Victoria – Melbourne*, London 1973

Holzinger and Ziemke 1972, E. Holzinger and H.J. Ziemke, *Städelsches Kunstinstitut. Die Gemälden des 19. Jahrhunderts*, Frankfurt 1972

Hôtel Drouot, 1974, 1975a, 1975b, 1980a, 1980b, 1990, 1991a & 1991b
Vente Hôtel Drouot, Paris, 10 June 1974, *catalogue*, 1 letter from Sisley to Georges Petit, 1896, no.133; 1 letter from Sisley to Petit, 1897, no.134
Vente Hôtel Drouot(a), 21 November 1975, *Catalogue*, letters from Mme Ollivon to Pissarro, 1871, nos 137–5; 1 letter from de Béliard to Pissarro, 1871, no.6; 1 letter from Guillemet to Pissarro, 1872, no. 79; 1 letter from Sisley to Pissarro, 1872, no. 182; 1 letter from Gachet 1874, no.26; 1 letter from Sisley to Pissarro, 1876, no.184; 1 letter from

Gauguin to Pissarro, 1897, no.30; 1 letter from de Bellio to Pissarro, 1882, no.23; 1 letter from Signac to Pissarro, 1887, no.175; 1 letter from Adolf Gutbler to Pissarro, 1899, no.85
Vente Hôtel Drouot (b), 19 December 1975, *Catalogue*, 1 letter from Sisley to Roll, 1891, no.134
Vente Hôtel Drouot (a), 30 January 1980, *Catalogue*, 1 letter from Sisley to Vollard, 1897, no. 69
Vente Hôtel Drouot (b), 23–24 October 1980, *Catalogue*, 1 letter from Sisley, 1891, no.133
Vente Hôtel Drouot, 30 May 1990, *Catalogue*, 1 letter from Sisley to Mourey, 1893, no.177
Vente Hôtel Drouot, 5 June 1991, *Catalogue*, 1 letter from Sisley to Duret, Sèvres, n.d.
Vente Hôtel Drouot, 13 November 1991, *Catalogue*, 1 letter from Sisley to an unknown addressee, 1892, no.84; 1 letter Sisley to an unknown addressee, 1897, no.84; 1 letter from Sisley to H. Durand-Tallier(?), no.86

Hubbard 1962, R.H. Hubbard, *European Paintings in Canadian Collections, Modern Schools*, Toronto 1962

Huth 1946, H. Huth, 'Impressionists Come to America', *Gazette des Beaux-Arts* 29 April 1946, pp. 225–52

Huyghe 1931, R. Huyghe, 'La Grande piété d'un maître impressionniste. Lettres inédites de Sisley', *Formes* 19, November 1931, pp. 151–54 & illus. pp. 156–59; 8 letters from Sisley to Georges Charpentier, 1879, 1891, 1895, 1897, & 1898; 3 letters from Sisley to Ch. Tavernier 1893, 1895 & 1898; 1 letter from Sisley to O. Mirbeau, 1892

Huyghe 1974, R. Huyghe, 'L'impressionnisme et la pensée de son temps', in exhib. cat., *Centenaire de l'Impressionnisme*, Paris, Grand Palais 1974, pp. 11–27

Huysmans 1881, J.-K. Huysmans, 'L'Exposition des Indépendants en 1881',(see 'Appendice' for review of Sisley) *L'Art moderne*, Paris 1883

Huysmans 1887, J.-K. Huysmans, 'L'Exposition internationale de la rue de Sèze', *La Revue indépendante*, June 1887, p. 353

Impressionist Exhibitions 1874, 1876, 1877, 1882, for individual reviews see Isabelle Cahn, *Critical Summary*, pp. 282–83 in exhib. cat, *Alfred Sisley* Royal Academy of Arts, London 1992

Impressionist Group 1981, *Impressionist Group Exhibitions 1874–1886*, Garland repr. 1981

Les Impressionnistes 1950, *Les Impressionnistes, Renoir, Manet, Monet, Pissarro, Sisley, Degas*, Paris 1950

Ingamells 1967, J. Ingamells, *The Davies Collection of French Art*, Cardiff 1967

Institut Néerlandais, *Institut Néerlandais*, Paris, Fondation Custodia, 1 letter from Sisley to

G. de Bellio, 1890, no.7345; 2 letters from Sisley to Tavernier, 1892, nos 1973–A.1 & 1973.- A.3; 1 letter from Sisley to Tavernier, 1893, no.1973–A.4; 1 letter from Sisley to Tavernier, June 1895; 1 letter from Sisley to an unknown addressee, 1895 no.1984–A.165; 3 letters to Tavernier, 1896, nos 1973–A.6, A.7 & A.12; 3 letters to Tavernier, 1897, nos 1973–A.11, A.13 & A.14; 1 letter from Sisley to Charpentier, 1897, no,11853; 1 letter from Sisley to Tavernier, 1898, no.1973–A.6; 1 letter from Sisley to Viau, 1898, no.6738a

Isaacson 1979–80, J. Isaacson, exhib. cat., *The Crisis of Impressionism 1878–1882*, University of Michigan Museum of Art, 1979–80

Isaacson 1986, J. Isaacson, 'The Painters called Impressionists' in exhib. cat., *The New Painting. Impressionism 1874–1886*, Washington, San Francisco 1986

Ishibashi and Dorival 1965, S. Ishibashi and B. Dorival, *Catalogue de la Bridgestone Gallery, Tokyo*, Tokyo 1965

Jamot 1914, P. Jamot, 'La Collection Camondo au Musée du Louvre', *Gazette des Beaux-Arts*, July 1914, p. 58

Jedlicka 1949, G. Jedlicka, *Sisley*, Bern 1949, (Italian edition, Milan 1950, French edition, Lausanne 1950)

Jeudwine 1956, Jeudwine, 'Modern Paintings from the Collecton of W. Somerset-Maugham', *Apollo* LXIV (October 1956), pp. 101–6

Jewell 1944, E.A. Jewell, *French Impressionists and their Contemporaries, represented in American Collections*, New York 1944

Johannesburg 1930, *Catalogue of the Johannesburg Municipal Art Gallery*, Johannesburg 1930

Johnston 1982, W.R. Johnston, *The Nineteenth-Century Paintings in the Walters Art Gallery*, Baltimore 1982

Kahn 1888, G. Kahn, 'Chronique de la littérature et de l'art, "Exposition des Impressionnistes – Durand-Ruel"', *La Revue indépendante* 7 (June 1887), pp. 544–46

Kapos 1991, M. Kapos, *The Impressionists – A Retrospective*, New York 1991

Kardinov 1979, N. Kardinov, *Alfred Sisley*, Dresden 1979

Klint 1931, R. Klint, 'The Private Collection of Josef Stransky', *The Art News*, 16 May 1931

Krafft and Schümann 1969, E. M. Krafft and C.W. Schümann, *Katalog der Meister des 19. Jarhunderts in der Hamburger Kunsthalle*, Hamburg 1969

Kysela 1964, J. D. Kysela, S.J., 'Sara Hallowell Brings Modern Art to Midwest', *Art Quarterly* 27 (1964), pp. 150–67

La Faille 1949, J.-B. de La Faille, 'Alfred Sisley's Lente', *Phoenix* III (1949), pp. 42–43

La Fosse 1958, D. de La Fosse, 'Sisley à Berne', *Journal de Genève*, February 1958, p. 1

Laclotte et al. 1984, M. Laclotte et al., *Chefs-d'oeuvre impressionnistes du Musée du Jeu de Paume*, Paris 1984

Laclotte et al. 1986, M. Laclotte et al., *Musée d'Orsay, Chefs-d'oeuvre impressionnistes et post-impressionnistes*, Paris 1986

Laffon 1982, J. Laffon, *Musée du Petit Palais, Catalogue sommaire illustré des peintures*, Paris 1982

Laforgue 1903, J. Laforgue, 'L'Impressionnisme', in *Mélanges posthumes*, Paris 1903, pp. 133–45 (intended as review of Impressionist exhibition organised by Durand-Ruel at the Gurlitt Gallery, Berlin, September 1883) repr. in M. Dottin, *Laforgue, textes de critique d'art*, Lille 1988, pp. 167–75

Laforgue 1986, J. Laforgue, 'Correspondance', (Letters LX, LXVIII & LXXX) in *Oeuvres complètes* I, ed. and annotated by J.-L. Debauve, D. Gronjowski, Pascal Pia and P.-O. Walzer, Paris (L'Age d'Homme) 1986, pp. 7–8, pp. 29–30, pp. 59–60

Landers 1953, M.L. Landers, 'Sisley's House at Argenteuil', *The Bulletin of the Art Association of Indianapolis*, Indiana 1953, pp. 19–21

Lanes 1966, J. Lanes, 'Current and Forthcoming Events', *The Burlington Magazine* CVIII, 1966, pp. 645–9 (review of the Alfred Sisley exhibition held at Wildenstein & Co, New York, 1966)

Lanöe & Brice 1907, G. Lanöe and T. Brice, *Histoire de l'école française du paysage*, Paris 1907

Lapauze 1924, H. Lapauze, 'La Collection Orodsi', *La Renaissance*, Paris 1924

Lassaigne and Gache-Patin 1983, J. Lassaigne and S. Gache-Patin, *Sisley*, Paris 1983

Laver 1937, J. Laver, *French Painting and the Nineteenth Century*, London 1937

Lawson 1979, 'Ernest Lawson 1873–1939', exhib. cat., University of Arizona, in *Phoenix*, 1979, p. 4

Laÿ 1989, J. and M. Laÿ, *Bulletin d'Accueil de Louveciennes*, Louveciennes 1989.

Laÿ 1989, J. and M. Laÿ, *Louveciennes – mon village*, Louveciennes 1989

Leclercq 1899, J. Leclercq, 'Alfred Sisley', *Gazette des Beaux-Arts* I, 1899, pp. 227–36

Lecomte 1891, G. Lecomte, 'Sisley', *L'Art dans les deux mondes*, (Durand- Ruel) 21 February 1891

Lecomte, 1892, G. Lecomte, *L'Art impressionniste d'après la Collection privée de M. Durand-Ruel*, Paris 1892
G. Lecomte, 'L'Art contemporain', *La Revue indépendante* 23, April-June 1892, pp. 1–29

Leeds 1974, *Leeds City Art Gallery, Concise Catalogue*, Leeds 1974

Lejeune 1879, L. Lejeune, 'The Impressionist School of Painting', *Lippincott's Magazine* 24, part 2, 1879, pp. 720–27

Lesage 1987, G. Lesage, 'L'Église de Moret, Les travaux de 1842 à 1908', *La Revue de Moret et de sa région* 2, 1987, pp. 41–43

Lesage 1989, G. Lesage, 'Sisley à Moret, 1889–1989', *La Revue de Moret et de sa région* 1, 1989, special issue

Lespinasse, 1983, F. Lespinasse, *Alfred Lebourg (1849–1928)*, Arras 1983

Lethève 1959, J. Lethève, *Impressionnistes et symbolistes devant la presse*, Paris 1959

Leymarie 1956, J. Leymarie, *L'Impressionnisme*, 2 vols., Geneva 1956

Leymarie and Melot 1971, J. Leymarie and M. Melot, *Les Gravures des Impressionnistes - Oeuvre complet*, Paris 1971 (includes a catalogue of Sisley's graphic works)

Lloyd, 1981, C. Lloyd, *Pissarro*, Geneva 1981.

Lloyd 1985, C. Lloyd, *Sisley*, exhib. cat., Japan 1985

Lloyd, 1986, C. Lloyd, 'Camille Pissarro and Rouen', in *Studies on Camille Pissarro*, ed. C. Lloyd, London 1986, pp. 75–93

Lloyd and Thomson 1986, C. Lloyd and R. Thomson, *Impressionist Drawings from British Public and Private Collections*, Oxford 1986

London 1987, *The Courtauld Collection – Impressionist and Post-Impressionist Masters*, New Haven and London 1987

Lostalot 1887, A. de Lostalot, 'Exposition Internationale de peinture', (Georges Petit), *Gazette des Beaux-Arts* 35, 1887, pp. 522–27

McGreevy 1938, T. McGreevy, 'Les Petits Prés au Printemps', *The Studio* CXVI, 1938, p. 181 and p. 197

Madsen 1889, K. Madsen, 'Kunst Impressionisterne i Kunst foreningen', *Politiken* I,II, 9 and 10 November, 1889

Madsen 1918, K. Madsen, *Malerisamlingen Ordrupgaard, Wilhelm Hansen's samling*, Copenhagen 1918 (review of exhibition at the Copenhagen Art Society 1889)

Mainardi 1987, P. Mainardi, *Art and Politics of the Second Empire*, New Haven and London 1987

Mallarmé 1876, S. Mallarmé, 'The Impressionists and Edouard Manet', *The Art Monthly Review*, 30 September 1876, in *Documents Stéphane Mallarmé* (7 vols), ed. C.-P. Barbier, Paris 1968–1980, I, pp. 66–86. First complete re-translation by P. Verdier in *Gazette des Beaux-Arts* (November 1975), pp. 147–56

Manchester 1980, *Concise Catalogue of Foreign Paintings – Manchester City Art Gallery*, Manchester 1980

Manet 1987, J. Manet, *Journal 1893–1899*, Paris 1987

Mannhein 1953, *Kunsthalle Mannheim, Verzeichnis der Gemälde und Skulpturensammlumg*, Mannheim 1953

Manson 1926, J.B. Manson, 'The Workman Collection', *Apollo* III, March 1926, pp. 139–44

Martin Wood 1916, F. Martin Wood, 'The National Gallery, Melbourne and the Felton Bequest', *The Studio* 66, January 1916, pp. 229–40

Masson 1927, Ch. Masson, *Musée national du Luxembourg, Catalogue des Peintures, Sculptures et Miniatures*, Paris 1927

Mathieu 1986, C. Mathieu, *Musée d'Orsay, Guide*, Paris 1986

Mauclair 1904, C. Mauclair, *L'Impressionnisme, son histoire son esthétique, ses maîtres*, Paris 1904

Mauclair 1912, C. Mauclair, *The French Impressionists*, London 1912

Mauclair 1923, C. Mauclair, *Les maîtres de l'impressionnisme, leur histoire, leur esthétique, leurs oeuvres* (new ed. revised and augmented) Paris (Ollendorf) 1923

Mauclair 1930, C. Mauclair, *Un siècle de peinture française 1820–1920*, Paris 1930

Maxon 1970, J. Maxon, *The Art Institute of Chicago*, New York 1970

Meier-Graefe 1907, J. Meier-Graefe, *Impressionisten*, Munich 1907

Meier-Graefe 1952, J. Meier-Graefe, *Auguste Renoir*, Paris 1952

Melanotte 1988, A. Melanotte, *Sisley*, Milan 1988, (English ed. trans, K. Milis, London 1991)

Merlhès 1984, V. Merlhès, ed., *Correspondance de Paul Gauguin*, I, Paris 1984

Miles and Spencer-Longhurst 1983, H. Miles and P. Spencer-Longhurst, *Handbook of the Barber Institute of Fine Arts*, Birmingham 1983

Milkovich 1977, M. Milkovich, *Paintings and Sculpture 1. The Dixon Gallery and Gardens*, Memphis 1977

Mirbeau 1892, O. Mirbeau, 'Le Salon du Champ-de-Mars', *Le Figaro*, 25 May 1892

Mirbeau 1990, O. Mirbeau, *Correspondance avec Camille Pissarro*, ed. P.-M. and J.-F. Nivet, Charente 1990

Moffett 1986, C. S. Moffett, exhib. cat., *The New Painting – Impressionism 1874–1886*, Fine Arts Museum of San Francisco 1986

Moore 1976, G. Moore, *Hail and Farewell. Ave, Salve, Vale*, ed. Richard Cave, Gerrards Cross 1976

Montreal 1950, *Catalogue of Paintings*, Montreal Museum of Fine Arts 1950

Munich 1990, *Gemäldekatologe VII, Impressionisten, Post-Impressionisten und Symbolisten Ausländische Künstler*, Neue Pinakothek, Munich 1990

Munk 1991, J. P. Munk, 'Sisley's landskaber fra Marly', in *Meddelelser fra Ny Carlesberg Glyptotek*, Copenhagen 1991

Munroe 1893, L. Munroe, 'Chicago Letter', *The Critic* 20, July 1893, no.594, p. 30

Mura 1980, A.-M. Mura, *Sisley – Grands Peintres*, Paris 1980

Nash 1979, S.A. Nash, *Painting and Sculpture from Antiquity to 1942*, Albright-Knox Art Gallery, Buffalo 1979

Natanson 1899, Th. Natanson, 'Spéculations sur la Peinture à propos de Corot et des Impressionnistes', *La Revue Blanche* 143 1899, pp. 123–33

Nathanson 1981, R. Nathanson, *Alfred Sisley 1839–1899*, exhib. cat., David Carritt Ltd. London, 16 June-11 July 1981

Near 1985, P.L. Near, *French Paintings in the Collection of Mr and Mrs P. Mellon – Virginia Museum of Fine Arts*, Virginia 1985

New York Times 1886, 1887, 1888, 1905, 1910 and 1917, 'Painting for Amateurs', *New York Times*, 10 April 1886, 'The Durand-Ruel Picture Sale', *New York Times*, 6 May 1887 *New York Times*, 15 April 1888 (on Boussod, Valadon and Co. in New York), 'The Fine Collection of the Late Cyrus J. Lawrence, to be sold at Auction Next Month, Art at Home and Abroad', *New York Times*, 2 January 1910 'Miss Sara Hallowell Unique in the Art World', *New York Times* 31 December 1905 'John G. Johnson, Noted Lawyer, Dies', *New York Times*, 15 April 1917

Niculescu 1970, R. Niculescu, 'Georges de Bellio, l'ami des Impressionnistes', *Revue Romaine d'Histoire d'Art* 1, 1964, pp. 209–78, 2 (1966) repr. *Paragone* XXI, 1970, 247, pp. 25–66

Nochlin 1966, L. Nochlin, *Impressionism and Post-Impressionism*, Princeton 1966

Ohio 1967, *Catalogue of European and American Paintings and Sculpture in the Allen Memorial Art Museum*, Oberlin College, Ohio 1967

Ohio 1978, *The Toledo Museum of Art, European Paintings*, Toledo, Ohio 1978

Ortwin-Rave 1945, P. Ortwin-Rave, *Die Malerei des 19. Jahrhunderts*, Berlin 1945

Otterlo 1957, Otterlo, *Catalogue of Nineteenth- and Twentieth-Century Painting with a Selection of Drawing from the Period*, Otterlo 1957

Oxford 1980, *Summary Catalogue of Paintings in the Ashmolean Museum*, Oxford 1980

Palmer, *Bertha Honore Palmer Correspondence*, The Ryerson Library, Art Institute of Chicago

Paris 1904, *Catalogue des collections municipales*, Paris 1904

Paris 1906, *Catalogue des collections municipales*, Paris 1906

Paris 1914, *Musée national du Louvre, Catalogue de la collection Camondo*, Paris 1914

Paris 1923, *Le Musée du Luxembourg, Peintures, Ecole française*, Paris 1923, new ed. 1924

Paris 1927, *Musée national du Luxembourg, catalogue des peintures, sculptures et miniatures*, Paris 1927

Paris 1947, *Catalogue des peintures et sculptures exposées au Musées de l'Impressionnisme*, Paris 1947

Paris 1958, *Musée du Louvre, Catalogue des peintures, pastels, sculptures impressionnistes*, Paris 1958

Paris 1961, *La Peinture au Musée Louvre, Ecole Française, XIXe Siècle*, vol.2, P-Z, Paris 1961

Paris 1972, *Musée national du Louvre. Catalogue des Peintures, I, Ecole française*, Paris 1972

Paris 1973, *Musée du Louvre, Musée du Jeu de Paume*, Paris 1973

Paris 1986, *Catalogue sommaire illustré des peintures du Muséee du Louvre et du Musée d'Orsay, Ecole française*, Paris 1986

Paris 1990, *Catalogue sommaire illustré des peintures du Musée d'Orsay*, Paris 1990

Philadelphia 1953, *The John G. Johnson Collection*, The Philadelphia Museum of Art, Philadelphia 1953

Phillips 1924, 'The Phillips Memorial Gallery', *The Studio*, October 1924

Pica 1908, V. Pica, *Gl'Impressionisti francesi*, Bergamo 1908

Pissarro 1950, C. Pissarro, *Lettres à son fils Lucien*, edited by J. Rewald, Paris 1950

Pissarro 1980, 1986, 1988, 1989 and 1991, See J. Bailly-Herzberg, 1980, 1986, 1988, 1989 and 1991

Pissarro 1990, J. Pissarro, *Monet's Cathedral, Rouen 1892–1894*, London 1990

Pittsburgh 1945, *Catalogue of the Permanant Collections of Pittsburgh*, Carnegie Institute, February 1945

Plant 1976, M. Plant, *French Impressionists and Post-Impressionists, National Gallery of Victoria*, Melbourne 1976

Pougeois 1928, Abbé A. Pougeois, *L'Antique et royale cité de Moret-sur-Loing*, Moret 1928

Poulain 1930, G. Poulain, 'De Courbet à Chagall chez M. et Mme Fernand Bouisson', *La Renaissance*, December 1930

Poulain 1932, G. Poulain, *Bazille et ses amis*, Paris 1932

Poulet and Murphy 1979, A. L. Poulet and A. Murphy, *Corot to Braque, French Paintings from the Museum of Fine Arts*, exhib. cat., Boston 1979

Quinlan 1984, H. Quinlan, *National Gallery of Ireland: Fifty Paintings*, Dublin 1984

Réau 1926, L. Réau, *Histoire de l'art* VII, Paris 1926

Reclus 1873, E. Reclus, *The Ocean, Atmosphere and Life*, trans. B. Woodward, ed. H. Woodward, London 1873

Reed 1991, N. Reed, *Sisley and the Thames*, London 1991

Régnier 1919, H. de Régnier, *L'Art moderne*, 2 vols, Paris 1919

Reidemeister 1956, L. Reidemeister, 'Die Brücke von Hampton Court', *Die Kunst* I (1956), pp. 1–3

Reidemeister 1963, L. Reidemeister, exhib. cat., *Auf der Spuren der Maler der Ile de France*, Berlin 1963

Renoir 1981, J. Renoir, *Pierre-Auguste Renoir, mon père*, Paris 1981

Reuterswaerd 1952, O. Reuterswaerd, *Impressionisterna inför publik ochkritik*, Stockholm 1952, O. Reuterswaerd, 'Sisley's Cathedrals, A Study of the Church at Moret Series', *Gazette des Beaux-Arts* 39, sér. 6, 1952, pp. 199–203

Rewald 1946, J. Rewald, *The History of Impressionism*, New York 1946

Rewald 1955, J. Rewald, *Histoire de l'Impressionnisme*, Paris 1955

Rewald 1961, J. Rewald, *The History of Impressionism*, New York 1961

Rewald 1973, J. Rewald, *The History of Impressionism*, 4th revised ed., New York 1973 (with revised and extended bibliography)

Rewald 1986, J. Rewald, *Studies in Impressionism*, London 1986

Ribault-Ménétière 1958, J. Ribault-Ménétière, 'Sur les Impressionnistes', *Journal de l'Amateur d'art* 215 (10 July 1958), p. 7

Riout 1989, D. Riout, ed., *Les Ecrivains devant l'impressionnisme*, Paris 1989

Rivière 1877, G. Rivière, 'La Troisième exposition impressionniste', *L'Impressionniste*, 14 April 1877

Roberts 1970, K. Roberts, *The Burlington Magazine*, July 1970, p. 480

Robida 1958, M. Robida, *Le Salon Charpentier et les impressionnistes*, Paris 1958

Robinson, *Theodore Robinson Diaries*, Frick Art Reference Library

Roger-Marx 1956, C. Roger-Marx, *Les Impressionnistes*, Paris 1956

Rostand 1955, M. Rostand, *Quelques amateurs de l'époque impressionniste*, Paris 1955

Rostrup 1958, H. Rostrup, *Franske Malerier I Ordrupgaardsamlingen*, Copenhagen 1958, H. Rostrup, *Malerier og Tegninger I Ny Carlsberg Glyptotek*, Copenhagen, 1958

Rothenstein 1949, J. Rothenstein, *Modern Foreign Pictures in the Tate Gallery*, London 1949

Rotterdam 1963, *Museum Boymans-van Beuningen – Catalogus Schilderijen na 1880*, Rotterdam 1963

Rouart 1950, D. Rouart ed., *Correspondance de Berthe Morisot avec sa famille et ses amis*, Paris 1950

Ryndel 1961, N. Ryndel, *Franskt Maleri i Göteborgs Kunstmuseum*, Göteborg 1961

Saarinen 1958, A. Saarinen, *The Proud Possessor*, New York 1958

Saffroy 1984, *Vente Saffroy*, March 1984, *Catalogue*, 1 letter from Sisley to de Bellio, 1887, no.1762

Saint-Gall 1937, *Sturzenneggersche Gemälde Sammlung der Stadt St. Gallen*, Saint-Gall, 1937

Scharf 1966, A. Scharf, *Alfred Sisley, The Masters No. 24*, London 1966

Scheffler 1920–21, K. Scheffler, 'Die Sammlung Oscar Schmitz in Dresden', *Kunst und Künstler* XIX, 1920–21

Scheffler 1930, K. Scheffler, 'Die Sammlung Alfred Cassirer', *Kunst und Künstler* XXVIII, 1930

Schmidt 1956, G. Schmidt, *Sammlung Rudolf Staechlin*, exhib. cat., Kunstmuseum, Basel, June 1956

Schmidt 1981, G. Schmidt, *Kunstmuseum Basel 150 Gemälde 12.-20. Jahrhundert. 5. Auflage*, Basel 1981

Schmitz 1936, *The Oscar Schmitz Collection*, (Wildenstein) Paris 1936

Serri 1989, J. Serri, *Bleu, Blanc, Rouge: les Couleurs de la France dans la peinture française*, Paris 1980

Shone 1979, Richard Shone, *Sisley*, Oxford 1979

Shone 1981, R. Shone, review of 'Alfred Sisley 1839–1899', held at David Carritt Ltd. London, 16 June–11 July 1981, *The Burlington Magazine* CXXIII, 1981, p. 378

Shone 1992, R. Shone, '"La famille": An Unpublished Sisley Drawing', *The Burlington Magazine* CXXXIV, 1992, pp. 34–35

Shone 1992, R. Shone, *Sisley*, London 1992

Sickert 1947, W.R Sickert, *A Free House! or the Artist as Craftsman*, ed. O. Sitwell, London 1947

Silvestre 1873, A. Silvestre, *Galerie Durand-Ruel, Recueil d'estampes gravées à l'eau-forte*, Paris 1873 (unpublished)

Siren 1928, O. Siren, *Catalogue descriptif des collections de peintures du Musée National de Stockholm, Maîtres étrangers*, Stockholm 1928

Sisley 1933, 'Sisley', *Bulletin des expositions* (Galerie d'Art Braun), Paris, 30 January – 18 February 1933, pp. 3–13; 4 letters from Sisley to Duret; 1 letter from Sisley to Monet; 12 letters from Sisley to Georges Viau

Sisley 1949, C. Sisley, 'The Ancestry of Alfred Sisley', *The Burlington Magazine* XCI, 1949, pp. 248–52

Sterling 1957, C. Sterling, *Musée de l'Ermitage. La Peinture française de Poussin à nos jours*, Paris 1957

Sterling and Salinger 1966, Ch. Sterling and M. Salinger, *French Paintings. A Catalogue of the Collection of the Metropolitan Museum of Art*, New York 1966

Sterling and Adhémar 1990, Ch. Sterling and H. Adhémar, *Musée d'Orsay, Catalogue sommaire illustré des peintures, M-Z*, Paris 1990

Stockholm 1949, *National Museum Stockholm, Peintures étrangères*, Stockholm 1949

Stoll 1957, R.-Th. Stoll, *La Peinture impressionniste*, Lausanne 1957

Sutton 1966, D. Sutton, 'Connoisseurs' Haven', *Apollo* 84, December 1966, no.58, pp. 2–13

Swane 1954, L. Swane, *Katalog over Kunstvaerne paa Ordrupgaard*, Copenhagen 1954

Tabarant 1947, A. Tabarant, *Manet et ses oeuvres*, Paris 1947

Tavernier 1893, A. Tavernier, 'Sisley', *L'Art français* VI, 18 March 1893, n.p.

Ternovietz 1925, Ternovietz, 'Le Musée d'Art moderne de Moscou (Anciennes Collections Stchoukine et Morosoff)', *L'Amour de l'art*, December 1925, pp. 455–88

Thomas 1987, D. Thomas, *The Age of the Impressionists*, London 1987

Thomson 1981, R. Thomson, 'A Sisley Problem' [letter], *The Burlington Magazine*, 1981, p. 676

Tokyo 1974, *Catalogue du Bridgestone Museum of Art*, Tokyo 1974

Toronto 1959, *Painting and Scupture. The Art Gallery of Toronto*, Toronto 1959

Tschudi 1909, H. von Tschudi, 'Die Sammlung Arnhold', *Kunst und Künstler*, 1909

Tucker 1981, P.H. Tucker, *Monet at Argenteuil*, New Haven and London 1981

Tucker 1990, P.H. Tucker, *Monet in the '90s. The Series Paintings*, New Haven and London 1990

Uhde 1937, W. Uhde, *Impressionisten*, Vienna 1937

Valentiner 1913–14, Wilhelm R. Valentiner, *Catalogue of the Collection of Paintings and Some Art Objects*, 3 vols, Philadelphia 1913–14

Vaudoyer 1955, J.-L. Vaudoyer, *Les Impressionnistes de Manet à Cézanne*, Paris 1955

Vauxcelles 1908, L. Vauxcelles, 'La Collection de M. Paul Gallimard', *Les Arts* 81, September 1908, pp. 1–32

Venturi 1939, L. Venturi, *Les Archives de l'impressionnisme*, 2 vols., Paris 1939; 16

letters from Sisley to Durand-Ruel, 1881–1888, vol.2, pp. 55–63, nos 1–16; 5 letters from Sisley to Maus, vol.2, pp. 241–43, *Mémoire de Paul Durand-Ruel*

Venturi 1953, L. Venturi, *De Manet à Lautrec*, Paris 1953

Venturi 1970, L. Venturi, *La Via dell'impressionismo da Manet a Cézanne*, Turin 1970

Verdier 1975, Ph. Verdier, 'Stéphane Mallarmé: Les Impressionnistes et Edouard Manet, 1875–1876', *Gazette des Beaux-Arts* 86, November 1975, pp. 147–56

Vergnet-Ruiz and Laclotte 1962, J. Vergnet-Ruiz and M. Laclotte, *Petits et grands musées de France, Ecole française*, Paris 1962

Vigurs 1976, P. Vigurs, *The Garman-Ryan Collection*, Walsall 1976

Vincent 1956, M. Vincent, *Catalogue du Musée de Lyon. VII. La Peinture des XIXe et XXe siècles*, Lyon 1956

Vinton 1891, F. P. Vinton, 'Sisley' in *Catalogue of Paintings by the Impressionists of Paris, Claude Monet, Camille Pissarro, Alfred Sisley, from the Galleries of Durand-Ruel* Paris, exhib. cat., J. Eastman Chase Gallery, Boston, March 1891

Vollard 1937, A. Vollard, *Souvenirs d'un marchand de tableaux*, Paris 1937, repr. 1984

W.H.W 1892, W.H.W., 'What is Impressionism', *Art Amateur*, November 1892, pp. 140–1

W.H.W and Riordan, W.H.W. and R. Riordan, 'What is Impressionism', *Art Amateur*, December 1892, p. 5

Wadley 1991, N. Wadley, *Impressionist and Post-Impressionist Drawing*, London 1991

Waern 1892, C. Waern, 'Some Notes on French Impressionists', *Atlantic Monthly 62*, April 1892, pp. 535–41

Washington 1952, Washington, *The Phillips Collection. A Museum of Modern Art and its Sources*, Washington 1952

Watson 1921, F. Watson, 'Sisley's Struggle for Recognition', *The Arts*, I no.3, February-March 1921, pp. 10–18

Weitzenhoffer 1984, F. Weitzenhoffer, 'The Earliest American Collectors of Monet', *Aspects of Monet, A Symposium on the Artist's Life and Times*, ed. J. Rewald, F. Weitzenhoffer, New York 1984, pp. 74–91

Weitzenhoffer 1986, F. Weitzenhoffer, *The Havemeyers, Impressionism Comes to America*, New York 1986

Whinney 1949, M. Whinney, 'The Courtauld Institute of Arts', *The Studio* 137, June 1949, pp. 161–69

White 1968, J. White, *National Gallery of Ireland*, London 1968

Whittet 1951, G.S. Whittet, 'A Gallery of Art Dealers. 4. Wildenstein', *The Studio* 142, July 1951, pp. 16–22

Wildenstein 1959, G. Wildenstein, 'Un carnet de dessins de Sisley au Louvre', *Gazette des Beaux-Arts* 53, sér. 6, 1959, pp. 57–60

Wildenstein 1974, 1979, 1979 and 1985, D. Wildenstein, *Claude Monet, Catalogue raisonné*, vols I–IV, Lausanne and Paris 1974, 1979, 1979, & 1985

Wilenski 1928, H.R. Wilenski, 'The Sisley Compromise', *Apollo* VII, 1928, pp. 69–74

Wilenski 1940, R. Wilenski, *Modern French Painters*, London and New York 1940

Williamstown 1956, *The Sterling and Francine Clark Art Institute*, Williamstown 1956

Wornsum 1847, R. N. Wornsum, *Descriptive and Historical Catalogue of the Pictures in the National Gallery*, London 1847

Yerkes 1893, *Catalogue de la Collection Charles T. Yerkes*, New York 1893

Young 1960, D.W. Young, *The Life and Letters of J. Alden Weir*, New Haven 1960

EXHIBITION LIST

compiled by Juliet Simpson

Aberdeen 1963, Aberdeen Art Gallery, 4 October–3 November 1963, *French Paintings from the Burrell Collection*

Albi 1980, Albi, Musée Toulouse-Lautrec, 27 June–31 August 1980, *Trésors impressionnistes du Musée de Chicago*

Amsterdam 1931, Amsterdam, Galerie Huinck and Scherjon, 2–30 May 1931, *Claude Monet, Pissarro, Sisley*

Amsterdam 1938, Amsterdam, Stedlijkmuseum, Summer 1938, *Honderd Jahr Fransche Kunst* (Preface by René Huyghe)

Amsterdam 1962, Amsterdam, Wisselingh & Co., 1962, *Maîtres français XIXe et XXe siècles*

Antwerp 1893, Antwerp, February 1893, *Salon des 13 à Anvers*

Arts Council of Great Britain 1947–48, Scottish Committee Tour, 1947–48, *Paintings from the Burrell Collection*

Arts Council of Great Britain 1947, Edinburgh,

Arts Council of Great Britain 1948, Southern Region, 1948, *The Artist and the Country*

Arts Council of Great Britain 1950–51, English Tour, *French Paintings of the 19th Century from the Burrell Collection*

Arts Council of Great Britain 1953, Peterborough, October 1953, *Exhibition of French Paintings*

Arts Council of Great Britain 1955, Exeter, Exeter Art Gallery, 1955, *Contemporary Paintings from Southampton Art Gallery*

Arts Council of Great Britain 1960, Welsh Committee and the National Museum of Wales, National Museum of Wales, Cardiff, 16 June–21 August 1960, *How Impressionism Began*

Arts Council of Great Britain 1977–78, Touring exhibition, *The Burrell Collection, 19th-Century French Paintings*

Baltimore 1936–37, Baltimore, Baltimore Museum of Fine Arts, 27 November 1936–1 January 1937, *Paintings by the Master Impressionists*

Baltimore 1951, Baltimore, Baltimore Museum of Fine Arts, 1951, *From Ingres to Gauguin*

Barcelona 1917, *Art Français*

Basel 1949, Basel, Kunsthalle, 3 September–20 November 1949, *Impressionisten*

Basel 1956, Basel, Galerie Beyeler, August–October 1956, *Maîtres de l'art moderne*

Berlin 1883, Berlin, Galerie Fritz Gurlitt, September 1883, *Ausstellung der Impressionnisten*

Berlin 1927, Berlin, Galerie Thannhauser, 9 January–15 February 1927, *Erste Sonderausstellung in Berlin*

Berlin 1958, Berlin, Schloss Charlottenburg, 1958, *Französische Malerei von Manet bis Matisse*

Berne 1934, Berne, Kunsthalle, 1934, *Französische Meister des 19. Jahrhunderts und Van Gogh*

Berne 1947, Berne, Kunsthalle, 1947, *Quelques oeuvres des collections de la ville de Paris*

Berne 1958, Berne, Kunstmuseum, 9 February–13 April 1958, *Alfred Sisley*, (Preface by Max Huggler, catalogue and biography by F. Daulte and H. Wagner)

Birmingham (Alabama) 1980, Birmingham (Alabama), Birmingham Museum of Art, 1 February–30 March 1980, *Fifty Years of French Painting: the Emergence of Modern Art.*

Boston 1883, Boston, Mechanic's Building, September 1883, 'Foreign Exhibiton', *International Exhibition for Art and Industry*

Boston 1891, Boston, J. Eastman Chase Gallery, 7 Hamilton Place, 17–28 March 1891, *Paintings by the Impressionists of Paris, Claude Monet, Camille Pissarro, Alfred Sisley, from the Galleries of Durand-Ruel*

Boston 1908, Boston, Walter Kimball & Co., 10–30 March 1908, *Paintings by Alfred Sisley*

Boston 1913, Boston, Saint Botolph Club, 20–31 January 1913, *Impressionist Paintings Lent by Messrs Durand-Ruel*

Bordeaux 1965, Bordeaux, Musée des Beaux-Arts, 1965, *Chefs-d'Oeuvres de la Peinture française dans les Musées de l'Ermitage et de Moscou*

Bordeaux 1974, Bordeaux, Musée des Beaux-Arts, 3 May–1 September 1974, *1874 – Naissance de l'Impressionisme*

Bremen 1978, Bremen, Kunsthalle, 1978, *Zurück zur Natur. Die Kunstlerkolonie von Barbizon*

Brives – Reims – La Rochelle – Angoulême – Rennes 1955, Brives – Reims – La Rochelle-Angoulême – Rennes 1955, *Impressionnistes et Précurseurs*

Brussels 1885, Brussels, Hôtel du Grand Miroir, June 1885, *Tableaux des Galeries Durand-Ruel*

Brussels 1890, Brussels, *Les XX*, February–March 1890, *VIIème Exposition des XX*

Brussels 1891, Brussels, *Les XX*, February–March 1891, *VIIIème Exposition des XX*

Brussels 1935, Brussels, Palais des Beaux-Arts, 15 June–29 September 1935, *L'Impressionnisme* (catalogue introduction by Charles Bernard)

Buenos Aires 1933, Buenos Aires, Museo Nacional de Bellas Artes, Buenos Aires, 20 October–5 November 1933, *Escuela Francese*

Buffalo 1907, Buffalo, Buffalo Fine Arts Academy, Albright Art Gallery, 31 October–8 December 1907, *Exhibition of Paintings by French Impressionists*

Cambridge MA, 1929, Cambridge MA, Fogg Art Museum, March–April 1929, *Exhibition of French Painting of the 19th and 20th Centuries*

Chicago 1893, Chicago, May–October 1893, *Loan Exhibition of Foreign Works from Private Collections in the United States*

Chicago 1901, Chicago, Art Institute of Chicago, 8–27 January 1901, *Loan Collection of Selected Works of Modern Masters*

Chicago 1933, Chicago, 1933, *A Century of Progress*

Colorado Springs 1946, Colorado Springs, Fine Arts Center, 5 November–15 December 1946, *19th-Century French Painters*

Columbia 1908, Columbia, The Museum of Classical Archeology of the University of Missouri, February 1908, *Second Exhibition of Paintings, Art Lover's Guild of Columbia*

Copenhagen 1889, Copenhagen, Kunstforeningen, organised by the 'Society for Friends of the Arts', October–November 1889, *Exhibition of French and Scandanavian Impressionists*

Copenhagen 1914, Copenhagen, Statens Museum for Kunst, 1914, *Fransk Malerkunst fra det 19. Aarhundrede*

Copenhagen 1945, Copenhagen, Ny Carlsberg Glyptotek, 1945, *Fransk Kunst*

Copenhagen 1957, Copenhagen, Statens Museum for Kunst, 1957, *Fransk Kunst*

Edinburgh 1929, Edinburgh, Royal Scottish Academy 1929

Edinburgh 1961, Edinburgh, Royal Scottish Academy, August–September 1961, *Masterpieces of French Painting from the Bührle Collection*

Edinburgh 1968, Edinburgh, Royal Scottish Academy, 17 August–8 September 1968, *Boudin to Picasso*

Edinburgh 1986, Edinburgh, National Gallery of Scotland, 1 August–19 October 1986, *Lighting up the Landscape – French Impressionism and its Origins*

Florence-Rome 1955, Florence, Rome 1955, *Capolavori Dell'ottocento Francese*

Geneva 1918, Geneva, Musée d'Art et d'Histoire, 15 May–16 June 1918, *Exposition d'Art français*

Ghent 1895, Ghent, 1 September–28 October 1895, *Salon Triennal de Gand*

Gifu-Kamakura 1982–83, Gifu, The Museum of Fine Arts 1982, Kamakura, The Museum of Modern Art, 1982–83, *Paris Around 1882*

Glasgow 1946, Glasgow City Art Gallery and Museum, Kelvingrove, 17 May–18 August 1946, *The Burrell Collection: A Selection*

Glasgow 1951, Glasgow City Art Gallery and Museum, McLellan Galleries, 8 June–8 September 1951, *A Selection from the Burrell Collection*

Inverness 1966, Inverness Art Gallery, 9 September–1 October 1966, *French Paintings and Drawings from the Burrell Collection*

Iowa City 1964, Iowa City, University of Iowa Gallery of Art, 1964, *Impressionism and its Roots*

Kurume 1961, Kurume, Ishisbashi Art Gallery, 1961, *Kindai Seiyo Kaiga Meisaku*

Kurume 1963, Kurumi, Ishibashi Art Gallery, 1963, *Seio Meiga*

Laren 1964, Laren, Singer Museum, 4 July–16 September 1964, *Schilderkunst uit 'La Belle époque'*

Leningrad 1956, Leningrad, Hermitage Museum, 1956, *12th–20th Century French Art*

Leningrad 1974, Leningrad, Hermitage Museum, 1974, *Impressionist Paintings*

London 1872, London, 168 New Bond Street, Summer 1872, *4th Exhibition of the Society of French Artists*

London 1882, London, Langham Hotel, June–July 1882, *Exposition Durand-Ruel* (see I. Cahn, Documentary Chronology, p. 268)

London 1883, London, Dowdeswell and Dowdeswell, 133 New Bond Street, 15 April–20 July 1883, *La Société des Impressionnistes*

London 1884, London, Dudley Gallery, Spring 1884, *Exhibition of Impressionist Works*

London 1885, London, Dowdeswell and Dowdeswell, 133 New Bond Street, 1885, *Exposition Dowdeswell*

London 1891, London, Mr Collie's Rooms, 39B Old Bond Street, Winter 1891, *La Société des Beaux-Arts* (see I. Cahn, Documentary Chronology, p. 275)

London 1898, London, Skating Rink, Knights-bridge, Summer 1898, *International Society of Sculptors, Painters and Engravers*

London 1901, London, Hanover Gallery, 1901, *Pictures by the French Impressionsts and other Masters*

London 1905, London, Grafton Galleries, January–February 1905, *Pictures by Boudin, Cézanne, Degas, Manet, Monet, Morisot, Pissarro, Renoir, Sisley*

London 1914, London, Grosvenor House, 1914, *Exposition d'Art décoratif contemporain* (Preface by J.-E. Blanche)

London 1923, London, Agnew and Sons, June 1923, *Masterpieces of French Painting*

London 1926, London, Lefevre Gallery, 1926, *French Impressionist Painting*

London 1927, London, The Independent Gallery, November–December 1927, *Paintings by Alfred Sisley*

London 1931, London, Knoedler Galleries, October–November 1931, *The Landscape in French Art*

London 1932, London, Royal Academy of Arts, 1932, *Exhibition of French Art* (catalogue introduction by W.G. Constable)

London 1937, London, Reid and Lefevre Gallery, January 1937, *Pissarro and Sisley*

London, Arthur Tooth and Sons, 20 May–19 June 1937, *La Grande Epoque de Sisley*

London 1942, London, National Gallery, 1942, *Ninteenth-Century French Paintings*

London 1949–50, London, Royal Academy of Arts, 10 December 1949–5 March 1950, *Landscape in French Art, 1550–1900*

London 1954, London, Reid and Lefevre Gallery, February 1954, *French Painting, 19th and 20th Century*

London 1955, London, Marlborough Gallery, June–July 1955, *Pissarro-Sisley* (catalogue Preface by Alan Clutton-Brock)

London, Wildenstein Gallery, 1955, *Marcel Proust and his time (1871–1922)*

London 1957, London, Agnew and Sons, March–May 1957, *Pictures from the City Art Gallery Birmingham*

London 1962, London, Royal Academy of Arts, 1962, *Primitives to Picasso*

London 1963, London, Wildenstein and Co. Ltd., April–May 1963, *The French Impressionists and Some of Their Contemporaries*

London 1968, London, Reid and Lefevre Gallery, 1968, *19th and 20th Century French Paintings*

London 1972, London, Arthur Tooth and Sons Ltd., November 1972, *Old Masters and Modern Paintings*

London 1973, London, Hayward Gallery, 3 January–11 March 1973, *The Impressionists in London*

London 1974, London, Royal Academy of Arts, 9 February–28 April 1974, *Impressionism, Its Masters, its Precursors and its Influence in Britain* (catalogue Introduction by J. House)

London 1975, London, Hayward Gallery, 18 March–4 May 1975, *Treasures from the Burrell Collection*

London 1981, London, David Carritt Ltd., 16 June–11 July 1981, *Sisley* (Catalogue by R. Nathanson)

London 1988, London, National Gallery, 1988, *French Paintings from the USSR: Watteau to Matisse*

London 1989, London, Sotheby's, 1989 *National Art-Collections Fund Loan Exhibition*

Los Angeles – San Francisco 1956–57, Los Angeles, Los Angeles County Museum of Art, San Francisco, California Palace of the Legion of Honor, 1956–7, *The Edward G. Robinson Collection*

Los Angeles 1967, Los Angeles, City National Bank, 1967, *Selected Paintings from the Collection of Mr and Mrs William Goetz*

Los Angeles – Chicago – Paris 1984–5, Los Angeles, Los Angeles County Museum of Art, 28 June–16 September 1984, Chicago, The Art Institute of Chicago, 23 October 1984–86 January 1985, *A Day in the Country Impressionism and the French Landscape*, Paris, Grand Palais, 4 February–22 April 1985, *L'Impressionnisme et le paysage français*

Louveciennes 1984, Louveciennes, Marly-le-Roi, Musée-promenade, 27 March–24 June 1984, *De Renoir à Vuillard*

Lucerne 1963, Lucerne, Kunstmuseum, August–October 1963, *Sammlung E.G. Bührle, Französische Meister von Delacroix bis Matisse*

Lugano 1987, Lugano, Villa La Favorita, 1987, *Capolavori impressionisti e postimpressionisti dei musei sovietici, II*

Madrid 1918, *Pintura Francesa Contemporanea 1870–1918*

Manchester 1907–8, Manchester, City Art Gallery, December 1907–January 1908, *Exhibition of Modern French Paintings* (catalogue introduction by J. Ernest Phythian)

Manchester, NH 1945, Manchester, NH, Currier Gallery of Art, 8 October–6 November 1945, *Monet and the Beginnings of Impressionism*

Manchester NH – New York – Dallas – Atlanta 1991–92, Manchester NH Currier Gallery of Art, New York, IBM Galleries, Dallas, Museum of Art, Atlanta, The High Museum, 1991–92, *Corot to Monet: The Rise of Landscape Painting in France*

Memphis 1976–77, Memphis, Dixon Gallery, January 1976–January 1977, *Gifts of Mr and Mrs Hugo Dixon to Brooks Memorial Art Gallery*

Memphis 1977–78, Memphis, Dixon Gallery, 4 December 1977–78 January 1978, *Impressionists in 1877*

Michigan 1979–80, Michigan, University of Michigan Museum of Art, 2 November 1979–January 1980, *The Crisis of Impressionism 1878–1882* (catalogue by Joel Isaacson)

Minneapolis 1989, Minneapolis, Institute of Arts, 1 June–31 July 1989, *Selections from the Permanent Collection of Memphis Brooks Museum of Art*

Montreal 1966–67, *Masterpieces from Montreal, Selected Paintings from the Collection of the Montreal Museum of Fine Arts* (circulating exhibition)

Montreal 1989–90, The Montreal Museum of Fine Arts, 1989–90, *Discerning Tastes, Montreal Collectors 1880–1920*

Moscow 1939, Moscow, State Museum of Western Art, *French 19th- and 20th-century Landscapes*

Moscow 1955, Moscow, Pushkin Museum, 1955, *15th–20th-century French Art*

Moscow 1960, Moscow, Pushkin Museum, 1960, *French Art of the second half of the 19th century from the Museums of Fine Art in the USSR*

Moscow 1975, Moscow, Pushkin Museum, 1975, *Impressionist Painting* (catalogue text in Russian)

Munich 1958–59, Munich, Haus der Kunst, December 1958–February 1959, *Hauptwerke der Sammlung E.G. Bührle*

Nantes 1891, Nantes, Galerie Préaubert, November 1891, *Société des Amis des Arts de Nantes*

Nashville TN 1990–91, Nashville TN, Tennessee State Museum, 14 October 1990–20 January 1991, *Masterworks: Paintings from the Bridgestone Museum of Art*

New Delhi 1977, New Delhi, 1977, *French Modern Paintings*

New York 1886, New York, American Art Galleries, Madison Square, 10 April–25 May 1886, National Academy of Design, 25 May–30 June 1886, *Works in Oil and Pastel by the Impressionists of Paris*

New York 1886–7, New York, American Art Galleries, December 1886–January 1887, *Collection Modern Paintings*

New York 1887, New York, National Academy of Design, 25 May–30 June 1887, *Celebrated Paintings by Great French Masters*

New York 1889, New York, Durand-Ruel Galleries, 27 February–15 March 1889, *Exposition, Works of Alfred Sisley*

New York 1892, New York, Durand-Ruel Galleries, December 1892, *Paintings of Sisley, Renoir, J.L. Brown, Degas, Jongkind and Pissarro*

New York 1893, New York, Boussod and Valadon Galleries, January–February 1893, *Painting of Monet, Renoir, Sisley, Raffaëlli and Pissarro*

New York 1894, New York, Delmonico Gallery, January 1894, *Impressionist Exhibition*

New York 1899, New York, Durand Ruel Galleries, 27 February–15 March 1899, *Exposition, Works of Alfred Sisley* (catalogue Preface by A. Alexandre)

New York 1905, New York, Durand-Ruel Galleries, 18 March–8 April 1905, *Exhibition of Paintings by Alfred Sisley*

New York 1912, New York, Durand-Ruel Galleries, 10–27 April 1912, *Exhibition of Paintings by Sisley*

New York-Chicago-Boston 1913, New York, 69th Infantry Regiment & Armory, 15 February–15 March 1913; Chicago 24 March–16 April 1913; Boston, 28 April–14 May 1913, *International Exhibition of Modern Art, Association of American Painters and Sculptors*

New York 1913–14, New York, Durand-Ruel Galleries, 20 December 1913–8 January 1914, *Exhibition of Paintings representing Still-life and Flowers by Manet, Monet, Pissarro, Renoir, Sisley, André d'Espagnat*

New York 1914, New York, Durand-Ruel Galleries, 28 November–12 December 1914, *Exhibition of Paintings by Sisley*

New York 1917, New York, Durand-Ruel Galleries, 1917, *Great French Masters*

New York 1921, New York, Durand-Ruel Galleries, 8–22 January 1921, *Exhibition of Paintings by Alfred Sisley*

New York 1925, New York, Durand-Ruel Galleries, 18 February–31 March 1925, *Exhibition of Paintings by Camille Pissarro and Alfred Sisley*

New York 1927, New York, Durand-Ruel Galleries, 19 April–3 May 1927, *Exhibition of Paintings by Alfred Sisley*

New York 1928, New York, Durand-Ruel Galleries, 7–22 December 1928, *Exhibition of Paintings by Pissarro and Sisley*

New York 1929, New York, Knoedler Galleries, 12 November–8 December 1929, *A Century of French Painting*

New York 1934, New York, Durand-Ruel Galleries, 12 February–10 March 1934, *Paintings by the Master Impressionists*

New York 1935, New York, Durand-Ruel Galleries, 23 January–13 February 1935, *Exhibition of Paintings by Sisley*

New York 1938, New York, Durand-Ruel Galleries, 14 November–2 December 1938, *Monet, Pissarro and Sisley*

New York 1939, New York, Durand-Ruel Galleries, 2–21 October 1939, *Alfred Sisley Centennial*

New York 1941, New York, The Metropolitan Museum of Art, 1941, *Exhibition of French Painting from David to Toulouse-Lautrec*

New York 1950, New York, Knoedler Galleries, 6–25 February 1950, *A Collector's Exhibition*

New York 1958, New York, Fine Arts Associates, Summer 1958, *Paintings, Watercolours, Sculpture*

New York 1961, New York, Paul Rosenberg and Co., 1961, *Alfred Sisley*

New York 1966, New York, Wildenstein and Co., 26 October–3 December 1966, *Sisley* (catalogue Preface by F. Daulte)

New York 1968, New York, Acquavella Galleries, 25 October–30 November 1968, *Four Masters of Impressionism*

New York 1970, New York, Wildenstein & Co., 1971, *100 Years of Durand-Ruel*

New York 1971, New York, Durand-Ruel Galleries, 1971, *Alfred Sisley*

New York-Detroit-Los Angeles-Houston-Mexico City-Winnipeg-Montreal 1975–76

New York 1983, New York, Wm Beadleston Inc., 1983, *Alfred Sisley*

Northampton Mass 1964, Northampton, Mass., Smith College, Museum of Art, 1964, *The Homburger Collection*

Nottingham 1971, Nottingham, University Art Gallery, 6–27 February 1971, *Alfred Sisley (1839–1899) Impressionist Landscapes* (catalogue by R. Pickvance)

Omaha 1956–7, Omaha, Joslyn Art Museum, 29 November 1956–1 January 1957, *25th Anniversary Exhibition*

Osaka 1955, Osaka 1955, *Sekai Meisaku Bijutsu*

Ottawa-Toronto-Montreal 1934, Ottawa, The National Gallery of Canada, January 1934, Toronto, The Art Gallery of Toronto, February 1934, Montreal, The Art Association of Montreal, March 1934, *Exhibition of French Painting of the Nineteenth Century*

Oslo 1948, Oslo, Kunstnernes Hus, 1948, *Utstillet*

Otterlo 1972, Otterlo, Rijksmuseum Kröller-Müller, 1972, *From Van Gogh to Picasso: 19th- and 20th-century Paintings and Drawings from the Pushkin Museum, Moskow and The Hermitage, Leningrad*

Paris 1866, Paris, Salon de 1866, May 1866

Paris 1868, Paris, Salon de 1868, May 1868

Paris 1870, Paris, Salon de 1870, May 1870

Paris 1874, Paris, Nadar, 35 boulevard des Capucines, 15 April–15 May 1874, *Première Exposition des Impressionnistes*, ('Société anonyme des Artistes Peintres, Sculpteurs, Graveurs')

Paris 1876, Paris, Galerie Durand-Ruel, April 1876, *Deuxième Exposition des Impressionnistes*, ('Société anonyme des Artistes Peintres, Sculpteurs, Graveurs')

Paris 1877, Paris, Galerie Durand-Ruel, April 1877, *Troisième Exposition des Impressionnistes*

Paris 1881, Paris, Bureaux de la *Vie moderne*, 7 boulevard des Italiens, Spring 1881, *Exposition Sisley*

Paris 1881, Paris, Bureaux du *Gaulois*, Autumn-Winter? 1881, *Exposition Sisley*

Paris 1882, Paris, Salons du Panorama de Reischoffen, 251 rue Saint-Honoré, March 1882, *Septième Exposition des Artistes indépendants*

Paris 1883, Paris, Galerie Durand-Ruel, 9 boulevard de la Madeleine, 1 June –25 June 1883, *Exposition Sisley*

Paris 1884, Paris, Cercle artistique de la Seine, 3bis rue de la Chaussée d'Antin, January 1884, *Exposition du Cercle artistique de la Seine*

Paris 1887, Paris, Galerie Georges Petit, 7–30 May 1887, *Exposition internationale de Peinture*

Paris 1888, Paris, Galerie Durand-Ruel, 25 May–25 June 1888, *Exposition (Renoir, Pissarro et Sisley)*

Paris 1888, Paris, Galerie Georges Petit, 12 rue Godot-de Mauroy, December 1888, *Tableaux de Sisley*

Paris 1890, Paris, Galerie Durand-Ruel, 6–26 March 1890, *Deuxième Exposition des Peintres-Graveurs* (Preface by Ph. Burty)
Paris, Champ-de-Mars, *Salon de la Société Nationale des Beaux-Arts*, 15– 30 May 1890

Paris 1891, Paris, Champ-de-Mars, *Salon de la Société Nationale des Beaux-Arts* 15–30 May 1891

Paris 1891–2, Paris, Galerie Georges Petit, 8 rue de Sèze, December 1891–January 1892, *Exposition Internationale de peinture*

Paris 1892, Paris, Champ-de-Mars, *Salon de la Société Nationale des Beaux-Arts*, 15–30 May 1892

Paris 1893, Paris, Galerie Boussod-Valadon, 13 March–1 April 1893, *Exposition Alfred Sisley*
Paris, Champ-de-Mars, 10–30 May 1893, *Salon de la Société Nationale des Beaux-Arts*
Paris, Galerie Martin-Camentron, December 1893, *Exposition d'Oeuvres de Degas, Monet, Cassatt, Morisot, Pissarro, Sisley, Manet, Renoir, Guillaumin*

Paris 1894, Paris, Champ-de-Mars, 25 April–10 May 1894, *Salon de la Société Nationale des Beaux-Arts*

Paris 1895, Paris, Champ-de-Mars, 15–30 May 1895, *Salon de la Société Nationale des Beaux-Arts*
Paris, La Bodinière, rue Saint-Lazare, 23 November–13 December 1895, *Exposition Murer* (catalogue Preface by François Coppée -'LH.' and Paul Alexis).

Paris 1896, Paris, Champ-de-Mars, 25 April–30 June 1896, *Salon de la Société Nationale des Beaux-Arts*

Paris 1897, Paris, Galerie Georges Petit, 5–28 February 1897, *Exposition A. Sisley* (Preface to catalogue by L. Roger-Miles)

Paris 1898, Paris, Champ-de-Mars, 1–15 May 1898, *Salon de la Société Nationale des Beaux-Arts*
Paris, Galerie Durand-Ruel, 1–18 June 1898, *Exposition d'oeuvres récentes de Camille Pissarro* (and Renoir, Monet, Sisley and Puvis de Chavannes)
Paris, Galerie George Petit, August 1898, *Exposition Estivale*

Paris 1899, Paris, Galerie Georges Petit, 16 February–18 March 1899, *Exposition de Tableaux par P.-A. Besnard, J.-C. Cazin, C. Monet, A. Sisley, F. Thaulow*
Paris, Galerie Durand-Ruel, April 1899, *Exposition de Tableaux de Monet, Pissarro, Renoir et Sisley* (Preface by A. Alexandre)

Paris 1900, Paris, Champ-de-Mars, *Centennale de l'Art français*

Paris 1902, Paris, Galerie Durand-Ruel, 15 February–1 May 1902, *Exposition de tableaux de Sisley*

Paris 1903, Paris, Galerie Georges Petit, 26 January–13 February 1903, *Cent tableaux par Boudin, Jongkind, Lépine, Sisley*

Paris 1904, Paris, Galerie Paul Rosenberg, 7–24 November 1904, *Exposition Sisley*

Paris 1907, Paris, Galerie Bernheim-Jeune, 2–14 December 1907, *L'Atelier de Sisley* (catalogue Preface by Adolphe Tavernier)

Paris 1908, Paris, Galerie Durand-Ruel, 20 January–8 February 1908, *Exposition de 45 tableaux de Sisley*

Paris 1910, Paris, Galerie Durand-Ruel, 1–25 June 1910, *Monet, C. Pissarro, Renoir et Sisley*

Paris 1911, Paris, Galerie Bernheim-Jeune, 27 February–15 March 1911, *Collection Maurice Masson*

Paris 1914, Paris, Galerie Durand-Ruel, 16 April–2 May 1914, *Tableaux par Alfred Sisley*

Paris 1917, Paris, Galerie Georges Petit, 14 May–7 June 1917, *Exposition d'oeuvres d'Alfred Sisley*

Paris 1920, Paris, Galerie Barbazanges, 1920, *Monet, Pissarro, Sisley*

Paris 1922, Paris, Galerie Durand-Ruel, 23 January–18 February 1922, *Exposition de tableaux d'Alfred Sisley*
Paris, Galerie Paul Rosenberg, 3 May–3 June 1922, *Exposition d'OEuvres des Grands Maîtres du XIXe siècle*

Paris 1924, Paris, Galerie Knoedler, May 1924, *Exposition de Peintres de l'École française du XIXe siècle*
Paris, Jos. Hessel, 1924, *Sisley*

Paris 1925, Paris, Galerie Durand-Ruel, 5–24 January, *Oeuvres importantes de Monet, Pissarro, Renoir et Sisley*

Paris 1930, Paris, Galerie Durand-Ruel, 22 February–13 March 1930, *Tableaux de Sisley*
Paris, Galerie Georges Petit, June 1930, *Cent Ans de Peinture française*

Paris 1932, Paris, Galerie Durand-Ruel, February–March 1932, *Oeuvres importantes de Manet à Van Gogh*

Paris 1933, Paris, Galerie d'Art Braun, 30 January–8 February 1933, *Sisley*

Paris 1934, Paris, Galerie Durand-Ruel, 11 May–16 June 1934, *Quelques oeuvres importantes de Corot à Van Gogh*

Paris 1937, Paris, Galerie Durand-Ruel, 23 January–13 February 1937, *Alfred Sisley, 1839–1899*
Paris, Palais National des Arts, 1937, *Chefs d'Oeuvre de l'Art français*
Paris, Galerie de la Gazette des Beaux-Arts,, May 1937, *Naissance de l'Impressionnisme* (catalogue by Raymond Cogniat, Preface by André Joubin)

Paris 1939, Paris, Galerie Paul Rosenberg, 9 May–10 June 1939, *Exposition Sisley, 1839–1939*

Paris 1951, Paris, Orangerie des Tuileries, 1951, *Impressionnistes et Romantiques français dans les Musées allemandes*

Paris 1952, Paris, Musée du Petit Palais, 1952, *Chefs-d'Oeuvre de la Collection van Beuningen*

Paris 1955, Paris, Galerie Beaux-Arts, 22 April–31 May 1955, *Tableaux de Collections parisiennes, 1850–1950* (Preface by M. Boegner)

Paris 1953, Paris 1953, Musée du Petit Palais, 1953, *Un Siècle d'Art français 1850–1950*

Paris 1957, Paris, Galerie Durand-Ruel, 29 May–22 September 1957 *Sisley, 1839–1899* (catalogue Preface by Claude Roger-Marx)
Paris, Bibliothèque nationale, 1957, *Gustave Geffroy et l'art moderne*

Paris, Musée Jacquemart-André, 1957, *Le Second Empire*

Paris 1962, Paris, Musée National d'Art Moderne, 1962, *La Peinture française de Corot à Braque dans la collection Ishibashi de Tokyo*

Paris 1965, Paris, Bibliothèque Nationale, 1965, *Marcel Proust*

Paris 1965–66, Paris, Musée du Louvre, 1965–66, *Chefs-d'oeuvre de la peinture française dans les musées de Leningrad et de Moscou*

Paris 1974, Paris, Galerie Durand-Ruel, 37 avenue de Friedland, 15 January–15 March 1974, *Hommage à Durand-Ruel. Cent ans d'Impressionnisme* (catalogue Preface by G. Bazin, biography by J. Rewald)
Paris, Grand Palais, 21 September–24 Nov-

ember 1974, *Centenaire de l'Impressionnisme*

Paris 1977, Paris, Grand Palais, 1977, *Salon de la Société Nationale des Beaux-Arts*

Pau 1878, Pau, Musée de Pau, January 1878, *Salon de la Société Béarnaise des Amis des Arts*

Pau 1879, Pau, February 1879, *Société des Amis des Arts de Pau*

Philadelphia 1893, Philadelphia, 11–27 May 1893, *Union League of Philadelphia*

Philadelphia-Detroit-Paris 1979, Philadelphia, Philadelphia Museum of Fine Art, 1979; Detroit, Detroit Institute of Art; Paris, Grand Palais, 1979, *The Second Empire*

Pittsburgh 1895, Pittsburgh, Carnegie Institute, November–December 1895, *International Exhibition of Contemporary Painting*

Pittsburgh 1897–98, Pittsburgh, Carnegie Institute, 4 November–1 January 1898, *Second Annual Exhibition*

Pittsburgh 1898, Pittsburgh, Carnegie Institute, 4 November–31 December 1898, *Third Annual Exhibition*

Pittsburgh 1900, Pittsburgh, Carnegie Institute, November–December 1900, *Fifth Annual Exhibition*

Pittsburgh 1907, Pittsburgh, Carnegie Institute, November–December 1907 *Twelfth Annual Exhibition*

Pittsburgh 1910, Pittsburgh, Carnegie Institute, November–December 1910, *Fifteenth Annual Exhibition*

Pittsburgh 1959, Pittsburgh, Carnegie Institute, 1959, *Retrospective Exhibition of Paintings from Previous Internationals*

Pittsburgh-Kansas City-St Louis-Toledo 1989, Pittsburgh, Carnegie Institute, Minneapolis, Institute of Arts, Kansas City, Nelson Atkins Museum of Art, St Louis Art Museum; Toledo Museum of Art, 21 April–25 November, *Impressionism, Selections from Five American Museums*

Prague 1982, Prague, Valdstojnska Jizdarna, 1982, *De Courbet à Cézanne*

Reims 1948, Reims, Musée des Beaux-Arts, 1948, *La Peinture française au XIXème siècle, De Delacroix à Gauguin*

Rotterdam 1949, Rotterdam, Museum Boymans-van Beuningen 1949, *Chefs-d'Oeuvre de la Collection van Beuningen*

Rotterdam 1952, Rotterdam, Museum Boymans-van Beuningen, 1952, *Maîtres français du Petit Palais*

Rotterdam 1955, Rotterdam, Museum Boymans-van Beuningen, 19 June–25 September 1955, *Kunstschatten uit Nederlandse Verzamalingen*

Rouen 1884, Rouen, Hôtel du Dauphin et d'Espagne, June–August 1884, *Exposition Murer*

Rouen 1896, Rouen, Hôtel du Dauphin et d'Espagne, May 1896, *Exposition Murer*

Saint Louis 1893, Saint Louis, Saint Louis Exposition and Music Hall, February 1893, *10th Annual Exhibition*

Saint Louis 1894, Saint Louis, Saint Louis Exposition and Music Hall, February 1894, *11th Annual Exhibition*

Saint Louis 1895, Saint Louis, Saint Louis Exposition and Music Hall, February 1895, *12th Annual Exhibition*

Saint Louis 1896, Saint Louis, Saint Louis Exposition and Music Hall, February 1896, *13th Annual Exhibition*

Saint Louis 1904, *Universal Exposition*

San Francisco 1894, *California Mid-Winter International Exhibition*

San Francisco 1915, San Francisco, California Palace of the Legion of Honor, 1915, *Panama Pacific International Exposition, Fine Arts, French Section*

San Francisco 1938, San Francisco Museum of Art, 1938, *Exhibition of Impressionism*

San Francisco 1939, *Golden Gate Exhibition*

San Francisco 1939–40, San Francisco, California Palace of the Legion of Honor, December 1939–January 1940, *Seven Centuries of Painting*

San Francisco 1959, San Francisco, Palace of the Legion of Honor, 1959, *The Collection of Mr & Mrs William Goetz*

San Francisco-Toledo-Cleveland-Boston 1962, San Francisco, Palace of Legion of Honor, Toledo, Toledo Museum of Art, Cleveland, Cleveland Museum of Art, Boston, Museum of Fine Arts, 1962, *Barbizon Revisted*

San Francisco-Dallas-Minneapolis-Atlanta 1981, San Francisco, Palace of Legion of Honor; Dallas, Dallas Museum of Art; Minneapolis, Minneapolis Institute of Art; Atlanta, High Museum of Art, 1981–2, *Masterpieces from the Phillips Collection*

Schaffhausen 1963, Schaffhausen, Museum zu Allerheiligen, 1963, *Die Welt des Impressionisten*

Toronto-Montreal 1954, Toronto, Art Gallery of Toronto, 1954, Montreal, Montreal Museum of Fine Arts, 1954, *Paintings by European Masters from Public and Private Collections*

Tours 1882, Tours, 'Société des Amis des Arts de la Touraine', Hôtel de Ville, 1 October–1 November 1882, *Société des Amis des Arts de la Touraine*

Tokyo 1926, *5th France Gendai Bijutsu*

Tokyo 1932, *Seijo Kindai Kaiga*

Tokyo 1955, Tokyo, National Museum of Modern Art, 1955, *Kyosho no 20 dai*

Tokyo 1957, Tokyo, Bridgestone Gallery, 1957, *Mikokai Sakuhin*

Tokyo-Sapporo-Osaka-Yamaguchi-Nagoya-Tokyo, Ueno 1974, Tokyo, Ginza Matsuzakaya 1974, Sapporo Matsuzakaya, Osaka Matsuzakaya, Yamaguchi, Prefectural Museum, Nagoya, Matsuzakaya- Shizuoka, Tokyo, Ueno, Matsuzakaya, 1974, *Centenaire de l'impressionnisme*

Tokyo 1978, Tokyo, Japan Art Center, 1978, *Sisley*

Tokyo-Fukuoka-Nara 1985, Tokyo, Isetan Museum of Art; Fukuoka Art Museum, Nara Prefectural Museum, March–June 1985, *Retrospective Alfred Sisley* (Catalogue by Christopher Lloyd)

Tokyo-Yokohama-Toyohashi-Kyoto 1989–90, Tokyo, Nihonbashi Takashimaya, Yokohama, Yokohama Takashimaya, Toyahashi, Toyohashi City Art Museum, Kyoto, Kyoto Takashimaya, August 1989–January 1990, *French Masterpieces from the Ordrupgaard Collection in Copenhagen*

Venice 1938, Venice Biennale, 1938, *Impressionisti XXI Biennale*

Venice 1947, Venice, Biennale, 1947, *Impressionisti XXIV Biennale*

Vienna 1894, Vienna, Kunstlerhaus, March 1894, *International Exhibition of Art*

Vienna 1949, Vienna, Institut français, 1949, *Peintres français impressionnistes*

Warsaw 1956, Warsaw, Muzeum Narodowe, 1956, *From Courbet to Cézanne, 1848–1886, Works from French Museums*

Washington-New York-Los Angeles-Chicago-Fort Worth-Detroit 1973

Washington-San Francisco 1986, Washington, National Gallery of Art, 17 January–6 April 1986; San Francisco, The Fine Arts Museum of San Francisco, 19 April–6 July 1986, *The New Painting – Impressionism 1874–1886*

Winterthur 1955, Winterthur, Kunstmuseum, 12 June–24 July 1955, *Ausstellung Europäische Meister, 1790–1910* (Preface by Heinz Keller)

Wolfsburg 1961, Wolfsburg, Volkswagenwerk, Stadhalle, Wolfsburg, 1961, *Französische Malerei von Delacroix bis Picasso*

Zurich 1917, Zurich, Kunsthaus, 5 October–4 November 1917, *Französische Kunst des XIX. und XX. Jahrhunderts*

Zurich 1933, Zurich, Kunsthaus, 14 May–6 August 1933, *Französische Maler des 19. Jahrhunderts*

Zurich 1947, Zurich, Kunsthaus, 9 June–31 August 1947, *Quelques Oeuvres des Collections de la Ville de Paris*

Zurich 1950, Zurich, Kunsthaus, 6 June–13 August 1950, *Europäische Kunst 13.–20. Jahrhunderts*

Zurich 1958, Zurich, Kunsthaus, 7 June–30 September 1958, *Sammlung E.G. Bührle*

INDEX

Numbers in **bold** refer to the pages of catalogue entries of works exhibited. Figures are indicated by (fig.) after page number. When works by Sisley are not followed by a D number, their precise identification remains uncertain.

PHOTOGRAPHIC CREDITS

Numbers in **bold** refer to catalogue entries, all others refer to comparative illustrations.

Archives Skira 136
Arthothek, Joachim Blauel **27**
Basel, Colourphoto Hans Hinz **61**
Bern, Peter Lauri **75**
Boston, Museum of Fine Arts, © **10**, **52**, 104
Chicago, The Art Institute, © **33**; Joseph Winterbotham Collection 23; Potter Palmer Collection 51; Charles and Mary F.S. Worcester Collection 61; Gift of Mrs Clive Runnells 102; Coburn Memorial Collection 140.
Chicago Historical Society 49, 50
Cologne, Rheinisches Bildarchiv **25**
Copenhagen, Hans Petersen **16**, **20**
Copenhagen, Ole Woldbye **3**, **45**

Dallas, Tom Jenkins **22**
Detroit, Institute of Arts c 1991 **71E**
H.M. The Queen 19, 21
Hamburg, Elke Walford Fotowerkstatt 57
London Borough of Richmond-upon-Thames 22
London, Bridgeman Art Library **35**
London, Prudence Cumming Associates Ltd **62**
London, Tate Gallery **47**
Montreal, Museum of Fine Arts, Brian Merrett **53**
New York, Noel Allum Photography **32**
New York, Helga Photo Studio **44**
New York, The Metropolitan Museum of

Art **14**, **72**
Norwich, Norfolk Museum Service **11**
Paris, Bernard Silag (Monjarret) 45
Paris, Lauros-Giraudon 154
Paris, Librairie Hachette 159
Paris, Musée d'Orsay, © RMN **9**, **17**, **19**, **29**, **37**, **38**, **46**, **68**, **69**, **70**
Paris, Musée d'Orsay, Patrice Schmidt, Service de Documentation 148, 152, 156, 157, 164
Paris, Musée d'Orsay, on deposit at the Musée Fabre, Montpellier, © RMN **7**
Paris, Musées de la Ville de Paris, © by SPADEM 1992 **2**, **71G**
Paris, © RMN 8, 9, 10, 26, 66, 72, 101, 107,

108, 111, 113, 114, 115, 116, 122, 123, 124, 129, 134, 137, 143, 150, 160
Paris, Société Française de Photographie 133
Richmond, VA, Virginia Museum of Fine Arts, © 1991 **42**, 74
Stockholm, Erik Cornelius, Statens Konstmuseer 135
Washington, DC, The Phillips Collection **31**
Williamstown, Clark Art Institute, © 1991 **43**, **48**
Zurich, Foto Studio H. Humm **71F**
Zurich, Walter Dräyer **36**

All other photographs were provided by the owners of the works.